Stained Glass
in England during
the Middle Ages

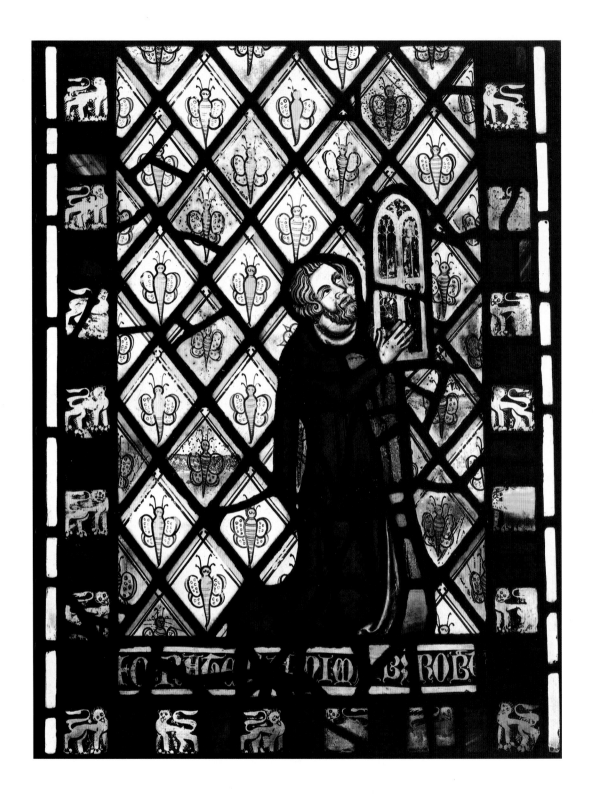

Frontispiece YORK, ST DENYS WALMGATE: donor—almost certainly—Robert Skelton, *c.*1350

Stained Glass
in England during
the Middle Ages

Richard Marks

University of Toronto Press
Toronto and Buffalo

First published in North America in 1993 by
University of Toronto Press Incorporated
Toronto and Buffalo

First published in the UK in 1993
by Routledge
11 New Fetter Lane, London EC4P 4EE

Typeset in 10½/11pt Perpetua, Scantext by Leaper & Gard Ltd, Bristol

Printed in Great Britain by Butler & Tanner Ltd, Frome and London

Printed on paper in accordance with the proposed
ANSI/NISO Z 39.48-199X and ANSI Z 39.48-1984

Canadian Cataloguing in Publication Data
Marks, Richard,
Stained Glass in England during the Middle Ages
Includes bibliographical references and index.
ISBN 0-8020-0592-6
1. Glass painting and staining, Medieval –
England. I. Title.
NK5343.M37 1993 748.592 C93-093941-7

For Rita

Contents

List of Colour Plates .. ix

List of Figures ... xi

Window Notation .. xx

Abbreviations .. xxi

Acknowledgments ... xxii

Introduction .. xxiv

Part I: Donors, Technique, Iconography, Domestic Glass

1 Donors and Patrons ... 3

2 The Technique of Medieval Glass-painting and the Organization of Workshops 28

3 The Iconography of English Medieval Windows 59

4 Domestic Glass ... 92

Part II: Chronological Survey

5 The Earliest English Stained Glass *c.*670–1175 105

6 Stained Glass *c.*1175–1250 ... 113

7 The Decorated Style *c.*1250–1350 141

8 The International Style *c.*1350–1450 166

9 The End of the Middle Ages ... 190

10 The Dominance of the Foreign Glaziers 205

11 The Reformation and After ... 229

Notes .. 247

Select Bibliography ... 280

Index ... 287

Colour Plates

Between pages 102 and 103

Unless otherwise stated the plates are reproduced by kind permission of the Royal Commission on the Historical Monuments of England.

Frontispiece YORK, ST DENYS WALMGATE: donor – almost certainly Robert Skelton, *c.* 1350.

Plates

I Virgin and Child, panels taken from the same cartoon: (*above*) FLADBURY; (*below*) WARNDON (Heref. & Worcs.), *c.* 1330-40.

II Aspects of the glazier's craft:
(a) detail of De Vere shield of arms from FAWSLEY HALL (Northants.) now in the Burrell Collection, Glasgow, showing *rinceaux* picked out on a wash ground and applied with a brush and the molet produced by abrading the ruby, 1537-42 (*R. Marks*);
(b) female head from the Seven Sacraments window at TATTERSHALL (Lincs.), 1482 (see also plate III) with hair and ear applied on the reverse of the glass (*Keith Barley*);
(c) imitation jewelled glass inserts in the mitre of St Thomas Becket at the BEAUCHAMP CHAPEL, WARWICK, 1447-64 (see also plate III) (*R. Marks*);
(d) medieval repairs to the Virgin and Child in WINCHESTER COLLEGE CHAPEL, *c.* 1393 (see also plate XIX) (*R. Marks*).

III Types of fifteenth-century glazing and their costs per square foot:
(a) ODDINGLEY (Heref. & Worcs.): St Martin, *c.* 1461-95 (probably 8d–10d per square foot) (*R. Marks*);
(b) STOCKERSTON (Leics.): St Clement, *c.* 1470-85 (probably 1s per square foot) (*York Glaziers Trust*);
(c) TATTERSHALL (Lincs.): Baptism from a Seven Sacraments window, 1482 (1s 2d per square foot);
(d) WARWICK, BEAUCHAMP CHAPEL: St Thomas Becket, 1447-64 (2s per square foot) (*R. Marks*).

IV (*above*) JARROW (Tyne & Wear): excavated window glass set in a chancel Saxon window, after 682, before *c.* 867; (*below*) WINCHESTER (Hants.): painted window glass from various sites, eleventh/early twelfth centuries (*British Museum*).

V YORK MINSTER: scene from the legend of St Nicholas, *c.* 1170-90 (see also Fig. 90).

VI CANTERBURY CATHEDRAL (Kent): Aminadab from the genealogy of Christ series, *c.* 1180-1205.

List of Colour Plates

VII CANTERBURY CATHEDRAL (Kent), Corona: the Virgin from a Tree of Jesse window, *c.* 1200.

VIII (a) BRABOURNE (Kent): ornamental window in coloured glass, *c.* 1175 (*R. Marks*);
(b) EASBY (N. Yorks.): St John the Evangelist, *c.* 1180–90 (*R. Marks*);
(c) ELY STAINED GLASS MUSEUM: grisaille and coloured glass window (on loan from Alf Fisher), *c.* 1200–50.

IX (*above*) DORCHESTER (Oxon.): Archbishop Asterius blessing St Birinus, *c.* 1225; (*below*) WESTMINSTER ABBEY, Undercroft Museum: stoning of St Stephen(?), *c.* 1246–59.

X GLASGOW, BURRELL COLLECTION: Beatrix van Valkenburg, *c.* 1270–80 (*Burrell Coll.*).

XI YORK MINSTER, nave north aisle: Bellfounders window, *c.* 1325.

XII OXFORD, MERTON COLLEGE CHAPEL: donor Henry de Mamesfeld, *c.* 1294.

XIII EXETER CATHEDRAL (Devon), choir east window: prophet Isaiah (borders, base, canopy and almost all of side-shafts 1884-96), 1301–4 (*Sonia Halliday and Laura Lushington*).

XIV WELLS CATHEDRAL (Somerset): heads in Lady Chapel tracery lights, *c.* 1325 (*R. Marks*).

XV (*above*) YORK, YORKSHIRE MUSEUM: head of a king, *c.* 1335–50 (*David O'Connor*); (*below*) GLASGOW, BURRELL COLLECTION: arms of Somery, *c.* 1330–50 (*Burrell Coll.*).

XVI YORK MINSTER, nave west window: St John the Evangelist (detail), 1339.

XVII ELY CATHEDRAL (Cambs.), Lady Chapel: canopy with niche figures, *c.* 1340–9.

XVIII TEWKESBURY ABBEY (Glos.), choir clerestory: holders of the honour of Tewkesbury, *c.* 1340–4.

XIX WINCHESTER COLLEGE CHAPEL (Hants.): William of Wykeham (head modern) kneeling before the Virgin and Child, *c.* 1393.

XX YORK MINSTER: scene from the St William window, *c.* 1415.

XXI THURCASTON (Leics.): detail of rector John Mersden (d. 1425) (*P. Newton*).

XXII LUDLOW (Salop): Creed window, *c.* 1445–50 (*R. Marks*).

XXIII TATTERSHALL (Lincs.): St Helena presenting part of the True Cross to the Emperor Constantine, 1482 (*Keith Barley*).

XXIV GLASGOW, BURRELL COLLECTION: Labour of the Month roundel (February) from the former parsonage of St Michael-at-Coslany, Norwich, *c.* 1450–60 (*Burrell Coll.*).

XXV GLASGOW, BURRELL COLLECTION: Princess Cecily from the 'Royal' window in Canterbury Cathedral, *c.* 1482–7 (*Burrell Coll.*).

XXVI FAIRFORD (Glos.): Transfiguration (detail) from chancel south chapel east window, *c.* 1500–15.

XXVII FAIRFORD (Glos.): Hell from the Last Judgement in the west window (detail), *c.* 1500–15 (*R. Marks*).

XXVIII CAMBRIDGE, KING'S COLLEGE CHAPEL, nave north side: a golden table offered to Apollo, 1515–17 (*King's College*).

XXIX CAMBRIDGE, KING'S COLLEGE CHAPEL, nave north side: Joachim with his shepherds and flocks, 1527 (*King's College*).

XXX GOODNESTONE-NEXT-FAVERSHAM (Kent): Thomas Fisher's drawing of fourteenth-century glass formerly in the east window (BL MS Add. 32363, fol. 118), *c.* 1800 (*British Library*).

Figures

Unless otherwise stated the figures are reproduced by kind permission of the Royal Commission on the Historical Monuments of England.

Figures
1 YORK MINSTER, nave north aisle: Richard Tunnoc, goldsmith and bellfounder, presenting his window to St William of York, *c.* 1325. 5

2 Donors by social class: 7
 (a) The parish priest: ALDWINCLE (Northants.), St Peter's church: William de Luffwyk, rector 1335-80;
 (b) The lord of the manor: John de Newmarch at CARLTON SCROOP (Lincs.), *c.* 1307;
 (c) Merchants: wine-sellers in the nave north clerestory of YORK MINSTER, early fourteenth century;
 (d) Nobility: TEWKESBURY ABBEY (Glos.), choir clerestory east window: female donor (probably Eleanor de Clare, d. 1337), *c.* 1340-4.

3 MIDDLETON (Greater Manchester): archers and their chaplain, dated 1505 (*David O'Connor*). 8

4 ST NEOT (Cornwall): nave north aisle window given by the wives from the western part of the parish, dated 1523. The wives kneel below the *Pietà*, Christ and two Cornish saints, Mabena and Meubred. 9

5 WESTMINSTER ABBEY, St Edmund's Chapel: arms of Cornwall, *c.* 1254-59. 10

6 UPPER HARDRES (Kent): the Virgin and Child between donors Philip and Salomon, *c.* 1250. 10

7 MELBOURNE, NATIONAL GALLERY OF VICTORIA: Sir John de Hardreshull (d. *c.* 1365) and his wife Margaret from Merevale (Warwicks.), *c.* 1350 (*National Gallery of Victoria*). 11

8 WELLS CATHEDRAL (Somerset), choir south aisle: donor kneeling before Christ on the Cross, *c.* 1310-20. 12

9 HELMDON (Northants.): William Campiun, stonemason, *c.* 1313. 13

10 WATERPERRY (Oxon.): Walter Curson (d. 1527) and his sons. 13

11 (*left*) Sir Reginald Bray (d. 1503) from the *Magnificat* window in the north transept façade of GREAT MALVERN PRIORY (Heref. & Worcs.), *c.* 1501-2; (*right*) Richard Beauchamp, Earl of Warwick (d. 1439) (head replaced by that of one of his daughters/wives) from the BEAUCHAMP CHAPEL, WARWICK, 1447-64 (*G. King & Son*). 14

12 (*above*) DRAYTON BASSET (Staffs.): Ralph, Lord Basset (d. 1342/3) and his wife Joan with his squire and horse. Formerly in the east window (Dugdale's *Book of Monuments*, BL Loan MS 38, fols 60v and 61r) (*British Library and the Trustees of the Winchelsea Settled Estates*); (*below*) Sir Geoffrey Luttrell (d. 1345), his wife and daughter-in-law in the *LUTTRELL PSALTER* (BL MS Add. 42130, fol. 202v) (*British Library*). 15

13 Ross-on-Wye (Heref. & Worcs.): Bishop Spofford (1421–48) before St Anne and the Virgin. 16

14 West Wickham (Kent): Sir Henry Heydon (d. 1503/4) as a skeleton, c. 1490–1500 (*Nigel Morgan*). 17

15 Badges and devices: (*above*) Tattershall (Lincs.): roundels with Yorkist and religious devices and the badge of Ralph, Lord Cromwell, c. 1480–2; (*below*) merchant's mark, initials and barrel rebus of John Barton (d. 1491) at Holme-by-Newark (Notts.) (*R. Marks*). 18

16 Glasgow, Burrell Collection: quarry bearing the device of Abbot John Islip (1500–32) (*Burrell Coll.*). 19

17 Glasgow, Burrell Collection: arms within garter of Sir Henry Fitzhugh (d. 1424) (*Burrell Coll.*). 20

18 Stanford on Avon (Northants.): Henry Williams and his 'ymage of deth' roundel, c. 1500 (*Keith Barley*). 21

19 Instructions for glazing the Observant Friars' church at Greenwich (BL MS Egerton 2341a), c. 1490–4 (*British Library*). 23

20 Instructions and rough drawings of Thomas Froxmere and his wife (BL MS Lansdowne 874, fol. 191), c. 1484–98 (*British Library*). 24

21 Edinburgh, National Galleries of Scotland: *vidimus* for a 13-light window; penwork and colour washes, c. 1525–6 (*Nat. Galleries of Scotland*). 26

22 Glass-making depicted in an early fifteenth-century Bohemian manuscript of Sir John Mandeville's *Travels* (BL MS Add. 24189, fol. 16) (*British Library*). 29

23 Medieval glass-house excavated at Blunden's Wood, Hambledon (Surrey). *After E.S. Wood.* 29

24 *The Pepysian Sketchbook* (Cambridge, Magdalene Coll. Pepysian MS 1916) and parallels in stained glass: 32–3
 (a) Penwork and coloured wash birds, end of fourteenth century (*Magdalene College*);
 (b) Salehurst (East Sussex): bird in grisaille, c. 1400 (*R. Marks*);
 (c) Canopy section, sacred monogram and Virgin and Child, late fifteenth century (*Magdalene College*);
 (d) Stamford, St John's Church (Lincs.): canopy, c. 1451 (*York Glaziers Trust*).

25 Gerona Cathedral (Spain): glaziers' whitewashed table with designs for a canopy and a trelliswork ground, early fourteenth century (*Ramon Roca Junyent*). 34

26 York, two versions of the Holy Trinity, c. 1470, probably taken from the same cartoon: (*left*) St Martin-le-Grand, Coney Street; (*right*) Holy Trinity Goodramgate. 35

27 Helmdon (Northants.): medieval leading from the William Campiun stonemason panel (Fig. 9), c. 1313. 36

28 Wells Cathedral (Somerset): glaziers' position marks, early fourteenth century. *From JBSMGP, vol. IV (1931–2).* 37

29 Canterbury Cathedral (Kent): design of armatures, late twelfth–early thirteenth centuries. *After M. H. Caviness.* 38

30 The arms of two leading medieval glazing guilds: (*left*) London, Worshipful Company Of Glaziers & Painters Of Glass: London Glaziers' Company, fifteenth century (*R. Marks*); (*right*) York, St Helen's Stonegate: the York Guild of Glass-Painters, early sixteenth century with later repairs. 43

31 Three leading late medieval glass-painters: 45
 (a) Winchester College Chapel (Hants.): 1822 copy in east window of the original figure of Thomas Glazier of Oxford;
 (b) Winchester Westgate (Hants.): arms of Henry Smart (active 1457–72), with grozing irons in saltire (*R. Marks*);
 (c) Figure of John Petty (d. 1508) formerly in a York Minster south transept window drawn by Henry Johnston in 1669–70 (Oxford, Bodl. Lib. MS Top. Yorks C14, fol. 74r) (*Bodleian Library, Oxford*).

32 ELY CATHEDRAL (Cambs.), Lady Chapel interior looking west, 1321-49. 52
33 Micro-architecture in various media: 53
 (a) HARDINGSTONE (Northants.): Eleanor Cross, 1291-3;
 (b) WESTMINSTER ABBEY: niche figures on the tomb-chest of Edmund Crouchback, Earl of
 Lancaster (d. 1296);
 (c) BRITISH MUSEUM, Dept. of Medieval & Later Antiquities: earthenware tiles of an
 archbishop made at Chertsey Abbey (Surrey) for Westminster Abbey, c. 1293-8 (*British
 Museum*).
 (d) ELY, STAINED GLASS MUSEUM: St Catherine from Wood Walton (Cambs.), c. 1310-30.
34 WING (Bucks.): tracery of the south aisle east window and the Coronation of the Virgin from
 this window, early fourteenth century (*R. Marks*). 54
35 DORCHESTER (Oxon.): Tree of Jesse window, early fourteenth century (*Conway Library,
 Courtauld Institute of Art,* © *Canon M.H. Ridgway*). 55
36 Recurrent designs in tiles and stained glass: (*above*) tile from CHERTSEY ABBEY (Surrey) and
 grisaille at LINCOLN CATHEDRAL, thirteenth century. *After E. Eames and J. Kerr*; (*below*) ape
 holding urine flask on a tile in the BRITISH MUSEUM and in a nave north aisle window in YORK
 MINSTER, early fourteenth century. *After E. Eames.* 56
37 Similarly posed knights in a side-shaft of a YORK MINSTER choir clerestory window, c. 1340
 (*left*) and on the brass of Sir Hugh Hastings (d. 1347) at ELSING (Norfolk) (*right*). *The latter after
 P. Binski.* 56
38 BUILDWAS ABBEY (Salop): tile mosaic pavement, c. 1300-50. *After Eames & Keen.* 57
39 WINDSOR, ST GEORGE'S CHAPEL (Berks.): kings painted on wooden panels, c. 1493 (*St George's
 Chapel, Windsor*). 57
40 (*left*) *THE HOURS OF ELIZABETH THE QUEEN* (BL MS Add. 50001, fol. 7): Last Supper miniature by
 Johannes, 1420-30 (*British Library*); (*right*) YORK MINSTER, choir north aisle: St Paulinus of York
 with initials of Robert Wolveden in the border, c. 1426-32. 58
41 YORK MINSTER: St Cuthbert with the monks of Farne from the St Cuthbert window, c. 1435-45. 60
42 GREAT MALVERN PRIORY (Heref. & Worcs.): SS George and Christopher from the nave north
 clerestory, c. 1480. 62
43 WEST WICKHAM (Kent): St Anne teaching the Virgin to read, c. 1490-1500 (*Nigel Morgan*). 63
44 OXFORD, ALL SOULS COLLEGE CHAPEL: St Sidwell, c. 1441. 64
45 OXFORD, ALL SOULS COLLEGE CHAPEL: Holy Kindred, c. 1441. 66
46 Two late medieval images: (*left*) *Pietà* from the nave north clerestory at LONG MELFORD
 (Suffolk), late fifteenth century; (*right*) Lily crucifix at WESTWOOD (Wilts.), late fifteenth
 century. 67
47 GREAT MALVERN PRIORY (Heref. & Worcs.): Creation of the World, c. 1480-90. 68
48 (*above*) STAMFORD, ST MARTIN'S CHURCH (Cambs.): Moses striking the rock, Samson carrying
 the gates of Gaza, and David and Goliath from the chancel glazing of Tattershall (Lincs.),
 c. 1466-80; (*below*) corresponding scenes from the Netherlandish block-book edition of the
 BIBLIA PAUPERUM, c. 1464-5. 69
49 MARGARETTING (Essex): prophets from a Tree of Jesse, late fifteenth century. 70
50 Scenes from the life of the Virgin in YORK MINSTER, c. 1340: (*left*) Annunciation to Joachim or to
 the shepherds in the nave south aisle; (*right*) Death of the Virgin in the Lady Chapel clerestory. 71
51 BECKLEY (Oxon.): St Thomas receiving the Virgin's girdle, c. 1325-50. 72
52 MORLEY (Derbyshire): scene from the life of St Robert of Knaresborough (formerly in the
 cloisters of Dale Abbey), c. 1480-1500 (*R. Marks*). 73
53 GREYSTOKE (Cumbria): scene from the life of St Andrew, late fifteenth century (*Conway Library,
 Courtauld Institute of Art,* © *Canon M.H. Ridgway*). 73
54 YORK, ST MARTIN-LE-GRAND, CONEY STREET: St Martin with a devil, c. 1442. 74
55 DRAYTON ST LEONARD (Oxon.): St Leonard, c. 1350 (*R. Marks*). 74

56 STANFORD ON AVON (Northants.): St Anne teaching the Virgin to read, *c.* 1325–40. Watercolour by C. Winston, 1835 (BL MS Add. 35211) (*British Library*). — 75

57 OXFORD, CHRIST CHURCH CATHEDRAL, Lucy Chapel: martyrdom of St Thomas Becket, early fourteenth century. — 76

58 CREDENHILL (Heref. & Worcs.): St Thomas Becket and St Thomas Cantilupe, *c.* 1300. — 77

59 YORK MINSTER choir south transept clerestory: Archbishop Scrope, early fifteenth century. — 77

60 DRAYTON BEAUCHAMP (Bucks.): St Thomas from an Apostles' Creed window, *c.* 1420–30 (*R. Marks*). — 79

61 TATTERSHALL (Lincs.): Clothing the Naked from a Corporal Works of Mercy window, *c.* 1480–2. — 80

62 STANFORD ON AVON (Northants.): warning against idle gossip, *c.* 1325–40 (*Keith Barley*). — 80

63 WELLS CATHEDRAL (Somerset): resurrection of the dead from the Last Judgement, *c.* 1338–45. — 81

64 TICEHURST (East Sussex): fragments of a Last Judgement window, *c.* 1425–50. — 82

65 YORK MINSTER, east window: St John and the Seven Churches of Asia, 1405–8. — 83

66 YORK, ALL SAINTS NORTH STREET: Death and Mourning from the *Pricke of Conscience* window, early fifteenth century. — 84

67 NORWICH, ST ANDREW'S: Death and a bishop or abbot, late fifteenth or early sixteenth century. — 84

68 GLASGOW, BURRELL COLLECTION: angel with *Te Deum* scroll. East Anglia, *c.* 1450–1500 (*Burrell Coll.*). — 85

69 Angels holding scrolls with antiphons: (*left*) BUCKDEN (Cambs.), *c.* 1436–49 (*C. Woodforde*); (*right*) WARWICK, BEAUCHAMP CHAPEL, 1447–64 (*G. King & Son*). — 86

70 (*above*) STANTON ST JOHN (Oxon.): Funeral of the Virgin, *c.* 1300–10; (*below*) YORK MINSTER, nave north aisle: monkey's funeral, *c.* 1320–30. — 87

71 GLOUCESTER CATHEDRAL, choir east window: king (detail), *c.* 1350–60. — 88

72 STOTTESDON (Salop): head of knight, early fourteenth century (*Conway Library, Courtauld Institute of Art*). — 90

73 STAMFORD, ST GEORGE'S CHURCH (Lincs.): Sir John Lisle as depicted in one of the Garter windows, *c.* 1450. (Dugdale's *Book of Monuments*, BL Loan MS 38, fol. 158) (*British Library and the Trustees of the Winchelsea Settled Estates*). — 90

74 GREAT MALVERN PRIORY (Heref. & Worcs.): St Wulfstan presenting a charter to Prior Aldwin, *c.* 1460. — 91

75 EAST HADDESLEY (N. Yorks.): reconstruction of excavated window, *c.* 1325–50. *After H.E.J. Le Patourel.* — 94

76 OCKWELLS (Berks.): glazing of the great hall, *c.* 1460 (*Country Life*). — 95

77 EARSDON (Northumberland): glazing from the great hall of Hampton Court, 1532–3 (*David O'Connor*). — 96

78 FAWSLEY HALL (Northants.): glazing of the great hall, 1537–42 (*Country Life*). — 98

79 LEICESTER MUSEUM: Extreme Unction from a Seven Sacraments series in 18 Highcross Street, *c.* 1500. — 99

80 Two complete domestic lights: (*left*) 18 Highcross Street, LEICESTER, *c.* 1500 (*Leicester Museums*); (*right*) OXFORD, MERTON COLLEGE, window in the Old Library, early fifteenth century. — 100

81 OXFORD, ALL SOULS COLLEGE: Henry V from the Old Library glazing (now in the chapel), mid-fifteenth century (*R. Marks*). — 101

82 STAMFORD, BROWNE'S HOSPITAL (Lincs.): Solomon and William Browne's device in the Audit Room glazing, *c.* 1485–90 (*G. King & Son*). — 102

83 JARROW (Tyne & Wear): church window, late seventh century (*R. Marks*). — 106

84 Crucifixion in an Anglo-Saxon psalter (BL MS Cotton Tiberius C.VI, fol. 13r), *c.* 1060 (*British Library*). — 107

85 CANTERBURY CATHEDRAL (Kent): Abia from the genealogy of Christ in the clerestory (head modern), *c.* 1130–60(?). — 110

86 DALBURY (Derbys.): St Michael, *c.* 1100–35(?). — 111

87 POLING (W. Sussex): remains of oak window shutter, eleventh–twelfth century. *From Sussex Arch. Colls., vol. LX (1919).* 112

88 YORK MINSTER, Crypt Exhibition: king from a Tree of Jesse, *c.*1180–90. 114

89 YORK MINSTER, nave north clerestory: borders, *c.*1170–90. 115

90 YORK MINSTER: scene from the legend of St Nicholas, *c.*1170–90. This photograph was taken in 1967, before the panel was restored (see also plate V). 116

91 (*left*) YORK MINSTER, nave south clerestory: Miraculous Draught of Fishes, *c.*1170–90; (*right*) *GOUGH PSALTER* (Oxford, Bodl. Lib. MS Gough Liturg. 2, fol. 20): Marriage at Cana, *c.*1170–5 (*Bodleian Library, Oxford*). 117

92 CANTERBURY CATHEDRAL (Kent): choir and Trinity Chapel looking east; 1175–84 (*Walter Scott (BRADFORD) Ltd.*). 118

93 CANTERBURY CATHEDRAL (Kent), two figures from the genealogy of Christ series; (*left*) Lamech, *c.*1175–80; (*right*) Hezekiah, after 1213, probably *c.*1220. 119

94 CANTERBURY CATHEDRAL (Kent), north choir aisle: Christ leading the Gentiles away from pagan gods in the typological cycle, *c.*1175–80 (*Victoria and Albert Museum*). 120

95 CANTERBURY CATHEDRAL (Kent), north choir aisle: sower on stony ground from the typological windows, *c.*1175–80. 121

96 CANTERBURY CATHEDRAL (Kent), Trinity Chapel: boy saved from drowning from the Becket miracle windows, *c.*1213–20. 122

97 Detail from the *GUTHLAC ROLL* (BL MS Harley Roll Y.6), penwork with colour washes, *c.*1210 (*British Library*). 125

98 LINCOLN CATHEDRAL: (*left*) north choir aisle: two scenes from the Miracles of the Virgin, *c.*1220–30; (*right*) St Peter, probably mid-thirteenth century. 126

99 GRATELEY (Hants.): martyrdom of St Stephen from Salisbury Cathedral, *c.*1220–5 (*G. King & Son*). 127

100 ABBEY DORE (Heref. & Worcs.): grisaille design formed by the leading, *c.*1180–1250 (*R. Marks*). 128

101 Grisaille designs formed by leading: 130
 (a,b) SALISBURY CATHEDRAL (Wilts.). Watercolours by C. Winston, 1849 (BL MS Add. 35211), 1220–58 (*British Library*);
 (c,d) YORK MINSTER, late twelfth or early thirteenth century.

102 Three thirteenth-century painted grisaille designs: 131
 (a) LINCOLN CATHEDRAL (*after J. Kerr*);
 (b) SALISBURY CATHEDRAL (Wilts.). Watercolour by C. Winston, 1856 (BL MS Add. 35211) (*British Library*);
 (c) WESTMINSTER ABBEY. Watercolour (*Victoria and Albert Museum*);
 (d) CHALGRAVE (Beds.): nave capital, early thirteenth century (*R. Marks*).

103 Early thirteenth-century painted grisaille designs from: (*left*) LINCOLN CATHEDRAL (*after J. Kerr*); (*right*) AUXERRE CATHEDRAL (*after E.E. Viollet-le-duc*). 132

104 Early thirteenth-century painted grisaille lancets in parish churches: 132
 (a) WESTWELL (Kent);
 (b) STOWBARDOLPH (Norfolk);
 (c) STOCKBURY (Kent);
 Watercolours by C. Winston, (a) 1843, (b) 1853, (c) 1852 (BL MS Add. 35211) (*British Library*).

105 YORK MINSTER, painted grisaille: (*left*) in the south transept, *c.*1220–41; (*right*) in the Five Sisters window, *c.*1250 (from an etching by J. Browne). 133

106 WESTMINSTER ABBEY, Undercroft Museum: miracle of St Nicholas, *c.*1246–59. 134

107 (*left*) EDENHALL (Cumbria): bishop (St Cuthbert?), early thirteenth century; (*right*) Frontispiece to BEDE'S *LIFE OF ST CUTHBERT* (BL MS Yates Thompson 26, fol. Iv), *c.*1200 (*British Library*). 137

108 (*left*) HASTINGLEIGH (Kent): lancet window with the grisaille design formed by leading, thirteenth century (*R. Marks*); (*right*) WESTWELL (Kent): Tree of Jesse, *c.*1220. 138

109 WEST HORSLEY (Surrey): martyrdom of St Catherine, *c.* 1225-50. Watercolour by C. Winston, 1849 (BL MS Add. 35211) (*British Library*). 139

110 ASTLEY ABBOTS (Salop): Christ (drapery much restored), early thirteenth century (*Conway Library, Courtauld Institute of Art*). 140

111 CHETWODE (Bucks.): St John the Baptist and grisaille, after 1245, probably *c.* 1270-80. 142

112 EAST TYTHERLEY (Hants.): Christ, *c.* 1260-70. 142

113 SALISBURY CATHEDRAL (Wilts.): bishop and king from the chapter house, *c.* 1265-70(?). 143

114 (*left*) STANTON HARCOURT (Oxon.): St James the Greater and grisaille, *c.* 1260-75. Engraving by C. Winston; (*right*) BRYN ATHYN, USA, PITCAIRN COLLECTION: grisaille from the chapter house of Salisbury Cathedral, *c.* 1265-70(?) (*Metropolitan Museum of Art*). 144

115 (*left*) OXFORD, ST MICHAEL'S CHURCH: St Edmund of Abingdon, *c.* 1260-90; (*right*) HOLDENBY (Northants.): Coronation of the Virgin, *c.* 1285-95. 145

116 YORK MINSTER: chapter house, *c.* 1285-90. 146

117 YORK MINSTER, chapter house: grisaille and borders, *c.* 1285-90. Etching by J. Browne. 147

118 WELLS CATHEDRAL (Somerset): grisaille in a chapter house vestibule window, *c.* 1286 (*Victoria and Albert Museum*). 147

119 STANTON ST JOHN (Oxon.): grisaille and heraldic glass, *c.* 1285-1300. 148

120 SELLING (Kent): east window, 1299-1307. 149

121 The triumph of naturalistic foliage: sections of grisaille and borders in two chancel windows at CHARTHAM (Kent), *c.* 1293-4 and *c.* 1300. Engraving and watercolour by C. Winston, 1841 and 1843 (BL MS Add. 35211) (*British Library*). 150

122 The development of the third dimension: (*left*) king in the chapter house vestibule of YORK MINSTER, *c.* 1290-5; (*right*) St Gregory in the choir clerestory of WELLS CATHEDRAL (Somerset), *c.* 1338-45. 151

123 Types of window composition: (*above*) the band window, detail with figures of Henry de Mamesfeld flanking an apostle in MERTON COLLEGE CHAPEL, OXFORD, *c.* 1294; (*below*) grisaille and heraldry in the chancel windows at NORBURY (Derbys.), early fourteenth century. 152

124 Birds and beasts: (*left*) birds in the borders of an excavated window at BRADWELL ABBEY (Bucks.), *c.* 1270(?). *After J. Kerr*; (*right*) border hybrids from a nave window at STANFORD ON AVON (Northants.), *c.* 1325-40. Watercolour by C. Winston, 1835 (BL MS Add. 35211) (*British Library*). 155

125 Contrasting styles in early fourteenth-century Northamptonshire glass: (*left*) Jacob from a Jesse Tree at LOWICK (*R. Marks*); (*right*) Nativity at BARBY (most of centre section restored). 156

126 (*left*) *HOURS OF JEANNE D'EVREUX* (New York, Cloisters Museum 54.1.2, fol. 16): Annunciation, *c.* 1325-8 (*Metropolitan Museum of Art*); (*right*) YORK MINSTER, nave south aisle: Annunciation, *c.* 1340. 159

127 ELY CATHEDRAL (Cambs.), Lady Chapel: angel musician, *c.* 1340-9. 160

128 (*left*) KINGERBY (Lincs.): St Catherine, *c.* 1345-50 (*Christopher Dalton*); (*right*) Psalm initial in a psalter (Oxford, Bodl. Lib. MS Liturg. 198, fol. 76v), *c.* 1340-50 (*Bodleian Library, Oxford*). 161

129 WESTMINSTER, ST STEPHEN'S CHAPEL: remains of glazing as illustrated by J.T. Smith, 1349-*c.* 1352. 161

130 Two figures by a West Midlands workshop, *c.* 1330-50: (*left*) St Catherine (detail) in the Latin Chapel of CHRIST CHURCH CATHEDRAL, OXFORD; (*right*) Virgin Annunciate (detail) from HADZOR (Heref. & Worcs.) on loan to the Stained Glass Museum at Ely. 162

131 BRISTOL CATHEDRAL (Avon), cloisters: king from the east window Tree of Jesse, *c.* 1340 (*R. Marks*). 162

132 GLOUCESTER CATHEDRAL: choir and east window, *c.* 1350. 163

133 (*left*) GLOUCESTER CATHEDRAL, choir east window: Virgin, *c.* 1350-60; (*right*) *DE LISLE PSALTER* (BL MS Arundel 83, fol. 134v): Coronation of the Virgin, *c.* 1330-9 (*British Library*). 164

134 EDINGTON (Wilts.): Virgin from Crucifixion group, 1358-*c.* 1361 (*R. Marks*). 167

135 HEYDOUR (Lincs.): SS Edward the Confessor, George and Edmund under canopies, *c.*1360
(*Conway Library, Courtauld Institute of Art*). 168

136 Canopy designs (left to right): OPPENHEIM (Germany): Judgement of Solomon window (detail)
*c.*1330–40 (*CVMA Germany*); WICKHAMBREAUX (Kent): beheading of St John the Baptist, *c.*1360
(*Conway Library, Courtauld Institute of Art*); PSALTER (BL MS Royal 13. D i*, fol. 16v, detail): saints,
*c.*1350–60 (*British Library*). 170

137 OLD WARDEN (Beds.): Abbot Walter de Clifton, *c.*1380–1 (*R. Marks*). 171

138 (*above*) LETCOMBE REGIS (Berks.): Christ displaying His wounds, *c.*1360–90 (*Alf Fisher*); (*below*)
CARMELITE MISSAL (BL MS Add. 29705, fol. 193v): Holy Trinity, Virgin and donors, *c.*1393
(*British Library*). 172

139 BIRTSMORTON (Heref. & Worcs.): member of the Ruyhale family, *c.*1385–1400. 173

140 *LYTLINGTON MISSAL* (Westminster Abbey, MS 37, vol. II. fol. 157v): Crucifixion, 1383–4 (*Conway
Library, Courtauld Institute of Art*). 175

141 OXFORD, NEW COLLEGE CHAPEL: St Thomas (detail), *c.*1380–6 (*R. Marks, by permission of the
Warden and Fellows of New College*). 176

142 (*left*) OXFORD, MERTON COLLEGE CHAPEL: Virgin and Child, *c.*1390–1400; (*right*) THENFORD
(Northants.): St Anne teaching the Virgin to read, *c.*1400 (*G. King & Son*). 177

143 CANTERBURY CATHEDRAL (Kent), nave west window: English king, 1396–1411. 178

144 Four heads: 179
 (a) EXETER CATHEDRAL (Devon): St Edward the Confessor (surround 1884–96), by Robert
 Lyen, 1391 (*Alf Fisher*);
 (b) YORK MINSTER: head of King Manasses from New College Chapel, Oxford, by Thomas
 Glazier, *c.*1390–5;
 (c) CANTERBURY CATHEDRAL (Kent): head of king, 1396–1411;
 (d) YORK MINSTER east window: detail from John Thornton's east window, 1405–8.

145 YORK MINSTER east window: St John weeps and is comforted (Revelation, 5: 2–5),
1405–8. 180

146 YORK, ALL SAINTS NORTH STREET: Entertaining strangers, from a Corporal Works of Mercy
window, early fifteenth century. 181

147 COVENTRY (West Midlands): fragments in south porch memorial chapel of former cathedral,
early fifteenth century (*G. King & Son*). 182

148 NEWARK (Notts.): suitors in the Temple, early fifteenth century (*R. Marks*). 183

149 GLASGOW, BURRELL COLLECTION: Annunciation from Hampton Court (Heref. & Worcs.),
*c.*1425–35 (*Burrell Coll.*). 183

150 MELLS (Somerset): head of female saint, *c.*1430. Engraving by C. Winston. 184

151 (*left*) PSALTER (Oxford, Bodl. Lib. MS Don. d. 85, fol. 130r): St George, early fifteenth century
(*Bodleian Library, Oxford*); (*right*) NORTH TUDDENHAM (Norfolk): St George, *c.*1415–25. 185

152 (*left*) NORTH TUDDENHAM (Norfolk): scene from the life of St Margaret, *c.*1415–25;
(*right*) BEDFORD PSALTER & HOURS (BL MS Add. 42131, fol. 95): initial to Psalm 26, 1414–23
(*British Library*). 186

153 WEST RUDHAM (Norfolk): Christ displaying His wounds, *c.*1430–40 (*G. King & Son*). 186

154 YORK MINSTER, south transept: Archangel Gabriel (detail), *c.*1440. 187

155 (*left*) LYDDINGTON BEDEHOUSE (Leics.): Bishop Alnwick (detail), 1436–49 (*R. Marks*); (*right*)
BATTLEFIELD (Salop): head of saint, *c.*1434–45 (*Conway Library, Courtauld Institute of Art, ©
Canon M.H. Ridgway*). 188

156 GREAT MALVERN PRIORY (Heref. & Worcs.), east window: Last Supper, *c.*1423–*c.*1439. 189

157 SALLE (Norfolk): prophet (detail), *c.*1441–50 (*David King*). 189

158 GREAT MALVERN PRIORY (Heref. & Worcs), north transept façade: Virgin in the *Magnificat*
window, 1501–2 (*R. Marks*). 191

159 COVENTRY, ST MARY'S HALL (West Midlands): English kings, *c.*1451–61 (*R. Marks*). 192

List of Figures

160 WINCHESTER COLLEGE CHAPEL (Hants.): St Helena (detail) in Thurbern's Chantry, *c.* 1502
 (*R. Marks*). 193
161 SHERBORNE ABBEY (Dorset): Christ and other fragments, after 1437, probably *c.* 1460 (*Conway
 Library, Courtauld Institute of Art*). 193
162 STAMFORD, ST JOHN'S CHURCH (Lincs.): SS Matthew and Peter Martyr, 1451 (*York Glaziers
 Trust*). 194
163 STAMFORD, ST GEORGE'S CHURCH (Lincs.): St Catherine, mid-fifteenth century. 195
164 WARWICK, BEAUCHAMP CHAPEL: Virgin Annunciate (detail), 1447-64 (*G. King & Son*). 195
165 KINGSCLIFFE (Northants.): angel from Fotheringhay collegiate church, *c.* 1461-75. 196
166 NORWICH, ST PETER MANCROFT (Norfolk): Visitation, 1445-55. 197
167 EAST HARLING (Norfolk): Sir Robert Wingfield (d. 1480), *c.* 1463-80 (*R. Marks*). 198
168 GLASGOW, BURRELL COLLECTION: St Mary Magdalene from north Norfolk, *c.* 1450-70 (*Burrell
 Coll.*). 199
169 LONG MELFORD (Suffolk): St Edmund and an abbot of Bury St Edmunds, 1479-97. 200
170 STAMFORD, BROWNE'S HOSPITAL (Lincs.): *Fenestra caeli* (detail), *c.* 1475 (*R. Marks*). 201
171 STOCKERSTON (Leics.): St Christopher, 1467-77/85. 202
172 BROUGHTON (Staffs.): St Roche, *c.* 1500 (*R. Marks*). 202
173 ODDINGLEY (Heref. & Worcs.): married donors, *c.* 1475-90 (*S. Pitcher*). 203
174 WESTMINSTER ABBEY, apse clerestory: bishop saint (detail), *c.* 1507-10. 204
175 STAMFORD, ST MARTIN'S CHURCH (Cambs.): angel holding shield of the Russell family arms,
 c. 1480-94 (*R. Marks*). 206
176 BRUSSELS, MUSÉES ROYAUX DES BEAUX-ARTS: *vidimus* probably for the upper lights of a side
 window in Cardinal Wolsey's chapel at Hampton Court; penwork, *c.* 1525-6 (*ACL – Brussels*). 208
177 WINDSOR, ST GEORGE'S CHAPEL (Berks.): two heads in the west window, *c.* 1500-6 (*R. Marks*). 209
178 FAIRFORD (Glos.): Crucifixion in the east window, *c.* 1500-15. 210
179 FAIRFORD (Glos.): Christ's appearance to the Virgin in chancel south chapel east window,
 c. 1500-15. 211
180 WINCHESTER CATHEDRAL (Hants.): St Sitha in a choir aisle tracery light, *c.* 1501-15.
 Pre-restoration engraving by O.B. Carter. 213
181 HILLESDEN (Bucks.): miracles performed by St Nicholas, *c.* 1510-19 (*R. Marks*). 214
182 WESTMINSTER ABBEY, Henry VII's Chapel: angels in the tracery of the west window (glass
 destroyed), *c.* 1510-15. 215
183 WESTMINSTER ABBEY, Henry VII's Chapel: eastern apsidal chapel (glass destroyed), *c.* 1510-15. 216
184 CAMBRIDGE, KING'S COLLEGE CHAPEL: (*left*) *vidimus* for the nave south side window depicting
 SS Peter and Paul healing the lame man (*Bowdoin Coll. Mus. of Art, Brunswick, Maine*); (*right*) the
 lights in the window itself, 1535-47(?) (*Ramsey & Muspratt*). 218
185 CAMBRIDGE, KING'S COLLEGE CHAPEL, nave south side: (*left*) St Peter denouncing Ananias
 (detail), 1535-47(?) (*G. King & Son*); (*right*) Elijah in his burning chariot, after 1544(?) (*Ramsey &
 Muspratt*). 219
186 WESTMINSTER, ST MARGARET'S CHURCH: St Catherine (detail) in east window, *c.* 1525-7
 (*Victoria and Albert Museum*). 220
187 THE VYNE (Hants.), chapel east window: Crucifixion and Henry VIII, *c.* 1523. 221
188 HENGRAVE HALL (Suffolk): early life of Christ scenes in the chapel glazing, early sixteenth
 century. 223
189 GREAT BRINGTON (Northants.): St John the Baptist, *c.* 1525-30. 224
190 WITHCOTE CHAPEL (Leics.): prophet Daniel, 1536-7 (*Keith Barley*). 225
191 YORK, ST MICHAEL-LE-BELFREY: St George, *c.* 1530-40. 226
192 KIRK SANDALL (S. Yorks.), Rokeby Chapel: St Paul(?), *c.* 1522-5 (*Keith Barley*). 227
193 COMPTON VERNEY (Warwicks.): Lady Anne Verney and her children (panel formerly in the
 chapel, present whereabouts unknown), dated 1558. 233

194 STOPHAM (W. Sussex): members of the Stopham family. Watercolour by S.H. Grimm dated
 1780 (BL MS Add. 5674, fol. 45), early seventeenth century (*British Library*). 234

195 VICTORIA AND ALBERT MUSEUM: deposition from Hampton Court (Heref. & Worcs.). By
 Abraham van Linge, dated 1629. 236

196 Thomas Johnson: *Choir of Canterbury Cathedral*. Oil on panel, dated 1657 (private collection).
 The painting shows iconoclasts attacking the glass. 239

197 Notes on heraldic glass in the counties of Devon, Dorset and Somerset (BL MS Egerton 3510, fol.
 107r, detail). Early seventeenth century (*British Library*). 240

198 STOKE-BY-NAYLAND (Suffolk): a lost window depicting Sir John Howard (d. 1426) and his wife in
 the *Howard Genealogy* (Coll. Duke of Norfolk, Arundel Castle, W. Sussex), p. 106. Painted by
 William Sedgwick in 1638 (*British Museum*). 241

199 FOTHERINGHAY (Northants.): engraving of lost figures published in J. Bridges, *The History and
 Antiquities of Northamptonshire*. 242

200 STANFORD ON AVON (Northants.): St Peter in the chancel glazing of *c*. 1315-26: (*left*) as depicted
 by Charles Winston in a watercolour dated 1834 (BL MS Add. 35211) (*British Library*); (*right*) as
 it existed in 1987. 245

Window Notation

This ground plan of Burford church in Oxfordshire has the window numbering system used in this book which adopts the *Corpus Vitrearum* format. Reproduced from P.A. Newton, *The County of Oxford: A Catalogue of Medieval Stained Glass (Corpus Vitrearum Medii Aevi*, Great Britain, vol. 1) Oxford, 1979, by kind permission of the British Academy.

Abbreviations

Age of Chivalry	J. Alexander and P. Binski (eds), *Age of Chivalry: Art in Plantagenet England 1200–1400*, exhibition catalogue, Royal Academy of Arts, London, 1987
Ants. Jnl	*The Antiquaries Journal*
Arch. Jnl	*Archaeological Journal*
BL	The British Library, London
Bodl. Lib.	The Bodleian Library, Oxford
CVMA	*Corpus Vitrearum Medii Aevi*
JBAA	*Journal of the British Archaeological Association*
JBSMGP	*Journal of the British Society of Master Glass-Painters*
Med. Christ. Im.	G. McN. Rushforth, *Medieval Christian Imagery*, Oxford, 1936
'Med. Glazing Accounts'	L.F. Salzman, 'Medieval Glazing Accounts', *JBSMGP*, vol. II (1927-8), pp. 116-20, 188-192; vol. III (1929-30), pp. 25-30
O'Connor and Haselock	D. O'Connor and J. Haselock, 'The stained and painted glass' in G. E. Aylmer and R. Cant (eds), *A History of York Minster*, Oxford, 1977, pp. 313-93
RCHM	Royal Commission on Historical Monuments of England
'Schools'	P. A. Newton, 'Schools of glass-painting in the Midlands 1275-1430' (unpublished Ph.D. thesis, University of London, 3 vols, 1961)
Tattershall	R. Marks, *The Stained Glass of the Collegiate Church of the Holy Trinity, Tattershall (Lincs.)*, New York & London, 1984
VCH	Victoria History of the Counties of England

Acknowledgments

This book has been completed after a long, slow and sometimes tortuous journey, both metaphorically and literally. Work on it commenced over ten years ago in London, continued in Glasgow and was completed in Brighton and Buckinghamshire. It has also accompanied (not to say haunted) me on short sojourns in Burgundy, Germany, Mount Athos and the island of Samos.

The seeds of the book were, however, sown rather more than a decade ago and it is entirely appropriate that I should begin by thanking Professor George Zarnecki, my mentor and tutor at the Courtauld Institute of Art, who pointed me in the direction of stained glass. When I embarked on a doctoral dissertation on the subject I benefited from the critical tutelage of Christopher Hohler and Peter Newton. It is a matter of great regret to me, both as a friend and a colleague, that Peter died before this book was completed; the present work is deeply indebted to his methods and ideas. Many other scholars have generously provided me with the fruits of their researches and observations. Dr Eva Frodl-Kraft has for many years brought the highest standards of scholarship to stained glass. Not only has she been a source of personal encouragement, she did me the honour of reading this book in manuscript and making some very helpful suggestions. Anna Eavis and my colleague Christopher Norton also read the manuscript from their different perspectives; their critical challenging of my assumptions and rigorous questioning have led to some important

amendments. Another colleague, Jim Binns, kindly checked the Latin quotations. I am particularly grateful to fellow-students of stained glass in this country and abroad: Michael Archer, Ernst Bacher, Rüdiger Becksmann, Sarah Brown, Jim Bugslag, Madeline Caviness, William Cole, C.R. Councer, Penny Dawson, Jane Hayward, Jill Kerr, David King, Ulf-Dietrich Korn, Karl-Joachim Maercker, Nigel Morgan, David O'Connor, Tom Owen, Meredith Lillich Parsons, Françoise Perrot, Yvette Vanden Bemden, Joan Vila-Grau, Hilary Wayment and Christiane Wild-Block. Colleagues engaged on other aspects of medieval material culture have been equally generous, notably Jonathan Alexander, Janet Backhouse, Martin Biddle, Paul Binski, Claude and John Blair, Chris Brooks, Marian Campbell, John Cherry, Nicola Coldstream, Rosemary Cramp, Paul Crossley, Linda Dennison, Robin Emmerson, Christa Grössinger, George Henderson, Sandy Heslop, Richard Hodges, Michael Kauffmann, Francis Kelly, Peter Kidson, Philip Lankester, Phillip Lindley, Andrew Martindale, Nigel Morgan, the late Sir Roger Mynors, Nick Norman, David Park, Ann Payne, Nigel Ramsay, Lucy Freeman Sandler, Robert Scheller, Gerhart Schmidt, Veronica Sekules, Tim Tatton-Brown, the late Derek Turner, Leslie Webster, Lady Wedgwood, Paul Williamson and Christopher Wilson. Many of the above are acknowledged in the notes.

This book would not have been possible without the co-operation of those charged with the care of the windows and panels which are

discussed in it, be they dean and chapter, parish priest and churchwarden, college authority or householder; all have been unfailingly generous in providing access and have often gone out of their way to supply additional facilities (usually ladders) for inspection and photography. Limitations of space preclude the naming of individual custodians and also of those responsible for the many archives and libraries that have been consulted. I hope, however, that no one will feel offended if John Hopkins, for many years Librarian to the Society of Antiquaries of London, and his successor Bernard Nurse are singled out. An equal debt of gratitude is owed to those architects, conservators, restorers and scientists whose practical knowledge and experience have been extremely helpful: Keith Barley (whose comments on the techniques section were invaluable), Corinne Bennett, Lawrence Bond, Frederick Cole, Alfred Fisher, Peter Gibson and the staff of The York Glaziers Trust, Dennis King, Laurence Lee, June Lennox, Roy Newton, Janet Notman, Norman Tennent and Kenneth Wiltshire. None of the above, of course, can be blamed for errors of fact and interpretation in this book, the responsibility for which rests firmly on the author's shoulders. The publishers have displayed the patience of Job and Norman Franklin was from the outset a constant source of encouragement. Janice Price and Penny Wheeler have proved to be tactful and sympathetic, yet constructively critical editors. Janice Holmes had the arduous task of translating the manuscript into a clean, typed copy and she accomplished it speedily and efficiently. The index was compiled by Julie Ann Smith.

To all of the above I am deeply grateful and I hope that anyone whose name is missing and should have appeared will accept my apologies for the inadvertent oversight. Photographic acknowledgments will be found under the Lists of Colour Plates and Figures.

My final task is the pleasurable one of thanking two people without whose assistance this book would not have seen the light of day. My friend Maurice Wiggs has been a frequent companion on field trips, invariably shouldering the burden of driving long distances with the dubious reward of spending time in cold and damp churches; his humour and common sense have been invaluable. So too have that of my wife Rita, who has had to live with this book for so long. She has in fact acted as an (unpaid) assistant, taking notes on the study trips, applying her critical eye to the text and providing support and encouragement during my (many) moments of self-doubt. It is with the deepest affection that this book is dedicated to her.

RICHARD MARKS
Centre for Medieval Studies
University of York
October 1992

Introduction

English stained glass is the least appreciated of the medieval pictorial arts. Some of the reasons for this are practical. Only a minute fraction of all the glazing created between the seventh century and the Reformation survives; what remains is often in poor condition, usually fragmentary and, especially in parish churches, poorly recorded. In addition, problems of authenticity frequently have been created by re-arrangement and restoration. Unlike manuscript scholars, students of stained glass do not enjoy the relative comfort of a library; to the incon-venience of taking notes whilst examining windows through binoculars are added the inhospitality of an inclement environment and frustrating delays caused by locating keys to locked churches.

These difficulties are compounded still further by the fact that what survives, both medieval glazing and related documentation, gives a distorted picture. Of the nearly nine centuries of medieval glass-painting in England, substantial quantities only exist from the thir-teenth to the early sixteenth centuries; even this statement requires a further qualification, for down to the end of the thirteenth century we are dealing almost exclusively with the glazing of great churches and there is not much evidence from the parish churches. The contemporary written sources contribute to the unbalanced picture. Almost the only detailed early refer-ences to glazing, i.e. in the thirteenth century, are in the royal building accounts because these happen to have been preserved. They are joined from the fourteenth century by a few fabric

rolls and glazing contracts, but again these relate to major buildings and commissions. It is only in the fifteenth and sixteenth centuries, with the appearance of wills and churchwardens' accounts, that any light is shed on glazing in parish churches; even then glass does not often feature in testamentary bequests, which were in any case only made by a minority of wealthier parishioners. Moreover, all the documents are either legal, financial, or a civic record, and emanate from the patron's side of the arrange-ment; consequently they provide very little of the information art historians would really like to know: how and why subjects were chosen, how glass-painters were selected and how commissions were executed. Nor do we glean from the written sources anything of the person-alities of either the glazier or the patron; there is no English equivalent of either Vasari or Cellini (the same, of course, goes for the practitioners of all medieval pictorial and building crafts).

Yet despite the obstacles, stained glass has much to offer scholars of the Middle Ages. Notwithstanding the losses, considerable quanti-ties still exist and usually in the church or domestic residence for which they were origin-ally intended. Consequently the medium is important for the study of regional styles, patronage and iconography. Again, the docu-mentation is copious compared with what exists for other forms of medieval pictorial art and sculpture; analysed and evaluated carefully it is extremely valuable.

The study of English stained glass has also made enormous advances within the last three

decades. The foundations were laid in the 1960s by the late Peter Newton with his unpublished doctoral dissertation on stained glass in the Midlands 1275–1430. Under the tutelage of Francis Wormald, Peter Newton applied the tools of modern art-historical and iconographical scholarship to stained glass and for the first time English medieval glass-painting was examined systematically within the context of other branches of contemporary artistic activity. Moreover, the last twenty years have seen the appearance of *Corpus Vitrearum* volumes on Canterbury Cathedral, King's College Chapel, the west windows of York Minster and the county of Oxfordshire, which have immeasurably increased knowledge of these monuments, not least by establishing definitively the precise degree of restoration and rearrangement their windows have undergone. In addition there have been a number of important articles and monographs on individual monuments and major discoveries of unknown material have been made, notably in the Anglo-Saxon period, with the result that it is now possible to begin the story in the seventh rather than in the late twelfth century, as has hitherto been the case. It is as a response both to these advances and to the requests of students and colleagues specializing in related fields of medieval material culture for an up-to-date survey of the subject that this book has been written. It incorporates the recent researches and discoveries and also includes my own studies, both published and unpublished. Although reference is made to glass in Wales, the vast majority of the surviving material is found in England; Scottish glazing is known only from a few excavated fragments and I hope readers from north of the border will therefore not be offended by its almost complete omission, with the major exception of the important but non-indigenous holdings of the Burrell Collection.

Apologies are also due to those who, like myself, deplore the loss of traditional English counties which resulted from the 1974 reorganization of local government; regrettably the new boundaries and appellations have now come into such general use that to adhere to the ancient forms would only serve to confuse. The changes currently under consideration had not been finalised by the time this book went to press.

Many discoveries remain to be made in English glass-painting. A survey of Northamptonshire carried out for the *Corpus Vitrearum* project revealed nearly ninety churches and private houses containing medieval glazing, much of it previously unnoticed. The investigation produced works of significance, such as the stonemason at *Helmdon* and the 'gossiping' panel *Fig. 9* at *Stanford on Avon*, not forgetting the remarkable 'ymage of deth' roundel also at *Stanford*. *Fig. 62* *Fig. 18* Similar surveys of other counties either completed or in progress have shown that Northamptonshire is not exceptional, which is why a stained glass field trip can still be a voyage of discovery. Quite often the vague descriptions 'ancient glass' or 'fragments' in Nelson's county lists and Pevsner's *Buildings of England* turn out to conceal panels of the quality of the early figures at *Easby*. *Pl. VIII(b)*

Because so much material remains to be discovered in parish churches this book makes no claim to be the final word on the subject. It is equally important to keep in mind that in the more than eight centuries spanned by this study there were numerous changes in practice, patronage and iconography, etc.: what was valid in AD 700 did not necessarily apply in AD 1500. By the same token, a survey of so vast and varied a period is bound to contain errors, misinterpretations and areas for debate. Equally, there are aspects which merit much deeper exploration than has been attempted here. These include regional variations in patronage, iconography and workshop practices and organization, the role of women as donors, glazing as a reflection of changing devotional patterns, the impact of the spread of literacy on window design and interpretation, the significance of fourteenth-century border imagery, wage and price fluctuation. And so on. For these and other failings I make no apology, for if the book achieves nothing else I hope it will stimulate interest in this highly important and rewarding aspect of medieval art. If it does succeed in spurring further research which challenges and disproves the statements made here I can hardly take offence. With the wealth of material still *in situ* it should be possible to dispute the assertion made in the catalogue of the important *Age of Chivalry* exhibition held at the Royal Academy in 1987

that 'illuminated manuscripts provide the only detailed and comprehensive view of pictorial art in England during the Gothic period' (p. 156). A full appreciation of the contribution of stained glass to English medieval culture and society is long overdue.

Part I

~~~

# Donors, Technique,
# Iconography,
# Domestic Glass

# I

# *Donors and Patrons*

General surveys of medieval stained glass have tended to open with a chapter or section on the technical aspects of the craft.[1] As almost every window was executed to the specific commission of those paying for the work, be they monarch, prelate, noble, merchant or churchwarden, it is perhaps more logical to begin by examining the various classes of donors and patrons in medieval England, how their generosity was commemorated and how both patron and craftsman ensured that the commission was carried out to their mutual benefit and satisfaction.

## *Patrons*

Information on stained glass patronage before the fourteenth century is as sparse as the surviving glass. The earliest known specific reference is in 675, when Benedict Biscop, Abbot of Monkwearmouth in Tyne and Wear, sent to Gaul for craftsmen to glaze the monastery windows; at about the same time Bishop Wilfrid of York glazed the windows in his Minster.[2] Even in these instances it is by no means certain that the individuals in question actually met the cost of the glazing from their own personal financial resources, as opposed to those of the institution. Likewise, there are no indications as to how the sumptuous glazing of the late Anglo-Saxon churches of the Old and New Minsters at *Winchester* was financed.[3] There is even a dearth *Pl. IV* of information on the donors of the first surviving major ensemble of glass in England, the late twelfth- and early thirteenth-century glazing

of *Canterbury Cathedral.*[4] Completely lacking *Pls VI,* from its windows are any representations of *VII;* donors such as those which appear in profusion *Figs* in the contemporary glass of Chartres Cathe- *92–6* dral.[5] The absence of donor figures may imply that the Canterbury windows were financed by the priory of Christ Church as a corporate body, rather than from individual benefactions.

Something of the kind certainly happened at *Exeter,* where in the late thirteenth and early *Pl. XIII* fourteenth centuries the chapter undertook a major reconstruction of the east end of the cathedral, which included the glazing.[6] A Fabric Fund was created from substantial annual contributions from successive bishops of the See, yearly donations of a proportion of their salaries by the various cathedral office-holders, and the canons gave a half-share of the income from their prebends. Further sources of income were obtained by the dean and chapter through assigning a small group of annual rents to the Fund, and clerical subsidies within the diocese were raised by the bishops. In addition the rebuilding attracted alms and posthumous bequests from members of the foundation. Similar methods of financing major building and glazing work were adopted in the same period by the chapter of *Wells Cathedral,* including the *Pl. XIV;* imposition on its own members of a tax of one- *Figs 63,* tenth of the annual revenue from all prebends;[7] *118, 122* the names of a number of canons and other officials which now occur in the Lady Chapel glazing are probably a record of those clergy who contributed to the work.[8]

The more fortunate religious establishments

were relieved of the burden of fund-raising for windows and/or the fabric by having a patron who met the costs from his or her resources. Often these establishments were royal foundations or churches closely associated with the monarchy. To cite one very important example, the costs of the glazing as well as the structure of *Westminster Abbey*, the coronation church and royal mausoleum, were met entirely by Henry III (1216-72).[9] He was a prolific builder and there are frequent references to the ordering of stained glass windows in the royal residences in the *Liberate Rolls* and other accounts during his reign.[10] Later sovereigns also commissioned glazing as part of their building projects, both in their palaces and castles and in their religious foundations. Edward III (1327-77) was responsible for the windows in *St Stephen's Chapel*, Westminster, and in the royal chapel at Windsor.[11] The Lancastrian and Yorkist monarchs embellished their residences with glazing, and under Henry VIII (1509-47) two of the most prestigious ecclesiastical glazing schemes of the early sixteenth century were carried out, the windows of his father's great chapel at the east end of *Westminster Abbey* and those of Henry VI's foundation at *King's College*, Cambridge.[12] It is ironic that the reign of the same monarch witnessed the beginnings of a religious reform movement which had as one of its consequences the ending of glass-painting as a major artistic medium.

From the fourteenth century onwards many foundations were established by magnates and prelates, the primary function of which was to pray for their souls. These ranged in size from great dynastic mausolea such as the Yorkist collegiate church at *Fotheringhay* in Northamptonshire or the large college at *Tattershall* in Lincolnshire endowed by Ralph Cromwell (d. 1456), Lord Treasurer of England, down to more modest chantry chapels.[13] One of the most elaborate chantries is the *Beauchamp Chapel* attached to St Mary's church in Warwick and founded by Richard Beauchamp, Earl of Warwick (d. 1439).[14] The windows of Tattershall and Warwick were in fact commissioned (and the subject-matter chosen) by the executors of the two founders, a by no means uncommon situation. Establishments such as these could be sumptuously glazed by the leading craftsmen of

*Pl. IX;*
*Figs 5,*
*102(c),*
*106*

*Fig. 129*

*Figs 182,*
*183*
*Pls XXVIII,*
*XXIX;*
*Figs*
*184, 185*

*Figs 165,*
*199*
*Pls III(c),*
*XXIII;*
*Figs 15,*
*48, 61*
*Pl. III(d);*
*Figs 11,*
*69, 164*

the time. Thus the windows in the chapels at *New College*, Oxford, and *Winchester College* were executed by Thomas Glazier of Oxford in the 1380s and 90s. Both colleges were founded by William of Wykeham, Bishop of Winchester, who also left 500 marks in his will for the glazing of the nave of his cathedral church.[15] Wykeham must be considered one of the most important patrons of stained glass in the late Middle Ages.

Since the early thirteenth century responsibility for the fabric of parish churches had been divided between the rector (lay or clerical), who looked after the chancel, and the parishioners who had the upkeep of the nave; however, sometimes they were glazed entirely at the expense of a single individual or family, usually the lord of the local manor. In the middle of the fourteenth century the De Fresnes family installed a fine series of windows in the twelfth-century church at Moccas in Hereford & Worcester; 150 years later John Tame and his son Sir Edmund rebuilt and lavishly glazed *Fairford* church, Gloucestershire, using Netherlandish glass-painters.[16] On occasions the parochial clergy, who quite frequently appear as donors of windows, paid for the entire reconstruction of their churches; one instance is Thomas Alkham, rector of Southfleet in Kent between 1323 and 1356.[17]

Institutions which were able to enjoy the support of a royal or other benefactor for an entire scheme were in the minority. In most instances the community looked to donors for individual stained glass windows. By the fourteenth and fifteenth centuries, when the evidence becomes more than occasional, patrons reflected the transformation of English society which was taking place, from the traditional 'three estates' (priests, knights and labourers) to a more complex structure which embraced *inter alia* a rich urban mercantile class. The windows of *York Minster* nave were glazed between 1291 and c.1339 by a series of individual donors, including several clerics attached to the Minster, notably Peter de Dene, a canon and vicar-general to Archbishop Greenfield (window nXXIII), and Robert de Riplingham, chancellor of the diocese from 1297 to 1332 (window sXXXI).[18] Most important of all was Archbishop Melton, who in 1338/9 donated 100 marks for the glazing of the

*Figs 141,*
*144(b)*
*Pl. XIX;*
*Fig. 31(a)*

*Pls XXVI,*
*XXVII;*
*Figs*
*178,*
*179*

great nave west window (wI).[19] The lay patrons  *Pl. XVI*
numbered not only local magnates such as the
Percy and Vavasour families (windows NXX,
NXXV, SXXI), but also wealthy merchants and
tradesmen like Richard Tunnoc, a goldsmith and  *Pl. XI;*
bellfounder (window nXXIV). A similar range  *Fig. 1*
of benefactors met the cost of the windows of
*Great Malvern Priory* in Hereford & Worcester,
the glazing of which extended from the 1420s
into the early sixteenth century.[20] The largest
windows were given by members of the nobility:
the east window was donated by Richard Beau-  *Fig. 156*
champ, Earl of Warwick, and the nave west
window by Richard, Duke of Gloucester (later
Richard III): the *Magnificat* window filling the  *Figs 11,*
north transept façade (window nVI) is associated  *158*
with Sir Reginald Bray (d. 1503), a notable
patron who was also concerned with glazing in
Peterborough Cathedral and St George's Chapel,
Windsor.[21] Great Malvern was fortunate in its
location within the diocese of another important
patron, Bishop John Alcock (d. 1501). He gave
one window in the nave south clerestory (SV)
and was also responsible for the elaborate east
window of Little Malvern Priory, in addition to a
lost window in the vestry of Worcester Cathe-
dral Priory. When he moved to Ely he built a
chapel in the cathedral there which still contains
his badge and motto in the glass.[22] Individual
members of the Benedictine monastic
community at Great Malvern also seem to have
paid for glass there, including a window in the
north choir clerestory donated by Prior John
(window NII). Others were the gift of prominent  *Fig. 74*
local families such as Richard Colwyke and
Richard Oseney, both bailiffs of Worcester on
several occasions (windows NIII, NX).[23]

Parish churches also usually had to rely on the
generosity of a number of donors. The fine
church at *Long Melford* in Suffolk has tradition-
ally been associated with the Martin and
Clopton families. They did indeed play a major
part in its rebuilding during the last four decades
of the fifteenth century, but the evidence of the
surviving glass and records of lost inscriptions
show that the glazing was financed by as broad a
spectrum of society as the windows of the York
Minster nave and Great Malvern Priory.[24] In
most of the nineteen north clerestory windows
were figures representing the Cloptons and

*Fig. 1*  YORK MINSTER, nave north aisle: Richard
Tunnoc, goldsmith and bellfounder, presenting his
window to St William of York, *c.* 1325.

various families connected with them either by
kinship or through social links. Some were  *Figs 46,*
apparently given by, amongst others, Thomas  *169*
Rattlesden, Abbot of Bury St Edmunds (1479-
97), rector Giles Dent (1474-84) and Elizabeth,
Duchess of Suffolk. The donors of the south
clerestory glazing were drawn from a series of

local families, not only Martin, but also Maryell, Hyne, Bec, Sparrow, Colet, Howe, Waryn and Harset. In several instances they paid for part of the fabric as well as the glass. For example, an inscription in the stonework records that John Pie and his wife Alice funded the construction of a bay and the glazing of two clerestory windows above.

As early as the first half of the fourteenth century the cheaper monumental brasses were affordable by yeoman farmers, but the surviving evidence suggests that entire windows remained beyond the purses of the less well-to-do throughout the Middle Ages.[25] Between 1465 and 1538 the price of an average-size figural brass was below £2 and even the more elaborate brasses were cheaper than glazing. The brass of Sir Thomas Stathum (d. 1470) and his two wives at Morley in Derbyshire cost £4, which may be compared with the bequest of £10 in 1476 for a window containing the Seven Sacraments at Lydd in Kent; the same amount was left in 1494 by John Aylewyn for another Lydd window with inscriptions to himself and seven other members of the Aylewyn family.[26] Glazing was, however, commissioned collectively by members of trade guilds or religious confraternities. The former category is poorly represented in surviving glass. The Fishmongers, Vintners and Drapers are known to have given windows in the great Franciscan church in the City of London during the fourteenth century.[27] The westernmost window in the north chancel wall at Ludlow (nIV) is very heavily restored and has lost its original inscription, which showed that it was the gift of the Clothiers or Shearmen of the town: 'Orate pro bono statu totius artis scissora [scissorie?] de Lodelowe. Qui hanc fenestram fieri fecerunt Ann. Dom. MCCCCXXV [1425]'.[28]

St John's Chapel in the same church belonged in the Middle Ages to a religious confraternity known as the Palmers (or pilgrims) Guild; the east window of this chapel (nV) depicts scenes from a popular legend on which the brotherhood was based, namely that pilgrims returned to Edward the Confessor a ring which the king had given to St John the Evangelist in the guise of a beggar.[29] Associations like the Palmers multiplied from the fourteenth century; as churchwardens' accounts show, they enabled the entire community to contribute to the embellishment and maintenance of its parish church. An inscription formerly in a window at Beeston-next-Mileham in Norfolk summarizes the functions of confraternities:

*Orate specialiter p. salubri statu fratrum et soror. gilde gloriose Virginis Marie, cujus honori haec dedicatur eccl'ia, et omnium viventium benefactor. eorund et p. a'ab; omnium fratrum et soror. defunctor. ejusd. gilde, ac etiam p. a'iab' defunctor', benefactor. eorund. qui proprijs expensis et pecunijs eidem gilde habende largitis has octo fenestras vitro fieri devote curaverunt A. 1410.*[30]

A series of windows paid for by the parish still exist at *St Neot* in Cornwall, albeit drastically restored by Hedgeland in 1825–30. The north aisle glazing includes three windows (nVII, nVI, nV) donated respectively by the young men of the parish, their sisters (in 1529) and the wives who lived in the western part of the parish (1523). Almost certainly these and other groupings at St Neot represented confraternities; the guilds at Croscombe, Somerset, in the late fifteenth and early sixteenth centuries bore similar titles.[31] The same was no doubt the case in East Anglia. At Hingham in Norfolk there was formerly an inscription recording that a window was made at the expense of the maidens of the parish. In 1496 the sum of 9s was raised by 'a Gadering of the Wyvys…for a Glas Wyndown' in Walberswick Church, Suffolk.[32] At *Middleton*, Greater Manchester (window sII), is a series of seventeen kneeling named archers, each with his longbow and quiver of arrows and accompanied by their chaplain, together with Sir Richard Assheton (also with arrows) and his wife. For long this glass has been interpreted as a memorial to the village contingent of bowmen who fought at the Battle of Flodden in 1513, but this is incorrect as below the archers there was formerly an inscription giving the date 1505. The panel depicting Assheton and his wife differs in some respects from the section with the archers and as it bore the date 1524 it may originally have come from another window. Probably both panels commemorate a confraternity to which Assheton and the bowmen belonged; guilds of archers are recorded elsewhere, as at Croscombe.[33]

Lay-folk also paid for windows by pooling their resources in less formal organizations. The

*Fig. 4*

*Fig. 3*

*Fig. 2* DONORS BY SOCIAL CLASS:

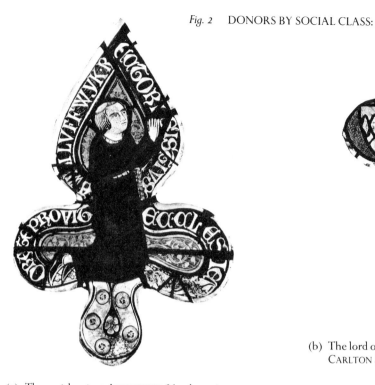

(b) The lord of the manor: John de Newmarch at CARLTON SCROOP (Lincs.), *c.* 1307;

(a) The parish priest: ALDWINCLE (Northants.), St Peter's church: William de Luffwyk, rector 1335–80;

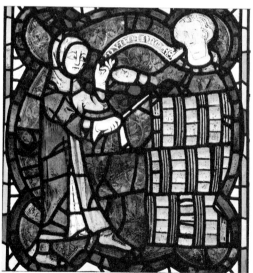

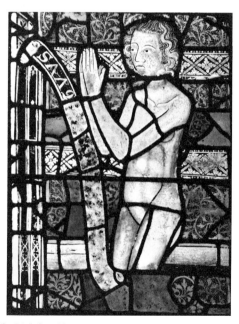

(c) Merchants: wine-sellers in the nave north clerestory of YORK MINSTER, early fourteenth century;

(d) Nobility: TEWKESBURY ABBEY (Glos.), choir clerestory east window: female donor (probably Eleanor de Clare, d. 1337), *c.* 1340–4.

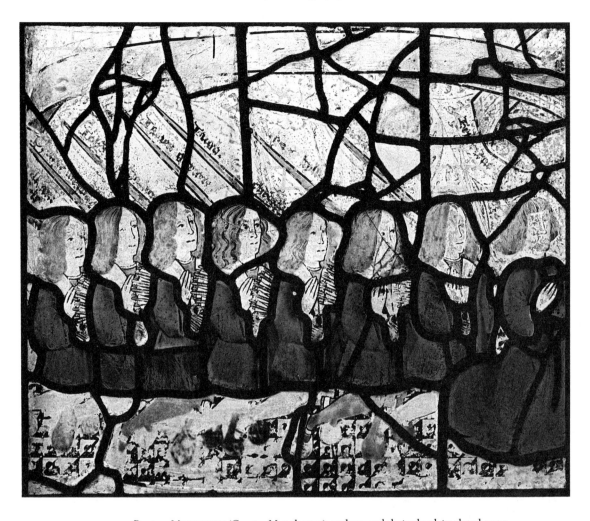

*Fig. 3*   MIDDLETON (Greater Manchester): archers and their chaplain, dated 1505.

four couples in the late fifteenth-century north aisle east window (nIV) at Winscombe, Avon, probably represented either a family or a group of friends.

So far donors have been discussed in terms of gifts of windows. Normally, the cost of repairs to glazing was met by the institution or community as a whole; occasionally, however, individuals made bequests in their wills for mending glass.

## Commemoration of donors

Donors and patrons in the late Middle Ages may have been primarily concerned with the salvation of their souls through good works, but they expected their philanthropy to be suitably acknowledged and made known to present and future generations, in the same manner as contemporary sponsors and benefactors. The stipulation made in his will of 1380 by one John de Beverley, that he would bequeath 40 shillings for alterations to the glazed windows in three specified churches on condition that a shield of

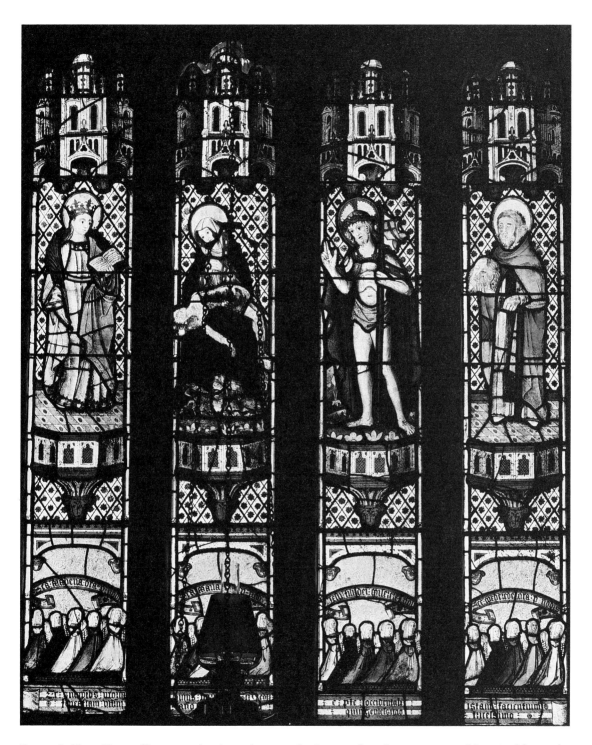

*Fig. 4*  ST NEOT (Cornwall): nave north aisle window given by the wives from the western part of the part of the parish, dated 1523. The wives kneel below the *Pietà*, Christ and two Cornish saints, Mabena and Meubred.

*Fig. 5*   WESTMINSTER ABBEY, St Edmund's Chapel: arms of Cornwall, *c*. 1254-9.

his arms was placed in any window newly painted, must have been far from unique amongst prospective patrons.[34]

As in other media, donors were commemorated by inscription, shield of arms, or by a representation of the patron(s) dressed according to his or her station in life; usually two and often all three of these elements are found together. Heraldry appears in stained glass from the middle of the thirteenth century. Several of Henry III's palaces and castles contained heraldic glass, the earliest apparently being the shields of arms of the King and of the Count of Provence ordered in 1247 for Rochester Castle.[35] None of these survives and very few shields of arms in stained glass are known to exist before 1300: amongst them are three shields now set in St Edmund's Chapel, *Westminster Abbey*, and a shield of the royal arms in the chancel south window (sII) of the former priory church at Chetwode in Buckinghamshire.[36] It should not be assumed, however, from the presence of the arms of England that the church in question enjoyed royal patronage unless, as in the instances of Westminster and Chetwode, there

*Fig. 5*

are known connections with the monarch. Usually the royal arms appeared as representing the sovereign to whom the donor owed ultimate allegiance. The introduction of heraldry transformed the means by which many donors were recognized. Clergy and knights were instructed in family lineage and taught how to identify shields of arms in monumental art; heraldic glass was cited frequently in the Scrope-Grosvenor, Lovell–Morley and Grey–Hastings chivalric lawsuits.[37]

The figures of Henry II and his queen Eleanor of Aquitaine in the axial window of Poitiers Cathedral, which is datable to *c*.1165-70, are the earliest donor 'portraits' with English connections.[38] None is known on this side of the Channel before the thirteenth century, but as donors or owners are depicted in insular manuscripts and in French and German windows before 1200 it is likely that they were represented in contemporary English glass.[39] The first known appear to be Philip and Salomon (De Hardres?) who kneel on either side of the Virgin and Child in a medallion at *Upper Hardres* in Kent.[40] Regrettably this was irreparably damaged in a fire a few years ago. The Upper Hardres glass is probably of about the same date as the lost panel commissioned in 1250 by Henry III for the Queen's Hall at his residence at Clarendon in

*Fig. 6*

*Fig. 6*   UPPER HARDRES (Kent): the Virgin and Child between donors Philip and Salomon, *c*.1250.

Wiltshire, which depicted a queen (presumably Eleanor) kneeling in prayer at the feet of the Virgin and Child.[41] The only intact donor figure dating from before the very end of the thirteenth century to have been identified so far is the panel in the *Burrell Collection* depicting Beatrix van Valkenburg. She was the third wife of Henry III's brother Richard, Earl of Cornwall (d. 1271); the roundels in the background bearing eagles refer to his title of King of the Romans. The panel probably comes from the Franciscan church in Oxford, where Beatrix was buried in 1277.[42]

*Pl. X*

Numerous donors appear in English glass between the end of the thirteenth century and the Reformation. During this long period several changes occurred in the modes of depiction, although the basic formula of a kneeling figure remained constant. Donors in fourteenth-century glass are found in both main and tracery lights. In the tracery of the east window at *Carlton Scroop* in Lincolnshire is the kneeling figure of John de Newmarch, accompanied by the priest William de Briddeshall, whom he presented to the living in 1307.[43] Women appear less frequently than men and rarely unaccompanied by their husbands; a tracery panel from the former *capella ante portas* at *Merevale*, Warwickshire, now in the National Gallery of Victoria, Melbourne, Australia, shows Sir John de Hardreshull (1293/4-d.*c.* 1365) and his wife Margaret.[44] Until the end of the fourteenth century donor figures placed in main lights were frequently depicted on a scale matching that of the saints or other religious figures in the window. A number of instances can be cited from the *York* nave aisle windows which date from the early years of the century; these include Richard Tunnoc and the very fragmentary male and female donors flanking St Peter in the Pilgrimage window (windows nXXIV, nXXV).[45] Walter de Clifton, Abbot of Warden from after 1365 and before 1397, fills an entire light of a two-light window (nIV) at *Old Warden* in Bedfordshire. Warden was a Cistercian house and the panel appears to be the only surviving representation of an abbot of this order in English glass.[46] The practice of depicting donors on the same scale as saints was not confined to this country and examples are known on the Continent from the thirteenth century,

*Fig. 2(b)*

*Fig. 7*

*Fig. 1*

*Fig. 137*

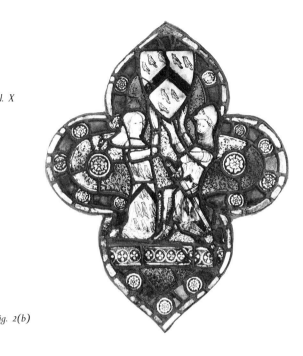

*Fig. 7* MELBOURNE, NATIONAL GALLERY OF VICTORIA: Sir John de Hardreshull (d.*c.* 1365) and his wife Margaret from Merevale (Warwicks.), *c.* 1350.

including Abbot Henry von Admont (1275-97) at St Walpurgis bei St Michael in Austria.[47]

Most modes of donor representation were not unique to England, although some seem to have been more popular with European glaziers than their counterparts on this side of the Channel. The inclusion of patrons within a New Testament scene or episode from the life of a saint comes into this category. An early instance in German glass is a panel in the Schnütgen Museum in Cologne, which depicts the figures of Philip and Agnes in prayer below the Virgin on her death-bed; the glass dates from *c.* 1240-50.[48] Examples in English glass of this phenomenon are rare: the Resurrection panel in the east window of the chancel south chapel at North Moreton in Oxfordshire (sII) possibly includes the donor, Miles de Stapleton and his wife, kneeling in prayer; the window was glazed between 1299 and *c.* 1314.[49] Slightly later in date is the naked female donor figure which forms part of a Last Judgement in the east window of the choir clerestory of *Tewkesbury Abbey* in

*Fig. 2(d)*

Gloucestershire. The lady has been identified as Eleanor de Clare (d. 1337).[50]

Donors kneeling at the feet of individual saints or Christ on the Cross are common in English fourteenth-century glass. In the tracery of a chancel north window at Meldreth in Cambridgeshire (nIV) is a panel dating from the early fourteenth century which shows a monk kneeling before St John the Baptist. The monk must have been a member of the community at Ely Cathedral Priory which owned the advowson of Meldreth.[51] Of about the same date is the tracery glazing of a window in the choir south aisle (sXII) at *Wells Cathedral* in which is represented a donor kneeling before Christ on the *Fig. 8*

*Fig. 8*     WELLS CATHEDRAL (Somerset), choir south aisle: donor kneeling before Christ on the Cross, *c.* 1310–20.

Cross.[52] Sometimes the donors are enclosed within niches below the images of the saints, as at Wroxall in Warwickshire and Eaton Bishop in Hereford & Worcester (the former also possesses a pair of male and female donors set within pointed quatrefoils, a very unusual composition).[53] At the end of the fourteenth century, William of Wykeham kneels at the feet of the Virgin and Child in a main light panel from the east window of the chapel in his foundation of *Winchester College*; most of the *Pl. XIX* remaining glass, including the Wykeham panel, is now in Thurbern's Chantry in the chapel.[54]

A few instances are known of a donor holding a model of the church, the construction or reconstruction of which he (or his executors) paid for. Examples exist in Continental glass from the first half of the thirteenth century, such as the figure of Provost Henry at Ardagger in Austria, dating from shortly after 1224.[55] All the recorded English donors represented in this manner are of fourteenth-century date, including William de Ferrers at Bere Ferrers in Devon and a knight of the Drayton family at Lowick, Northamptonshire (east window at Bere Ferrers, nV at Lowick).[56]

Similarly the depiction of donors presenting windows is not common in English glass, although they occur in France from the late twelfth century.[57] Three are in York: the nave north aisle of *York Minster* has the figure of *Fig. 1* Richard Tunnoc in the Bellfounder's window (nXXIV) and a donor named Vincent in window nXXVI.[58] The third, almost certainly identifiable as a mercer named Robert Skelton, is in a north aisle window (nIV) of the parish church of *St Denys Walmgate*. Skelton was Chamberlain of *Frontispiece* York in 1353 and bailiff in 1353–6, and the window dates from *c.* 1350.[59]

The Bellfounder's window derives its name from the panels depicting the casting and tuning of bells. Windows illustrating the trade or profession of the donor are encountered more frequently in Continental glass than in England, notably a very wide-ranging series at Chartres and other French thirteenth-century cathedrals.[60] In addition to the Bellfounder's window, in the nave clerestory of *York Minster* (NXXI) *Fig. 2(c)* there are two panels probably depicting wine-selling.[61] The figure of a stonemason named

William Campiun is in a nave tracery light (nV) at *Helmdon*, Northamptonshire. This panel is datable to *c.* 1313 and the incomplete inscription suggests that it commemorated the work done by Campiun on the church.[62]

*Fig. 9*

Some of the ways in which donors were depicted in the fourteenth century fell into disuse after 1400. There appear to be no instances in English fifteenth- and early sixteenth-century glass of donors presenting windows or models of churches. Moreover, with the reduction in size and importance of tracery in Perpendicular window design compared with the Decorated Period it became much less popular to place donor figures in the upper sections of windows. The practice did not entirely die out, as is demonstrated by the early fifteenth-century figures of Henry Rumworth and Robert Gilbert in the tracery of two north aisle windows (nIV, nV) at Horley in Oxfordshire, of which they were successive rectors.[63] Donors after 1400 could still be represented kneeling at the feet of their patron saints, such as Abbot Thomas Rattlesden at *Long Melford* (window nXVII).[64]

*Fig. 169*

Married couples occur, as in the fourteenth century, but in the later period it became more common to represent children. They are not unknown before 1400, as is shown by the very restored figures of the two sons and two daughters of Sir John de Charlton (d. 1353) and his wife in the east window of St Mary's church, Shrewsbury; also the sons of Peter de Mauley in a nave south aisle window in York Minster (sXXXII).[65] In both instances no differentiation in size is made between child and parent. After 1400, as with monumental brasses, it was customary to represent the children on a smaller scale. Typical examples are the figures of Walter Curson (d. 1527) and his wife Isabel, together with their eight sons and six daughters,

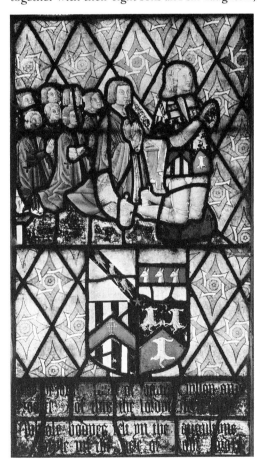

*Fig. 9* HELMDON (Northants.): William Campiun, stonemason, *c.* 1313.

*Fig. 10* WATERPERRY (Oxon.): Walter Curson (d. 1527) and his sons.

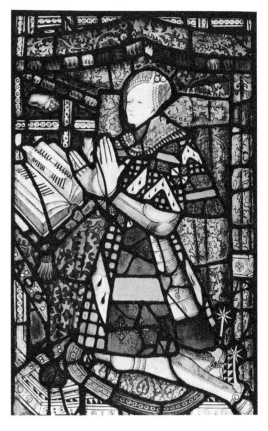

*Fig. 11*    (*left*) Sir Reginald Bray (d. 1503) from the
*Magnificat* window in the north transept façade of
GREAT MALVERN PRIORY (Heref. & Worcs.), *c.*1501–2;
(*right*) Richard Beauchamp, Earl of Warwick
(d. 1439) (head replaced by that of one of his
daughters/wives) from the BEAUCHAMP CHAPEL,
WARWICK, 1447–64.

at *Waterperry* in Oxfordshire (sIV).[66]    *Fig. 10*

From the 1360s owners of English illumin-
ated manuscripts are quite frequently portrayed
kneeling before desks or altars;[67] the earliest
occurrences of the desk in stained glass noticed
so far all date from the early fifteenth century,
including the panel depicting a priest in All
Saints North Street, York (window nIV).[68] The
desk (or altar) is often placed at an angle to the
front plane of the composition, thereby intro-
ducing a three-dimensional element into donor
panels. As the century progressed this element
increased in depictions of some of the wealthier
patrons. The figure of Richard Beauchamp, Earl
of Warwick, in the east window of his family chapel
at *Warwick*, is shown kneeling before a desk and    *Fig. 11*
with an elaborately draped tester.[69] During the
late fifteenth century donors were sometimes set
against a damask back-cloth, as in the 'Royal'
window (NXXVIII) in the north-west transept of
*Canterbury Cathedral*, dating from *c.*1482–7.[70] In    *Pl. XXV*
the *Magnificat* window (nVI) at *Great Malvern* the
figures of Sir Reginald Bray and Sir Thomas Lovell    *Fig. 11*
are placed against a back-cloth which is enclosed
within an architectural framework.[71] Here the
spatial setting is unconvincing, but the much
greater understanding of perspective displayed by
the Netherlandish glaziers active in the 1520s and
1530s is evident in their portrayal of Henry VIII
and Catherine of Aragon in the east window of St

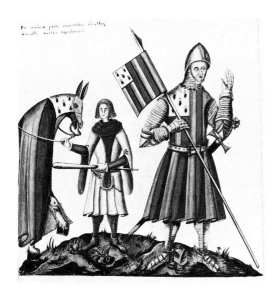

*Fig. 12*　(*above*) DRAYTON BASSET (Staffs.): Ralph, Lord Basset (d. 1342/3) and his wife Joan with his squire and horse. Formerly in the east window (Dugdale's *Book of Monuments*, BL Loan MS 38, fols 60v and 61r); (*below*) Sir Geoffrey Luttrell (d. 1345), his wife and daughter-in-law in the *LUTTRELL PSALTER* (BL MS Add. 42130, fol. 202v).

15

Margaret's, Westminster.[72]

Not all representations of donors conformed to the modes described above. The most vain-glorious of the variants are the twenty-four representations of Henry de Mamesfeld in the chancel glazing of *Merton College* chapel (*c.* 1294).[73] In the early fourteenth-century Pilgrimage window at York Minster (nXXV) male and female figures lead horses with their riders holding flags or lances.[74] The closest parallel is a destroyed composition in the east window of *Drayton Basset* church in Staffordshire. This depicted Ralph, Lord Basset of Drayton (d. 1342/3), wearing a heraldic surcoat over armour and carrying a banner with his arms; his wife Joan presented him with his helmet and on the left side of the panel an esquire held his horse, caparisoned with the Basset of Drayton arms.[75] Both the York Minster and the Drayton Basset scenes are related to the well-known image of Sir Geoffrey Luttrell (d. 1345) in the *Luttrell Psalter* (BL MS Add. 42130) and to tombs in Exeter Cathedral and Minster-in-Sheppey, Kent. Another unusual composition is the figure of Thomas Spofford, Bishop of Hereford (1421–48), kneeling before St Anne and the Virgin in the east window of *Ross-on-Wye* in Hereford & Worcester. Spofford had a particular devotion to St Anne; he was formerly represented with her in lost windows at Catterick in North Yorkshire and Ludlow.[76] In the Ross-on-Wye glass Spofford is offering his heart to the saint, which associates the panel with monumental brasses depicting the deceased with a heart in his/her hands; most of these hearts represent their souls.[77]

The middle years of the fourteenth century saw the emergence of a preoccupation with the transience of human life and concomitant emphasis on the macabre aspects of death and physical corruption. In sepulchral monuments a taste developed for depicting the effigy of the deceased as a decomposing corpse. The fashion seems to have originated on the Continent and one of the earliest recorded examples is the tomb of Francis de la Sarra (d. 1362) at La Sarraz near Lausanne.[78] During the fifteenth and early sixteenth centuries such effigies were sometimes surmounted by a second effigy showing the deceased clad in the full panoply of his office.

*Pl. XII;*
*Fig. 123*

*Fig. 12*

*Fig. 12*

*Fig. 13*

*Fig. 13*   ROSS-ON-WYE (Heref. & Worcs.): Bishop Spofford (1421–48) before St Anne and the Virgin.

These 'double effigy' monuments found particular popularity with higher ecclesiastics such as Bishop Fleming (d. 1431) at Lincoln and Archbishop Chichele (d. 1443) at Canterbury,[79] and images of the deceased as a decaying corpse or skeleton are quite common in English monumental brasses.[80] To date only one has been noted in English stained glass, although examples are recorded in windows dated between *c.* 1520 and 1560 in the churches of Saint-Vincent and Saint-Patrice in Rouen.[81] In the chancel north chapel (nII) at *West Wickham* in Kent is the figure of Sir Henry Heydon (d. 1503–4) represented as

*Fig. 14*

a kneeling skeleton.[82] Issuing from Sir Henry's mouth is a scroll bearing an invocatory text.

Donor panels almost invariably include labels and scrolls. The earliest, as at *Upper Hardres*, merely identify the patrons; from the fourteenth century the development of prayers for the dead, which is reflected by the popularity of chantries, also found expression in the almost *de rigueur* practice of including the phrase 'orate pro anima' (or its English equivalent) on donor labels, as in the panels depicting the Curson family at *Waterperry*.[83] If the window was glazed posthumously the date of death is usually given. In these instances the wording of the labels is very similar to that found on sepulchral monuments. In the Waterperry glass the various posthumous benefactions to the fabric of the church by the donors are recorded in the inscription. Quite frequently reference is made to the gift of the window in question, as in the Clothiers window at Ludlow,

*Fig. 6*

*Fig. 10*

*Fig. 14*   WEST WICKHAM (Kent): Sir Henry Heydon (d. 1503/4) as a skeleton, *c.* 1490–1500.

mentioned above (see page 6).

These inscriptions are valuable for dating glass, but need to be treated with caution. The occurrence of the words 'orate pro anima' does not invariably mean that the glazing was executed after the donor's decease. In the east window of the chapel at Haddon Hall in Derbyshire is an incomplete label which included this phrase and the date 1427; however, the donor, Sir Richard Vernon, lived until 1451.[84] Similarly prayers for the soul of Bishop Alcock are requested in the east window of Little Malvern Priory, which dates from 1480–2, although he lived until 1501.[85] Even when the 'orate pro anima' formula can be taken as a reliable *terminus post quem*, it should not be assumed that the window was always commissioned and erected without delay: Ralph Cromwell founded *Tattershall College* in 1439, but the glazing of the chancel did not commence until the late 1460s at the earliest and the nave windows were still in progress in 1482.[86]

*Pls III(c), XXIII; Figs 15, 48, 61*

The majority of labels and invocatory texts are in Latin, which in the words of Michael Camille was 'the discourse of divinity … an international medium of communication for the elite, a prerogative of those in power which permeated all levels of society, secular as well as sacred'.[87] Some fourteenth-century inscriptions are in French, which was at the time the language of the upper echelons of society. Below the figures of Sir John de Charlton and his family at Shrewsbury is this text: 'pries: pr: mons: iohan: de carleton: q fist fare ceste verrure et p dame hawis sa companion'. Shorter bidding texts in French are in nave north aisle windows at Asthall in Oxfordshire (nIII) and York Minster (nXXVI).[88] After the Norman Conquest English was reduced to a non-official status and it was not until the middle of the fourteenth century that it was permitted in Parliamentary petitions and legal documents such as wills, although it was used on a sepulchral slab at Stow in Lincolnshire as early as *c.* 1300, and in inscriptions to early fourteenth-century depictions of the Three Living and the Three Dead Kings in a wall-painting at Wensley in North Yorkshire and in the *De Lisle Psalter* (BL MS Arundel 83).[89] The use of English in stained glass is rare before the late fifteenth century; the earliest occurrence so

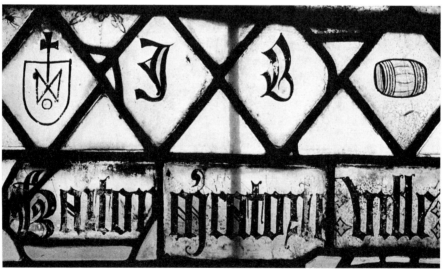

*Fig. 15* Badges and devices: (*above*) TATTERSHALL (Lincs.): roundels with Yorkist and religious devices and the badge of Ralph, Lord Cromwell, *c.* 1480–2; (*below*) merchant's mark, initials and barrel rebus of John Barton (d. 1491) at HOLME-BY-NEWARK (Notts.).

far noted was formerly in the east window of Elsing church in Norfolk and referred to Sir Hugh Hastings (d. 1347).[90] The labels held by the Everard family at Leverington, Cambridgeshire (window sIII), which date from *c.* 1400, are in English.[91]

Donors were not only represented by images or shields of arms, their generosity could also be commemorated by mottoes, initials, punning devices and badges. Mottoes were particularly suited to domestic glazing because they did not reduce the translucency of windows to the same extent as did figures and pictorial compositions. Labels inscribed 'soueignez vous de moy' and 'Soueraigne' were ordered in 1401–2 for windows in the royal palace at Eltham.[92] These do not survive, but the mottoes of Bishops Alnwick (1436–49) and Smith (1496–1514) can still be seen in the glazing of Lyddington Bedehouse, Leicestershire, a residence of the bishops of Lincoln. Other examples are in the glazing of *Ockwells* in Berkshire and (heavily restored) in Halle's house, Salisbury.[93]  *Fig. 76*

Initials of donors began to appear in windows in the late fourteenth century, sometimes in association with figures of the patrons. In this period they are confined to borders, as at *Birts-morton* in Hereford & Worcester (R for the Ruyhale family), Stoke Charity, Hampshire (TH for Thomas de Hampton), Farleigh Hungerford in Somerset (TH for Sir Thomas Hungerford) and *Old Warden* (W, either for Warden Abbey or Abbot Walter).[94] In fifteenth- and early sixteenth-century glazing initials also appear on quarries (diamond-shaped panes), roundels and shields. A considerable number of quarries exist with the monarch's initial surmounted by a crown, often accompanied by the initial of his consort. At Badby in Northamptonshire (window sIII) is a roundel bearing the initials of Thomas Newbold, Abbot of Evesham (1491–1514), which owned the advowson of Badby. Cold Ashton in Avon has a series of shields with the initials of Thomas Key, rector of the parish between 1508 and 1540, who rebuilt and glazed the entire church with the exception of the tower.[95]  *Fig. 139* *Fig. 137*

Badges and devices, with or without initials or names, were very popular from the late fourteenth century until the Reformation. At

*Tattershall* is a series of roundels bearing the purse and gromwell plant of Ralph Cromwell, together with the white rose and other emblems of the House of York.[96] Rebuses or punning devices like the gromwell plant seem to have been introduced during the fifteenth century. A barrel or tun was a common motif for those whose names ended in *tun* or *ton*. At *Holme-by-Newark* in Nottinghamshire John Barton's (d. 1491) barrel is accompanied by his initials and merchant's mark.[97] The *Burrell Collection* contains probably the most elaborate of these plays-on-words. It shows a man beginning to slip from a tree, the trunk of which is flanked by a human eye and the word SLIP. This was the device of John Islip, Abbot of Westminster (1500–32).[98]  *Fig. 15* *Fig. 15* *Fig. 16*

The Order of the Garter was one of the most prestigious of the European chivalric associations and those who were elected to it were keen to commemorate the honour by depicting the garter device and motto in windows. No doubt they appeared in the original glazing of the Order's chapel at Windsor, but its windows no

*Fig. 16* GLASGOW, BURRELL COLLECTION: quarry bearing the device of Abbot John Islip (1500–32).

*Fig. 17*   GLASGOW, BURRELL COLLECTION: arms within garter of Sir Henry Fitzhugh (d. 1424).

longer exist. The earliest surviving example of the garter badge and motto in stained glass is in the *Burrell Collection*, enclosing a shield of arms of   *Fig. 17* Sir Henry Fitzhugh; he was elected to the Order in 1413 and died in 1424.[99] A considerable number of quarries with the garter badge and motto also survives from the series of windows which depicted the Founder Knights of the Order in St George's church at *Stamford* in   *Fig. 73* Lincolnshire.[100]

## The commissioning of windows

Very few traces of transactions between patron and glass-painter have survived, and most are confined to the close of the Middle Ages. These indicate that the subjects to be represented were usually determined by the patron, perhaps after consulting his or her parish priest or spiritual adviser. Sometimes those who bequeathed money for the purchase of a window as a memo-

rial left detailed instructions in their wills. In 1519 Sir Edward Benstede requested his executors to make a window on the south side of Hertingfordbury church, Hertfordshire, and glaze it with figures of St Alban and St Amphibalus, and escutcheons of his wife's arms and his own.[101] Fragments still exist (in windows nVII and sV) of the Doom which Sir Robert Throckmorton in 1518 stipulated should be placed in the east window of Coughton church in Warwickshire; he also named the subjects for two other windows.[102]

Some medieval wills from Kent are informative on glazing. John Roper exhibited a by no means uncommon concern that his executors might be tardy in carrying out his wishes. He ordered the east window of the chancel north aisle of St John's Hospital in Canterbury to be 'glazed with such images or pictures as I shall show unto my executors, and that to be done within two years after my decease'. The will is dated 1526 and although the window no longer exists an inscription formerly in it shows that the glazing was carried out in 1529.[103]

Three wills give detailed information on the glazing of All Saints parish church at Lydd.[104] In 1476 John Seawlys bequeathed £10 to make a new window containing the Seven Sacraments, which was to replace a small window and be of the same dimensions as another large window there. Twenty-five years later John Breggs requested that 'the glass window in the gable of the chancel of St Nicholas be broken down and made new well sufficiently and cleanly, and making mention of the life of St John the Baptist'. In 1494 John Aylewyn's prime concern was that his family was portrayed accurately:

*That my tenement in the parish of St Lawrence in Romney, with the lands, shall be sold after the death of Juliane my wife, and with the money that a new window shall be made in the chapel of St Mary of Lydd; and for a new image of the same St Mary and new painting of the same image, £25. But if anyone else will do this, then from the £25 to the making of a new window in the chapel of St John Baptist in the church of Lydd, £10; so that in the middle of the same window shall be – Dom Andrew Aylewyn; and on the right part of the same window the names of James Aylewyn with Christiane and Juliane his wives; and in the left part the names of Thomas Aylewyn and Agnes his wife; and in another part the names of John Aylewyn and Juliane his wife.*

It is particularly regrettable that none of this glass survives, as is so often the case when documentary evidence exists. A rare instance where the will is recorded and the relevant glazing is still to be seen is at *Stanford on Avon* in Northamptonshire. So detailed were the instructions laid down on 5 April 1500 by the vicar, Henry Williams, that the glazier could have translated them directly into a cartoon:

*I wyll that the glasse windowes in the chancell w^th ymagery that was thereyn before allso w^th my ymage knelying in ytt and the ymage of deth shotyng at me, another wyndowe before Saynt John with ymagery in ytt now w^th my image knelying in ytt and deth shoting at me theys to be done in smalle quarells of as gode glasse as can be goten.*

One of these 'ymage of deth' roundels survives together with a representation of Henry Williams; they show how closely the glass-painter adhered to the terms of the will (window nII).[105]

Donors did not always set out their requirements for windows so precisely. The last testament of William of Wykeham (d. 1404) left the choice of subject-matter to his executors, but gave detailed instructions for the sequence in which the glazing of the nave of Winchester Cathedral was to be carried out:

*Item lego pro fenestris tam superioribus quam inferioribus partis australis ecclesiae praedictae per me reparatae,*

Fig. 18

*bene & honeste & decenter juxta ordinationem & dispositionem Executorum meorum vitriandis, Quingentas Marcas. Et volo quod fiant hujusmodi fenestrae vitreae incipiendo in fine occidentali ecclesiae praedictae in novo opere per me facto seriatim & in ordine usque ad completionem ac consummationem omnium fenestrarum dicti novi operis partis australis antedictae. Et si quid tunc de dicta summa remanserit non expenditum, volo quod circa fenestras alae borealis totaliter expendatur, incipiendo in fine occidentali ad primam fenestram novi operis per me facti, & sic continuando versus partem orientalem, prout de parte australi superius specialiter ordinavi.*[106]

The wishes of a donor or testator had to be incorporated into a binding agreement with the glass-painter who undertook the commission. There is at least one known instance of verbal instructions being given to a glazier. In 1340 John de Walworth received 6s 8d 'for mending glass windows in the King's white chamber over the Queen's gate towards the east [in Westminster Palace] with the quartered arms of the King of England and France, made and mended by verbal command of the King'.[107] This, however, is an understandable procedure in the case of a salaried glazier employed to carry out repairs in the royal residences. The normal form of agreement, as for other commercial transactions, was a written contract. The earliest reference to a contract is in 1237, when Peter the Painter received 5s 6d as agreed by contract for making a glass window for Marlborough Castle in Wiltshire; the first existing contract, for Chichester Cathedral, dates from three years later.[108] There are also contracts for glazing in the Carmelite monastery at Ploërmel in Brittany, dated 1307, and for Chartres (1317), which provide useful comparative information.[109] Most of those for which we have detailed knowledge date from the early sixteenth century. Very few contracts survive; for the most part there are only abstracts which give little more than the name of the glazier, the patron and the price. Some contracts are known from later copies which should therefore be treated with caution. None the less there are certain features common to most of these documents.

One of the original contracts which still exists dates from 1513 and is between Robert Shorton, Master of St John's College, Cambridge, and Richard Wright, glazier:

*Fig. 18*    STANFORD ON AVON (Northants.): Henry Williams and his 'ymage of deth' roundel, *c.* 1500.

*This indenture made bytwen Maister Robert Shorton Clerk, doctor of Diuinite Maister and Keper of the Collegge of Seynt John Theuangeliste in Cambrigge on that oon partie*

*And Richard Wryght of Bury Seynt Edmund in the Countie of Suffolk Glasyer on that other parte, Witnessyth that the said Richard couenaunteth ... that he shall Glase with good and hable Normandy Glasse All the Wyndowes belongyng to the Maisters loggyng within the said Collegge with Roses and purcholious conuenyent for the same*

*And also the Wyndowes within the halle of the said Collegge also with Rosez and purcholious and the Bay Wyndowe within the said halle with the pyctour of seynt John Theuangeliste and with Tharmes of the Excellent pryncesse Margaret late Countesse of Rychemond and Derby Welle and Workemanly made conuenient for the same*

*And also all the Wyndowes belongyng to the Chappell within the Collegge aforesaid with Imagery Werke and Tabernaclis suche as the said Maister Robert Shorton shall appoynte and assigne for the same after his discression*

*And also ij Wyndowes atte the Weste ende of the said Chappell within the said Maysters loggyng also with Rosez and purcholious all thyse premyssez with as goode and hable normandy Glasse of colourz and pyctourz as be in the Glasse Wyndowes within the Collegge called Cristes Collegge in Cambrigge or better in euery poynte*

*And clerly and holly shall fynysshe all the said Wyndowes in fourme as is aforesaid after and accordyng to the best workemanshipp and proporcion a thisside the feste of midsomer next cummyng after the date herof*

*for the whiche premyssez so to be accomplisshed and doon The said Maister Robert Shorton couenaunteth ... that he shall pay ... to the said Richard ... That is to Wytte for euery foote of the said Wyndowes within the said Maisters loggyng and halle aforesaid iiijᵈ ob the foote; and for euery Rose and purcolious within the said wyndowes viijᵈ; And for Thymage of seynt John theuangeliste and tharmes aforesaid ijˢ; And for the foresaid Wyndowes within the said Chappell xlv li of good and lawfull money of yngland wherof the said Richard knowlegeth him silf to haue resceyued and hadde the day and yer of makying herof of the said maister Robert Shorton x li sterlinges and therof utterly acquiteth and dischargeth the said maister Robert Shorton ... And xxxv li Residue of the said summe of xlv li the sayd maister Robert Shorton couenaunteth ... to pay ... to the said Richard ... in maner and fourme folowyng That istosey as the said Richard maketh expedicion of the said workes and nedeth to haue money for the same The said maister Robert Shorton shall pay to him the said xxxv li after his discression as he nedeth yt*

*And wher as the said Richard by his wryting obligatorie beryng date the day and yere of makyng herof is holden and bounden to the said mayster Robert Shorton in the summe of l li sterlinges payable atte the feste of Estir next*

*cymmyng after the date herof as in the said obligacion more pleynly doth apper Neuerthelesse the said Maister Robert Shorton wylleth and graunteth by thise presentes that yf the said Richard dothe holde kepe perfourme and fulfille all and singuler couenauntes condicions promysys grauntts and Articlis aforesaid ... That than the said Obligacion to be voyde Orelles yt to stonde and be in the hole strenght and effecte*

*Into witnesse wherof to this Identures the parties aforesaid Interchaungehably haue sette their Sealles.*

*yoven the xvijᵗʰ day of Decembre the fyueth yere of the reigne of oure soueraign lorde kynge henry the viijᵗʰ.*[110]

This contract does not differ in essence from other medieval European commercial agreements, such as those between the limewood retable sculptors of south Germany and their patrons.[111] It combines the deposit or earnest by the patron to the craftsman which bound the latter to complete within an agreed period, a bond or surety by the glazier to fulfil the contract and the obligation of the patron in turn to pay the balance as necessary. It also includes instructions to the glazier regarding subject-matter and stipulates that glass from Normandy was to be used.

Although payments and prices will be considered in the next chapter, a few observations need to be made here in so far as they concern donors and their contracts. The total cost of the St John's College scheme was in excess of £45, of which £10 was paid to Wright as an advance. It was customary by this time to pay such an advance, or *prest* as it is sometimes known. In 1511 Barnard Flower received £20 as down-payment for work at the Chapel of Our Lady, Walsingham, Norfolk, and four years later had an advance of £100 for the great scheme at *King's College Chapel*, Cambridge. An advance was also paid in 1526 at King's College.[112] *Pls XXVIII, XXIX; Figs 184–5*

It is not certain that advances were paid before 1500. No mention of such payments occurs in the fourteenth- and fifteenth-century contracts from England of which we have knowledge, although they do feature in the Breton contract of 1307 mentioned above. The contract of 1338/9 for the great west window in the nave of *York Minster* merely stated that the glazier Robert (probably Robert Ketelbarn) was to receive 6d per square foot for white and 12d for coloured glass; the two flanking windows *Pl. XVI*

(nXXX, sXXXVI) were glazed by Thomas de Bouesdun at a cost of 11 marks for each window.[113] Where a weekly wage was paid there was no need for an advance. In 1405 John Thornton of Coventry contracted to glaze the choir east window of the *Minster*; for this he was paid 4s per week in addition to an annual payment of £5 and the sum of £10 on satisfactory completion of the work.[114] There is no mention of an advance, nor is there in the contract of 1447 with John Prudde for the glazing of the *Beauchamp Chapel*, Warwick: for this he was to receive 2s per square foot.[115]

The St John's College contract is not alone in specifying the type of glass to be used. Prudde had to glaze the Beauchamp Chapel windows

*with Glasse beyond the Seas, and with no Glasse of England; and that in the finest wise, with the best, cleanest, and strongest glasse of beyond the Sea that may be had in England, and of the finest colours of blew, yellow, red, purpure, sanguine, and violet, and of all other colours that shall be most necessary. ... Of white Glasse, green Glasse, black Glasse he shall put in as little as shall be needfull for the shewing and setting forth of the matters, Images and storyes.*[116]

Wright contracted to complete the St John's College glazing by midsummer 1514. Time limits are specified in a number of other contracts. In 1405 John Thornton was allowed three years by the dean and chapter of York in which to glaze the great east window of the Minster.[117] The contracts of 1526 for the glazing of King's College Chapel stipulate that Hone, Bond, Reve and Nicholson had to finish six windows within one year and twelve in the following four years; the indenture for Williamson and Symondes gave them two years for two windows and another three years for two more; this was amended to give them five years for all four windows.[118]

To ensure that glass-painters kept to the agreed dates 'bonds' or penalty clauses were included in contracts. Wright had to pay £50 if he failed to fulfil the contract and the two teams of King's College glaziers were bound in 500 marks and £200 respectively.

The St John's College agreement specifies the subject-matter for all the windows except those in the chapel; there is a broad description of

*Figs 65, 144(d), 145*

*Pls II(c), III(d);*
*Figs 11, 69, 164*

'Imagery Werke and Tabernaclis' which can be interpreted to mean figures and canopies, the details of which would be supplied to Wright by Shorton. These have nôt survived, but several other instructions by patrons to glaziers still exist. Two rolls concerning the glazing of the Observant Friars' church at Greenwich in *c.*1490–4 give a very precise brief. The section illustrated in Figure 19 reads:

*Fig. 19*

*Lowes kyng of Fraunce of whos body kyng Henry the vij[th] kyng of England is lynyally dyscended and sonne to hym in the ix[th] degree.*
*Make hym armyd with a mantill over his harnes an opyn crowne and a berde a sceptyr in his lefte hande and a ball wyth a crosse in his ryght hande.*
*His armes the felde asure flourte golde.*
*Ethelbert kyng of Kent shryned at Seint Austynes at Cauntlburye.*
*Make hym in the abytte of a peasible kyng santly a berde*

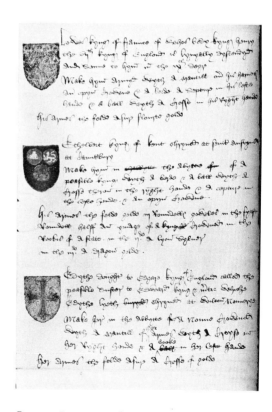

*Fig. 19* Instructions for glazing the Observant Friars' church at Greenwich (BL MS Egerton 2341a), *c.*1490–4.

& a ball wyth a crosse theron in the ryght honde & a septyr in the lefte honde & an opyn crowne. His armes the felde gold iij roundells gowles in the fyrst roundell halff an ymage of a kynge crowned in the roobis of astate in the ij$^d$ a lyon sylver in the iij$^d$ a dragon golde.

Edythe dought[er] to Edgare kyng of England called the peasible suster to Edward kyng & martir whyche Edythe lyeth shryned at Wilton Nonnerye. Make her in the abbytte of a nonne crowned wyth a mantill of her armes the felde asure wyth a croyse on her ryght honde & a booke in her left honde her arymes the felde asure a crosse of golde.

To ensure that the heraldry was accurately portrayed the arms so described are painted in the margin.[119]

A similar concern is evident in the written instructions regarding the heraldic charges to be depicted in a window (or alternatively on a mural or even a sepulchral monument) commissioned by *Thomas Froxmere* between *c.* 1484 and 1498. The instructions are accompanied by very rough drawings of Froxmere, wearing a heraldic tabard, and his wife, kneeling in prayer. These sketches are so crude that they are probably the work of the donor himself.[120]

Reference is made in several documents to pictorial, rather than written specifications. Prudde's contract for the windows of the Beauchamp Chapel states that '… the matters Images, and stories … shall be delivered and appointed by the said Executors by patterns in paper'.[121] Henry VII's will stipulates that the subjects for the windows of his chapel at Westminster Abbey were to be delivered 'in picture' to the Master of the Works.[122]

A drawing of this kind was termed a *vidimus*,

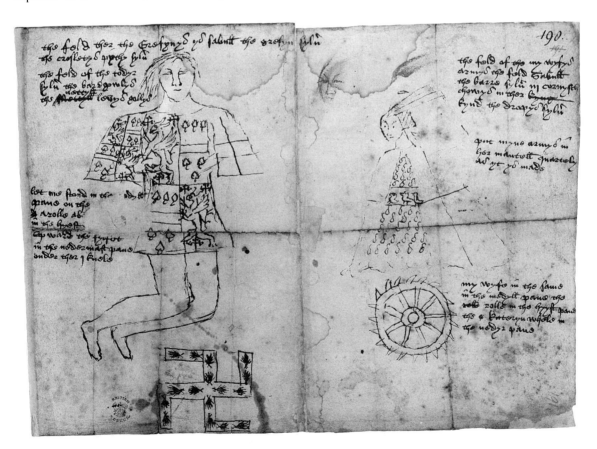

*Fig. 20*    Instructions and rough drawings of Thomas Froxmere and his wife (BL MS Lansdowne 874, fol. 191), *c.* 1484–98.

as in the 1526 agreement for glazing King's College Chapel.[123] Their use was not confined to glass-painting, but were found in all crafts which required individual designs; reference is made to them in documents associated with monumental brasses, late Gothic limewood altarpieces in south Germany, Italian painted altarpieces and French murals.[124] Several Continental examples for stained glass exist from the fourteenth century,[125] but none is known from England prior to the Froxmere drawing, with the possible exception of the series of penwork drawings with light colour washes which comprise the *Guthlac Roll* (BL MS Harley Roll Y.6) probably of *c.*1210.[126]

*Fig. 97*

The entry in the 1389–90 fabric accounts for *Exeter Cathedral* of a payment of 8d 'pro j pelle *Fig. 144(a)* pergomeni empta ad pinguendum magnam fenestram in capite ecclesie' has been interpreted as referring to a glazier's full-size cartoon.[127] However, the other documentation for the enlarged east window indicates that this must have been a mason's drawing for the approval of the dean and chapter rather than a glazing *vidimus* or a cartoon. On 21 April 1390 Canon Henry de Blakeborne offered 100 marks towards the cost of enlarging this window, the stonework of which seems to have been completed a year later; it was only then, on 7 May 1391, that Robert Lyen contracted with the chapter to glaze the window.[128]

Sometimes the *vidimus* was the work of the donor himself, as is probably the case with the Froxmere drawing. The wording of John Roper's will also suggests that the preliminary drawings for the east window in St John's Hospital in Canterbury may have been from his own hand (see above, p. 20). In most instances these drawings were probably prepared for the patrons and craftsmen by professional *limnours* or draughtsmen, who themselves might be leading artists. In 1505 seven shillings were paid to John Delyon, the glazier employed at Lady Margaret Beaufort's manor at Collyweston in Northamptonshire: 'for the changyng of the Antelope unto an Ivell in the bay wyndowe in the grett chambre, wt xx^d yevyn to William Hollmer for the draght of the said Ivell at London'.[129] Several years later a glazier named Wright (possibly the craftsman named in the St John's College

contract) was employed at Little Saxham Hall and received 10s 'for purtraying of my [Sir Thomas Lucas's] chapel windowe and settying out the coloures of the same unto my glasier'.[130] In the *Musées Royaux des Beaux-Arts* in Brussels is *Fig. 176* a volume containing twenty-four *vidimuses* which date from *c.*1525–6 and may be connected with Cardinal Wolsey's lost glazing of the chapel at Hampton Court.[131] Associated with them is a *vidimus* in the *National Galleries of Scotland* for a large thirteen-light window; as the *Fig. 21* subjects depicted in it include St William of York, this *vidimus* is also probably a Wolsey project (he was Archbishop of York), perhaps for either of his grandiose unfinished schemes at York Place (later Whitehall Palace) and Cardinal College, Oxford.[132] The other subjects in the Edinburgh drawing are three saints, Passion scenes, the Crucifixion and the Last Judgement. The Hampton Court series comprises a glazing programme for a large east window and eight four-light side windows. The *vidimus* for the east window includes a Crucifixion flanked by other Passion scenes, several saints, a cardinal, a king and a queen (Henry VIII and Catherine of Aragon) and a young girl who probably represents Princess Mary. The *vidimuses* for the side windows show that in the upper row of lights was a cycle of the life of Christ; below were the apostles, prophets and the Four Doctors of the Church. The Edinburgh and Brussels *vidimuses* are by the same workshop, if not the same hand. The style of the drawings indicates that the artist(s) was not English, and although it has been suggested that they are to be associated with the Nuremberg engraver Erhard Schön,[133] it is more likely that they are the work of the Netherlandish-born glazier James Nicholson who was employed by Wolsey on various projects in 1528–30. The Edinburgh *vidimus* and several of the Brussels series have contemporary annotations in English, although some Dutch words are included which betray the Netherlandish origin of the writer. A comparison of these inscriptions with Nicholson's signature on the 1526 King's College contract points to his authorship of at least the texts and probably the drawings as well. These annotations, particularly on the Edinburgh *vidimus*, do not always tally with the subjects depicted; for example, *ecce homo* is

*Fig. 21*  EDINBURGH, NATIONAL GALLERIES OF SCOTLAND: *vidimus* for a 13-light window; penwork and colour washes, *c.*1525–6.

written over St Thomas of Canterbury and the Entombment on the Edinburgh drawing. Presumably these represented changes of mind by the patron.

The three *vidimuses* which survive for windows at *King's College Chapel* represent a later stage in the design process than the Edinburgh and Brussels drawings.[134] The King's College sketches include grid-lines representing

Fig. 184

the window *ferramenta*, which suggest that they were not the original *vidimuses* but copies made from them after final approval had been given by the patron, and intended for use as guides by the maker of the full-scale cartoons for the window.[135] With this stage we enter the world of the glass-painter proper and the technical aspects of the craft.

# 2

# *The Technique of Medieval Glass-painting and the Organization of Workshops*

The practices of most contemporary glass-painters have not changed substantially from those described in various medieval treatises on the arts: those of Theophilus (early twelfth century), Eraclius (late twelfth–early thirteenth century), Anthony of Pisa and Cennino Cennini (late fourteenth century).[1] As the glazier had to obtain his raw materials before he could begin to exercise his craft, some preliminary remarks should be made on the making of glass.

## Glass-making

The craft of glass-making was a different process from that of glass-painting and in England from at least the mid-thirteenth century was not carried out by the same artisans.[2] The glass-makers of northern Europe, who supplied both window glaziers and the manufacturers of glass vessels, were located in wooded areas close to the natural resources they required. These comprised sand and wood- or plant-ash which was rich in potash and had quite a high lime content. The sand used by English glass-makers contained a very low percentage of iron oxide (0.5 per cent or less) which resulted in white glass with a distinct green tinge. Because of impurities in the raw materials, white glass was rather cloudy, not clear, until the fourteenth century.[3]

The ash and the sand were mixed together in clay pots and then placed in a furnace. When heated sufficiently, the ingredients fused together to form liquid white glass. To make coloured glass various oxides were added to the ash and sand. Cobalt was used to produce blue glass, and green or yellow came from iron oxide. Until the sixteenth century the non-white glass used by English glaziers was more or less coloured throughout and is known as 'pot' glass. The main exception was red (or ruby glass as it is usually termed): because the copper oxide used in its manufacture was a very heavy colorant, in order to retain the translucency of the material it was 'flashed', i.e. one side of white glass was coated with a thin layer of ruby; in the early sixteenth-century glazing of Fairford, Gloucestershire, ruby occurs on blue glass.

After the ingredients had fused into liquid glass the temperature of the furnace was cooled sufficiently for the glass to be made into sheets by means of blowing on a pipe. Two methods of blowing were employed. The process described by Theophilus is the 'muff' or sleeve method which had been practised since Roman times: the molten glass was blown and swung on the pipe until a long bottle shape was formed. The ends were pinched off, leaving a cylinder or sleeve. This was re-heated and split along its length with a hot iron and then opened out to form a flat sheet. The 'crown' method was known in the Near East from about the fourth century AD. In this process the liquid glass was transferred from the pipe to an iron rod, re-heated and rolled until the glass was opened out by centrifugal force to form a flattish circular dish. Whichever process was used, the finished flat sheet was then placed in an annealing furnace, where it was allowed to cool slowly and

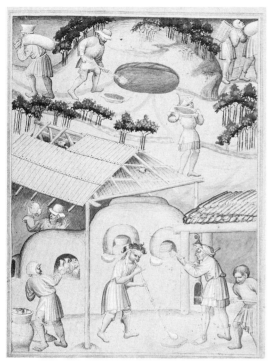

Fig. 22 Glass-making depicted in an early fifteenth-century Bohemian manuscript of Sir John Mandeville's *Travels* (BL MS Add. 24189, fol. 16).

harden over several days.

The manufacture of glass is illustrated in an early fifteenth-century Bohemian manuscript of Sir John Mandeville's *Travels* (BL MS Add. 24189).[4] In the upper section of the miniature, workmen are digging sand and carrying it in troughs down to the furnace which is placed under an open shed in the foreground. To the right are stacked billets of wood and below a workman is tending the hearth at the entrance to the fire-trench. In front of the main furnace are two glass-blowers and on the left another workman is removing the finished products from the smaller annealing furnace. Although in this instance the products are glass vessels rather than glass sheets for windows, the process was the same for both.

The principal centre for glass-making in England during the Middle Ages was the Weald of Surrey and Sussex, and in particular the vicinity of Chiddingfold on the border between the two counties.[5] In this region the essential raw materials of beech-wood and sand were to hand. A medieval glass-house has been excavated at *Blunden's Wood* in Hambledon parish, which adjoins Chiddingfold. Three kilns or furnaces were found, of which the largest (A), was used

*Fig. 22*

*Fig. 23*

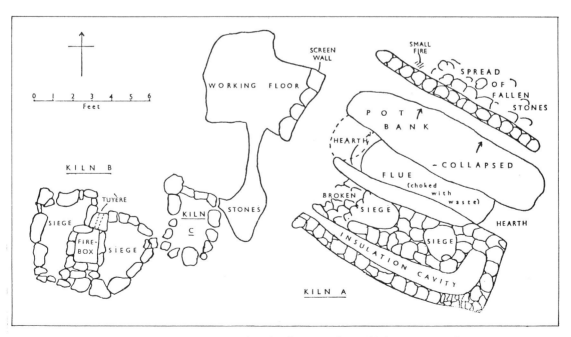

Fig. 23 Medieval glass-house excavated at Blunden's Wood, Hambledon (Surrey). *After E.S. Wood.*

for melting the ingredients. It is thought that the purpose of the two smaller furnaces (B and C) was for pre-heating the clay pots and fritting (fusing) and annealing.[6]

Magnetic dating tests and pottery finds indicate that the Blunden's Wood site was in operation during the second quarter of the fourteenth century. The Chiddingfold area had already been a centre of glass-making for a considerable time, for just before 1240 Laurence *Vitrearius* obtained 20 acres of land there.[7] In 1351 and 1355 John Alemayne of Chiddingfold supplied substantial quantities of white glass for the windows of *St Stephen's Chapel*, Westminster, and the new chapel in Windsor Castle.[8] John Alemayne, who judging by his name was a native of the Holy Roman Empire, occurs at Chiddingfold between 1330 and 1370; in 1367 he granted a lease of his property in Hazelbridge to John Schurterre, glazier, and the Schurterre (or Shorter) family were prominent practitioners of the craft until the end of the fourteenth and possibly into the fifteenth centuries.[9]

*Fig. 129*

Not all of the glass used for St Stephen's Chapel came from the Weald. In 1349 a glazier named John de Brampton was ordered to purchase glass for the chapel in Staffordshire and Shropshire.[10] In the former county the main areas of manufacture were Bromley Hurst near Abbot's Bromley and Wolseley near Rugeley.[11] A charter of 1289 refers to *le Glasslone* at Bromley Hurst and in 1416 a field there was called *Glasshouse Field*. Fifteen glass-house sites in Bagot's Park in this area have been discovered; although none has been dated before the early sixteenth century they demonstrate the importance of the region as a centre of glass-making. There are references to Rugeley workmen bearing the name Glasman from the early fifteenth century and in 1418 white glass was purchased for York Minster from John Glasman of Rugeley.[12] There are also references to a glass-house in the Rugeley area in the mid-fifteenth century and ferns were sold to glass-makers in 1479.[13] In the following year glass from Staffordshire was supplied for the collegiate church at *Tattershall* in Lincolnshire.[14]

*Pls III(c), XXIII; Figs 15, 61*

Some medieval glass-making was carried out in Cheshire. The Cistercian abbey of Vale Royal was associated with the craft between 1284 and 1309 and window glass has been discovered at a glass-house site in Delamere Forest. Pottery finds indicate a fifteenth-century date, but a coin of Edward I's reign (1272–1307) and fragments of early thirteenth-century grisaille show that the site was in use earlier.[15]

There has been considerable debate as to whether coloured as well as white glass was made in English medieval glass-houses.[16] In 1449 a monopoly was granted to a Fleming, John Utynam, to make coloured glass for the windows of Eton College and King's College, Cambridge, and to instruct others in the process 'because the said art has never been used in England'.[17] No coloured window glass has so far been found on any medieval kiln-site and there is no documentary evidence that coloured glass was ever purchased from English sources, so it must be doubted whether Utynam's efforts met with success.

Even English white glass was considered inferior to that produced on the Continent. The contract of 1447 for the glazing of the *Beauchamp Chapel* at Warwick went so far as to stipulate that the glazier, John Prudde, was to use 'Glasse beyond the Seas, and with no Glasse of England'.[18] English medieval glass is often of indifferent quality and the high potash content made it particularly prone to corrosion.[19]

*Pls II(c), III(d); Figs 11, 69, 164*

The principal sources of this 'glasse beyond the seas' were those parts of Flanders and Lorraine which border the Rhine (known as 'Rhenish' glass) and Normandy. The earliest reference to the purchase of foreign glass appears to be in 1318, when 629 weys of white and 203 weys of coloured glass were obtained for Exeter Cathedral from Rouen.[20] Coloured glass for the windows of St Stephen's Chapel, Westminster, and for Windsor was bought in 1351–2 from the London warehouses of the Hanse Merchants in the Steelyard at the bottom of Thames Street.[21]

East coast ports such as Hull and King's Lynn tended to be the entry-points for glass from the Rhineland and Flanders, but in the fifteenth and early sixteenth centuries glaziers throughout the country used the products of glass-houses from all the areas mentioned above. The York glass-painters, who through the proximity of Hull availed themselves of glass from Flanders and the Rhineland, are also known to have purchased

glass from Normandy (1538).[22] In 1508 the York glazier *John Petty* bequeathed to the Minster six tables of Normandy glass as well as ten sheaves of Rhenish glass.[23] For the windows of Coldharbour in London in 1485 glass was used from Normandy, England, 'dusche' (i.e. the Rhineland) and Venice; the last appears to be the first reference to the use in the British Isles of glass from this famous centre.[24] Frequently in the early sixteenth century a combination of glass from the Rhineland and Normandy was used in glazing schemes.[25]

The sheets of glass supplied to the glass-painting workshops were usually priced by weight. In the fourteenth and fifteenth centuries this was expressed in terms of a 'wey' or 'ponder', which weighed 5 lb; 24 weys comprised a 'seam' or 'hundred', i.e. 120 lb. In October 1351 John Alemayne received 37s 6d for '303 weys of white glass, each hundred of 24 weys and each wey of 5 lb'; these were destined for the windows of St Stephen's Chapel.[26] During the fifteenth and early sixteenth centuries some new terms appeared, the 'wawe', 'sheaf', 'wisp', 'case' and 'cradle'. The wisp appears to have corresponded with the wey and weighed 5 lb, and the case and cradle were the same as the seam. The sheaf seems to have weighed 6 lb and the wawe comprised 60 sheaves. At Collyweston in Northamptonshire a wawe of white glass cost 30 shillings, exclusive of carriage, in the early sixteenth century. In 1537 the costs of glass bought for Sheriff Hutton Castle, North Yorkshire, were as follows:

*Payed to Robert Hall, merchant of Yorke, for iiij cradyll of Normandye glasse, at xviijs a cradyll – lxxijs. Item payed to Robert May of Yorke, merchant, for a chest of wyspe glasse, xvijs vjd. Item to the said Robert for x wyspes glasse, at ixd a wyspe – vijs vjd.*[27]

Normandy glass was generally considered to be superior to both Rhenish and English glass and this is reflected in the price. For the glazing of Croydon Manor in 1505 Barnard Flower supplied 16 square feet of Rhenish glass at 4d per square foot; the same amount of glass from Normandy cost 5d per square foot.[28]

The costs quoted above all refer to white glass; coloured glass was always more expensive.

*Fig. 31(c)*

In August 1253 glass purchased for *Westminster Abbey* cost 3d per wey for white and 6d for coloured glass (respectively 3s and 6s per seam), and the price of the 203 weys of coloured glass bought for Exeter in 1318 was £10 3s 0d compared with £15 14s 9d for the 629 weys of white glass.[29] White glass obtained from Chiddingfold for the royal chapels at Westminster and Windsor in the middle of the fourteenth century was priced at 6d per wey and foreign white glass cost between 8d and 9d per wey. The coloured glass used here was very much more expensive: the ruby glass cost 2s 2d per wey, azure (blue) and sapphire 3s.[30] These were the prices of the raw materials and did not include the cost of painting the glass and forming it into windows; this process will now be described.

*Pl. IX;*
*Figs 5,*
*102(c),*
*106*

## The glazier's craft [31]

The first stage in the making of a window was the preparation of a full-size drawing, or cartoon, of the design. The cartoon itself would usually be based on the *vidimus* supplied by the patron of the window or made for his approval (see above, pp. 24–7). The *vidimus* could be supplemented by stock design features such as canopies, borders and decorative embellishments robes and haloes taken from the glass-painter's own working sketchbooks. The will of the York glazier William Thompson (d. 1539) makes reference to a 'book of portitour' which he left to his partner or apprentice; this was presumably such a sketchbook.[32] The well-known manuscript in the Pepysian Library at *Magdalene College*, Cambridge (MS 1916), is made up of a collection of drawings by various hands which were probably originally loose sheets kept together in a portfolio. Most appear to date from the end of the fourteenth century and include what may be copies of late thirteenth-century works of art. The human figures are too lively and animated to be circumscribed within Gothic tracery and therefore are unlikely to have been used for glazing, although the exquisite coloured illustrations of birds are closely paralleled in the south aisle windows at *Salehurst* in East Sussex. The volume may have come into the

*Figs 21,*
*176, 184*

*Fig. 24(a)*

*Fig. 24(b)*

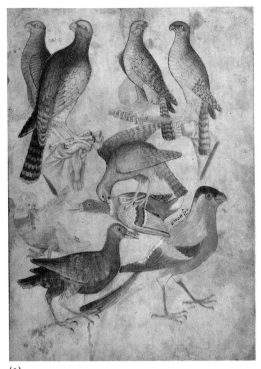

(a)

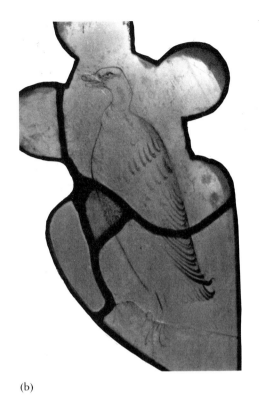

(b)

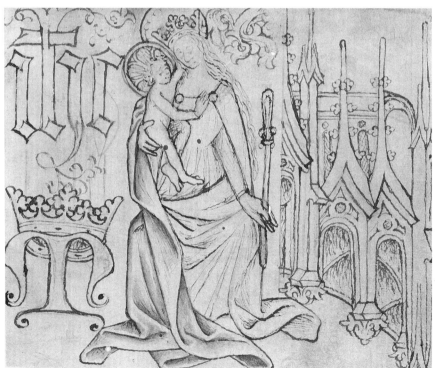

(c)

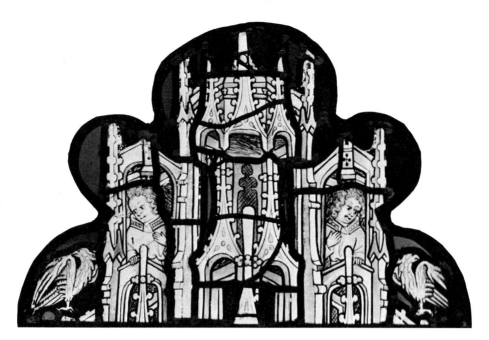

(d)

*Fig. 24*    *THE PEPYSIAN SKETCHBOOK* (Cambridge, Magdalene Coll. Pepysian MS 1916) and parallels in stained glass:
(a)  Penwork and coloured wash birds, end of fourteenth century;
(b)  SALEHURST (East Sussex): bird in grisaille, *c.* 1400;
(c)  Canopy section, sacred monogram and Virgin and Child, late fifteenth century;
(d)  STAMFORD, ST JOHN'S CHURCH (Lincs.): canopy, *c.* 1451.

hands of a glass-painter towards the end of the Middle Ages, for there are some drawings added in this period including a section of a type of architectural canopy confined almost exclusively to stained glass; the sacred monograms IHC and the crowned M on the same folio also occur frequently in this medium.[33]  *Figs 24 (c), (d)*

The cartoon guided the work at all stages and so was precisely set out and included all subject-matter and the lead-lines, and had the required colours indicated by a symbol or letter. From the time of Theophilus (and probably before) down to at least the mid-fourteenth century cartoons were drawn on boards or trestle tables prepared with chalk or whitewash. None of these boards has been discovered in England, although a pair of whitewashed tables bearing designs for stained glass panels and dating from the early fourteenth century exists at *Gerona* in Spain;  *Fig. 25*  three more designs, probably of the mid-fourteenth century, have been re-used on the

reverse of the Bohemian retable in Brandenburg Cathedral, Germany.[34] Cartoons were still being prepared on such tables in 1351-2 at St Stephen's Chapel, Westminster:

*For ale bought to wash the drawing tables for the glaziers' work, 3d ... Masters John de Chestre, John Athelard, John Lincoln, Hugh Licheffeld, Simon de Lenne, and John de Lenton, 6 master glaziers, designing and painting on white tables various designs for the glass windows of the Chapel...*[35]

Cartoons on tables were unwieldy and, as the Gerona boards show, would often be erased when new designs were required; notwithstanding this inconvenience, such cartoons were re-used, for example the Virgin and Child panels at *Fladbury* and *Warndon* in Hereford &  *Pl. 1*  Worcester. Here the figures are taken from the same cartoon, although the respective architectural niches are based on different designs.[36]

There is no evidence that parchment, which was convenient but expensive, was used by

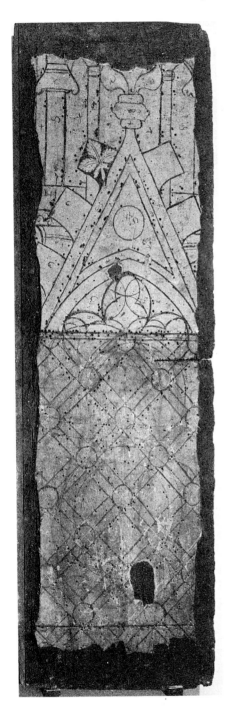

*Fig. 25*  GERONA CATHEDRAL (Spain): glaziers' whitewashed table with designs for a canopy and a trelliswork ground, early fourteenth century.

English glass-painters. By the second half of the fourteenth century their Italian counterparts were employing paper for their cartoons.[37] The first record of the use of paper by glaziers in this century is provided by an inventory of the Westminster glazing lodge made in 1443.[38]

Cartoons traced on paper greatly facilitated the glazier's work, for they could be rolled up, stored and re-used. One cartoon is used for no fewer than twelve of the ecclesiastical saints in the early fifteenth-century western choir clerestory of York Minster (NVIII–NXI, SVIII–SXI) and other cartoons were also employed repeatedly there.[39] A cartoon depicting a prison scene was slightly adapted for panels depicting scenes from the lives of SS John the Baptist and Peter in other windows in the eastern part of the Minster (windows nX, sX).[40] Amongst the glass dating from *c.* 1470 in the east window of *Holy Trinity Goodramgate* in York is a panel depicting the Holy Trinity in the form of a *Corpus Christi* which is probably from the same cartoon as a panel from *St Martin-le-Grand*, Coney Street (window sIV).[41] The passing down of cartoons from one generation of glass-painters to another in York is well documented. William Inglish (d. 1480) bequeathed to his son Thomas 'all the cartoons belonging to my work' and Robert Petty (d. 1528) obtained his 'scroes' from his elder brother John.[42] No doubt this practice was quite common.

The cartoon having been laid out on a flat work-top, pieces of glass of the required colours were laid over it, cut to the approximate shape by splitting with a hot iron and then trimmed with a metal tool with a hooked end known as a grozing iron. In 1351-2 'groisours' for St Stephen's Chapel cost 1¼d each.[43] In more recent times a 'cutline' or tracing has been drawn over the cartoon on tracing paper or cloth, on which the glass is laid rather than on the cartoon itself. 'Cutlines' are not mentioned in any of the medieval treatises and it is not known whether they were used in the Middle Ages. After the glass was cut and shaped, it was painted by means of a pigment formed by mixing ground copper or iron oxide, powdered glass and wine, urine or vinegar, and gum arabic: the last binds the pigment to the glass. Purchases of 'arnement'

*Fig. 26*

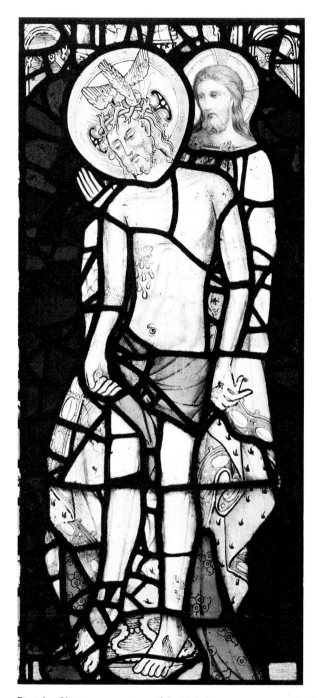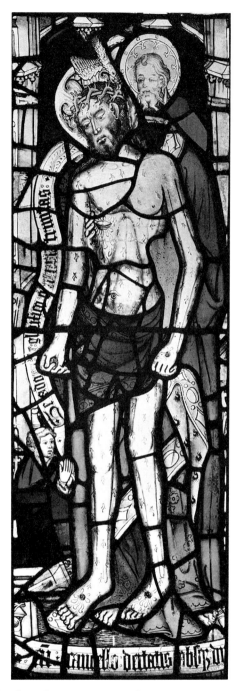

*Fig. 26* YORK, two versions of the Holy Trinity, *c.* 1470, probably taken from the same cartoon: (*left*) ST MARTIN-LE-GRAND, CONEY STREET; (*right*) HOLY TRINITY GOODRAMGATE.

(iron oxide) and 'gumme arabik' are recorded in the St Stephen's accounts.[44] The pigment was applied with brushes made of the hair of various animals, including hog, squirrel, badger and cat; quills and needles were employed for very precise work.

Painting was usually done in several layers on the interior surface of the glass: the main outlines of the subjects were painted first, following the cartoon, and then washes and details were applied, including highlights and modelling. From the fourteenth century oil was used as a medium for some washes. Fully translucent highlights were created by picking out letters of inscriptions, background ornamental patterns and other details with the tip of the brush handle. Some of the background curling *rinceaux* designs produced by this process (which is usually termed stickwork) during the fourteenth century were particularly delicate.

*Pls II(a), XV*

From at least the twelfth century the external surface was painted to reinforce shadows and give a three-dimensional effect to the medium. This back-painting was particularly well done in the fifteenth century; in the example illustrated in plate II(b) the trace-lines of a translucent veil or headdress are painted on the inner surface and the principal features covered by the headgear applied to the outside.

*Pl. II(b)*

During the fourteenth century glass-painters began to use a very soft brush on a wet wash surface to give a stippled effect, which improved the modelling of facial features and draperies. The technique was used to particularly good effect by the glass-painters working in the International Gothic style of the early fifteenth century.

*Fig. 144*

After the pieces of glass making up the panel or window had been painted they were stacked and the pigment was fired on to them in a furnace. Several references to furnaces exist in documents. The accounts of 1469 for the glazing of the nave of Westminster Abbey include a payment 'for brike and other necessaries for making the anelyng herth'.[45] Following removal from the furnace, the glass pieces with the pigment fired onto them were laid out again for leading. The individual pieces were leaded together and secured by closing or cloring nails. On 1 August 1351, 250 'clozyngnaill' costing

*Fig. 27*   HELMDON (Northants.): medieval leading from the William Campiun stonemason panel (Fig. 9), *c.*1313.

18d were purchased for St Stephen's Chapel.[46] The lead was cast in moulds with an H shape in cross-section and was supplied in strips known as cames (from the Latin *calamus*: reed). The leads were then planed and trimmed to the required shape and size. Sometimes wider and stronger leads were used for the main contour lines of figures and other features such as borders, thereby emphasizing the principal elements of the design as well as fulfilling a structural need. The panels were joined together using solder of tin and lead; at St Stephen's Chapel tallow was used as a flux to bind the solder with the lead, but nearly 200 years later a form of cement or putty was employed.[47] Soldering irons are mentioned occasionally in accounts, as in the 1474 inventory of the glazing stores at Shene in Surrey.[48]

*Fig. 27*

The final stage was the insertion of the glass panels into the window openings. As a preliminary, small numbers, geometrical devices or letters were sometimes scratched, picked out or painted on the glass for the purpose of ensuring that the panels were inserted in the correct location and order. This practice is common in other medieval crafts: for example, position marks are quite frequently found on the backs of

*Fig. 28* WELLS CATHEDRAL (Somerset): glaziers' position marks, early fourteenth century. *From JBSMGP, vol. IV (1931–2).*

English alabaster panels from altarpieces.[49] Marks occur in the tracery light glazing in the Lady Chapel at *Wells*, on Thomas Glazier of Oxford's panels for the side windows of New and Winchester College Chapels and in some of the windows at Fairford, Gloucestershire, and King's College Chapel, Cambridge.[50]

Glazing could follow on very quickly behind the construction of buildings. At Canterbury Cathedral in the late twelfth century the choir clerestory windows evidently were glazed as soon as the stone vaults had been constructed, probably to take advantage of the scaffolding required for the latter.[51] The fabric accounts for the reconstruction of the eastern parts of *Exeter Cathedral* in the early fourteenth century show that the glass-painters were working alongside masons and other craftsmen.[52] In at least one French instance windows were installed before some of the adjacent structure had been completed. In 1511 and 1523 glazing took place in the church of Saint-Vincent in Rouen, but in 1528–9 there are payments to glaziers to remove the choir clerestory windows during the construction of the vaults and replace them afterwards.[53] In schemes where the glazing did not take place so promptly temporary fillings for

the windows were required. In 1253 a large amount of canvas was purchased for this purpose for Westminster Abbey, probably to fill the chapter house windows, and more of the same material was obtained in the period 1267–72.[54] In 1349, 350 yards of canvas were bought for the *obscuracio* of the windows in St Stephen's Chapel.[55]

The glass panels were inserted either into wooden frames or located in the stonework by grooves or rebates and held in place by armatures, stanchions and saddle-bars, to which they were secured by ties soldered to the leading and iron lug-bars. The armatures, stanchions and saddle-bars were usually made of iron (hence the collective word *ferramenta*) and supplied by smiths, although evidence has been found in France of wooden armatures dating from as early as the twelfth century; in England wooden saddle-bars occur in churches as late as the seventeenth century.[56] During the twelfth and the following century the elaborate historiated windows of *Canterbury*, Chartres, Sens, Laon, Bourges and elsewhere in France had armatures echoing the quatrefoils, circles and other geometrical shapes found in the composition of the glazing itself. Stanchions and saddle-bars also exist from these centuries in association with single figure, non-figural and ornamental or heraldic panels. Geometrical shapes were discarded in window design during the late thirteenth century, so armatures fell into disuse and stanchions and saddle-bars were employed for all types of window. Often these were set into the stonework during the construction of the window itself. Stanchions are vertical members and sometimes are found on both the exterior and interior of window openings. They were not always required, but the horizontal support, the saddle-bar, is invariably present. In the St Stephen's accounts saddle-bars are termed *soude-letts*: for example, 12 December 1351 'To Master Andrew the Smith for 120 soudelett for the glass of the said windows, weighing 190 lbs at 1½d a pound, 23s 9d.'[57] Sometimes a thin iron protective grille or screen, such as are common in nineteenth-century windows, was placed on the exterior. In 1445 lattices were set in the King's Chapel at Clarendon, Wiltshire, to protect three glazed windows.[58]

*Fig. 28*

*Pl. XIII*

*Fig. 29*

| n:IX | n:VIII | s:VIII | s:IX | s:X | s:XI |

*Fig. 29*     CANTERBURY CATHEDRAL (Kent): design of armatures, late twelfth–early thirteenth centuries. *After M.H. Caviness.*

Some additional details of technique and practice need to be noted. The title 'stained glass' is in itself misleading, for almost until the Reformation the English glass-painter did not stain glass. As we have seen, he was supplied with sheets which were, apart from ruby, coloured throughout and he painted them with an opaque vitrifiable pigment. An important exception to this was the use of yellow stain. The application of a preparation containing silver sulphide to white glass which turned yellow when fired enhanced the translucency of windows and permitted greater freedom of composition. Until the introduction of yellow stain, the hair of a figure had to be painted on a separate piece of glass from the face, if the former was to be of yellow and the latter of white glass; yellow stain enabled both to be achieved on the one piece of glass. The silver compound was also applied to blue glass in order to provide green damask details to robes or flowers and trees in landscapes and backgrounds. The recipe had been known in Egypt since the tenth century for the decoration of vases, and reached western Europe at the end of the thirteenth century by means of an Arab work translated for King Alfonso X of Castile and León. The date and location of its first application to window glass are still disputed. It is claimed that the technique appeared in France during the last decade of the thirteenth century, although the first securely dated example of its

*Pl. XV*

use there is in a chancel window (nIII) in the small parish church at Le Mesnil-Villeman, Manche, which includes an inscription with the year 1313.[59] Yellow stain is, however, present in the Franciscan church at Esslingen near Stuttgart, Germany, of c. 1300 and in the Heraldic Window in York Minster (nXXIII), which is datable to c. 1307–12.[60] Silver filings (*lymail*) to make yellow stain were purchased in large quantities for the glazing of *St Stephen's Chapel* in 1351–2.[61]

*Fig. 129*

Until the sixteenth century the only other method by which two colours could appear on one piece of glass was by abrading flashed ruby to reveal the white glass which could then be stained yellow, if required. This technique was particularly employed for heraldic charges and ornamental patterns.

*Pl. II(a)*

An alternative way of treating heraldry in the late Middle Ages was to drill a hole in the field of the shield, insert into it a piece of glass painted with the required charge and secure it by leading.[62] This was a technique which demanded great skill from the craftsman both in leading and in avoiding breaking the glass which he was drilling. It was also used for draperies, crowns and haloes to give a jewel-like effect; like many medieval carved figures, which also have their robes enlivened by glass inserts and pastes in imitation of precious stones, the idea was probably copied from contemporary attire. Its

earliest glazing occurrence is in King David's crown in the series of prophets at Augsburg Cathedral in Germany, executed between the late eleventh century and *c.*1120. The first English examples in figural glass only appear in the early fifteenth century, for example, at Tong in Shropshire. During the second half of the fifteenth and early sixteenth centuries figural windows with leaded 'jewelled' inserts became fashionable with patrons who could afford this expensive technique and examples can be found throughout the country, with a particular concentration between the Thames and the Trent.[63] Possibly the technique was popularized by the glass-painters who executed some costly commissions for the king in *c.*1400. None of these survives, but it may be significant that the most lavish use of leaded jewelling was by the King's Glazier, John Prudde, in the windows of the *Beauchamp Chapel* (1447–64). The inserts into the robes of St Thomas Becket and the other figures here give the Beauchamp Chapel glazing a glittering effect unmatched within the British Isles and comparable only with the contemporary Jacques Coeur window in Bourges Cathedral, the royal donors at Le Mans and the south rose of Angers Cathedral in France.[64] The Beauchamp Chapel certainly made an impact on later glaziers in the Midlands and the jewelled technique was frequently employed in that region.

*Pls II(c), III(d)*

A less demanding method of enriching glass was to fasten the 'jewel' to the base glass by means of black paint which was then fired in the furnace so that the two glasses adhered. This method was known to Theophilus and examples of it can be seen in the early fifteenth-century east window (sII) of the south aisle at St Michael Spurriergate, York.[65] A variant was adopted in the St Cuthbert window in York Minster (sVII), where there are traces of coloured inserts placed in hollows in the base glass and fused together in the furnace.[66]

Although it was normal practice to attach paint to glass by firing, sometimes it was applied cold. Cennini states that this method was useful for small figures and heraldry, and it was sufficiently widespread to be expressly forbidden in guild regulations at Cracow in Poland (1490), Lyons (1496), France, and s' Hertogenbosch in the Netherlands (1524). Unfired painting has been detected in windows dating from the fourteenth to the fifteenth centuries at Avioth and Evreux Cathedrals in France and Berne Cathedral, Switzerland.[67] No examples have been discovered in England, although Salzman has drawn attention to the purchase in 1326 at Ely of various colours for colouring glass, which suggests that details may have been executed in unfired paint on this side of the Channel.[68]

On the eve of the Reformation the process of painting glass with coloured enamel paints which were then fused by firing was introduced into England. This had the effect of diminishing the quantity of leading required and hastened the development that had already begun towards more pictorial compositions. The closer identification of the glazier with the painter of pictures led eventually to the subordination of the former to the latter. During the period from the late sixteenth to the early nineteenth centuries, when the use of coloured enamel glass was universal, glass-painting as a distinct and separate craft all but disappeared. The use of coloured enamels only appeared on the Continent in *c.*1538 and to date their presence has been located in only one pre-Reformation monument, on a crown in window sIII in St Michael-le-Belfrey in York, of *c.*1540.[69]

Stained glass is a fragile medium and very prone to damage. References to repairs to windows are frequent in medieval glazing accounts: the Exeter Cathedral fabric records contain many payments to glaziers for repair of windows between 1285 and 1350.[70] Some medieval glazing repairs can still be seen, including the panel depicting William of Wykeham with the Virgin and Child executed by Thomas Glazier of Oxford for the east window of *Winchester College Chapel*. In the centre of the Virgin and Child are some pieces painted to match the original, but in glass of a lighter tone and with painting inferior to that of Thomas. The repairs probably date from the late fifteenth century, although they cannot be connected with several payments for such work recorded in the college accounts between 1457–8 and 1531–2.[71]

*Pls II(d), XIX*

The medieval glass-painter was capable of imitating styles popular centuries earlier. The

Infancy and Jesse cycles of *c.*1145–50/55 in the west windows of Chartres Cathedral contain some replacement heads dating from the fifteenth century which are painted in a Romanesque style to match the original glass, and other examples in French glass have been cited at the Sainte-Chapelle, Paris, and Fécamp Abbey in Normandy.[72] The head of a monk inserted in the late thirteenth century into a twelfth-century St Benedict panel from York Minster (window SXXV) is the only English instance of this practice that has been published to date; examination during the recent restoration of the east window of *Exeter Cathedral* has established that Robert Lyen's glass of 1391 was not, as had traditionally been thought, made in either style or composition to match the figures of 1301–4.[73]

The York panel mentioned above was re-used in the nave clerestory when this part of the *Minster* was reconstructed during the last years of the thirteenth and the first half of the fourteenth centuries. Glass was an expensive material and the re-use of earlier windows or panels in later structures is not uncommon. In addition to the St Benedict and other panels (including probably also the geometric grisaille) incorporated into the nave clerestory, there is a series of figures and panels dating from *c.*1340 which appear to have been placed subsequently in various windows in the eastern arm of the Minster choir.[74] The parish church at *Lowick* in Northamptonshire was rebuilt in the Perpendicular style at the end of the fourteenth century, re-using in the north aisle windows (nV–nVIII) a series of figures from a Tree of Jesse, several saints and a donor knight of the Drayton family dating from the early fourteenth century. The Jesse must originally have been in a single window and the re-location of the various prophets and kings over several windows destroyed the original iconography. When they were placed in their new position some of the figures were given new texts and labels.[75] There are several references to the re-use of earlier glass in medieval building accounts. In 1391 Lyen was to receive 3s 4d per week for re-using the early fourteenth-century panels in the reconstructed east window at Exeter.[76] In 1501 William Neve was paid the same sum 'for setting of 20 ft of old glass in lead' in the Bishop of

*Pl. XIII*

*Pl. V; Figs 50, 89–91, 101(c), (d)*

*Fig. 125*

*Fig. 144(a)*

London's Palace, and in *c.*1505–10 Thomas Peghe incorporated some older panels in the glazing of the chapel at Christ's College, Cambridge.[77] A variation on this practice occurred at Bodmin in Cornwall. Amongst the means adopted by the parishioners of St Petroc's church to raise funds for its rebuilding was the sale of windows: 'Item recevyd for a wyndowe y sold to the Parish of Hellond xxvj s. Item y recevyd for a wyndowe of Seynt Kewa xxvjs viijd'.[78] A post-suppression survey of the fabric of Bradwell Abbey in Buckinghamshire carried out in 1526 noted glass in the church 'which would be taken down and saved for the mending of divers Chancels, etc.'[79]

## The organization of the craft

In the late Middle Ages glass-painting seems to have been a highly organized craft, carried out by lay artisans. Prior to the thirteenth century, records of glaziers are few and far between and provide very little information. For the most part they consist of names, such as Osbernus *vitrearius*, who witnessed three deeds of Ramsey Abbey, Cambridgeshire, between 1114 and 1160, or Daniel *vitrearius*, another Ramsey monk in the early twelfth century who subsequently became abbot there and later at St Benet-at-Holme, Norfolk. As this nomenclature was applied to both glass-makers and glaziers it is uncertain in these and other instances as to which craft they belonged.[80]

From the thirteenth century onwards a large number of glass-painters are recorded, all of whom were laymen with the exception of a *conversus* at the Cistercian abbey at Pipewell in Northamptonshire, who in 1278 made windows for Rockingham Castle.[81] In his case it is a reasonable assumption that he was a glazier by trade who later entered monastic life.

In the thirteenth century a large proportion of recorded glaziers came from the major towns and cities containing important ecclesiastical establishments, such as Bath, Canterbury, Chester, Colchester, Coventry, Lincoln, London, Norwich and Oxford. In this century there is also some evidence of movement by glass-painters between great churches.[82] Although glazing was

carried out in York in the late twelfth century, no names of York glass-painters have been discovered before 1300. Subsequently there is more information on the York glaziers than on those associated with any other centre. Walter le Verrour is the first recorded, in 1313; thirteen others are named before 1363, twenty-one names occur between 1363 and 1413, twenty-three between 1413 and 1463 and twenty-seven between 1453 and 1513.[83] The York glaziers were concentrated in Stonegate, particularly around St Helen's church, where many of them were buried. Recently more than 2,000 window glass fragments, apparently rejects from one of the workshops, were found in a medieval pit in Blake Street, a few yards from Stonegate.[84] From the early fourteenth century onwards the York glass-painters seem to have obtained most of the important glazing commissions in the north. In similar fashion Norwich became the dominant centre in East Anglia in the second half of the fifteenth century, and at least seventy glaziers are known from this city between 1280 and 1570.[85] East Anglia in general was well-supplied with glass-painters: the names of nearly one hundred are recorded in the counties of Norfolk, Suffolk, Cambridgeshire and Essex.

There is surprisingly little evidence until the sixteenth century that the London area was a major centre of glass-painting. From at least the fifteenth century the glaziers responsible for the making and repair of the windows for the royal residences were based at Westminster.[86] Glass-painters also resided across the river in Southwark: Nicholas de Creping, who in 1292 made windows for Guildford Castle in Surrey, was a resident of Southwark.[87] It was in Southwark that the foreign glaziers settled from the late fifteenth century in order to escape from the control of the Glaziers' Company of the City of London. Little can be said of the City glass-painters, except that the Company was in existence in 1328 and by 1364–5 it had a set of craft ordinances. In *c.*1523 there were seven glaziers exercising their craft within the boundaries of the City of London, although it was claimed that until shortly before there had been at least twenty-two.[88]

The enlargement both of churches and windows from the end of the thirteenth century must have brought in its wake an increased demand for the services of glass-painters; even in the fourteenth century most major towns south of the Trent had at least one resident glazier. Exeter provides a series of names from the beginning of the fourteenth century to the Reformation, several Salisbury craftsmen are also recorded and Chester was a centre of some importance. The wide distribution of glaziers by the middle of the fourteenth century is demonstrated by the writ for the collection of craftsmen for the glazing of St Stephen's Chapel, Westminster, and by the names of those who worked here and at the royal chapel in Windsor Castle. The writ covers twenty-seven counties and the glaziers recruited bear the names of such places as King's Lynn, Bury St Edmunds, Norwich, Halstead, Dunmow, Waltham, Sibton and Haddiscoe (all in East Anglia), Lincoln, Lichfield, Coventry, Bromley, Chester, Thame and Hereford.[89]

By the fifteenth or early sixteenth centuries even minor towns and villages sometimes had a glazier. Probably many of these were capable of little more than cutting and leading clear glass, or at best painting simple figures or ornamental patterns for local churches. John Glasier of Coningsby in Lincolnshire falls into this category. In 1457–8 he glazed the windows in a chamber in the nearby collegiate establishment at *Tattershall*, but the glazing of the church itself with rich coloured glass and complex iconography was beyond his capabilities. Glass-painters from much further afield were brought in for this task. In 1482 these included John Glasier of Stamford, John Wymondeswalde of Peterborough, Robert Power of Burton-on-Trent and Richard Twygge and Thomas Wodshawe from the Malvern area.[90] The more highly regarded glaziers travelled considerable distances to undertake commissions. Richard Twygge also worked on the nave of *Westminster Abbey* and during the early fifteenth century John Thornton probably ran two workshops concurrently in Coventry and York; John Prudde can be connected with glass at *Warwick*, Eton, Oxford and Winchester, amongst other commissions.[91]

Patronage is often the thread connecting glaziers with commissions in different parts of

*Pls III(c), XXIII;*
*Figs 15, 48, 61*

*Fig. 174*

*Pls II(c), III(d);*
*Figs 11, 69, 164*

the country. It can hardly be coincidental that the chapels of William of Wykeham's foundations of *New College* and *Winchester College* were glazed by Thomas Glazier of Oxford, who in 1394 also executed work for Wykeham's episcopal residence at Highclere.[92] Patronage links explain some of the more important commissions undertaken by the Twygge-Wodshawe workshop. Its first major patron was Bishop Alcock of Worcester, who between July 1480 and October 1482 entrusted it with the glazing of the east window of Little Malvern Priory in Hereford and Worcester. Alcock moved in the same royal administrative circles as Bishop William Waynflete of Winchester. It is very likely that the participation of Twygge and Wodshawe in the glazing of Tattershall stemmed from this connection (Waynflete was the executor of Ralph Cromwell, the founder of Tattershall College). Similarly Alcock would have been acquainted with Abbot Farley of Gloucester, under whom the Lady Chapel was completed, including the east window which Twygge and Wodshawe at least partially glazed in the period c. 1472-93. Alcock was also the donor of a window in *Great Malvern Priory* church (SV), and although he was not directly associated with the *Magnificat* window in the north transept (nVI), executed by the Twygge-Wodshawe workshop in 1501-2, he may well have recommended it to the donors of the windows. These included Sir Reginald Bray, who certainly knew Alcock. That the *Magnificat* window was donated by Bray and others who were closely connected with the royal abbey of Westminster, were no doubt important factors in the selection of Twygge as glazier of the west window and many clerestory windows in the nave of Westminster Abbey.[93]

*Pl. XIX; Figs 31 (a), 141, 144(b)*

*Figs 11, 158*

Naturally the most highly regarded glass-painters were the most peripatetic and often their technical and design traits had an impact on local craftsmen. In the past there has been a tendency to see English fifteenth- and early sixteenth-century glazing in terms of clearly defined regional 'schools'. The picture is more complex and varied, depending on factors such as demand. The north may have been dominated by the York glaziers, but even in East Anglia, where Norwich was the main centre, other

towns had glass-painters and there was sufficient work to support a number of workshops. The productivity of the medieval glass-painter perhaps has been underestimated and elsewhere the pattern seems to be one of single ateliers securing most of the commissions in their locality, rather than several workshops conforming to a regional style.[94]

Some glaziers had additional occupations and interests. A Durham craftsman carried out whitewashing and other tasks and Matthew le Verrer of Colchester (d. c. 1358) and *John Petty* of York (d. 1508) kept inns. Both of these were individuals of some standing. Petty held in succession the offices of Chamberlain, Sheriff, Alderman and Lord Mayor of York, and Matthew le Verrer represented his city in Parliament. John Godwyn of Wells (early fifteenth century) and *Henry Smart* of Winchester (active 1457-72) were two more glass-painters who sat in Parliament.[95] Other glaziers attained civic status: Simon was an alderman of King's Lynn in the fourteenth century and a number of late medieval glaziers in York and Norwich were sufficiently prosperous to make wills; in the former city 20 per cent of the glaziers made wills which survive and amongst building craftsmen they only lagged behind the masons in prosperity.[96]

*Fig. 31(c)*

*Fig. 31(b)*

As was mentioned earlier, in large cities the glaziers were, like other crafts, organized in the guild system. In *London* and *York* they had a guild of their own; the Chester glass-painters in 1534 were incorporated into a guild which included the painters, embroiderers and stationers, thus formalising an existing association as these trades had long before combined to perform one of the mystery plays.[97] Similarly the Norwich glass-painters formed part of the guild of St Luke with the bell-founders, brasiers, painters, pewterers and plumbers.[98] At Shrewsbury the glass-painters combined with the saddlers.[99] Craft and trade guilds evolved throughout Europe in the twelfth and thirteenth centuries, although no reference to an English guild involving glaziers has been found before the fourteenth century. Regulations of 1364-5 survive for the London craft, and of the late fourteenth century and 1463-4 for the York guild; a summary of the

*Fig. 30*

*Fig. 30*    The arms of two leading medieval glazing guilds: (*left*) LONDON, WORSHIPFUL COMPANY OF GLAZIERS & PAINTERS OF GLASS: London Glaziers Company, fifteenth century; (*right*) YORK, ST HELEN'S STONEGATE: the York Guild of Glass-Painters, early sixteenth century with later repairs.

rules for the Chester glaziers is in the 1534 charter.[100] In common with other craft guilds those to which the glaziers belonged were concerned not just with the maintenance of standards of workmanship, but also with the regulation of commercial practices in their field. The York regulations of 1463–4 are particularly restrictive:

*Item, that no maister of the said craft supporte any maner of foreyner within this citee or without ayeinst any other maister in any poynt concernying the wele, worship and proffecte of the same craft, opayne of leisyng of xiijs iiijd to be payed as is aforewriten, and that noo foreyne sett up a shop as a master in the said crafte unto suche tyme he aggre with the serchours of the said craft, for a certain some.*[101]

This 'some' is not specified, making it possible, if the assessors so decided, to demand a prohibitive payment. At this time the York glaziers consisted of a small number of interrelated family firms, including the Chambers, Pettys, Shirleys and Inglishes, and this clause shows how concerned they were to preserve their oligarchy.[102]

The London guild rules also laid down precise selection procedures for the admission of outsiders:

*if any stranger come to the City and desires to use the said mistery as a master, the good folk elected and sworn to rule the said mistery shall come to the Mayor and Aldermen and inform them of the name of such person, and the Mayor and Aldermen shall cause him to appear before them, and he shall be examined by good folk of the mistery to see if he be fit and sufficiently informed to use the mistery and of character to remain in the City.*[103]

The Chester glaziers were concerned to prevent other members of their guild from practising their trade:

*Alsoe that noe person as is aforesaid shall use or exercise the trade of a Glassiere etherr to cut lead simon [seam] or annal [anneal] and sort of glasse whatsover for profitte or gane but such as been of the said brotherrhood and societye.... And that likeways the Glassierrs shall not intermeddle with or in any of the trades of paintinge, imbranderinge or stacioninge, but follow that to which they served as apprentices.*[104]

The master glass-painter was also protected from unfair competition by his fellow-craftsmen. A York ordinance of 1463–4 stated that a glass-painter could not take a second apprentice until his first apprentice had completed four of his seven years' service.[105] This regulation was designed to prevent the formation of large

workshops based on the cheap and semi-skilled labour of apprentices.

By the late fifteenth century the guild system in northern Europe was beginning to break down. The glaziers were not immune and in the early sixteenth century the monopoly of the London guild was challenged successfully by the Flemish and German glaziers who had taken up residence in Southwark, which lay beyond the jurisdiction of the London craft.[106]

During the late Middle Ages most urban glazing firms probably consisted of no more than the master glass-painter and one or two assistants, including an apprentice. In 1337 John de Walworth was employed at Westminster at the rate of 5d per day and his 'garcio' (the usual term for an apprentice as they began at a young age) had 3d a day.[107] Master Walter le Verrator was assisted by two apprentices in setting in place two clerestory windows in the choir of Exeter Cathedral in 1310–11, whereas Robert Lyen had only one servant towards the end of the same century. Lyen himself was almost certainly the Robert who was admitted to freeman status at Exeter in 1380; he was described in the document as having been the servant and apprentice of Thomas Glasiere for ten years.[108] In York John Chamber the younger (d. 1450) had three servants, another term which embraced apprentices, and a son in his practice. The will of Thomas Shirley (d. 1458) names two servants, and mentions other men and women servants who may, however, have been domestic. His son Robert was also in the firm and his father left him 'all my drawings appliances and necessaries also the tables and trestles belonging in any way to my craft'. The will of *John Petty* (d. 1508)   *Fig. 31(c)* mentions only two servants and his 'scribe' or book-keeper.[109] Even John Prudde, the King's Glazier, may have had no more than two assistants: in 1443–4 his employees Richard and William were paid for work at Fromond's Chantry in Winchester College. A later King's Glazier, Barnard Flower, in 1497 was licensed to employ three or four workmen.[110]

Large commissions were sometimes entrusted to several glaziers or their firms. This occurred, as we have seen, at Tattershall in 1482, and with King's College Chapel, Cambridge, in 1526. At *St Stephen's Chapel*, Westminster, there were twenty to thirty glaziers at work under five   *Fig. 129* or six master glass-painters. The entry in the accounts for 3 October 1351 is typical:

*Masters John de Chestre, John Athelard, John Lincoln, Hugh Licheffeld, Simon de Lenne, and John de Lenton, 6 master glaziers, designing and painting on white tables various designs for the glass windows of the chapel, for 6 days, at 12d each, 36s. William Walton, John Waltham, John Carleton, John Lord, William Lichesfeld, John Alsted, Edward de Bury, Nicholas Dadyngton, Thomas Yong, Robert Norwic, and John Geddyng, 11 glaziers painting glass for the said windows, each at 7d, 28s 6d. John Couentr', William Hamme, William Hereford, John Parson, William Nafreton, John Cosyn, Andrew Horkesle, W. Depyng, Geoffrey Starley, William Papelwic, John Brampton, Thomas Dunmowe, John atte Wode and William Bromle, 14 glaziers breaking and fitting glass upon the painted tables, for the same time, at 6d a day, 42s. Thomas Dadyngton and Robert Yerdesle, 2 glaziers' mates (garcionibus vitriariis) working with the others at breaking glass, each of them at 4½d a day, 4s 6d.*[111]

The role of the master glaziers is worth noting in these accounts. They did not paint any glass, but executed the cartoons and, presumably, exercised a general supervision over all the work. The restriction of the master-glaziers' labour to the cartoons was almost certainly dictated by the desire to finish the glazing speedily and by the employment of a large workforce to paint and lead the glass. The contract of 1405 for the great   *Figs 65,* east window of *York Minster* stipulated that   *144(d),* Thornton should 'obliging himself with his own   *145* hands to portraiture (sic) the sd window with Historical Images & other painted work'; he was also to 'paynt the same, where need required'. As the contract refers to workmen provided by Thornton it was not envisaged that he would personally execute all the glass, which is not surprising considering the huge scale of the window and the three-year time-span for its completion.[112] Given the size of the average workshop such a degree of specialization was probably exceptional, although in the larger Continental ateliers established in the twelfth and early thirteenth centuries there is evidence that aspects of the work, such as border designs and composition of the armatures, were assigned   *Pl. III(d);* to specific craftsmen or teams. The contract for   *Figs 11,* the *Beauchamp Chapel* states that the cartoons   *69, 164*

(a)

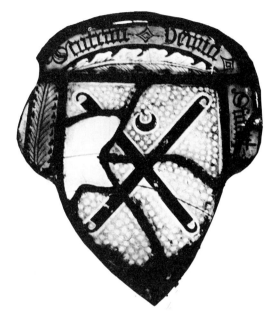

(b)

(c)

*Fig. 31* THREE LEADING LATE MEDIEVAL GLASS-PAINTERS:

(a) WINCHESTER COLLEGE CHAPEL (Hants.): 1822 copy in east window of the original figure of Thomas Glazier of Oxford;

(b) WINCHESTER, WESTGATE (Hants.): arms of Henry Smart (active 1457–72), with grozing irons in saltire;

(c) Figure of John Petty (d. 1508) formerly in a YORK MINSTER south transept window drawn by Henry Johnston in 1669–70 (Oxford, Bodl. MS Top. Yorks c14, fol. 74r).

for the windows were not to be drawn by John Prudde, but by another painter. Prudde himself was to paint and lead the glass: 'to fine, glase, eneyln it [the glass], and finely and strongly set it in lead and souder, as well as any Glasse is in England'.[113]

In Italy the superiority of painters of altar-pieces and frescoes over other crafts from the fourteenth century onwards led to their frequent employment as suppliers of designs and cartoons for other media, including embroid-eries and stained glass windows. Cennini was dismissive of the glazier's craft, observing that they have 'more skill than draughtsmanship, and they almost are forced to turn, for help on the drawing, to someone who possesses finished craftsmanship, that is, to one of all-round, good ability'. To him that could only be a monumental painter. From the late fourteenth century paint-ers in France were entrusted with designing for works in other media and leading German artists such as Dürer received commissions for stained glass cartoons in the early sixteenth century; the first Netherlandish roundels of the same period were probably based on cartoons made by paint-ers.[114] In England too painters executed cartoons for important glazing projects, apart from the Beauchamp Chapel instance mentioned above; in the middle of the fourteenth century a painter named John Athelard was employed in this capacity at Windsor. Thomas Glazier of Oxford's adoption of the International Gothic Style may have owed something to the presence of the painter Herebright of Cologne in the same circle of artists and craftsmen centred on William of Wykeham.[115] As the York east window contract demonstrates, cartoons for major commissions were not invariably the province of painters, and the best glass-painters were considered capable of bridging the divide between design and manufacture. John Thornton was one of the leading craftsmen of his day and the design of the east window a major creative achievement, though the complex iconographical programme with its Latin texts (a language he is unlikely to have known) would have been based on models supplied by and devised in consultation with an educated cleric.

The relationship of design to manufacture/execution leads us to the question as to how individual workshops can be distinguished. A number of criteria can be used, but they are not set and unvarying. The most obvious is by the delineation of facial features and bodily forms i.e. figure style. This is self-evident in workshops with clearly distinctive style traits, such as the mid-fourteenth century *Hadzor* workshop and the *York* atelier associated with Robert and Thomas, but it is a more complex matter when it comes to the late twelfth and early thirteenth-century glazing of *Canterbury Cathedral*. Here there are a number of distinctive hands, but do they represent different workshops or are they individual glass-painters employed together within one large atelier? In the fifteenth century some workshops can be identified by design elements such as canopies and side-shafts and backgrounds which almost act as their trade-marks; often these occur in conjunction with an easily recognizable figure style. A good example is the workshop active towards the end of the century in and around *Stamford* and Peter-borough. It has been suggested that the quality and range of glass can be used to help distinguish workshops.[116] There are instances when this is demonstrably so: the late twelfth-century St John at *Easby* exhibits the same range and combination of coloured and white glass as some of the contemporary panels in *York Minster*. At *Stanford on Avon* the very different coloured glasses used in the nave and eastern chancel glazing are one of the principal factors which establish that two separate workshops were involved. The use of glass as a means of ident-ifying workshops should be treated with caution, particularly in the fifteenth and early sixteenth centuries; it is safer to employ it in combination with the other factors including style (as at Easby).

The output of individual glass-painters and workshops was not necessarily rigid and unchanging; glaziers were capable of absorbing novel ideas and incorporating new designs. The most dramatic example is Thomas Glazier of Oxford. If we had no documentary evidence and had to rely solely on visual interpretation it is highly unlikely that the *New College* chapel (except for the Jesse) and *Winchester College* chapel glazing would have been connected with the same craftsman.

*Pl. XVI
Figs 50,
126,
130

Pls VI,
VII;
Figs
92-6*

*Figs 82,
170, 171*

*Pl. VIII(b)

Figs 88-
90
Figs 56,
62, 124,
200*

*Pl. XIX;
Figs
141,
144(b)*

John Prudde worked at Westminster and Shene Palaces in 1442 and c. 1445. An inventory of stores in both places compiled in 1443 provides useful information on the contents of a medieval glazier's workshop:

*... I iron compace for the use of the glaziers ... 25 shields painted on paper with various arms of the King for patterns for the use of glaziers working there, 6 crestis with various arms for the same works ... 12 payntyng dyssches of lead ... 12 patterns made in the likeness of windows, 8 iron grosyeres [grozing irons] ... 42 glosyng nayle used up in glosyng work ... a leaden wasschbolle used to make leads for glazing windows ... 2 portreyyng tables of waynescote, 2 tables of popeler [poplar], 11 trestles, used for glazing work.*[117]

It was in his capacity as King's Glazier that Prudde was employed at Westminster and Shene. This office existed in some form from at least the late thirteenth century. In 1297 William of Kent, glazier,

*took office in place of Robert the glazier, to mend defects where necessary in many places and to receive the same wages that Robert received, namely 4d a day. And he found as security for his faithful service to the King, Henry le Plomer.*[118]

The daily wage or retainer varied in amount. John Brampton, when he was appointed in 1378, received 12d per day only whilst he was engaged on the king's works. His successor, Richard Savage, did not receive a set wage, only 'whatever shall be agreed between the Clerk of the King's Works and the said Richard'. Savage was followed in 1412 by Roger Gloucester, for whom the 12d fee was reinstated. It remained at this rate until the early sixteenth century, except between 1461 and 1472 when it was reduced to 8d.[119] Barnard Flower, King's Glazier probably from the late 1490s until 1517, received the sum of £24, which was usually paid twice-yearly, at Michaelmas and Lady Day.[120] From at least the fifteenth century the King's Glazier had a shed or lodge in the western part of Westminster Palace; the dimensions of this are given in one document as 60 feet by 20 feet.[121]

The office of King's Glazier was prestigious and worth more than the daily fee, for it did not preclude the holder from undertaking work outside the royal palaces and castles; on the contrary the post could attract important and lucrative commissions. This certainly happened to John Prudde with the Beauchamp Chapel glazing and also probably explains his involvement with the windows of All Souls College, Oxford (1441), and Fromond's Chantry in Winchester College (1443–4).[122]

Almost all the named English medieval glass-painters are known to us from contracts and accounts; in addition a few 'signed' their works. There are several examples of glaziers' signatures in Continental glass, ranging in date from the mid-thirteenth-century Frater Lupuldus at Haina in Germany, down to the sixteenth-century windows signed by Arnoult de Nijmuegen and his contemporaries in France.[123] A few northern European glaziers are also depicted in their windows: Gerlachus in a German panel of c. 1150–60 and Clement of Chartres in a window dating from c. 1220–30 at Rouen Cathedral.[124] 'Portraits' of glass-painters are also known in England. A copy made in 1822 of the original figure of Thomas Glazier of Oxford is at the base of the east window of *Winchester College Chapel* (accompanied by the mason, carpenter and master of the works) and a south transept window in *York Minster* once contained a figure of John Petty with an inscription giving the date of his death (8 November 1508).[125] An inscription in an early sixteenth-century north aisle window (nIV) of St Neot's church, Cornwall, may indicate that the donor was also the glazier: 'Ex dono [et sumptibus] Radulphi Harys et [eius] la[bore ista fenestra] facta fuit.' Harys is one of the figures kneeling above this inscription, but the text is too ambiguously worded to be interpreted as stating for certain that Harys was a glass-painter.[126] The only other personal mark of an English glazier is the shield of arms of Henry Smart in the *Westgate, Winchester*, the charges of which consist of two grozing irons in saltire. Grozing irons also appear on the shield of arms of the York Glaziers Company in *St Helen's, Stonegate* (window sVII), on a fifteenth-century shield belonging to the *Worshipful Company of Glaziers, London*, on small banners in the east and two other early fifteenth-century choir windows in York Minster (nX, sX), and on a fragment at Sherborne Abbey, Dorset.[127]

*Fig. 31(a)*

*Fig. 31(c)*

*Fig. 31(b)*

*Fig. 30*

## Prices and payments

The majority of new glazing schemes were priced per square foot. Costs fluctuated considerably between the early thirteenth and early sixteenth centuries and it is impossible to quantify what they meant in real terms, as so many of the accounts are too imprecise regarding the glass and only a small and unrepresentative proportion of the glass mentioned in documents survives. There is no means of knowing, for example, whether the white glass which, at a rate of 12d per square foot, was purchased from Henry Stauerne and John Brampton in 1364 for Hadleigh Castle, Essex, was the same in quality and decoration (or plainness) as that for which William Burgh in 1400 received only 10d per square foot for a window in the Exchequer at Westminster.[128] On the other hand, the survival of some glass associated with accounts gives an indication of the types of glazing purchased by the various rates. In August 1253 the windows of *Westminster Abbey* cost 8d a square foot for painting and working coloured glass and 4d for white glass. The few panels of coloured glass which survive take the form of small but detailed narrative scenes and the white glass consists of geometrical designs of stylized stems and leaves in conventional thirteenth-century fashion.[129] In the *Exeter Cathedral* accounts for the new presbytery windows in the period 1301–7 no distinction is made between white and coloured glass and the cost is merely given as 5½d per foot; in the years 1309–11 the rate rose to 6½d per foot. Here the measurement of the foot was by a span rather than the usual square foot. The glass was already painted. Of the glass referred to in the 1301–7 accounts only parts of the east window and a north clerestory window survive (NV); they contain figures under canopies in coloured glass which in the latter window are set on grisaille grounds within a border.[130] The prices quoted in the accounts do not include the expense of setting the glass in the windows, which is costed separately: in 1304 Master Walter le Verr' received £4 10s for setting in place 'vitrum summi gabuli et viij summarum fenestrarum et vj fenestrarum in alis novi operis'.[131]

Practice varied as to whether the price per square foot included or excluded the cost of the raw materials. At Westminster the wages paid to Henry III's glaziers per square foot were exclusive of the cost of the glass. Similarly the price of the glass does not appear to have been included in the rate of 6d per square foot for white and 12d for coloured glass which Robert was to receive in 1338/9 for the great west window of *York Minster*, although the wording of the transcription of the contract is somewhat ambiguous; in common with the east window of Exeter this window principally comprises standing figures under canopies.[132] In 1391, however, when Robert Lyen contracted to glaze the reconstructed east window of *Exeter*, his fee of 20d for each foot of new glass included all necessary materials.[133] The rates quoted for royal glazing projects at Shene in c.1445, the Savoy Hospital in London (1516–20) and King's College Chapel (1526) were also inclusive of the cost of the glass.[134]

In 1363–4 glass with royal arms in the borders placed in the royal apartments at Windsor Castle cost 13d per square foot.[135] This rate remained fairly constant for the next three decades. Thus at Windsor in 1383 John Brampton received 13d per square foot for 160 feet of coloured glass decorated with falcons and the royal arms. For the glazing which William Burgh carried out around 1400 in the royal palaces at Westminster and Eltham prices rose very sharply.[136] In 1399 he was paid 12d a foot for glass decorated with birds and 1s 8d for glass with the royal arms and those of St Edward in Westminster Palace (from the end of the fourteenth century birds enjoyed a considerable vogue as a quarry pattern in windows, together with ornamental designs bearing an affinity with the gold dots and sprays found in the borders of contemporary English manuscripts).[137] In 1400 glass embellished with birds was priced at 16d per square foot; plain white glass cost the king 10d per square foot. In 1401 Burgh charged 2s per square foot for a four-light window at Eltham which contained 'Escuchons, garters and Colers of the Bagez of our Lord the King'. This was surpassed by the 3s 4d per foot which Burgh received for another window comprising the figures of SS John the Baptist, Thomas, George, the Annunciation, the Holy Trinity, and John the Evangelist. In the following year Eltham was

*Pl. IX;*
*Figs 5,*
*102(c),*
*106*

*Pl. XIII*

*Pl. XVI*

*Fig. 144(a)*

glazed with more very expensive glass:

*For 91 square feet of new glass, diapered and worked with broom-flowers, eagles and rolls inscribed Soueraigne, bought of William Burgh, glasier, for the said 3 Baywyndowes and costres, each of 2 lights, at 3s 4d a foot, 15li 3s 4d. And for 54 square feet of new glass worked with figures and canopies, the field made in the likeness of cloth of gold, bought from the same William for 3 windows each of 2 lights in the new oratory, at 3s 4d a foot, 9li–24li 3s 4d.*[138]

The Eltham glazing was evidently very sumptuous and indeed the rate of 3s 4d per square foot is never repeated in any surviving accounts. The most expensive glazing scheme subsequently was the *Beauchamp Chapel* which cost 2s per square foot.[139]

    From the thirteenth century glazing ranged from plain white glass to complex iconographical schemes. From the accounts referring to John Prudde quite an accurate picture can be obtained of what the various piecework rates purchased, inclusive of the cost of materials, in the middle of the fifteenth century.[140] For Shene Palace in *c.*1445 he made a window of white glass for 7d per foot. The costs of his figural glass here varied between 10d and 12d. For 'powdred glasse' (probably decorated quarry backgrounds) 'cum xij ymaginibus prophetarum', executed for the rebuilt chancel of the old church at Eton in 1445–6, Prudde received 8d per square foot, and the glass 'cum diuersis ymaginibus et borduris' which in the following year he placed in the same chancel of Eton cost 1s per foot.[141] The factor common to all these schemes was that they comprised single figures in lights and the differences in price can be explained in terms of the respective amounts of coloured glass used and additional elements such as canopies and borders. None of these windows survives, but the saints under canopies in the antechapel at *All Souls College*, Oxford, also cost 1s per square foot in 1441; possibly these are by John Prudde. Together with the figures set within borders in the east window of *Oddingley* church in Hereford and Worcester, they probably provide a good impression of the kind of glazing found at Shene and Eton.[142] In the *Tattershall* accounts of 1482 the types of figural glass are spelt out: windows

*Pls II(c), III(d); Figs 11, 69, 164*

*Pl. III*

*Figs 44, 45*

*Pl. III(a)*

*Pl. III(c); Fig. 61*

'de ymaginibus' cost 8d per square foot and windows comprising figures placed under canopies 'de ymaginibus cum tabernaculis' about 10d per foot. 'Vitri historiales', i.e. glass containing scenes rather than single figures cost 1s 2d, which was the same price that Prudde charged for 'vitri historiales' in the hall of Eton College in 1450. The 'vitri (*sic*) cum diuersis picturis' which Prudde used in 1445–6 to enlarge the west window at Eton cost 1s 4d per square foot, which is the rate quoted in 1526 for the narrative windows of *King's College Chapel*.[143] The price of unpainted white glass declined in the early sixteenth century. In 1513 Richard Wright received 4d per square foot for installing white glass at St John's College, Cambridge;[144] by *c.*1517–20 the cost of white glass had fallen still further, for at the Savoy Hospital Chapel Richard Bond was only paid 2d. The same rate occurs in 1533.[145]

    Some early sixteenth-century glazing accounts are very specific with regard to pricing, particularly for shields of arms and badges. Roundels depicting red roses and portcullises were supplied in 1500–2 by Barnard Flower for Eltham Palace and the Tower of London at a cost of 1s each. Four roundels painted with the king's badges were placed by him in Westminster Hall for the same price.[146] The red roses and portcullises for the hall windows of St John's College, Cambridge, cost 8d each in 1513.[147] The shields of arms and badges provided by Galyon Hone for the side windows of the great hall in *Hampton Court Palace* cost rather more:

*Pls XXVIII, XXIX; Fig. 184*

*Fig. 77*

*Also in the said wyndows in the haull is 30 of the Kynges and the Quenys armys, pryce the pece, 4s. Also 46 badges of the Kynges and the Quenys, pryce the pece, 3s. Also 77 scryptors with the Kynges worde, pryce the pece, 12d.*[148]

Even this price was exceeded by the shields of arms of Henry VIII and Catherine of Aragon which were commissioned for the Savoy Hospital in *c.*1517–20 at 6s 8d each. The Savoy accounts are particularly informative with regard to precisely what the various amounts purchased, as this entry reveals:

*Paid ffor the Glasyng off the Sowth wyndowe in the seid hospitall with the Cruciffyxe Mary and John the Kyngis*

*Armes And the Orate cont' in colored glasse xlvj ffote price le ffote xijd ... £2 6s 0d. Paid ffor the glasyng off the seid wyndowe with whyte glass cont' clxviij ffote price le ffote ijd ... £1 8s 0d.*[149]

Some glazing contracts name a fixed price for the work, as in the contract of 1338/9 for the two windows at the west end of the York Minster nave aisles (nXXX and sXXXVI), which each cost 11 marks; also in the contract dated 1341 with John le Glasiere of Calne for the chapel glazing at Ludgershall in Wiltshire: the entire scheme here was priced at £6.[150] In the St John's College agreement of 1513, the windows in the hall and the Master's lodging are priced per square foot, but for those in the chapel a fixed price of £45 is named. John Thornton, on the other hand, was paid a weekly wage of 4s for his work on the east window of *York Minster*; in addition he received an annual payment of £5 and another £10 on the satisfactory completion of the entire project. The contract also states that the costs of materials (glass and lead) and workmen's labour would be met by the dean and chapter.[151]

In certain very large schemes, such as the glazing of *St Stephen's Chapel*, Westminster, the team of craftsmen was employed on the basis of a fixed daily wage. The extract from the accounts cited above reveals that master glaziers received 1s per day, 'working' glaziers (for want of a better term) 6d or 7d, and their assistants 4d or 4½d. Similar rates applied at Windsor in 1351-2.[152] There were many compulsory feasts and saints' days, so at St Stephen's it was arranged that the men would be paid for every alternate holiday.

The most frequent occurrence of payments by wage as opposed to piecework is in connection with glazing repairs. This system was already in operation by 1240, the date of the earliest detailed glazing agreement that has survived. The contract was between the dean and chapter of Chichester and John the glazier, and by it the latter and his heirs undertook to keep the cathedral windows in repair in return for a daily allowance of bread and an annual fee of 13s 4d. They would also receive further remuneration for any additional work:

*They shall preserve the ancient glass windows, and what has to be washed and cleaned they shall wash and clean,* *and what has to be repaired, they shall repair, at the cost of the church, and what has to be added they shall add, likewise at the cost of the church; and there shall be allowed them for each foot of addition one penny. And so often as they repair the glass windows, in whole or in part, they shall be bound, if so ordered by the keeper of the works, to make one roundel with an image in each. And if they make a new glass window entirely at their own cost, which is without pictorial decoration and is 53 ft in total area they shall receive for it and for their expenses, 12s.*[153]

As stated above, the King's Glazier received a daily payment for mending windows in the royal residences. Other craftsmen were employed on similar terms, both in the king's palaces and castles and also outside the royal service. There are quite frequent references in the Exeter Cathedral fabric accounts to the employment of glaziers on weekly terms to mend windows and also install new ones.[154]

In 1406 four men were each paid 6d a day for making a panel for a window in the King's Chamber and for mending various defective windows at Eltham Palace. Included in this account is a payment of 4½d for 3 lb of candles bought and used by the four glaziers for working at night.[155] Evidently it was considered unreasonable that the workmen should have to meet such expenses out of their own pockets. There are occasional references to incidental expenses paid to glaziers, chiefly for travel, board and lodging when they were working away from home. In 1443-4 John Prudde's assistants at Winchester received 3s 4d from the college 'pro eorum expensis versus London ex curialitate domini custodis'.[156]

The expense involved in transporting finished glass could be considerable, as the accounts for the carriage of the Windsor windows from Westminster in 1352 demonstrate. The cost of the very careful packing required was an important element:

*For 18 boards to make cases for carrying glass panels from Westminster to Windsor, 3s. For 38 elm-boards for the same, at 4d a piece, 13s 8d. For carriage of the same from London to Westminster, 5d. For hay and straw to put in the said cases for safe keeping of the glass panels, 14d. For a 'palet' with 1 soldur [soldering-iron] bought for the glazing, 12d. For 300 nails for making the said cases 12d.*

*Figs 65, 144(d), 145*

*Fig. 129*

To John Wodewyk for freight of the said cases with the glass panels for the chapel windows from Westminster to Windsor, 4s.[157]

The cost of carriage was much higher for the windows made in 1393 by Thomas Glazier of Oxford for *Winchester College Chapel*: 19s 3d was paid for two waggons going from William of Wykeham's residence at Esher in Surrey to collect the glass at Oxford and take it via another of Wykeham's houses at Highclere, to Winchester. The task took nine days and involved twelve horses and six waggoners.[158] Whenever it was convenient water transport was used. In 1332 John de Walworth took some windows from Candlewick Street (now Cannon Street) to Westminster via the Thames.[159] The transportation costs for the Windsor and Winchester glazing schemes were met by the respective patrons (Edward III and Winchester College), but the dearth of references to expenditure under this heading in building accounts suggests that usually it was the glazier who had to pay for carriage and allowed for this in his contract price. This was certainly the case at the *Beauchamp Chapel*, for the contract stipulated that Prudde had at his own expense to bring the painted and leaded panels to Warwick from Westminster.[160]

*Pl. XIX*

*Pls II(c), III(d); Figs 11, 69, 164*

### Glass-painters, masons and other crafts

Stained glass is an architectural art and cannot be fully comprehended in isolation from its monumental framework. Indeed as Dr Coldstream has observed, in buildings like Chartres Cathedral where the glass and sculpture have survived more or less intact 'the architecture is the background to the figurative arts ... [it] was designed to support and exhibit the vast "summa" of Christian history represented on the doorways and windows.'[161] It is less easy to understand this fact in England than in France owing to the losses through iconoclasm and neglect of so much sculpture and painted decoration, not only glass but also wall-paintings and polychrome embellishment on tombs and carved surfaces. As a result the stark architectural setting often

appears to dominate and have little relation to the few scraps of glass that in most instances are all that remain. The original effect of buildings like Ely Lady Chapel and St Stephen's, Westminster was very different. In the fourteenth century *Ely* was far from being the monochrome skeleton that we see today. The few traces of painted decoration that survive on the internal stonework and the glazing of this building, together with the antiquarian records of *St Stephen's*, show that the interiors of both were saturated with colour. In the words of Paul Crossley, 'From the sombre glowing colours of twelfth-century Canterbury, to the light brilliance of fourteenth-century York or Gloucester, English Gothic churches must have seemed like miraculous recreations of the Heavenly Jerusalem on earth.'[162]

*Pl. XVII; Fig. 32*

*Fig. 129*

The impression given by churches like Blythburgh in Suffolk or Tattershall is that the Perpendicular architecture of the fifteenth and early sixteenth centuries is to be understood in terms of stark mouldings, simple tracery, strong natural light and little colour. For a more accurate conception of the original aesthetics it is necessary to visit buildings of this period where considerable quantities of the original glazing survive, as at Great Malvern and Fairford. Here the painted glass provides a subtle kaleidoscope of light colours playing on and softening the mouldings of pillars and arches.

For most of the Gothic period masons, glass-painters and other craftsmen involved in the construction and furnishing of churches made use of a common repertoire of designs. Thus in the first half of the thirteenth century trefoil-headed leaf forms appear on capitals, tombs, floor tiles and glass. A synthesis between fabric and fittings became achievable throughout much of western Christendom during the late thirteenth and early fourteenth centuries through the development of micro-architectural forms, above all the canopied niche with its crocketed gable, pinnacles and flying buttresses. These niches were adopted by masons, glaziers, mural painters, tomb carvers, the makers of monumental brasses and altarpieces and choir stalls and (less frequently) by tilers. They were also applied to precious vessels used in the

*Fig. 102*

*Fig. 33*

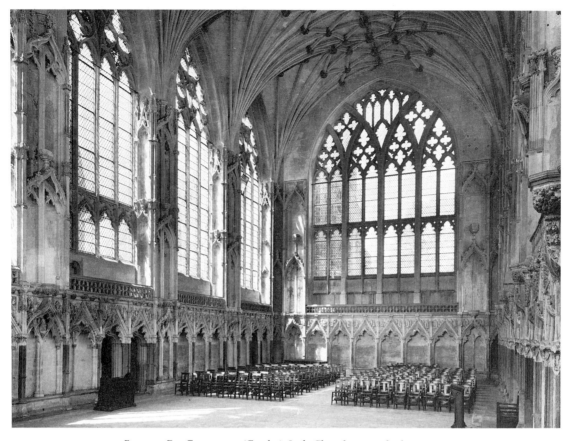

*Fig. 32*　Ely Cathedral (Cambs.), Lady Chapel interior looking west, 1321–49.

church services and occur on the seals of the clergy and ecclesiastical corporations.[163] Other unifying factors included small-scale imagery such as 'baboueny' and drolleries and a figure style which conformed to certain common canons, whether applied to saints in the windows or painted on walls, votive sculptures or sepulchral effigies.

Total harmony between the various components that made up the medieval church was only rarely achieved and lasted for a brief period. It was largely precluded by piecemeal additions and alterations to churches and their furnishings over many decades; also by developments in the architecture of the window itself and by the adoption by north European glaziers of the spatial innovations of Italian Trecento painting, although English glass-painters were much more

reluctant than their Swiss, German and French counterparts to ignore the architectural divisions of window mullions and spread their compositions over several lights.

Generally speaking, in the later Middle Ages the master mason rather than the glazier seems to have had the final word in the design of windows. The primacy of the master mason in the embellishment of buildings is spelt out in several medieval documents. In 1303 Nicolas de Antona was engaged by the bishop and chapter of Valencia in Spain to oversee the cathedral workshop. His brief was not confined to the architecture of the building:

*Ita quod ... teneamini operari de omnibus vestris actibus in quibus sciatis operari et que sunt necessaria et oportuna operi supradicto tam videlicet faciendis vitreis, imaginibus*

52

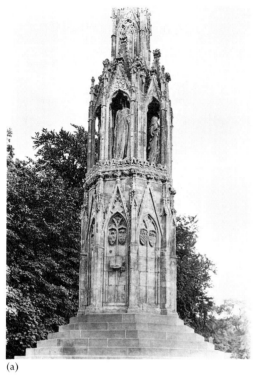

(a)

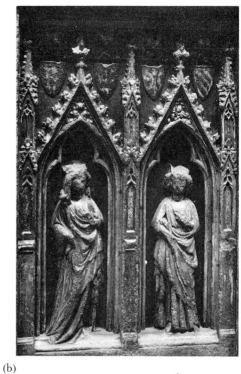

(b)

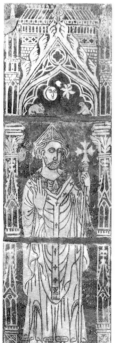

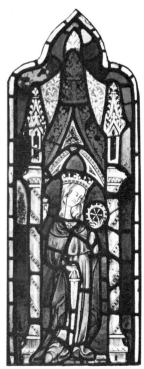

*Fig. 33*   MICRO-ARCHITECTURE IN VARIOUS MEDIA:

(a) HARDINGSTONE (Northants.): Eleanor Cross, 1291–3;

(b) WESTMINSTER ABBEY: niche figures on the tomb-chest of Edmund Crouchback, Earl of Lancaster (d. 1296);

(c) BRITISH MUSEUM, Dept. of Medieval & Later Antiquities: earthenware tiles of an archbishop made at Chertsey Abbey (Surrey) for Westminster Abbey [*c.* 1293–8];

(d) ELY, STAINED GLASS MUSEUM: St Catherine from Wood Walton (Cambs.), *c.* 1310–30.

*et picturis quam quibuslibet aliis operibus que dicto operi fuerint necessaria.*

In 1316 the will of an important administrator in Toulouse stated that two named master masons who were to construct four chapels in the church of the Austin Friars were also to exercise control over all aspects of their decoration and furnishings, including even the liturgical vessels and vestments:

*quatuor capellas ... cum earum altaribus et competentibus instoriis (sic.) super conversatione sanctorum, quorum erunt, et ornamentis omnibus calicis, maparum, cortinarum, vestium et aliorum omnium ad dictas capellas pertinentium, exceptis libris, cum fenestris vitreis eius signo signatis, et lampadibus, ad cognitionem magistrorum Johannis de Lobres et Petri Gualhardi massioneriorum Tholose et juxta ordinationem eorumdem, seu illius qui tunc vixerit.*[164]

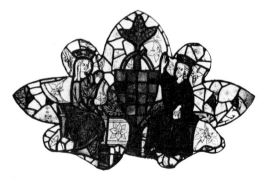

*Fig. 34*     WING (Bucks.): tracery of the south aisle east window and the Coronation of the Virgin from this window, early fourteenth century.

Until the introduction of bar tracery into England in the 1240s, windows consisted of lancets, either singly or grouped. With the development of bar tracery, window design could be adapted to suit the particular iconographical requirements of the glazing. At *Wing* in *Fig. 34* Buckinghamshire the tracery of the early fourteenth-century east window in the nave south aisle (sIII) is shaped to accommodate the enthroned and crowned Virgin receiving Christ's blessing, which is larger than the standard version of this subject on account of the shield of Warenne suspended from a tree between the two figures.[165] A chancel window (nII) at *Dorchester* in Oxfordshire is a fine example of *Fig. 35* collaboration between mason, sculptor and glazier: the glass contains figures from a Tree of Jesse and additional figures are carved on the stone mullions, which are in the form of the stem and branches of the tree with its roots springing from the reclining figure of Jesse.[166] A later instance of a window which must have been tailored to suit the glazing is the extraordinary tracery of the west window at Mersham in Kent, *c.* 1400, although here the precise iconographical scheme of the glass is not known, apart from the shields of arms, apostles, musical angels and Evangelist symbols.[167] Wing, Dorchester and Mersham are exceptional, however, and there is little evidence that window design was influenced to any significant degree by the intended glazing, although the vast east window and the windows depicting the legends of St William and St Cuthbert in York *Pl. XX;* Minster must have been intended to receive *Figs 41,* unusually large glazing programmes, even if the *65,* precise details were probably not worked out *144(d),* when the stonework was planned. For the most *145* part it seems that glaziers (and patrons) had to select and adapt their subjects as best they could to an already set window pattern.

The contract dated 1420 for the rebuilding of the chancel at Surfleet in Lincolnshire probably represents the normal state of affairs. The document states that the east window was to be of five lights and the three windows on each side were to be of three lights, but the glazing is only mentioned in general terms: 'quodlibet luminare fenestrarum predictarum unam ymaginem habeat et scripturam per voluntatem predicti

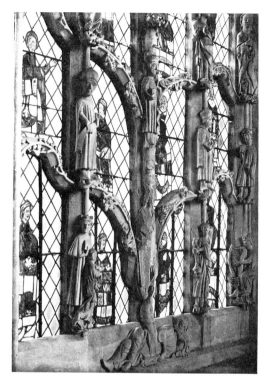

*Fig. 35*   DORCHESTER (Oxon.): Tree of Jesse window, early fourteenth century.

Adlardi [the rector]'.[168] The window design thus established did not allow the incumbent much freedom of choice for the subjects in the glass.

Reference has already been made to the existence of a common repertoire of architectural and ornamental designs. The controlling hand of the master mason would have been an important factor in their dissemination amongst the various crafts; another was presumably the presence in one guild of various crafts, as at Chester and Norwich. A third would have been the employment as designers of craftsmen trained and making a living in another medium. In the fifteenth and early sixteenth centuries some craftsmen evidently combined the skills of glazier, marbler and monumental brass engraver; it may therefore be more than coincidental that in this period there are similarities in the portrayal of kneeling donors in glass and figures on brasses.[169] Model-books like the *Pepysian Sketchbook* must also have played a crucial role in

the spread of design motifs.[170] It has been suggested that early tile pavements and grisaille windows found in French and German Cistercian monasteries were derived from similar pattern-books, such as the *Reuner Musterbuch* (Vienna, Osterreich. Nationalbibl. Cod. 507) and the scanty evidence suggests that the same applied in English houses of the Order.[171] Later in the thirteenth century, the important series of tiles with symmetrically arranged leaves and stems found at *Chertsey Abbey* in Surrey seem to share a common design source with the grisaille *Fig. 36* windows at *Lincoln*, Salisbury and Westminster. The occurrence of the identical motif of an ape holding a urine flask in borders of windows at *York Minster* and Dronfield, Derbyshire, and on tiles, is another instance of the circulation (or copying) of designs.[172] Another example is the window in the choir clerestory of *York Minster* *Fig. 37* with a side-shaft containing the figure of a knight which is virtually identical with one of the small knights on the brass to Sir Hugh Hastings (d.1347) at Elsing.[173] Similarly the horsemen donor compositions in the Pilgrimage window at York (nXXV) and *Drayton Basset* are closely *Fig. 12* related to the *Luttrell Psalter*.

There are few specific works which point to borrowings of more than minor motifs between glass-painting and other crafts. Evidence of tile-makers copying monumental designs is provided by a set of three figures under canopies excavated at a kiln at *Chertsey* which imitate either *Fig. 33(c)* contemporary windows or wall-paintings. Also by a line-impressed tile mosaic pavement found in the presbytery of *Buildwas Abbey* in Shropshire *Fig. 38* which is decorated with hybrid monsters; although these are of a common fourteenth-century type, the enclosing quatrefoils suggest that the design was copied from a window similar to the tracery glazing of window sVII of St Lucy's Chapel in Christ Church, Oxford. Fragments of several similar pavements are known.[174] The Clare Chasuble of 1272-94 in the Victoria and Albert Museum has barbed quatrefoils containing figures set against a ground embroidered with foliage scrolls. The arrangement may be an adaptation of a window with historiated panels in coloured glass set in grisaille *Figs 24(a),* such as those at *West Horsley* in Surrey and in the *Fig. 109* *(c)* *York chapter house*.[175] The painter of the late *Fig. 116*

fifteenth-century panels depicting kings in *St George's Chapel*, Windsor, also borrowed the *Fig. 39* basic design from glazing, for the figures are placed against quarry grounds imitating contemporary windows.[176]

Twelfth- and thirteenth-century glazing in northern Europe exhibits close connections with metalwork, reflecting the primacy of precious metals in Romanesque and Early Gothic spiritual aesthetics. Although there are also stylistic affiliations between stained glass and manuscript illumination in this period (e.g. at York), it is only from the late thirteenth century that glazing takes its cue from painting and architecture. The destruction of so much monumental pictorial art makes this process difficult to trace in England, so *faute de mieux* it is with book illumination that stained glass has most often

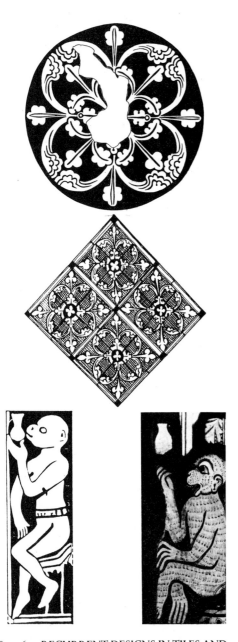

 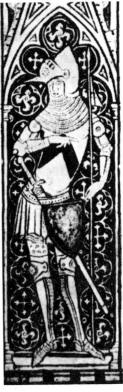

*Fig. 36*   RECURRENT DESIGNS IN TILES AND STAINED GLASS:
(*above*) tile from CHERTSEY ABBEY (Surrey) and grisaille at LINCOLN CATHEDRAL, thirteenth century. *After E. Eames and J. Kerr*; (*below*) ape holding urine flask on a tile in the BRITISH MUSEUM and in a nave north aisle window in YORK MINSTER, early fourteenth century. *After E. Eames.*

*Fig. 37*   Similarly posed knights in a side-shaft of a YORK MINSTER choir clerestory window, *c.* 1340 (*left*) and on the brass of Sir Hugh Hastings (d. 1347) at ELSING (Norfolk) (*right*). *The latter after P. Binski.*

*Fig. 38* BUILDWAS ABBEY (Salop): tile mosaic pavement, *c.* 1300–50. *After Eames & Keen.*

been compared. Although glaziers were not in the same craft guilds as those who worked in the book trade they must have had frequent contacts with miniature painters, as in Oxford where during the early thirteenth century the glaziers lived in the same quarter as the illuminators and a house named 'the Glaziers' was next door to the residence of Walter the Illuminator.[177] There is some evidence from thirteenth-century England and France that manuscript painters sometimes borrowed ideas from glaziers.[178] An affinity has been noticed between an early thirteenth-century psalter (Cambridge, Trinity Coll. MS B.11.4) and contemporary glass at Canterbury and Lincoln, and in more general terms, the adoption of gold-leaf backgrounds and strongly silhouetted figures in manuscripts

*Fig. 39* WINDSOR, ST GEORGE'S CHAPEL (Berks.): kings painted on wooden panels, *c.* 1493.

appears to have been a attempt to emulate the translucency and leading of windows.[179] The use of contrasting colour combinations by English illuminators also finds close counterparts in window design. Moreover the composition of pages in some manuscripts may be connected with the medallions and other geometrical shapes found in contemporary glazing.[180] In the succeeding centuries there is less evidence of borrowings by manuscript painters from glaziers, although the two professions adopted similar figure styles. The canopies surmounting several figures in a *psalter* of *c.* 1350–60 (BL MS Royal 13 D i*) are related to those at *Heydour* in Lincolnshire.[181] The early fifteenth-century illuminator *Johannes* also appears to have made use of stained glass architectural and ornamental features and there are affinities between his

*Fig. 136*

*Fig. 135*

*Fig. 40*

work and contemporary glazing in York and the Midlands.[182] It must be borne in mind, however, that stained glass is not fully comparable with other forms of painting. The glazier worked in a translucent medium, quite the opposite of the solidly opaque grounds of manuscript, wall and panel painters. As the former was painting with light his techniques were peculiar to the craft. Moreover the monumental scale of most glass separates it from illumination and most panel painting. It was often designed to be seen from a considerable distance, which affected the way windows were delineated. It is only in the sixteenth century, with the introduction of the 'pictorial' window by the Southwark-based immigrant glaziers, that glass-painting ceased to be a distinctive craft and became a branch of painting.

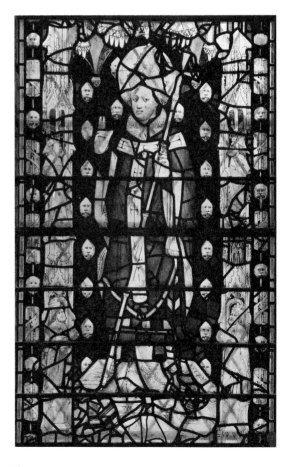

*Fig. 40* (*left*) THE HOURS OF ELIZABETH THE QUEEN (BL MS Add. 50001, fol. 7): Last Supper miniature by Johannes, 1420–30; (*right*) YORK MINSTER, choir north aisle: St Paulinus of York with initials of Robert Wolveden in the border, *c.* 1426–32.

# 3

# *The Iconography of English Medieval Windows*

Biblical references to light in Genesis 1: 2–5 and Revelation 21: 11–25, 22: 5 invested windows with particular metaphysical significance. Light as a symbol of God's presence was common sermon material; medieval preachers would have interpreted the multi-coloured, glittering transparency of stained glass in the windows around their congregations in terms of creating on earth the heavenly Jerusalem built of shimmering gold and precious stones as described by St John in the Book of Revelation. Windows in medieval churches also had more tangible spiritual functions. They were paid for and installed for the greater glory of God and the company of Heaven. They could be objects of meditation or contemplation for both clergy and laity and, when 'readable', used for instruction. Usually their subject-matter must have reflected the particular devotions of the donor or patron as well as bearing witness to their generosity and hopes for spiritual benefits. The last are often expressed on the labels which accompany donor portraits; these not only record for posterity their names but also exhort the viewer to pray for them. An explicit instance is recorded at Mapledurham, Oxfordshire, where a chancel window once contained this text below the late fifteenth-century figures of John Iwardby and his wife:

*John Iwarby and Katherine his wife specialy you pray to say as oft as ye this window see ii deprofundis for them Edward Elizabeth John and Jane there fathers and mothers or on(e) pater noster and on(e) Ave and for the soule of John wich here by the walle lieth sonne of the said John and Katherine of whome almighti Ihesu have mercy.*[1]

As late as the seventeenth century, the efficacy of a deed granted four hundred years previously by John de Mowbray to the tenants of his manor at Epworth in Humberside, which barred his successors from making encroachments on the common land, was strengthened by its juxtaposition with an image in a nearby parish church:

*The manner of keeping this deed hath been in a chest ... in the parish-church of Haxey ... by some of the chief freeholders, who had the keeping of the keys, which chest stood under a window, wherein was the portraicture of Mowbray [presumably a donor figure] set in ancient glass, holding in his hand a writing which was commonly reputed to be an emblem of the deed.*[2]

A number of medieval writers justified the use of images in churches on the grounds that they served to instruct the unlearned in the central tenets of the Christian faith and hagiography. The most famous exponent of this view is St Gregory the Great:

*to adore images is one thing; to teach with their help what should be adored is another. What Scripture is to the educated, images are to the ignorant, who see through them what they must accept; they read in them what they cannot read in books.... It is not without reason that tradition permits the deeds of the saints to be depicted in holy places.*[3]

How and to what extent images were used didactically is however a complex issue, as some recent studies have underlined.[4] A basic practical consideration affecting stained glass windows was their legibility. It is one thing to 'read' an aisle window in a parish church where its

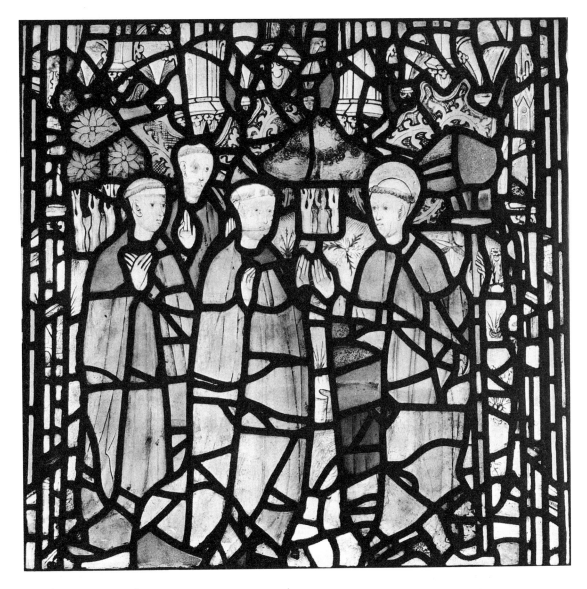

*Fig. 41*   YORK MINSTER: St Cuthbert with the monks of Farne from the St Cuthbert window, *c.* 1435-45.

contents are just above eye level; it is quite another to attempt to interpret without some sort of key the ranks of saints set high in the choir clerestory at Wells and York Minster. The same applies even more to the small historiated medallions frequently arranged in what are to twentieth-century eyes complex narrative patterns in the tall lancets of the choir and

Trinity Chapel of Canterbury Cathedral. Glazing (and murals), however, could be utilized for instruction, edification and to inspire devotion. To cite but one instance of the last, in 1511 a bequest of a taper was made to burn before an image of St Christopher in the glass of a window at Lyminge in Kent; the testator would have looked to the saint to intercede for him in

Heaven. Such beliefs in the efficacy of imagery in windows could even survive the Reformation. In 1633 a celebrated case was heard before the Court of Star Chamber concerning the destruction of a window depicting the Creation in St Edmund's church, Salisbury. One of the justifications for this iconoclasm was that the window had been a 'cause of idolatry to some Ignorant People' and evidence was cited of lay-folk bowing, kneeling and praying before it.[5] The didactic value of windows and wall-paintings would explain why moral themes such as the Corporal Works of Mercy, Seven Sacraments and Warning against Gossiping are more commonly represented in these media than in manuscript illumination.[6] The absence of, or very brief, explanatory labels in these and other historiated subjects (e.g. the St William and St Cuthbert windows in *York Minster*) indicates that they often had to be interpreted or explained to the onlooker, perhaps with the aid of an illustrated or written guide. The *Guthlac Roll* (BL MS Harley Roll Y.6) of *c.*1210 may either have been a *vidimus* or a guide to a window dedicated to the life of this Lincolnshire saint; it has been suggested that a fourteenth-century roll, on which are recorded inscriptions from the typological windows in the choir aisles of Canterbury Cathedral, was originally displayed in this part of the church as an interpretative aid (Canterbury Cathedral Library, MS C 246). That windows needed explaining to layfolk is underlined by *The Tale of Beryn*, one of the additions to Chaucer's *Canterbury Tales*, in which a group of pilgrims revealed their ignorance of the images in the glazing of Canterbury Cathedral.[7]

*Pl. XX; Fig. 41*

*Fig. 97*

Subjects in windows were based on various sources. Inevitably those which we have knowledge of are written, but we can assume that oral traditions and sermons must have been utilized. The *c.*1200 *Pictor in carmine* text provided a source for typological cycles in painting, later supplanted by the illustrated *Biblia Pauperum*. The fifteenth-century St Cuthbert cycles at York and Durham drew upon a variety of manuscript sources including Bede's *Life* itself (the narrative at York was affected both by the design of the window and by the wish not to eclipse the St William window opposite).[8] The portrayal of episodes in the lives of saints and other sacred personages was probably often based on popular devotional texts such as Jacobus de Voragine's (d. *c.*1298) *Legenda Aurea* (translated into English and published by William Caxton at the end of 1483) and liturgical books like the *Breviarium ad Usum Insignis Ecclesiae Sarum*. Books used in church services were also quarried for inscriptions in pictorial versions of liturgical themes such as the *Te Deum*, for both stained glass and mural paintings.

It is evident from the wills and contracts cited in chapter 1 that subject-matter generally was dictated by those who paid for the work. Because of this, the pictorial models or textual sources would usually have been provided by the donor or patron (or perhaps in the case of humbler folk, by their parish priest), although most glaziers probably had images of the more popular saints or subjects in their model-books or cartoons. The same applied to wall-paintings. In 1250 Queen Eleanor recalled a manuscript of the 'gesta Antiochie et regum etc. aliorum' which was on deposit at the London Temple; it can hardly be coincidental that soon afterwards Antioch stories were depicted in murals in the royal residences at Clarendon, the Tower of London, Westminster and Winchester.[9] Cardinal Wolsey's personal copy of Dürer's engraved *Passion* may well have been used by the glazier responsible for the panels in the east window of Balliol College chapel.[10]

There are very few direct indications as to why a patron chose the subjects depicted, although in some instances these can be inferred; almost all of the available evidence is confined to the late Middle Ages. Often those entrusted with the task of implementing bequests for windows which did not specify the subject-matter took account of the particular devotions of the deceased. The executors of the will of Richard Beauchamp, Earl of Warwick (d. 1439), instructed John Prudde to place the figures of SS Thomas Becket, John of Bridlington, Alban and Winifred in the east window of his mausoleum in St Mary's church at *Warwick*; in his last testament the Earl had ordered gold images to be made for their respective shrines.[11] Similarly, the presence of SS George and Christopher from the nave north clerestory of

*Pl. III(d)*

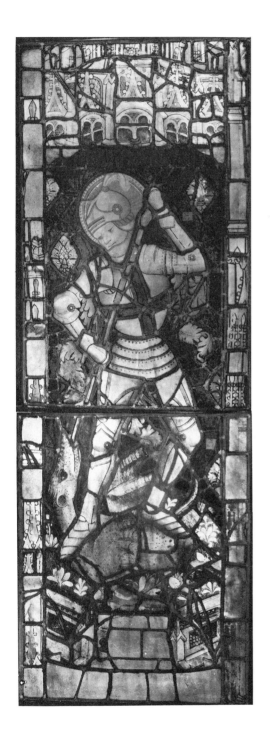
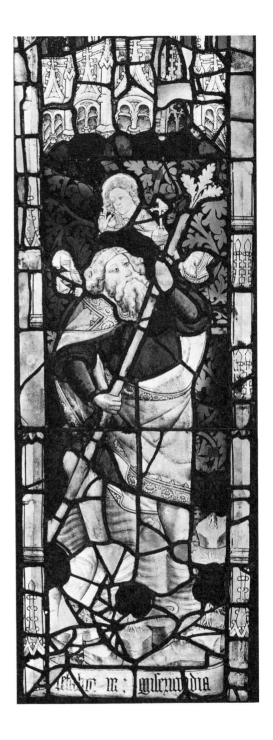

*Fig. 42*  GREAT MALVERN PRIORY (Heref. & Worcs.): SS George and Christopher from the nave north clerestory, *c.* 1480.

*Great Malvern Priory* (now in the west window), can be explained by the will of one of the donors (Sir Thomas Lyttelton d. 1481), which shows that he had a particular devotion to St Christopher and founded a chantry at the altar of SS George and Christopher in Worcester Cathedral Priory.[12]

Some families had a particular devotion to certain saints. In 1299 Miles de Stapleton founded the chantry dedicated to St Nicholas at North Moreton in Oxfordshire, in which the saint was depicted in three scenes in the glass (window sII); at the end of the fourteenth century the same family almost certainly commissioned a lost altarpiece of St Nicholas for Ingham church in Norfolk.[13]

Saints bearing the same name as the donor were frequently represented in glass. An extreme example is the window (nII) given by Peter Carslegh (d. 1535), rector of Winscombe in Avon, which contains three saints, all of whom bear the name Peter (Peter the Apostle, Peter the Deacon, Peter the Exorcist).[14] The choice of SS Anne, Catherine, Christopher and Dorothy in the east and two other north chancel windows (nII–nIV) at *West Wickham*, Kent, seems to have been strongly influenced by the Christian names of Sir Henry Heydon's family. His wife was named Anne, as also was one of his daughters. Another daughter bore the name Dorothy and a son married Catherine, daughter of Sir Christopher Willoughby.[15]

Sometimes the careers of individuals associated with glazing schemes explain the iconography. Canon Robert Wolveden (d. 1432) gave a window in *York Minster* (nVIII) which contains the figures of, and scenes from, the legends of SS Chad, Paulinus (first Bishop of York) and Nicholas. Wolveden evidently had a personal devotion to St Nicholas, for in his will he left donations to the hospital in York dedicated to him. St Chad has no local associations with York but was the founder of the See of Lichfield, of which cathedral Wolveden was precentor and later dean.[16] Similarly the appearance of St Sidwell, a saint of Devon origin, in the mid-fifteenth-century windows of *All Souls College* chapel, Oxford, can be connected with Roger Keyes, the supervisor of the college building works, who a few years previously had been

*Fig. 42*

*Fig. 43*

*Fig. 40*

*Fig. 44*

*Fig. 43*    WEST WICKHAM (Kent): St Anne teaching the Virgin to read, *c.* 1490–1500.

collated to a canonry in Exeter Cathedral.[17]

Other factors which could affect the choice of subjects were the dedication of the church or of its individual altars, the presence of a famed relic in the locality, and pilgrimages. The one surviving St Stephen scene from the thirteenth-century glazing of *Salisbury Cathedral* probably came from a window associated with the altar of St Stephen.[18] The mid-fifteenth-century nave

*Fig. 99*

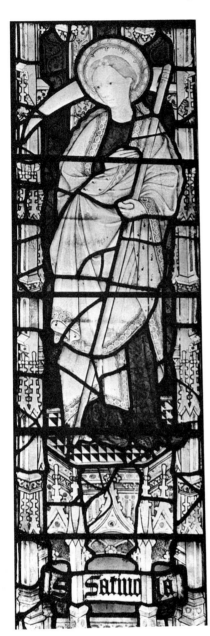

*Fig. 44* OXFORD, ALL SOULS COLLEGE CHAPEL: St Sidwell, *c.* 1441.

and the Virgin of the Mantle, also popular with the Dominicans; the presence of these two subjects can probably be linked with the house of Blackfriars in the town.[19] The importance of relics and pilgrimages can be demonstrated by the glazing of Tattershall. In or shortly before 1479 William Erneys, the steward of the hospice at Tattershall, went on pilgrimage to the shrine of St James the Greater at Compostella in Spain, and three years later a window was glazed in the church which depicted this saint's life. Another window at *Tattershall* contained the legend of *Pl. XXIII* the discovery of the True Cross by the Empress Helena, its loss to the Persians and recovery by the Emperor Heraclius: the choice of this subject was presumably connected with the relic of the True Cross possessed by the college.[20]

Only rarely did churches present a coherent iconographical programme. The *Canterbury* *Pls VI, VII;* *Cathedral* glazing is exceptional in its clarity and *Figs 92–* logic, which can be explained by the fact that the *6* scheme seems to have been carefully planned from the outset, possibly by prior Benedict, later Abbot of Peterborough (1177–93), and con- *Pls XIII,* trolled by a single corporate body comprising the *XIV;* monks in chapter.[21] During the fourteenth *Figs 8,* century the chapters of *Exeter* and *Wells* (and *122* probably also the monastic chapters of Tewkes-bury and Gloucester) financed the glazing of the eastern parts of their buildings. Much has been *Pl. XII;* lost, but sufficient survives to suggest that they *Figs 123,* also had a planned scheme.[22] The same applies to *141,* the chapels at *Merton* and *New Colleges*, Oxford, *144(b)* and *Winchester College*, and in the fifteenth and *Pl. XIX* early sixteenth centuries some large-scale and *Pls XXVIII,* prestigious edifices, such as the royal founda- *XXIX;* tions of *King's College Chapel* and *Henry VII's* *Figs 184–* *Chapel*, Westminster, had an overall icono- *5* graphical scheme for the windows. So too did *Figs 182–3* the Yorkist establishment at *Fotheringhay* and the *Figs 165,* parish church at *Fairford*. In each of these *199* examples the patron was a single individual or *Pls XXVI,* family. The early sixteenth-century windows of *XXVII;* *St Neot* in Cornwall are a rare instance of a *Figs 178–* unified programme provided by multiple *9* donors, although even here there is some repeti- *Fig. 4* tion of saints.[23] Mostly there is considerable duplication of subject-matter, even in churches glazed more or less in one campaign. Two

tracery glass of St John's church at *Stamford*, *Fig. 162* Lincolnshire, includes a medley of universal and locally venerated saints (e.g. Etheldreda of Ely) together with the Dominican St Peter Martyr

windows in different parts of the church at Tattershall were concerned with St Guthlac and there may have been two cycles of the life of St Catherine.[24] At *Great Malvern*, which was glazed *Figs 42, 74* with the help of many donors between the late 1420s and the beginning of the sixteenth century, SS Christopher and Lawrence both appear in three separate windows, St Wulfstan is represented at least twice and possibly three times, and SS Catherine of Alexandria and George twice.[25] Losses of so much glass, wall-painting and sculpture make it impossible to assess if there were any integrated icono-graphical schemes such as those of *c.*1260–70 and *c.*1343 which still exist at Gurk Cathedral in Austria;[26] probably such instances were the exception rather than the rule. The small church at Little Kimble in Buckinghamshire retains both mural paintings and glass of the same early fourteenth-century date. On the nave north wall are hagiographical scenes and several single figures of saints which extend into the splays of two windows (nIV, nV). All of those in the splays except St Francis are set under standard canopies, but the fairly complete grisaille and shields of arms in the glazing of nIV bear no relationship to the murals.

A comparison of the *Great Malvern* windows with the Canterbury glass demonstrates that iconographical programmes were not frozen in a rigid, unchanging formula between the late twelfth century and the Reformation. Both churches were Benedictine foundations and both had sufficient window area in which to display extensive and varied imagery. There is no equivalent at Malvern to the Canterbury series of Ancestors of Christ and the Tree of Jesse; both have Old and New Testament cycles, although *Fig. 47* Malvern has a greater emphasis on the life of Christ. In addition to the New Testament cycle in the nave, the Malvern choir east window and *Fig. 156* adjacent clerestory windows (NII, SII) contain Infancy and Passion scenes. Great Malvern did not possess any relics of importance and consequently it has no counterpart to the Becket windows at Canterbury. Instead two north choir clerestory windows (NIII, NIV) contain saints *Fig. 74* connected with the diocese of Worcester and depict the early history of the priory. More single

figures of angels and saints were in the choir south clerestory and south aisle and the north *Fig. 42* clerestory and west window of the nave. The apostles featured in the tracery of the east window and, holding Creed scrolls, in the choir south clerestory and north aisle. In the north aisle they formed part of a Catechism series, which included the Decalogue, the Seven Sacra-ments and the Lord's Prayer. The Four Doctors of the Church were also in a window here. The liturgy provided the subject-matter for the north transept, which is dominated by the vast *Magni-* *Fig. 158* *ficat* window; another window here seems to have contained the *Nunc Dimittis*. Finally, the Last Judgement filled the tracery of the nave west window.

The Great Malvern programme thus differs quite considerably from Canterbury. Particularly noticeable in the former is the presence of liturgical themes and of didactic themes like the Seven Sacraments, which are absent from Canterbury. In addition Malvern includes subjects such as the Holy Kindred (the three *Fig. 45* Marys and their children) which were unknown in the period when Canterbury was glazed. Apart from the introduction of new subjects over the centuries, iconography was also affected by general architectural and aesthetic changes. In England as well as France there is evidence that in the late thirteenth and early fourteenth centuries the priority given to light and translu-cency was at the cost of the complex narrative cycles seen in profusion at Chartres and Canterbury. The balance was redressed in the fifteenth century, notably in the great east window and St William and St Cuthbert windows of *York Minster*.[27] *Pl. XX;*

Other images and cults which developed late *Figs 41,* in western Christendom can be found in English *65, 145* fifteenth-century stained glass, including the *Pietà*, the Mass of St Gregory and the Virgin of *Figs 4, 46* the Mantle (or Mercy). All three subjects first appear in English manuscript illumination during the second half of the fourteenth century.[28]

England in the Middle Ages was part of a Christian commonwealth which embraced all of western Europe. Consequently most of the subjects represented in art on this side of the Channel also occur on the Continent. None

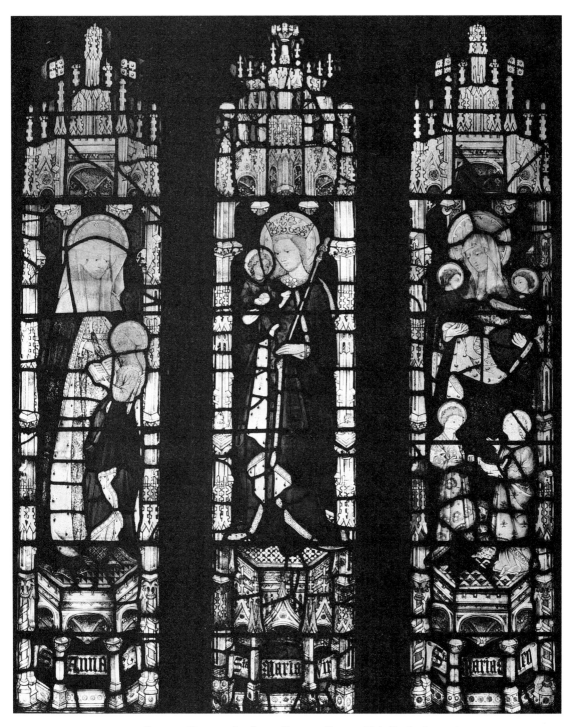

*Fig. 45*     OXFORD, ALL SOULS COLLEGE CHAPEL: Holy Kindred, *c.* 1441.

the less English medieval art possesses certain individual iconographical traits and, leaving aside the obvious examples of native saints, a few subjects were peculiar to English art. For example, the Crucifix on the Lily features in several late medieval depictions of the Annunciation.[29] This in turn demonstrates another important point: the iconography of certain themes such as the Annunciation and the Tree of Jesse was subject to change over the centuries.[30]

*Fig. 46*

## Biblical themes

Subjects taken from the Old and New Testaments are very common in English stained glass from the late twelfth century to the Reformation. In the larger churches there was sufficient space to develop elaborate pictorial cycles in which events and persons in the Old Testament were interpreted as foreshadowing the Christian dispensation. Typological cycles in various media had a long tradition in England.[31] In stained glass the remains of the *Canterbury* cycle survive from the last quarter of the century.[32] The treatise *Pictor in Carmine* shows that there was a need for an artists' guide to typology by *c.* 1200. It contains a collection of 138 anti-types (New Testament subjects) and 510 types (Old Testament subjects) together with alternative explanatory couplets, and it was intended for use by artists.[33] At Lincoln there are some Old Testament scenes of the early thirteenth century which may have belonged to a series of typological windows; presumably they existed elsewhere in this period.[34] No fourteenth-century typological cycles are known in stained glass, although an important series survives in the *Peterborough Psalter* (Brussels Bibl. Roy. MS 9961–62).[35] Probably in *c.* 1430–40 the cloister of Peterborough Abbey was given a set of Old and New Testament windows. Another cycle was commissioned for thirty-two windows in the cloister of St Albans Abbey by Abbot John de Whetehamstede between 1455 and 1464.[36] Shortly afterwards came the typological windows in the chancel at Tattershall (1466–80), followed by the Old and New Testament scenes in the *Great Malvern Priory* windows (*c.* 1480–90);

*Figs 94–5*

*Fig. 47*

**Fig. 46**   Two late medieval images: (*left*) *Pietà* from the nave north clerestory at LONG MELFORD (Suffolk), late fifteenth century; (*right*) Lily crucifix at WESTWOOD (Wilts.), late fifteenth century.

although the latter are arranged as two distinct sequences a number of the scenes are based on a typological source.[37] There was also a typological cycle in the windows of Lambeth Palace chapel, glazed between 1486 and 1500, and elements of typology occur at Fairford.[38] The latter windows were executed in the early sixteenth century by immigrant glaziers; foreign glass-painters were also responsible for the lost series in Henry VII's Chapel, Westminster Abbey, and for the magnificent typological windows of *King's College Chapel*, Cambridge.[39]

Prior to the Tattershall cycle there was considerable variety in the choice of 'types' and 'anti-types', reflecting the diversity of sources

*Pls XXVIII, XXIX; Figs 184–5*

*Fig. 47* GREAT MALVERN PRIORY (Heref. & Worcs.): Creation of the World, *c.* 1480–90.

used. Most of the Canterbury scenes and those in the *Peterborough Psalter* derive from common models which may have been associated with prior Benedict of Canterbury.[40] Towards the end of the Middle Ages the forty-leaf block-book edition of the *Biblia Pauperum*, which was first produced in the Netherlands *c.* 1464–5, was used quite extensively by English glaziers.[41] The *Tattershall* cycle was almost totally dependent on the woodcut illustrations of this work in the iconography and in the overall arrangement of the cycle, with the New Testament 'anti-type' flanked by the two 'types' in each window corresponding with the page layout of the *Biblia Pauperum*.[42] A number of the Old and New Testament scenes at Great Malvern are based partly on the *Biblia Pauperum* and partly on another popular block-book, the *Speculum Humanae Salvationis*. Some appear to be direct copies, others borrow certain features and texts only. The west windows of the nave aisles (nX, sX) and the main west window at Fairford,

*Fig. 48*

which depict the Last Judgement and its Old Testament precursors, the Judgement of Solomon and the Death of the Amalekite, are taken from the *Biblia Pauperum*; the same work provided the models for some of the King's College windows.[43]

Another theme linking the Old with the New Testament was the Tree of Jesse. This was a pictorial interpretation of the prophecy in Isaiah 11: 1,2,10 and the basic format is of a tree or vine springing from the recumbent figure of Jesse with the branches inhabited by Christ's royal ancestors and prophets and the Virgin and Child at the apex. The theme occurs in the early glass at *York* and *Canterbury* and retained its popularity throughout the Middle Ages. Jesse windows can be found dating from every period and in all parts of England, from Salisbury (thirteenth century) to Morpeth in Northumberland (fourteenth century) and St Kew in Cornwall (fifteenth century) to Gedney in Lincolnshire (fourteenth century).[44] There are considerable differences in scale between the various versions and several display individual iconographical features; for example, at *Dorchester* in Oxfordshire some of the inscriptions associated with the figures are taken from the genealogy of Christ (Matthew 1: 1–17).[45] The manner of portraying the subject also evolved over the centuries as can be observed by a comparison between *Westwell* in Kent, of the early thirteenth century, with *Margaretting* in Essex, which dates from the late fifteenth century.

*Pl. VII;*
*Fig. 88*

*Fig. 35*

*Fig. 108*
*Fig. 49*

Episodes from the Old and New Testaments also appear in stained glass independently of typological cycles. The early thirteenth-century Moses scenes and Sacrifices of the Old Law at Lincoln are not normal Old Testament 'types' and may therefore have formed part of a 'theological' window on the theme of sacrifice, paralleling the Mass with the Old Testament.[46] There are far fewer surviving Old than New Testament subjects in stained glass, apart from groups of prophets linked with the apostles, of which there are many examples. The largest surviving Old Testament cycle is the twenty-seven scenes in the east window of York Minster beginning with the Creation and continuing to

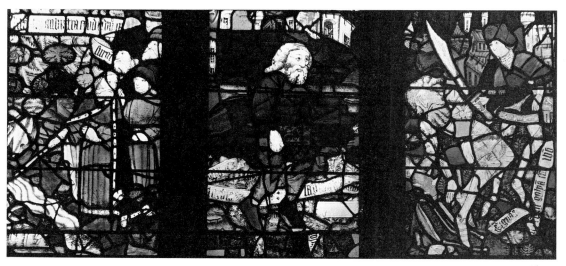

*Fig. 48*    (*above*) STAMFORD, ST MARTIN'S CHURCH (Cambs.): Moses striking the rock, Samson carrying the gates of Gaza, and David and Goliath from the chancel glazing of Tattershall (Lincs.), *c.* 1466–80; (*below*) corresponding scenes from the Netherlandish block-book edition of the *BIBLIA PAUPERUM, c.* 1464–5.

*Fig. 49* MARGARETTING (Essex): prophets from a Tree of Jesse, late fifteenth century.

the Death of Absalom.[47] Two early sixteenth-century windows in the south aisle at St Neot in Cornwall (sII, sIII) contain respectively the Creation and the story of Noah, but apart from several Genesis panels at Newark in Nottinghamshire (sII) and Thaxted, Essex (sVIII), the Moses and Sacrifice of Isaac panels of *c.* 1300 at Checkley, Staffordshire, and the Joseph panels in Hereford Cathedral (sXXI), only a few scattered individual Old Testament scenes appear to exist.[48]

In contrast, scenes from Christ's life and Passion are common, in both cycles and individual scenes such as the Annunciation and Crucifixion. Most of the surviving Passion cycles date from the fifteenth century; in addition to the east window of Great Malvern there are the well-preserved series at Newark (window sII) and St Kew (nIII), all of which commence with the Entry into Jerusalem and terminate with Pentecost. In the Last Supper at *Great Malvern* Judas is shown in the act of concealing a fish he has taken from the dish in front of Christ, a motif based upon his thieving tendencies mentioned in John 22: 6. This iconographical detail is found occasionally from the twelfth century onwards, including a miniature in the *Hours of Elizabeth the Queen* (BL MS add. 50001), which is probably

*Fig. 156*

*Fig. 40*

more or less contemporary with the Great Malvern east window.[49]

## The saints

Scenes from the Life of Christ merge almost imperceptibly into episodes from the Life of the Virgin, often derived from apocryphal rather than biblical sources. The easternmost north choir clerestory window at Great Malvern (NII) contains the Annunciation and Purification or Presentation in the Temple, which act as a preface to the Passion cycle in the east window. Scenes from the early life of Christ were originally continued in the opposite window (SII). In addition window NII also has four episodes from the early life of the Virgin: the Annunciation to Joachim, the Meeting of Joachim and Anne at the Golden Gate, the Birth of the Virgin and (probably) the Presentation of the Virgin in the Temple. To these should be added the panel depicting St Anne teaching the Virgin to read in the following window (NIII).[50] The Virgin featured prominently in several other windows at *Malvern*, including the nave north clerestory (the Holy Kindred – part of which survives in the west window), the nave north aisle typological cycle and the *Magnificat* window (nVI), as well as in various tracery lights. The prominence given to the Virgin in the Malvern glass is not unusual, for her cult became immensely popular in the Middle Ages. She was represented more than any other saint in medieval art, either as a single image, holding the Child Christ or crowned as Queen of Heaven, or in elaborate cycles such as that at Great Malvern. The scenes of her early life and of the events surrounding her death were based on apocryphal accounts such as the *Protoevangelium of St James* and the *Gospel of Pseudo-Matthew*, which closely parallel the Life and Passion of Christ.[51] The windows of *York Minster* provide a particularly fruitful field for studying the iconography of the Virgin. The earliest panels are in the chapter house (window CH nII) of *c.* 1285–90, and include the early life of Christ and the Death, Funeral and Coronation of the Virgin. An early fifteenth-century window in the choir south aisle (sIX) has the Holy Kindred and Joachim and Anne scenes, accompanied by the

*Fig. 158*

*Pl. I*
*Figs 34,*
*115, 133*

Birth and Presentation of the Virgin in the Temple. Other windows in the Minster contain individual scenes, such as the Annunciation and either the Annunciation to Joachim or the Annunciation to the Shepherds in the nave south aisle (sXXXV), and the Death and Funeral of the Virgin in the choir south clerestory (SIII, SIV).[52]

Eight early thirteenth-century panels at *Lincoln* appear to come from at least two windows dedicated to the Virgin. One depicted scenes from her life, including the choice of Joseph as her husband. The other window(s) contained the Miracles of the Virgin, amongst which are four scenes from the legend of Theophilus, a priest who made an agreement with the Devil from which he was rescued by the Virgin. Two other panels portray the legend of the Jewish boy of Bourges, a Christian convert rescued by the Virgin from the furnace into which he had been cast by his father. Scenes of the Virgin's miracles are rare in English stained glass, although the Theophilus legend occurs in the thirteenth-century glass of St Denys Walmgate in York (nV) and formerly existed in the early glazing of Canterbury. The miracles of the Virgin are represented in a number of contemporary windows in France.[53]

Fourteenth-century panels at Stanton St John and Beckley in Oxfordshire depict legends associated with the Funeral and Assumption of the Virgin. The source of the scene at *Stanton St John* (window sIV) is the sixth-century text *De Transitu Beatae Mariae*, which recounts the story of the Jew who tried to overturn the Virgin's coffin; in so doing his hands stuck to the bier and he was only released when St Peter converted him to the true faith.[54] Another example of this legend is in the York chapter house (window CH nII). *Beckley* is dedicated to the Assumption of the Virgin and the subject appears twice in the glass. The earlier scene (window sII), of *c.* 1300–10, is in the more common iconographical form and shows the Virgin ascending to Heaven in a

*Fig. 126*

*Fig. 50*

*Fig. 98*

*Fig. 70*

*Fig. 51*

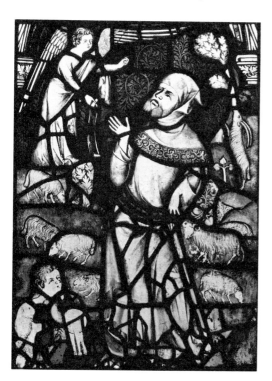

*Fig. 50*    Scenes from the life of the Virgin in YORK MINSTER, *c.* 1340: (*left*) Annunciation to Joachim or to the shepherds in the nave south aisle; (*right*) Death of the Virgin in the Lady Chapel clerestory.

*Fig. 51*    BECKLEY (Oxon.): St Thomas receiving the
Virgin's girdle, *c.* 1325–50.

mandorla supported by angels. In the other
version (window I), which dates from *c.* 1325–
50, the Virgin hands her girdle to St Thomas
who had refused to believe in the miraculous
event, thereby repeating his doubts over the
resurrection of Christ. Although the story was
considered apocryphal even in the *Legenda
Aurea*, it was by no means uncommon in English
medieval art, with most versions dating from the
period *c.* 1290–1340. Westminster Abbey
possessed a relic of the Virgin's girdle, which may
explain the popularity of the subject.[55]

The saints are amongst the most common
subjects in medieval stained glass. Calendars of
service books are full of commemorations of
saints and martyrs and their lives were read
during Matins in the Breviary and as part of
private devotions. They had an important role as
intercessors for those who invoked them in their
prayers, their lives were cited as moral and
spiritual *exempla*, and their relics could work
miracles of healing. The holy company of
Heaven were real personalities to medieval folk

(a visit to the Orthodox monastic communities
on Mount Athos today gives a vivid glimpse of
medieval beliefs in the efficacy of the saints). The
saints were represented as individual images,
usually identified by an emblem or attribute, in
narrative cycles of their lives or by single scenes
of martyrdom.[56] Often they were attired
according to their station in life, as in the case of
St Etheldreda, who is depicted as a Benedictine
abbess and crowned to denote her royal status;
St John the Baptist is robed in the camel skin he
wore in the wilderness. Others are identified by
emblems relating to episodes in their lives or
legends. St Peter has the keys to the Kingdom of    *Fig. 98*
Heaven, St Christopher carries the child Christ    *Fig. 42*
across the river and St Cuthbert holds St
Oswald's head, which was placed in his coffin
during the transfer of the relics from Lindisfarne
to Durham. St Mary Magdalene is identified by    *Fig. 168*
the jar of ointment she used for washing Christ's
feet. The most common attributes are those
associated with martyrdom. St Catherine usually    *Figs 33(d),*
holds both the spiked wheel on which she was    *128, 130,*
tortured and the sword with which she was    *163, 186*
beheaded, St Lawrence bears the gridiron on
which he was roasted and St Andrew the cross
saltire. St Peter Martyr has a dagger or sword    *Fig. 162*
through his head or heart, St Stephen carries
stones, St Edmund of East Anglia the arrows of    *Fig. 169*
his martyrdom and St Denis his decapitated
head. Sometimes important episodes from the
lives of saints occur: St Martin is often repre-
sented dividing his cloak with the beggar, as in
the St Lucy Chapel at Christ Church Cathedral,
Oxford (window sVII), and in window sV at
Mere in Wiltshire.[57] More common are
martyrdom scenes, as at *West Horsley* in Surrey    *Fig. 109*
(east window), where St Catherine's death is
shown, and the fine panel representing the
beheading of St John the Baptist watched by
Salome at *Wickhambreaux* in Kent (sV). Several    *Fig. 136*
windows in York Minster contain martyrdoms,
including two in the nave north aisle in which
are depicted the deaths of SS Lawrence, Vincent,
Stephen and Edmund (nXXVI) and SS Paul and
Peter (nXXVII).[58]

*York Minster* and chapter house possess the
largest collection of hagiographical subjects in
the country. The glass is particularly notable for
the numerous cycles of the lives of the saints

dating from the late twelfth to the early sixteenth centuries.[59] The long time-span and the many individual donors made duplication inevitable. For example, there are two Becket cycles (nIX, CHsIV);[60] another three are devoted to St William of York (nVII, nIX, CH nIII). As the latter demonstrates, the cycles vary in size and scope from a few historiated scenes (as in nIX) to tier upon tier of narrative (nVII).

*Pl. XX*

The cloister windows in monastic establishments provided space for large hagiographical cycles. In addition to the St Cuthbert windows at Durham, the cloister of the cathedral priory at Worcester contained scenes from the life of St Wulfstan. In the north aisle of *Morley* church in Derbyshire are several windows from the cloisters of Dale Abbey, which depict the legends of the True Cross and St Robert of Knaresborough (nIII, nIV).[61] Narrative windows occur widely in parish churches: St Nicholas cycles can be seen at North Moreton (sII) and *Hillesden* in Buckinghamshire (sIV), there is an extensive St Andrew cycle at *Greystoke* in Cumbria and others of SS Anthony and John the

*Fig. 52*

*Fig. 181*

*Fig. 53*

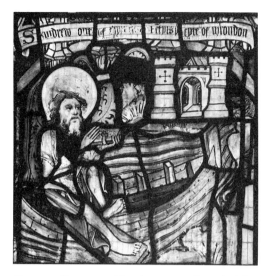

*Fig. 53*    GREYSTOKE (Cumbria): scene from the life of St Andrew, late fifteenth century.

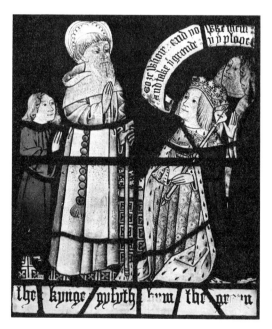

*Fig. 52*    MORLEY (Derbys.): scene from the life of St Robert of Knaresborough (formerly in the cloisters of Dale Abbey), *c.* 1480–1500.

Baptist at Gresford, Clwydd.[62] The life of St George is depicted at St Neot in Cornwall and *North Tuddenham*, Norfolk; there also formerly existed a narrative cycle of St George in the chancel windows of St George's church at Stamford, Lincolnshire, glazed at the expense of William Bruges, Garter King of Arms (d. 1449). *North Tuddenham*, St Peter Mancroft in Norwich and Combs in Suffolk contain the remains of St Margaret windows: Mancroft and Combs also possess panels from St Catherine cycles; others are at Hessett in Suffolk and Clavering in Essex, in addition to the less fragmentary cycles in York Minster (nXXIII, CH nIV) and Balliol College chapel (sII).[63] Scenes from the history of the True Cross can be seen at Ashton-under-Lyne in Greater Manchester and *Tattershall*, in addition to Morley.[64] In *c.* 1442 a large window depicting the life of St Martin was installed in the church dedicated to him in *York* at the expense of the incumbent, Robert Semer. St Peter's church at St Albans has the remains of a narrative cycle dedicated to SS Alban and Amphibalus (windows nVII, nIX). This list is by no means exhaustive.[65] Most of the narrative windows portray events from the lives and martyrdoms of the saints, although in a few of the more extensive, notably the Becket windows at *Canterbury*

*Fig. 151*

*Fig. 152*

*Pl. XXIII*

*Fig. 54*

*Fig. 96*

Roche is depicted with the plague-spot on his thigh and St Apollonia was tortured by having her teeth removed with pincers, which thus became her emblem. Other saints became associated with various trades and occupations. St Barbara is depicted with the tower in which *Fig. 172*

*Fig. 54* YORK, ST MARTIN-LE-GRAND, CONEY STREET: St Martin with a devil, *c.* 1442.

and the great St William window at *York* (nVII), posthumous miracles performed at the saint's shrine are also included.[66] *Pl. XX*

The saints found in English medieval glass fall into two main categories: those of universal popularity throughout western Christendom, and native saints. Anne, Barbara, Blaise, Catherine of Alexandria, Christopher, the Four Doctors of the Church (Ambrose, Augustine, Jerome and Gregory), John the Baptist, Lawrence, Margaret, Nicholas, Stephen, etc., can be found throughout England. Many possessed protective or curative powers. St Leonard was *Fig. 5* the patron saint of prisoners, St Margaret looked after the welfare of those in childbirth and those who saw an image of St Christopher were safe from death on that day. St Roche provided protection against plague and Apollonia against toothache. The last two became associated with these afflictions through their own sufferings: St

*Fig. 55* DRAYTON ST LEONARD (Oxon.): St Leonard, *c.* 1350.

she was incarcerated and so she became the patron saint of builders. Similarly St Blaise, who was martyred by being skinned with a wool comb, was the patron of woolmen and most of his representations occur in sheep-rearing areas, including Lincolnshire, Norfolk and Suffolk (Stamford St John's, Harpley, Blythburgh) and the west country (Great Malvern, Wells, Lydiard Tregoze in Wiltshire and Doddiscombsleigh in Devon). St Blaise was also popular in England because of the presence of his relics in Canterbury. Many major cathedrals and monasteries possessed relics of important saints. The particular strength of St Anne's cult in England may have been connected with relics such as that owned by Reading Abbey by the end of the twelfth century.[67] The subject of St Anne instructing the Virgin to read appears to be mainly confined to English medieval art. Several examples exist in glass, including *Thenford* in *Fig. 142* Northamptonshire (window nIII) where the letters of the alphabet appear on the pages of the book. At *Stanford on Avon* (sIV) the book bears *Fig. 56* the opening words of the Office 'Domine labia mea aperies'; another variant in the east window of All Saints North Street in York is inscribed with the beginning of Psalm 143 ('Domine exaudi orationem meam', etc.).[68]

Other 'universal' saints enjoyed particular devotion in England. In the fourteenth century St George came to be seen as the protector of *Figs 42,* England and, through Edward III's interest, was *135, 151* the patron saint of the Order of the Garter.[69] St George was a Cappadocian military saint adopted from the Byzantine Empire; St Helena was also associated with the Eastern Roman world in that she was the mother of the Emperor Constantine and discovered the True Cross. No *Pl. XXIII;* doubt the number of relics of the True Cross to *Fig. 160* be found in medieval England, perhaps the most famous of which was the Rood of Bromholm in Norfolk, prompted devotion to it; another important factor was the erroneous belief that Helena was the daughter of King Coel of Colchester and was therefore of native birth, a tradition that had become firmly established by the end of the twelfth century.[70]

The most popular of the English saints was St Thomas Becket, whose shrine attracted pilgrims from throughout western Christendom. This is

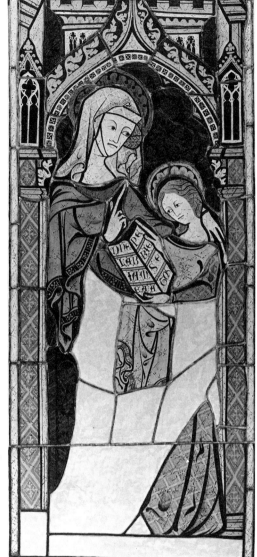

Fig. 56    STANFORD ON AVON (Northants.): St Anne teaching the Virgin to read, *c.* 1325–40. Watercolour by C. Winston, 1835 (BL MS Add. 35211).

reflected in the widespread distribution of his images in art.[71] The most important cycle is the early thirteenth-century miracle windows at *Canterbury* which also included scenes from *Fig. 96* Becket's life; the latter were probably related in iconography to the roughly contemporary window at Sens Cathedral, Burgundy, where the

*Fig. 57*   OXFORD, CHRIST CHURCH CATHEDRAL,
Lucy Chapel: martyrdom of St Thomas Becket, early
fourteenth century.

archbishop spent part of his exile in 1164. Other
narrative cycles in glass are at Angers, Chartres
and Coutances cathedrals (thirteenth century);
Saint-Ouen at Rouen and Checkley in Stafford-
shire (fourteenth century); Nettlestead in Kent
and the Bodleian Library (fifteenth century); and
the series in the Minster and St Michael-le-
Belfrey in York which variously date between
the end of the thirteenth and the early sixteenth
centuries.[72] Numerous single representations
exist of Becket and his martyrdom: a good
example of the latter is in the tracery glazing of
St Lucy's Chapel in *Christ Church*, Oxford (sVII).   *Fig. 57*
Some of the single images have the assassin's
sword cleaving his head, as at Ayston in Leices-
tershire (window sIV).[73]

Second only in popularity to Becket was
Edward the Confessor, but the only surviving
narrative cycles in glass are the early fourteenth-
century panels at Fécamp Abbey in Normandy
and the Ludlow scenes (fifteenth century).[74]

Single images of St Edward usually show him
with the ring which he offered to St John the
Evangelist disguised as a pilgrim, as in York
Minster (nVI, sII, sV, sXXXIV).[75] In some
versions he is identified by the shield of arms
which was adopted by Westminster Abbey   *Fig. 135*
(*Azure a cross paty between five martlets or*).

The cults of other English saints were more
localized. In East Anglia the chief focus of
veneration was St Edmund, killed by the Danes   *Fig. 169*
in 869, whose shrine was at the Abbey of Bury St
Edmunds. Images of the king with his arrows of
martyrdom are quite common in medieval
glazing in eastern England, although he also
occurs outside the area.[76] The principal northern
cult was that of St Cuthbert; less popular were St   *Fig. 41;*
William of York, St John of Bridlington and St   *Pl. XX*
John of Beverley, although the last's cult
prospered after the battle of Agincourt in 1415,
which occurred on his feast-day (25 October).[77]
In the West Midlands St Wulfstan, Bishop of
Worcester (d. 1095), was depicted in his cathe-
dral cloister as well as in *Great Malvern Priory*. In   *Fig. 74*
the West Country, St Sidwell with the scythe of   *Fig. 44*
her martyrdom was a popular subject in Devon
churches, in both glass and screen-paintings.[78]
The early sixteenth-century windows of *St Neot*   *Fig. 4*
parish church are of considerable iconographical
interest for the representation of Cornish saints,
many of Celtic origin. In addition to St Neot
there are single images of Germanus, Lalluwy (?),
Clere, Mancus, Mabena and Meubred.[79] Even
more localized cults have left their traces in
stained glass. The Augustinian priory at *Dor-*   *Pl. IX*
*chester* in Oxfordshire housed the shrine of St
Birinus, the Anglo-Saxon evangelist of Wessex,
and two panels survive from windows dedicated
to him, one dating from the thirteenth (window
nIII), the other from the early fourteenth
century (east window).[80] Considerable efforts
were made to secure the canonization of
Thomas Cantilupe, Bishop of Hereford between
1272 and 1282. At *Credenhill* (window sIV) he   *Fig. 58*
appears with Thomas Becket and the association
of the two, underlining the parallels in their lives,
together with the absence of haloes suggests that
the glass was designed to stimulate the canoniza-
tion process, which was achieved in 1320.[81]

*Fig. 58* CREDENHILL (Heref. & Worcs.): St Thomas Becket and St Thomas Cantilupe, *c.* 1300.

During the fifteenth century certain cults were promoted for political ends by both Yorkists and their Lancastrian opponents. On 8 June 1405 Richard Scrope, Archbishop of York, was beheaded outside the walls of his metropolitan city for his part in leading a rebellion with the Percys against Henry IV. His body was buried in York Minster and his cult almost immediately became an important weapon in the armoury of those opposed to the claims and authority of the House of Lancaster. During the first half of the century the Scrope cult flourished locally, but in the middle years of the century he was transformed into a figure of much wider significance as a result of the loss of the English possessions in France and increasing disenchantment with the Crown. These factors, together with the rise of Richard Duke of York as a claimant to the throne, revived the memory of Scrope as a martyr to Lancastrian rule. During this period a figure of the archbishop, with the label '[Sanc]tus Ricard Scrope Eboracem' was included in the nave glazing of the Yorkist mausoleum at

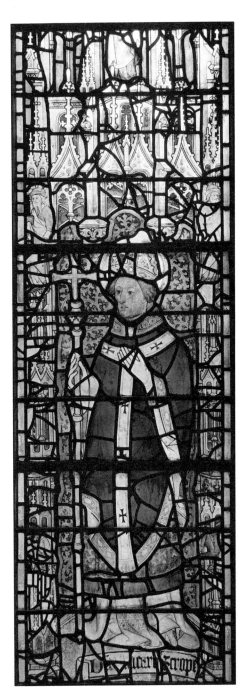

*Fig. 59* YORK MINSTER choir south transept clerestory: Archbishop Scrope, early fifteenth century.

Fotheringhay. This is lost, but a representation of Scrope can still be seen in the choir south transept clerestory (SVI) of *York Minster*. The window was given by the archbishop's kinsman Stephen Scrope, Archdeacon of Richmond (d. 1418). It is not in a prominent position and although the figure is nimbed the label refers to him as 'dominus' not 'sanctus'. In the next window (SVII), however, is an image of St William of York; the juxtaposition is more than coincidental and echoes the association of Thomas Cantilupe with Thomas Becket at Credenhill. Beginning in the late 1460s and continuing through the next decade there was a vigorous counter-attack by opponents of the Yorkists, with a cult developing around Henry VI and a revival of that associated with Thomas of Lancaster. Several figures of the former survive in English medieval art, but none in stained glass has been identified so far, apart from those belonging to a series of English monarchs. There was a figure of Henry VI in a window in St Paul's church Bedford and another was probably at Oddingley in Hereford & Worcester.[82]

*Fig. 59*

## Didactic and moralizing themes

The reforming bishops of the thirteenth century realized that the religious revival envisaged by the Fourth Lateran Council depended partly on a thorough understanding by the laity of the elementary truths of the Christian faith. Accordingly Grosseteste (Lincoln), Walter de Cantilupe (Worcester) and Weseham (Lichfield) drew up programmes by which the parish priests were to instruct their congregations. These programmes received their final form in the decree *Ignorantia Sacerdotum* made by Archbishop Pecham at the Council of Lambeth in 1281. This laid down that each cleric must:

*per se vel per alium exponat populo vulgariter, absque cujuslibet subtilitatis textura fantastica, quatuordecim fidei articulos; decem mandata decalogi; duo praecepta evangelii, scilicet, geminae charitatis; septem opera misericordiae; septem peccata capitalia, cum sua progenie; septem virtutes principales; ac septem gratiae sacramenta.*[83]

The influence of this decree was immense and it soon became the standard manual for the instruction of the laity. That it retained its importance is attested by William of Wykeham's ordering a rector to memorize it, and by the dispatch of an English translation by John Stafford, Bishop of Bath and Wells (1425-43), to his archdeacon with instructions that every parish priest was to obtain a copy and expound it to his congregation as Pecham had prescribed. In the north, John Thoresby (1353-73), Archbishop of York, composed a Latin catechism based on this decree and had prepared a version in rhyming English known as the *Lay Folk's Catechism.*[84]

The teaching of the Catechism from the pulpit was but one aspect of the instruction of the largely illiterate laity. A strong appeal was also made visually by wall-paintings, stained glass, and in one particular respect, sculpture on fonts. In these media can be seen pictorial versions of the articles of the Faith propounded in *Ignorantia Sacerdotum*. There are no instances of the entire series in a single monument, although as we have seen four of the articles are known to have been in the north choir aisle windows of Great Malvern Priory.

### The Creed

As early as the fourth or fifth century the legend was current that each of the apostles after Pentecost contributed an article of the Creed.[85] In the fourteenth and especially the fifteenth centuries, a fashion developed for representing the apostles pictorially with their clauses, sometimes accompanied by prophets and appropriate Old Testament texts. The theme occurs in English manuscript illumination, e.g. the *Queen Mary Psalter* (BL MS Royal 2 B VII) and stained glass (Fledborough, Nottinghamshire), during the first half of the fourteenth century. Numerous sets of apostles with Creed scrolls survive from the fifteenth and early sixteenth centuries; amongst the more complete are the east window of *Drayton Beauchamp*, Buckinghamshire, Ludlow and the chapel at Hampton Court in Hereford & Worcester (now in the Museum of Fine Arts, Boston, Massachusetts). The assignation of the different Creed clauses to individual apostles

*Fig. 60*

varied from place to place. This was because a number of texts give the order of the apostles in different sequences. The most common version is that of the Canon of the Mass, but there is evidence that texts by William Durandus and Richard de Wetherset, Archbishop of Canterbury (1229–31), had some influence.[86]

### The Seven Sacraments

The depiction of the Sacraments of Baptism, Confirmation, Matrimony, Eucharist, Penance, Holy Orders and Extreme Unction is quite a common subject in English late medieval art, notably on a number of East Anglian fonts.[87] A feature of Seven Sacraments compositions in glass which is not found on the fonts is the streams of blood connecting the representations of each Sacrament. The imagery symbolizes the fact that every Sacrament derived its virtue from Christ's sacrifice.[88] The earliest known example of this kind is a triptych painted in *c.* 1396 by Bonifacio Ferrer in the Museo de Belles Artes at Valencia, in Spain.[89] This has the Sacraments grouped around the Crucifixion, as do windows at Llandyrnog in Denbighshire and Cartmel Fell, Cumbria, in addition to a wall-painting at Kirton-in-Lindsey, Humberside. Several of the Seven Sacraments windows in the south have Christ showing the Passion wounds, as at Cadbury in Devon, Melbury Bubb, Dorset, and Crudwell in Wiltshire. Rushforth tried to demonstrate that there is a clear geographical division between the two types, but too many of the central Christ figures are missing for the evidence to be conclusive.[90]

*Fig. 79*

*Pl. III(c)*

### The Seven Works of Mercy

Six of the Works - Clothing the Naked, Giving Drink to the Thirsty, Feeding the Hungry, Visiting Prisoners, Giving Alms to the Poor and Sheltering the Homeless - are taken from Christ's words in Matthew 25: 35-6. The seventh, Burying the Dead, is based on the Book of Tobit I: 16-17. This was added some time after the twelfth century. The emphasis in late medieval devotional literature on salvation through good works no doubt explains the popularity of the Works of Mercy in art.

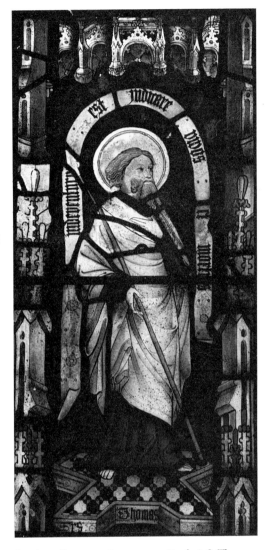

*Fig. 60*   DRAYTON BEAUCHAMP (Bucks.): St Thomas from an Apostles' Creed window, *c.* 1420-30.

There is considerable variety amongst the surviving and recorded representations.[91] Some show the influence of contemporary literature, in which various personifications, e.g. Mercy, Charity, 'Grace Dieu', and the Porter who represents Dread or Fear of God, may be found associated with the Works. Thus in Deguileville Mercy performs them and the Porter brings messengers (Prayers and Alms) to show the dying Pilgrim the way to the Heavenly City. This

*Fig. 61*  TATTERSHALL (Lincs.): Clothing the Naked from a Corporal Works of Mercy window, *c.* 1480–2.

is illustrated in the fourteenth-century wall-paintings at Potter Heigham, Norfolk, where there is a central female figure representing Mercy or Charity holding a small building, in the doorway of which is the Porter. The surrounding Works are also performed by a female figure, presumably representing Mercy or Charity again. She also carries out the Works in the wall-paintings at Wickhampton and Moulton, Norfolk, and Hoxne in Suffolk.[92] In glass versions at Guestwick, Quidenham and Lammas, all in Norfolk, a woman is recorded as performing some of the Works.[93] Elsewhere, as at Chinnor in Oxfordshire, *Tattershall*, *All Saints North Street*, York, and some roundels in Leicester Museum, they are done by men.[94] In some cases those performing the Works may represent the donors.

None of the stained glass Corporal Works is known to have had a large central figure of Mercy. Nor are there any arranged as scenes in a wheel with an angel at the hub, as in the wall-paintings at Arundel, in West Sussex.[95] On the

*Figs 61, 146*

other hand, there only appears to be one equivalent in mural painting to the Last Judgement scenes which are known to have been associated with the Works of Mercy in the glass of Lammas and Brandeston in Suffolk. These two also have English inscriptions to each of the scenes, as do a number of others in East Anglia and a fragmentary series at Glastonbury in Somerset. The Tattershall panels have Latin texts taken from the words used in the Form of Confession of the Sarum Hours for the Works.[96]

### Blasphemy and Gossiping in Church

There formerly existed a window at Heydon in Norfolk which depicted the injury done to Christ by the blasphemous invocation of various parts of God's body; also the fate in Hell of sinners, who included drunkards and dice-players. The habit of blasphemous swearing by God's body was quite a common topic in English medieval sermon literature and poetry and the most common causes of it were considered to be gambling and drinking. The Heydon window is lost, although a dice-player at Swannington Court may have belonged to it and the subject can be seen in wall-paintings at Broughton in Buckinghamshire and Corby Glen in Lincolnshire.[97]

Preachers also inveighed against those who chattered or gossiped during sermons. Women were considered to be particularly prone to this sin, which was encouraged by the Devil, and in

*Fig. 62*  STANFORD ON AVON (Northants.): warning against idle gossip, *c.* 1325–40.

80

almost every known pictorial version of this subject it is women who are shown with their heads close together and urged on by the denizens of Hell. At least nine examples are known in wall-painting from the second half of the thirteenth century onwards and the subject also occurs on misericords and in stone sculpture. Only two 'gossiping' panels have so far been recorded in stained glass, both in Northamptonshire. One is from the nave glazing at *Stanford on Avon*, of *c.* 1325–40 (now in window nII), and the other is at Old (window sVI); the latter dates from *c.* 1500 and is unique in that the protagonist is male.[98]

Fig. 62

## Mortality and the Last Judgement

Meditations on death and the Second Coming of Christ to judge the world were popular subjects in medieval monumental art.[99] The Doom or Last Judgement, based on Matthew 24: 29–31; 25: 31–46; Corinthians 15: 52 with humankind summoned by angels from its graves to face Christ sitting in judgement, is a theme which has left fewer traces in stained glass than in wall-painting. In the latter medium it usually occupied the prominent space over the chancel arch. The iconography of the Last Judgement is similar in both media, although the representations in murals do not suffer from the constraints imposed by mullions and transoms and are therefore often more elaborate. The first surviving examples in stained glass are some late twelfth-century panels in York Minster (windows SXXIII, SXXIV); then follows an early thirteenth-century medallion originally in the axial window of the Trinity Chapel clerestory at Canterbury and the Last Judgement in the north transept rose at Lincoln, in which Christ is shown displaying the Passion wounds together with angels, the Kingdom of Heaven and the Resurrection of the Dead.[100] At York and Lincoln and in later versions the resurrected dead are usually shown naked and some have crowns and mitres to indicate that all ranks of society had to face their Maker. With the exceptions of the south transept rose window at Lincoln of *c.* 1330 and the east window of Tewkesbury Abbey, all the known fourteenth-

Fig. 63    WELLS CATHEDRAL (Somerset): resurrection of the dead from the Last Judgement, *c.* 1338–45.

century examples of this theme are confined to tracery lights, including the east windows of Carlisle Cathedral and *Wells Cathedral* (where the Last Judgement spills over into the neighbouring clerestory windows, NII, SII) and Etchingham in East Sussex; also Stanford on Avon (nIV) and at the end of the century, New College, Oxford, and Winchester College.[101] Within this restricted space there was only room for the dead rising from their graves, the summoning angels and Christ. During the fifteenth century the Last Judgement filled main lights of windows and representations became more complex and elaborate. The weighing of souls by St Michael is quite often shown, together with the damned being dragged into Hell by fearsome devils and the blessed ushered by angels towards the Gates of Heaven where St Peter stands in welcome. All these elements are present in the most complete Last Judgement composition in glass, the west window of *Fairford*, of *c.* 1500–15.[102] The upper half of the window, with the Virgin and St John interceding with Christ on behalf of mankind (a standard feature of late medieval Last Judgement iconography) is restored, but is based on the remains of the original design. The awesome Hell's

Fig. 63

Pl. XXVII

Fig. 64    TICEHURST (East Sussex): fragments of a Last Judgement window, *c.* 1425–50.

mouth in the lower section is particularly impressive. The Last Judgement in the east window of the Savile Chapel (nII) attached to the parish church of Thornhill, West Yorkshire, has some interesting features. The inscription near the base of the window gives the name of the donor, Sir William Savile, and the date 1493. The church is dedicated to St Michael and All Angels, and the former appears in the window weighing souls, and angels figure prominently (there are also fragments of a Nine Orders of Angels window in sV). In the Thornhill Last Judgement the emphasis is on the admission of the elect to Heaven with no reference to the fate

of the damned. St Peter stands at the entrance to Heaven, holding the hand of a kneeling man; on the latter's right is a figure in a shroud dating from the 1870s restoration for which there is no evidence in earlier drawings of the glass. However, these drawings indicate another pair of shrouded figures just to the left of St Michael and facing the man. The latter may represent Sir William Savile as it is placed directly above his conventional donor portrait at the base of the window. An alternative interpretation is that the figure depicts Sir William's father John who died in 1482 and is commemorated both in the inscription and, probably, by a standard donor representation. The shrouded figures may well be other members of the family awaiting their entry into Heaven. The condition of the window is too poor to illustrate.[103]

Other Last Judgement windows dating from the fifteenth and early sixteenth centuries can be seen at Bradley in Staffordshire (window sV), Coughton, Warwickshire (nVII, sV), St Michael's in Coventry, Prees (from Battlefield) (nII) and in the chancel at Donington in Shropshire and *Ticehurst* in East Sussex (nII). All are in a very fragmentary state.[104]    *Fig. 64*

St John's apocalyptic vision of the end of the world provided John Thornton's workshop (or rather its presumed patron, Bishop Skirlaw) with a rich source of inspiration for the great east window of *York Minster*: no fewer than eighty-one scenes are based on the Book of Revelation and display very considerable iconographical ingenuity, not least in the panel depicting St John with the Seven Churches of Asia: the latter are personified as seven archbishops encompassed within a single architectural setting which expresses the unity of the Church.[105] The Thornton workshop was also probably responsible for an interesting version of the Last Days in a north aisle window (nIII) of *All Saints North Street* in York. The window comprises fifteen scenes in which the various events of the Last Days are vividly illustrated and accompanied by the appropriate verses of a northern English poem entitled *The Pricke of Conscience*. In the tracery are devils pushing souls towards Hell and the blessed are received by St Peter at the gate of Heaven. Copies of *The Pricke of Conscience*    *Figs 65,*
    *145*

    *Fig. 66*

*Fig. 65* YORK MINSTER, east window: St John and the Seven Churches of Asia, 1405–8.

*Fig. 66*   YORK, ALL SAINTS NORTH STREET: Death and Mourning from the *Pricke of Conscience* window, early fifteenth century.

*Fig. 67*   NORWICH, ST ANDREW'S: Death and a bishop or abbot, late fifteenth or early sixteenth century.

circulated widely amongst the Yorkshire clergy and educated laity during the first half of the fifteenth century, including Alice Bolton, a member of the Blackburn family, who donated much glass at All Saints North Street.[106]

Reference has been made to the presence in Last Judgement windows of the dead bearing trappings of high office in Church and State. The contrast between the 'vanitas' of earthly rewards and the reduction of all ranks of society to the same state after death ('sic transit gloria mundi') was quite a common subject in late medieval art. There are no known examples in stained glass of the Three Living and the Three Dead Kings, a theme which is well-known in wall-painting, but in *St Andrew's at Norwich* is a late fifteenth- *Fig. 67* or early sixteenth-century panel depicting a skeleton in a shroud clasping a bishop or abbot which may be a variation on this subject ('as you are, so we have been, and as we are, you yourselves shall shortly be').[107]

## Liturgical themes

During the fifteenth century subjects based on the hymns and antiphons found in the service books of the English medieval church appeared in stained glass. The most extensive seem to be those illustrating the *Magnificat*, i.e. the words spoken by the Virgin after the Visitation (Luke I: 46-55). The earliest known representation in glass was in existence by 1452 and was at the east end of the north aisle of the Dominican church at Norwich; another was executed in 1482 by

John Wymondeswalde of Peterborough for Tattershall collegiate church.[108] Both are lost, but the *Magnificat* filling the great window in the north transept façade (nVI) of *Great Malvern Priory* is largely intact. It was commissioned between November 1501 and February of the following year. The inner four main lights recount the story of the Incarnation from the Annunciation to the Coronation of the Virgin in eleven scenes, each accompanied by a verse of the *Magnificat*. In the two outer lights were, apparently, the archangels Michael, Gabriel, Raphael and Uriel.[109] The *Magnificat* was not a subject confined to the medium of glass, for an example is recorded on a reredos formerly in St Mary's church at Bury St Edmunds.[110]

    The *Te Deum* occurs on English fifteenth-century alabaster retables and in stained glass. The most elaborate version in the latter medium dates from *c*.1425–50 and is in the south transept (sXXVII, sXXVIII) of York Minster. It comes from the church of St Martin-le-Grand, Coney Street in York, and shows figures of God the Father surrounded by ecclesiastics and accompanied by verses of the *Te Deum*. Perhaps more common was a scaled-down version with angels holding scrolls bearing the *Te Deum*. Several incomplete series survive in East Anglia, notably in the east window at East Harling in Norfolk and in the *Burrell Collection*, Glasgow.[111] The verses of the *Nunc Dimittis* also appear in Norfolk, at St Peter Hungate, Norwich, and in Bawburgh church, as well as at Great Malvern.[112]

Themes borrowed from and illustrating hymns and antiphons were also depicted. In the chapel of *Browne's Hospital, Stamford* (window sI) of *c*.1475 is a figure of the Virgin holding a three-light window, representing the *fenestra caeli*. Although unique in English glass this imagery of the Conception was widely known; it can be found, for example, in a hymn for the Feast of the Annunciation in the Sarum Breviary.[113]

    Antiphons praising the Virgin on scrolls held by angels occur in fifteenth-century glass. Several are taken from the Sarum Processional, such as those at *Buckden* in Cambridgeshire (sV, sX) and Cockayne Hatley in Bedfordshire (nIII), where the scrolls bear the verses of an antiphon sung at Eastertide. The antiphons at St Peter Hungate in

*Fig. 158*

*Fig. 68*

*Fig. 170*

*Fig. 69*

*Fig. 68*   GLASGOW, BURRELL COLLECTION: angel with *Te Deum* scroll. East Anglia, *c*.1450–1500.

Norwich and Old Buckenham and South Creake, both in Norfolk, are borrowed from the Sarum Breviary.[114] The verses of the antiphons are accompanied by musical notation on the scrolls held by angels in the *Beauchamp Chapel*.[115]

    Not all texts are in praise of the Virgin. At Taverham in Norfolk (window nV) tracery light angels bear scrolls with the verses of an antiphon in honour of St Edmund, King and Martyr, to whom the church is dedicated. Originally he appeared in one of the main lights, and it seems likely that in many instances where the angels survive in tracery lights the texts refer to lost subjects below.[116] A donor priest in window nII at Newington, Oxfordshire, has a scroll with the final verse of a hymn sung at Compline on Easter Sunday; the verse invokes the Trinity, which is depicted in the panel above.[117]

*Fig. 69*

## Secular and historical subjects

There is a considerable amount of non-religious imagery in English medieval glass. The fabulous creatures and drolleries found principally in borders and tracery in fourteenth-century glass, for example those at *Stanford on Avon* in Northamptonshire and Dronfield, Derbyshire, express the same indigenous taste for the amusing and anecdotal as is displayed in manuscripts and sculpture. Recent research has attached a more subversive interpretation to these 'images on the edge'.[118] Often their allusions remain elusive and few are as obvious as the well-known monkey's funeral at *York Minster*

*Fig. 124*

*Fig. 70*

*Fig. 69* Angels holding scrolls with antiphons: (*left*) BUCKDEN (Cambs.), *c.* 1436–49; (*right*) WARWICK, BEAUCHAMP CHAPEL, 1447–64.

which is a parody of the iconography of the Funeral of the Virgin. The Labours of the Months also occasionally appear in church windows. Other non-religious themes have a more prominent place, especially heraldry.

In addition to the arms of individual donors, a very extensive series of heraldic shields sometimes appears, particularly in the first half of the fourteenth century when heraldic display in monumental art reached its apogee. In this period armorial glass was on occasions as much

to the fore as religious iconography and was an important manifestation of the intrusion of the secular world – especially that of the patron(s) – into churches. In those where a single individual or family funded the building or rebuilding of a parish church, the presence of heraldic devices and badges in the windows and on the stonework and the sepulchral monuments could transform it into virtually a family mausoleum; in England this secular element persisted in some places until the Reformation.[119] At *Selling* *Fig. 120*

in Kent the east window of 1299–1307 contains five shields of arms set below saints against a 'grisaille' ground.[120] The series of arms of northern lords in the nave clerestory windows of York Minster was probably executed in *c.* 1310–20. Here the heraldry exactly counterbalances the religious subject-matter as the windows consist of two bands of coloured glazing set against grisaille, the upper row comprising figural subjects, the lower the shields of arms. At *Norbury* in Derbyshire the early fourteenth-century shields in each light of the chancel side windows are set in grisaille unaccompanied by any figural glass.[121]

Fig. 123

The choice of shields of arms to be depicted was not haphazard; although the precise rationale behind much heraldic glass is unknown today, often they conform to a coherent scheme. The devising of the more complicated programmes was probably beyond the abilities of the patrons and required professional expertise. For glazing commissioned in 1540 at St Margaret's, Westminster, a herald was consulted: 'To Symon Symones glasier for making and setting up of divers arms in the Trinity chapell by the advice and commandement of Mr Lancaster Herrold at armes Xs.'[122]

Many heraldic programmes correspond with the Rolls of Arms which first appeared in England during the second half of the thirteenth century.[123] Occasional Rolls, which record the arms of those present on a particular occasion such as a tournament or military campaign, possibly find their counterpart in the east window of the choir of Gloucester Cathedral; here the shields may represent those who took part in Edward III's French campaign of *c.* 1346–9, although it has been pointed out that they could equally signify those who participated in his Scottish expedition. Furthermore as the arms include those of the leading nobles of the period the Gloucester series could be considered as a General Roll.[124] General Rolls are arranged in descending hierarchical order, commencing with the arms of foreign and English monarchs and the royal princes, followed by those of the English nobility and knights. Local Rolls usually have an abbreviated set of royal shields and concentrate on the heraldry of families in a given area. In stained glass there are variants of both

*Fig. 70* (*above*) STANTON ST JOHN (Oxon.): Funeral of the Virgin, *c.* 1300–10; (*below*) YORK MINSTER, nave north aisle: monkey's funeral, *c.* 1320–30.

General and Local Rolls. At Dronfield the east window was in effect a General Roll and contained the arms of England, France, Navarre, Provence, Aragon and the Holy Roman Emperor, together with those borne by the English earls and barons. The chancel side windows seem to have corresponded to a Local Roll as in them were displayed the arms of local landholding families. Only two of the latter series remain, but the entire heraldry is recorded in antiquarian sources. An abbreviated version of a General Roll can be seen in the tracery of the east window of Stanford on Avon.[125]

From the second half of the fourteenth century onwards, elaborate armorial cycles tended to feature less prominently in glazing schemes. However, in at least three instances dating from the late fifteenth and early sixteenth centuries heraldic and genealogical elements were still very much to the fore. It can hardly be coincidental that all three churches were associated with families keen to underline their recently acquired political or social status. The ground storey windows of *Henry VII's Chapel* in

Fig. 183

Westminster Abbey were filled with the royal arms and badges of the Tudors. Not content with proclaiming his good works in rebuilding the splendid church at Shelton in Norfolk by having his initials, arms and rebus carved on every roof corbel and niche, Sir Ralph Shelton in his will of 1497 ensured that the tracery lights of all the chancel and nave aisle windows also contained his personal devices; even the east window is mainly given up to depictions of the Shelton family. Secular and dynastic elements are even more prominent at Long Melford, Suffolk, where the nave north clerestory was filled with members of the Clopton family and its associates, eye-catchingly arrayed in their heraldic tabards and mantles and acting as the monumental equivalent of contemporary genealogical rolls like the *Salisbury Roll* (BL Loan MS 90).[126]

Subjects taken from English history occur in medieval glazing. English kings appear in several ecclesiastical schemes from the end of the thirteenth and into the fifteenth centuries. The earliest are the eight kings and queens in a chapter house vestibule window at *York* (CH nVIII), together with the canonized English monarchs in an adjacent window (CH nIX). The former are unidentified but probably represent a royal genealogy of Edward I and Queen Eleanor and their immediate predecessors.[127] Several kings inserted in the east windows of the choir and Lady Chapel at *Gloucester Cathedral* appear to have belonged to a series of forty royal figures from the choir clerestory. Amongst them is St Edmund of East Anglia and they probably represent the royal lineage of England from the time of Osric, who founded the abbey in 681. If this interpretation is correct, Edward II's tomb would have been enclosed by his royal ancestors.[128] The lost fifteenth-century cycle of kings in the north cloister walk at Peterborough Cathedral must have been similar in concept to the Gloucester series as it also commenced with the founder, in this instance King Peada of Mercia.[129] The English monarchs located in the great west window of the nave of *Canterbury Cathedral* date from 1396–1411 and possibly commemorate those who had been crowned by the Archbishop of Canterbury. The representation of kings at the west end of the building was a long-established practice in French and English

*Fig. 122*

*Fig. 71*

*Figs 143, 144(c)*

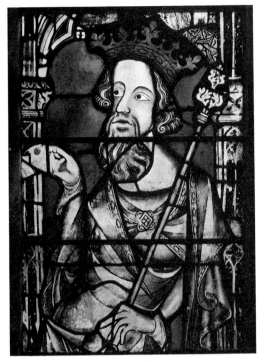

*Fig. 71* GLOUCESTER CATHEDRAL, choir east window: king (detail), *c.* 1350–60.

cathedral sculpture, as at Wells, Exeter and Lincoln, and it seems likely that it was at this entrance that the prior and monks of Canterbury met the reigning monarch when he visited the cathedral.[130]

Two other 'royal' cycles in stained glass appear to have had overtly political connections.[131] From the moment Henry Bolingbroke seized the throne in 1399, the Lancastrian dynasty was acutely conscious of the vulnerability of its claim to the English crown. It is not surprising that it should have endeavoured to influence opinion by visual imagery designed to show that its kings were the natural successors to past English monarchs. The 'Royal' window in the antechapel of *All Souls College*, Oxford, was originally in the Old Library and dates from the mid-fifteenth century. It has been heavily restored, but it is known that the kings originally included Constantine, Arthur, Ethelbert, Oswald, Alfred, Edmund, Athelstan, Edgar, Edward the Martyr (d. 979), Edward the

*Fig. 81*

Confessor, Edward II, John of Gaunt (described as 'Rex Hispaniae'), Henry IV, Henry V and Henry VI. Here is a justification of the Lancastrian claim to the throne from the Edwards via John of Gaunt.[132] In addition the window visually associated the Lancastrian kings with previous famed (and fabled) rulers. Almost certainly Archbishop Chichele was largely responsible for the iconographical programme of the All Souls glass: Chichele was a firm supporter of the House of Lancaster and was co-founder of the college with Henry VI. A similar philosophy appears to lie behind the north window of St Mary's Hall at *Coventry*, which contains a series *Fig. 159* of heavily restored royal figures, no longer in their original sequence. They read, from left to right, Arthur, William I, Richard I, Henry III, Henry VI, Edward III, Henry IV, Henry V and Constantine. The earlier monarchs were clearly chosen for their glory, and Henry III either because he was the direct ancestor of the House of Lancaster, or because he (and Edward III) confirmed earlier and granted new charters to the townspeople. As at All Souls, the last three Henrys, all of the Lancastrian dynasty, were evidently included to appear to those who saw the window as the successors of distinguished English rulers of the past. Coventry had good reason to be grateful to the dynasty, for in 1451 the mayor and council obtained an important charter from Henry VI, greatly enlarging their franchises and liberties. The window probably dates from c. 1451–61.[133]

The kings formerly in the west cloister walk of Worcester Cathedral Priory, which seems to have been glazed in the last three decades of the fourteenth century, were combined with a number of clerical figures and the entire series commemorated the benefactors of the monastery from Anglo-Saxon times, together with a record of their gifts. The inscriptions in the fifth window are typical:

*Sewaldus Rex dedit Ouerbury.*
*Johannes Rex dedit libertatem quatuor maneriorum de Lindrege Woluerly Stoke et Cleue.*
*Henricus Rex dedit Bromwiche et medietatem castri Wigorn.*
*Edwynus Rex dedit Fepeston et quinque fornaces salis apud Wich.*
*Berwulfus Rex dedit ecclesiam de Cliue.*[134]

The Worcester cycle can best be described as a monumental illustrated cartulary or book of benefactors. Following the Statute of Mortmain (1279) large gifts of land to the monasteries drastically declined, and these windows no doubt performed the dual function of honouring past benefactors and of reminding potential new donors of the exalted company amongst which they would be numbered. The cycle is paralleled by the illustrations in the *Sherborne Missal* of kings and monks holding charters representing their gifts to the abbey, and the benefactors in the *Golden Book of St Albans* in the British Library (MS Cotton Nero D.vii).[135]

Other cycles are not confined to benefactors, but commemorate important figures of the past connected with the church in which they are depicted. A row of lights in the choir east window of Gloucester contains the remains of a series of mitred figures alternating with tonsured clerics holding croziers; they are without haloes and presumably represent bishops of Worcester, the diocese in which Gloucester was situated, and abbots of Gloucester.[136] The lowest row of John Thornton's east window in York Minster contains a series of legendary and historical kings, popes and prelates associated with the establishment of the Church in the north, together with the presumed donor of the glass, Bishop Skirlaw. The thirty-eight figures in eight choir clerestory windows (SXI–SVIII, NXI–NVIII) are an enlarged version of the same theme.[137]

Two clerestory windows (NIV, SIV) at *Pl. XVIII* *Tewkesbury* are devoted to the portrayal of eight men who succeeded to the honour of Gloucester and were lords of Tewkesbury. The earliest is Robert Fitzhamon (d. 1107), the founder of the abbey, and the last two were husbands of Eleanor de Clare (d. 1337). The first of these was Hugh le Despenser the younger, the favourite of Edward II, who began the remodelling of the church as a grandiose family mausoleum. The figures are not represented in devotional or supplicant poses but in the panoply of war with hands on swords, much like contemporary sepulchral effigies. The figures in the glass formed a memorial gallery of ancestors.[138] A similar concept may lie behind the identical heads of knights at *Stottesdon* in *Fig. 72* Shropshire which are connected with the history

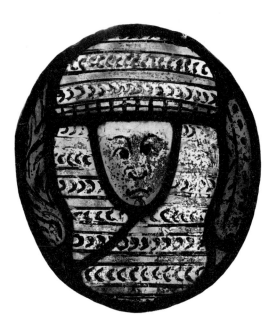

*Fig. 72*    STOTTESDON (Salop): head of knight, early fourteenth century.

*Fig. 73*    STAMFORD, ST GEORGE'S CHURCH (Lincs.): Sir John Lisle as depicted in one of the Garter windows, *c.* 1450. (Dugdale's *Book of Monuments*, BL Loan MS 38, fol. 158.)

of the manor in the early fourteenth century.[139] The chancel windows of St George's church at *Stamford* have already been mentioned in connection with the scenes from the life of St George, the patron saint of the Order of the Garter; the windows fall into the 'historical' category as they also contained the kneeling figures of Edward III and the Founder Knights of the Order.[140]

*Fig. 73*

Fifteenth-century Benedictine historians took a particular interest in the origins of their houses; several monasteries had pictorial versions of these writings.[141] The cloister windows at Gloucester contained twenty-two Latin verses relating to the establishment of the monastery, and a similar cycle existed in the west walk of the Peterborough cloisters, where the windows illustrated the history of the abbey from its foundation by King Peada of Mercia down to its

restoration in the tenth century by King Edgar.[142] At *Great Malvern* the 'foundation' window probably of *c.* 1460 still exists (NIV). The upper lights depict the story of the pre-Conquest monastic community at Malvern and the scenes below illustrate the establishment of the Benedictines under Prior Aldwin. In two of them St Wulfstan, Bishop of Worcester (1062–95), and King William I are presenting charters to Aldwin.[143] A comparable scheme was in the east window of the former collegiate church of St Edith at Tamworth in Staffordshire. William I was shown presenting a charter to Robert de Marmion, the legendary founder of the church and champion of the Conqueror; in the background was an elaborate castle set in a landscape. The window, which is associated with Dean Ralph Ferrers (1479–1504), appears to have been the work of foreign craftsmen.[144]

*Fig. 74*

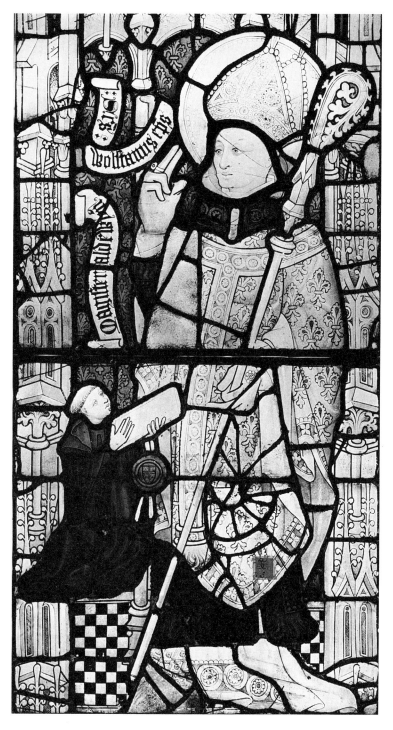

*Fig. 74*   GREAT MALVERN PRIORY (Heref. & Worcs.): St Wulfstan presenting a charter to Prior Aldwin, *c.* 1460.

# 4

# Domestic Glass

Glazing in medieval domestic quarters is a neglected aspect of stained glass studies, both in England and on the Continent.[1] However, a large amount survives and there is plentiful documentary evidence, particularly for royal residences.

For present purposes, domestic glazing may be defined as that found in the living quarters of private and corporate establishments, including places of worship attached to private domestic residences. It is not confined to the palaces, castles and manor houses of monarchs, secular lords and prelates, but is also found in the domestic rooms of corporate ecclesiastical establishments, i.e. monasteries, colleges, hospitals and almshouses. There is also evidence of decorative glazing in town houses and inns. Nevertheless glass remained something of a luxury throughout the Middle Ages. Substitutes in the form of wooden shutters were employed; also in poorer dwellings greased paper or linen was used: in 1519 it was observed that 'Paper, or lyn clothe, straked a crosse with losynges, make fenestrals in stede of glasen wyndowes.'[2]

Most of the surviving fragments of Anglo-Saxon window glass are associated with ecclesiastical sites, although remains of plain glass have been found at the royal palace at Kingsbury (Old Windsor), probably dating from the late tenth century, and domestic sites at Hamwih in Southampton and Thetford, Norfolk; Hamwih dates from between the eighth and the tenth centuries, and Thetford from the tenth century.[3] These are almost certainly exceptions and it is very likely that very few Saxon domestic buildings of importance had window glass. An indica-

tion of how highly prized glass was in the Dark Ages is given by the Holy Roman Emperor Charles the Bald's (875-77) practice of taking his windows with him as he moved from residence to residence.[4] Domestic window glass remained a great luxury until the thirteenth century. A few fragments have been found at Ascot Doilly Castle and the hall of Deddington Castle, both in Oxfordshire; these are of twelfth or early thirteenth-century date;[5] all the fragments are plain with no traces of paint. There is also some early documentary evidence. In 1179, 6s 8d was paid to Ailnoth the Engineer 'ad reparandas fenestras vitreas domus Regis de Westmonsterie'.[6] It is to be expected that the king, before anyone else, should have enjoyed this comfort.

It was only in the thirteenth century that glass became comparatively widespread in royal residences; windows were not filled merely with plain glass, but included painted decoration and figural subjects. This change is but one aspect of Henry III's lavish embellishment of his palaces and castles. The introduction of glazing can be traced in the royal accounts. The first reference is in 1221, when John le Verur received 6s for making three glass windows for St Catherine's Chapel in Winchester Castle; in the following year Albin le Verur was paid 12s for four windows in St Thomas Becket's chapel also in Winchester Castle.[7] There are many more references in the 1240s and 1250s. Sometimes glass was made for existing window openings. In 1238 white glass was ordered for the iron-barred window of the end chamber of a garderobe at

Westminster Palace 'so that chamber may not be so draughty as it has been'. A few years later all the windows in the royal privy chambers at Clipstone in Northamptonshire were ordered to be glazed. Occasionally glass replaced the lead grilles which were used to provide ventilation and keep out birds: in 1243 and 1246 Henry III had the leaden windows in the chapel of Oxford Castle replaced with glazing.[8]

The accounts for glazing in the royal residences sometimes mention the subjects depicted. Predictably the chapels frequently contained religious subjects. In 1240 St John's chapel in the Tower of London was glazed with the Virgin and Child, the Holy Trinity and St John the Evangelist. In 1249 a figure of St Edmund of Pontigny was ordered by Henry III for the chapel at Cliffe. Three years later both the King's and the Queen's chapels at Gillingham received figures of saints in stained glass, the former the Virgin and SS Edmund and Eustace, the latter SS Edmund and Edward the Confessor. The royal chapels included heraldry in their windows. Shields of the royal arms and of Henry's queen, Eleanor of Provence, were ordered for the windows of the King's lower chapel at Havering in 1251 and 1253. Heraldry also featured in the glazing of the royal halls: in 1247 shields of the royal arms and of the late Count of Provence were ordered for two windows in the King's Hall in Rochester Castle. In addition this hall contained two figures of kings, and figural subjects were by no means confined to chapels in Henry III's residences. The Nativity was represented in the King's Hall at Winchester in 1265, and the four Evangelists were placed in the King's Hall at Clarendon, Wiltshire, in 1267. In the Great Hall at Northampton was a stained glass version of the parable of Dives and Lazarus, one of several moralizing iconographical subjects popular with the king. Religious subjects also occurred in the royal chambers, as at Windsor, where in 1236–7 a Tree of Jesse was ordered for the Queen's Chamber.[9]

It would be a mistake to imagine that Henry III's palaces were filled entirely with coloured historiated glass. Quite apart from considerations of cost, the need for light would have ensured that white glass predominated. The lack of comparable documentation for non-royal residences makes it impossible to gauge whether figural panels were a common feature of domestic glazing during the reign.

The only traces of all this activity by Henry III are a few fragments of grisaille from Clarendon and Ludgershall in Wiltshire. They consist of conventional border motifs and trefoil leaves on cross-hatched grounds, similar to the contemporary grisaille of Lincoln, Salisbury and Westminster. The excavations at the Bishop of Winchester's residence at Wolvesey Palace also produced grisaille of the same type.[10]

During the fourteenth century figural glass in royal residences tended to be concentrated in the chapels, with heraldry predominating in halls and domestic quarters. In 1341 John le Glasiere of Calne received £6 'for glazing all the windows of the chapel [in the royal residence at Ludgershall], containing in all 180 feet, of which the great window before the high altar is painted with royal shields and with a panel of all the Passion of the Lord'. In 1374 the windows of the king's private chapel at Queenborough Castle had figures which needed repair, and in the same year John Brampton of London was paid 8s for a Christ in Judgement in 8 square feet of glass to be set in the façade of the chapel in Shene Palace. The extent of heraldic decoration in the royal residences during the fourteenth century is shown by Portchester Castle in Hampshire. In 1397, 216 square feet of glass with shields, badges and borders was ordered for the windows of the chapel, hall, great chamber, exchequer and an upstairs chamber.[11]

Heraldry also became a major element in fourteenth-century domestic glazing outside the royal castles and houses. The tracery of the east window of the chapel in Broughton Castle, Oxfordshire, contains three early fourteenth-century shields of arms of the Arden, Mohun and Sutton families. These are probably not *in situ* and therefore may not have originated in a domestic context.[12] The two exquisitely diapered shields bearing the arms of the Bohuns, Earls of Northampton, at Southwick Hall in Northamptonshire are still in their original locations in the tracery of two windows in a room which was probably used as a chapel; they

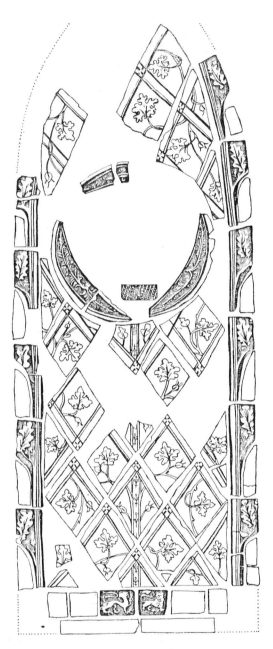

date from *c.* 1350. An almost complete window of the first half of the fourteenth century was found in excavations at *East Haddesley*, in North

Yorkshire. It consists of a border of yellow stain oak leaves on a vertical stem and a ruby roundel formerly containing a shield of arms and set against a grisaille ground of white quarries decorated with trails of hawthorn leaves.[13]

An elaborate pictorial cycle is described in Chaucer's poem, *The Book of the Duchesse*:

*And sooth to seyn, my chambre was*
*Ful wel depeynted, and with glas*
*Were al the windowes wel-y-glased,*
*Ful clere, and nat an hole y-crased,*
*That to beholde hit was gret joye.*
*For hoolly al the storie of Troye*
*Was in the glasing y-wroght thus.*[14]

This Trojan legend cycle may have been imaginary and thus probably cited here merely as a literary device. There is no other source in which such a scheme is mentioned, although the excavation of Wolvesey Palace in Winchester revealed that historiated coloured glass was known in non-royal residences during the fourteenth century.[15]

The accounts for the royal palace at Eltham in Kent provide a detailed survey of the types of glazing found in living quarters at the turn of the century:

1401 *For 36 square feet 8 inches of new glass worked with Escuchons, garters and Colers of the Bagez of our Lord the King bought of William Burgh, glacier, for a great window of 4 lights within the new chamber by the door of the King's study, at 2s a foot, 73s 4d. And for 44 feet of similar glass worked with Escucheons, Colyers and corones and flores [= flowers] with soueignez vous de moy, bought of the same William for a great window called Baywyndowe made with 4 lights, at 2s a foot, 4ˡⁱ 8s. And for 12 feet of glass worked with the Bages of our Lord the King and ornamented [floric'], bought of him for a window near the said Bayewyndowe, at 2s a foot, 24s. And for 10 feet of similar glass worked with the arms of St George and ornamented with birds, bought of him for a window near the fireplace of the said chamber, at 2s a foot, 20s. And for 78 feet 4 inches of new glass worked and ornamented with various figures, birds and beasts, namely in the first light a figure of St John Baptist, in the second light a figure of St Thomas and in the third light St George, in the 4th and 5th light the Salutation of the Blessed Mary, in the 6th the Trinity, in the 7th light a figure of St John the Evangelist, bought of the same for the King's study, at 3s 4d a foot, 13ˡⁱ. And for 24 feet of new*

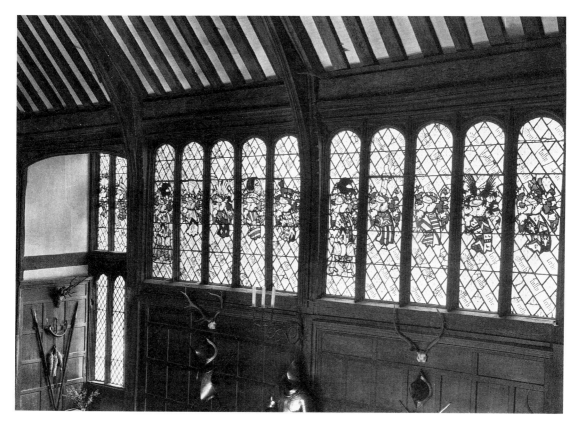

*Fig. 76* OCKWELLS (Berks.): glazing of the great hall, *c.* 1460.

*glass worked with figures of the Holy Trinity and the Salutation of Blessed Mary, bought of the same William for a window beyond the stairs at the entrance of the King's chamber, at 20d a foot, 40s. And for 42 feet of new glass worked and ornamented with birds and other grotesques [Baboueny], bought of the same William for 6 windows in the parlour, at 20d a foot, 70s. And for 8 feet of new glass, ornamented, bought of him for 2 windows in the chamber of Mons' Thomas Erpyngham, at 20d a foot, 13s 4d. In all 39ᵸⁱ 8s 8d.*

*1402 For 91 square feet of new glass, diapered and worked with broom-flowers [genestres], eagles [ernes] and rolls inscribed Soueraigne, bought of William Burgh, glasier, for the said 3 Baywyndowes and costres, each of 2 lights, at 3s 4d a foot, 15ᴸⁱ 3s 4d. And for 54 square feet of new glass worked with figures and canopies [tabernaculis], the field [le champe] made in the likeness of cloth of gold, bought from the same William for 3 windows each of 2 lights in the new oratory, at 3s 4d a foot, 9ᴸⁱ. 24ᴸⁱ 3s 4d.[16]*

Here at Eltham is the familiar combination of heraldic devices and figures of saints, etc. Royal badges and devices also featured prominently. These first occur in royal residences during the late fourteenth century: in 1383 Richard II's device of a falcon and the royal arms were purchased for windows in Windsor Castle.[17] The windows of Fotheringhay Castle, the Northamptonshire residence of the Dukes of York in the fifteenth century, included the Yorkist device of falcons within fetterlocks.[18] Rebuses, where appropriate, also appeared in domestic glass. John Gunthorpe's (d. 1498) device of a cannon appears in the remains of the glazing as well as proliferating on the stonework of his Deanery at Wells.[19]

Mottoes (described as rolls bearing 'Soueraigne') are encountered for the first time at Eltham and henceforward appear frequently in

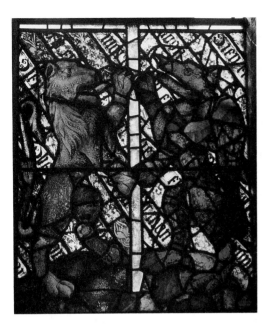

*Fig. 77*    EARSDON (Northumberland): glazing from the great hall of Hampton Court, 1532-3.

domestic glazing. In *c.*1445 John Prudde's windows at Shene Palace included 'the King's mottoes'.[20] Scrolls bearing mottoes still exist in several places, including *Ockwells* in Berkshire.[21]    *Fig. 76* Some of the finest examples, with royal mottoes on diagonal bands as well as shields of the royal arms and beasts as supporters, can be seen in the parish church of *Earsdon* in Northumberland.    *Fig. 77* This glass comes from the Great Hall of Hampton Court Palace, glazed in 1532-3 by Galyon Hone.[22]

Substantial remains of domestic glazing schemes survive from the fifteenth and early sixteenth centuries, especially in chapels. The earliest is at Haddon Hall in Derbyshire. The east window and the chancel north window (nII) were glazed, according to an inscription at the base of the former, by Sir Richard Vernon and his wife Benedicta in 1427. Fragmentary figures of the couple flank three angels holding shields of arms, and above, in the three centre lights is Christ on the Cross flanked by the Virgin and St John against a background of quarries. In the tracery lights are the royal arms, the Annunciation and several saints. The north window contains the figures of St George, St Anne with the Virgin and St Michael.[23] Haddon is on a large scale for a private chapel and in its fittings and decoration (the nave is embellished with splendid wall-paintings) it is scarcely distinguishable from a small parish church. The glazing of the chapel at *Hampton Court* in Hereford & Worcester was on    *Fig. 149* an even grander scale, although regrettably it is now dispersed amongst several museums and private collections.[24] The surviving panels include a series of the apostles with Creed scrolls, the Annunciation and Assumption of the Virgin, St Elizabeth with St John, the Virgin and Child and various saints and scenes from tracery lights. Sir Roland Lenthall had licence to crenellate Hampton Court in 1434 and the glass which can be attributed to John Thornton of Coventry and his workshop, appears to date from the late 1420s or early 1430s.

Apostles holding Creed scrolls seem to have been popular subjects in the more sumptuous private chapels. At *Withcote* in Leicestershire the    *Fig. 190* apostles are accompanied by their Old Testament counterparts and the scheme may have been a scaled-down version of the glazing designed and executed in the late 1520s for the chapel of Cardinal Wolsey's palace at Hampton Court on the Thames.[25] The complexity and quality of domestic glazing naturally depended upon the wealth and/or social aspirations of the owner. Men like Wolsey (and Roger Ratcliffe, who was almost certainly the patron at Withcote) could afford to employ the leading foreign craftsmen. Sir Thomas Kytson, who between *c.*1525 and *c.*1538 built an impressive house at *Hengrave* in Suffolk, may have imported glass    *Fig. 188* from the Continent in 1527 and installed it in the east window of the chapel in 1539-40. It comprises an elaborate glazing programme depicting the history of the world from the Creation to the Last Judgement.[26] On a more homely scale is the glazing of the chapel erected late in the fifteenth century by the Edgcumbe family at Cotehele in Cornwall. In the south window are the full-length figures of SS Catherine and Anne in rich coloured glass, but of run-of-the-mill quality.[27]

Figural or historiated glass appears to have been less common in non-royal domestic

quarters. When it did occur it was usually located in the large oriel or bay window in the great hall, as is specified in the 1513 contract for St John's College, Cambridge; all the other windows in the hall had royal badges.[28] The oriel window in the great hall of the Bishop's Palace at Lincoln contained a series of English kings, with rhyming Latin couplets below. In other windows in the palace complex were the arms and motto ('Delectare in Domino') of Bishop Alnwick (1436–49).[29] Alnwick's arms and motto, and those of Bishop William Smith (1496–1514), also occur in the hall and great chamber at *Lyddington Bedehouse* in Leicestershire, another *Fig. 155* residence of the Bishops of Lincoln.[30]

The great hall was the principal focus of heraldic display; it was here that the medieval lord feasted in state, with his guests and household; here he could demonstrate his wealth by the lavishness of his hospitality and by the splendour of the architecture and fittings;[31] equally the importance of his lineage and political connections was underlined by the shields of arms in the windows. Nowhere is this better exemplified than by the hall windows at *Ockwells*, glazed by Sir John Norreys around *Fig. 76* 1460.[32] Each light of the oriel and of the other two windows on the same side of the hall contains a shield of arms enclosed in elaborate mantling and cresting and set on a ground consisting of diagonal scrolls bearing royal and other mottoes alternating with decorated quarries. The large quantity of coloured glass and the extensive employment of 'jewelled' inserts show that the Ockwells glazing was expensive. The heraldry includes the arms of Henry VI and Queen Margaret of Anjou and various nobles, dignitaries and friends of Norreys, in addition to the arms of the family itself. A similar scheme exists in the hall of John Halle, a merchant of Salisbury (d.1479). The three windows in the east wall have quarries alternating with scrolls bearing Halle's motto 'drede' and amongst the shields set in the upper parts of the lights are the arms of England quartering France and of the Earls of Salisbury. The arms of Halle himself occur three times. This glass was very extensively restored by Willement.[33]

The inclusion of the royal arms was almost *de rigueur* in domestic glass. At Wolsey's York

Palace (later to become the Palace of Whitehall) Barnard Flower in 1515 glazed a window in the chapel chamber with 'the Kingis and the Quenys Armes' as well as those of the Cardinal.[34] Royal arms are also present in the series of thirty-nine shields from *Fawsley Hall* in *Pl. II(a);* Northamptonshire, now in the Burrell Collec- *Fig. 78* tion, Glasgow. Almost all the shields date from between 1537 and 1542 and were commissioned by Sir Edward Knightley. Here the emphasis is on his own ancestry and that of his wife Ursula, sister and coheiress of John de Vere, Earl of Oxford. The shields were originally set in bands across the windows and oriel of the great hall at Fawsley.[35]

From the middle of the fifteenth century roundels depicting the Labours of the Months and religious subjects appear in English domestic glazing. These are usually in white glass painted only in black pigment and yellow stain. The taste for these roundels appears to have derived from Flanders, as exemplified by the windows in Hans Memling's diptych of *Martin Nieuwenhove* of 1487 (Bruges, St John's Hospital Memling Museum). Several incomplete sets of Labours of the Months survive in England, for the most part not in their original locations, including four from the old parsonage of *St Michael-at-Coslany* *Pl. XXIV* in Norwich and seven in the church at Checkley, Staffordshire, from the former medieval rectory; the latter probably date from the incumbency of Anthony Draycott (1535–60).[36] The six roundels at Norbury Manor, Derbyshire, may date from the time of Sir John Fitzherbert (d.1531) whose farming interests were reflected in his authorship of the *Boke of Husbandrie*.[37] The most complete series of roundels are the twenty-nine panels from the ground floor windows of 18 Highcross Street, Leicester, now in *Leicester* *Figs 79,* *Museums*. Most are placed in frames and they *80* were all originally set against quarries within a climbing foliate border. The initials RW in the glass are probably those of Roger Wigston (d.1507), three times Mayor of Leicester. The Leicester roundels comprise the Life and Joys of Mary, the Seven Sacraments and Seven Corporal Works of Mercy, single figures of saints, and two heraldic panels.[38]

No. 18 Highcross Street is the first-urban dwelling to be mentioned in this chapter.

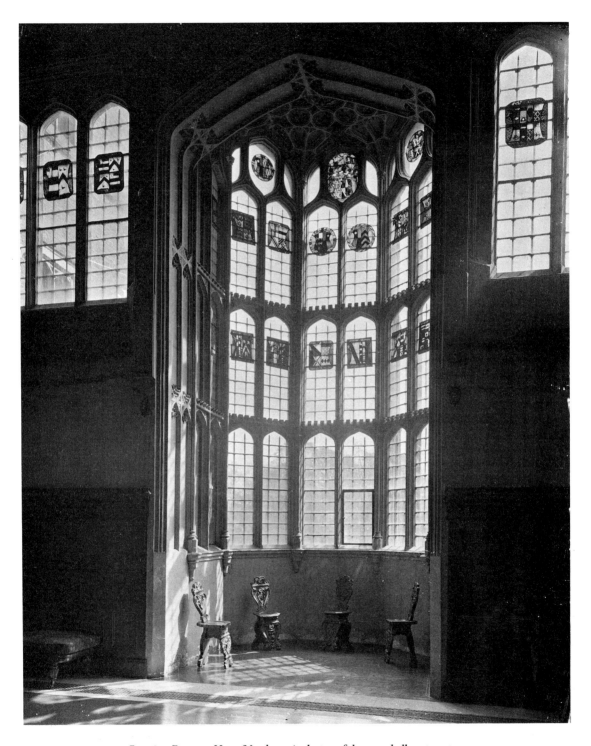

*Fig. 78*　FAWSLEY HALL (Northants.): glazing of the great hall, 1537–42.

Domestic glazing in towns and cities is rarer than in manor houses (probably because of the greater destruction rate of town-houses) and seems to have been even more of a luxury. This is suggested by a number of documents in which window glass is treated as a moveable fixture. Around 1470 a London tailor named William Smyth brought a Chancery suit on the grounds that when he left the house he had rented in St Gregory's, he was prevented from taking with him 'certayn his goodes that is to witte glas wyndowes, latices … which after the custome of the Citie be removable …'. Again in 1493 the churchwardens of St Mary-at-Hill in London paid 4s to 'Syr James Sannys for hys lattes and hys glase wyndowys that he lefte behynde hym'.[39] On the other hand chance survivals such as the fifteenth-century shields of arms held by angels in the King's Head Hotel at Aylesbury in Buckinghamshire show that decorated glass in inns and hostelries was known in the late Middle Ages.[40]

Mention was made above of roundels in rectories and parsonages; in the fifteenth and sixteenth centuries the residences of parochial clergy in the wealthier benefices could be as substantial as manor houses and their glazing also had much in common with their secular counterparts. The most complete surviving scheme is in the rectory at Buckland, Gloucestershire, where the hall windows contain the arms of Gloucester Abbey (the owners of the living), the rebus of William Grafton, rector from 1466, and the badge of Edward IV; the quarries have birds holding inscribed scrolls. A series of shields held by angels and the motto 'emanuel' was noted in 1644 by Richard Symonds in Fladbury parsonage, Hereford & Worcester.[41]

Little is known concerning the glazing of domestic quarters in monasteries, cathedrals and collegiate establishments, apart from a few libraries. The cathedral library at Wells has a series of two-light windows with the arms of Bishop Bubwith (1407-24) set against quarries within borders, a simple scheme providing plenty of light.[42] Even more translucent is the glazing in *Merton College* Old Library, Oxford. *Fig. 80* The six windows in the east wall of the west range each contain patterned quarries with a

*Fig. 79*   LEICESTER MUSEUM, Extreme Unction from a Seven Sacraments series in 18 Highcross Street, *c.* 1500.

roundel bearing the *Agnus Dei*, dating from the early fifteenth century. According to tradition this glass was brought from the transept windows of the chapel, but the formula seems better suited to a library.[43] Rather more elaborate is the glazing of the Upper Library of Balliol College, Oxford. The western bays were constructed in 1431, largely at the cost of Thomas Chase, a former Master of the college: a window on the north side of the chapel (nIV) contains figures of Chase and eight Fellows which were brought from the library. The four eastern bays of the library were built by Robert Abdy, Master between 1477 and 1494. The glass still in the library comprises a series of arms of benefactors of the College enclosed by elaborate floral garlands, intertwined with inscribed scrolls. Most of the glass is heavily restored. In the vestibule are fifteenth-century figures of the prophet Zephaniah and St Jerome: the latter is depicted in his study at work on the Vulgate.[44] Still in Oxford, the two-light windows in the Old Library of *All Souls College* were glazed in the *Fig. 81* mid-fifteenth century with figures of sixteen famous or mythical English kings down to Henry VI, the four Doctors of the Church and twelve

*Fig. 80* Two complete domestic lights: (*left*) 18 Highcross Street, LEICESTER, *c.* 1500; (*right*) OXFORD, MERTON COLLEGE, window in the Old Library, early fifteenth century.

Archbishops of Canterbury from St Augustine to Henry Chichele, the founder of the college. Twenty-eight figures survive, although some are heavily restored. In 1820 twenty-two were placed in the antechapel at All Souls (sIX), and the remaining six followed in 1879.[45]

Two series of library windows are known to have alluded to the subjects of the books found on the shelves. At Jesus College, Cambridge, there are a number of inscribed scrolls in the library windows which have related texts.[46] The scheme devised by Abbot John Whetehamstede for the library he built at St Albans Abbey in 1452–3 was more complex. With one exception each of its twelve windows contained four of the leading figures in the various branches of science and literature. No doubt the position occupied by each figure was influenced by the arrangement of the several classes of books. The first window contained Donatus, Didymus, Priscian and Hugutio and seems to have lit the Grammar class. The second window represented Rhetoric and Poetry and had the figures of Cicero, Sallust, Musaeus and Orpheus. In the third were Aristotle and Porphyry (Logic) and Plato and Pythagoras (Ethics). The fourth window represented Arithmetic (Chrysippus and Nicomachus) and Music (Guido of Arezzo and Michalus). In the fifth window stood Euclid and Archimedes (Geometry), Ptolemy (Astronomy) and Albumasar (Astrology). The sixth window contained the figure of Abbot Whetehamstede. The seventh and eighth were devoted to Jewish and Christian theologians; the former numbered Moses, Aaron, Rabbi Moses and Rabbi Solomon, the latter Peter, Paul, Athanasius and John Chrysostom. Authorities on Civil and Canon Law stood in the ninth window: Justinian, Gratian, Accursius and Hugutius. In the tenth were writers on the Monastic Rule (St Benedict, St Augustine, Bernard of Monte Cassino and Nicolas Trivet). The eleventh window contained physicians (Hippocrates, Galen, William, 'Rymius'/Brunus Lasca). The series was completed in the twelfth window by writers on agriculture: Palladius, Virgil, Peter de Crescentiis and Bartholomew Glanville.[47] Whetehamstede was a man of considerable learning and St Albans was famed from the richness of its library, so an elaborate

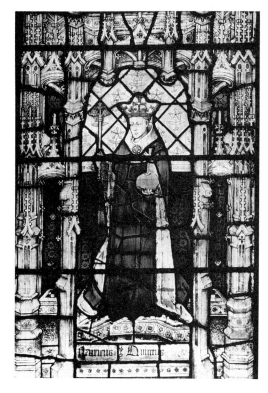

*Fig. 81*   OXFORD, ALL SOULS COLLEGE: Henry V from the Old Library glazing (now in the chapel), mid-fifteenth century.

glazing scheme of this nature is perhaps to be expected.

Although not strictly speaking domestic, the glazing of some chapels in hospitals and alms-houses is worthy of mention. Contemporary glass is preserved in the early fourteenth-century chancel of the chapel of the leper hospital dedicated to St Nicholas at Harbledown, near Canterbury. In the east window are censing angels and in the heads of the main lights of the easternmost north window (nII) are some fine *in situ* borders of *campanula* flowers (or Canterbury bells). Below is an incomplete figure of St Nicholas and in the tracery an *in situ* Ascension; the latter subject is repeated in the tracery of the westernmost window on the south side (sIII).[48] There are considerable quantities of late fifteenth-century figural glazing in the church of St Cross Hospital at Winchester, principally in

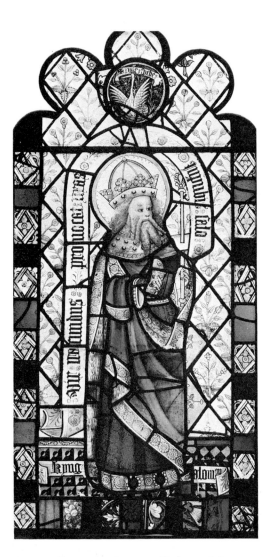

*Fig. 82* STAMFORD, BROWNE'S HOSPITAL: Solomon and William Browne's device in the Audit Room glazing, *c.* 1485–90.

four windows in the east wall, and in the south window of the chapel of the almshouse of SS John the Baptist and John the Evangelist at Sherborne in Dorset are figures of the two patron saints flanking the Virgin; although the entire complex was dedicated in 1444 the glass may not have been executed until *c.*1475.[49] *Browne's Hospital* at Stamford in Lincolnshire preserves the most complete glazing of all the charitable foundations. The buildings were erected in 1475–6 by William Browne, a wealthy wool-merchant. The chapel contains figures of the Virgin and various saints, and the Audit Room (formerly the dormitory) includes figures of David, St Paul (twice), Solomon, and a scroll referring to the philosopher Seneca. The overall iconographical theme is complex. A manuscript once belonging to the Hospital (BL MS Harley 2372) contains advice to recluses following the example of a number of Biblical personages, amongst whom David, Solomon and Paul figure prominently. Their texts, however, do not correspond exactly with those in the Audit Room glass. Shields of arms of Browne and his Stokke-Elmes relatives, and of Browne's device of a stork, occur in these windows and in the entrance passage.[50]

*Figs 82, 170*

The practice of embellishing private houses with heraldic glass did not cease with the Reformation, and the nobility and gentry continued to fill their halls and chambers with heraldic achievements until well into the seventeenth century. A particularly splendid series of eight medallions depict the alliances of the Croft family of Saxham Hall in Suffolk and date from the early seventeenth century. Seven of these are in the Burrell Collection where they can be seen in company with the Fawsley Hall set.[51]

# Plates

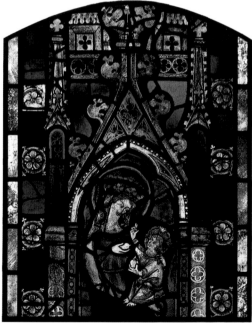

*Plate 1*  Virgin and Child, panels taken from the same cartoon: (*above*) FLADBURY; (*below*) WARNDON (Heref. & Worcs.), *c.*1330–40.

(a)

(b)

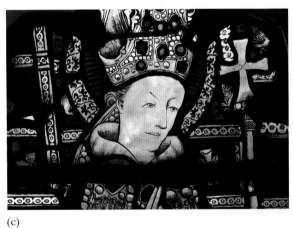

(c)

(d)

*Plate II*   ASPECTS OF THE GLAZIER'S CRAFT:
(a) detail of De Vere shield of arms from FAWSLEY HALL (Northants.) now in the Burrell Collection, Glasgow, showing
*rinceaux* picked out on a wash ground and applied with a brush and the molet produced by abrading the ruby, 1537–42;
(b) female head from the Seven Sacraments window at TATTERSHALL (Lincs.), 1482 (see also plate III) with hair and ear
applied on reverse of the glass;
(c) imitation jewelled glass inserts in the mitre of St Thomas Becket at the BEAUCHAMP CHAPEL, WARWICK, 1447–64
(see also plate III);
(d) medieval repairs to the Virgin and Child in WINCHESTER COLLEGE CHAPEL, *c.*1393 (see also plate XIX).

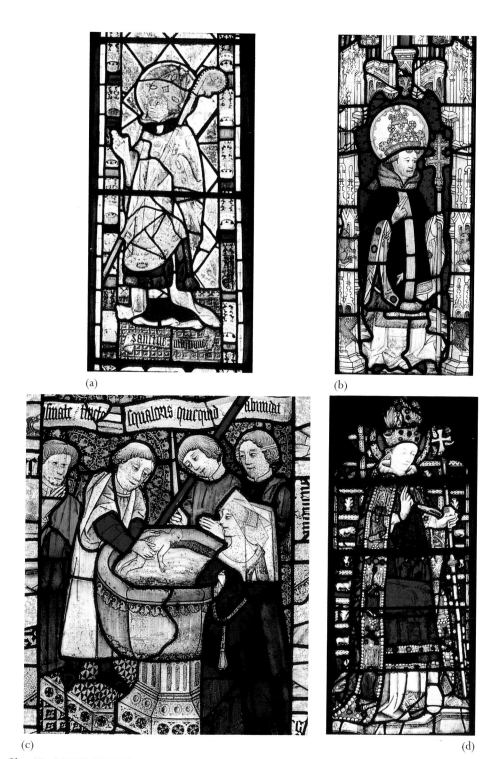

*Plate III* TYPES OF FIFTEENTH-CENTURY GLAZING AND THEIR COSTS PER SQUARE FOOT:
(a) ODDINGLEY (Heref. & Worcs): St Martin, *c.* 1461–95 (probably 8d–10d per square foot);
(b) STOCKERSTON (Leics.): St Clement, *c.* 1470–85 (probably 1s per square foot);
(c) TATTERSHALL (Lincs.): Baptism from a Seven Sacraments window, 1482 (1s 2d per square foot);
(d) WARWICK, BEAUCHAMP CHAPEL: St Thomas Becket, 1447–64 (2s per square foot).

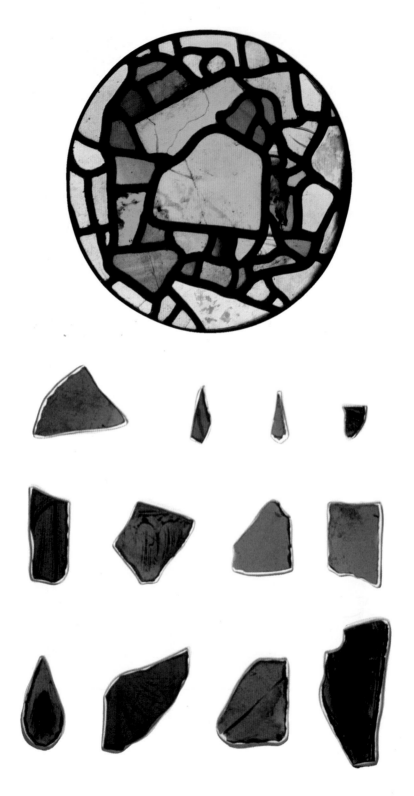

*Plate IV*   (*above*) JARROW (Tyne & Wear): excavated window glass set in a chancel Saxon window, after 682, before *c*.867;
(*below*) WINCHESTER CITY MUSEUM (Hants.): painted window glass from various sites, eleventh/early twelfth centuries.

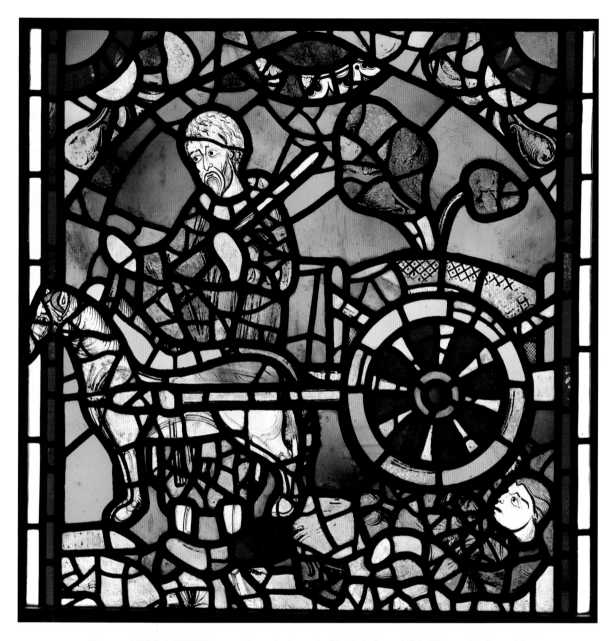

*Plate V*   YORK MINSTER: scene from the legend of St Nicholas, *c.*1170–90 (see also figure 90).

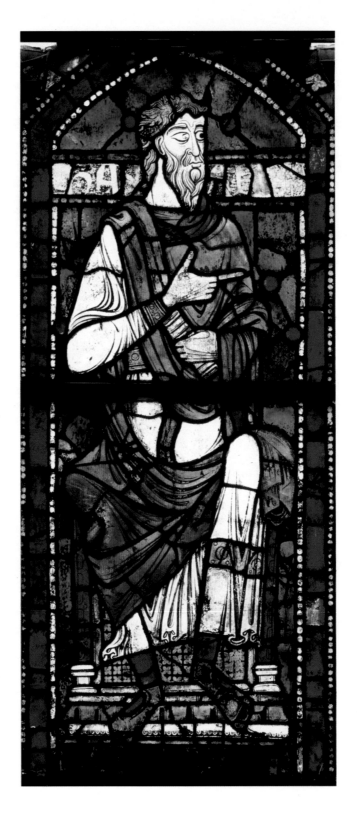

*VI* CANTERBURY CATHEDRAL (Kent): Aminadab from the genealogy of Christ series, *c.*1180–1205.

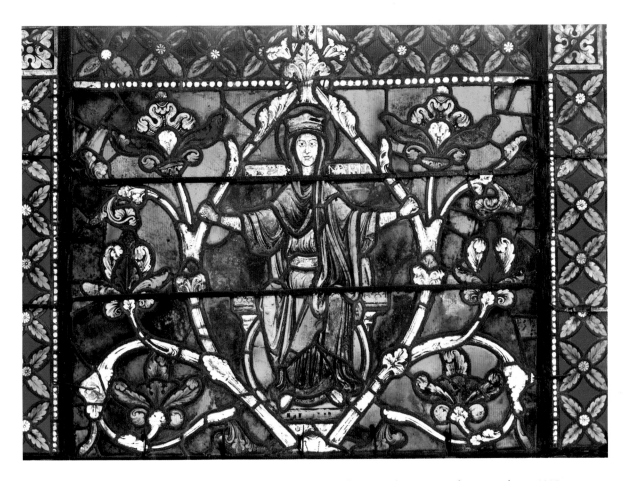

*Plate VII*  CANTERBURY CATHEDRAL (Kent), Corona: the Virgin from a Tree of Jesse window, *c.*1200.

(a)                                  (b)                                  (c)

*Plate VIII*    (a) BRABOURNE (Kent): ornamental window in coloured glass, *c.*1175.
(b) EASBY (N. Yorks.): St John the Evangelist, *c.*1180–90)
(c) ELY STAINED GLASS MUSEUM: grisaille and coloured glass window (on loan from Alf Fisher), *c.*1200–50.

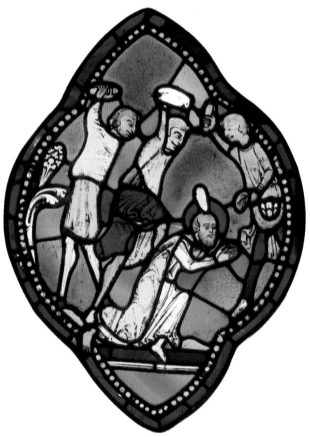

*Plate IX* (*above*) DORCHESTER (Oxon.): Archbishop Asterius blessing St Birinus, *c.*1225; (*below*) WESTMINSTER ABBEY, Undercroft Museum: stoning of St Stephen(?), *c.*1246–59.

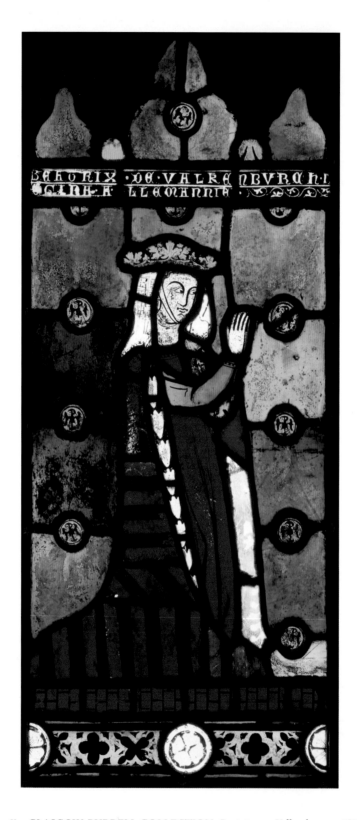

*Plate X* GLASGOW, BURRELL COLLECTION: Beatrix van Valkenburg, *c.*1270–80.

*Plate XI*   YORK MINSTER, nave north aisle: Bellfounders window, *c.*1325.

*Plate XII*    OXFORD, MERTON COLLEGE CHAPEL: donor Henry de Mamesfeld, *c.*1294.

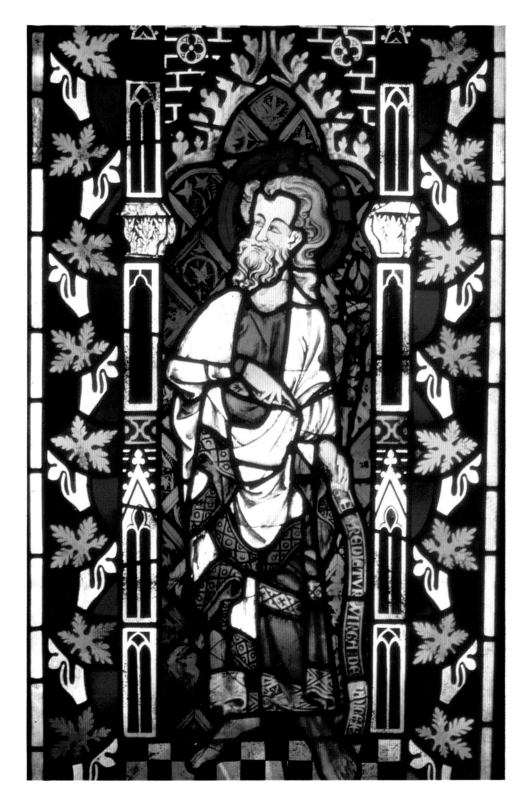

*Plate XIII*   EXETER CATHEDRAL (Devon), choir east window; prophet Isaiah (borders, base, canopy and almost all of side-shafts 1884–96), 1301–4.

*Plate XIV*    WELLS CATHEDRAL (Somerset): heads in Lady Chapel tracery lights, *c.*1325.

*Plate XV*    (*above*) YORK, YORKSHIRE MUSEUM: head of a king, *c.*1335–50; (*below*) GLASGOW, BURRELL COLLECTION: arms of Somery, *c.*1330–50.

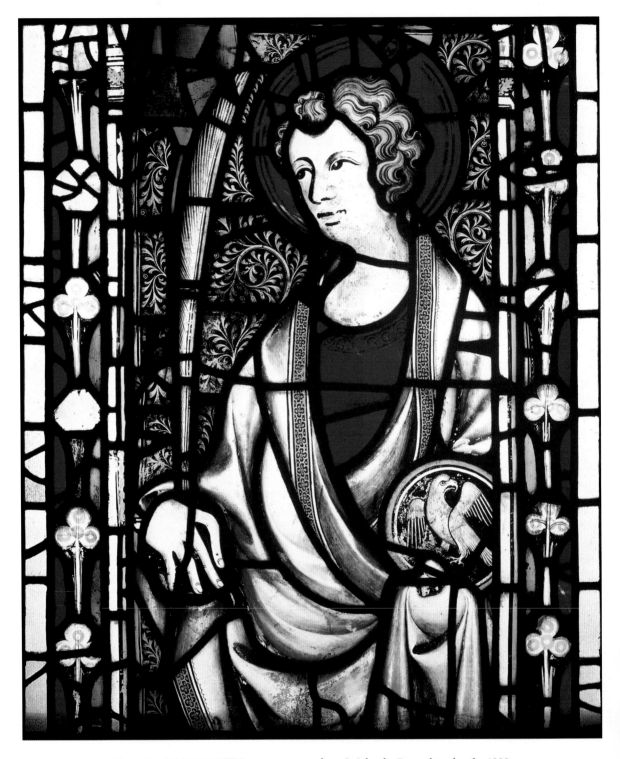

*Plate XVI*   YORK MINSTER, nave west window: St John the Evangelist (detail), 1339.

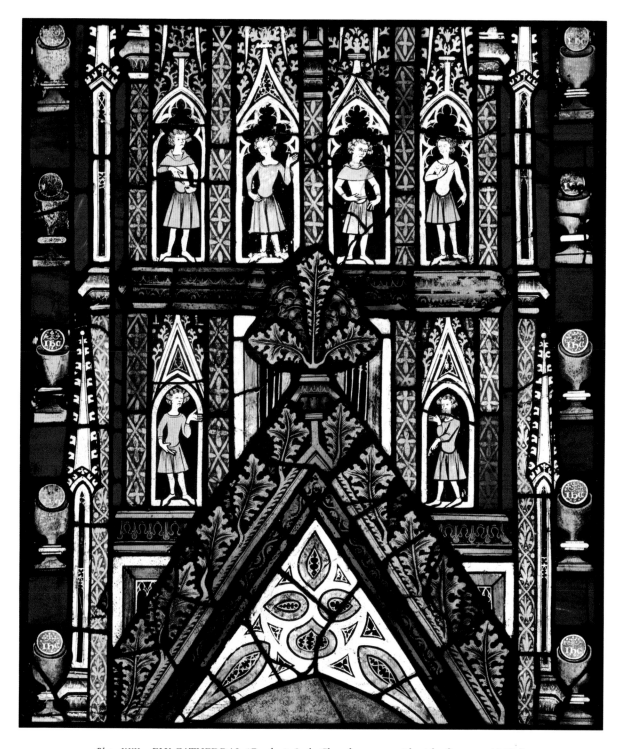

*Plate XVII*   ELY CATHEDRAL (Cambs.), Lady Chapel: canopy with niche figures, *c.*1340–9.

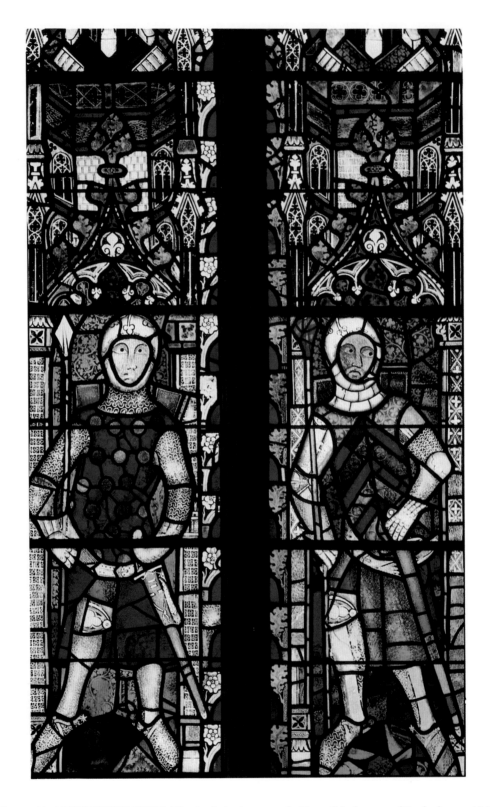

*Plate XVIII*    TEWKESBURY ABBEY (Glos.), choir clerestory: holders of the honour of Tewkesbury, *c.*1340–4.

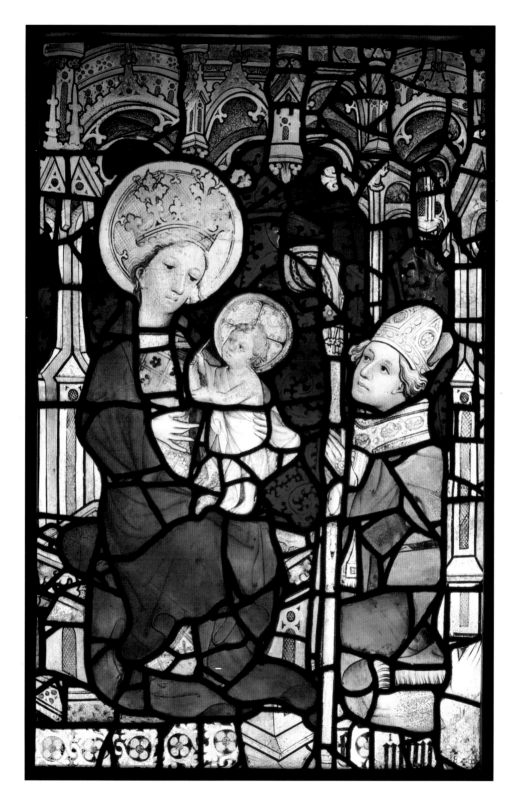

*Plate XIX*   WINCHESTER COLLEGE CHAPEL (Hants.): William of Wykeham (head modern) kneeling before the Virgin and Child, *c.*1393.

*Plate XX*    YORK MINSTER: scene from the St William window, *c*.1415.

*Plate XXI*    THURCASTON (Leics.): detail of rector John Mersden (d.1425).

*Plate XXII* LUDLOW (Salop): Creed window, *c.*1445–50.

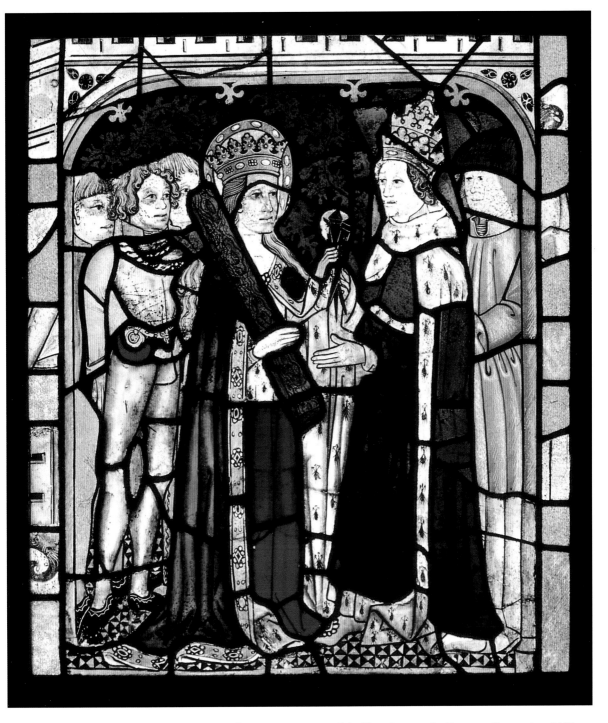

*Plate XXIII*    TATTERSHALL (Lincs.): St Helena presenting part of the True Cross to the Emperor Constantine, 1482.

*Plate XXIV*    GLASGOW, BURRELL COLLECTION: Labour of the Month roundel (February) from the former parsonage of St Michael-at-Coslany, Norwich, *c.*1450–60.

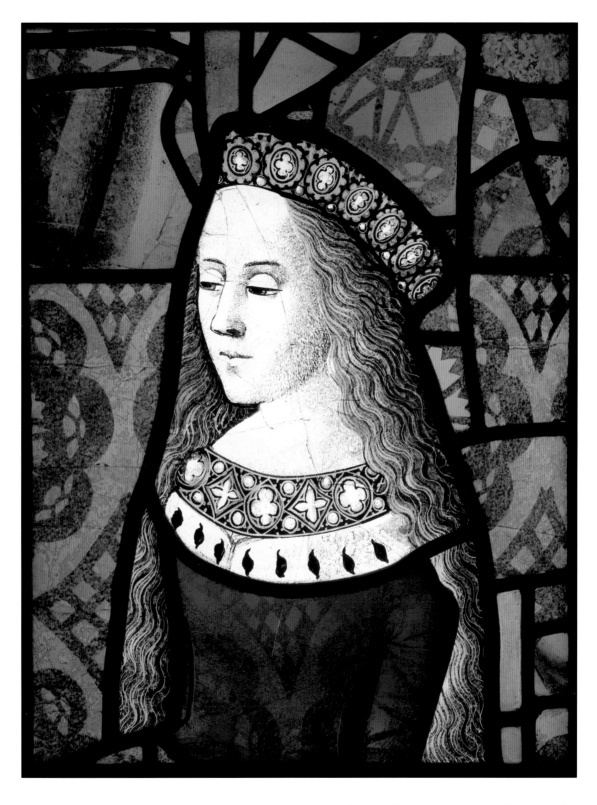

*Plate XXV* GLASGOW, BURRELL COLLECTION: Princess Cecily from the 'Royal' window in Canterbury Cathedral,
*c.*1482–7.

*Plate XXVI* FAIRFORD (Glos.): Transfiguration (detail) from chancel south chapel east window, *c.*1500–15.

*Plate XXVII* FAIRFORD (Glos.): Hell from the Last Judgement in the west window (detail), *c*.1500–15.

*Plate XXVIII* CAMBRIDGE, KING'S COLLEGE CHAPEL, nave north side: a golden table offered to Apollo, 1515–17.

*Plate XXIX* CAMBRIDGE, KING'S COLLEGE CHAPEL, nave north side: Joachim with his shepherds and flocks, 1527.

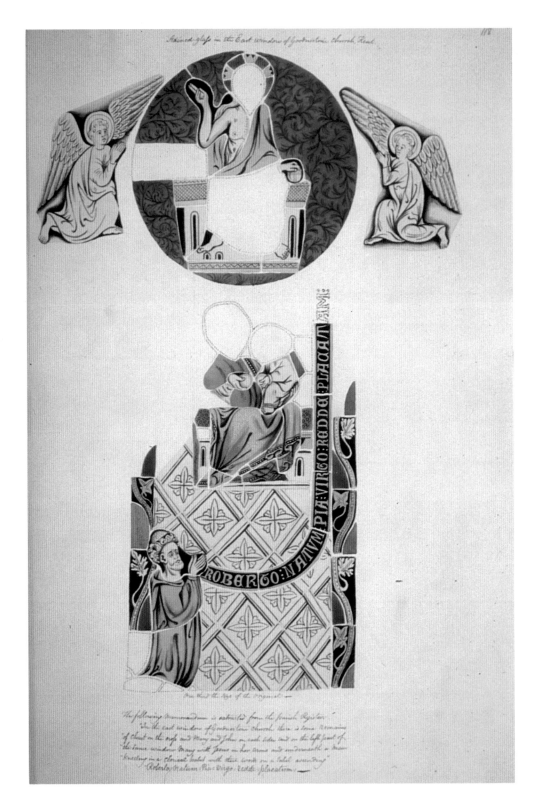

*Plate XXX*   GOODNESTONE-NEXT-FAVERSHAM (Kent): Thomas Fisher's drawing of fourteenth-century glass formerly in the east window (BL, MS Add. 32363, fol. 118), *c.*1800.

# Part II

# Chronological Survey

# 5

# *The Earliest English Stained Glass*

## c.670–1175

### *Anglo-Saxon and Saxo-Norman glass*

Window glass was known in England during Roman times and white or clear fragments have been excavated at dwelling-sites dating from the middle of the first century AD to the end of the fourth century.[1]

The craft came to an end with the withdrawal of the Roman legions and the collapse of Roman civilization during the fifth century. Until recently, the only evidence for glazing between the late fourth and the late twelfth centuries has been a few references in documentary sources. In 675, Benedict Biscop, Abbot of Monkwearmouth in Tyne & Wear, sent to Gaul for glaziers as there were none in England. The foreigners taught the craft to the Saxons, as Bede recorded:

*proximante autem ad perfectum opere, misit legatarios Galliam, qui uitrifactores, artifices videlicet Brittanniis eatenus incognitos, ad cancellandas aecclesiae porti-cumque et caenaculorum eius fenestras adducerent. Factumque est, et uenerunt; nec solum opus postulatum compleuerunt, sed et Anglorum ex eo gentem huiusmodi artificium nosse ac discere fecerunt; artificium nimirum uel lampadis aecclesiae claustris; uel uasorum multifariis usibus non ignobiliter aptum.*[2]

Monkwearmouth is not the only church glazing of the late seventh century to be mentioned in contemporary sources. Between 669 and (probably) 678, Wilfrid, Bishop of York, restored York Minster, which had fallen into decay. The windows had previously been unglazed: 'per fenestras introitum avium et imbrium vitro prohibuit, per quod tamen intro lumen radiabat.'[3]

In either the eighth or early ninth century the church of a cell of the monastery of Lindisfarne (the precise location of this cell is unknown) was glazed. The windows are mentioned in the poem *De Abbatibus* composed by Aethelwulf, a monk of the cell who was writing between 803 and 821: 'Haec est illa domus, porrectis edita muris,/ quam sol per uitreas illustrans candidus oras/ limpida prenitido diffundit lumina templo.'[4]

These sources are very imprecise and give no idea as to the type of glazing in these churches, but within the last few years this paucity of information has been transformed by archaeo-logical discoveries. Remains of Anglo-Saxon window glass from the pre-Viking period have been excavated at a number of ecclesiastical sites, notably Monkwearmouth, Jarrow, Whitby and Escomb, all in the ancient kingdom of Northumbria, and Repton and Brixworth in Mercia.[5]

At Monkwearmouth and *Jarrow* over one thousand pieces of plain and coloured window glass were found, none of them painted. The colours comprise blue of several hues, green, amber, yellow-brown and red; some have colour streaks. Many pieces are unbroken and form quarries of various shapes. The most common are rectangular and triangular, with grozed edges. Some lead cames of H-section were also discovered. The general arrangement seems to have consisted of glass set in leads to create a mosaic of colours.[6] The pieces were found in the foundations of the domestic quarters at Monkwearmouth and *Jarrow* and the existing windows in the two churches show the type of opening this glazing filled; some of the fragments

*Pl. IV;*
*Fig. 83*

*Fig. 83*

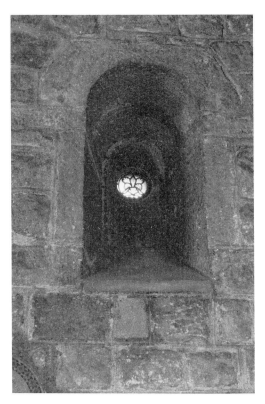

*Fig. 83* JARROW (Tyne & Wear): church window, late seventh century.

have been re-set in a 'mosaic' pattern in one of the Jarrow windows (sIII).

Two finds call for special comment as they may indicate other kinds of glazing. At Monkwearmouth a rectangular frame of lead containing interlacing patterns showed evidence that it was superimposed on to the glass. This is not without later parallel, for lead-ornamented windows dating from the late twelfth century have been found in a more sophisticated form at Studenica in Serbia.[7] A number of quarries of various shapes excavated on the site of the guest house at Jarrow have been re-set in the Bede Monastery Museum in the form of a nimbed figure with predominantly blue drapery. This reconstruction is questionable, not least because of the absence of paint from the glass; consequently there are no indications of either facial features or drapery folds.

It is not possible to establish the precise dates of the window glass at Monkwearmouth and

Jarrow, but it must have been made between the foundations of the two monasteries in 674 and 681-2 respectively, and their destruction in the Viking raids of *c.*867. Finds from the other Saxon sites which pre-date the Norse raids are similar and also lack any traces of paint. At Brixworth, for instance, the fragments display a wide range of colours and there are indications that they formed 'mosaic' patterns akin to those at Monkwearmouth and Jarrow. All the glass from Monkwearmouth, Jarrow, Escomb, Repton and Brixworth was made by the sleeve method, with the exception of two pieces of crown glass found at Brixworth. Their date is uncertain, although they must be earlier than the twelfth century. Crown glass was also discovered in an eleventh-century context at Winchester.

Anglo-Saxon glass-painters participated in that great outburst of creative activity which followed the revival of religious life in the tenth century and their stylistic traits continued after the Norman Conquest. Window glass has been found at Glastonbury Abbey in Somerset, Thetford in Norfolk, York Minster and the royal palace at Kingsbury (Old Windsor, Berkshire), but the most exciting discoveries are the fragments excavated by Professor Martin Biddle at various locations in *Winchester.*[8] The main site *Pl. IV* was the Old Minster, originally built in the seventh century, extensively re-modelled by Bishops Aethelwold and Aelfheah in 971-94 and demolished in 1093-4. Window glass was also discovered in the excavations at Lower Brook Street, Wolvesey Palace and the domestic buildings of the New Minster (founded 903, abandoned in 1110) and the Nunnaminster. The finds consist of plain colourless glass, some opaque fragments which may or may not have been coloured and blue glass which has survived immersion in the soil without decay. Painted decoration occurs on some of the opaque fragments, but principally it is found on the un-corroded blue glass. Most of the pieces have grozed edges. The archaeological contexts of the Old Minster fragments indicate that both plain and painted glass was used in its windows. The earliest piece of colourless glass was found in a stratified layer which points to a date of the mid- to late tenth century. This suggests that the

fashion for 'mosaic', non-representational windows survived the disruption caused by the Viking attacks. Similar fragments were excavated at Glastonbury.[9] The archaeological context indicates that the fragments with painted decoration date from three periods. The earliest is represented by a single opaque piece (ref. no. CG RF 3365) found on the Old Minster site in a layer with a possible date of the early to mid-tenth century. This fragment is therefore of considerable significance as it may be the first evidence so far discovered of painted window glass in the British Isles. It appears to be of drapery, with paint applied quite firmly and consistently. It is stretching a point to make comparisons from such a tiny and damaged survival, but it is perhaps worth noting that the brush-strokes are not dissimilar in strength and thickness from those on a fragment of wall-painting re-used in the New Minster foundations and dating from between the late ninth and mid-tenth centuries; they are also comparable with the treatment of drapery in a manuscript of Bede's *Life of St Cuthbert* (Cambridge, Corpus Christi Coll. MS 183), of soon after 934.[10]

The next phase is also represented by a single fragment from the Old Minster (CG RF 4834). The stratification indicates a date of the early to mid-eleventh century. The piece is so decayed that no recognizable design is discernible, but the pigment is applied in broad and heavy lines, quite distinct from the manner of painting found in the first and final phases.

The Winchester finds of the final phase are by far the most rewarding. They consist of a number of fragments of the uncorroded blue glass with very fine painted decoration. The scale is small, with the largest fragment (CG RF 5293) measuring only 6.3 × 2.6 cm; thickness varies between 2 and 3 mm. The glass was found on several sites, including the Old Minster and the Nunnaminster, and the archaeological contexts give a date-range from the first half of the eleventh to the first half of the twelfth centuries. One of the earliest pieces was discovered in the domestic quarters of the Nunnaminster (COE RF 58) and has acanthus foliage of the same type as that found in Anglo-Saxon manuscripts of the period *c.*966–1066.[11] Some of the fragments were excavated from demolition deposits of the

early and middle years of the twelfth century and it is uncertain whether they date from before or after the Norman Conquest. This uncertainty is compounded by the style of the painted drapery found on some pieces. The curving folds schematized in thick and thin parallel lines on several Old Minster fragments (CG RF 5196, 5293, 5297) are typical of the hardening and formalizing of late Saxon calligraphic and agitated drapery conventions which took place in the middle years of the eleventh century and continued after the Norman Conquest into the first decades of the following century.[12] The Winchester glass fragments may be compared variously with the drawings in a *psalter* executed *Fig. 84* shortly before the Conquest (BL MS Cotton Tiberius C.VI), the figure of St Michael engraved on the reverse of a copper-gilt cross made or

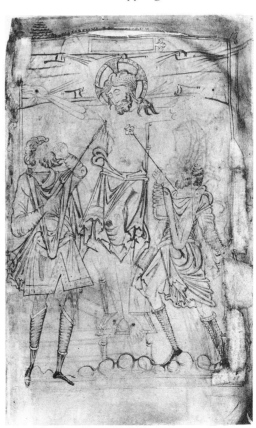

*Fig. 84*   Crucifixion in an Anglo-Saxon psalter (BL MS Cotton Tiberius C.VI, fol. 13r), *c.* 1060.

commissioned in the late eleventh century by a Saxon named Aethelmaer (Copenhagen, Nationalmuseet, D894) and even the early twelfth-century illustrations in a passional and martyrology both from St Augustine's Abbey, Canterbury (BL MSS Arundel 91 and Cotton Vitellius C.XII(i)).[13] The imitation jewelled hem on two pieces (CG RF 5293 and 5297) is an edging device found in the illustration of Queen Emma, wife of Canute, in a manuscript written at Saint-Omer near Calais in *c.*1040 (BL MS Add. 33241) and in two other manuscripts: a copy of *Jerome's Commentary on Isaiah* illustrated in the late eleventh century by a Norman monk named Hugo (Oxford, Bodl. Lib. MS Bodley 717) and Bede's *Life of St Cuthbert* executed around the turn of the century for Durham Cathedral Priory (Oxford, Univ. Coll. MS 165).[14] In the last, although the figures are unmistakably Anglo-Saxon in inspiration, they have a solidity and strength of outline that is already Romanesque; the Winchester glass gives a similar impression.

The few fragments of window glass of the same period that have been excavated at York Minster are very similar to the Winchester pieces and consist of uncorroded blue glass with painted lines. They were found immediately to the north of the transept north wall of the eleventh-century Minster and appear to belong to the church of Archbishop Thomas of Bayeux (1070–1100).[15]

The only documentary evidence of late Saxon glazing is in connection with Westminster Abbey, built by Edward the Confessor and dedicated in 1065. *L'Estoire de Seint Aedward le Rei* (Cambridge, Univ. Lib. MS E.e.3.59) mentions 'E aestoirés les vereres', an ambiguous statement which could be interpreted as referring to historiated windows. The poem dates from the middle of the thirteenth century, so the reference to pre-Conquest glazing must be treated with caution.[16]

To summarize: the Winchester finds show that unpainted 'mosaic' windows were still being made in late Saxon times; that painted window glass possibly occurred in England by the early to mid-tenth century; that by the first half of the eleventh century, if not earlier, coloured glass had appeared which was painted in a manner closely related to contemporary manuscript illumination, metalwork and sculpture. The window glass of this period was thus another element in the lavish embellishment given to certain late Anglo-Saxon churches, embellishment which also included wall-paintings (as at Nether Wallop in Hampshire), sculpture and ceramic tiles.[17] Finally, windows containing figural panels in the Saxo-Norman overlap style continued to be made into the early twelfth century.

These recent discoveries of Anglo-Saxon window glass have advanced substantially our knowledge of the early history of glazing in western Europe. A few texts refer to windows in churches in terms which suggest that translucent alabaster or coloured glass set in plaster or stucco was known in the west from the fifth to the seventh centuries. Possibly the idea was imported from the Byzantine Empire and certainly the great church of Haghia Sophia in Constantinople built by the Emperor Justinian in 532–7 had glass windows.[18] It is also at another of Justinian's buildings, San Vitale in Ravenna, that the first evidence of painted glass in western Europe has been discovered. It consists of the fragments of a small clear glass roundel with Christ in Majesty blessing two individuals. It may date from the middle of the sixth century, when the church was built, and was probably held in place by plaster or stucco. It has not been established whether the paint was fired on to the glass or was applied cold.[19] In addition to the San Vitale roundel, fragments of lead cames and painted figures and backgrounds in coloured glass have been found associated with the apse window of the south church of the Pantocrator monastery (Zeyrek Camii) and in the main church of the Chora (Kariye Camii) in Constantinople. The former can be dated between *c.*1124 and 1136 and the Chora fragments are also probably of twelfth-century date.[20]

Bede's statement that glaziers were brought from Gaul to Monkwearmouth shows that the craft was practised in France in the late seventh century, but with the possible exception of some fragments of coloured glass excavated at Mondeville in Normandy, which may date from Merovingian times, nothing has been discovered as early as the Monkwearmouth and Jarrow

remains.[21] Some pieces of window glass with painted decoration have been found at Beauvais, but their dating may be anywhere between the end of the eighth and the twelfth centuries.[22] Fragments of coloured glass were discovered in a cemetery at Séry-les-Mézières, Aisne, which was abandoned around 1000. They have been reconstructed in the form of a cross paty with two stylized flowers above the arms and the symbols of Alpha and Omega below. The edges of the cross had a palmette pattern picked out on an enamel wash and the paint may not have been fired. The panel appears to have been leaded, but it is not certain whether it came from a window or formed part of a reliquary. The glass was destroyed during the First World War.[23]

The most important recent finds of early window glass on the Continent are from the refectory at the abbey of San Vincenzo al Volturno, between Rome and Naples. In addition to approximately 9,000 fragments of coloured glass, traces of the glass-making workshop for vessels and windows together with its kiln were also uncovered. None of the window glass appears to have been painted and nearly 90 per cent of the pieces are green. The remainder are blue or clear and a number have streaks of red veining running through them. The pieces are similar to the window glass at Monkwearmouth and Jarrow, and can be securely dated to *c.*800–20.[24] There is some documentary evidence of painted figure panels in Carolingian and Ottonian church windows. In the *Life of St Ludger*, completed in 864, it is recounted that a blind man who spent the night at the saint's tomb in Werden Abbey, Germany, was miraculously cured and so could make out the images in the windows ('Aurora iam rubescente et luce paulatim per fenestras irradiante, imagines in eis factas monstrare digite cepit'). A century later, the abbey of Saint-Rémi at Rheims had windows containing various stories ('diversas continentibus historias'). A letter to Count Arnold von Vohburg from Gozbert, abbot of the Benedictine monastery of Tegernsee in Bavaria between 982 and 1001, states that up to then the church's windows were filled with fabric and that thanks to the Count it now had coloured and painted windows, which had been executed by workmen recommended by Gozbert. Finally, an eleventh-century text mentions a window in Saint-Bénigne at Dijon in Burgundy depicting the story of St Paschal 'antiquitus facta'.[25]

The written evidence is supported by a few precious survivals. In the Hessisches Landesmuseum at Darmstadt is the remains of the head of a bearded saint with a blue nimbus. It was found at the Carolingian abbey of Lorsch and stylistic parallels indicate a late ninth-century date, although Grodecki suggested that it could be two centuries later.[26] Some fragments of Ottonian window glass are known. A head from Magdeburg Cathedral in Germany, unfortunately destroyed during the Second World War, probably dates from the first half of the eleventh century. Another head was excavated at the Benedictine monastery church at Schwarzach, not far from Strasbourg. Comparisons with miniatures in manuscripts such as the *Gospels of Otto III* (Munich, Bayerische Staatsbibl., clm 4453) suggest that the Schwarzach head dates from the late tenth century.[27] There are two important monuments from the beginnings of the Romanesque period. A bearded and nimbed head probably of Christ now in the Musée de l'Œuvre Notre-Dame at Strasbourg is associated with the abbey at Wissembourg in Alsace and was probably executed in the middle of the eleventh century.[28] The application to this head of three painted washes of varying concentrations conforms with the technique described by Theophilus.[29] Five prophets in an excellent state of preservation can be seen in the nave clerestory of Augsburg Cathedral in Germany; they were painted between the late eleventh century and *c.*1120.[30] It is regrettable that nothing on the scale of these majestic figures exists on this side of the Channel; nevertheless the discoveries of Saxon glass are important additions to what is still a small corpus of early window glass.

## Anglo-Norman glass

Less is known about glazing in England in the years *c.*1100–75 than in the Saxon and early Norman periods. There is an almost total silence on the subject in contemporary records and in contrast with France and Germany, where extensive *ensembles* of glass survive, almost

nothing remains of significance in England prior to the last quarter of the twelfth century.[31] This dearth is much to be regretted, especially as important glass of the period exists at Le Mans, Poitiers, Angers and other locations in western France, which formed with England part of the vast Angevin Empire under the rule of Henry II (1154–89).[32]

The windows of the choir of *Canterbury Cathedral*, completed by Prior Conrad (1108–26) and consecrated in 1130, were enthusiastically described by a contemporary, William of Malmesbury: 'ut nichil tale possit in Anglia videri in vitrearum fenestrarum luce …'.[33] Gervase of Canterbury, writing towards the end of the twelfth century, considered that some of the choir windows were small and dark: 'Super quos

Fig. 85

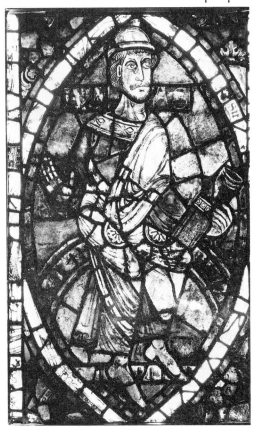

*Fig. 85* CANTERBURY CATHEDRAL (Kent): Abia from the genealogy of Christ in the clerestory (head modern), *c.* 1130–60(?).

murus solidus parvulis et obscuris distinctus erat fenestris.'[34] It has recently been suggested that four survivors from this glazing were re-used in the Trinity Chapel windows after Conrad's choir was destroyed by fire in 1174. The figures of David, Nathan, Roboam and Abia, which are now divided between the south-west transept window (SXXVIII) and the nave west window, are more archaic in drapery style than the rest of the series comprising the Ancestors of Christ and are comparable in certain features with the wall-paintings in the apse of St Gabriel's Chapel in the cathedral crypt, which recently have been dated *c.* 1155–60. If the four figures are of the same period as these murals the choir glazing could not have been completed until some time after Prior Conrad's death.[35]

The metropolitan church of the south of England can be expected to have had elaborate window glass. Less predictably, the Augustinian priory at Kirkham in North Yorkshire, founded by Walter l'Espec in *c.* 1122, had coloured glass windows in this period. The evidence is provided by a document in the cartulary of the Cistercian abbey of Rievaulx. It is a draft agreement between the monks of Rievaulx and the canons of Kirkham and originated in the decision of Waltheof, the latter's prior and stepson of the Scottish king David I, to join the Cistercian Order. For a time it seemed likely that a considerable number of the canons would follow him and a struggle took place for the possession of the priory. This agreement was a compromise by which those who chose to remain Augustinians were to surrender the monastic buildings at Kirkham to the Rievaulx monks; in return Waltheof and his followers would construct a new house for the Augustinians at Linton in north-west Yorkshire. The latter were to be allowed to remove from Kirkham their sacred vessels, books, vestments and the 'fenestras vitreas coloratas … pro quibus illis albas faciemus'.[36] In the event the agreement was never implemented and only Waltheof left to join the Cistercians. The date of the document is not certain. It must have been drawn up in 1143 at the latest, in which year Waltheof began his noviciate at Warden Abbey in Bedfordshire, and it may even be as early as *c.* 1139.[37] Kirkham was a house with influential connections and it is not

possible to assess how typical its glazing was of English non-Cistercian monasteries in this period.

The Kirkham episode also throws valuable light on the attitude of the first English Cistercians to window glass. At an early stage in the history of the Cistercian Order regulations were laid down with regard to glazing: 'Vitreae albae fiant, et sine crucibus et picturis.' The date of this statute, as with all early Cistercian legislation, is disputed: latest research suggests it belongs to the period *c.* 1145–51. That the white monks had coloured glass in the windows of their monasteries prior to this ban is revealed by a ruling of the 1159 General Chapter: 'Vitreae diversorum colorum ante prohibitionem factae, infra triennium amoveantur.'[38] The draft agreement in the Rievaulx cartulary thus probably pre-dates the first statute and is the first firm evidence anywhere of Cistercian espousal of white glass in preference to coloured glass. That it should occur in connection with Rievaulx is not surprising in view of the close ties that existed at the time between this house and St Bernard.

Fragments of early Cistercian window glass were found in 1979–80 during excavations at Fountains Abbey. They were discovered below the primary floor of the existing church and supposedly come from the first stone church on the site, which was built between 1135 and possibly damaged by fire in 1146/7.[39] Each piece measures no more than a few millimetres and all are opaque through de-vitrification, so only scientific examination will reveal whether any of the finds are of coloured glass. It is doubtful whether there is any prospect of reconstructing the original design of the early Fountains windows as the fragments are so few in number and small in size; also no recognizable leading patterns were found.

A small figure of St Michael in the parish church at *Dalbury*, not far from Derby (window sV), was discovered and identified by the late Dr Peter Newton and restored by The York Glaziers Trust in 1980.[40] The archangel is depicted full-length, facing frontally, against a white ground and set within a modern ruby border. Head, hands and feet are white and the wings are ruby with white feathers. The robes comprise a yellow alb, green amice and white stole or pall with a

*Fig. 86*

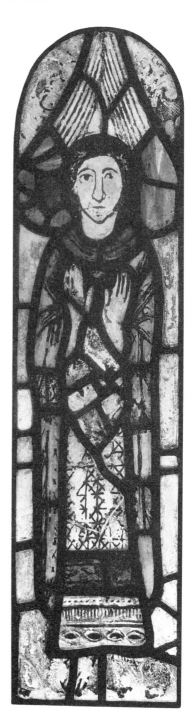

*Fig. 86*   DALBURY (Derbys.): St Michael, *c.* 1100–35(?).

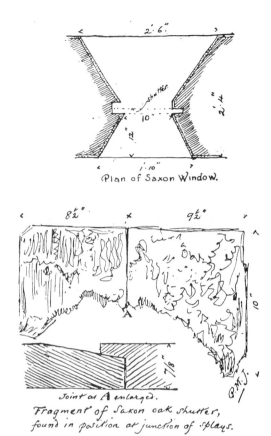

2' 6"

(Plan of Saxon Window.

8½"  9½"

10"

Joint at A enlarged.
Fragment of Saxon oak shutter,
found in position at junction of splays.

*Fig. 87*  POLING (W. Sussex): remains of oak window shutter, eleventh–twelfth century, *From Sussex Arch. Colls., vol. LX (1919).*

green band near the lower end.

The frontal pose and clerical vestments provide little opportunity for stylistic comparison; the figure is stiff and formal, with thick trace lines for the simple facial features and vertical strokes for most of the drapery folds. For these reasons the dating of the Dalbury St Michael is a matter of guesswork. In terms of quality it is far removed from early Continental figural glass and it is also quite unlike the surviving English glazing of the late twelfth and early thirteenth centuries.[41] On the other hand the rigidity of the pose and the delineation of the facial features and drapery folds place it within the Roman-

esque monumental tradition. But is it the unsophisticated and *retardataire* work of a local glass-painter working at the end of the twelfth century, or is the panel considerably earlier? There are slight indications that the Dalbury St Michael may date from the early twelfth century. The late eleventh-century date that has been suggested is unlikely as the characteristic features of the Saxo-Norman overlap style are absent.[42] There are also no traces of the 'damp-fold' drapery convention which first appeared in English painting in about 1135, so this may point to a dating of *c.* 1100 to *c.* 1135 for the Dalbury St Michael. Another feature which supports this date is the range of colours, which has very little in common with some French glass of the 1140s and later, such as Saint-Denis and the Chartres Cathedral west windows; on the contrary, the use of white grounds conforms with a tradition referred to by Theophilus and occurs in eastern French and German Romanesque glass, including the Augsburg prophets.[43]

These observations are hardly conclusive and the date of the panel remains uncertain. It must at least pre-date the existing parish church which was rebuilt around 1200. All the windows of this period at Dalbury are pointed lancets of much larger size than the stained glass panel, which was designed to fit a small round-headed window opening like those in the perfectly preserved Norman architectural gems of Heath Chapel in Shropshire and Barfreston, Kent.

The Dalbury St Michael is the only surviving trace of Romanesque parish church glazing in England to have been discovered to date. Probably few twelfth-century parish churches enjoyed the luxury of glass windows; the openings for the most part would have been filled by wooden shutters like the remarkable survival of late Saxon or Norman date at *Poling* in West Sussex. Made of oak, this was found in 1917 still in position in a blocked window (nIV). Only the upper section exists and the lower part probably had a hinged flap or pierced opening to admit the light, perhaps through a piece of horn or oiled canvas. Parts of another oak shutter were also discovered in a window of similar date at Witley in Surrey.[44]

*Fig. 87*

# 6

# *Stained Glass*

## c. 1175–1250

References to glazing in the period *c.* 1175–1250 occur in several contemporary records. Bishop Hugh du Puiset (1153–95) gave glass in the east end of Durham Cathedral: 'multiplicatis insigni pictura fenestris vitreis circa altaria.' Robert de Lindesey, Abbot of Peterborough between 1214 and 1222, is known to have glazed thirty windows in his church.[1] William, Abbot of St Albans (1214–35), was responsible for the glazing of the west front and many other windows in the abbey church and in St Cuthbert's chapel and an extension to the dormitory. By 1240 Chichester Cathedral had glass windows which were already described as ancient. In addition there are references to the extensive glazing carried out in Henry III's residences.[2] Not a trace survives of any of the church glass described in these records; conversely the glazing that still exists is hardly mentioned at all in contemporary documents. This even applies to the principal monument, Canterbury Cathedral. Leaving Canterbury aside, the material, compared with France and Germany, is hardly plentiful.[3] There is some late twelfth-century glass at York Minster and the surviving glazing of Lincoln Cathedral dates mainly from the early thirteenth century. After these, there are slight remains at Salisbury Cathedral, Westminster Abbey and Beverley Minster. In addition fragments of early thirteenth-century glass can be found in parish churches throughout England.

The affinities of English glass-painting lie with northern France rather than the Holy Roman Empire, particularly in window design and colour and, in general terms, style. Broadly speaking the same applies to manuscript illumination of this period and the natural affiliations brought about by geographical proximity were strengthened by political and dynastic links. This is not to say that all English glass in the period covered by this chapter should be seen purely in French terms or as reflections of French art. The major monuments exhibit to varying degrees connections with indigenous artistic traditions, some of which may be peculiar to certain localities, although the surviving material is far too scanty and scattered for this to be more than hinted at.

## York

The twelfth-century glass of *York Minster* consists of a series of panels and remains of borders rescued from the earlier church during the rebuilding of the Minster in the late thirteenth and early fourteenth centuries; most were re-used in the nave clerestory windows. All the panels have been extensively altered, but a study of the lead-lines has enabled a number of scenes to be identified. Much still needs to be done, but thanks to the iconographical researches of the late Dr Peter Newton, to date the remains of at least eight historiated cycles have come to light, in addition to about fifteen border designs.[4] The cycles consist of the following: a Tree of Jesse (one panel is extant, now on display in the crypt exhibition), one Old Testament scene of Daniel in the Lions' Den

Fig. 88    YORK MINSTER, Crypt Exhibition: king from a Tree of Jesse, *c.* 1180–90.

(presently in the Five Sisters window in the north transept), together with an apocryphal episode from the prophet's life, and events from the Passion and the Last Judgement. The other scenes are from the lives of various saints, of which SS Benedict, Martin and Nicholas have been identified; some panels have also been associated with St Richarius, the seventh-century founder of the Abbey of Saint-Riquier north of Amiens. In addition the various geometrical grisaille designs in the nave clerestory may either be copied from twelfth or early thirteenth-century prototypes or, more likely, are the original panels, adapted and re-used in a new location.[5] *Figs 101 (c), (d)*

Apart from the figure from the Tree of Jesse, the historiated glass consists of quatrefoil medallions and rounded or vesica-shaped panels, originally with curved acanthus fronds and sprays in the angles: good examples of both types are the Miraculous Draught of Fishes and St Benedict in a cave, fed by his disciple Romanus. The borders combine bold geometrical strapwork patterns with foliate sprays. The predominant colours are brilliant blue, sage green, purple and white; ruby is also present, but it is used less obtrusively than at Canterbury; the tone of all the colour is made more opaque by washes of fired paint on the exterior of the glass. *Fig. 91*

Although it is difficult to draw many conclusions regarding style owing to the heavy amount of restoration and loss of paint-lines, the scenes and borders are notable for their clarity of composition, with figures strongly silhouetted against the clear blue backgrounds and with thick leading for their outlines. The borders differ considerably from the late twelfth-century borders in the Canterbury choir aisles; their best parallels seem to be in northern rather than western France (the latter region was suggested *Pl. V; Fig. 90* *Fig. 89*

by Lethaby).[6] Some of the designs may be derived from borders in the royal abbey at Saint-Denis (1141–4), although there are considerable differences.[7] Professor Caviness has also compared several of the curled acanthus fronds at the angles of the quatrefoil historiated panels with similar foliate forms at Saint-Denis and the abbey of Saint-Rémi at Rheims.[8] The affinities between Saint-Denis and York extend to the historiated glass. The pose of the seated king and the arrangement of the foliage in the surviving panel from the Tree of Jesse derive from either the Saint-Denis Jesse or the very similar Jesse in the west façade of Chartres Cathedral, the former of *c.*1145, the latter of *c.*1145–55. This connection has in the past given rise to a dating of *c.*1150 for the York Jesse, but the solidity and monumentality of the York king demonstrate

*Fig. 88*

that it is moving away from the Romanesque and towards the so-called Transitional or Classicizing phase of the late twelfth and early thirteenth centuries.[9] Similar treatment of drapery is found in glass from Troyes Cathedral dating from before a fire of 1188 and in related manuscripts. Convincing comparisons have also been made with the reliquary of St Oswald in Hildesheim Cathedral, Germany, which is unquestionably of northern English origin and was probably made in the 1180s. Features in common between the York king and the figures of SS Edmund and Sigismund on the reliquary are the proportions, the high belts and the treatment of drapery.[10]

Although there are differences in style between the various panels, in general terms they can be related, like the Tree of Jesse figure, to local artistic traditions. The tall proportions, strong outlines, silhouetting, glum expression and (prior to restoration) the heavy modelling around the eyes of the figures in the historiated scenes are traits found in a group of northern English manuscripts which includes the *Gough* and *Copenhagen Psalters* (Oxford, Bodl. Lib., MS Gough Liturg. 2 and Copenhagen, Royal Lib. MS Thott 143.2°) dating from *c.*1170–5. A similar spatial confusion has also been discerned in the interweaving of the legs and feet of the carter in the St Nicholas panel with those of the horses and the figure crushed under the wheels of the cart to that in the Flight into Egypt miniature in the *Gough Psalter.* In addition the range and combination of colours, the solemn expressions, large eyes and prominent eyeballs (the head of the figure underneath the cart has been taken from another of the York clerestory windows) occur in other northern manuscripts of the 1170s such as a psalter in Glasgow University (Hunterian Lib. MS Hunter U.3.2.) and the initial to the opening of the second book of Samuel in the *Puiset Bible* (Durham Cathedral Lib. MS A.II.I).[11] The drapery conventions in some of the York glass appear to have lost the stylized, still Romanesque, surface patterns found in the miniatures and are arranged more naturalistically in large, looping folds which emphasize the bodily forms beneath. As Professor Zarnecki has noted, the same features occur on a stone relief of the Evangelist symbol for St Matthew set at the top of the interior west

*Fig. 91*

*Fig. 89*   YORK MINSTER, nave north clerestory: borders, *c.*1170–90.

*Fig. 90*  YORK MINSTER: scene from the legend of St Nicholas, *c.* 1170–90. This photograph was taken in 1967, before the panel was restored (see also plate V).

wall of the Minster nave and on a series of statues and voussoir carvings from St Mary's Abbey in York which are now in the Yorkshire Museum. The affinities between these sculptures, which were probably executed between *c.* 1180 and 1190, and the York glass are very close.[12]

The evidence suggests, therefore, that the early Minster glass was executed by a workshop or workshops indigenous to the York area and closely in touch with local metal-working, sculptural and manuscript-painting developments as well as having an awareness of glazing in northern France. The comparisons indicate that the glass dates from the 1170s onwards. Some of it probably came originally from the

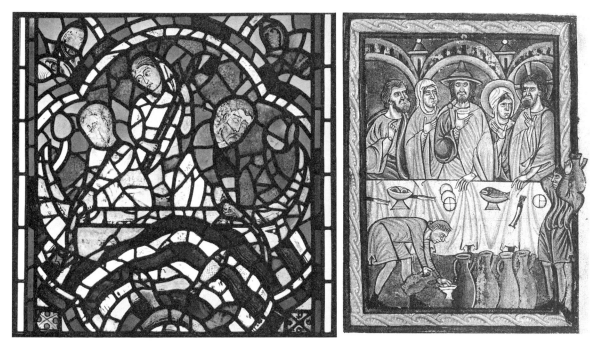

*Fig. 91*    (*left*) YORK MINSTER, nave south clerestory: Miraculous Draught of Fishes, *c.* 1170–90; (*right*) *GOUGH PSALTER* (Oxford, Bodl. Lib. MS Gough Liturg. 2, fol. 20r): Marriage at Cana, *c.* 1170–5.

choir rebuilt by Roger of Pont l'Evêque, Archbishop of York between 1154 and 1181; the rest may have belonged to the westwork added to the nave at the end of the twelfth century or even to the eleventh-century nave itself. Although it has been suggested that the glazing was completed before Roger's death,[13] work may have continued into the subsequent vacancy which ended in 1191.

Not enough of the York historiated glass has survived to attempt a convincing reconstruction of the original window designs. As the Jesse conformed to the general iconographical pattern of those at Saint-Denis and Chartres, the window would have consisted of Christ's royal Ancestors forming the trunk of the tree, with the Virgin and Christ at the top; the principal figures would have been flanked by prophets in demi-medallions.[14] The other historiated windows were probably composed of medallions, quatrefoils, segments of circles, lozenges and other

shapes set against coloured foliate grounds and supported by iron armatures similar to those in windows of the late twelfth and early thirteenth centuries at Canterbury and in northern French cathedrals.[15]

The Jesse window may have been located in the flat east wall of the choir north aisle, with the Passion scenes in the central east window, possibly accompanied by the Old Testament scenes and thereby forming a typological cycle. The Last Judgement could have occupied an oculus or even a rose window like that in existence by 1180 at Laon Cathedral in France.[16] All this is, however, highly speculative and there is no firm evidence for the original locations of any of the surviving panels. The situation is very different with the other great monument of English glass-painting of the late twelfth and early thirteenth centuries: the choir, Trinity Chapel and Corona of Canterbury Cathedral.

*Fig. 92*    CANTERBURY CATHEDRAL (Kent): choir and Trinity Chapel looking east, 1175–84.

## Canterbury

*Anno gratiae Verbi Dei Mᵒ Cᵒ LXXᵒ IIIIᵒ justo sed occulto Dei judicio combusta est ecclesia Christi Cantuariae, chorus scilicet ille gloriosus industria et sollicitudine Conradi prioris magnifice consummatus, anno dedicationis suae xlᵒ iiiiᵒ.[17]*

Thus begins Gervase of Canterbury's vivid account of the fire which devastated the choir of Canterbury Cathedral. He goes on to describe the construction of a new east end under the *Fig. 92* direction first of William of Sens and subsequently of William the Englishman. Work began at the west end of the choir and during 1175 two piers on each side were raised. The new early Gothic choir was first used by the monks at Easter 1180 and the crypt was completed by 1181. By the end of 1184 the fabric of the Trinity Chapel and Corona was ready. Unlike Abbot Suger in his accounts of the work at Saint-Denis, Gervase makes no mention of stained glass in his account, apart from three glass windows in a

wooden partition erected in 1180. Fortunately much of the original glazing survives, although not all of it is *in situ* and a few panels have found their way into museums.[18]

The Canterbury glass contains an iconographical programme of great clarity. In the early thirteenth-century glazing of Chartres Cathedral there were many donors who apparently insisted on their own choice of subjects to be portrayed in their windows; at Canterbury by contrast, there is no evidence of patronage by individuals, although the selection of some of the Becket miracle episodes may have been influenced by those who contributed to the cost of the windows.[19] The coherence of the iconographical programme points to the guiding hand of one individual; a possible candidate for this role is the prior of Canterbury, Benedict, subsequently Abbot of Peterborough between 1177 and 1193. The models for the programme were at hand in the cathedral library. Probably the subject-matter of the windows was settled in broad outline at an early stage, possibly by

*c.* 1180, although there is evidence that the scheme was modified as work progressed.[20]

The clerestory contained a series of more than eighty figures depicting the Ancestors of Christ, commencing with Adam at the west end of the north choir elevation and terminating (presumably) with the Virgin and Christ in the corresponding window in the south choir elevation. Thirty-five still survive, although none is *in situ*, including the four figures which may have been re-used from the pre-1174 glazing.[21] The sequence was broken by three of the windows in

*Pl. VI;*
*Fig. 93*

*Fig. 85*

the Trinity Chapel apse which apparently consisted of narrative subjects, including the Last Judgement in the axial window. Other interruptions occurred in the north and south oculi. In the former is the Old Law, represented by Moses and Synagogue, the four cardinal virtues and four major prophets (Isaiah, Jeremiah, Ezekiel, Daniel). The south oculus presumably contained the New Law represented by Christ and Church. Nineteenth-century reconstructions by George Austin junior occupy this position.

In the choir aisles, eastern transepts and

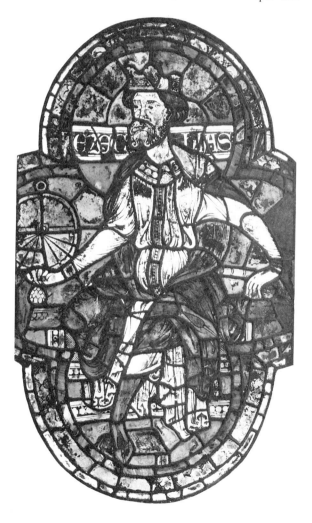

*Fig. 93*    CANTERBURY CATHEDRAL (Kent), two figures from the genealogy of Christ series: (*left*) Lamech, *c.* 1175–80; (*right*) Hezekiah, after 1213, probably *c.* 1220.

SELLAM GOS DVXI GEN EOS AB IDRO DE RE DV XIT.

SIES A A ANAM GENTES FVG IVNT GE X PE SEQ VENTES

*Fig. 94* CANTERBURY CATHEDRAL (Kent), north choir aisle: Christ leading the Gentiles away from pagan gods in the typological cycle, *c.* 1175-80.

presbytery was a series of twelve typological windows, the remains of which can be seen in windows nXIV and nXV. The sequence began *Figs 94,* with the Incarnation at the west end of the north *95* aisle and was completed at the same end of the south aisle by the Passion. In each window the New Testament scene was flanked by 'types', for the most part from the Old Testament. The programme was completed by the lower windows of the Corona Chapel, of which the axial opening is typological and included the Ascension and Pentecost; in other windows were probably displayed the Tree of Jesse panels *Pl. VII* which are now in window nIII in the Corona, and Christological or narrative subjects. The windows of the four eastern transept chapels almost certainly contained scenes of the lives of the saints above whose altars they were posi-

tioned; a panel from St Martin's life is still *in situ* in the chapel dedicated to him (nX) and a St Gregory window is also recorded. The small trefoil 'triforium' openings in the choir aisles, transepts and presbytery seem also to have been narrative. Only some scenes from the lives of SS Dunstan and Alphege are extant and there is some doubt as to whether they originally came from their present locations (windows NtIX, X, XI). The programme was completed by the twelve ambulatory windows of the Trinity Chapel devoted to St Thomas Becket. The first two (nVI, nVII) appear to have depicted his life and the rest concentrated on posthumous miracles; scenes from the miracles at present fill seven of these windows (nII–nV, sII, sVI, sVII). *Fig. 96*

The Canterbury windows bring together several themes in one coherent programme. In

*Fig. 95*    CANTERBURY CATHEDRAL (Kent), north choir aisle: sower on stony ground from the typological windows, c. 1175–80.

the clerestory is presented the continuity of God's actions from the beginnings of history through to the New Testament. To this is linked the theme of Redemption, represented by the Christological cycle and its 'types'. Finally there is the hagiographical element in the form of the scenes consecrated to the saints, culminating in the cycle devoted to Becket, whose relics were the prized possession of the Cathedral priory and became the focus of pilgrimage throughout western Christendom. There was a direct connection between the shrine and the glass during the Middle Ages, for in a customary of 1428 it is recorded that at Michaelmas the sacristan drew £5 from the shrine receipts in return for which he had to keep in repair all the glass and the roof in the shrine precincts.[22]

'It would be hard to overestimate the importance of the early stained glass of Christ Church, Canterbury, in the history of English painting styles', Professor Caviness justifiably claims.[23] It belongs with the great series of northern French glazing schemes of the late twelfth and early thirteenth centuries, which include Chartres, Saint-Rémi at Rheims, Saint-Quentin, Troyes, Orbais, Châlons-sur-Marne, Laon, Soissons and Sens. The members of this group have in common a lavish use of ornament, especially of acanthus foliage coiling in *rinceaux* in borders and backgrounds, brilliant colouring and an overall jewel-like impression. In certain aspects, notably the use of multiple compartments containing figural scenes which are assembled in a virtuoso series of complex formulae, it seems *Fig. 29* that Canterbury set the pattern for the rest.[24]

*Fig. 96* CANTERBURY CATHEDRAL (Kent), Trinity Chapel: boy saved from drowning from the Becket miracle windows, *c.* 1213-20.

Professor Caviness has resolved the awesome problems of authenticity created by successive restorations of the Canterbury glass. By a careful study of the design of the armatures, and of ornament as well as figure style, she has also established a chronology for the glazing which differs slightly from previous accounts.

The evidence indicates that the glaziers followed on very closely behind the masons at least in the earlier stages of the work, filling all three tiers of windows in each bay (aisle window, 'triforium' and clerestory) as the building progressed from west to east.[25] Glazing probably commenced during the 1175-6 campaign with the western bays of the choir, and all of the windows in the choir were probably completed in time for its first use by the monks at Easter 1180. The Corona and Trinity Chapel, including the clerestory windows in the latter, appear to have been glazed after 1184, but the campaign was prolonged and suffered periodic delays through financial and political problems, not least the exile of the archbishop and monks between 1207 and 1213. The Corona seems to have been completed before the Trinity Chapel ambulatory and clerestory, in around 1195-1200, and the entire programme was probably

ready for the translation of the relics of St Thomas Becket into the Trinity Chapel on 7 July 1220.

Madeline Caviness has concluded that in spite of this lengthy period the Canterbury glass was the work of a single atelier, made up of a number of individual glaziers or teams of glaziers.[26] Certain ornamental motifs recur throughout the glazing programme and several painters have been traced who first manifest themselves as assistants in particular windows and subsequently appear as the main glaziers of other windows. A number of the artists can be associated with French monuments, although these affiliations need further exploration. The individual painters in some instances also transcend the main stylistic divisions of modern art-historical terminology (Late Romanesque, Classicizing/Transitional and Early Gothic), under which headings the Canterbury glass has been categorized. It is therefore an over-simplification to see each of these phases as the work of different craftsmen; moreover at least one of the Canterbury glass-painters, the Jesse Tree Master, changed his style during the course of his work.[27] The salient features of each phase can be highlighted by an analysis of three of the clerestory figures: Lamech, Aminadab and Hezekiah.

The figure of Lamech, the head of which is *Fig. 93* modern, falls within a phase of the Late Romanesque period which is sometimes – and confusingly – termed 'Baroque' Romanesque. The prophet has a restless pose and seems full of movement, with the drapery folds swirling in agitated fashion over the powerful limbs and torso. Aminadab, in contrast, has a similar stance *Pl. VI* but is far more calm and serene. The drapery folds are more finely drawn and in the classicizing conventions characteristic of the last years of the twelfth and of the early thirteenth centuries. In the third prophet, Hezekiah, the power *Fig. 93* and solemnity of the other two figures has gone, replaced by the calligraphic, almost decorative qualities of the Gothic style. The outline and draperies are restless and swirling, but the impression of vitality is purely decorative, with no suggestion of body and limbs beneath. The strength and solidity of both Lamech and Aminadab are replaced by an elegance of pose and a balance of gesture. The same distinctions

can be observed between the earlier and the later historiated scenes, such as the typological panel depicting the Sower on Stony Ground (window nXV) and the Boy Saved from Drowning from one of the Becket miracle windows (window nII). The painter of the earlier scene builds up his composition with minute attention to detail: various landscape features, foliage forms carefully distinguished and an impression of receding space. In the 'miracle' scene the elements in the composition are reduced almost to shorthand. The landscape consists of a single tree with a standardized foliage form, and the river is a relatively minor element at the base of the panel. The loss of detail is more than counterbalanced by the dramatic silhouetting of the figures, with their economical and agile gestures, against the plain blue background. In general there is in the later windows a progressive simplification of the ornamental motifs in borders and in the spaces between the figural panels; the same phenomenon is observable in the great contemporary churches of northern France.

*Figs 95, 96*

The individual stylistic affiliations of some of the Canterbury painters are rooted in indigenous artistic traditions. The Methuselah Master appears to have been active in the late 1170s and was responsible for much of the early glass in the choir aisles and clerestory.[28] In his colour combinations (white, green and yellow used with pink) and soft drapery conventions the Methuselah Master has much in common with other early Canterbury painters, but he is distinguished by his outstanding draughtsmanship. His clerestory figures are powerful and monumental, yet lively and natural in pose and with very varied individual characteristics. His interest in classical forms is a trait which he shares with a number of contemporary craftsmen, including the creators of the Troyes glass of *c.*1170–80, and of the *Ingeborg Psalter* (Chantilly, Musée Condé MS 1695), the goldsmith Nicholas of Verdun and the 'Antique' Master of the Rheims Cathedral sculpture. The Methuselah Master is part of this movement, but he is a distinct artistic personality in his own right. Although the Master may have had access to a model-book based on Byzantine works of art, the closest parallels for his interest in individual expression are not found on the Continent, but in English

*Fig. 94*

manuscripts, notably in the work of the Master of the Morgan Leaf in the *Winchester Bible*, of *c.*1175–80 (Winchester Cath. Lib). The Methuselah Master's drawing qualities also fall within an English tradition stretching back to at least the tenth century.[29]

Another distinctive hand takes his name from the typological window (nXV) which includes the Parable of the Sower.[30] His colours are exceptionally strong and bright and the compositions of his panels are very clear. The figures are tall and slender, with small heads. In common with the Methuselah Master there is a debt to Byzantium, but the roots of his figure style are to be found in indigenous works of previous generations, such as the Balfour ciborium in the Victoria and Albert Museum, dating from *c.*1160–70.[31] The closest contemporary parallels are to be found in the last of the three extant copies of the Carolingian *Utrecht Psalter*, written and illustrated at Canterbury in *c.*1180–90 (Paris, Bibl. Nat. MS Lat. 8846). There is a similar intensity of colour in both works and the artists of the *Canterbury Psalter* and of the Parable of the Sower window share a common repertory of foliage forms and a related figure style.

*Fig. 95*

Comparisons for several of the other Canterbury hands are also to be found in media other than stained glass. The finely delineated seated figures in the Tree of Jesse from the Corona (nIII) are very similar to the second great seal of Richard I, the matrix for which was made in *c.*1198. The seal and, by extension, the Jesse Tree Master's glass, have close affinities with the personifications of the Liberal Arts carved on the central portal of Sens Cathedral, dating from the 1190s, and to figures in the Becket window at Sens.[32]

*Pl. VII*

If the Jesse Tree Master points towards France, the Petronella Master certainly worked there and probably was a Frenchman. He seems to have been active at Canterbury between 1180 and 1207 and his style can be detected in at least two of the Becket windows in the Trinity Chapel (nIII, nIV) and the clerestory figures of Aminadab and Naasson (west window).[33] His work is the most miniature-like and delicate of all the Canterbury glaziers. The figures, border designs and colour and even the quality of the glass used,

*Pl. VI*

which has corroded less than the rest of the early Canterbury windows, place the Petronella Master firmly in the *milieu* of north-east French glazing. Not only are the borders to one of the Becket windows very close to those at Saint-Quentin, Châlons-sur-Marne and Saint-Rémi, but the stylistic similarities between the choir clerestory figures at Saint-Rémi and the two Canterbury prophets are such that the Petronella Master and his assistants must have been employed on both schemes. The choir clerestory at Saint-Rémi was glazed in the early 1180s and the Master also worked on the clerestory windows of the abbey church of Saint-Yved at Braine, the structure of which was completed by 1208; the remains of the Ancestors of Christ series from these windows are divided between Soissons Cathedral and several American collections.[34] The Petronella Master's work at Canterbury is also related to the scenes from the life of St Matthew in the south rose window of Notre-Dame at Paris, and to the two windows depicting the life of St Peter in the Lady Chapel of Troyes Cathedral.

The ties between Canterbury and France are just as close in the last, 'Early Gothic', phase of the glazing.[35] Several of the Trinity Chapel ambulatory windows (nII and sII, sVI and sVII) are very similar to their counterparts at Bourges, Chartres and Rouen in intensity of colour and the reduction of ornamental designs and figural compositions to their basic elements; also in the swirling draperies and lively, elegant poses. The connections between the later Canterbury windows and the four windows in the north choir ambulatory of Sens Cathedral, which date from the first two decades of the thirteenth century, are particularly striking. The range of colours employed, compositions, ornamental motifs and geometrically based armatures at Sens and Canterbury (and also in the Joseph window at Chartres) are so closely related that the glass is likely to have been the work of a single designer. At least one Canterbury painter appears to have participated in the Sens ambulatory glazing. The Master of Fitz-Eisulf seems to have been a pupil of the Master of the Parable of the Sower and was therefore reared in the Canterbury glass-painting tradition. The chronology of his work is complicated, but Professor

Caviness has argued that the hand of the Master of Fitz-Eisulf is first seen in the Corona east window and windows sVI and sVII in the Trinity Chapel ambulatory. The work was probably interrupted by the exile of the monks between 1207 and 1213 and in this period the Master seems to have been engaged on the hagiographical windows at Sens; subsequently he returned to Canterbury to complete windows sVI and sVII and execute windows nII and sII in time for the translation of Becket's relics in *Fig. 96* 1220.[36]

It still remains to be established how widespread the influence of the Canterbury painters was beyond the city and its environs.[37] One item of documentary evidence from the West Country suggests that Canterbury glaziers may have been active elsewhere in England. In about the middle of the thirteenth century Roger le Verour of Canterbury appears to have settled in Glastonbury, Somerset, where he married Alice, daughter of Master Simon of St Albans.[38] Unfortunately nothing survives of the glazing of Glastonbury Abbey which might have substantiated this link with Canterbury. As we have seen, York's affinities lie elsewhere than Canterbury; the same is true of Beverley Minster in Humberside. The twenty-one historiated panels now in the east window include scenes from the legends of St Martin and St Nicholas which probably date from the 1230s. Nigel Morgan and David O'Connor have pointed to similarities in figure style, design, iconography, colour and technique between the Beverley glass and that of Lincoln Cathedral.[39]

## The 'grisaille' cathedrals: Lincoln, Salisbury, Westminster and York

*Summa fenestrarum series nitet inclita forum*
*Involucro, mundi varium signante decorem;*
*(Metrical Life of St Hugh of Lincoln)*[40]

At *Lincoln* the remains of a once-extensive series *Figs 102* of historiated and grisaille windows survive in *(a), 10* the east windows of the choir aisles (nII and sII), in the north transept rose window and the

Fig. 97 Detail from the *GUTHLAC ROLL* (BL MS Harley Roll Y.6), penwork with colour washes, *c.*1210.

lancets below this rose and that in the south transept (windows NXXX–NXXXIV, SXXVIII-SXXXI).[41] Only the Last Judgement in the north rose is largely *in situ*; the remainder is all diaspora arranged haphazardly in the late eighteenth century, including a number of Old Testament scenes, probably from a typological series, but possibly also consisting of Old Testament narrative windows in their own right, such as a Life of Moses. There are eight surviving panels from a cycle of the Life and Miracles of the Virgin; also a series of saints' lives, including John the Evangelist, Matthew, Nicholas, Denis, Etheldreda (?), James (?) and an episode from the Life of St Hugh of Lincoln depicting the carrying of his body into Lincoln. It is likely that the individual saints' lives were originally located in windows near the altars dedicated to them; most of these were in the transepts. Seven standing figures of apostles and the prophet Isaiah are set within elongated quatrefoils and the remaining early glass comprises two seated archbishops, three bishops, a Christ in Majesty, Christ carrying a soul and two censing angels.

In border design, colour and general figure style Lincoln is related to Canterbury and the contemporary northern French cathedrals, but the parallels are not sufficiently close to attribute any of the Lincoln glass to workshops operating elsewhere (apart possibly from Beverley). At least one distinctive hand can be recognized in the Life of the Virgin panels who can perhaps best be designated as 'the Master of the Staring Eyes'.[42] His attenuated, supple figures and his treatment of facial features are comparable with the *Life of St Guthlac of Crowland* (BL MS Harley Roll Y6), which suggests that there may have been a local group of painters. The *Roll* has traditionally been dated to the twelfth century, but recently it has been suggested that *c.*1210 is more likely.[43] None of the extant Lincoln glass ante-dates the building of the choir, which was begun in 1192. The design of borders and other features, and the figure styles, indicate that most of the glass dates from between the late 1190s and *c.*1235.[44] The scene depicting the carrying of St Hugh's body to Lincoln must date from after the event (23 November 1200) and it is known that the north rose was glazed before 1235 and possibly as early as 1220. There is a difference of opinion regarding the date of the standing apostles and prophet. Morgan relates them stylistically to a group of Apocalypse manuscripts of the middle of the thirteenth century, but Caviness (less convincingly) considers that they are closer to a *Life of St Cuthbert* (BL MS Yates Thompson 26), executed *c.*1200.[45] The remains of the contemporary grisaille glass at Lincoln will be considered with the extensive collection of grisaille designs at Salisbury.

*Fig. 98*

*Fig. 97*

*Fig. 98*

*Fig. 107*

*Figs 36, 102(a), 103*

When that redoubtable and inveterate traveller Celia Fiennes visited *Salisbury* in the last two decades of the seventeenth century the cathedral still retained much of its medieval glazing: 'The Windows of the Church but especially the Qoire are very finely painted and large of the history of the Bible...'.[46] Tragically very little escaped Wyatt's 'restorations' in 1787-8.[47] Part of a Tree of Jesse, with the seated figures of Christ and the Virgin enclosed in vine-tendrils forming ovals and flanked by smaller figures of prophets and patriarchs, is now in the eastern lancet of a window in the nave south aisle (sXXXIII). In the companion lancet *inter alia* are identical polylobed medallions depicting the Angel appearing

*Fig. 98* LINCOLN CATHEDRAL: (*left*) north choir aisle: two scenes from the Miracles of the Virgin, *c.*1220–30; (*right*) St Peter, probably mid-thirteenth century.

to Zacharias in the Temple (from Luke 1) and the Adoration of the Magi. The second, and possibly the first panel, must have come from a Life of the Virgin or Infancy of Christ window, although the Zacharias medallion may have belonged to a window dedicated to St John the Baptist. A martyrdom of St Stephen and the angel from an Annunciation, together with border fragments, are at *Grateley* in Hampshire (window sII). The three bishops and the king and a series of roundels containing half-length angels in the nave south aisle and west windows of the aisles (windows sXXXIII, sXXXVI, nXXXV) come from the chapter house and are discussed in the next chapter.

There is, therefore, not much to work with. The St Stephen panel was probably associated with the altar dedicated to him which stood at the east end of the south choir aisle; this was one of the three altars consecrated by Bishop Poore in 1225. If correct, this assumption would fit neatly with Thomas Gray's description in 1764 of glass (by implication coloured and historiated) remaining at the east ends of the aisles. It would

*Fig. 99*

*Fig. 113*

also indicate that the glazing followed very closely behind the construction of the cathedral. The second of the altars dedicated by Poore was the Holy Trinity altar, located in the projecting axial chapel at the east end of the cathedral. This chapel was used for the important daily Mass of the Virgin and so both the Tree of Jesse and the Virgin or Infancy cycles would have been appropriate subjects for its windows. Although part of the Jesse is known to have been in the nave before 1794, given the prominence accorded to the subject in the glazing of other great churches of the late twelfth and early thirteenth centuries (Saint-Denis, Laon and Canterbury to name only three), it is highly probable that the Salisbury Jesse was originally located in the east end; conveniently its dimensions match those of the central lancet in the Trinity Chapel.

The style and design of the figural glass are compatible with a date of *c.*1220–5. The martyrdom of St Stephen is almost identical in composition to some of the medallions with foliate sprays in the spandrels used in the Charle-

magne window in one of the ambulatory chapels of Chartres Cathedral; this window dates from the early 1220s.[48] The lively, slender figures with fluttering draperies and rhythmical folds outlined against the blue background and the landscape suggested only by a single tree, are close to the Becket windows in the Canterbury Trinity Chapel ambulatory. The Jesse fragment appears to be in much the same style as the St Stephen panel. The poor condition of the Angel appearing to Zacharias and the Adoration of the Magi medallions precludes any judgement on their style; their polylobed shape is not found at Canterbury and Lincoln, but a similar design occurs in the grisaille of the Five Sisters window at York Minster, which dates from about the middle of the century.[49] The motif is apparently derived from French architectural designs and occurs in glass at Lyons Cathedral (*c.* 1215–20), in the Prodigal Son window in Sens Cathedral (*c.* 1207–15) and in the Life of St Peter window at Notre-Dame in Dijon (*c.* 1230–5).[50] The borders to the Tree of Jesse are a continuation of the progression observable in the later glass at Canterbury towards narrower and more simplified edgings.[51]

Grisaille played a major role in the Salisbury glazing and much thought and care went into its effect on the interior of the building. Excluding the later chapter house windows there are at least sixteen different patterns amongst the surviving grisaille panels from the cathedral, which make it the largest single repository of thirteenth-century grisaille designs not only in England but probably in Europe. Of these, only the panels filling a triforium window in the west wall of the great south-west transept (StXII) and some of the glazing in the triforium and clerestory of the south façade of the south-east transept (StII, III, IV, SVIII) are possibly *in situ*. Winston also saw some grisaille in its original location in the clerestory of the great north-west transept and noted that four more sections from the clerestory glazing had been set at the base of the three large lancet windows in the south façade of the south-east transept, where they can still be seen today (sXXII). The remainder of the glass in these lancets and possibly some of that filling the triforium and clerestory windows in this façade was collected in 1896 and the glazing

*Fig. 99*    GRATELEY (Hants.): martyrdom of St Stephen from Salisbury Cathedral, *c.* 1220–5.

in a choir north aisle window (nIX) was inserted in 1948–9. More grisaille exists in a few other windows including the west windows of the nave aisles (sXXXVI, nXXXV).[52]

The Salisbury grisaille windows together with those at Lincoln and others in the transept at York, at Westminster and in various parish churches provide the principal evidence for a form of glazing that must have been very common in England from the end of the twelfth and into the first half of the thirteenth centuries, even in the great churches. The reasons were partly economic – grisaille was cheaper than coloured glass – but aesthetics and practical issues must have been important considerations in great church glazing.[53] The coloured windows of Chartres permit very little light to filter through and consequently the interior of the building and its architectural details and carvings are very difficult to discern. Grisaille, by contrast, transmits much direct light and enhances architectural and sculptural elements. It is probably no coincidence that at Chartres interior embellishments in the way of capitals, mouldings and wall decorations are extremely spartan, whereas the cathedrals at Rheims and Coutances, which are known to have had many

grisaille windows, are richly articulated. The same applies in England, not only at Salisbury, but also Lincoln, Westminster and York: all indulge to varying extents in surface decoration, elaborate mouldings and rich dark marble columns. In its use of grisaille Salisbury is thus in the mainstream of English thirteenth-century great church glazing practice. Only in the range and number of designs used does it stand out – and this may be due to accident of survival. On the other hand the variety of designs employed here shows a recognition that the grisaille windows were an essential and integral component of the overall decoration of the interior. Compared with some of its contemporaries the Salisbury elevation is restrained, even sober; it is tempting to suggest that the variations in the window designs were deliberately planned to act as a counterpoint to the regularity of the architectural framework.

Grisaille windows can be classified under two main types: those of plain white glass, with the designs formed entirely by the leading, and white glass painted with foliage and stems.[54] Both types are frequently embellished with coloured glass bosses, borders and straps which render them far from monochrome. Grisaille windows with a repertoire of vegetal and geometrical patterns formed by the leading occur in a number of Continental Cistercian monasteries before 1200; the range of designs is very similar to those found on Cistercian tiles of the late twelfth and early thirteenth centuries.[55] There is insufficient evidence to resolve the question as to whether the white monks adopted window designs which were already in current usage or if they were the inventor of these patterns which were subsequently copied in non-Cistercian churches. There is, however, one English ornamental window from a non-Cistercian context which may indicate that grisaille of this kind was common before 1200. The easternmost window in the chancel north wall (nII) at *Brabourne* in *Pl. VIII(a)* Kent retains its original glass, consisting of white demi-rosettes enclosed in loops linked by straps. Yellow, red and green glass is used for the buds, grounds and straps. There is no direct evidence for dating the Brabourne window, but comparison of the architectural sculpture in the chancel

*Fig. 100*    ABBEY DORE (Heref. & Worcs.): grisaille design formed by the leading, *c.*1180–1250.

with that of Horton Priory, to which the church belonged, suggests that if the glass is contemporary with the fabric then it was probably executed around 1175; moreover there is an affinity in design with one of the windows in the Cistercian abbey of Obazine in France, of *c.*1176–90, although Brabourne uses rosettes rather than palmettes and coloured as well as white glass.[56] Until recently the westernmost window (sVII) in the south aisle of the presbytery at *Abbey Dore*, Hereford & Worcester, *Fig. 100* contained two rows of white glass with a scale-like pattern formed by overlapping concentric semicircles. This is a unique design in early Cistercian glass, although very similar 'fish-scale' patterns are found in French Cistercian tiles, notably at La Bénisson-Dieu of *c.*1190–1220 (albeit lacking the concentric element);[57] the same motif occurs as a painted masonry pattern at Fountains and Rievaulx and, in non-Cistercian monuments, in a clerestory window at Notre-Dame de Valère bei Sitten in Switzerland as well as in the Salisbury glazing. The Fountains and Rievaulx examples are dated respectively to the 1170s or 1180s, and *c.*1200,[58] and the Sitten and Salisbury windows are of the first half of the thirteenth century.

There are several problems with the Abbey Dore grisaille glass. It was not *in situ*, but was amongst the finds made during the excavation and restoration of the church at the beginning of the present century, and was placed in this window around 1904. As the leading was carried out at this time even the ornamental arrangement is open to doubt. Furthermore the devitrification was so far advanced as to make it impossible to establish whether there was originally any painted decoration. The date is equally uncertain. The monastic church was rebuilt

from *c*.1180 onwards with the east end reconstructed early in the thirteenth century. Although the glass was probably not as late as the consecration of the church, which was undertaken by Bishop Thomas Cantilupe (1272–82), it could still have been made at any time between *c*.1180 and the middle of the thirteenth century. Unfortunately all the uncertainties must remain unresolved for the glass has now disappeared.

In addition to the 'fish-scale' pattern there are the remains of at least five other lead-formed window designs at *Salisbury*. Two consist of a *Figs 101* single and double strapwork motif and another *(a), (b)* two are variants of strapwork frets interlacing with circles. It seems from Winston's observations that the unpainted grisaille windows were confined to the upper levels of the cathedral, with the painted grisaille reserved for the more visible ground storey windows. The interlacing designs are comparable with windows from the Cistercian abbeys at Obazine, La Bénisson-Dieu, Pontigny and Marienstatt: also with the ornamental windows reputedly from non-Cistercian churches at Mussy-sur-Seine and Châlons-sur-Marne in France.[59] In England similar designs occur *in situ* in a nave lancet (nVI) at *Hastingleigh Fig. 108* in Kent and from a smaller lancet displayed in the Stained Glass Museum at *Ely*. In both the *Pl. VIII(c)* geometrical grisaille is enlivened by coloured glass. Some of the twelfth or early thirteenth-century (or possibly early fourteenth-century) ornamental grisaille designs in the *York* nave *Figs 101* clerestory are also comparable with the Salisbury *(c), (d)* patterns.[60]

At *Salisbury* there are at least ten different *Fig. 102(b)* designs for grisaille windows with painted decoration, which testify to the ingenuity displayed within a single glazing programme. *Lincoln Cathedral* also has several and others are *Figs 36,* known from *Westminster Abbey, York Minster* and *102 (a),* some parish churches, notably in Kent (Petham, *(c), 103* Preston near Faversham, *Stockbury* and Stod- *105* marsh).[61] There is no evidence for the appear- *Fig. 104(c)* ance of this type of grisaille before the beginning of the thirteenth century: the trefoil- and cinquefoil-headed 'stiff-leaf' foliage found in these windows made its appearance in English sculpture at about the turn of the century.[62] This stylized foliage is set on cross-hatched grounds

and (on the whole) contained within rather than overlapping the lead-lines, in much the same manner as contemporary grisaille windows in France and Germany. However, English windows of this period differ from their Continental counterparts, principally because they are based on geometrical forms such as circles, quatrefoils, diamonds and vesicas which are usually superimposed one on another so as to suggest that the panels making up each 'layer' overlap and partly conceal those below.[63] These geometrical forms occur on the Continent, but there they tend to be interrupted by interlacing straps or bands of similar type to those found in unpainted grisaille windows.[64] The differences between the systems can be seen by comparing two designs from *Lincoln* and *Auxerre*, France; *Fig. 103* these are very similar, but whereas the 'layers' of the former are clearly defined, at Auxerre the superimposing is negated by the interlacing of the straps.[65] This Lincoln design is unusual, for English glaziers did not favour plain strapwork and preferred wide enframing bands with painted patterns on cross-hatched grounds, leaving a small edge of clear glass. Examples can be seen at Lincoln, Salisbury, Westminster and elsewhere.[66] One of the Salisbury designs follows the French pattern, using coloured glass for the interlacing strapwork, but in general English painted grisaille is more regular and less complex than French and German grisaille.

Some Lincoln designs consist of a lattice of diamond or square quarries bearing foliage of various forms on cross-hatched grounds. One of these patterns was also employed at *Westwell Fig. 104(a)* in Kent (what appears to be a nineteenth-century version of the Westwell design is to be seen in the chancel north window (nII) at Badlesmere in the same county). Another Lincoln quarry pattern, with a rosette on a cross-hatched ground, recurs at Salisbury Cathedral, amongst the fragments excavated from nearby Clarendon Palace (1236–67) and in St Denys Walmgate church at York, to name but a few. A third quarry design is to be seen at Waterperry in Oxfordshire (windows nIII, nIV) and others are known at Westminster.[67] Grisaille windows based on quarries appear to be an indigenous type which is rarely found in France before the fourteenth century. As has been pointed out, a

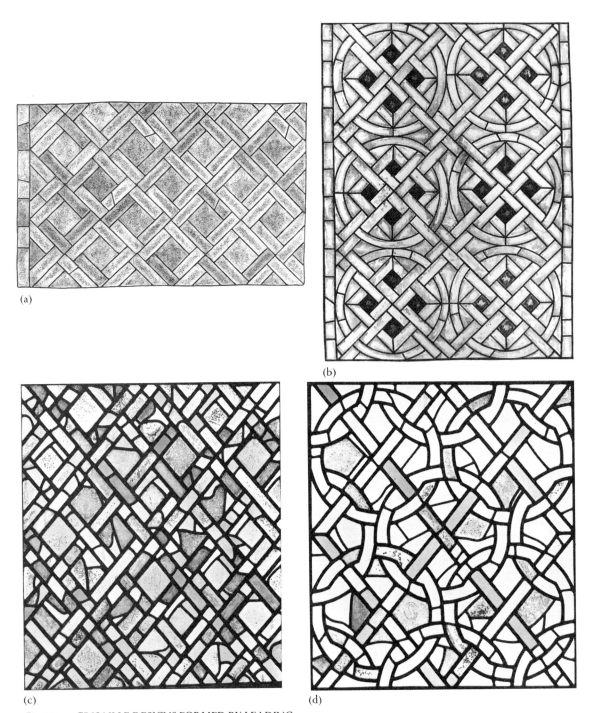

(a)

(b)

(c)

(d)

*Fig. 101*   GRISAILLE DESIGNS FORMED BY LEADING:
(a, b) SALISBURY CATHEDRAL (Wilts.). Watercolours by C. Winston, 1849 (BL MS Add. 35211), 1220–58;
(c, d) YORK MINSTER, late twelfth or early thirteenth century.

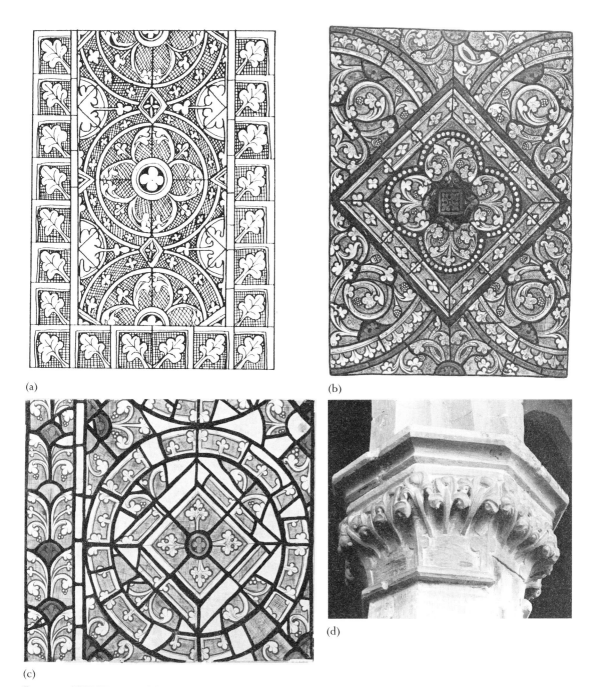

(a)

(b)

(c)

(d)

*Fig. 102*    THREE EARLY THIRTEENTH-CENTURY PAINTED GRISAILLE DESIGNS:
(a) Lincoln Cathedral (*after J. Kerr*);
(b) Salisbury Cathedral (Wilts.). Watercolour by C. Winston, 1856 (BL MS Add. 35211);
(c) Westminster Abbey. Watercolour;
(d) Chalgrave (Beds.): nave capital, early thirteenth century.

*Fig. 103* EARLY THIRTEENTH-CENTURY PAINTED GRISAILLE DESIGNS FROM: (*left*) LINCOLN CATHEDRAL (*after J. Kerr*); (*right*) AUXERRE CATHEDRAL (*after E.E. Viollet-le-duc*).

(a)                                    (b)                                    (c)

*Fig. 104* EARLY THIRTEENTH-CENTURY PAINTED GRISAILLE LANCETS IN PARISH CHURCHES:
(a) WESTWELL (Kent);
(b) STOWBARDOLPH (Norfolk);
(c) STOCKBURY (Kent);
Watercolours by Charles Winston, (a) 1843, (b) 1853, (c) 1852 (BL MS Add. 35211).

132

number of these quarry patterns are so similar to those found on floor tiles that craftsmen working in both media must have had access to similar pattern-books.[68] In some of the Salisbury panels and those from Petham, *Stockbury* and *Stowbardolph* in Norfolk the designs include large leaf sprays and bosses.

*Figs 104 (b), (c)*

The heads of two grisaille lancets in the south transept south wall of *York Minster* (sXXV, sXXVI) seem to have been glazed by 1241, when Archbishop Gray founded a chantry in the south transept, and they may even have been executed a decade earlier. The design comprises the usual conventional trefoil, quatrefoil and cinquefoil foliage on cross-hatched grounds, enlivened by coloured bosses and coloured edgings to the quatrefoils and squares. The straightforward nature of the south transept grisaille glazing contrasts dramatically with the sophistication of the Five Sisters window in the north transept

*Fig. 105*

north façade (nXVI).[69] Each of the five lancets retains its grisaille and although this has suffered severely from corrosion and repair, its original glory can be judged from the illustrations in Browne's history of the Minster.[70] In common with Lincoln, Salisbury and Westminster, the Five Sisters has foliate borders and complex geometrical patterns with varying designs in each lancet. The foliage differs from that found in the south transept in that clusters of grapes are here attached to many leaves, as in some of the grisaille at Salisbury and Westminster; also present are some very early examples of embryonic naturalistic leaf forms. The date of the Five Sisters window has not been precisely established, but it is generally considered to have been glazed around 1250.

*Fig. 105*

Some of the *Westminster Abbey* grisaille glass survived the Second World War, together with seven figural panels (heavily restored), six in the

*Fig. 105*    YORK MINSTER, painted grisaille: (*left*) in the south transept, *c.* 1220–41; (*right*) in the Five Sisters window, *c.* 1250 (from an etching by J. Browne).

*Fig. 106*    WESTMINSTER ABBEY, Undercroft
Museum: miracle of St Nicholas, *c.* 1246–59.

Abbey Museum in the Norman Undercroft and
one in the Muniment Room in the south transept.
In addition three much-restored shields of arms
are now set in St Edmund's Chapel.[71]

The building chronology is well established.
In 1245 the foundation stone for the new abbey
church was laid and construction began soon
afterwards. By June 1259 it seems that the choir
and transepts were complete. Work continued
on the five eastern nave bays and on 13 October
1269 the body of St Edward the Confessor was
solemnly translated into the splendid edifice.[72]

By the time of the first surviving detailed
building account in 1253 glazing was in full
progress. Seams of both white and coloured glass
were purchased from Lawrence the glazier and
Roger Borser; also quantities of canvas as
temporary filling for the windows in the church
and chapter house. Between 1 February and 13
July of that year some thirteen or fifteen glaziers
were employed weekly; between 14 July and 10
August the total was reduced to six per week

and from then until the end of the account on 6
December the number varied between two and
three. The basis of payment was set out on 4
August: a piecework rate of 8d per square foot
for working coloured glass and 4d for white
glass. Unfortunately no details are given of the
contents or locations of the windows. Glazing
was still continuing between 1264 and the king's
death in 1272. Between 20 July and 17 October
1265 Edward the glazier (who is mentioned in
1253, and in 1258 received a suit of clothes as
part of his remuneration for service to the
Crown) was paid 11s 3d and William Southwark
8s 2d for work on Westminster Abbey and
Palace. Payments for glass windows for the
church, together with their transportation,
occur in these years; also between 29 September
1267 and 2 February 1272 canvas was purchased
for temporary filling of windows.[73] The glazing
was unfinished at Henry III's death and in 1285–6
Edward I gave the prior and sacrist £200 towards
the work. In 1290 a further £64 13s 4d was paid
to John of Bristol for making glass windows for
the abbey church.[74]

The subjects of the seven surviving figural
panels include a miracle of St Nicholas, which    *Fig. 106*
was probably originally located in the apsidal
chapel dedicated to this saint. If so, then it was
presumably in place before the completion of
the transepts in June 1259. If the male saint
being beheaded in another panel is St John the
Baptist, then this also probably came from the
apsidal chapel consecrated to him. A third panel
appears to depict the stoning of St Stephen and it    *Pl. IX*
may be relevant that the abbey possessed relics
of all three saints, in addition to those of the
Holy Innocents, the massacre of whom forms
the subject of the fourth panel.[75] The Resurrec-
tion, Ascension and Pentecost (the last two were
originally linked together) are from a Passion
window. All seven panels are so close in style
that they were probably executed in the same
campaign. At least thirteen shields of arms still
existed in the seventeenth century, probably
including the three now in the Chapel of St
Edmund. They depicted the arms of Castile and
Leon (twice) (for Eleanor of Castile, first wife of
Edward I) and England (twice), Ponthieu (twice),
Edward the Confessor, *England and on a label of
5 points azure fleurs-de-lis or* (probably for Prince

Edward, later Edward I), Provence (for Eleanor of Provence, d. 1291, Henry III's queen), Clare, Lacy Earl of Lincoln, Gernay and Cornwall (for Richard Earl of Cornwall, King of the Romans, d. 1272). The presence of Eleanor of Castile's arms and those of her husband Edward before he became king demonstrate that at least some of the series must post-date their marriage in 1254 and pre-date his accession to the throne in 1272. Sandford and Dart recorded a shield of Castile and Leon in a west window of the north transept and it is likely that these shields were contemporary with those carved on the wall arcades in the eastern nave aisles between *c.* 1253 and 1260.[76] The chapter house windows also contained shields of arms, a pattern that was to be repeated soon after in the century in the chapter house at Salisbury.[77] The surviving shields of arms are amongst the first appearances of English heraldry in monumental art, together with the armorial tiles in the chapter house and the shields on the nave wall arcades. This taste for heraldic display was perhaps initiated by Henry III. The king had a great liking for heraldry and there are frequent references to shields or arms in the glazing ordered for his residences. From the second half of the thirteenth century onwards heraldry was an important component of window design.[78]

Westminster Abbey was in Dr Christopher Wilson's words 'England's closest approximation to a thirteenth-century French cathedral'.[79] The height and tall proportions of the building are French-inspired and the ground plan of the east end and the use of bar tracery windows reveal a particular debt to Rheims Cathedral.[80] The Abbey cannot, however, be mistaken for a French church. It incorporates ideas borrowed from Italy (the Cosmati floors, tomb of Henry III and base of the shrine of St Edward) and indigenous features are also in evidence, notably the use of Purbeck marble piers, multiple mouldings and the prominence given to the middle storey of the elevation, all of which reflect a long-established native taste for mural decoration and embellishment. The English elements in the architecture and decoration are underlined by the glazing, which shows no trace of French influence.[81] The vesica shapes of two of the Westminster historiated panels find precursors

in the Canterbury choir clerestory and in English manuscripts of the second quarter of the thirteenth century, notably those associated with the Oxford illuminator William de Brailes whose work has affinities with stained glass; similarly the elongated and tapering quatrefoils of the two martyrdom and the Innocents panels may be compared with the Christ in Majesty leaf from a psalter of *c.* 1220 (BL MS Cotton Vespasian A.I.).[82] Vesicas are also found in the glass at Madley, Hereford & Worcester, and Saxlingham Nethergate in Norfolk, which are either contemporary with or slightly later than Westminster.[83]

The style of the Westminster panels owes nothing to the Sainte-Chapelle and other French glass of the 1240s and 1250s, despite claims to the contrary.[84] No traces of French-derived broad-fold drapery patterns are present, although they can be seen in contemporary sculpture in the abbey, principally on the Archangel Gabriel from the Annunciation group on the inner portal of the chapter house.[85] A comparison of the respective St Stephen panels from *Westminster* and *Salisbury* shows that the former is still within the early Gothic tradition established in the last stages of the Canterbury glazing programme. There is the same minimal use of landscape elements and apart from the more agitated gestures in the Salisbury scene it is difficult to distinguish between the figures. In their exaggerated slenderness and elongation the Westminster characters have more in common with manuscripts executed in London in *c.* 1220–30, such as two psalters in Cambridge (Trinity Coll. MS B.11.4 and Emmanuel Coll. MS 252), than with contemporary books associated with Westminster, notably the second hand in *L'Estoire de Seint Aedward le Rei* (Cambridge, Univ. Lib. MS E.e.3.59). On the other hand the economical use of folds and the facial features in the St Nicholas panel have affinities with the St Edward miniatures in a copy of the Abbreviated Domesday Book (London, Public Record Office MS (E36) 284). This has been dated to *c.* 1250–60 and it may have been executed in London. The manuscript was kept at Westminster Abbey along with the other Exchequer records from at least the later Middle Ages.[86] The extensive employment of green, white and yellow glass in

*Fig. 5*

*Pl. IX;*

*Fig. 99*

the Westminster panels differentiates them from contemporary French glass, and they also do not follow the latter's trend towards greater opacity, evident in the Saint-Chapelle; there is no appreciable difference in this respect between the Westminster glass and the Lincoln glazing executed twenty-five years previously.[87]

Similarly the grisaille at Westminster Abbey can be analysed purely within an English context. With rare exceptions grisaille does not occur in the apsidal chapels and chevets of major French churches. At Chartres, Bourges, Rouen and elsewhere the windows in these parts of the church were reserved almost exclusively for historiated scenes in richly coloured glass. Westminster may have diverged from this formula and even more so from the Sainte-Chapelle glazing, which had no grisaille in the upper (main) chapel. During the late nineteenth century three grisaille panels were found in the easternmost window in the Chapel of St Nicholas.[88] They are unlikely to have been *in situ* as they consisted of different designs, but possibly in some at least of the apsidal chapels of Westminster grisaille windows alternated with those containing historiated glass. In any event it is evident from the amount of white glass purchased and the rates of pay in the 1253 accounts that grisaille was an important element in the glazing of the choir and transepts, including of course the clerestory where this type of glass is likely to have been predominant. Moreover the patterns of the Westminster grisaille are English rather than French. In addition to the three designs a number of individual quarries with centralized motifs are recorded which presumably formed a latticework pattern as at Lincoln and *Westwell*, etc.[89] There is the same repertoire of stylized foliage on cross-hatched grounds arranged in geometrical designs as occurs at Lincoln and Salisbury; the grisaille is also enlivened by coloured bosses and borders in similar fashion.

*Fig. 102(c)*

*Fig. 104(a)*

## Lesser buildings

Apart from the great churches discussed above, not much window glass of this period survives. Of monastic glazing other than Canterbury and Westminster there is almost no trace, with the exception of scattered fragments mostly from excavations, notably at Battle Abbey in East Sussex.[90] The former Augustinian priory at *Dorchester* in Oxfordshire retains a solitary roundel, possibly of *c.*1225, from a cycle depicting the life of St Birinus, whose relics were housed in the church.[91]

*Pl. IX*

Excavations at a number of Cistercian sites have revealed a considerable number of thirteenth-century finds.[92] Those at Bordesley in Hereford & Worcester, Newminster, Northumberland, and Warden in Bedfordshire came from the respective abbey churches. Traces of glazing have also been found in the refectories at Hailes, Gloucestershire, and Kirkstall in West Yorkshire. The former can be dated to the middle of the thirteenth century, the latter appears from coin finds to have been rebuilt in *c.*1225–50. A few fragments were found on the floor of the room over the chapter house at Calder in Cumbria and there are some pieces in the museum at Melrose in Scotland. The find locations of the latter are unrecorded, as also are the large quantities of glass from Rievaulx in North Yorkshire. Finally, there are some remains of excavated glass of this period incorporated into roundels in window sVII at Abbey Dore.

It is clear from an analysis of these sites that by the second quarter of the thirteenth century the Cistercians in England and Wales were not only using painted decoration in their grisaille, but the designs, consisting of stylized foliage set against cross-hatched grounds, are indistinguishable from those in general use on this side of the Channel. The same picture emerges from Europe as a whole in this period: everywhere the Cistercians were conforming to indigenous glazing designs and had moved away from a repertoire which was peculiar to their Order, if indeed there ever was a distinctively Cistercian glazing style. With the possible exception of the 'fish-scale' window at *Abbey Dore*, no geometrical and foliage patterns formed by the leading have been discovered. Moreover neither coloured nor figural glass dating from the thirteenth century has been identified to date. This situation may be modified by further excavations, although by analogy with continental Cistercian glass it is unlikely that coloured or figural glazing played

*Fig. 100*

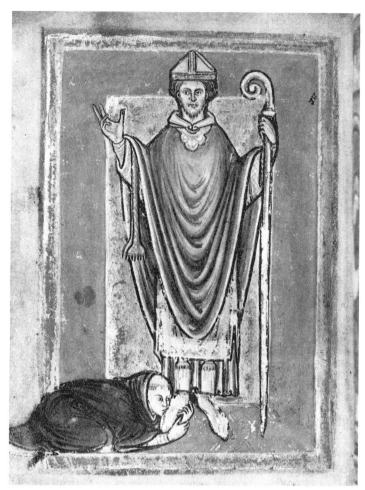

*Fig. 107* (*left*) EDENHALL (Cumbria): bishop (St Cuthbert?), early thirteenth century; (*right*) Frontispiece to BEDE's *LIFE OF ST CUTHBERT* (BL MS Yates Thompson 26, fol. Iv), *c.* 1200.

much of a part before the last quarter of the century.

Glazing of the period *c.* 1170–1250 can be found in parish churches distributed the length and breadth of the country, but only in Kent and Oxfordshire does glass of the period survive in appreciable quantities. In the former county nine parish churches, some of which have already been discussed in connection with grisaille designs, are confined to a small area in the North Downs: Bekesbourne, Brabourne, Doddington, *Hastingleigh*, Kennington, Nackington, Petham *Fig. 108*

(the glass from here is now in Canterbury Cathedral), Preston near Faversham and *Westwell*; on the periphery are another four: Edenbridge, Stodmarsh, *Stockbury* and Wood- *Fig. 104(c)* church. The original arrangements of the glass at Petham and in the east window of *West Horsley* in *Fig. 109* Surrey, with the historiated panels set in grisaille, indicate that full-coloured windows may have been exceptional in parish churches.[93] Even in such a sophisticated building as *Westwell* the *Figs 104(a),* Tree of Jesse in the east wall was flanked by *108* grisaille lancets. The Westwell Jesse and the Jesse

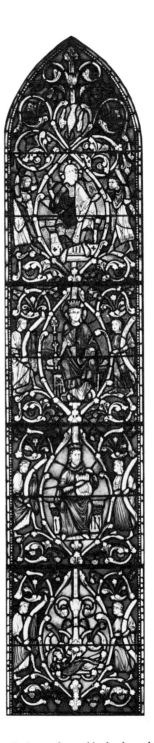

*Fig. 108* (*left*) HASTINGLEIGH (Kent): lancet window with the grisaille design formed by leading, thirteenth century; (*right*) WESTWELL (Kent): Tree of Jesse, *c.* 1220.

at Nackington (window nII) are both very heavily restored, although Winston made a valuable record of the former.[94] The roundel representing the Flight into Egypt at Doddington (window sII) and the Death of the Virgin panel at Woodchurch (window sVIII) are too badly preserved for any stylistic assessment to be made.[95]

In general terms the range of colours, figure style and composition of historiated glass in parish churches are similar to the glazing of the great churches. Usually the panels lack elaborate borders as the window openings are smaller and they tend to be less sophisticated works of art. The Westwell Jesse in its original state must have been impressive, and given the proximity of this church to Canterbury it is reasonable to suppose that its windows were glazed by craftsmen based there. It has also been suggested that the Petham figural glazing may derive from the work of the Master of the Parable of the Sower at Canterbury.[96]

A figure of Christ at *Astley Abbots* in Shrop- *Fig. 110* shire (window I) is set under a pointed trefoil arch resting on capitals. This is comparable with a canopy over the figure of Noah from the Canterbury choir clerestory, which is possibly the first appearance of a canopy in stained glass. Although similar enframing devices occur in French stained glass of the first half of the thirteenth century, as in the cathedrals at Châlons-sur-Marne and Troyes and in the parish church at Norrey-en-Auge (Normandy), they are also present in English manuscript illumination from the twelfth century and are found in contemporary wall-painting.[97]

The subjects depicted in parish church glazing of this period include the Tree of Jesse, a panel from which is in the east window at Kidlington in Oxfordshire, in addition to the examples at Westwell and Nackington.[98] Scenes from the lives of the Virgin and Christ are quite common. The most extensive series is the five panels at Ashbourne in Derbyshire (window nXVII) and others can be seen at West Horsley, Doddington and Nackington, Aldermaston in Berkshire, Lanchester in Tyne & Wear, and Madley in Hereford & Worcester. At St Denys Walmgate in York the two surviving medallions in window nV depict the legend of Theophilus

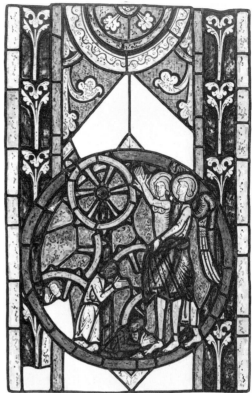

*Fig. 109*   WEST HORSLEY (Surrey): martyrdom of St Catherine, *c.* 1225–50. Watercolour by C. Winston, 1849 (BL MS Add. 35211).

and the Virgin.[99] She occurs holding the child Christ at Compton in Surrey and her death and coronation are depicted at Woodchurch and Aldermaston respectively.[100] Crucifixion groups exist at Croxton in Humberside (window sIV, from Boroughbridge in North Yorkshire) and in the east window of *Easby* church near Richmond *Pl. VIII(b)* also in North Yorkshire.[101] Single figures of saints appear at Nackington, *Edenhall* in Cumbria and *Fig. 107* White Notley in Essex (the last is possibly the Virgin from a Crucifixion group). At *West* *Fig. 109* *Horsley* is a medallion showing the execution of St Catherine.[102] Madley has scenes from the life of St John and in a chancel window at Saxlingham Nethergate in Norfolk (sII) are panels representing the martyrdom of St Edmund of East Anglia and of his offering up the arrows of his martyrdom to Heaven; also of the

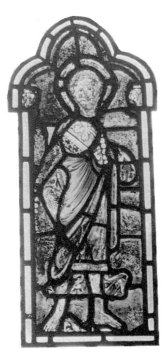

*Fig. 110*    ASTLEY ABBOTS (Salop): Christ (drapery much restored), early thirteenth century.

beheading of another saint and seated figures of SS John and James.[103] Eight standing apostles occur in the Petham glass, in company with four prophets; apart from these, Old Testament subjects are conspicuous by their absence.

The assigning of dates to parish church glass is particularly difficult as there is wide variety in individual styles and quality, and much of the glass is in poor condition. In addition there may be strong elements of archaism: parish church glaziers may well have lagged behind their counterparts in the great churches in adopting new modes. The Easby glass is closely related in colour and style to the York Minster nave clerestory panels and probably dates from *c.* 1180–90.[104] The bishop at *Edenhall* is a less    *Fig. 107* sophisticated version of the figure of St Cuthbert in the manuscript of Bede's *Life* illuminated around 1200 for Durham Cathedral Priory (BL MS Yates Thompson 26). The comparison of the Petham figures with the Canterbury glass points to a date early in the thirteenth century and the style and composition of the *Westwell* Jesse    *Fig. 108* suggest a date of *c.* 1220; the Westwell glass is very close in design to the Jesse of *c.* 1220–30 from Gercy now in the Musée de Cluny, Paris.[105] The *West Horsley* scenes bear some resemblance    *Fig. 109* to manuscript illumination of the second quarter of the century and the Ashbourne panels can be associated with the dedication of the church in 1241; the architectural and sculptural evidence indicates a similar date for the Lanchester glass. Croxton, Madley and Saxlingham Nethergate also probably date from the mid-thirteenth century. The figure style in these six churches, in common with the apostles and prophet at *Lincoln*, shows a development towards a broad    *Fig. 98* treatment of drapery with few folds. The new drapery style which evolved together with other innovations was to transform English glazing during the next fifty years.

# 7
# *The Decorated Style*
## c. 1250–1350

In the century between 1250 and 1350 many of the cathedrals and larger monasteries carried out vast and costly glazing schemes of great richness and sophistication: Exeter, Wells, Bristol, Tewkesbury, Gloucester, Ely and York all retain glass which bears eloquent testimony to the talents of their glaziers. Their windows and those of parish churches the length and breadth of the country display common characteristics in overall design, figure style, and architectural and ornamental features which can be encompassed by the modern term, the Decorated Style.

These major cycles date from the end of the thirteenth and first half of the fourteenth centuries. Glazing of the period *c.*1250–90 is sparse and has largely escaped attention. None the less what does survive is of considerable interest, for it is in these decades that various important innovations took place. Amongst the principal monuments of the years 1250–90 are Chetwode, Buckinghamshire, St Michael's at the North Gate in Oxford, Stanton Harcourt, also in Oxfordshire, two heavily restored lights from St Peter's church now in the Lady Chapel of Hereford Cathedral, Kempsey in Hereford & Worcester and the chapter houses of Salisbury Cathedral and York Minster. Unfortunately there is a dearth of reliable dating evidence for any of these monuments. The construction date of the Salisbury chapter house is disputed. Coinage found during the 1854 restoration has been used to argue for a post-1279 date; the reliability of the evidence has been challenged by those scholars who, noting that the building is closely related to the chapter house at West-

minster Abbey, completed by 1259, seek to place it rather earlier, in the 1260s. The Salisbury glazing format also followed Westminster closely and the stylistic and heraldic evidence indicates that the late 1260s is more likely. The chapter house at York seems to have been erected and glazed in the 1280s; it was in use by 1295–6.[1]

The *Chetwode* glass may be used as a touchstone for analysing the developments of these decades. The Augustinian Priory of Chetwode was founded in 1245 and was recognized as a royal foundation, receiving endowments from Henry III. The glass in question was probably executed between *c.*1270 and 1280. It now fills the central lancet of the south chancel window (sII), but was until 1842 in the lancets forming the east window. The light consists of grisaille with stylized leaves and stems arranged in roundels and other geometrical shapes and with the royal arms of England and two vesica-shaped panels enclosing an archbishop and St John the Baptist; the royal arms and the figural panels are in coloured glass and the grisaille is enlivened by coloured border strips, bosses and foliate fillings. The stylized leaves and stems are of the same basic design as those found in grisaille during the first half of the thirteenth century. Also still in evidence is the overlaying of one geometrical shape on another to give the impression of several 'planes' of glass. The Chetwode grisaille, however, differs in two important respects from earlier English ornamental windows. First, the foliate designs are no longer principally made up of separate groups confined within the geo-

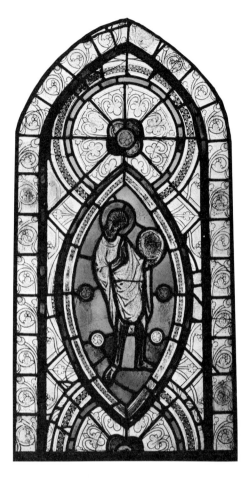

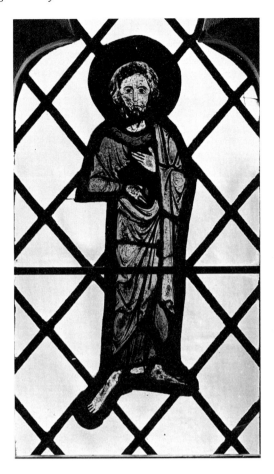

Fig. 111    CHETWODE (Bucks.): St John the Baptist
and grisaille, after 1245, probably *c.* 1270–80.

Fig. 112    EAST TYTHERLEY (Hants.): Christ,
*c.* 1260–70.

metrical shapes; instead several stems traverse
the main lead-lines to give a hint of an overall
scheme for the entire light (there are traces of a
similar development in parts of the Five Sisters
window in York Minster).[2] The second innova-
tion apparent at Chetwode, *Salisbury* and else-
where (although not at Stanton Harcourt) is the
abandonment of cross-hatched in favour of clear
grounds, thereby increasing the translucency of
the glass. The same development is evident in
French grisaille glass of the 1260s and 70s,
notably in some panels thought to be from the
Château de Rouen and Saint-Urbain at Troyes.[3]

    This move towards greater transmission of
direct light was facilitated by other changes. The
figural panels set in the Chetwode grisaille are

composed of larger pieces of glass than had been
the norm in the first half of the century. In
addition at Salisbury the colours are less dense
and sombre than hitherto, as can be seen by
comparing the deeper tones of the Jesse from the
cathedral glazing with the greater translucency
and brilliance of the prelates and king from the
chapter house now in the adjoining light. The
move towards enhanced translucency followed
an architectural development of profound
significance for the medieval glazier: the intro-
duction of bar tracery windows. The first major
English manifestation of this French innovation
is the eastern part of Henry III's Westminster
Abbey.[4] Bar tracery windows made much larger
spaces available for glazing than hitherto, as can

*Fig. 114*

be demonstrated by comparing the *Brabourne* and *Hastingleigh* (Kent) lancets with the great series of traceried windows in the chapter houses at Salisbury and *York*. The new formula permitted the glazier to create immense transparent retables like the *Gloucester* east window, leading ultimately to the great Perpendicular and Renaissance glazing schemes of the fifteenth and early sixteenth centuries.

*Pl. VIII(a);*

*Fig. 108*

*Fig. 116*

*Fig. 132*

Returning to the Chetwode glass, in the figure of St John the Baptist the calligraphic, multiple folds of the first half of the thirteenth century are replaced by crumpled and heavy draperies; the figure is tall with a small head and takes on an elegant swaying stance. The origins of the broad-fold style, as it is commonly termed, lie in sculpture and painting at Rheims, Amiens and Paris during the 1220s and 1230s.[5] Some of the earlier English versions in these and other media reveal a process of assimilation, with the new French elements mingling with, or distorted by, indigenous traditions; in works such as the Westminster Abbey chapter house Annunciation group (1250–3), the *Oscott Psalter* (BL MSS Add. 50000, 54215), probably of the 1280s, and the manuscripts associated with the Sarum Master, the multiple folds occur in conjunction with broad areas of drapery rendered in stiff, sharp-edged patterns.[6] Comparable examples in stained glass are the angels, prelates and kings from the tracery of the *Salisbury* chapter house windows, together with a related figure of Christ at *East Tytherley* in Hampshire, which are less animated versions of illustrations in mid-century manuscripts from the same locality attributed to the Sarum Master, such as the *Missal of Henry of Chichester* and the *Paris Apocalypse* (Manchester, John Rylands Lib. MS Lat. 24, and Paris, Bibl. Nat. MS fr 403); in addition the *Stanton Harcourt* St James has something of the elongated and lively stance of the *Oscott Psalter* apostles.[7] Between the late 1260s and *c.* 1290, English painters and sculptors embraced the French style more whole-heartedly, with the broad folds softened to give a more crumpled, heavier effect and the last traces of multiple pleats eliminated. Simultaneously the rigid pose of figures was replaced by elegant and sinuous postures and small heads. Examples of this phase are the sculptures of the Angel Choir in Lincoln Cathe-

*Fig. 113*

*Fig. 112*

*Fig. 114*

dral (*c.* 1265–70) and the *Westminster Retable* in Westminster Abbey, probably of *c.* 1270–80. It is with these works that the *Chetwode* St John and the four figures in the east window of *St Michael's Oxford* can best be compared. To them should be added the exquisite Coronation of the Virgin at *Holdenby* in Northamptonshire (window sIV), which shows similarities in the delineation of faces with the earliest miniatures in the *Alphonso Psalter* (BL MS Add. 24686), begun in *c.* 1284, and the York chapter house figural glazing.[8] This treatment of bodily forms was to endure in all branches of artistic activity for nearly a century.

*Fig. 111*

*Fig. 115*

*Fig. 115*

The *York* chapter house and vestibule glazing contributed several major innovations to the developments described above, resulting in the forging of a new aesthetic.[9] The new elements present in its windows are naturalistic foliage, with the stems forming a unified overall design, canopies based on architectural forms, an increased range of colours and an overall design of bands of colour set against the grisaille.

*Fig. 116*

The windows have been much disturbed, but enough can be pieced together from the surviving sections and antiquarian illustrations to establish that the borders and grisaille consisted of passably naturalistic leaf forms

*Fig. 113*  SALISBURY CATHEDRAL (Wilts.): bishop and king from the chapter house, *c.* 1265–70(?).

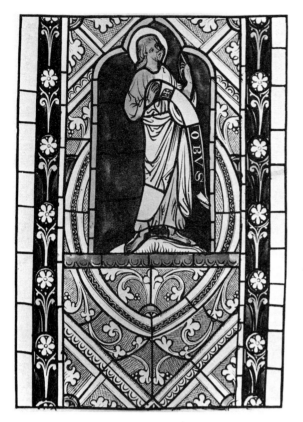 

*Fig. 114* (*left*) STANTON HARCOURT (Oxon.):
St James the Greater and grisaille, *c.* 1260–75. Engraving by C. Winston; (*right*) BRYN ATHYN, USA, PITCAIRN COLLECTION: grisaille from the chapter house of Salisbury Cathedral, *c.* 1265–70(?).

springing from a central stem running vertically from the base to the summit of each light. The replacement of stylized leaves by designs based on oak, ivy, vine, maple and other species was of far-reaching importance and set the pattern for more than fifty years. This was not a development peculiar to English glaziers, but was part of an interest in the depiction of the natural world which can be traced throughout Europe during the same period. The first major displays of naturalistic leaf forms occur in French architectural sculpture at Rheims and Notre-Dame in Paris; they had appeared in English sculpture at Windsor and Westminster by 1250 and the fashion soon spread into other media. Vine and oak leaves occur occasionally in *L'Estoire de Seint Aedward le Rei* (Cambridge, Univ. Lib. MS

*Fig. 117*

E.e.3.59), dating probably from *c.* 1255; by the time the *Douce Apocalypse* was decorated in *c.* 1270, naturalistic foliage had become well established in English manuscript illumination.[10] The sparse evidence available suggests that both English and French glass-painters may have lagged a little in their adoption of the new forms. In France the first manifestations are at Saint-Pierre at Chartres, Saint-Urbain at Troyes and the chapel at Saint-Germer-de-Fly. These date variously from the 1260s and 1270s and the presence of stylized trefoil-headed leaves side by side with more naturalistic foliage forms suggests that the latter were only adopted hesitantly.[11] England tells a parallel story. Some embryonic ivy and oak leaves are present amongst the numerous trefoil-, quatrefoil- and cinquefoil-

headed foliage designs in the Five Sisters window in *York Minster*, but this appears to be exceptional and the glaziers of Chetwode, Stanton Harcourt and window sXI in Hereford Cathedral still clung to the long-established stylized forms (window sXII at Hereford has leaves which are moving towards naturalism).[12] The Five Sisters and the leaves on the crown of *Beatrix von Valkenburg* (d. 1277) show that the York chapter house windows do not mark the earliest appearance of naturalistic foliage in English stained glass, but it is there that we see for the first time the complete supplanting of stylized leaf forms with a dazzling array of naturalistic foliage which complements the carvings on the chapter house capitals and

*Fig. 105*

*Pl. X*

bosses. The speed of adoption of naturalistic foliage was not uniform throughout the country. Ivy leaves appear in the windows to the chapter house vestibule at *Wells* (c. 1286),[13] but stylized foliage is still employed in the glazing of the chapel of St John the Evangelist (nIV) overlapping the north side of the Lady Chapel at Exeter Cathedral; its counterpart, St Gabriel's Chapel, was described in 1280 as 'de novo constructa' and was unfinished in 1289.[14] During the 1290s naturalistic foliage found wider acceptance in major building complexes, such as the *York* chapter house vestibule; it also occurs amongst the slight remains of the chapter house glazing at Southwell Minster in Nottinghamshire (principally in a south window) and in the side

*Fig. 118*

*Fig. 122*

Fig. 115 (*left*) OXFORD, ST MICHAEL'S CHURCH: St Edmund of Abingdon, c. 1260–90; (*right*) HOLDENBY (Northants.): Coronation of the Virgin, c. 1285–95.

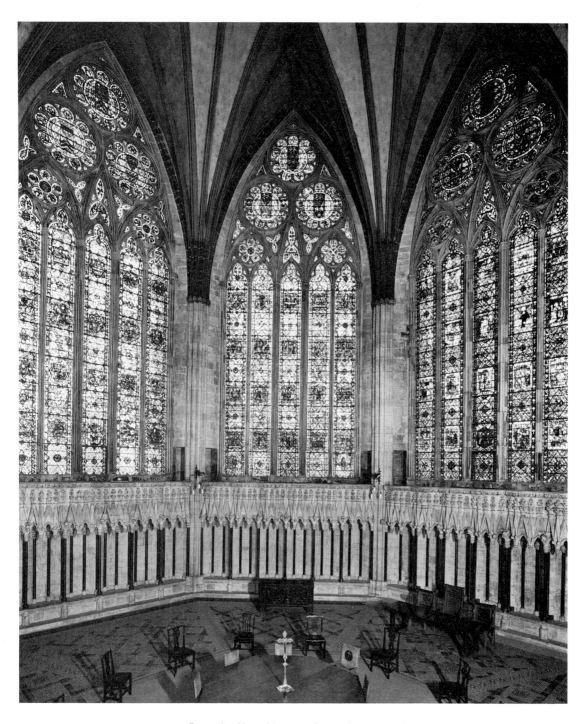

*Fig. 116*    YORK MINSTER: chapter house, *c.* 1285–90.

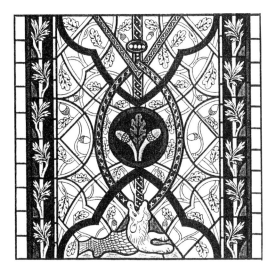

*Fig. 117* YORK MINSTER, chapter house: grisaille and borders, *c.* 1285–90. Etching by John Browne.

windows of *Merton College Chapel*, Oxford, of *c.* 1294.[15] Parish churches of the period are more conservative. At *Stanton St John* in Oxfordshire naturalistic and stylized foliage appear together in the same chancel window (nIV), and in the two pairs of easternmost chancel windows of *Chartham* in Kent (sII, sIII, nII, nIII) vine leaves occur in the coloured borders, but the grisaille patterns are entirely composed of trefoil leaves and stems; Chartham was under construction by 1294.[16] The east window of *Selling* in the same county is even later (1299–1307) and yet there is still no trace of naturalistic foliage in the grisaille.[17] Selling is probably exceptional and it seems that by the turn of the century naturalistic foliage had almost everywhere supplanted the older forms in grisaille and border decoration. The change is demonstrated in the other chancel windows at *Chartham* (sIV, sV, nIV, nV), where the trefoil leaves are replaced by those based on naturalistic foliage.

Most of the borders in the York chapter house, at Merton and Chartham consist of a climbing trellis of leaves and stems in pot yellow or white glass on ruby or blue grounds; in the York and Southwell chapter houses birds occasionally appear amongst the foliage. These designs are a far cry from the formal edgings of the first half of the thirteenth century and also

*Pl. XII;*
*Fig. 123*
*Fig. 119*

*Fig. 121*

*Fig. 120*

*Fig. 121*

mark the culmination of the process of reduction in size of the border.

One window in the *York* chapter house and the slightly later windows in its vestibule and at *Merton* and Selling all have a new form of architectural niche which henceforward became an important element in figural glazing. Its characteristic features are a cusped arch surmounted by a steep crocketed gable capped by a finial and flanked by pinnacled shafts, and with or without an elaborate traceried and buttressed superstructure mounted on a platform. In the early stages in the evolution of the idea all the component parts were represented parallel with the front plane of the picture and showed no attempt to use perspective in order to create a sense of depth. The source of this canopy design, which is found with local variations throughout northern Europe, is ultimately architectural and can be traced back to the crocketed gables over the windows of the Sainte-Chapelle in Paris. Professor Becksmann has shown that the glass-painters of the Rhineland borrowed the design from architectural drawings and it is highly probable that the same process occurred in England.[18] Micro-architectural versions appear

*Fig. 122*

*Pl. XII*

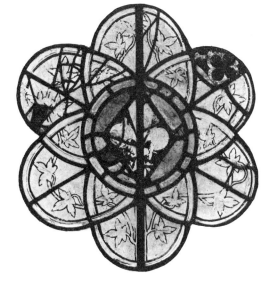

*Fig. 118* WELLS CATHEDRAL (Somerset): grisaille in a chapter house vestibule window, *c.* 1286.

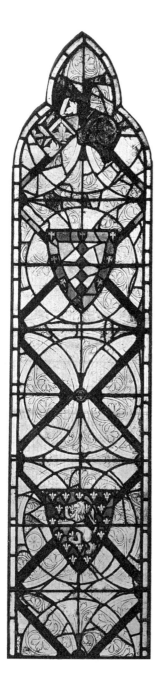

*Fig. 119* STANTON ST JOHN (Oxon.): grisaille and heraldic glass, *c.* 1285–1300.

in the 1270s on the *Westminster Retable* (probably) and on seals; during the late thirteenth and first half of the fourteenth centuries they are found in almost all branches of artistic activity as well as embellishing the interiors of buildings and structures like the *Eleanor Crosses*.[19]   *Fig. 33*

Two more important new developments present in the *York* chapter house and vestibule windows were to become characteristic features of English glass during the first half of the fourteenth century. In the figural panels several new colours – earth browns, murrey and mauve as well as a greatly expanded selection of colour hues – are added to the already existing range of red, blue, yellow, green and purple. These rather autumnal colours are particularly to the fore in some west of England glass, notably *Warndon* and *Fladbury* (Hereford & Worcester) and in the   *Pl. 1* choir clerestory at Wells. Second, the windows continue the trend already evident at Salisbury towards less dense colours; at the end of the thirteenth century this was facilitated by improvements in the manufacture of glass in France (the source of much of the coloured glass used in England in the fourteenth century) which resulted in the production not only of larger but also thinner sheets.[20]

The translucency of the York chapter house and vestibule glass is also due to the arrangement of the coloured figural panels in parallel strips running across the windows and separated from each other by expanses of grisaille. This type of composition is known as the band window and the York chapter house windows appear to mark   *Fig. 116* its first recorded appearance in England. The placing of coloured glass medallions and panels in grisaille was known both in France and England in the early thirteenth century, as at Petham, *West Horsley* and St Denys Walmgate   *Fig. 109* in York, and also occurred later in the century at Chetwode and Stanton Harcourt.[21] The band window proper, however, was almost certainly introduced from across the Channel; it appeared in France during the 1260s at Tours Cathedral and developed over the succeeding decades, notably at Saint-Urbain at Troyes, the Château de Rouen and Sées Cathedral.[22] Apart from the York chapter house and vestibule, early examples can be seen at *Merton College Chapel*   *Figs 123,* and in the east window of *Selling*.[23] The design   *120*

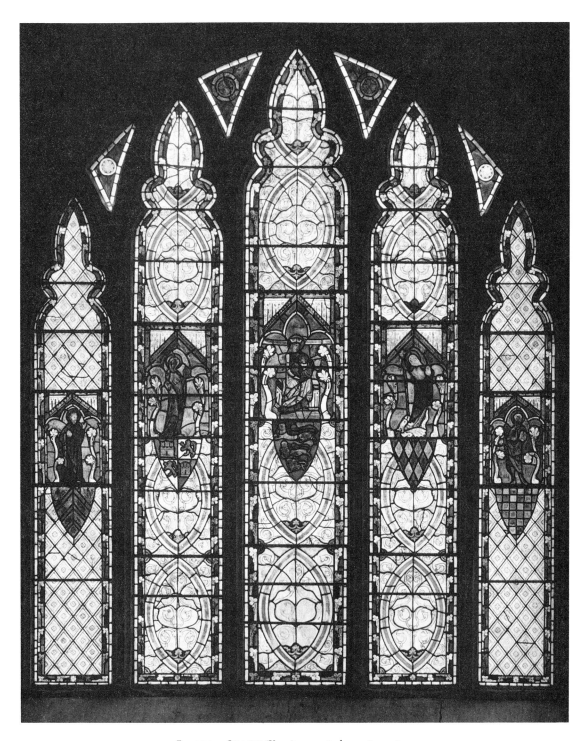

*Fig. 120* SELLING (Kent): east window, 1299–1307.

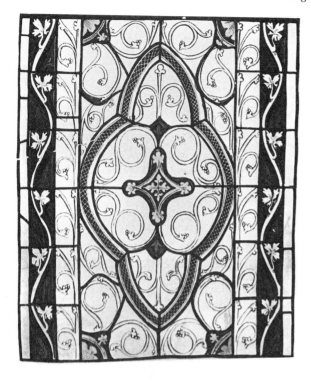 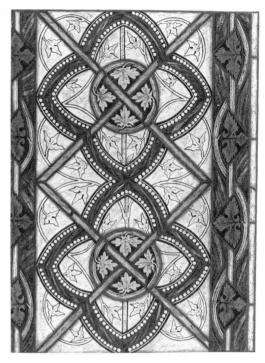

*Fig. 121* The triumph of naturalistic foliage: sections of grisaille and borders in two chancel windows at CHARTHAM (Kent), *c.* 1293–4 and *c.* 1300. Engraving and watercolour by C. Winston, 1841 and 1843 (BL MS Add. 35211).

was widely adopted during the first half of the fourteenth century for tall and narrow windows in cathedrals and parish churches alike, as in the nave aisles of *York Minster* and the chancel side windows at Stanford on Avon in Northampton-shire, the latter datable to *c.*1315–26.[24] York, Merton and Stanford also exhibit another common characteristic of the period: the en-livening of the grisaille and borders by heads, grotesques and foliage in small medallions of coloured glass, another motif which appears at Saint-Urbain, Troyes, although here they are not *in situ* and it has been suggested that they may date from as late as *c.* 1300.[25]

The band window was not employed to the total exclusion of other forms of window composition. A window (nIV) in the heavily restored chancel glazing at Bredon in Hereford & Worcester has small panels depicting St Mary of Egypt and St Mary Magdalene set in large expanses of grisaille in a manner reminiscent of

*Pl. XI*

Stanton Harcourt.[26] More common is the complete or almost complete filling of lights by figures or scenes under canopies in coloured glass. These are often found in the great eccle-siastical establishments like *Wells*, *Gloucester* and *Tewkesbury*, but also occur in parish churches; the east window of the chantry chapel founded in 1299 by Miles de Stapleton at North Moreton, Oxfordshire (window sII), and the Old and New Testament panels in the east window of the chancel south aisle at Newark in Nottingham-shire (window sII) are examples of full-colour windows in parish churches. Sometimes this arrangement was necessitated by the icono-graphy of the window, notably those containing a Tree of Jesse, as at Ludlow, Shropshire, Madley in Hereford & Worcester, and Mancetter, Warwickshire.[27]

*Figs 122, 132;*
*Pl. XVIII*

Surviving monuments from the first quarter of the fourteenth century are numerous. They

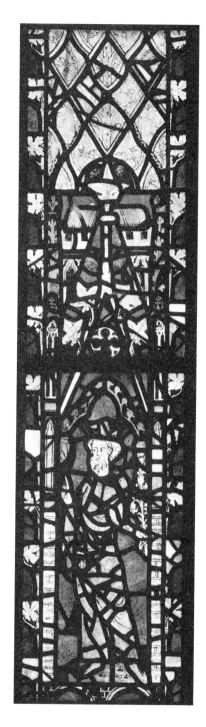
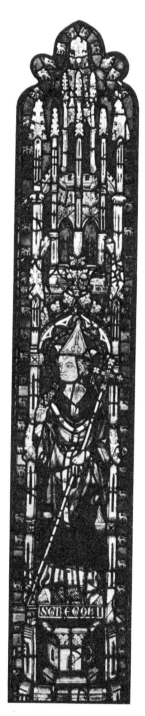

Fig. 122    THE DEVELOPMENT OF THE THIRD DIMENSION: (*left*) king in the chapter house vestibul of YORK MINSTER, *c.* 1290–5; (*right*) St Gregory in the choir clerestory of WELLS CATHEDRAL (Somerset), *c.* 1338–45.

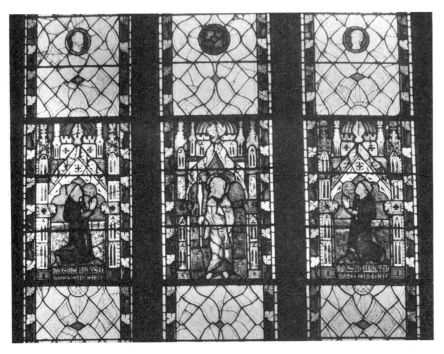

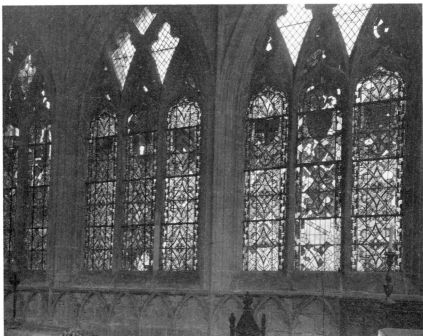

*Fig. 123*     TYPES OF WINDOW COMPOSITION: (*above*) the band window, detail with figures of Henry de Mamesfeld flanking an apostle in MERTON COLLEGE CHAPEL, OXFORD, *c.* 1294; (*below*) grisaille and heraldry in the chancel windows at NORBURY (Derbys.), early fourteenth century.

encompass individual panels in parish churches such as that depicting SS Thomas Becket and Thomas Cantilupe at *Credenhill* in Hereford & Worcester (window sIV), the exquisite St Catherine at Deerhurst in Gloucestershire (window sVIII), the equally attractive figure of the same saint from *Wood Walton* in Cambridgeshire (now in the Stained Glass Museum at Ely) and the donor John de Newmarch in the east window at *Carlton Scroop*, Lincolnshire.[28] There are also remains of larger glazing schemes in parish churches, as at Checkley in Staffordshire, Newark, North Moreton and *Stanford on Avon*, although the predominantly grisaille glazing of the chancel side windows at *Norbury* in Derbyshire and *Chartham* serves as a reminder that even quite grand parish churches sometimes had little or no figural glass.[29] Inevitably the most important works are the vast glazing schemes undertaken from the end of the thirteenth century in the great cathedrals of Exeter, York, Wells and elsewhere.

*Fig. 58*

*Fig. 33(d)*

*Fig. 2(b)*

*Figs 56, 124, 200*

*Fig. 123*

*Fig. 121*

The scanty remains of the *Exeter* glazing of this period are fully documented in the fabric accounts. The great east window contains *inter alia* figures of three female saints, three apostles and three prophets, all of which were purchased in 1301–4 ready painted for the new choir at a cost of 5½d per foot; in 1304 they were set in place by Master Walter.[30] The east window was reconstructed at the end of the fourteenth century and it is difficult to believe from the diverse iconography that these figures all originally belonged in it; on the other hand there is no documentary evidence for their removal from elsewhere and stylistically they are homogeneous. The figure of Isaiah is a particularly impressive example of English glass of the early fourteenth century, although the enclosing architectural framework and borders were almost entirely restored by Frederick Drake in 1884–96.

*Pl. XIII*

The nave of *York Minster* provides the most complete glazing ensemble of the first four decades of the fourteenth century.[31] The foundation stone was laid at its south-east corner in 1291 and the three windows in the west façade were commissioned in 1338–9. The clerestory windows and the seven windows in each aisle were probably glazed between *c.* 1305 and 1330.

In the clerestory and many of the nave aisle windows the band formula is adopted. There is some heraldic and donor evidence which suggests that most of the clerestory windows pre-date the nave aisle glazing. They comprise a row of shields of arms below a band of figural panels, some of which, as we have seen, are re-used from the late twelfth-century windows of the Minster.[32]

*Pl. XI*

*Fig. 2(c)*

The nave aisle windows were paid for by a series of individual donors, which accounts for the lack of any unified iconographical scheme. There is also stylistic diversity in these windows, so much so that only two, the Penancers and Bellfounders windows (nXXVII, nXXIV), appear to be by the same workshop, which also executed some of the clerestory glazing, notably the scenes from the life of Christ in NXXIII. These windows share identical head types, heraldic grounds and grisaille patterns. Fragments in the west window of the north aisle at Patrick Brompton church in North Yorkshire are also attributable to this workshop.[33]

*Fig. 1*

Notable features of the York nave aisle windows are the profusion of real and fantastic zoomorphic designs, and the prominence given to heraldry. Birds began to appear in border and *bas-de-page* decorations in late thirteenth-century manuscripts such as the *Cuerden Psalter* (New York, Pierpont Morgan Lib. M 756) and the *Alphonso Psalter*. In stained glass the window possibly of *c.* 1270 excavated at *Bradwell Abbey* in Buckinghamshire has borders composed of birds set amongst a climbing foliage trellis.[34] The use of such motifs greatly expanded during the first half of the fourteenth century in manuscript illumination and stained glass as well as other media. Zoomorphic motifs appear in the York chapter house glazing and dominate the borders of the flanking lights in several windows of the Minster south aisle, including the heavily restored glass given by Canon Robert de Riplingham and the Mauley family (sXXXI and sXXXII). In these, birds in green and white glass are interspersed amongst oak leaves and stems. This marginalia is taken a stage further in the Pilgrimage window in the north aisle (nXXV).[35] On the extreme left of the lower border is a fox preaching from a lectern to a cockerel, a favourite medieval fable.[36] The next scene

*Fig. 124*

*Fig. 70*

depicts a funeral procession headed by two apes carrying a bell and a cross and with four more bearing the bier; a fifth pushes against the draped coffin; this is an adaptation of the apocryphal legend of the Virgin's Funeral, with the apes substituting for the apostles and the Jew. In the scene to the right of the funeral, apes appear in *Fig. 36* the guise of physicians attending a monkey patient; one of the doctors inspects a urine flask. This is another popular theme in medieval ape-lore.[37] Monkey doctors intermingle with others holding owls on their wrists in imitation of falconers and with squirrels eating nuts in the side borders of this window. Other border scenes found in the same window include Reynard the Fox with a goose in his mouth pursued by a woman, and a stag-hunt. Both were popular subjects with the illuminators of *bas-de-page* scenes in contemporary manuscripts.[38]

Zoomorphic representations, both real and fantastic, hybrid men and drolleries were not confined to borders. The Pilgrimage window has a series of monsters, griffins and centaurs in the small roundels which enliven the grisaille panels between the main historiated scenes. Again, these motifs are part of a repertoire common to craftsmen working in all media in this period.

The border to the central light in the Pilgrimage window has an alternating design of the royal arms of England and those of France ancient. Heraldic borders began to appear towards the end of the thirteenth century, at Merton College and in the York chapter house; during the first half of the fourteenth century heraldic charges became one of the most common border designs. The Pilgrimage window is not the most elaborate example of border heraldry in York Minster. In the nave south aisle easternmost window (sXXIX) are covered cups and the castles of Eleanor of Castile and several other windows contain heraldic devices in their borders. The most extensive use of heraldry in York Minster occurs in the aptly-named Heraldic window, given by Peter de Dene (nXXIII).[39] In addition to eight shields of arms set on the grisaille, the borders have heraldic eagles (for the Holy Roman Empire) and lions of England. There is also a unique series of small figures of knights in chainmail and heraldic surcoats on which are variously depicted the

royal arms of England and France and those of the Clifford, Roos, Mowbray, Warenne, Beauchamp and Clare families. One of the knights is a Templar, which indicates that the window dates from before the dissolution of the Order in 1312. Canon Peter de Dene, who was a figure of some influence, is recorded in York by 1307 and the window is therefore likely to have been executed between then and 1312. The dating is important for establishing the earliest appearance of yellow stain so far recorded in English glass.[40]

Knowledge of yellow stain was disseminated very quickly throughout England. One of its first appearances in parish church glazing is in the chancel at *Stanford on Avon*. Here yellow stain is *Fig. 200* used very sparingly and is largely confined to beading and some of the foliage in the grisaille; in the borders it alternates with pot metal yellow.

The chancel glazing at Stanford on Avon is typical of the best window design of the period, even if the animated figure style lacks the sophistication of Exeter and Merton College. In its original arrangement each of the side windows was conceived in terms of a subtle interplay of alternating colours and motifs. The apostle in the centre light of each window is clad in a pink mantle and green robe and is set against a blue ground with a vine leaf design picked out against a matt wash; the border comprises a climbing stem with oak leaves on a ruby ground; the grisaille consists of vine leaves. The apostles in the two flanking lights are always in pot metal yellow mantles and blue robes and are set on ruby grounds embellished with oak leaves; their borders have either covered cups or vine leaves and stems and the grisaille has oak leaves and acorns.

The adherence of glaziers working in the first quarter of the fourteenth century to certain formulae in figure style as well as in overall design makes it difficult to identify workshops, although they will no doubt be revealed by further research. The splendid Jesse figures of this period which were re-set during the late fourteenth-century reconstruction of the church at *Lowick* in Northamptonshire (windows nV– *Fig. 12* nVIII) are by a local glazier who was also responsible for the head of Christ in the apex of the east window of the nearby church of Cranford St

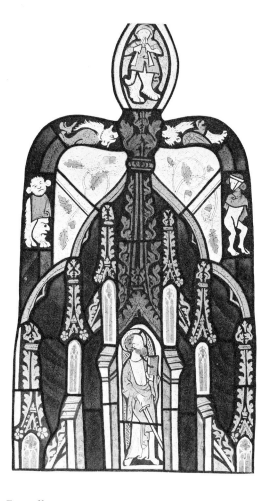

*Fig. 124*    Birds and beasts: (*left*) birds in the borders of an excavated window at BRADWELL ABBEY (Bucks.), c. 1270(?). *After J. Kerr*; (*right*) border hybrids from a nave window at STANFORD ON AVON (Northants.), c. 1325-40. Watercolour by C. Winston, 1835 (BL MS Add. 35211).

John. Some of the Lowick figures have a sensitivity in facial delineation more characteristic of a miniaturist than a monumental painter.[41]

Glass of this period elsewhere in the Midlands exhibits affinities with local manuscript painting. The angels in the Nativity at *Barby* (nIV), also in Northamptonshire, have the same distinctive 'tear-drop' drapery fold as some *bas-de-page* illustrations in a psalter written by John Tickhill, prior of Worksop in Nottinghamshire between 1303 and 1314. The Barby panel was executed by the workshop responsible for several censing angels, canopies and borders in two windows (nV, nVII) at Evington near Leicester. There formerly existed in this glass the arms of Sir Richard Grey of Codnor and Evington, who was the owner of a Book of Hours (Cambridge,

*Fig. 125*

Fitzwilliam Mus. MS 242) which is associated stylistically with the *Tickhill Psalter* (New York, Public Lib. MS Spencer 26) and several other manuscripts with Midlands connections. The possibility of a link between illuminators and glaziers working in the same locality is strengthened by the birds and *baboueny* in the Evington borders which are a prominent feature of the *Tickhill Psalter* group.[42] Similar motifs occur in a number of other Midlands churches, including Dronfield, Netherseal and Sandiacre in Derbyshire, Okeover in Staffordshire, the nave glass at *Stanford on Avon*, Allexton and Lockington in Leicestershire and Heydour, Lincolnshire. These border motifs are not all by the same hand and the distinct differences in figure style and canopy design indicate that the group was

*Fig. 124*

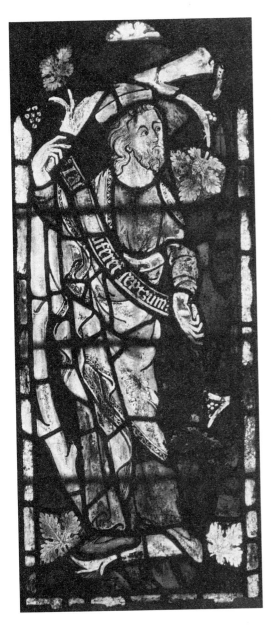

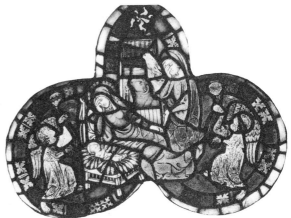

Fig. 125    Contrasting styles in early
fourteenth-century Northamptonshire glass: (*left*)
Jacob from a Jesse Tree at LOWICK; (*right*) Nativity at
BARBY (most of centre section restored).

Decorated Style. This can be demonstrated by
examining the various phases of one large glazing
scheme of the period, the Lady Chapel, choir,
retrochoir and choir clerestory of *Wells
Cathedral*.[44]

The date of the Lady Chapel, retrochoir and
eastern choir aisle windows (I, nII–nVIII, sII–
sVIII) has not been precisely established. The
Lady Chapel is described as 'noviter constructa'
in 1326 and a *terminus ante quem* for the retro-
choir and eastern choir aisles is given by the
foundation in 1329 of chantries in St Catherine's
Chapel, followed in February 1331 by that of
another chantry at the altar of Corpus Christi
(the chapels were located in the small eastern
transepts of the retrochoir); the Corpus Christi
altar was in existence by this date but had not yet
been dedicated.[45] The glazing of the two choir
windows in each aisle west of these chapels (nIX,
nX, sIX, sX) should date from about the same
period. We have, therefore, a glazing campaign
which commenced before 1326 in the Lady
Chapel and was completed in the retrochoir and
eastern choir aisles around 1331. The demoli-
tion of the twelfth-century east wall of the choir
did not take place until just before 1333 and
building was still in progress in 1336; work may
even have been protracted for some time after

the work of several craftsmen who either had
access to a common design source or copied
from each other.[43]

The basic design, colour and stylistic traits
that were established at the very end of the
thirteenth century survived more or less intact
for fifty years, but important developments took
place within the overall framework of the

damage was reported in May 1338. It is likely that the choir clerestory glass (east window, windows NII, NIII, SII, SIII) was not executed *Fig. 63* until after the last date and was completed in the early 1340s. Features such as the tectonic heads, colour range, tracery and border motifs, and canopy design common to the glazing of the choir clerestory and the Lady Chapel and retro-choir windows suggest that the same craftsmen were involved. In certain respects, however, the choir clerestory glazing differs from the earlier glass at Wells. The remains of some canopies occur in the main lights of the Lady Chapel windows and in the traceries are many *in situ* heads of canonized prelates, Old Testament *Pl. XIV* patriarchs and angels holding censers and Passion emblems. Slightly more elaborate canopies and very similar tracery heads appear in the retrochoir and eastern choir aisles. The heads are particularly striking, with the eyes some-times leaded in separately and different coloured glasses used for hair and beards. Shading is heavy in places, applied by thick washes of smear. In the Lady Chapel yellow stain is employed very tentatively, but in the choir and retrochoir the technique is encountered more often. The canopies are more complex than those in the York chapter house vestibule, Merton College and the chancel of Stanford on Avon, but like them they are two-dimensional. In the choir clerestory yellow stain is used in much greater quantities and the canopies and bases are partly tipped forward in 'bird's-eye' perspective to *Fig. 122* given an illusion of spatial depth, which is enhanced by making the saints appear to project from their architectural framework by over-lapping the side-shafts. Similarly, in the east window the Jesse Tree vines run behind the canopy side-shafts and in front of the figures. There is pronounced modelling on faces and subtle, deeply shadowed drapery folds. This sculptural effect is further emphasized by re-inforcing folds and facial features by heavy back-painting.

The Wells choir clerestory glazing conforms to a general trend in English glass-painting of the second quarter of the century, in parish churches as well as cathedrals. At *Stanford on* *Fig. 124* *Avon* the canopies in the east windows of the nave aisles (nIV, sIV) have buttresses offset at

angles to convey depth, and the much greater use of white glass together with the dominance of yellow stain over pot metal are major factors contributing to the much enhanced translu-cency and lighter tone of the nave figural panels compared with their companions in the chancel. The Stanford nave glazing probably dates from *c.* 1325–40 and is by a different workshop from that responsible for the chancel windows.[46]

The innovations described at Wells and Stanford on Avon are also evident in other areas of artistic activity. A predilection for a more sculptural treatment of figures first manifests itself around 1325 in the *Ormesby Psalter* (Oxford, Bodl. Lib. MS Douce 366); in the Crucifixion page of the *Gorleston Psalter* (BL MS Add. 49622), the *St Omer Psalter* (BL MS Yates Thompson 14) and the *Douai Psalter* (Douai, Bibl. Mun. MS 171), techniques of highlighting draperies, the use of painterly modelling in faces and convincing representation of spatial depth are all features dependent on an Italian model – either Sienese or from a centre influenced by Sienese painting – albeit translated into indigenous traditions of style, composition and subject-matter.[47] Some works may have been copied from Italian paint-ings in England at the time, such as the Lombard altarpiece in six sections mentioned in the will of Hugh Peyntour of St Albans (d. 1361), who was employed by Edward III. The Virgin from an Annunciation painted in *c.* 1330 on the west wall of Prior Crauden's chapel at Ely seems to have been based on an Italian prototype, and the ivories owned by Bishop Grandisson of Exeter (1327–69), who also possessed Italian embroid-eries, show knowledge of Sienese painting in both iconography and style.[48] The impact of the modelling and spatial innovations made by Duccio and his successors was felt throughout northern Europe, although in other works of the period Italianate elements seem to have been assimilated at second-hand, filtered via different sources. One was through the Holy Roman Empire, from Vienna and southern Germany, up the Rhine and into the Low Countries; a second was via Paris and Normandy. The second seal of Richard of Bury, Bishop of Durham, dating from 1334–5, has architectural niches tipped forward in bird's-eye perspective in similar fashion to the

canopies at Wells and Tewkesbury; the designer may have come from north-east France or Flanders. The throne on which Edward III is seated on his second Great Seal of 1327 is shown three-dimensionally; this seal is derived from the second Seal of Louis X.[49]

A series of books associated with the Parisian illuminator Jean Pucelle (d. 1334) are strongly influenced by Italian painting.[50] In turn they had an impact on English art, notably that part of the *De Lisle Psalter* illustrated by the artist known as *Fig. 133* 'The Majesty Master' and datable to *c.* 1330-9.[51] The flowing and delicately modelled drapery curves, the faces and the poses of his figures are all closely comparable with the work of Pucelle and his followers as seen in the *Psalter of Bonne of Luxembourg* (New York, Cloisters Coll. 6986).

The two glaziers named in the contracts for the three windows in the west façade of *York* *Pl. XVI* *Minster*, Robert (possibly Robert Ketelbarn) and Thomas, were also well acquainted with 'Pucellian' art.[52] They must have collaborated very closely, for their styles and techniques are indistinguishable from each other. To the same workshop can be attributed a series of panels distributed over the Lady Chapel clerestory (SIII, SIV), the choir aisles (sII, nII, nIV, nV, nVI) and a *Fig. 50* nave south aisle window (sXXXV).[53] The subjects include single figures and historiated scenes from the life of the Virgin and Christ's Infancy and Passion; they were probably painted around 1340. All this glass is of a remarkable quality, especially that in the great west window. Although the archbishops and apostles and Joys of the Virgin scenes in this window can only be seen from a distance, much attention is paid to ornamental details on drapery and in the coloured grounds with their tightly curled arabesques and foliage. The drapery and figure style is elegant, the use of colour sumptuous, and the third dimension is suggested by the angles of the bases and the interiors of the canopies over the archbishops and is reinforced by the strong painting of drapery on both surfaces of the glass. Perspective elements are carried a stage further in the Annunciation in sXXXV, the architectural *Fig. 126* setting of which is derived ultimately from Duccio's *Maestà* altarpiece, executed in 1311 for Siena Cathedral, and re-worked into a northern

idiom by Pucelle and his followers in the Annunciation miniatures of the *Hours of Jeanne d'Evreux* (New York, Cloisters Coll. 54.1.2) of *c.* 1325-8, the *Hours of Jeanne de Navarre* (Paris, Bibl. Nat. MS Nouv. Acq. Lat. 3145) and the *Belleville Breviary* (Paris, Bibl. Nat. MSS Lat. 10483-4).[54] The 'Pucellian' connections are also evidenced by the use of white glass and yellow stain for the figures in sXXXV and some of the Lady Chapel panels, which thereby stand out against their coloured grounds; this practice was derived from Pucelle's introduction of grisaille figures into manuscript illumination. Strong affinities exist between York and a series of important Pucellian stained glass monuments in Normandy of the period *c.* 1320-34. The comparisons are particularly close between the historiated scenes in Rouen Cathedral and those in the York Lady Chapel; also between the elegant figures in the choir clerestory of Saint-Ouen at Rouen and the York west window. Indeed the deeply modelled draperies, canopy designs and widespread employment of white glass and yellow stain in the Saint-Ouen glass seem to have set the tone for Master Robert and Master Thomas's work.[55] The head types, the use of niched figures in canopy side-shafts and the tightly curled *rinceaux* background patterns of the York glass can all be paralleled in glazing in Normandy at Rouen, La Mailleraye (from Jumièges Abbey) and Evreux. Although the overall appearance of the York panels differs considerably from their Norman counterparts, the similarities with glass in Normandy are close enough to suggest that Robert and/or Thomas may have spent some time in a French glass-painting workshop. This theory is not improbable, for there is documentary evidence for the presence of English craftsmen in Paris and elsewhere in France during the first half of the fourteenth century.[56]

Glass in the same style was also executed for St John's Ousebridge (now York Minster, windows nXXI and nXXII) and St Helen's Stonegate, both in York; also the east windows of Acaster Malbis, Lockington, Nether Poppleton, Beverley Minster and Selby Abbey (the few original panels from the last are widely scattered). In addition the head of a king in the *York-* *Pl. XV* *shire Museum* should be included in this group.

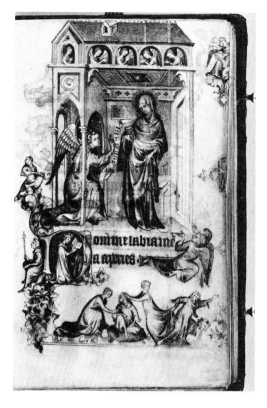
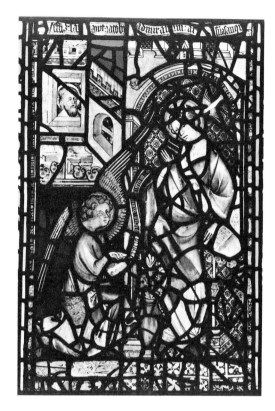

*Fig. 126* (*left*) HOURS OF JEANNE D'EVREUX (New York, Cloisters Museum 54.1.2, fol. 16): Annunciation, *c.* 1325–8; (*right*) YORK MINSTER, nave south aisle: Annunciation, *c.* 1340.

Further afield, some glass at Bothal and Ponteland in Northumberland, the Doom in the tracery of the east window of the cathedral and a head and a canopy in St Cuthbert's church in Carlisle are all probably by this York workshop.[57]

It is perhaps misleading to describe this atelier as either 'English' or 'French'. It would be more accurate to place it in a Pucellian cross-Channel mode which embraces glass in Normandy and parts of England as well as some manuscripts executed for English and French patrons (including the Majesty Master's contribution to the *De Lisle Psalter*). The York workshop may be amongst the purest manifestations of the Pucellian trend, but most of the major glazing carried out elsewhere in England during the 1340s to a greater or lesser extent adheres to the same stylistic tenets, sometimes mixing them with local traditions and borrowings from elsewhere. A notable example is a group of monu-

ments in the east of England of which the most important is the Lady Chapel at *Ely Cathedral.* *Fig. 32* The scanty remains from four windows (sII, sIII, sIV, nII), which have recently been collected in a south window, demonstrate that the glazing was lavish in colour and matched in sophistication the intricately carved surfaces below the windows.[58] The Chapel was started in 1321, but no more than the ground-level niches and stalls below the windows had been completed by 1337. Two windows on each side had been glazed by the time of the death in 1349 of John of Wisbech, the monk in charge of the work. The glazing was still in progress in 1356–9 when Simon de Lenne (King's Lynn) was paid for a window donated by John of Gaunt. If a normal east-to-west programme was followed for the glazing then most of the existing canopies would have been finished by 1349. The heads of the attractive angel musicians from the tracery lights *Fig. 127*

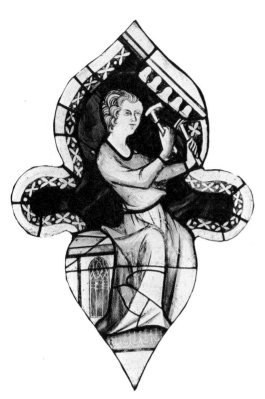

*Fig. 127*    ELY CATHEDRAL (Cambs.), Lady Chapel: angel musician, *c.* 1340–9.

have traits in common with the Saint-Ouen glass, and the small figures of knights and peasants placed in niches in the canopies are very *Pl. XVII* similar to some of the canopies in a choir chapel at Saint-Ouen.[59] It seems that the glaziers responsible for the Lady Chapel were resident in eastern England for the surviving glass has certain features common to a number of contemporary works of art from this region. The canopy knights are similar to the figures in the side-shafts of the brass to Sir Hugh Hastings (d. 1347) at *Elsing* in Norfolk, and in a nave *Fig. 37* window (nIII) at Buckland in Hertfordshire, a few miles south of Cambridge, a canopy includes a peasant in a niche which is comparable with the Ely figures. The Buckland glass can be dated to *c.* 1348 by a recorded donor inscription.[60] In turn both the Ely and Buckland peasants are related to miniatures in psalters in Brescia (Queriniana Lib. MS A.V.17) and Vienna

(Osterreich Nationalbibl. Cod. 1826*), executed by the same hand probably in the period *c.* 1345–9.[61] In the east window of Messingham in Humberside are some fragments of a similar canopy (or canopies) populated by small figures of musicians; this glass originally came from Kettlethorpe church near Lincoln and it is unlikely to be coincidental that the Brescia manuscript appears to have been commissioned by a member of the Lincolnshire family of Willoughby, although the calendar and litany localize it in the diocese of Ely.[62] Small houses with pitched roofs set above the main arch, turrets with arrow-slits and battlements are a feature of the *Fitzwarin Psalter* (Paris, Bibl. Nat. MS Lat. 765) and a *psalter* in Oxford (Bodl. Lib. *Fig. 128* MS Liturg. 198) which, except for ff. 21v and 22r in the former, are by an illuminator related in style to the *Brescia Psalter* artist. The litany of the Oxford manuscript indicates that the manuscript has north-eastern associations, but the *Fitzwarin Psalter* may have had an owner in eastern England.[63] The structures in the Oxford psalter find their nearest parallels in another window at Buckland (nIV), in two chancel windows (sII, sIII) at Elsing, probably glazed just before Sir Hugh Hastings's death, and at *Kingerby* *Fig. 128* in Lincolnshire (sV).[64] Just as the eastern English manuscripts of the period appear to be by several individual, although related hands, so the glass at Ely, Buckland, Elsing, Messingham and Kingerby betrays the presence of more than one workshop. It is not possible to establish from the chronology in which medium these architectural designs first appeared, but it appears that, as with the case of the *Tickhill Psalter* artists and the 'zoomorphic' glaziers of the Midlands, the various brass-engravers, illuminators and glass- and wall-painters working in eastern England in the 1340s made use of a common repertoire of designs. Small structures above arches are an ancient motif, found as far back as Ottonian illuminations and in English art as late as the *Oscott Psalter*, but the direct inspiration behind these elaborate canopies may have come from Flanders where they feature in manuscripts, notably in a *Romance of Alexander* (Oxford, Bodl. Lib. MS Bodley 264), executed between *c.* 1338 and 1344. This manuscript, which as in England by the early fifteenth century, contains multiple

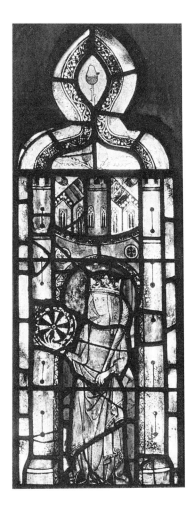

*Fig. 128* (*left*) KINGERBY (Lincs.): St Catherine, *c.* 1345–50; (*right*) Psalm initial in a psalter (Oxford, Bodl. Lib. MS Liturg. 198, fol. 76v), *c.* 1340–50.

turrets and battlemented structures, together with pitched roofs seen from various angles.[65]

The few fragments of the glazing of *St Stephen's Chapel*, Westminster (1349–*c.* 1352) which were illustrated by Smith include small crocketed gables and niche figures of similar design to the Ely canopies. There may be a direct connection between the glazing of Ely and St Stephen's (Simon de Lenne was employed on both schemes), but the evidence is too scanty for any firm conclusions to be made. Smith's drawings of the niche fragments, some of the heads and the coiling *rinceaux* background patterns at least establish that St Stephen's had absorbed Pucellian/Norman traits.[66] The same applies to a workshop active in the West Midlands during

*Fig. 129*

*Fig. 129* WESTMINSTER, ST STEPHEN'S CHAPEL: remains of glazing as illustrated by J.T. Smith, 1349–*c.* 1352.

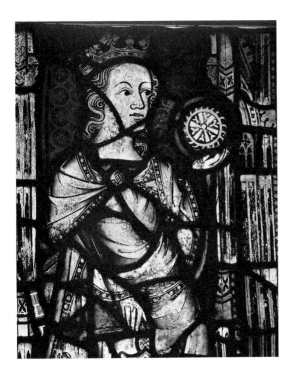

*Fig. 130*    Two figures by a West Midlands workshop, *c.* 1330–50: (*left*) St Catherine (detail) in the Latin Chapel of CHRIST CHURCH CATHEDRAL, OXFORD; (*right*) Virgin Annunciate (detail) from HADZOR (Heref. & Worcs.) on loan to the Stained Glass Museum at Ely.

the period *c.* 1330–50. Its most important surviving monuments are a Virgin from an Annunciation from *Hadzor* now in the Stained *Fig. 130* Glass Museum at Ely, the figures of SS Margaret, Catherine, Cuthbert and an unidentified archbishop in the chancel at Kempsey (windows nIII, sIII) and a heavily restored Coronation of the Virgin in the tracery of a nave south aisle window (sXVIII) in Worcester Cathedral. These are all in Hereford & Worcester; to them should be added the Tree of Jesse in the east window of Merevale, Warwickshire (probably from the Cistercian abbey there), a pair of angel musicians (Corning Museum and Montreal Museum of Fine Arts) and some of the saints in the Latin Chapel of *Christ Church*, Oxford. The workshop *Fig. 130* uses distinctive border motifs, notably large foliate bosses which appear to have been copied from glass of the previous decade in the same region, but once again the heads and the background designs represent an assimilation of French traditions. The Oxford canopies include elements found in the glass from eastern England.[67]

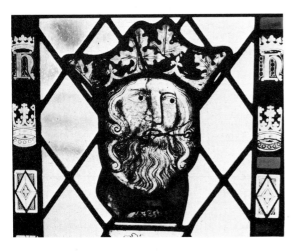

*Fig. 131*    BRISTOL CATHEDRAL (Avon), cloisters: king from the east window Tree of Jesse, *c.* 1340.

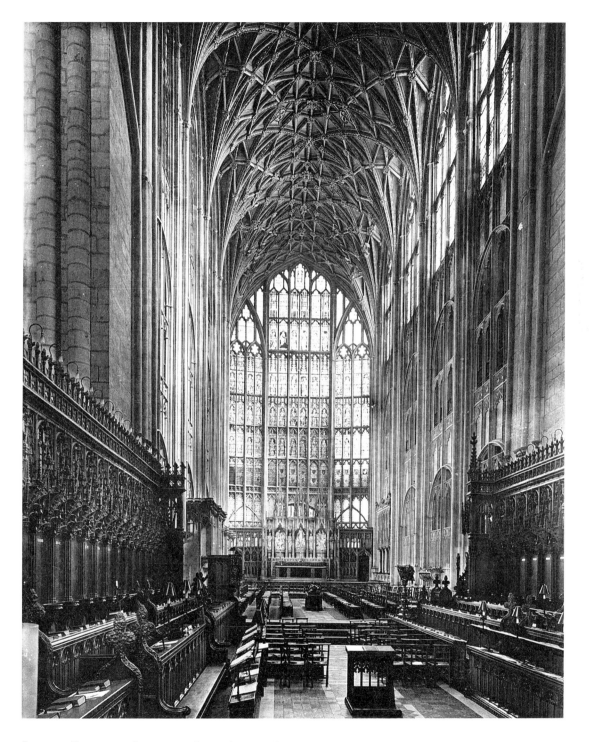

*Fig. 132*    GLOUCESTER CATHEDRAL: choir and east window, *c.* 1350.

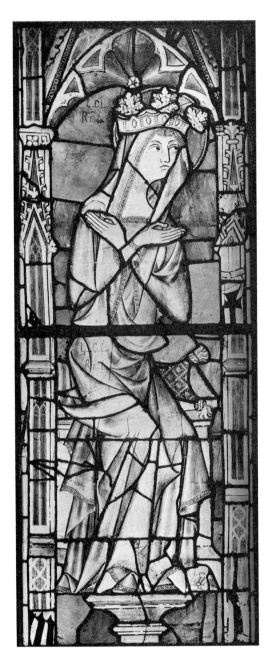

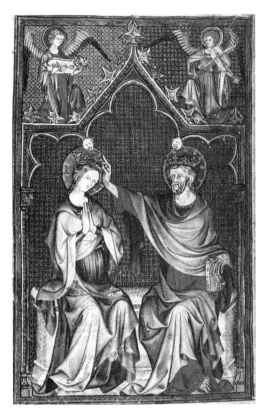

*Fig. 133* (*left*) GLOUCESTER CATHEDRAL, choir east window: Virgin, *c.* 1350–60; (*right*) *DE LISLE PSALTER* (BL MS Arundel 83, fol. 134v): Coronation of the Virgin, *c.* 1330–9.

Apart from these works the West Midlands and West Country contain a large *corpus* of major monuments dating from the late 1330s to the 1350s which likewise reveal the fusion of foreign and indigenous elements. They include Tewkesbury choir clerestory, the east

window of the choir of Gloucester Cathedral and a series of Jesse Trees at Tewkesbury, Bristol Cathedral, Ludlow in Shropshire and Madley in Hereford & Worcester, as well as some of the glass at Eaton Bishop and Moccas, also in Hereford & Worcester. These are all by the same workshop, but the entire group would repay detailed investigation, not least as to its relationship to the Wells choir clerestory glass. There is a close similarity between the canopies at Wells, Eaton Bishop, Moccas and Tewkesbury; on the other hand the affinities in figure style appear to be less clear. The heads at Bristol, Tewkesbury, Gloucester (for the most part), Ludlow and Madley are characterized by solemn expressions, hollow cheeks, beady eyes and heavy modelling. This rather coarse manner is quite a common

feature of English glass of the period and occurs in contemporary manuscripts such as the *Luttrell Psalter* (BL MS Add. 42130) and the first part (ff. 7-49v) of the *Vienna Psalter* mentioned above; it appears to be derived from the Italianate mode represented by the *St Omer* and *Douai* psalters.[68]

The Jesse in the east window at *Bristol* was installed as part of the reconstruction of the Augustinian abbey church begun by Abbot Knowle in 1298; the few surviving original heads suggest that the window was executed around 1340.[69] *Tewkesbury* has retained almost intact the glazing of its seven choir clerestory windows. In the east window are the Last Judgement and Coronation of the Virgin, with Old Testament kings, prophets and apostles in the four easternmost flanking windows (NII, NIII, SII, SIII); in NIV and SIV are depicted the nobles who held the lordship of Tewkesbury. Two of them were the husbands of Eleanor de Clare (d. 1337), who is probably the naked donor kneeling in the east window. The first of her husbands, Hugh le Despenser, had begun to convert the east end into a family mausoleum but the work was interrupted by his execution in 1326. The choir glass dates from *c.* 1340-4.[70]

The history of the great east window of the new choir at *Gloucester* has been elucidated by Winston and Rushforth and, most recently, Jill Kerr.[71] It has long been considered that the shields of arms at the base indicate that the window was designed as a memorial to those who fought in the French campaigns of *c.* 1346-9. However, as Kerr has demonstrated, the heraldry also represents those who fought in

*Fig. 12*

*Fig. 131*

*Pl. XVIII*

*Fig. 2(d)*

Edward III's Scottish expedition and furthermore that the arms are in fact a General Roll of the leading nobles of the period.

As Rushforth noted, the window is designed to act as a gigantic triptych of tiers of figures in niches, with the central section rising higher than the wings. Immediately above the shields of arms are fourteen mitred bishops and tonsured abbots. Next comes a row of saints and above them the twelve apostles with the crowned figures of the Virgin and Christ in the centre. At the top of the window are angels carrying palms. The heraldry and the evidence of the armour worn by St George point to a date in the 1350s for the glass.

The canopies, with their tall pinnacles and crocketed gables and illusion of spatial depth suggested by the depiction of the rib-vaulted interiors, differ markedly from those found in the other monuments by this workshop. The figure style is the same, although as Professor Sandler has noted, some of the elegance of the Pucellian mode is also detectable here: the face and draperies of the Virgin may be compared with the Majesty Master's Virgin in the *De Lisle Psalter*.[72] Another French-derived element present at Gloucester, as in the York glass, is the use of grisaille and yellow stain for the figures and canopies, with coloured glass relegated to the grounds. The Gloucester glazing goes a stage further than York, for it is associated with a new architectural aesthetic designed to reduce walls to a translucent screen by means of rectilinear, thin membranes of mullions and transoms. This aesthetic was to have profound implications for stained glass.

*Fig. 132*

*Fig. 133*

# 8

# *The International Style*

## c. 1350–1450

The century spanned by this chapter witnessed a transformation in both stained glass and architecture. Long before the middle of the fifteenth century the elaborate designs of Decorated windows had been supplanted by a grid pattern of mullion and transom and tracery had been reduced in both size and prominence. During the same period new styles of glass-painting evolved in line with other forms of pictorial art and sculpture. Some glaziers were in the forefront of these developments, notably towards the end of the century when they were to be found amongst the first exponents of the International Gothic style, mingling indigenous features with ideas absorbed from the Continent. In contrast with the first half of the thirteenth and the fourteenth centuries, when the closest links were with France, now the principal source of inspiration appears to have been the Holy Roman Empire. It is in this period that the survival of both glazing commissions and their documentation for the first time makes it possible to trace the careers and development of some of the leading craftsmen. Hand in hand with the introduction of novel stylistic and design traits went a transformation in colour. By the beginning of the fifteenth century the earth colours and flesh tones common in Decorated glass for the most part had been supplanted by brighter combinations, principally blue and red, in association with a greater prominence given to white glass and liberal use of yellow stain.

The years between *c.* 1350 and 1380 come as an anticlimax after the achievements of York,

Wells, Ely and Tewkesbury. Glass from these decades is scarce and even allowing for destruction there is little evidence of large glazing schemes, apart from the Gloucester east window, the royal chapel at Windsor and the completion of St Stephen's Chapel, Westminster, at the beginning of the period. A parallel dearth of material is apparent in manuscript illumination and the general down-turn in artistic activity is probably connected with the ravages of the Black Death, of which there were severe outbreaks in England in 1348-9 and again in 1361, 1362 and 1369.[1] The issuing of a writ for the collection of craftsmen to carry out the St Stephen's Chapel glazing in no fewer than twenty-seven counties suggests that the glaziers' craft was affected by this catastrophe.[2] Other circumstances may also have contributed to the situation, including the fact that the rebuilding programmes embarked upon by so many of the great cathedrals and monastic establishments from the end of the thirteenth century had been very largely completed by *c.* 1350. Another (and much less certain) factor could have been the decline in the prosperity of manorial landowners which had begun before 1350, coupled with Edward III's war taxation and levies on wool.[3]

In the decades 1350-70 the trend towards the increased use of white glass and yellow stain at the expense of pot metal colours accelerated. In many windows coloured glass was relegated to backgrounds behind figures. Possibly the decline in the use of coloured glass was caused by restrictions on imports from France during the wars but there were alternative sources of

supply via the Low Countries. Aesthetics, as at York in the 1340s, must have been a factor, but it is hard to avoid the conclusion that in many instances economy was the major consideration: white glass, even with yellow stain, was always cheaper than coloured.

During the same period the band window fell out of favour and the trelliswork of naturalistic foliage and stems on grisaille was replaced by diamond-shaped quarries bearing individual motifs and often with a yellow stain edging. Quarries occur in the thirteenth century at Lincoln and elsewhere, but this kind appears to have originated in France during the 1320s and examples can be seen in the Canon Thierry window at Chartres Cathedral of 1328 and in windows in the Chapel of the Virgin at Rouen Cathedral.[4] English quarry windows first occur in the 1340s, in the east windows of Tewkesbury and Elsing in Norfolk. They often carry designs in the form of yellow stain rosettes and various non-naturalistic patterns. An unusual series in the north aisle of *St Denys Walmgate* in York of *Frontispiece* c. 1350 (windows nIII, nIV) has insects.[5]

The years around 1350 also witnessed the final supplanting of Lombardic script by 'black-letter' on labels and inscriptions. The new lettering had already infiltrated into monumental art from manuscripts by the 1330s: it is found on a brass inscription of c. 1340 referring to the foundation of Bisham Abbey in Berkshire and is present in the great west window of York Minster (c. 1339).[6] There is more evidence of 'black-letter' in the 1340s. It is known to have been present at *St Stephen's Chapel* and in the east *Fig. 129* window of Elsing, and can still be seen on the Jesse labels at Merevale in Warwickshire and on the inscriptions to Archdeacon Roger de Mortimer (d. 1348) and Precentor William de Littleton (d.c. 1355) at Wells Cathedral.[7]

In other respects there were few innovations in other aspects of window design. The French-derived coiling *rinceaux* background patterns used in the York west window recur in the former priory church of the Bonhommes at Edington in Wiltshire, begun in 1358 and dedicated in 1361, and elsewhere; the kidney-shaped leaves present in the *St Omer Psalter* and the glass of Mancetter in Warwickshire, Okeover, Staffordshire (both probably of the

Fig. 134    EDINGTON (Wilts.): Virgin from Crucifixion group, 1358–c. 1361.

1330s) and St Stephen's Chapel are also found on backgrounds in the 1350s and 1360s. The exuberant naturalism and drolleries in glass of the first half of the century became more restrained; borders of birds fell out of favour and trailing leaves and stems were increasingly supplanted by heraldic lions and *fleurs-de-lis*.[8]

The same period saw no marked change in figure style. The tall and sinuously elegant figure of the Virgin from the Crucifixion group at *Edington* with its small head, sloping shoulders *Fig. 134* and long thin fingers is reminiscent of works of

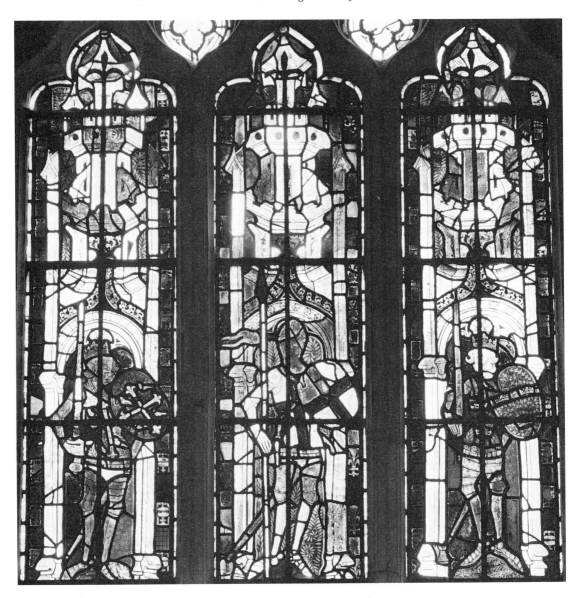

*Fig. 135*   HEYDOUR (Lincs.): SS Edward the Confessor, George and Edmund under canopies, *c.* 1360.

art of the period 1330–40, notably the *Thornham Parva Retable* and the Crucifixion in the murals at Brent Eleigh in Essex.[9] The predilection for heavily modelled heads which first manifested itself in the 1330s continued in the 1350s and 1360s. The figure of William de Luffwyk, rector of St Peter's church at *Aldwincle* in Northamptonshire between 1335 and 1380, closely re-

*Fig. 2(a)*

sembles the female donor at *Tewkesbury* and yet is almost certainly three decades later in date.[10] Generally this style became progressively coarser, with faces often over-shaded and almost caricatured, as instanced by heads at Lacock Abbey in Wiltshire and in the west window of Winchester Cathedral, and a head of Christ at Heydour in Lincolnshire (window nV).[11]

*Fig. 2(d)*

The steeply pitched roofs, battlements, square-headed traceried and barred windows which had been a particular feature of canopies *Fig. 128* in the eastern part of England in the 1340s recur elsewhere in the following decades, as at Weston Underwood in Buckinghamshire, where the canopies in a chancel window (nII) closely resemble those at Buckland in Hertfordshire yet can be dated to *c.*1368.[12] Pitched roofs also occur in miniature painting of the second half of the century, as in a Charter of Indulgence of the London Charterhouse dated 1354 (London, Public Record Office, E/135/15 1).[13] Similar roofs appear in a north aisle window at *Heydour* *Fig. 135* (nVI), given by Henry, Lord Scrope of Masham, between 1342 and his death in 1391; details of the armour worn by the three saints in the window point to a date around 1360.[14] The pitched roofs are minor elements relegated to the tops of the canopies, which are dominated by three-sided superstructures set above and behind the crocketed gables. These structures are a development from the design seen at Tewkesbury, *Wells* and elsewhere in the 1340s, *Fig. 122* and at Heydour they have become the major component in the canopy. The three-sided structure in the lower tier of the Heydour canopies is shown in bird's-eye perspective, but the upper register gives a more realistic impression of spatial depth. This more convincing treatment of perspective became standard during the 1360s and bird's-eye perspective seems to have been abandoned by the end of the decade. The solid three-sided platform with heavy cornices, battlements and square-headed windows became the most common canopy design from the 1360s into the 1380s. Some of the earlier variants, such as those in the south windows of the chancel and nave at Wycliffe, North Yorkshire (sII–sVI), in the panel depicting the beheading of St John the Baptist at *Wickham-* *Fig. 136* *breaux* in Kent (window sV) and in the Cruci-fixion window at Edington, still retain the multiple buttresses and crocketed gables which had been important elements in canopies of the first half of the fourteenth century, but gradually these embellishments were eliminated, together with the pitched roofs. Examples of the fully developed solid platform canopy can be seen in the west window of Winchester Cathedral,

dating from the time of Bishop Edington (d. 1366), Maxey in Cambridgeshire, of *c.*1367–8 (window nII), Lacock Abbey, the east windows of Kimberley in Norfolk and Kinlet, Shropshire, two windows in the Lady Chapel at York Minster (sII, sV) probably dating from soon after 1373, and *Old Warden* in Bedfordshire (window *Fig. 137* nIV), probably of 1380–1.[15] Similar canopies can be found in contemporary illuminated manuscripts, notably in some borders on f.16v of a *psalter* (BL MS Royal 13 D i*); also the miniatures *Fig. 136* on ff. 21v and 22r added in the third quarter of the fourteenth century to the *Fitzwarin Psalter* (Paris, Bibl. Nat. MS Lat. 765). The same canopy type occasionally occurs in the manuscripts commissioned by various members of the Bohun family, e.g. in Oxford, Exeter College MS 47, which were produced at various times between the 1340s and *c.*1385.[16] The Heydour canopies have certain features in common with the super-structures in Saint-Piat's Chapel in Chartres Cathedral, of *c.*1350,[17] but the type may have been transmitted to northern France and England from the Middle Rhineland: similar canopies can be seen in window nX in the church at *Oppenheim*, near Mainz, dating from *Fig. 136* *c.*1330–40.[18] As with canopy design in the 1340s the Low Countries cannot be overlooked as an alternative (or additional) source, although no relevant Flemish glass of the period survives. At least one Netherlandish glass-painter, Bernard, was working in England in 1365.[19]

Glazing of the late 1360s to the 1390s exhibits an even greater preference for white and yellow-stained glass and quarry backgrounds. The heraldic-based motifs found in borders during the middle decades of the century were largely replaced by a new border pattern composed of yellow stain crowns over initial letters; it can be seen at Letcombe Regis, Berkshire, Stoke Charity, Hampshire, Clothall and Barkway in Hertfordshire, Farleigh Hungerford, Somerset, and Old Warden.[20] Around the year 1400 initials in turn began to fall out of favour, but crowns remained the most popular border pattern into the sixteenth century.

Associated with these changes are two new figure styles. The first is related to those hands in the Bohun group of manuscripts which origin-

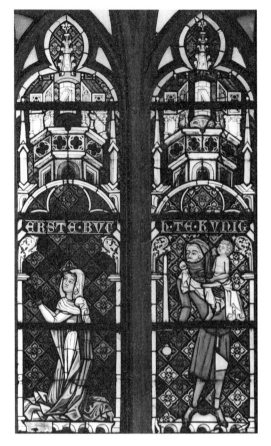

*Fig. 136*    Canopy designs (*left to right*): OPPENHEIM (Germany): Judgement of Solomon window (detail) *c.* 1330–40; WICKHAMBREAUX (Kent): beheading of St John the Baptist, *c.* 1360; *PSALTER* (BL MS Royal 13. D i*, fol. 16v, detail): saints, *c.* 1350–60.

ated in the English-Italianate traditions of the *St Omer Psalter.*[21] The glazier's version lacks the heavy facial modelling of the Bohun illustrations, but in other respects the affinities are close as is evident from the comparison of the Holy Trinity and donors miniature in the *Carmelite Missal* (BL MSS Add. 29704–5, 44892) with the Christ in the east window at *Letcombe Regis.* The figures have in common slender elongated torsos, wispy forked beards, beady, slit eyes and small mouths. The Letcombe Regis glass is undated, as are all the other windows in the Bohun manner which have been noted, with the exception of the tracery figures of *c.* 1367–8 at Maxey and in the east window of Weston Underwood. The Bohun style is not confined to books associated with

*Fig. 138*

members of the family and occurs in a number of manuscripts dating from the 1360s to the 1390s; the *Carmelite Missal* is one of its later manifestations as its text was only completed around 1393.[22] Other examples include the Coronation of the Virgin and censing angels at Wormshill, Kent, an angel and Christ in Majesty at Aston Rowant in Oxfordshire (window nIX), two tracery apostles in window sIII at Saxlingham Nethergate in Norfolk, the figure of Christ at Raunds, Northamptonshire (sVIII), the Jesse at Leverington (nV) in Cambridgeshire and a pair of donors at Bardwell in Suffolk (nIV).[23]

During the late 1370s the second style made its appearance in stained glass. It has close affinities with the style exhibited by an atelier of

illuminators active between the early 1370s and the end of the century and whose masterpiece is the *Lytlington Missal* (Westminster Abbey MS 37), made in 1383-4 for Nicholas Lytlington, abbot of Westminster.[24] The faces in this manner are distinguished by strongly emphasized eyes and arched brows, as in the figure of Sir James Berners (d. 1388) at West Horsley in Surrey (window nIV).[25] Other examples are Sir Thomas

*Fig. 140*

*Fig. 137*    OLD WARDEN (Beds.): Abbot Walter de Clifton, *c.* 1380-1.

Hungerford (d. 1398) at Farleigh Hungerford in Somerset (window nIV), an impressive St George at Long Sutton, Lincolnshire (sVI), a pair of tracery light figures in the south transept (sXVIII) of Wells Cathedral, and St Christopher and two members of the Ruyhale family at *Birtsmorton*, Hereford & Worcester (window sII). Most if not all of these seem to date from the late 1380s and 1390s.[26] In more remote areas the style lasted into the first decades of the fifteenth century, as is demonstrated by the heads of Ralph Nevill, Earl of Westmorland, and his wife Joan Beaufort (whom he married in 1396) at Penrith in Cumbria (window sVI).[27] It also occurs in other media, such as the ceiling paintings in Abingdon church, Oxfordshire, and the stall-paintings at Astley in Warwickshire.[28]

*Fig. 139*

By the time the Penrith glass was executed the Lytlington-related mode had been supplanted in the major centres by a new aesthetic which set the pattern for English glass for decades. The transformation in figure style was closely related to developments in European painting and sculpture and also must be seen in the context of the new Perpendicular architecture, which had important consequences for glaziers. The introduction of horizontal divisions into the main lights by means of transoms reduced canopies to smaller proportions and gave them a less dominant role than had been the case earlier. English glass-painters displayed a marked reluctance to run compositions across stonework, so in a light separated into two equal parts by a transom we find two figures under canopies, one above and one below the transom; this is the case in New College Chapel, Oxford. The major exception to this rule in the fourteenth century is the choir east window of Gloucester Cathedral, in which the uppermost row of canopies cuts through the horizontal divisions.[29]

The glazing of New College was mentioned as an instance of how the new architectural vocabulary affected stained glass. The college was founded by the powerful and influential William of Wykeham, bishop of Winchester between 1366 and his death in 1404, and the glass was executed by Thomas Glazier of Oxford.

New College was constructed between 1380 and 1386.[30] In the latter year the building was

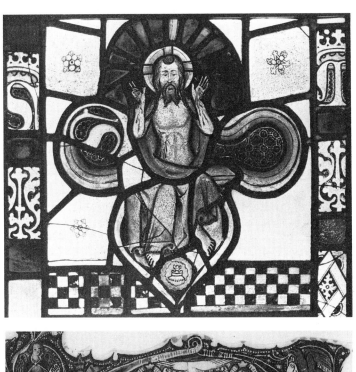

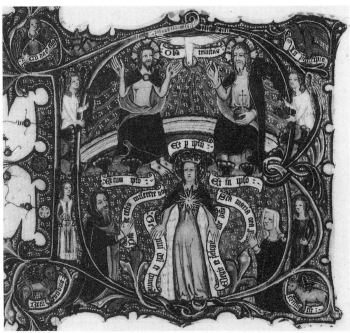

*Fig. 138* (*above*) LETCOMBE REGIS (Berks.): Christ displaying His wounds, *c.* 1360–90; (*below*) *CARMELITE MISSAL* (BL MS Add. 29705, fol. 193v): Holy Trinity, Virgin and donors, *c.* 1393.

formally occupied but it seems that the glazing was not quite complete. Although the glazing accounts do not survive for this period, the windows can be connected with Thomas through his documented associations with the college. Thomas dined regularly at New College between August 1386 and 1389, and rather less frequently between 1398 and 1422. His last recorded work there was in 1416-17.[31] Thomas's major project in the early 1390s was also carried out for William of Wykeham. This was Winchester College, the buildings of which were erected between 1387 and 1394: in 1393 he was transporting glass for its windows from Oxford and his 'portrait' was inserted into the chapel east window. The glazing was presumably completed by 1396-7, when repairs to the windows were necessary. In 1421-2 Thomas Glazier was repairing the glass in the chapel.[32] Thomas is also known to have carried out work at Wykeham's residence at Highclere in 1394 and in the following year he was employed at Canterbury College, Oxford. In 1397-8 his accounts were settled for glazing three windows in the vestry and one window over the high altar and repairing the chancel windows in Adderbury church, Oxfordshire. In 1409-10 he was paid for work on the windows of St Mary's church in Oxford. Thomas was dead by 1427-8. He had a son working as an assistant who may be identifiable as the John Glazier who was employed on the windows of All Souls College in 1441.[33]

Almost all of the original glass of *New College Chapel* is from the antechapel. In the main lights of the windows are a series of prophets and patriarchs, apostles, saints, and representations of the Crucifixion. The tracery lights contain the Nine Orders of Angels, the Coronation of the Virgin and William of Wykeham kneeling before Christ. The remains of the Jesse from the great west window in the antechapel are now in the south choir aisle of York Minster (window sVIII) and parts of the tracery Doom are in High Melton church, South Yorkshire (nII, nIII). Some of the original tracery glazing of the chapel proper survives amongst the eighteenth-century figures filling the windows and in the Muniment Tower.[34]

With the important exception of the Jesse, which is almost certainly later in date, the New

*Fig. 141*

*Fig. 144(b)*

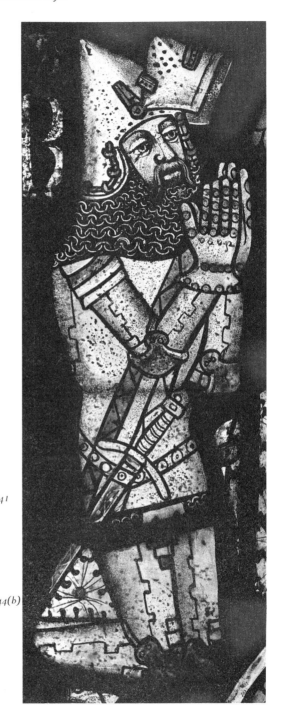

Fig. 139   BIRTSMORTON (Heref. & Worcs.): member of the Ruyhale family, *c.* 1385-1400.

College glass shows that at this stage of his career Thomas was not an innovator and still adhered to current fashions. Set in the coloured grounds behind some figures are initial letters under crowns of the same design as the borders at Letcombe Regis, Stoke Charity, Old Warden and the other places cited above. The New College canopies are festooned with multiple turrets and shafts, in a manner which finds echoes slightly later on the Continent, in Hermann von Münster's glass at Metz Cathedral (1384–c.1392), the west window of Altenberg Abbey near Cologne (end of the fourteenth century) and window nV in St Martin's basilica at Hal in Belgium, consecrated in 1409.[35] The three-sided platforms, square-framed traceried windows, heavy cornices and battlements of some of the New College canopies are, however, more closely related to the architectural forms seen at *Old Warden* and elsewhere and therefore *Fig. 137* developed from indigenous designs. In figure style too the New College saints and prophets are in the mainstream of contemporary English painting. Their large noses, prominent eyes and rather surprised expressions are akin to the *Lytlington Missal*; even allowing for the vast *Fig. 140* differences in scale, the Virgin Mary and Eve in the New College glass are comparable with the Virgin on the Crucifixion page in the *Missal*. Similar comparisons can be made with some of the figures in the *Pepysian Sketchbook* in Magdalene College, Cambridge.[36]

The iconographical scheme for the *Winchester* *Pl. XIX* *College* chapel glazing was similar to the New College formula. This time the Tree of Jesse was in the east window, at the base of which were depicted Edward III, Richard II, William of Wykeham (twice), Simon Membury (Clerk of the Works) and three of the craftsmen involved in the building of the college including Thomas Glazier himself. Most of the surviving glass from *Fig. 31(a)* this window is distributed between the west window of Thurbern's Chantry attached to the chapel and the east window of Fromond's Chantry. The eastern pair of windows on either side of the chapel each contained three prophets above three apostles and the remaining four windows were glazed with various saints. Two apostles and a prophet survive in the Victoria and Albert Museum.[37]

If the subject-matter of the two establishments shared common features, in style and design Thomas's work at Winchester introduces a number of features which collectively signal an important turning-point in the history of English glass-painting. In the treatment of figures the chief distinction between Thomas's output of the 1380s and that of the 1390s lies in the modelling. The New College glazing is essentially linear, with drapery folds treated in a uniform manner. By contrast, the Winchester figures are more subtly formed by means of varying the thickness of the trace-lines and masterly use of shading – especially by stippling – to create modelled bodily forms which are also more substantial than their New College counterparts. A comparison of St Thomas at New College with *Fig. 141* the Winchester Virgin and Child demonstrates the distinction very clearly. The latter has a sculptural, three-dimensional quality which coupled with an elegance of pose endows it with a different set of aesthetic values from St Thomas.

Were it not for the documentation it would be hard to believe that the two glazing schemes were the work of the same craftsmen (except for the Jesse at New College, which as it exhibits the *Fig. 144(b)* same characteristics as the Winchester glazing also probably dates from the 1390s).[38] The Winchester features described above are not an isolated phenomenon springing as it were from a void; on the contrary they are the hallmarks of the International Gothic style which dominated European art in the period c.1380–1420.[39] International Gothic, as the title indicates, shows a high degree of uniformity and evidently there was much cross-fertilization and exchange of artistic ideas between different media and across frontiers. These exchanges could, for example, explain the similarities between the Winchester glass and the splendid contemporary wall-paintings in the Byward Tower, Tower of London.[40] Precisely how and where Thomas of Oxford encountered International Gothic is unclear. The cultural climate at the time was extremely conducive for anyone receptive to new ideas. English patrons were purchasing items from overseas, principally from the various lands comprising the Holy Roman Empire (which included Bohemia). It has long been recognized

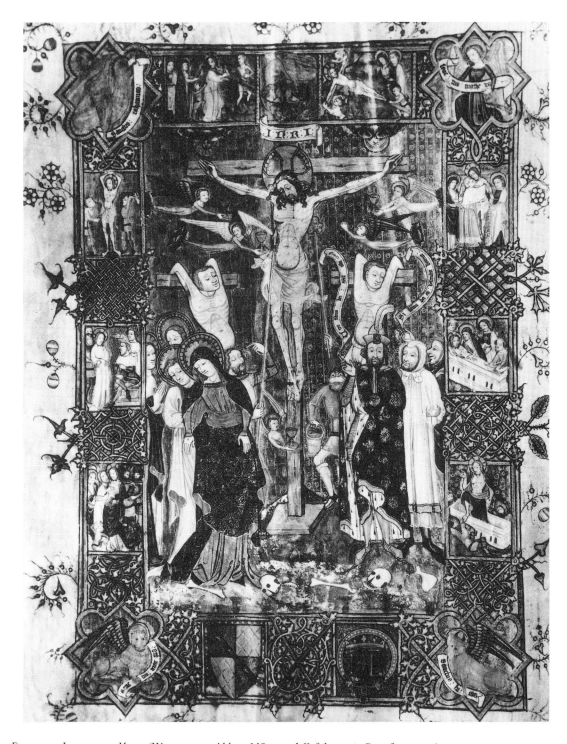

*Fig. 140* LYTLINGTON MISSAL (Westminster Abbey, MS 37, vol. II, fol. 157v): Crucifixion, 1383–4.

that the Apocalypse wallpaintings in the Westminster Abbey chapter houe are the work of a painter whose style was closely related to that of Master Bertram, the leading Hamburg artist of the late fourteenth century. Two drawings of *c.*1395 in a Cambridge manuscript (Cambridge Univ. Archives, Collect Admin.3), recently published by Nicholas Rogers, are also indebted principally to German art. The same author has drawn attention in documentary references to the presence of both German works of art and artists in England from the 1370s.[41] Amongst them was a painter named Herebright of Cologne; in the present context it may be more than coincidental that he was employed by William of Wykeham. There are affinities between Thomas's Winchester style and the works of two slightly later north German artists, the Master of St Veronica (active in Cologne) and the Westphalian panel painter Conrad von Soest.[42]

This is not to say that artistic output throughout the Holy Roman Empire and elsewhere in this period was homogeneous; on the contrary each centre contributed its own flavour to International Gothic. Similarly artists did not slavishly copy one version but made use of a variety of sources. This could explain the similarities that have also been noted between Thomas's work and the art of the Low Countries. Professor Sauerländer has compared the expressive strength of the Winchester College apostles with the work of the sculptor and illuminator André Beauneveu from Valenciennes, who between 1372 and at least 1381 worked for Louis de Mâle, Count of Flanders, and then, in *c.*1384, entered the service of the great patron, Jean, Duke of Berry.[43] In addition Jean Helbig saw an affinity between Winchester and a window of 1387-98 at Sichem in north-east Belgium, which depicts Christ on the Cross between the Virgin and St John.[44]

Other innovatory aspects of the Winchester glazing seem to have been without Continental precedents. The basic structure of the New College canopies is retained, but radically altered by hollowing-out the three-sided platform and concealing it by multiple crocketed arches, shafts and pinnacles; this became the standard canopy formula employed by English glaziers

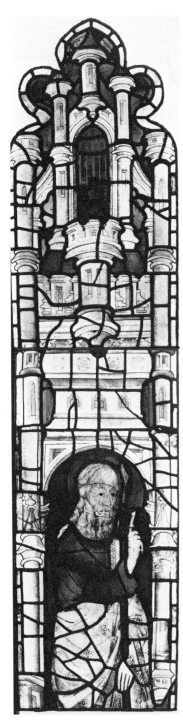

*Fig. 141*  OXFORD, NEW COLLEGE CHAPEL: St Thomas (detail), *c.*1380-6.

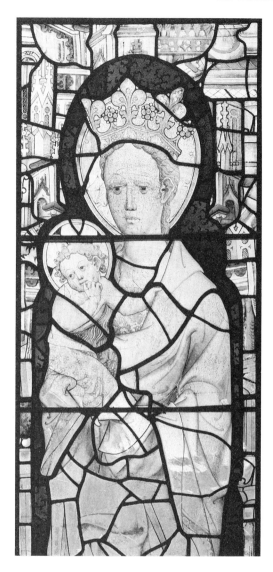

*Fig. 142* (*left*) OXFORD, MERTON COLLEGE CHAPEL: Virgin and Child, *c.* 1390–1400; (*right*) THENFORD (Northants.): St Anne teaching the Virgin to read, *c.* 1400.

throughout the fifteenth century. Similarly the 'seaweed' foliate pattern used on the coloured backgrounds to the figures at Winchester was adopted widely during the next half-century.

    A few other works can be attributed to Thomas Glazier of Oxford. In the Bodleian Library is the half-length figure of a military saint (St George?) from Adderbury church which was

*Pl. XIX*

appropriated to New College in 1381 by William of Wykeham. The figure is similar to some of the tracery light figures in the college chapel, which suggests that if it is by Thomas it dates from before his documented activity at Adderbury in 1397–8.[45] The east window of the nave north aisle (nIII) at *Thenford* in Northamptonshire contains a more or less complete St Christopher

*Fig. 142*

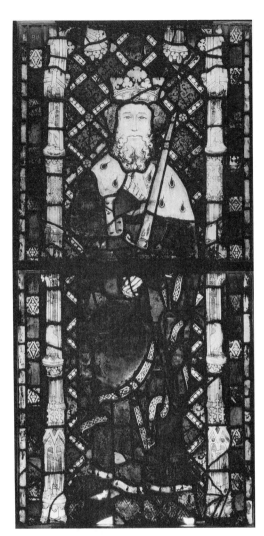

Fig. 143    CANTERBURY CATHEDRAL (Kent), nave west window: English king, 1396–1411.

*Chapel* and some glass in Winchester Cathedral are comparable with the fully-fledged 'soft' style of the Winchester College glazing. The Merton glass comes from the transept windows and comprises a Virgin and Child, St John the Evangelist and two abbesses. The cost of glazing almost all the nave aisle and clerestory windows of Winchester Cathedral was met by a bequest of 500 marks in William of Wykeham's will. Re-set in the choir clerestory are several figures within canopies and side-shafts, including a female saint and St Lawrence, which originally were in the nave clerestory; a few canopies and roses, a female saint and one of the cherubim also survive in the nave.[47]

His work from Winchester College onwards shows that Thomas Glazier of Oxford was one of the leading proponents of International Gothic and deserves to stand alongside painters such as the anonymous Master of the Wilton Diptych (London, National Gallery). Not all English glass-painters assimilated the new style from the last decade of the fourteenth century. On 7 May 1391 Robert Lyen and the chapter of *Exeter Cathedral* made an agreement for glazing the newly reconstructed east window, incorporating the figures executed in 1301–4. Lyen's own contribution consists of the full-length figures of SS Edmund of East Anglia, Edward the Confessor, Helena and Sidwell, each of which is set within an architectural framework and borders dating from Frederick Drake's restoration of 1884–96. The original canopies and bases were related to those at New College rather than to the Winchester College canopies and the treatment of faces, draperies and the colour combinations are also comparable with New College. In 1380 Robert the Glazier (surely Robert Lyen) became a freeman of Exeter, having been the servant and apprentice of Thomas Glasiere for ten years; the stylistic and design affinities between Lyen's work of 1391 and New College raise the intriguing possibility that his master Thomas Glasiere and Thomas Glazier of Oxford were one and the same man.[48]

Other craftsmen followed the same path as Thomas Glazier. The west window of *Canterbury Cathedral* is one of the most important monuments of the period around 1400. It contains a series of English monarchs, of whom Canute,

*Fig. 144(a)*

*Figs 143, 144(c)*

and a fragmentary St Anne teaching the Virgin to read, executed almost entirely in white glass with yellow stain touches. These figures display a remarkable quality of draughtsmanship and sophisticated modelling by means of subtle gradations of wash and stippling on both sides of the glass. Thenford is close to Adderbury and not far from Oxford; if this glass is by Thomas Glazier of Oxford it ranks amongst his finest works.[46] The east window of *Merton College*    *Fig. 142*

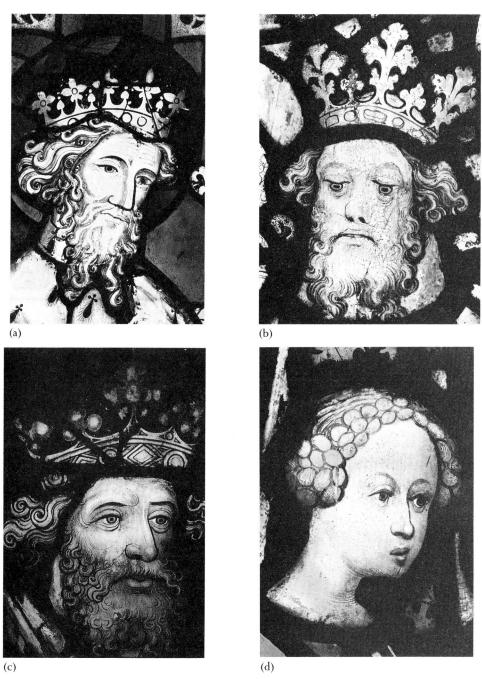

*Fig. 144*    FOUR HEADS:
(a)  EXETER CATHEDRAL (Devon): St Edward the Confessor (surround 1884–96), by Robert Lyen, 1391;
(b)  YORK MINSTER: head of King Manasses from New College Chapel, Oxford, by Thomas Glazier, *c.* 1390–5;
(c)  CANTERBURY CATHEDRAL (Kent): head of king, 1396–1411;
(d)  YORK MINSTER east window: detail from John Thornton's east window, 1405–8.

179

Edward the Confessor and William the Conqueror are identified in a description made in 1777.[49] The side-shafts enclosing each figure have niches, sometimes containing falcons and greyhounds, and the canopy consists of multiple small gables, pinnacles and buttresses organized around a central structure of varying design. The rich latticework grounds are a motif borrowed from English glass of the first half of the four-teenth century (as at Peterborough Cathedral, Stanford on Avon, Northamptonshire, Brinsop and Eaton Bishop in Hereford & Worcester), but the massive, bulky proportions of the figures and the simplified drapery place the glass in the International Style. The west window can be dated on heraldic evidence to after March 1396 and it was probably completed before Richard II's deposition in September 1399, although a lost inscription indicates that the glazing may have continued past 1400.

All the glass described so far is in the south of England; windows in the Lady Chapel clerestory and aisles (windows SV, NIV, NV, nVI, sII and sV) of York Minster demonstrate the assimi-lation of International Gothic.[50] The two south aisle windows contain figures of saints above narrative scenes, with both groups set under-neath canopies made up of battlemented and three-sided superstructures similar to those at Edington, Heydour and Old Warden. These windows probably date from soon after 1373, when the Lady Chapel appears to have been more or less completed. The same basic canopy design also occurs in the three clerestory windows, but there it is accompanied by variants embellished with multiple pinnacles and turrets and openwork arches comparable with the canopies in the Canterbury west window and Winchester College Chapel. The apostles and prophets below the canopies in these windows also have similarities in facial types, bulky drap-eries and soft modelling with the Canterbury kings, so it is likely that the Minster clerestory windows are contemporary.[51] It has been suggested that they are the work of John Burgh, a glazier frequently employed in the Minster between 1399 and 1419 and who was made a freeman of the city in 1375. He may have been the John Burgh who worked for Henry IV at

Eltham in 1404 and whose brother William was commissioned to execute heraldic glass for Westminster Hall in 1399 and also worked at Eltham between 1399 and 1404.[52] If correct, this connection would form a link between the development of International Gothic in the south and its first manifestations in York.

The city of York contains within its walls most of the finest surviving works by the second generation of glass-painters working in this style. The most influential of these was John Thornton of Coventry, who seems to have been instru-mental in disseminating International Gothic in the Midlands and the north. In 1371 one John de Thornton held a tenement in Coventry, but the first certain reference to the glass-painter is in 1405, when he contracted with the dean and chapter of York Minster to glaze the choir east window within three years. In 1410 Thornton was made a freeman of York, but he retained his Coventry links and in the following year he was living in a house in St John's Bridges in the latter city. In 1413 he acquired the lease of this property, obtaining its reversion for sixty years after the death of the previous tenant. Thornton is next documented in York in 1433, when the

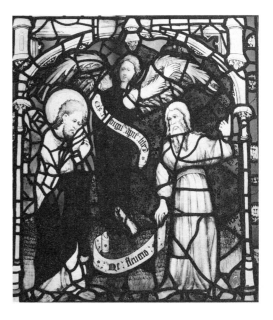

*Fig. 145* YORK MINSTER east window: St John weeps and is comforted (Revelation 5: 2–5), 1405–8.

dean and chapter made a payment to him and he was holding property there which belonged to them.

The touchstone for Thornton's style, and his great masterpiece, is the Minster east window. This vast translucent wall is the largest window in the building and contains approximately 1,680 square feet of glass. Its sheer size alone places it amongst the most impressive achievements of medieval glass-painting anywhere. The subject-matter added to the complexity of the project and must have involved the preparation of a very large number of cartoons; this would explain why the contract required Thornton personally to 'portraiture (sic) the sd window with Historical Images & other painted work in the best manner & form that he possibly could'. His models are unknown, but may well have included an illuminated Apocalypse manuscript like that purchased in 1346–7 to guide the carvers of the Norwich Cathedral roof bosses; copies of the Revelation of St John were to hand locally, for one was owned by Henry, Lord Scrope of Masham (d. 1415), whose arms occur on the Minster choir arcade.[53] The technical difficulties may have been compounded by the

death in 1406 of the probable donor, Walter Skirlaw, bishop of Durham, before the work was completed and by changes in personnel amongst the York clergy. There are well over one hundred main light panels and more figures in the tracery lights. The latter comprise the witnesses to God's omniscience arranged in descending hierarchical order from God in the apex, through the Nine Orders of Angels, the patriarchs, the worthies of Israel, the prophets and finally the saints. The first three rows at the top of the main lights depict twenty-seven Old Testament scenes commencing with the Creation cycle from Genesis and terminating with the death of Absalom. Then follows the main narrative sequence of eighty-one panels illustrating the Revelation of St John. At the base of the window is a row of figures connected with the history of the Church in the north of England and Bishop Skirlaw. The contract states that Thornton was 'to paynt the same, where need required'. The rest of the painting was to be done by the other craftsmen he was to find and the window does reveal the hands of several glass-painters. Probably, Thornton recruited from the glaziers resident in York at the time; at any rate his style and design traits seem to have been adopted wholesale in the city, so much so that to date it has not been possible to distinguish the output of one workshop from another during the fifteenth century. Probably Thornton was involved in the entire glazing of the Minster choir west of and including the north choir transept in the second decade of the fifteenth century (windows NVI–NXI, SVI–SXI, nVII–nX, sIX, sX). Whether he was responsible in the late 1430s or early 1440s for the St Cuthbert window in the south choir transept (sVII) is debatable.[54] Recent research suggests that its counterpart, the St William window (nVII) which contains a vast narrative cycle rivalling that in the east window, may have been executed in *c.*1415 rather than *c.*1420–3, which has been the accepted dating.[55]

The hallmarks of Thornton's version of International Gothic are visible in the glazing executed in the parish churches of York during the first three decades of the fifteenth century. Thornton is unlikely to have monopolized production, but almost certainly he was involved

*Figs 65, 144(d), 145*

*Figs 40, 59*

*Fig. 41*

*Pl. XX*

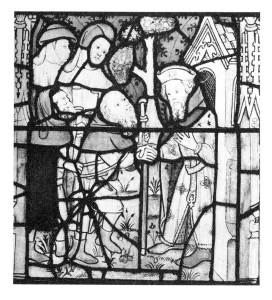

*Fig. 146*   York, All Saints North Street: Entertaining strangers, from a Corporal Works of Mercy window, early fifteenth century.

*Fig. 147* COVENTRY (West Midlands): fragments in south porch memorial chapel of former cathedral, early fifteenth century.

in the glazing of *All Saints North Street.* In 1409/10 an inventory made soon after the death of a mason recorded that he owed money for the stone of a window in this church and in turn was owed £4 by John Thornton and William Pontefract. The east window, *Pricke of Conscience,* Works of Mercy and Nine Orders of Angels windows (I, nIII, nIV, sV) here have much in common with the windows at the east end of the Minster.[56] The same applies to a greater or lesser extent to the Tree of Jesse and Nine Orders of Angels in St Michael Spurriergate (windows sII, sIII, sIV) and to the remains of a St Catherine window in St Denys Walmgate (window sII) and other glass here. More glass in the same style is to be seen elsewhere in York and its vicinity, including the east window of Bolton Percy, where the somewhat restored ecclesiastics are

*Figs 66, 146*

repeats of those in the Minster choir clerestory; this church was dedicated in 1424. The apostles and prophets in the tracery of the great east window of Beverley Minster, which probably dates from between 1416 and *c.*1420, and some heads excavated at Whitby Abbey, now in Whitby Museum, are also attributable to York glaziers working in the Thornton manner.[57] The city's craftsmen evidently ranged even further afield in the north. The east window of Cartmel Priory in Cumbria includes an archbishop saint taken from the same cartoon as the bishop saints in the western choir clerestory of the Minster. In Durham Cathedral there are some Thornton-style fragments which may have come from the re-glazing of the Chapel of the Nine Altars carried out for Bishop Thomas Langley (1406-37). He was previously Dean of York and was the donor of the St Cuthbert window in the Minster.[58]

Thornton's stylistic traits and design features have been associated so closely with York that their appearance in glass outside the north of England has been taken to signify that the work in question must be attributed to glaziers from that city. There can be little doubt that York craftsmen did indeed dominate production in this region, but Thornton's style was not exclusive to York, as the late Peter Newton established.[59] There is much glass in the Midlands in the same style as the York work described above and Thornton's origins in, and lasting connections with Coventry lead to the conclusion that he was operating workshops concurrently in both cities. In *Coventry* glass in the Thornton manner exists in St Mary's Hall (built 1394-1414) and in the remains of the glazing from the former cathedral.[60] Similar glazing can be seen at Mancetter and Wixford in Warwickshire (the latter in the chapel built by Thomas Crewe in 1411-18), in the collegiate church at Tong in Shropshire, probably glazed by 1410, some of the chancel glass at Ludlow also in Shropshire (a north window here formerly bore the date 1425), the chapel glazing at Haddon Hall in Derbyshire, dated 1427, and the east window of the parish church at *Thurcaston,* Leicestershire, given by the rector John Mersden (d. 1425). At Frolesworth in the same county are the remains of the chancel

*Fig. 147*

*Pl. XXI*

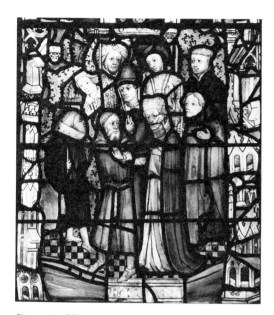

*Fig. 148* NEWARK (Notts.): suitors in the Temple, early fifteenth century.

are affinities in general facial types, and in the *Hours of Elizabeth the Queen* (BL MS Add. 50001) *Fig. 40* Johannes uses an architectural framework for the Last Supper miniature with small prophets set in niches which are reminiscent of those in the York Minster choir windows.

The International Gothic style was very quickly disseminated throughout England in the first three decades of the fifteenth century and there is plentiful evidence of the adoption of its canons by glaziers outside the major centres. It is not possible to discuss all the relevant monuments, but two areas in particular are worth a brief mention.

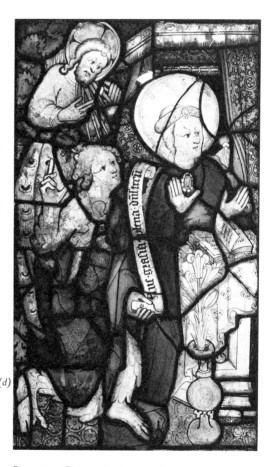

*Fig. 149* GLASGOW, BURRELL COLLECTION: Annunciation from Hampton Court (Heref. & Worcs.), *c.* 1425–35.

glazing executed in the time of Thomas Wolfe, rector from 1401, and at *Newark-on-Trent*, *Fig. 148* Nottinghamshire, is a series of seven panels depicting scenes from the lives of the Virgin and Christ.[61] The now dispersed glazing of the chapel at *Hampton Court* in Hereford & Worcester, *Fig. 149* which probably dates from the late 1420s or early 1430s, is another important work attributable to Thornton and his Coventry associates.[62]

All this glass shares certain characteristics: a predominance of white glass and yellow stain which contrasts with the blue or ruby 'seaweed' patterned backgrounds, the frequent use (in the York glass) of small figures of prophets set in niches in the side-shafts and a canopy design consisting of more or less standard elements. Heads are distinctive, with long noses with a bulbous tip and small mouths. Subtle modelling *Fig. 144(d)* is achieved by light and delicate washes and stipple-shading. Notwithstanding the differences in medium and scale, comparisons can be made between Thornton's work and that of three leading manuscript illuminators of the period, Herman Scheerre, John Siferwas and an artist named Johannes. Of the three, Thornton's style approximates most closely to Johannes'.[63] There

*Fig. 150*   MELLS (Somerset): head of female saint, *c.*1430. Engraving by C. Winston.

The West Country glass-painters active during the early fifteenth century maintained the traditions of their forefathers and were responsible for some fine glass. The sensitive modelling and delineation of the Virgin and Child in the east window at Farleigh Hungerford and of the apostles at Orchardleigh in Somerset suggests that they date from the first or second decade of the century. Slightly later are the female saints in the tracery of a north aisle window at *Mells* (nVI) in the same county and a head in Bristol Cathedral.[64]

In East Anglia the International Gothic style occurs in various branches of pictorial art, e.g. in a missal from the Diocese of Norwich (BL MS Add. 25588), on two panel paintings found in a house in Norwich (now in the Fitzwilliam Museum, Cambridge) and on altarpieces in the Lady Chapel of Norwich Cathedral and Christchurch Mansion, Ipswich.[65] Various interpretations of International Gothic can be found in Norfolk glass, notably the Ascension, Pentecost and Coronation of the Virgin scenes in the tracery lights of the east window at

*Fig. 150*

Saxlingham Nethergate, some fragments including angels in a north window (nV) at Litcham and two fine figures of God the Father in the tracery of a nave south aisle window at Salle (sXII). The Saxlingham glass was probably executed in the period *c.*1390–1413 and one south aisle window at Salle formerly bore the date 1411. The Salle figures are close in style to a very delicately drawn figure of Christ displaying His wounds at *West Rudham* (nV).[66] One of the panels at Saxlingham Nethergate has an 'ears of barley' pattern which was to become one of the hallmarks of East Anglian glass.[67] In the west window, some tracery lights in the nave and the north porch at *North Tuddenham* are some elegant panels purchased by the incumbent from a builder's yard at East Dereham during the second half of the nineteenth century.[68] The figures bear all the trappings of the refined International Gothic style. The rich caparisons of the horses and the armour of St George recall a drawing of the same saint added to an early fifteenth-century *psalter* (Oxford, Bodl. Lib. MS Don. d.85).[69] The narrow-waisted and high-necked dress worn by St Margaret is redolent of contemporary Court fashion and may be compared with the attire of the lords and ladies in the frontispiece illumination to a manuscript of Geoffrey Chaucer's *Troilus and Criseyde* (Cambridge, Corpus Christi Coll. MS 61). The North Tuddenham panels also have pastoral settings reminiscent of this miniature and two initials in the *Psalter and Hours of John Duke of Bedford* (BL MS Add. 42131) which reveal the influence of the Flemish illuminator known as the Boucicaut Master and his followers.[70] The *Troilus* manuscript is undated and the *Bedford Psalter and Hours* was executed between 1414 and 1423. The North Tuddenham panels may be contemporary with the latter manuscript. The 'ears of barley' pattern in one of the canopy interiors indicates that they are the work of a local atelier.

From the late 1430s the International Gothic tradition began to weaken. The draperies of the Coronation of the Virgin in sV and the heads of the angels in this and another window (sX) in the nave south aisle at *Buckden* in Cambridge-shire are still sensitively treated, but the shading

*Fig. 153*

*Fig. 151*

*Fig. 152*

*Fig. 69*

is heavy and the angel figures ill-proportioned. The aisle windows formerly contained the arms of William Gray, Bishop of Lincoln (1431-6), but as the corbels of the nave roof bear the heraldic shield of his successor, Bishop Alnwick, the glass almost certainly dates from the time of the latter's episcopate (1436-49).[71] In *York* the Thornton tradition appears to have remained active beyond the middle of the century. In *c.*1435-45 the St Cuthbert window in the Minster was glazed. This was the gift of Bishop Langley of Durham and is situated in the south choir transept (sVII) opposite the St William window. It is the latter's exact counterpart in size, consisting of twenty-one rows each of five historiated panels. 'Jewelled' inserts are used, and

*Fig. 41*

recently the traditional view that the window represents a decline in quality compared with Thornton's earlier work in the choir has been challenged convincingly; the excellent draughtsmanship is concealed by the large number of repair leads and back-glazing.[72] Other commissions included the large window (nII) depicting scenes from the life of St Martin donated in *c.*1442 to the church of *St Martin-le-Grand* in Coney Street by its vicar Robert Semer, and glass elsewhere in York, notably the east windows of St Olave's Marygate and St Denys Walmgate. Amongst the fragments in the chancel south chapel (sV) at Thornhill in West Yorkshire are the remains of a Nine Orders of Angels window which is unmistakably York work, probably of

*Fig. 54*

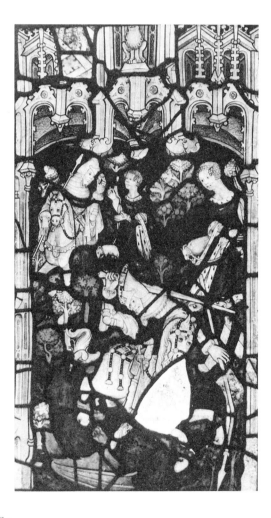

*Fig. 151* (*left*) PSALTER (Oxford, Bodl. Lib. MS Don. d. 85, fol. 130): St George, early fifteenth century; (*right*) NORTH TUDDENHAM (Norfolk): St George, *c.*1415-25.

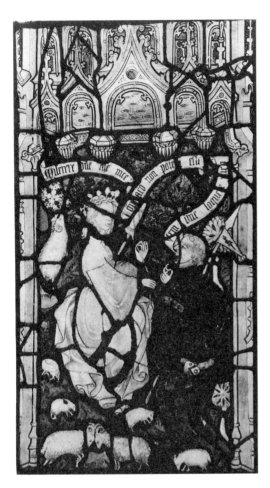

*Fig. 152* (*left*) NORTH TUDDENHAM (Norfolk): scene from the life of St Margaret, *c.* 1415–25; (*right*) *BEDFORD PSALTER & HOURS* (BL MS Add. 42131, fol. 95): initial to Psalm 26, 1414–23.

the late 1430s or early 1440s. A second window in the Savile Chapel here (nIV), bears the date 1447 and depicts the Holy Kindred.[73] The panels mark a hardening and coarsening of the Thornton tradition and may be compared with the Archangel Gabriel and St John the Baptist with donors in the south transept of *York Minster* (windows sXIII, sXIV). A similar loss of elegance is detectable in the Virgin and Child, Mass of St Gregory and St James (his head is not medieval) in window sVI in All Saints North Street, York.

*Fig. 154*

*Fig. 153* WEST RUDHAM (Norfolk): Christ displaying His wounds, *c.* 1430–40.

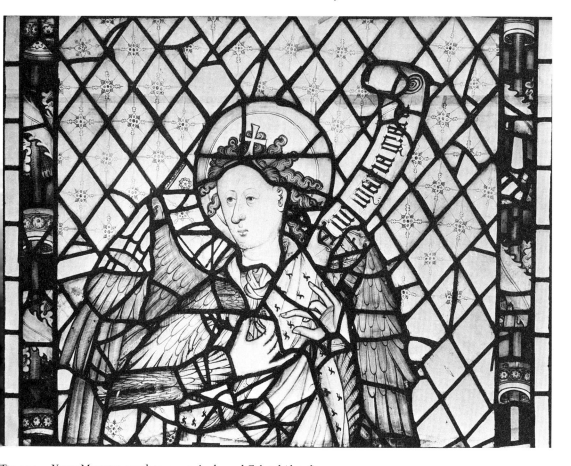

*Fig. 154*   YORK MINSTER, south transept: Archangel Gabriel (detail), *c.* 1440.

The Minster figures have been dated *c.* 1440 and those in the parish church to the period 1436–51.[74]

Craftsmen in the Midlands continued to execute important commissions during these years. The collegiate church of *Battlefield* in Shropshire was founded in 1409 on the site of the Battle of Shrewsbury, in which Henry IV triumphed over the Percy family and the Scots. Antiquarian records show that the windows included figures and lives of saints such as George, Nicholas and John the Baptist, in addition to Chad and Winifred who were popular in the area. The evidence of lost donor figures and inscriptions suggests that much of the glazing dated from *c.*1434–45. In 1749 the remaining glass was removed and much of it *Fig. 155*

destroyed. A century later most of the surviving fragments found their way to the nearby parish church at Prees (window nII); the few pieces remaining at Battlefield have been gathered in the vestry. Their style exhibits the characteristics of the Thornton version of International Gothic, but with much the same loss of elegance observable in the York glass of the period.[75] A similar judgement can be applied to the heavily restored figures of four saints and the donor, Thomas Spofford, Bishop of Hereford (1421–48), in the east window at *Ross-on-Wye* in Hereford & Worcester; these come from the east window of the Bishop's Chapel at Stretton Sugwas. Spofford previously had been abbot of St Mary's Abbey in York and would have been well-acquainted with the work of Thornton and *Fig. 13*

*Fig. 155* (*left*) LYDDINGTON BEDEHOUSE (Leics.): Bishop Alnwick (detail), 1436–49; (*right*) BATTLEFIELD (Salop): head of a saint, *c.* 1434–45.

his followers. The window is probably contemporary with the Battlefield glass.[76]

The east window of *Great Malvern Priory* Fig. 156 marked the start of a comprehensive programme of re-glazing the church which was not completed until the beginning of the sixteenth century.[77] The window contains a Passion cycle in the main lights and apostles and other figures in the tracery. In the apex is a shield bearing the arms of Richard Beauchamp, Earl of Warwick, and his wife Isabella Despenser, who married in 1423. The glass was almost certainly executed before their deaths in 1439 and probably predates the Battlefield glazing; the style is very close to the Hampton Court glass. The glazing of the three north choir clerestory windows (NII, NIII, NIV) was carried out from the 1440s, possibly into the 1460s, and provides further evidence of the decline of the International Gothic style.[78] Although in the easternmost window (NII) modelling is still apparent, in the companion windows it is almost completely Fig. 74 abandoned in favour of a more linear, two-dimensional treatment of faces and bodies. The same observation applies to other glass of this period, including the figure of Bishop Alnwick (1436–49) in *Lyddington Bedehouse*, Leicester- Fig. 155

shire.[79] Some fine glass is to be seen in the tracery of several windows at *Salle*. The east Fig. 15 window has scenes of the Nine Orders of Angels and the Fall of the Rebel Angels and in two chancel side windows (nII, sII) are prophets, patriarchs and cardinals. The chancel glazing can be dated by lost inscriptions to between 1441 and 1450 and is exceptionally sumptuous for a fifteenth-century parish church. The rich use of coloured glass, principally ruby and blue, and the yellow stain stars in the backgrounds invite comparison with the Beauchamp Chapel glazing of 1447–64, although Salle does not have any 'jewelled' inserts. The figures show a similar move away from the 'soft' style and towards a more linear treatment of draperies as at Great Malvern. They do not display typical features of East Anglian glass of the period, unlike the Salle transept glazing of *c.* 1440–50.[80] Some of the faces, however, are heavily modelled, which is also a feature of the apostles in the east windows of the antechapel at *All Souls College*, Oxford. The female saints here conform to a greater Figs 44 degree to International Gothic conventions in drawing style and the treatment of draperies in heavy swathes and few folds. The canopies and background to both sets of figures are very

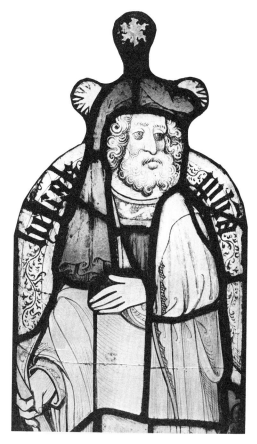

*Fig. 156*    GREAT MALVERN PRIORY (Heref. &
Worcs.), east window: Last Supper, *c.* 1423–*c.* 1439.

*Fig. 157*    SALLE (Norfolk): prophet (detail),
*c.* 1441–50.

similar, but the differences between the female
saints and the apostles suggest that they are not
the work of the same craftsmen, a theory which
has some documentary support. At the end of
1441 John Glazier of Oxford received £12 13s
4d in part payment for six windows in the ante-
chapel, at a rate of 1s per square foot. These
windows appear to be those containing the

apostles and female saints, but possibly John
Prudde, the King's Glazier, or his workshop had
some part in their execution. In the same
accounts there is a payment of 10s 8d to 'the
servant of John Prowte glazier',[81] and it is note-
worthy that the female saints have some affini-
ties with his Beauchamp Chapel glazing, which is
discussed in the next chapter.

# 9

# *The End of the Middle Ages*

The years between *c.*1450 and the Reformation are more notable for the quantities of surviving glass by indigenous craftsmen than for innovations (the work of the foreign glaziers active in England is examined in the following chapter). A possible explanation is that for much of this period English glazing is more insular and exhibits less contact with Continental art than in any previous century.

During the fifteenth century there seems to have been an expansion in the types of glazing available.[1] At the top of the scale is John Prudde's work at the *Beauchamp Chapel*, Warwick, executed between 1447 and 1464. Here white glass is mainly confined to faces and hands and a wide range of colours is employed. The impression of sumptuousness is enhanced by the use of coloured glass 'jewels' inserted into haloes and draperies. Prudde was not the first English glazier to use drilled inserts, but he did so on an unprecedented scale. The largest concentration of examples of imitation jewelling is to be found between the Thames and the Trent and their popularity in this region is probably due to the example of the Beauchamp Chapel. Outside this area, 'jewelled' inserts can be found in late fifteenth- and sixteenth-century glass from Yorkshire to Kent and in both the West Country and East Anglia.[2] 'Jewelling' and the use of generous quantities of coloured glass are not typical of English glazing in this period. The standard formula remained one of single figures or scenes set against coloured or quarry grounds under canopies. The price depended on the amount of coloured glass and the presence or

*Pls II(c), III(b), III(d)*

*Pl. III(b)*

absence of niche settings. The colours normally found between *c.*1450 and the end of the century also did not differ substantially from those employed in the era of Thomas Glazier of Oxford and John Thornton. Red and blue were still the most popular, followed by purple and green. At the end of the fifteenth and during the early decades of the sixteenth centuries a new range of colours was introduced by the immigrant Flemish and German glaziers.

The native glass-painters displayed few innovations in technique and design, apart from the substitution for 'seaweed' patterns on coloured grounds of large flowers – an early example is the All Souls Oxford Chapel glazing of 1441. Unlike their Continental counterparts, the English glaziers remained unwilling to create 'pictorial' windows by running narrative themes across the mullions. The first tentative move in this direction appears to be the Creed windows at *Ludlow* (nVI, nVII), where the apostles are set in an architectural interior which spans all three lights in each window. The date of these Ludlow windows in uncertain, but they were probably painted in the late 1440s.[3] The only fully-fledged 'picture' window by indigenous glass-painters is the *Magnificat* window (nVI) in the north transept façade of *Great Malvern Priory*, commissioned in 1501-2. Here the large figure of the Virgin in her glory traverses three lights, although the Incarnation scenes and the donors are confined to their individual lights.[4] Several instances in the first decades of the sixteenth century of 'pictorial' glazing schemes which ignore the architectural divisions, notably *Fair-*

*Pl. XXII*

*Fig. 158*

*Fig. 11*

*Fig. 158* GREAT MALVERN PRIORY (Heref. & Worcs.), north transept façade: Virgin in the *Magnificat* window, 1501–2.

*ford* and *King's College Chapel*, Cambridge, are the work of immigrant craftsmen.

Some canopy designs in this period reflect a similar interest in architectural interiors as the Ludlow Creed windows. The series of English kings in *St Mary's Hall,* Coventry, are placed beneath multi-pinnacled and crocketed tabernacles of the same basic type as those of the first half of the fifteenth century, but with the addition of a vaulted interior with windows at the back, thereby creating the impression that the monarchs stand in space. The window probably dates from *c.*1451–61. Half a century later, a similar attempt to create the illusion of three-dimensional niches was made in the canopies enclosing the figures of saints in the south-east

*Pls XXVII–XXIX* window of Thurbern's Chantry in *Winchester College Chapel.*[5] *Fig. 160*

*Figs 178, 179, 184* Another feature present in the Coventry window of the more sumptuous late medieval glazing schemes is the colourful backcloths behind the kings. Often these occur in donor *Fig. 159* panels and sometimes (as at Coventry) they are surmounted by testers. Although no examples dating before the 1440s appear to exist, backcloths were known in English royal glazing as early as the beginning of the century. In 1402 William Burgh supplied new glass 'worked with figures and canopies, the field made in the likeness of cloth of gold' for three windows in the new oratory at Eltham Palace.[6] The motif may have been derived from French glass, for

*Fig. 159*    COVENTRY, ST MARY'S HALL (West Midlands): English kings, *c.* 1451–61.

coloured backcloths in association with vaulted canopy interiors and windows can be seen at Evreux Cathedral, dating from the late four-teenth century onwards.[7]

The pattern of commissions continued the trend of the previous period and our knowledge of English late medieval glazing is largely derived from parish churches. However, the re-glazing of Sherborne Abbey, Great Malvern Priory, Westminster Abbey, Durham Cathedral Priory and the Lady Chapel of Gloucester shows that the Benedictines were still prepared to under-take major programmes. The most prestigious glazing schemes were those associated with chantries, whether chapels attached to larger buildings, such as the Beauchamp Chapel at Warwick, or major collegiate foundations like Tattershall, Lincolnshire, and the mausoleum of the House of York at Fotheringhay in Northamptonshire.

The middle years of the century witnessed in many areas a further shift away from the Inter-national Gothic style; with it went not only the homogeneity of the early part of the century, but also much of the subtlety and elegance that for so long had characterized the work of English glass-painters. A parallel change can be observed in English manuscript illumination, notably in the work of William Abell, active between the 1440s and 1460s.[8] His early works retain many of the characteristics of International Gothic with soft flowing draperies and delicately

modelled faces, whereas in his later manuscripts such as the *Abingdon Missal* of 1461 (Oxford, Bodl. Lib. MS Digby 227) the elegant draperies are replaced by sharp, angular folds, faces are vigorously modelled and the figures are starkly outlined against backgrounds by thick contour lines.

Here and there traces of International Gothic survived into the second half of the century. A considerable number of windows in Devon, Dorset, Somerset and Wiltshire have been attributed to a West Country workshop on the basis of figure style, border and quarry motifs and background patterns.[9] A characteristic feature is a sharply defined facial outline with prominent cheek-bones. The style can best be described as a debased version of International Gothic. Some of the workshop's output, such as the prophets, the upper half of a Christ and the head of the Virgin from an Annunciation at *Sherborne Abbey*, *Fig. 161* Dorset (windows sX, sXI), still retains touches of sensitive modelling. The prophets almost certainly formed part of the choir glazing and presumably date from after the fire in 1437 which badly damaged the church. Some traces of the 'soft' style still cling to glass executed in the 1470s and 1480s, such as some figures in Exeter Cathedral, the north aisle glazing at Doddiscombsleigh (nII–nIV) and some panels at Ashton (nIV), all in Devon. At Exeter Cathedral the figures of the Virgin and Child, two archangels, SS Martin, Barbara and Catherine in the great

Fig. 160    WINCHESTER COLLEGE CHAPEL (Hants.): St Helena (detail) in Thurbern's Chantry, *c.* 1502.

east window, donor figures of three canons in the east window of the Chapel of St John the Evangelist (nIV) and a fragmentary Crucifixion in St Gabriel's Chapel (sIV) were all originally in the east window of the chapter house. This was begun by Bishop Neville (1456–65) and completed in the time of his successor, John

Fig. 161    SHERBORNE ABBEY (Dorset): Christ and other fragments, after 1437, probably *c.* 1460.

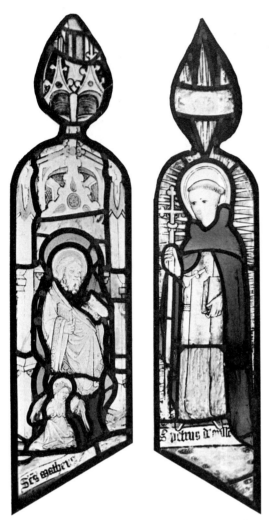

Fig. 162    STAMFORD, ST JOHN'S CHURCH (Lincs.): SS
Matthew and Peter Martyr, 1451.

Gothic traits,[10] but these are less in evidence in the approximately contemporary glass of St George's church in the same town. The head of a Founder Knight of the Order of the Garter in window nII is more linear in treatment and may *Fig. 73* be compared with the figures in the *Founder's Charter upon Act of Parliament for King's College, Cambridge*, illuminated in 1446 by Abell and still in the college's possession.[11] A different trend manifests itself in the opposite window (sII), in *Fig. 163* which the figures of St Catherine and St Anne teaching the Virgin to read both have heavily shaded heads.[12] Other mid-century glaziers developed styles based on heavy shading, including those responsible for the Creed windows at Ludlow.

Prudde's work at the *Beauchamp Chapel* is remarkable chiefly for its lavish use of coloured glass and technical virtuosity.[13] The east window of the Chapel contains the *in situ* figures of SS Alban, Thomas Becket, Winifred and John of *Pls II(c),* Bridlington, in addition to Richard Beauchamp, *III(d)* Earl of Warwick; in the tracery are angels *Fig. 11* holding scrolls with texts taken from the Sarum *Fig. 69* Missal and musical notation from the Sarum Gradual. Other figures in the main lights include the Visitation, the Virgin Annunciate, Christ, *Fig. 164* Isaiah and the remains of several other prophets. Most if not all of this last group originally belonged in the side windows which still contain in their tracery more angels either playing musical instruments or bearing scrolls with the words of anthems and musical notation. A remarkable degree of individual characterization and animation is exhibited by the prophets; their liveliness contrasts with the still poses of the four east window saints which may have been copied from the gold images bequeathed by the Earl to their respective shrines. Coloured glass is employed profusely even in the tracery as well as in the elaborate latticework grounds to the bejewelled and richly clad principal figures.

Glass commissioned by other leading magnates does not match the extravagance of the Beauchamp Chapel, as is indicated by the surviving tracery glazing in the Wenlock Chapel attached to Luton parish church in Bedfordshire built by Sir John Wenlock in 1461.[14] This even applies to the Yorkist church at Fotheringhay. Two tracery angels from the nave of Fother-

Bothe (d. 1478); the glazing probably dates from *c.* 1470. The date 1485 is in the Ashton glass. Other panels are more linear and harder in style, notably the Christ from the Seven Sacraments window (nII) at Cadbury, also in Devon. Cadbury seems to be the work of a different hand to Exeter and a third craftsman appears to have been responsible for the Seven Sacraments window at Crudwell, Wiltshire (nV).

The extensive series of nave tracery light *Fig. 162* figures in St John's church at *Stamford* in Lincolnshire, datable to 1451, also retains International

194

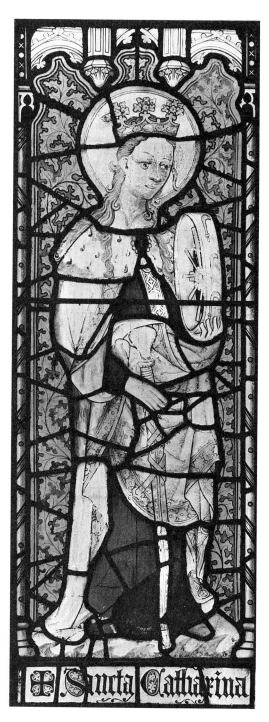

*Fig. 163* STAMFORD, ST GEORGE'S CHURCH (Lincs.): St Catherine, mid-fifteenth century.

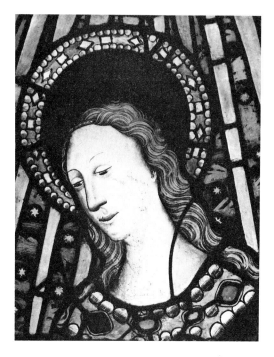

*Fig. 164* WARWICK, BEAUCHAMP CHAPEL: Virgin Annunciate (detail), 1447–64.

inghay are now in the neighbouring church at *Kingscliffe* (window nVIII). Although the contract for the construction of the nave is dated 1434 it appears that the glazing was not carried out until the years *c.* 1461–75.[15]  *Fig. 165*

From the middle of the fifteenth century there was an explosion of church building and rebuilding by wealthy parishioners in the towns and villages of Norfolk and Suffolk. Hand in hand with the new fabric went a demand for stained glass windows, a demand that was met in particular by the Norwich glaziers. Between 1430 and 1500 no fewer than thirty-five named glass-painters are recorded in Norwich, who must have been responsible for much of the glass in the city and in the churches of the neighbourhood.[16]

The principal monument of Norwich glass-painting is *St Peter Mancroft* in the city itself.[17] Most of the glass here was undertaken at various times between the 1440s and the end of the century, although at least one window dated

from as late as 1526–33. In 1441 the construction of a new chancel was in progress and by 1444 the north chancel chapel had either been completed or was nearing completion. In the following year bequests were left to the building of the east gable and east window of the chancel, and for the glazing of the east window of St Nicholas's chapel. The chancel, including its north and south chapels, and the transepts seem to have been glazed between 1445 and the dedication of the church in 1455.

The glazing originally consisted of an extensive series of historiated windows, the remains of almost all of which have been collected in the east window. The principal survivors are a series of main light panels celebrating the Virgin and comprising scenes from the Infancy of Christ and her Death, Funeral and Assumption; to this cycle belongs a male and three female donor

*Fig. 165*  KINGSCLIFFE (Northants.): angel from Fotheringhay Collegiate Church, *c.* 1461–75.

figures. This glass was probably originally located in the east window of the north chancel chapel (nIII). There are also scenes from a Life of St Peter which was either in the north or south chancel window (nII or sII), and from the Life of St John the Evangelist from the chancel north chapel (window nV). Three Passion scenes may originally have been in the adjacent window (nVI) and the scenes from the Lives of St Margaret and St Elizabeth of Hungary and of St Francis receiving the stigmata were probably placed in window sV.

In the careful modelling of figures and the elegant flowing drapery (especially in the Visitation panel), the painter of the Marian cycle *Fig. 166* reveals his debt to the International Gothic tradition and his glass has some affinities with the Christ displaying His wounds panel at *West Rudham* in Norfolk. However, the lively but *Fig. 153* linear treatment of the heads and the wide variety in head-types mark a new departure. Also present in the panels from this window are several of the decorative and stylistic conventions which characterized the work of East Anglian glass-painters throughout the second half of the century: borders with leaves wrapped around a stem and distinctive ground patterns, including the 'ears of barley' motif first encountered at Saxlingham Nethergate, and a liking for detailed landscapes probably inherited from the craftsmen responsible for the St Margaret and St George panels at *North* *Figs 151,* *Tuddenham.* To the same glazier can be attri- *152* buted some tracery light figures from a Genealogy of Christ window originally placed in the east window of the chancel south chapel (sIII) and the panel depicting the Disrobing of Christ and the Casting of Lots from the Passion window. The other two scenes from the latter window are the work of a painter who may be termed the Passion Master. To some extent the style of the Passion Master is a throwback to the softer and more naturalistic painting of an earlier generation. The Creation cycle now divided between the Norfolk churches of Martham (window sV) and Mulbarton (east window), the Holy Trinity at Thurton (window sV), a set of apostles in tracery lights at Pulham St Mary and a fragment at Warham St Mary can be attributed to him. He may well have been active into the 1460s.[18]

*Fig. 166*    NORWICH, ST PETER MANCROFT (Norfolk): Visitation, 1445–55.

The Life of St Peter panels at St Peter Mancroft appear to be by the craftsman responsible for the Marian cycle, although the style is less naturalistic and the drapery is treated in a simpler and more angular fashion. Body proportions also differ from the Virgin scenes, with the heads larger in relation to body size. The same workshop executed the glass in the east window of *East Harling*, near Thetford, which comprises *Fig. 167* fifteen scenes from the Life of the Virgin, together with angels, various fragments and the figures of Sir William Chamberlain (d. 1462) and Sir Robert Wingfield (d. 1480), the first two husbands of Anne Harling. She was an heiress who was largely responsible for the rebuilding and glazing of the church, apparently between 1463 and 1480.[19] The style of the glass is more vigorous than the St Peter cycle at Mancroft. There is a greater emphasis on line at the expense of modelling, the figures are stockier in their proportions, and drapery folds are even more angular.

In the absence of documentary evidence it is difficult to date most East Anglian glass precisely. Some affinities have been traced with contem-

porary screen paintings in Norfolk, notably those at Barton Turf, Ranworth and St John Maddermarket in Norwich (the last dated 1451 and now in the Victoria and Albert Museum); also with brasses and manuscript illumination, but whether the similarities extend to any more than use of a common repertory of designs and motifs would require more detailed research.[20] Changing fashions in clothing are an indication of date, but apart from an increasing trend towards a broken fold treatment of drapery and the use of a very dark painting pigment there is little to distinguish East Anglian glazing of *c.* 1500 from that of *c.* 1460. Nevertheless it is *Pl. XXIV;* apparent from the analysis of the St Peter *Fig. 67* Mancroft glass that even in Norwich itself there were several glaziers/workshops, each with its own individual characteristics, and there was sufficient demand in the region to support other workshops, not all of which were based in Norwich. This city was obviously the most important centre, but craftsmen are also known from Bury St Edmunds, Ipswich, Colchester and elsewhere in eastern England.[21] One of these workshops was responsible for a series of tracery light figures at Cley (sIX), Field Dalling (sII), Wighton (nIV), Stody (sIV) and East Barsham (nIII), all near Wells on the north Norfolk coast; also a pair of figures now divided between the *Burrell Collection*, Glasgow, and the Metropolitan *Fig. 168* Museum, New York.[22] They share common design motifs with the Norwich glass described above, but the figure style differs in some respects. They are distinctly *retardataire* if the date ascribed to them of the 1450s and 1460s is correct, for the elegant swaying figures with their voluminous and soft swathes of drapery and delicate treatment of facial features and careful modelling are still quite strongly in the International Gothic tradition.

The great church at *Long Melford* in Suffolk was rebuilt during the second half of the fifteenth century, principally (but not exclusively) by John Clopton and the Martin family.[23] The former was a rich and influential clothier who died in 1494. He had been executor to many leading personages, several of whom were represented in the clerestory windows on the north side, together with his ancestors, relatives and other associates. The south clerestory

*Fig. 167* EAST HARLING (Norfolk): Sir Robert Wingfield (d. 1480), *c.* 1463-80.

windows were given by various individuals. One window on the south side is dated 1460 in a recorded inscription and the donors show that the clerestory was glazed between this date and the end of the century. Little is known about the ground storey glazing, which however is unlikely to have matched the rich kaleidoscope of colours in the heraldic blazons of the clerestory figures. Norwich glass-painters seem to have executed the clerestory scheme, including the archangels which are set on the standard 'ears of barley' grounds and a figure of St Edmund with an abbot, all of which were originally in the north clerestory. The St Edmund panel can be dated to between 1479 and 1497. The kinsfolk and associates of the Clopton family are distinguished by a somewhat austere and unflattering treatment of physiognomy similar to the husbands of Anne Harling at East Harling. The canopies, backgrounds and floor patterns are of traditional Norwich design.[24]

*Figs 46, 169*

It is not hard to find glass elsewhere in East Anglia which differs from windows in Norwich and its vicinity. The tracery light figures at Norton of the late fifteenth century (window sII) and the remains of a series of abbots of Bury St Edmunds at Brandeston (window sIII), both in Suffolk, will suffice as examples. The latter date from the time of William Codenham, abbot between 1497 and 1511.[25]

Outside the eastern counties there is less evidence of regional styles; instead the picture appears to be one of small workshops with their own distinctive traits which could be active over quite a wide area. Woodforde saw late medieval glass in Somerset in terms of a regional school; it is more likely that a single workshop was responsible for much of the glass in the area in the late fifteenth and early sixteenth centuries.[26]

There is abundant documentary evidence to show that York remained an important centre for glass-painting in this period, with a number of family firms active in Stonegate and cartoons passed down from one generation to the next.[27] This may explain the longevity of the International Gothic tradition in the city. As we have seen, this was already weakening in the 1430s and 1440s, but traces lingered into the 1470s. The figures in the main lights of the east window of *Holy Trinity Goodramgate* have longer heads but the delineation of facial features, especially of the women, still bears some resemblance to early fifteenth-century York work. This window dates from *c.*1470, yet is not dissimilar to the

*Fig. 26*

*Fig. 168*   GLASGOW, BURRELL COLLECTION: St Mary Magdalene from north Norfolk, *c.*1450–70.

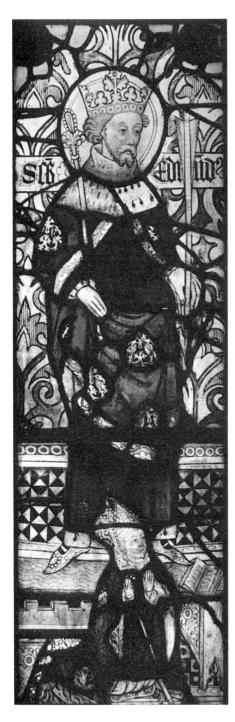

*Fig. 169* LONG MELFORD (Suffolk): St Edmund and an abbot of Bury St Edmunds, 1479–97.

Holy Kindred window (nIV) at Thornhill, executed over twenty years previously.[28] The York glaziers continued to cast their net widely over the north. John Chamber, William Glazier (probably William Inglish), Robert Preston and Robert Petty were variously employed between 1449 and 1488 on glazing for Durham Cathedral Priory, its dependency at Finchale and the parish church of St Mary Magdalene in Durham. John Petty (d. 1508) stated in his will that he had done much work at Furness Abbey in Lancashire and, nearer home, Ripon Minster in 1520 sent two men to purchase glass in York.[29] Matthew, another member of the Petty family, was paid in 1471 for heraldic and clear glazing in the lantern tower of York Minster.[30]

The York glass-painters did not enjoy a monopoly in the north. In the late 1430s and early 1440s Durham Cathedral Priory had its own resident glass-painter, Richard Glayzier. In 1438 and 1440 he made new windows in the choir and nave, in the latter year assisted by William Elmden. Between 1460 and 1487 a glazier named Thomas Shawden did work in the conventual buildings of the cathedral priory, and in the church and domestic quarters at Finchale. He also carried out glazing commissions in parish churches owned by Durham at Pittington in County Durham and Ellingham in Northumberland. The Finchale Priory accounts mention a William Glazier of Newcastle and refer on four occasions to the purchase of glass in that city, so it too may have been a centre for stained glass.[31] Moreover the wide divergence of styles apparent in northern glass indicates that various workshops were active. The Life of St Helena scenes commissioned by Sir Thomas Ashton in 1499 for the east window of the parish church at Ashton-under-Lyne, Greater Manchester, are very different from the work of the York atelier responsible for the glazing at Greystoke, Cartmel Fell and Windermere; the early sixteenth-century Archers' window at *Middleton*, near Ashton-under-Lyne (sII), and the *Fig. 3* contemporary figures in the west window of Wetheral, Cumbria, also display individual characteristics.[32]

The glazing of the collegiate church of the Holy Trinity at *Tattershall* in Lincolnshire provides

evidence of the proliferation of individual workshops in the Midlands.[33] The college was founded in 1439 but construction of the church did not commence before the end of 1466 and possibly not even until after April 1469. The chancel was completed by 1476 and glazed by 1480. Work was in progress on the transepts and nave between 1476 and 1479 and their glazing was under way in 1480–2. Tattershall was a major project in a fairly isolated part of the country and a number of glazing firms were employed there. The 1482 building accounts mention payments to several glass-painters: Robert Power of Burton-on-Trent, John Glasier of Stamford, John Wymondeswalde of Peterborough, Richard Twygge and Thomas Wodshawe. Several of the windows which these craftsmen glazed are identified in the accounts.

The original chancel glazing, which was removed in 1757, is dispersed between St Martin's church in *Stamford* (east window, *Fig. 48* windows sII, sIII, sIV, sV), the great hall of Burghley House and Warwick Castle Chapel. The rather unattractive figure style of the typological scenes and angels has not been encountered elsewhere, although the glass appears to be the work of an English atelier.[34] The surviving nave glass, now gathered in the east window at Tattershall, was executed by five workshops, all quite distinct from each other, apart from the common use of 'jewelled' inserts. Three can be identified from the 1482 accounts, including that of Richard Twygge and Thomas Wodshawe who executed the Works of Mercy and Seven *Pl. III(c)*; Sacraments scenes; a number of angels can also *Fig. 61* be attributed to them. There is one complete panel, and fragments of at least two more, from the Holy Cross window glazed by Robert Power; *Pl. XXIII* in addition several tracery light figures were executed by him. Finally, there are a few heads which can almost certainly be ascribed to either John Glasier or John Wymondeswalde on the basis of stylistic affinities with glass in and around Stamford and Peterborough. The former was a person of some importance in Stamford and his name occurs in several documents between 1472 and 1517.[35]

Analysis of the Tattershall building accounts and the surviving glass has made it possible to identify windows elsewhere by the same work-

*Fig. 170*  STAMFORD, BROWNE'S HOSPITAL (Lincs.): *Fenestra caeli* (detail), *c.* 1475.

shops. The principal monument in the Stamford–Peterborough region associated with the group of heads mentioned above is the glazing of *Browne's Hospital*, Stamford, which can be dated to between 1475 and the 1490s. The easternmost of the two large windows in the south wall of the chapel (sI) contains a prophet, several saints and five nimbed female figures, at least two of which represent the Virgin. The *Fig. 170* companion window (sII) retains glass in the tracery and in the Audit Room are figures of David and St Paul (both represented twice), Solomon and part of a Doctor of the Church.[36] *Fig. 82* Minor glazing remains in other windows. This atelier also executed a series of historiated panels devoted to Christ and St Peter originally in the west window of Peterborough Cathedral and now distributed over the six triforium and clerestory windows of the apse (Et, NtII, StII, CI, NII, SII). The glass seems to have been commissioned in the 1470s by Lady Margaret Beaufort, the mother of Henry VII, and Sir Reginald Bray, who at the time was receiver-general and steward of the household to her second husband Sir Henry Stafford. Apart from the tonsured

*Fig. 171*   STOCKERSTON (Leics.): St Christopher,
1467-77/85.

like mouths, beady eyes and a distinctive canopy
and side-shaft design.[37]

There is glazing in at least four Staffordshire
churches which possesses features in common
with the work of Robert Power of Burton-on-
Trent at Tattershall.[38] At Hamstall Ridware is a
Virgin from a Crucifixion and the head of a
canonized royal abbess (window sV); Blore Ray
church also contains the remains of a Cruci-
fixion, datable to 1519, in addition to a late
fifteenth-century donor figure and St Anne
teaching the Virgin to read (window sII);
*Broughton* has in the east window figures of St   *Fig. 172*

*Fig. 172*   BROUGHTON (Staffs.): St Roche, *c.* 1500.

head and figures of St Christopher and the
Restwold family in a window at *Stockerston* (nIX)   *Fig. 171*
in Leicestershire, and a head of the Virgin at
Barnack, Cambridgeshire (window nIII), the
other traces of the John Glasier/John Wymon-
deswalde workshop are confined to minor
fragments. The style of all this glass is distin-
guished by the use of heavy stipple shading, slit-

George and St Roche, and in Gnosall is a male head (window nIV). These all share features in common with Power's windows at Tattershall, notably the long, straight drapery folds, the treatment of eyes and the light thin trace lines of noses with nostrils defined by two short strokes. However, certain differences between the Staffordshire figures and the Holy Cross panels at Tattershall may indicate that they are the work of the Power atelier rather than the master glazier himself.

The Power and Stamford–Peterborough workshops were very much locally based, and evidently for them Tattershall was a rare excursion further afield. This statement does not apply to Richard Twygge and Thomas Wodshawe, who consequently are the most interesting of the glaziers employed at Tattershall.[39] Although the Tattershall accounts do not give their place of origin, other evidence shows this to have been the West Midlands. In 1507–10 Richard Twygge of Malvern glazed a large number of windows in the nave of *Westminster* Fig. 174 *Abbey* and several figures now in the apse clerestory can be associated with him. Furthermore, there is so much glass in and around the neighbourhood of Malvern in the same style as the Tattershall glass which he and Wodshawe executed that there can be no doubt where the workshop was based. It was involved in some of the most prestigious glazing schemes of the late fifteenth and early sixteenth centuries and enjoyed the patronage of powerful magnates such as Bishop Waynflete of Winchester and John Alcock, Bishop of Worcester. In addition to the documented work at Tattershall and Westminster Abbey the following major monuments can be attributed to the Twygge–Wodshawe workshop: the east window of Little Malvern Priory executed for Alcock between 1480 and 1482, part of the glazing of the Lady Chapel east window of Gloucester Cathedral (*c.*1472–93) and the *Magnificat* window (nVI) in Great Malvern Priory, commissioned in 1501–2. The earliest datable glass by the workshop is a St George, *Noli me tangere*, and a series of male and female donors in two windows in the nave north clerestory at Bledington, Gloucestershire (NIII, NIV); one of the donor panels gives the date 1476. There are at least ten other parish

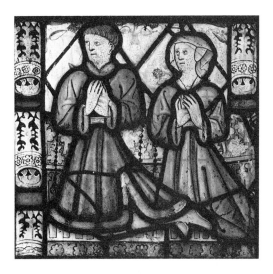

*Fig. 173*   ODDINGLEY (Heref. & Worcs.): married donors, *c.*1475–90.

churches with Twygge–Wodshawe glass, mainly in Hereford & Worcester, but also some in Warwickshire and Gloucestershire. The largest quantity is at *Oddingley*, the east window of Pl. III(*a*); which contains St Catherine, a canonized arch-     Fig. 173 bishop, St Martin and St Margaret and six donor figures. The east window at Buckland in Gloucestershire has three panels from a Seven Sacraments series and the other churches retain only miscellaneous fragments. These include the head of St John from a Crucifixion at Ashleworth (window sIII), which is one of the finest of all the works produced by the Twygge–Wodshawe atelier.

The traits of the workshop are easily recognizable. In addition to an individual figure style there are distinctive architectural, framing and background motifs, notably a yellow stain cresting over a tiled base and a canopy design with ogee-shaped ribs terminating in a finial and separated by white strips decorated with chevrons. The influence of the Beauchamp Chapel is apparent in the lavish use of 'jewelled' inserts. As with so much English glass of the late fifteenth and early sixteenth centuries, decoration triumphs over sophistication. The glaziers may have been aware of Netherlandish develop-  Fig. 158 ments in so far as part of the *Great Malvern Magnificat* window ignores the native conven-

*Fig. 174* WESTMINSTER ABBEY, apse clerestory: bishop saint (detail), *c.* 1507–10.

tion that figures and scenes should be confined within the architectural framework of the mullions. There is, however, no attempt at portraiture in the donor figures and little under- *Fig. 11*

standing of realistic modelling. The Twygge–Wodshawe workshop must have been highly thought of in order to be given such important commissions at Tattershall, Malvern and Westminster Abbey, but it is sufficient to compare the figures of Queen Elizabeth, her son Prince Edward (later Edward V) and four of her daughters at Little Malvern with those of the same royal family in the 'Royal' window in *Canterbury Cathedral* (NXXVIII) to appreciate *Pl. XXV* the gulf that already existed in the 1480s between native work and that of the immigrant foreign craftsmen. This gulf very quickly became apparent to leading patrons and the Continental glass-painters were able to establish a near-monopoly of the most prestigious and lucrative commissions. The history of the later glazing of *Westminster Abbey* summarizes the new state of affairs. At the same time as Richard Twygge was working on the nave windows, plans were in hand for fulfilling Henry VII's instructions for the glazing of his chapel at the east end. The king's executors, however, did not turn to Twygge, but entrusted the work to foreign-born *Figs 182,* and trained glaziers. *183*

# 10

# *The Dominance of the Foreign Glaziers*

Between the middle of the thirteenth and the late fifteenth centuries there is little evidence in either documentary sources or in surviving windows to suggest that the presence of foreign glass-painters in England was any more than occasional. In passing it may be noted that traces of traffic in the reverse direction are equally lacking, apart from a late fifteenth-century window by an English glazier in the parish church of Caudebec-en-Caux in Normandy, which was an English possession at the time; the glass was given by an English soldier named Fulkes Eyton and it was almost certainly imported.[1]

In the half-century preceding the Reformation there took place an influx of highly accomplished glaziers, principally from the Netherlands, who quickly obtained the patronage of the Court. Their triumph was even more complete than that achieved by their compatriots in France, primarily in Rouen, where Netherlandish glaziers also migrated in the early sixteenth century.[2] Stained glass became, in the hands of the foreigners, one of the principal media in which Renaissance forms and motifs were displayed in Tudor England.

During the second half of the fifteenth century important English patrons increasingly turned to Flanders, whose painters were establishing themselves in the forefront of artistic endeavour north of the Alps. As early as 1446 Sir Edward Grymestone had his portrait painted by the Netherlandish artist Petrus Christus (on loan to the National Gallery, London, from the Earl of Verulam Collection) and just over a decade later Thomas Chaundler, Chancellor of Oxford University, commissioned a manuscript containing pen drawings (Cambridge, Trinity Coll. MS R14.5) by a *limnour* who was either Flemish or an Englishman well acquainted with Netherlandish art.[3]

Two historical events led to an increased awareness of Flemish painting amongst the leaders of taste. In 1468 Edward IV's sister, Margaret of York, married Charles the Bold, Duke of Burgundy and ruler of the Low Countries. Two years later Edward himself, after his defeat by the Lancastrian party, chose Flanders as his place of exile. Both Margaret and Edward amassed collections of manuscripts, many of which count amongst the finest products of the Ghent–Bruges school of illumination.[4] The flow of commissions by English patrons steadily increased throughout the last quarter of the century. In the late 1470s Sir John Donne ordered a triptych from Hans Memling (National Gallery, London) and at about the same time, or possibly slightly later, Hugo van der Goes and his workshop painted a large altarpiece for the collegiate church of the Holy Trinity in Edinburgh (National Galleries of Scotland, Edinburgh, on loan from HM the Queen).[5] Moreover Netherlandish printed block-books such as the *Biblia Pauperum* became available and were used by glaziers at *Tattershall* and *Great Malvern*.[6]

At least one Netherlandish miniature painter was active here in the period *c.*1470–90, when he illustrated several manuscripts with pen drawings, including the *Beauchamp Pageants* (BL

Figs 47–8

*Fig. 175* STAMFORD, ST MARTIN'S CHURCH (Cambs.): angel holding shield of the Russell family arms, *c.* 1480–94.

Cotton MS Julius E.iv, art. 6).[7] Monumental painters from Flanders were also present in England in these decades. Although the English names of William Parker and Gilbert are documented in connection with the wall-paintings in Eton College Chapel, which appear to have been executed between 1479 and 1488, the use of grisaille colouring, the Netherlandish interiors, the slender proportions of the figures and the sharply broken drapery folds betray the presence of a Flemish designer and supervisor. Similar but less accomplished grisaille wall-paintings can be seen in the Lady Chapel of Winchester Cathedral, dating from the time of Prior Thomas Silkstede (1498–1524).[8] The earliest recorded complaint by the London Glaziers Company against foreigners is in 1474, at which time more than twenty-eight alien craftsmen were said to be exercising their craft in the City.[9] Soon afterwards there is the first clear evidence of foreign participation in an English glazing scheme, in the 'Royal' window in the façade of the north-west transept of *Canterbury Cathedral* (window NXXVIII). The tracery light prophets, apostles and canonized ecclesiastics are unmistakably indigenous work, but in the main lights the kneeling figures of Edward IV and Elizabeth Woodville with their sons and daughters betray the hand of a Netherlandish artist. There appears to be an attempt at realistic portraiture and the

*Pl. XXV*

treatment of faces, draperies and furnishings has affinities with the paintings of Hugo van der Goes and his associates. The window has traditionally been supposed to have been a gift of Edward IV, but Professor Caviness has suggested that Archbishop Bourchier (d. 1486), who was related to both Edward and Elizabeth, may have been the patron. Caviness dates the glazing to between *c.* 1482 and 1487.[10]

John Russell, Bishop of Lincoln (1480–94), was closely associated with both Bourchier and the Court and was a quite frequent visitor to the Netherlands. Amongst his benefactions was the reconstruction of St Martin's church at *Stamford*. *Fig. 175* Two angels bearing shields of arms in window sV are all that remain of Russell's glazing here; they are similar in style to the 'royal' figures at Canterbury and may well be by the same workshop.[11]

The figures of St Anne teaching the Virgin to read, St Christopher (depicted twice), the Virgin and Child, St Dorothy, the Virgin from a Crucifixion and St Catherine in the north chancel of *West Wickham* church in Kent (windows nII– *Fig. 43* nIV) also exhibit Netherlandish characteristics in drapery and head style and could be by an artist from the Low Countries. The avant-garde style can probably be explained by the connections of the donor, Sir Henry Heydon (d. 1503/4). He *Fig. 14* was married to Anne, daughter of Sir Geoffrey Bullen, Lord Mayor of London in 1458, and was steward of the household to Cecily, widow of Richard, Duke of York. His glass probably dates from the last decade of the fifteenth century.[12]

Robert Frost, the donor of the Tree of Jesse in the chancel east window at Thornhill, in West Yorkshire, also moved in Court circles. He was the holder of numerous rich livings and in addition to his duties as rector of Thornhill between 1484 and 1498 he was chancellor to Henry VII's first-born son Prince Arthur. The date 1499 occurs in the inscription in the window and the wording indicates that if the glazing was not then complete it must have been finished before Arthur's death early in 1502. In spite of extensive restoration, sufficient remains to show that it differs markedly from the earlier windows by York craftsmen in the church. The glass is richly coloured and the prophets are clad in garments which at least partly reflect contemporary

fashions. The animated and varied poses contrast with the solemn facial expressions. The draperies and the heavy modelling also point to the hand of a Continental glass-painter, although his precise origins remain to be established.[13]

The activities of the foreign glaziers increased dramatically after the turn of the sixteenth century. Barnard Flower, described variously as an *Almain* and born in the lands of the Archduke of Burgundy, worked at Woodstock Palace, Oxfordshire, in 1496 and Shene Palace in the following year; between 1500 and 1502 he was employed at the Tower of London, in company with glaziers bearing the foreign names of Adrean Andru, Wynand Curteign, Cornelius Mulys and Gherard Pyle, and also at the palaces of Westminster, Greenwich and Eltham. Probably he was already King's Glazier in the late 1490s and he was certainly holding this office by 25 March 1505. In 1503 he undertook a large commission at Richmond Palace, for which he was paid £60 19s 11½d. In 1511 and 1512 Flower painted windows for the pilgrimage chapel of Our Lady at Walsingham in Norfolk and for the royal manor at Woking, Surrey. From 1513 to 1516 he was working at the royal foundation of the Savoy Chapel in the Strand, during which period he became a naturalized Englishman. In 1515 Flower supplied heraldic glass for Archbishop Wolsey's palace at York Place (later the royal palace of Whitehall) and in the same year he was given an advance for the glazing of King's College Chapel, Cambridge. He died in July or August, 1517.[14]

Flower was a resident of Southwark, which lay outside the jurisdiction of the London Company, and it was there that the foreign glass-painters congregated. Galyon Hone, a native of Holland, was working in England before 1517. Between 1517 and 1526 Hone was employed by Eton College and in 1520 he was occupying the post of King's Glazier, at which time he was setting up the glazing for the Field of the Cloth of Gold. Hone was then a parishioner of St Mary Magdalene next to St Mary Overy in Southwark and from 1536 he lived within the precincts of St Thomas's Hospital, Southwark. In the late 1520s and 1530s he was much in demand and worked on some of the most prestigious projects of the day, including King's College Chapel (1526–31),

York Place (1531), Westminster Palace (1532), *Hampton Court* (1532–3), Windsor Castle (1533), Dartford (1540) and St James's Palace (1543). As the leader of the foreign glaziers Hone became the focus of attack from the London Company. He died in *c.* 1551.[15]  *Fig. 77*

James Nicholson was described as a subject of the Holy Roman Emperor and seems to have been born in the Netherlands. In 1518–19 he was employed at Great St Mary's, Cambridge. By 1526 he had taken up residence within the liberty of St Thomas's Hospital, Southwark, where he remained until his death in *c.* 1540. Between 1526 and 1531 Nicholson was a member of the team engaged in the glazing of King's College Chapel and was also employed on the armorial glass of Wolsey's foundation of Cardinal College, Oxford. At the date of the Cardinal's death late in 1530 Nicholson was owed £58 for glazing at Scroby and Cawood in Yorkshire and Southwell in Nottinghamshire. Probably he was the artist of the *vidimuses* which appear to be associated with Wolsey's glazing schemes at Hampton Court and either York Place or Cardinal College.[16] In the late 1530s Nicholson seems to have turned his attention to printing and the dissemination of Protestant literature.[17]  *Figs 21, 176*

The fourth member of the Southwark group of whom something is known was Francis Williamson. His signature ('Willem zoen') to the King's College contract of 1526 indicates that he too was of Flemish birth. At that time he was living in St Olave's parish; in 1541, when his goods were valued at £5 and he kept two servants, he was dwelling in St Thomas's Hospital. He appears to have died in 1544 or 1545.[18]

Other foreign glaziers were resident in England at this time. Peter Nicholson became King's Glazier on 21 February 1549/50 and was granted letters of denization a year later. In 1516/17 Henry Sutton *Ducheman* was the subject of a complaint by the Glaziers Company. About six years later the Company made a general protest about the immigrants:

*there ys dwellyng and inhabetyng within the Borowhe of Suthwerk saynt Katheryns and without Temple barre and in other places nygh adioyngyng unto the saide Cytie*

*Fig. 176* BRUSSELS, MUSÉES ROYAUX DES BEAUX-ARTS: *vidimus* probably for the upper lights of a side window in Cardinal Wolsey's chapel at Hampton Court; penwork, *c.* 1525–6.

*Glasyars beyng straungiers borne to the nombre of xviij howsholders whiche have in their sarvics at the lest ffortye or ffyftie servantts and apprentesys all straungers borne....*[19]

There were, therefore, a large number of alien glaziers working in England in the first half of the sixteenth century, even allowing for exaggeration by the native craftsmen. From the point of

*Fig. 177* WINDSOR, ST GEORGE'S CHAPEL (Berks.): two heads in the west window, *c.* 1500–6.

view of the Glaziers Company this undesirable situation was compounded by the English craftsmen who worked with the foreigners. Amongst these was Richard Bond, who is named in the 1526 contract for King's College Chapel; his other commissions included the Savoy Hospital. Bond lived in the parish of St Clement Danes.[20] Thomas Reve and Simon Symondes, two further signatories to the 1526 contract for King's College, were also probably native-born. The latter was a resident of the parish of St Margaret, Westminster, for which church he repaired some windows in 1521 and painted heraldic glass in 1540. It has been suggested that Simon Symondes is the 'Symond Glasyer' who in 1509 supplied windows for Christ's College, Cambridge.[21]

The documentary evidence for the large number of foreign glaziers is matched by the quantity of glass to be found in England which was executed in the first four decades of the sixteenth century by the immigrants. Only in a very few instances can the extant glass be assigned with any confidence to individual craftsmen.

Although it is not mentioned in the surviving fabric accounts, the west window of *St George's Chapel, Windsor*, was presumably glazed towards *Fig. 177* 1506, during the last stages of the building work.[22] The majority of the canonized popes,

other ecclesiastics and kings appear originally to have been in the window. Six figures in full plate-armour with the cross of St George on their surcoats and the Garter device, three knights bearing scrolls, five more figures in full armour and a king bearing the original label of St Oswald seem to have been brought from elsewhere in the chapel during repairs in 1767 and may be slightly earlier than the west window glazing. In 1842 six new figures, royal heraldry and the motto at the base of the window were added by Willement, who was also responsible for all the backgrounds, canopies and bases. Although the work of several painters, all the figures share a strong modelling of faces and drapery by means of heavy stippling. Several of the bearded and crowned heads are somewhat reminiscent of contemporary glass in Rouen by the workshop of Arnoult of Nijmuegen and his associates, e.g. the figures from the Tree of Jesse in the Burrell Collection.[23] Comparisons can also be made with the major surviving monument of the first two decades of the sixteenth century, the glazing of Fairford in Gloucestershire.[24]

The *Fairford* glazing is unusually complete, with ancient glass in all of its twenty-eight windows. It also exhibits, for a parish church, a remarkable degree of iconographical homogeneity. The glass divides neatly into two sections, corresponding almost exactly with the

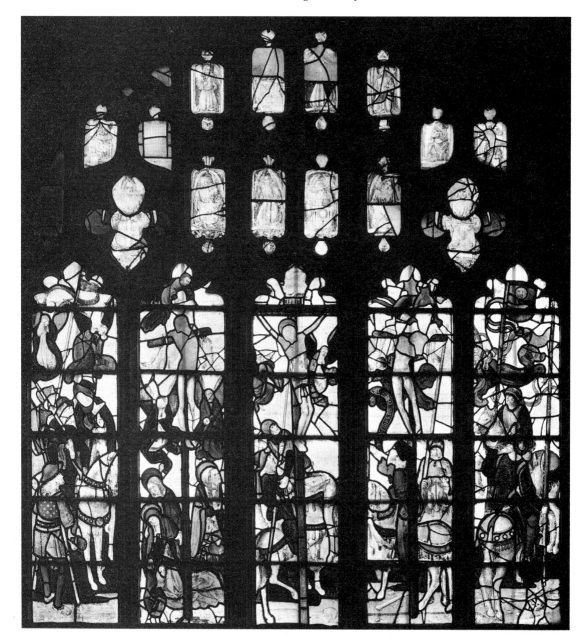

*Fig. 178*   FAIRFORD (Glos.): Crucifixion in the east window, *c.* 1550–15.

division between chancel and nave. The programme should be read beginning with the window immediately to the west of the screen separating the Lady Chapel from the nave north aisle (nV). This window contains four Old Testament scenes paralleling events from the Life of the Virgin, episodes from which are depicted in the three Lady Chapel windows, commencing in window nIV with the meeting of her parents Joachim and Anne at the Golden

Gate and terminating in nII with the Flight into Egypt, Assumption of the Virgin and Christ with the Doctors. The chancel east window is devoted to the Passion, with the Entry into Jerusalem, Agony in the Garden, Christ before Pilate, the Scourging and the Carrying of the Cross depicted in the lights below the transom and culminating with the Crucifixion, spread across *Fig. 178* the five main lights above the transom. The four windows in the chancel south aisle (Corpus Christi Chapel) continue the Passion sequence *Pl. XXVI;* from the Deposition (sII) to Pentecost (sV). The *Fig. 179* nave glazing primarily consists of standing figures. The apostles and prophets face each other across the aisles (sVI–sVIII, nVI–nVIII), as do the Four Doctors of the Church and the Evangelists (sIX and nIX). In the south clerestory twelve saints confront twelve persecutors of the Faith, amongst whom are numbered Judas, Herod and Caiaphas, in the north windows. The conflict of light with dark is continued into the clerestory tracery lights, with the angels in the south windows opposed by a series of devils on the north side. The only historiated glass in the nave is found in the three west wall windows (nX, w, sX). The Last Judgement in the great *Pl. XXVII* west window is flanked by its Old Testament 'types', the Judgement of Solomon and the Judgement of David on the Amalekite.

The Fairford glazing is the most positive statement of the new Netherlandish mode of glass-painting yet seen in England. The crowded Crucifixion scene is based on an iconographical composition used repeatedly by the carvers of the great wooden Passion altarpieces made during the late fifteenth and early sixteenth centuries in Brussels, Antwerp and Malines.[25] In more general terms, the 'pictorial' treatment of the windows at the east end, with landscape settings and realistic interiors, owes its inspiration to the work of Van Eyck and Memling and their contemporaries and followers in the Netherlands. Moreover, in the Crucifixion and several other scenes in windows at the east end and the three west windows, the compositions traverse the mullions, thereby denying, on a scale never seen before in England, the fundamental association between stained glass and its architectural framework. As Dr Wayment says: 'the urge arose to rival the achievement of the

*Fig. 179* FAIRFORD (Glos.): Christ's appearance to the Virgin in chancel south chapel east window, *c.* 1500–15.

panel painters, and to adapt their designs to the transparent medium of glass.'[26] Glazing had become an offshoot of painting. The various canopy types at Fairford have their closest parallels in the Netherlands and Germany, as also

do the details of buildings in scenes like the Transfiguration.[27] The treatment of drapery, the heavy modelling and the facial types underline the Netherlandish origins of the craftsmen, even if the recent suggestion that the principal designer may have been Adrian van den Houte of Malines cannot be substantiated on the available evidence.[28]

Why the new taste made such a sumptuous appearance in a Gloucestershire parish church remains a mystery. Royal patronage may have been forthcoming, but apart from shields bearing ostrich feathers and the motto 'ich dene' in the tracery of several windows, there is a dearth of any conclusive heraldic evidence; donor portraits and inscriptions in the glass are also lacking.[29] The antiquary John Leland visited the church in the 1540s and recorded that: 'John Tame began the fair new chirch of Fairforde and Edmund Tame finishid it.' In another entry he noted that: 'Mr. Ferrars told me that one of the Tames did make the fair chirch of Fairford.'[30] John Tame was granted custody of the manor of Fairford in 1479 together with his father-in-law. The Lady Chapel at the east end of the north aisle was presumably completed by January 1497 when John directed in his will that he should be buried in it. He died in 1500 and was succeeded by his son, Sir Edmund, who died in 1534. The absence of Renaissance ornamental motifs suggests a dating before *c.* 1515 for the glass and the affinities with Windsor indicate that it was executed during the preceding fifteen years. The heads of two bearded kings at Windsor are comparable with some of the Fairford apostles, although not quite of their quality; this may be due in part to the fact that the kings were designed to be seen from a distance.[31] It is likely that some of the Windsor glaziers were employed at Fairford. There are also close connections between the Fairford windows and the other three major glazing commissions undertaken in the reigns of Henry VII and Henry VIII: the eastern parts of Winchester Cathedral, Henry VII's Chapel in Westminster Abbey and King's College Chapel, Cambridge.

The remodelling of the east end of *Winchester Cathedral* commenced with the Lady Chapel in the time of Prior Hunton (1470–98); it was completed and decorated by Prior Silkstede (1498–1524), and Bishop Richard Fox (1501–28) was responsible for the rebuilding and glazing of the choir aisles and choir east window.[32] Little remains of the Lady Chapel glass apart from some heavily restored figures in the tracery of the east window. In the lowest row of lights are ten apostles together with a cleric (probably Silkstede) kneeling before St Sitha. These are all *in situ*, with the two missing apostles replaced by a pair of nimbed bishops or abbots probably from the south window of the chapel. The only other original figure in the upper tracery is St Benedict. All the figures are placed in Gothic niches and the range of colours, the heavy modelling and the style of the one decipherable original head indicate the hand of a Netherlandish glazier. The style is similar to that of the three nimbed and mitred clerics in window sVI at *Hillesden* in Buckinghamshire, a church which also has some fine naturalistic landscapes in the east window, nII and sIV, the last containing four scenes from the life of St Nicholas. The Hillesden glass probably dates from before 1519.[33]

Fox's glazing in the choir is also the work of Flemish craftsmen, although evidently not by the workshop responsible for the Lady Chapel. Fox served Henry VII as Lord Privy Seal for twenty-two years and was one of the leading cleric-administrators of the period; his abilities were also much admired by Henry VIII. Taking into account his interest in humanism and his central role in affairs of state, it was almost inevitable that the work commissioned by him at Winchester should be in an advanced style. The east window contains the *in situ* figures of the Virgin and St John the Baptist, two trumpeting angels, another four holding shields of arms and a pair of scrolls with Fox's motto ('Est Deo gratia'). In the other lights is a series of saints and prophets. The window was very heavily restored in 1852 and the style and quality of Fox's work can be judged better by the fragments in the choir clerestory and aisles. In the former (NII–NV, SII–SV) are some tracery light angels and heads of canopies. Several of the choir aisle windows (nVIII–nX, sVIII–sXI) also have canopies in the main lights, and in the tracery are full-length figures of saints and scenes from the Life of the Virgin; the smaller openings have Fox's motto and device of the Pelican in its piety.

*Fig. 181*

*Fig. 180*

Fig. 180   WINCHESTER CATHEDRAL (Hants.): St Sitha
in a choir aisle tracery light, *c.* 1501–15.
Pre-restoration engraving by O.B. Carter.

The figures in the east window and the standing
saints in the choir aisles are set against coloured
curtain backcloths with spacious interior
settings and Gothic canopies of similar design to
the Fairford nave aisles. The figure style is
Netherlandish, as can be observed from the
scenes of the Adoration of the Magi, Nativity and
Purification of the Virgin. Westlake noted that
the Winchester figures, canopies and other
details are closely related to Fairford and attri-
buted them to the same glass-painters.[34] The
similarities between the Winchester choir
glazing and Fairford suggest that it dates from
the earlier part of Fox's episcopate, i.e. 1501 to
*c.* 1515. In further support of this argument is the
absence from the glass of any Renaissance motifs
like those found on the stone presbytery screens
in the cathedral which are dated 1525.

Fox was an executor of Henry VII's will and
was therefore closely involved with the imple-
mentation of the king's instructions regarding
the glazing of the great royal mausoleum at the
east end of *Westminster Abbey.* Built as a Lady
Chapel and originally intended to contain the
body of the canonized Henry VI, the foundation
stone of what became Henry VII's Chapel was
laid by the king on 24 January 1503; the fabric
seems to have been nearly complete by the time
of his death on 21 April 1509. The glazing
accounts have not survived but it is known that
the windows had not been commenced by this
date; they were probably finished before
Flower's contract of 1515 for King's College
Chapel. The glazing was certainly ready by the
time of the 1526 contracts for the latter.[35] The
few fragments that survived the Reformation
and Commonwealth were almost totally
destroyed during the Second World War, but
fortunately they were well recorded in descrip-
tions and photographs.[36]

The glazing of the ground storey windows
was most unusual for an ecclesiastical building.
Each window probably repeated the scheme in
the east window of the axial chapel, which *Fig. 183*
comprised a series of thirty royal badges and
shields of arms in coloured glass, mostly set
within cartouches and surmounted by crowns,
all placed against a background formed by
quarries. The latter bore more royal badges and
devices including the crowned portcullis, the

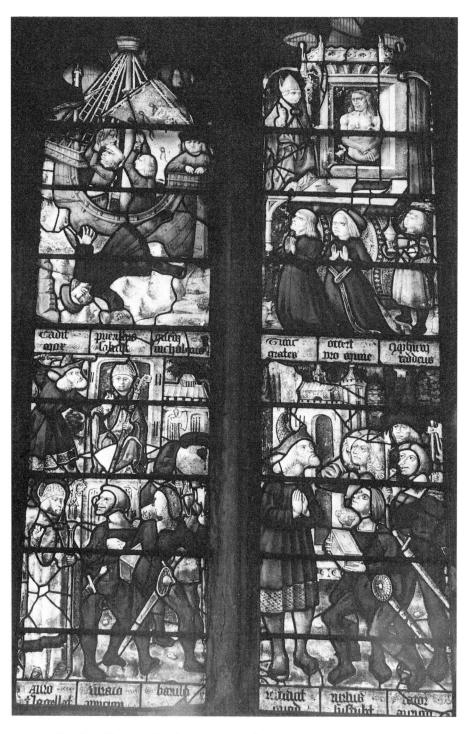

*Fig. 181*   HILLESDEN (Bucks.): miracles performed by St Nicholas, *c.* 1510–19.

initials 'h' and 'r' ('henricus rex') surmounted by a crown and the crown in the hawthorn bush (symbolizing the Tudor triumph at Bosworth). The glazing thus conformed to the king's wishes as expressed in his will that the windows should include his 'armes, bagies and cognoisaunts'.[37] In the same way that the architecture of the chapel was indebted to the design of Tudor royal palaces, the emphasis on royal devices in the ground storey windows can be related to domestic glazing in the royal palaces from at least the beginning of the fifteenth century.[38] Heraldry and badges recurred in the tracery of the chapel clerestory windows. The royal arms were placed in the central openings of the side windows and in the great west window were crowned portcullises, Tudor roses and *fleurs-de-lis*, together with the Prince of Wales's feathers and other badges. They were accompanied by two full-length angels both holding a *fleur-de-lis* and four others bearing shields with the initials 'h' and 'e'; in the apex there were another four angels. The main lights of the west window each contained a figure, judging from the canopy tops in the heads of the upper row of lights visible in photographs taken in the 1920s and 1930s. Possibly the three-quarter length prophet under a canopy, which together with a half-length angel in an incomplete niche (the two figures were not originally associated) could be seen in the east window until the Second World War, came from the west window. Alternatively the prophet could have been placed in one of the other clerestory windows. The 1526 contract for the glazing of King's College Chapel states that it was to have the 'Imagery of the Story of the olde lawe and of newe lawe after the fourme, maner, goodenes, curyousytie and clenelynes in euery poynt of the glasse wyndowes of the kynges new Chapell at Westmynster'.[39] The elaborate typological cycle at King's College was therefore modelled on that in the clerestory of Henry VII's Chapel, so presumably each window in the latter contained the appropriate Old Testament scenes (the Old Law) in the upper row of lights, together with a prophet and an angel acting as 'messengers' in the central light; in the lower row were New Testament scenes, also with two 'messengers'. The Crucifixion was almost certainly depicted in the east window.

*Fig. 182*

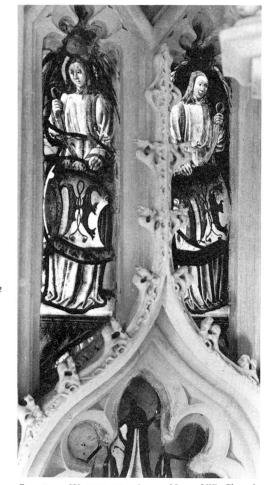

*Fig. 182*   WESTMINSTER ABBEY, Henry VII's Chapel: angels in the tracery of the west window (glass destroyed), *c.* 1510–15.

The style of the figural glass is Netherlandish and there are similarities with Winchester and Fairford. Common to all three is the design of a tracery angel holding a shield by a long strap, which occurs in the Westminster west window, the choir east window at Winchester and windows sIV and sV at Fairford (and also in the tracery lights of King's College Chapel).[40] They are evidently by different hands but are taken from the same pattern. There are also affinities between the heads and draperies of the trumpeting angels at Winchester and the Westminster angels, and the head of one of the latter's canopies is related to that over St Paul at

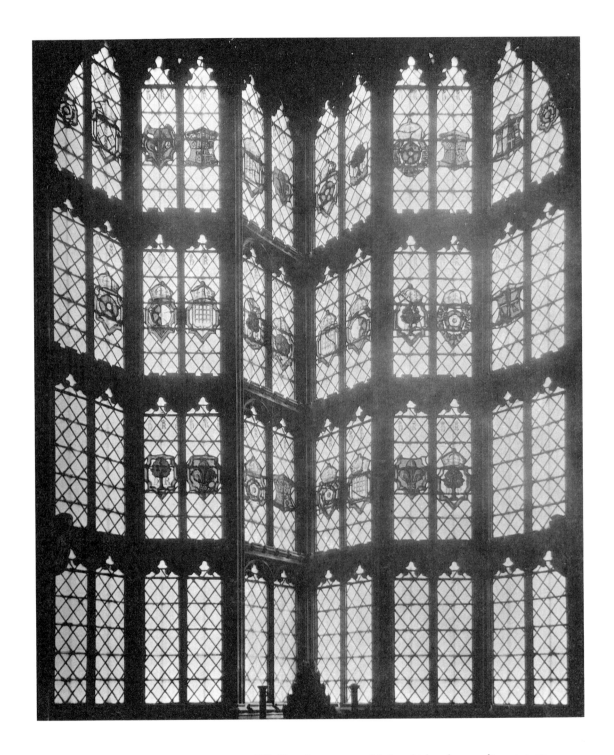

*Fig. 183*   WESTMINSTER ABBEY, Henry VII's Chapel: eastern apsidal chapel (glass destroyed), *c.*1510–15.

Winchester.[41] Furthermore, the two-sided canopy above the Westminster prophet is comparable with one of the Fairford designs.[42] The parallels between Fairford, Henry VII's Chapel and Winchester are sufficiently close to indicate the involvement in all three schemes of a single guiding hand. This can only have been Barnard Flower, who in his capacity as King's Glazier is the most likely candidate for the Westminster work. Further support for this hypothesis can be found in the resemblance noted by Westlake between the niche enclosing the angel from Henry VII's Chapel and those at the bases of the upper and lower main lights in one of the earliest windows (nXII) at King's College Chapel, with which Flower was involved.[43]

*King's College Chapel* is the masterpiece of foreign glass-painting in England and its full-blown Renaissance elements mark the end of the medieval tradition.[44] The stonework of the chapel was completed by the summer of 1515 and in November Barnard Flower received an advance of £100 for the glazing, the iconography of which was to be specified by Bishop Fox; in February 1517 he was paid a further sum of £100. Window nVIII bears the date 1517, and all or parts of four others (nII, nIV, nV and nXII) are thought to date from Flower's time. After his death in the summer of 1517 an interruption in the glazing seems to have occurred which lasted until 1526. In this year Galyon Hone, James Nicholson, Richard Bond and Thomas Reve were contracted to glaze eighteen windows, including the west and east, and Francis Williamson and Simon Symondes were to make another four; all twenty-two windows were to be completed within five years.[45] Window nXIII is dated 1527, but not all of the glazing was finished within the contract period. The Norfolk antiquary Francis Blomefield recorded that part of the fine imposed on Bishop Nix of Norwich by Henry VIII in 1534 was used to glaze King's College Chapel and Dr Wayment has produced stylistic and design evidence for dating no fewer than ten windows (sIV–sXI, nX, part of nV) to the years 1535-47. The glazing programme was not completed in the sixteenth century, for until 1879 the west window contained only white glass.[46]

*Fig. 184*

The history of the King's glass is therefore more complex than the documentation suggests. Furthermore, apart from window nVIII, which by its date can be associated with Flower, the attribution of the glass to the other glaziers named in the contracts is purely speculative. It is not even possible to distinguish the work of the native-born craftsmen (Bond, Reve and Symondes) from their foreign colleagues, so closely had the former absorbed the latter's styles and techniques. The situation is compounded by the stylistic evidence, which indicates the involvement of more craftsmen than the seven identified glass-painters. It has been claimed that the chief designer at Fairford (speculatively Adrian van den Houte) and the well-known Antwerp glazier Dierick Vellert had a hand in the design of the windows. Both may have been involved in the first campaign (1515-17) and Vellert could have been responsible for the *vidimuses* used in the second period (1526-31), apart from the four supplied by Hone.[47] If there is no documentation to support the claim for the involvement of either Van den Houte or Vellert in the King's College glazing, it is at least beyond doubt that the designers had access to Continental woodcuts and engravings. A number of the scenes in the glass are based on printed block-books such as the *Biblia Pauperum* and the *Speculum Humanae Salvationis*, and there are also borrowings from the work of Albrecht Dürer and other leading engravers (including Vellert).[48] The general outline of the elaborate typological cycle in the windows must have been settled at the time Flower started work in 1515, but the details were evidently worked out during the course of the glazing campaigns.

The windows are remarkable for the harmonious use of colour combinations, the attention to detail in figures and ornamentation and the subtle line-work and realistic physiognomy. Windows sVII, sVIII and sX, which have been attributed to Vellert, are outstanding for their sensitivity and depth of emotion. The craftsman concerned was very much aware that although the compositions are 'pictorial', painting on glass required different skills from panel-painting. As Wayment has observed, the glazier 'never forgets that it is the light which the paint lets pass that gives stained glass its quality'.[49]

*Fig. 184*   CAMBRIDGE, KING'S COLLEGE CHAPEL:
(*left*) *vidimus* for the nave south side window depicting SS Peter and Paul healing the lame man; (*right*) the lights in the window itself, 1535-47(?).

*Fig. 185*   CAMBRIDGE, KING'S COLLEGE CHAPEL, nave
south side: (*left*) St Peter denouncing Ananias (detail),
1535–47(?); (*right*) Elijah in his burning chariot, after
1544(?).

Close inspection reveals considerable differences
between and even within the windows, in figure
style, colour, composition and various details.
The glass attributed to the period 1515–17
(windows nXII, nV (lights C and D), nIV (lights
B and C), nII and nVIII) is still basically rooted in
the Gothic tradition. The compositions, with
statuesque figures clearly defined in space, are
closely comparable with the scenes in the
eastern windows at Fairford. The architectural
details are also similar, although in the early
King's windows Gothic details such as crocketed
arches and tracery windows are omitted in
favour of minor Renaissance elements. In the
later windows the architectural features exhibit
the full repertoire of ornament – marble

*Pl. XXVIII*

*Pl. XXIX;*
*Figs 184–*
*5*

columns, scallop-shell niches, classicizing swags
and putti, etc. – derived ultimately from Italian
Renaissance sources. The treatment of narrative
also undergoes a profound change in the later
glazing, where the monumental figures have a
remarkable naturalism of expression, movement
and pose reflecting their craftsmen's increased
ability to handle complex pictorial composi-
tions.

The later King's College glass is not an
isolated phenomenon, for during the 1520s and
1530s Renaissance designs and motifs became
established elements in English painting, sculp-
ture and architecture.[50] The presence in England
of sculptors and painters such as Torrigiano,
Giovanni da Maiano and Antonio Toto del

Nunziata must have been important factors in their dissemination. Renaissance designs and ideas were also introduced via artists from northern Europe. The late Professor Blunt demonstrated that French monuments were an influential intermediary; with regard to glass-painting the documentary and stylistic evidence of the King's College windows shows that the lead was taken principally by artists from the Low Countries.[51]

Leading figures in royal and governmental circles were not slow to commission glass in the new fashion. The east window of *St Margaret's* *Fig. 186* *Westminster* contains a Flemish-inspired Cruci-fixion spread across three lights, flanked by SS George and Catherine and the kneeling figures of a youthful Henry VIII and Catherine of Aragon. The two saints are set under canopies with scallop-shell niches and the full repertoire of Renaissance ornamentation, which suggest a date near 1527, when the king announced his intention to divorce Catherine. The window is not *in situ* and was only installed in 1758; it was previously in the east window of the chapel at New Hall in Essex, which was acquired by Henry VIII by 1517. New Hall may not, however, have been the original location of this glass.[52]

As has been mentioned, Cardinal Wolsey employed Flower and Nicholson respectively at York Place and Cardinal College. Lawrence Stubbs, an important member of Wolsey's household who was closely involved with his building works at Cardinal College, was respon-sible for some of the glazing of the new chapel at Balliol College. He is depicted in the east window, which is dated 1529, together with his brother Richard, Master of Balliol between 1518 and 1525; both men are also associated with the next window on the south side (sII) which contains scenes from the life of St Catherine, the patron saint of the college. These are similar in style to the Passion scenes in the east window, three of which are based on Dürer's engraved *Passion* and one (the Carrying of the Cross) on the same artist's woodcuts in the *Great Passion* series. Both the Passion and the St Catherine cycles contain naturalistic settings and Renais-sance ornamental details. The St Catherine cycle is inferior in execution to the Passion series, as

*Fig. 186*   WESTMINSTER, ST MARGARET'S CHURCH: St Catherine (detail) in east window, *c.* 1525-7.

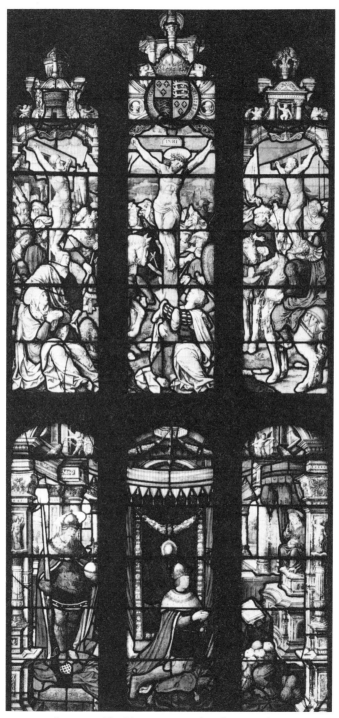

*Fig. 187*    THE VYNE (Hants.), chapel east window:
Crucifixion and Henry VIII, *c.* 1523.

can be seen from a comparison of the respective Flagellation panels. The scene in the east window displays a more sensitive treatment of shading and flesh-tones; there is also more attention to detail in the landscape and architectural setting and the colours are less strident than in the St Catherine window (the yellow stain in the latter has a very orange tone). The St Catherine painter may have been responsible for the figures of the Stubbs brothers in the east window as well as several saints in windows nV and sIII. These differences may support the suggestion that the Passion scenes were not originally intended for Balliol but had been ordered for Cardinal College Chapel. If this hypothesis is correct, the panels were most probably re-directed to Balliol in 1529–30 when Wolsey fell into disfavour. Lawrence Stubbs could well have been instrumental in arranging this transfer and it may also be relevant that other known donors of windows in Balliol chapel were intimately connected with Wolsey, including John Hygdon and Thomas Knolles, subdean of York. Moreover John Lobbens, the master mason responsible for the rebuilding of Balliol chapel between 1522 and 1529, was also Wolsey's master mason at Cardinal College. It should also be noted that Wolsey owned a copy of Dürer's *Passion*.[53]

Some excellent glass commissioned by William, Lord Sandys, can be seen in the chapel of his residence at The Vyne, near Basingstoke in Hampshire, in addition to a few scattered fragments elsewhere. The glass in *The Vyne* comprises three windows (I, nII, sII) containing *Fig. 187* the Carrying of the Cross, the Crucifixion and the Resurrection above the kneeling figures of Henry VIII, Catherine of Aragon and Margaret, Queen of Scots, together with their patron saints. Hilary Wayment has recently suggested, on good evidence, that this glass is not *in situ* but originally came from the Chapel of the Holy Ghost in Basingstoke, with which both Sandys and Bishop Fox were very closely connected.[54] In 1522 a group of ten Antwerp glass-painters visited Calais in search of work and met Sandys, who was then Treasurer of the town (he later became Henry VIII's Lord Chamberlain). The craftsmen subsequently came to The Vyne with him, but only carried out preliminary work on the scheme before returning home. Wayment

has drawn attention to affinities between the style of the Vyne glass and the works of the painter Bernard van Orley and his pupil Pieter Coeck. He suggests that Van Orley may have been the leader of the Antwerp group and was later contacted by Sandys to execute the Holy Ghost windows in Flanders.[55] The connections with Van Orley seem clearly established, even if his role as a glass-painter may be open to doubt; either his works were copied by the glaziers, or he may have supplied the *vidimuses*. The stylistic differences between the glass from the Holy Ghost Chapel and the works of the foreign craftsmen resident in England support the theory that Sandys's windows were executed on the Continent. The importation of stained glass windows met with the disapproval of the Glaziers' Company. In the late 1530s the Company levelled at Peter Nicholson the accusation that 'he setts more men aworke beyeonde the see and bryngithe his glasse reddy wrought over in to Englande'.[56] Another possible instance of this practice is the glazing of the chapel at *Hengrave Hall* in Suffolk, built by a leading *Fig. 188* merchant named Sir Thomas Kytson. Records of payment to Robert Wright, a glazier from Bury St Edmunds, reveal that he worked at Hengrave in 1539–40. It has, however, been claimed that the panels depicting the history of the world from the Creation to the Last Judgement show such close affinities with early sixteenth-century glass from the Troyes region of France that they must have been imported; this may have occurred in 1527, in which case it was more than a decade later that Wright was entrusted with the task of installing the panels in the chapel.[57]

Leaving aside the possibly imported glass at The Vyne and Hengrave Hall, there are numerous traces of the activities of foreign craftsmen, which even extended to areas as far-flung as Devon and Sussex. The north-east window of the north aisle (nIII) at Sampford Courtenay parish church in the former county contains borders with putti, Roman trophies of arms and classical columns, all taken from the standard repertoire of designs used by the foreign glaziers in the 1520s and 1530s. There is no positive evidence to identify the donor of the glass, but the manor of Sampford Courtenay belonged to Henry VIII's cousin, Henry

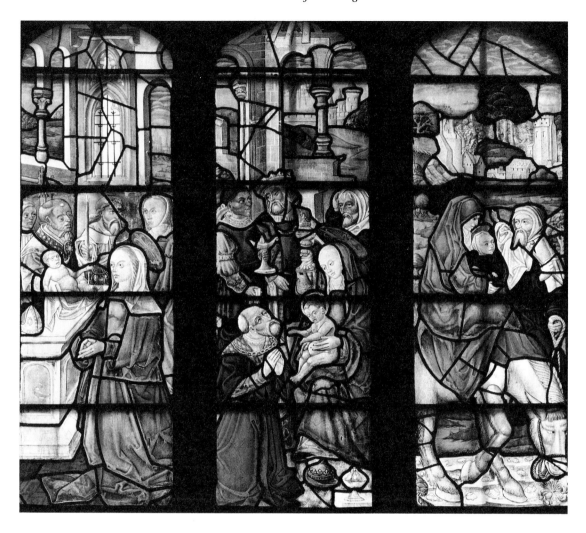

*Fig. 188*    HENGRAVE HALL (Suffolk): early life of Christ scenes in the chapel glazing, early sixteenth century.

Courtenay, created Marquess of Exeter in 1525 and executed in 1539. Glass of such sophistication in such a remote part of the kingdom is likely to have been commissioned by an individual with close Court connections.[58]

A putto also occurs as part of a canopy and in company with the grisaille figures of Moses and St James the Greater in window sIII in the chancel south chapel at Brede, East Sussex. These fragments can be associated with Sir Goddard Oxenbridge (d.1531), whose tomb is in the chapel. He too enjoyed good connections,

for his brother John was a canon of St George's Chapel, Windsor, and founded a chantry there.[59]

Educated and well-to-do clergy also turned to the immigrant glass-painters for windows in their churches, as at Cold Ashton in Avon which was built by Thomas Key, rector between 1508 and 1540. The scanty remains of the glazing comprise shields and canopy fragments in Renaissance style and Key's initials are in the form of dragons, a common design in contemporary woodcuts and manuscript illuminations.[60]

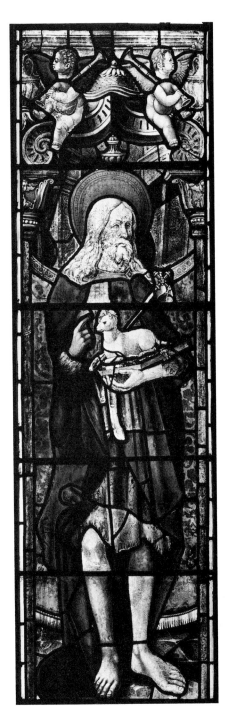

Glass by the foreign craftsmen can be seen in several Midlands churches. Sir John Spencer (d. 1522), bequeathed £60 in his will to the construction of the chancel roof, walls and windows, and for his arms to be placed in the glass at *Great Brington*, Northamptonshire. Still remaining in the church (window sIV) are some quite heavily restored heraldic and figural panels, which appear to have been part of the glazing scheme carried out in fulfilment of John Spencer's wishes. These include the full-length figure of St John the Baptist, set within an architectural framework composed of putti and other Renaissance details, an angel, small figures of St Helena and St John the Baptist, canopy *Fig. 189* fragments including urns, and a scallop-shell niche. The glass is quite similar in design to the east window of St Margaret's, Westminster and probably dates from around 1525–30.[61]

Not far away from Great Brington, the east window of the parish church at Marholm, Cambridgeshire, contains fragments of Renaissance motifs made up into borders; the chancel is described in Sir William Fitzwilliam's will of 1534 as having been 'late made and newly edified there'.[62] Much more survives of the glazing of *Withcote Chapel* in Leicestershire. On the north *Fig. 190* side are eight of the original twelve apostles holding Creed scrolls and in the south windows are ten of their Old Testament counterparts. Each figure is set under an elaborate canopy with Renaissance details and comparisons have been made with the King's College Chapel windows of 1526–31, particularly with window nIII. Jane Seymour's badge in the north-west window suggests that the glass dates from her reign as queen, i.e. between 30 May 1536 and 24 October 1537. The donor appears to have been Roger Ratcliffe, the holder of the two manors at Withcote, who had been a gentleman of the bedchamber to Catherine of Aragon.[63]

The chancel east window at Coughton, Warwickshire, contains three Sibyls with modern heads, which were removed after 1825 from the north-east window of the north chapel. Still in the tracery of four windows (nIII, nIV, sIII, sIV) are apostles holding Creed scrolls, the four Evangelists and the arms of Spiney in the same Flemish style; the east window of the north aisle has a few architectural fragments and the

*Fig. 189*   GREAT BRINGTON (Northants.): St John the Baptist, *c.* 1525–30.

usual Renaissance motifs such as putti. Leland visited Coughton and described the church as 'excedyngly well glasyed and adornyed, partly mad by Sir George Throgmorton's father [Sir Robert, d. 1518] partly by Sir George hym selfe'. The date 1530 originally associated with the Sibyls, together with the style of the glass, shows that the 'foreign' windows at Coughton were executed to Sir George Throckmorton's instructions.[64]

By no means every church with glazing which includes Renaissance designs and motifs was necessarily the work of foreign-born painters; it appears that some English glaziers, faced with demands by patrons for windows which included these fashionable elements, imitated the products of their immigrant rivals. It is not easy to separate glass by native-born craftsmen from that of the Southwark-based foreigners, but probably glazing in two East Anglian churches, at Shelton in Norfolk and Stambourne in Essex, can be attributed to local glass-painters who had to some degree assimilated the new taste. Shelton is an imposing brick church glazed in accordance with the will of Sir Ralph Shelton (d. 1497) as a monument to his family: in the east window are its members and Ralph's arms, initials and rebus were originally repeated in the tracery of every chancel and nave aisle window. The canopies and settings of the donor panels belong to the same late Gothic phase as Fairford, but are less accomplished and incorporate local border designs. David King has shown that the finest of the donor panels in window sII, which previously have been taken to represent John Shelton and his wife Anne, are almost certainly foreign glass inserted at a later date.[65] The principal remains of the Stambourne glazing are in the east window and also comprise lay figures, identifiable as Edward Mackwilliam and his wife Christian. Their son Henry was evidently responsible for the glazing and much other work to the church between 1505 and 1532. The bodies of the two surviving figures are concealed by elaborate heraldic garments which invite comparisons with contemporary monumental brasses. Some of the tracery lights have shields of arms suspended from trees in a landscape.[66]

Glass-painters in the north of England also assimilated foreign modes, no doubt having

*Fig. 190*  WITHCOTE CHAPEL (Leics.): prophet Daniel, 1536-7.

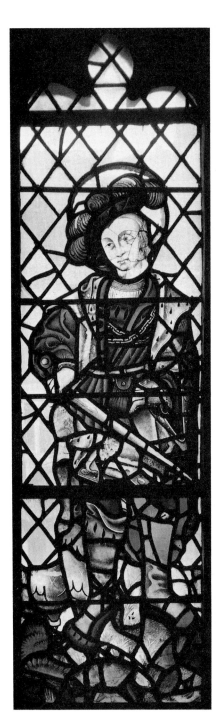

*Fig. 191*    YORK, ST MICHAEL-LE-BELFREY: St George,
*c.* 1530–40.

become aware of the threat to their trade posed by the Continental competitors through the Thornhill Jesse. The figures of the Virgin from an Annunciation and a canonized bishop in the east window of Greystoke church and glass in Cartmel Fell and Windermere, all in Cumbria, can be attributed to a York workshop (probably that of Robert Petty). The Windermere east window contains a Crucifixion group, SS Barbara, George and Catherine and a series of donors, including Augustinian canons of Cartmel Priory. In canopy design, figure style and the use of certain back-cloths this glazing is similar to the figures of SS William, Peter, Paul and Wilfrid in the south transept façade lancets of York Minster (windows sXX, sXXI, sXXII). The extensive series of saints and donors in *St Michael-le-Belfrey* and a single panel in St Helen's *Fig. 191* church in York are almost certainly by the same *atelier*, which in its architectural settings and treatment of figures shows an awareness of the work of the foreign glass-painters active in England. The Minster figures appear to date from about 1515 and the Greystoke, Cartmel Fell and Windermere glass a few years later. The windows in St Michael-le-Belfrey were executed in the 1530s.[67] The glazing in the chancel north chapel of *Kirk Sandall* near Doncaster is by a *Fig. 192* different craftsman who may even have been from the Netherlands. The remains of the inscription show that the chapel was glazed post-humously as a memorial to William Rokeby, Archbishop of Dublin, who died at the end of November 1521. Rokeby was well-connected: his brother Richard was comptroller of Wolsey's household. Renaissance motifs are absent from the canopies.[68]

There can be little doubt that the north chancel window (nII) at Winscombe in Avon is the work of a native glass-painter. In the three main lights are the figures of three different saints bearing the name Peter, all 'name' saints of the donor, Peter Carslegh, vicar of the parish between 1521 and 1532. He died in 1535 and it is uncertain whether the window was commissioned during his lifetime or by his executors after his death. Carslegh was a man of considerable learning as well as being a great pluralist, and he was the type of wealthy patron to whom the new artistic fashions might appeal. Accordingly

the glass is adorned with Renaissance cornucopia, scrolls and putti, but in all other respects the window is a typical product of the local Somerset workshop mentioned in the previous chapter.[69]

Glazing like Winscombe could hardly represent a serious challenge to the foreign craftsmen. Perhaps in recognition of this fact, or as an additional protection, the glaziers resident in the City of London took refuge in the restrictive practices of the guild system. As mentioned above, in 1474 the Glaziers' Company petitioned the Lord Mayor and Aldermen to prohibit foreign craftsmen who were not guild members from practising in the City. In 1516–17, against a prevailing background of general xenophobia in the capital, the Glaziers' Company returned to the attack and 'complayned by byll agenst oon Henry Sutton Ducheman & foreyn here present which occupyeth the feate of Glasyng within this citie to the greate hurte & preiudice of all the hole body of Glasyers beyng ffremen, etc.'.[70] In this instance Sutton was admitted to the Company, but a petition probably presented in 1523 shows that relations between the Glaziers' Company and the foreigners remained fractious. The Company alleged that the activities of the foreign glaziers resident in Southwark and outside Temple Bar had caused a decline in the number of glass-painters within the City boundaries from at least twenty-two to seven, and that they made 'moche craftie sleight and untrue warke to the grete discayt of the kyngs subiectts and gret slaunder unto the saide occupacion'.[71] The Glaziers' Company requested an Act of Parliament to subject the foreign glass-painters to the same regulations as its own and to prohibit 'fforayne and straungiers glasyers' from taking any apprentices born overseas. An Act passed in the same year met this demand and limited alien craftsmen (not just glaziers) from employing in the future more than two foreign-born servants, and stipulated that they could only have English apprentices. Several other statutes followed on similar lines, suggesting that the efforts to control the foreign craftsmen were not entirely successful. This is confirmed by the letters patent taken out in 1532 by Hone which permitted him to employ four foreign journeymen over and above the two allowed by the

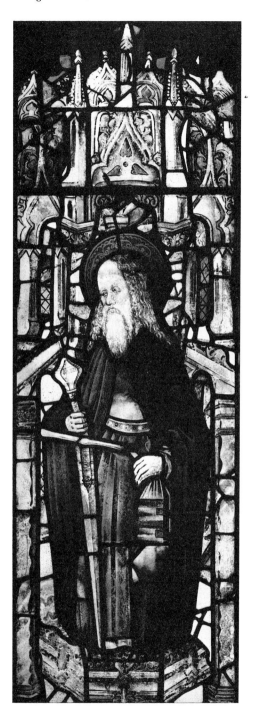

*Fig. 192*  KIRK SANDALL (S. Yorks.), Rokeby Chapel: St Paul(?), *c.* 1522–5.

1523 Act. At least Hone sought legal means to overcome the restrictions; judging from a petition of the Glaziers' Company presented to Thomas Cromwell in the period 1536-40, Peter Nicholson had blatantly ignored the 1523 Act by employing five aliens in addition to the permitted two. Another cause of friction was the practice of Hone and other foreign glaziers of undertaking commissions within the City boundaries. In about 1538 this led to their brief imprisonment and the matter appears to have been settled by an indenture, by which each of the foreigners was to pay 2 shillings a year to the Company in return for permission to work in the City. The agreement soon ran into difficulties and culminated in a case heard before the Court of Star Chamber in January 1542/3. The Court made an interim decision which in fact favoured the foreigners, who immediately recommenced their trade within the City boundaries. In 1546 the Company complained again about the foreign craftsmen, accusing them, *inter alia*, of not paying Company dues and costs of musters. Amongst the other grievances

was that 'of late the said forenglasiers denyzens and estraungers have practised devised and made a certen thing called a vice to draw out lead with'. The Company considered this 'to be dowytfulle and not mete to be used within this realme'.[72] In this instance restrictive practices triumphed and the device was ordered to be withdrawn. During the hearing of the case it emerged that Hone was the leader of the opposition to the Company and that the foreign craftsmen 'care not for yt' and had no interest in becoming members. This time the Star Chamber found in favour of the Glaziers' Company and at least two instances are recorded, in 1547 and 1554, when foreign glass-painters were fined for glazing within the City of London against the ordinances. By the time of the 1546 judgement the squabbling between the London glaziers and the alien craftsmen was already irrelevant and indeed counter-productive, for the survival of the entire craft had become threatened by a succession of political and religious events which they were powerless to influence.

# 11

# *The Reformation and After*

The destruction of ecclesiastical buildings and fittings during the Reformation profoundly affected the glazier's craft. Hostility to imagery in stained glass windows was not new in the sixteenth century. Several medieval authorities had expressed their antipathy to expensive and distracting glazing. In *c.*1145–51 coloured glass and figural representations were banned from windows in Cistercian abbeys, a ban that was repeated on several occasions.[1] The heretic John Wycliffe (d. 1384) saw the beauty of stained glass windows as a misdirection of men's admiration for God into self-love. He and many of his followers objected to costly fittings and furnishings (including glazing) of churches as they absorbed resources which should have been devoted to helping the poor.[2] Wycliffe's contemporary, William Langland, did not attack imagery as such in windows, but vented his scorn on donors who commemorated their gifts by 'portraits' and inscriptions (also on those who solicited such acts of generosity by promising pardon for sins committed by the donors):

*And [ich] shall keuery youre [kirke] and youre cloistre maken*
*Bothe wyndowes and wowes; ich wolle a-menden & glass,*
*And do peynten and portreyn who paide for the makynge,*
*that euery seg shal see, and seye Ich.am sustre of youre ordre.*
*Ac god to alle good folke suche grauynge defendeth*
*To wryten in wyndowes of eny wel-dedes,*
*Lest prude be peyntid there and pompe of the worlde.*
*For god knoweth thy conscience and thy kynde wille,*
*Thi cost and here couetyse and who the catelouhte.*
*For thy lewe lordes loue leueth suche wrytinges;*
*God in the gospel such grauynge nost a-loweth.*[3]

Stained glass provides no evidence of any rising antipathy amongst the laity towards orthodox religion in the last two decades preceding the Reformation, judging from the number of testamentary bequests of windows which although not numerous appear to be no fewer than in the late fifteenth century. During the 1520s and early 1530s outbreaks of iconoclasm occurred in various locations in England; the targets were three-dimensional images and crucifixes rather than windows or other paintings. As an Elizabethan homily against idolatry put it, 'Men are not so ready to worship a picture on a wall, or in a window, as an embossed and gilt image set with pearl and stone.'[4] For the same reason no official attack on pictorial stained glass took place until Edward VI's reign, but windows did not escape unscathed from the Henrician Reformation. So thorough was the despoliation of buildings during the dissolution of the monasteries (1536–41) that very little can be said of the glazing of monastic churches; only a few former Benedictine establishments, such as the metropolitan church of *Canterbury*, *Gloucester* (which was raised to cathedral status), *Tewkesbury*, *Great Malvern* and the nunnery at Wroxall in Warwickshire, serve to give much indication of what has been lost. The principal survivals of Augustinian glazing are *Christ Church*, Oxford, *Dorchester* in Oxfordshire, *Bristol Cathedral* (thirteenth and fourteenth centuries), Cartmel, Cumbria (fourteenth and early fifteenth centuries), and Launde in Leicestershire (early fifteenth century).[5] Only a few fragments exist of the stained glass of the Cluniacs, Premonstratensians, Cistercians, Gilbertines, Carthusians and the Mendicant

*Pls VI, VII, XXV;*
*Figs 92–6, 71, 132, 133.*
*Pl. XVIII;*
*Figs 2(d), 11, 42, 47, 74, 156, 158.*
*Figs 57, 130;*
*Pl. IX;*
*Fig. 35*
*Fig. 131*
*Pl. X;*
*Figs 52, 100*

229

Orders. Mostly the buildings were ruthlessly stripped for their materials in accordance with the official instructions to the dissolution commissioners: they were to 'pull down to the ground all the walls of the churches, stepulls, cloysters, fraterys, dorters, chapter howsys', etc.[6] The collegiate establishments suffered a similar fate and their dissolution was completed in Edward VI's reign.

The new lay owners of those monastic properties like Mottisfont and Titchfield in Hampshire which were converted into private houses had no interest in retaining the stained glass; if they installed any coloured glass it was confined to heraldic displays. Here and there monastic windows were purchased by local parish churches. In 1538-9 the churchwardens of Wing in Buckinghamshire obtained, amongst other fittings, 'a glass wyndo boght at Woburne' for 3s 4d; the cost of transporting it amounted to a further 7d. Francis Pole bought the cloister glazing from Dale Abbey in Derbyshire which was subsequently installed in the north aisle of the nearby church at *Morley*.[7]    *Fig. 52*

At the same time as the religious houses were being swept away an attack was mounted on the cult of Thomas Becket, not least because the example of his quarrel with Henry II over the relative powers of Church and State held obvious dangers for Henry VIII. In November 1538 a royal proclamation ordered Becket's removal from the church calendar and his images from churches:

*from hense forth the sayde Thomas Becket shall not be estemed, named, reputed, nor called a sayncte, but bysshop Becket, and that his ymages and pictures, through the hole realmé, shall be putte downe and auoyded out of all churches, chapelles, and other places.*[8]

Reference is made to the ravages caused by this policy in the churchwardens' accounts for St John's Bere Street, Norwich, during Edward VI's reign: 19 shillings was paid 'for makinge of a glasse wyndow wherein Thomas Beckett was'. At Gray's Inn Chapel the figure of Becket 'gloriously painted' was replaced by a panel depicting the Agony in the Garden. Few images of this saint remain in windows today.[9]    *Figs 57, 58*

If in his last years Henry VIII sought to restrain the more militant iconoclasts, Edward VI's accession in 1547 marked a distinct change in official attitude. There was an immediate outbreak of iconoclasm which received tacit government support and the royal injunctions issued in the same year adopted the most extreme line to date with regard to images. Injunction 28 has the first reference to stained glass in this context:

*Also that they shall take away ... & destroy all shrines ... pictures, paintings and all other monuments of feigned miracles ... so that there remain no memory of the same in walls, glass-windows, or elsewhere within their churches or houses.*

The Injunctions were reinforced in the following year by a royal proclamation and an instruction to Archbishop Cranmer to see to the removal of all images from places of worship throughout the realm.[10]

The inclusion of stained glass windows in Injunction 28 was a more radical step than had yet been taken by some of the leading Continental reformers, such as Luther, Calvin and Zwingli. As Zwingli explained in 1525, 'we do not think those [images] ought to be pulled down which were placed in windows for the sake of ornament, on the grounds that they bear no danger of scandal, for nobody worships in such a place.'[11] There is evidence that glazing was attacked in many localities. In September 1547 the imperial ambassador noted that 'For the last two days these images have begun to be taken down and cast away at Westminster, and they will not even leave room for them in the glass.' Even in dioceses with conservative bishops destruction took place. In 1548 the vicar of Tidenham in Gloucestershire was presented for breaking the painted windows in his parish church and overthrowing the churchyard cross. Significantly no action seems to have been taken.[12] The early fifteenth-century cloister windows at Durham, which had been glazed with the life and miracles of St Cuthbert at the expense of Bishops Skirlaw and Langley, perished in these years. In the regretful words of the anonymous compiler of the *Rites of Durham*, writing in 1593:

*And after in kyng Edward tyme this story was pulled downe by Deane Horne & broken all to peces, for he might*

*neu' abyde any auncient monum't, actes or deades, that gave any light of godly Religion.*[13]

There were those in the parishes, particularly in urban communities, who shared Dean Horne's views. In East Anglia, the churchwardens of St Lawrence's in Ipswich spent no less than £12 in 1547 on removing from the windows 'fained stories contrary to the king's majesty's injunctions' and replacing them with clear glass. Their counterparts in Norwich also expended large sums on replacement glazing during the reign:

*Item, in newe glasynge of the wyndows aboute the chirche with white glass, xl. s (St Augustine's church).*

*Also payde for glasynge of xxviij[ti] wyndows wyth whyghyt glasse, wyche was glasyd with faynde storys ... xiiij li (St George Colegate).*

*It. Payd for the glasiyng of fyften wyndows with new glasse in the church and chansell ... xvij li (St Mary at Coslany).*

The churchwardens of St Michael-at-Plea proposed to spend £20 in 'the new glassing of xvij wyndows wherein were conteyned the lyves of certen prophane histories, and other olde wyndows in our church'.[14]

The scale and intensity of the attack on windows under Edward VI should not be overestimated. It was scattered and spasmodic and even when glass had to be removed sometimes efforts were made to preserve or hide it (similarly with alabaster retables and altarstones). In 1549 the churchwardens of St Lawrence's church in Reading made this note: 'It. to remember what was done wth all the olde glasse of the wyndows in the churche.'[15] Moreover, it was not the medium itself which was offensive, only religious pictures or images depicted in windows. For this reason wholesale destruction was not always insisted upon by the authorities. Lord St John, president of the royal council, merely instructed the mayor and aldermen of the City of London to conceal offensive images in glass by painting them out. A visitation carried out by Archdeacon Harpsfield in Kent during Queen Mary's reign reveals that the same method had been used there. At *Westwell* his orders were 'To make clean the images' faces that be blotted in the glass windows immediately'; he left almost identical orders at Apple-

dore.[16] Throughout England there are stained glass figures lacking their heads which are probably the result of this policy. Even John Hooper, Bishop of Gloucester and Worcester under Edward VI, a man of such Protestant views that he is known as the father of English Nonconformity (and later died at the stake for his beliefs), was not implacably opposed to window decoration. His diocesan Injunctions of 1550-1 stated that if a window was to be painted, it must not be 'the image or picture of any saint but either branches, flowers or posies taken out of Holy Scripture'.[17]

During Mary's brief reign (1552-8) there was a complete reversal of her step-brother's religious policy and all the Protestant legislation was repealed. Although refurbishing of some churches took place there is no evidence that this included new glazing with religious subjects, apart from the windows installed by Cardinal Pole in his new gallery at Lambeth Palace; these have not survived.[18]

Very soon after Elizabeth's accession Catholic reaction was swept away and replaced by a reformed national church on much the same lines as had existed under Edward VI. The queen, however, did not quite share the same extreme iconoclastic views that had been expressed in the 1547 Injunctions and which were held by some of her bishops. Thus although the Injunctions issued in 1559 were based as a whole on those of 1547, there were some significant amendments which reflected Elizabeth's concern that church buildings should be decently maintained. Injunction 28 of the 1547 series was repeated (now numbered 23), but with the addition of a clause 'preserving nevertheless or repairing both the walls and glass windows'.[19] The contradiction between the wording of the Injunction and this clause was to lead to conflict in the seventeenth century.

These Injunctions were enforced by official visitations, but occasionally the visitation committee and unauthorized individuals were over-zealous and attacked sepulchral monuments. In 1560 Elizabeth issued a proclamation against breaking or defacing of tombs, 'erected up as well in churches, as in other public places ... only to show a memory ... and not to nourish any kind of superstition'. In the same document

*Figs 104(a), 108*

she placed restrictions on parochial iconoclasm by forbidding anyone 'to break down or deface any image in glass windows in any church, without consent of the ordinary'.[20] Such official measures attracted criticism from those who wanted a more reformed Church of England. One of the disaffected was Anthony Gilby who in 1566 wrote a dialogue which was published in 1573. Amongst the more than one hundred points of popery that still deformed England, Gilby included 'The Images of the Trinity, and many other monuments of superstition, generally in all church windows'.[21] He would have been even more disappointed had he known that more than four centuries later such 'Images of the Trinity' can still be seen in the windows of places of worship, at Browne's Hospital in Stamford, Lincolnshire, and elsewhere.

The government's restrictions helped to preserve stained glass from the attacks of iconoclasts. A contemporary saying put it succinctly:

*Whiche ben the moost profytable sayntes in the chyrche? – they that stonde in the glasse windowes, for they kepe out the wynde for wastynge of the lyghte.[22]*

Windows were permitted to remain intact because of the expense of replacement, as is attested by William Harrison, writing in 1577:

*Only the stories in glass windows excepted, which, for want of sufficient store of new stuff and by reason of extreme charge that should grow by the alteration of the same into white panes throughout the realm, are not altogether abolished in most places at once but by little and little suffered to decay, that white glass may be provided and set up in their rooms.[23]*

This factor rather than any conservatism of religious outlook may well explain the continuing delays in the removal of the old glass at Tenterden in the Protestant stronghold of Kent:

1581     *We have manye supstycyous Images in or wyndowes wch we have begun to deface and meane to goe forwarde.*

1585     *There ar in the wyndowes of the same [middle chauncel] the Image of th' crucifix St Myldred and praior for the dead which heretofore hathe bene p'sented and as yet no reformacon therein had to the great grief and offence of the congregaceons.*

1585–6     *We p'sent and desyre reformaceon of a certayne superstitious salutations paynted yn the chauncell wyndoes & certyne other ymages and pictures wch already hath been p'sented ... but no reformacon ensueth, etc.*
          *The forme of the salutation is this–Praye for me William Wealde sum' tyme Abbot of St Augustynes, a sup'stitious saying and worthy of reformacon.[24]*

Gradual decay and neglect may therefore have caused as many losses as iconoclasm. Whatever the reason, much glass was lost in Elizabeth's reign. Once again, the destruction can be gauged by the amount of repairs to windows recorded in churchwardens' accounts. Those of Ludlow for 1592–3 may be taken as typical of many:

*For vj fete of new glasse*                 *iij s.*
*For the making iiij foote of or owne glasse*     *xij d.*
*For fourescore and thertene quarreys at jd. a quarel*
     *vij s.*     *ix d.*
*For bonds for the glasse windowes and iij li of leade*
     *vj d.[25]*

Bishop Jewel repaired the lower parts of the nave north aisle windows at Salisbury Cathedral. Most of the windows bore his name and the date 1569; like the original thirteenth-century grisaille glazing above, Jewel's work was non-representational. In 1583 the churchwardens of St Thomas of Canterbury in the same city paid the sum of 4d to one Hacker 'for puttinge oute the picture of the Father in ye east windowe at Mr. Subdean's Comaundment'.[26]

Although in most instances where new glass was inserted it was clear and not painted, occasionally shields of arms were put in parish church windows. This happened at Tavistock, Devon, in 1567–8:

*For the quenes armes and my lord of Bedfords and for Setting of the same and for xxx quarrels sett at the same tyme xv s. viij d.*
*For master Fytz armes and for the Setting the armes and mendyng certyn quarrells att the same tyme x s. iiij d.[27]*

The east window of the Hoby chapel at Bisham in Berkshire retains an impressive set of twelve shields of arms of the Hoby family, dated 1609; interestingly the accompanying inscription still

ANNE·LADY·VARNE·1558

*Fig. 193*  COMPTON VERNEY (Warwicks.): Lady Anne Verney and her children (panel formerly in the chapel, present whereabouts unknown), dated 1558.

233

invites prayers for the souls of those commemorated.[28]

The Reformation had dire consequences for glass-painters. Their economic decline is shown most dramatically by the example of Galyon Hone. In 1541 his goods were assessed at £40 and he kept no fewer than five servants. By 1545 his goods were only worth 20 shillings and in 1549 and 1551 they were worth even less. The last recorded payment to Hone for glazing is in August 1551, when he received 20 shillings for work in the church of St Mary Rotherhithe, London.[29]

An even more sombre picture of the straits in which glass-painters now found themselves is painted by a 1570 census of the poor in St Stephen's parish, Norwich. Richard Gugle, aged 30 and with a wife and young daughter, is described as a 'glasier that worke not … in his owne home, indifferent'. John Burr, 'of the age of 54 yeres, glasier, verie sicke and worke not'. He had a wife and seven children 'in his owne house, no allums, indifferent'. Robert Roo, 'of the age of 46 yeres, glasier, in no worke'. He lived in Thomas Mason's house, had 'no alums, indifferent'.[30]

Some of the York families of glass-painters soldiered on, as for instance the Thompsons, who managed to make a living until well into the seventeenth century, but now the reduced demands could not give employment to more than a few. An indication of the depressed state of the craft in the city is provided by the York Mystery Plays. Traditionally the Corpus Christi play was performed jointly by the glaziers and saddlers, but in 1551 the former were in such financial difficulties that they could only pay one-third of the costs.[31] There was insufficient work for all the practitioners of the trade to be obtained from domestic glazing schemes such as the heraldic windows executed in 1585 by the Bohemian-born Bernard Dininckhoff at Gilling Castle in North Yorkshire.[32]

Figural glass from the second half of the sixteenth and early seventeenth centuries is almost non-existent. Two rare instances dating from Queen Mary's reign occur in the Midlands. In the east window of Stanford on Avon, Northamptonshire, are some incomplete panels

*Fig. 194* STOPHAM (W. Sussex): members of the Stopham family. Watercolour by S.H. Grimm dated 1780 (BL MS Add. 5674, fol. 45), early seventeenth century.

depicting Sir Thomas Cave (d. 1558) and his family. The remains of the inscription show that the glass dates from 1558 and may be connected with a bequest in Sir Thomas's will of £10 towards the church and chancel and their

ornaments. The other example is a panel also dated 1558 and formerly in the chapel at *Compton Verney*, Warwickshire. It depicts Lady *Fig. 193* Anne Verney and her children kneeling in prayer in conventional donor pose before a lectern within an architectural surround with fluted columns which is typical of the classicizing restraint exhibited by English tomb sculpture of the late 1550s and early 1560s.[33] The window installed by Dame Elizabeth Parlett in Broadwell church, Oxfordshire, in 1560 only lasted a year. It depicted herself and Sir Thomas Pope with an image of the Holy Trinity, but the last was considered superstitious and the entire window was removed.[34] Rather later in date are the members of the *Stopham* family in an enamelled glass *Fig. 194* window (nIII) in the village church of the same name in West Sussex. The panel depicting William de Stopham (*tempore* Edward III) and his three daughters in costume of *c.*1600 was probably based on a contemporary tomb design. The companion panel which includes the names of three Stophams and the date 1273, is of even greater interest as it depicts a knight in chainmail and surcoat which reveals an attempt to portray armour of the late thirteenth or early fourteenth centuries. The glazier's name, Roelant, is in the glass which appears to date from the early seventeenth century.[35]

During James I's reign an influential group of clergy who formed the Arminian party began to stress the importance of liturgy and the sacraments and, as a concomitant, the need for seemliness and ceremony in places of worship. Initially this group was only a very small minority, but thanks to the support of the Duke of Buckingham it gained access to Charles, Prince of Wales. After his accession to the throne in 1625 the Arminians were able to seize control of the Church through their appointment as bishops, deans, university chancellors and some heads of colleges in Oxford and Cambridge. In turn they could exercise their patronage in the appointment of parochial clergy. Although the Arminians never obtained total control of the episcopate they held some of the major sees. Durham was in the hands first of Neile and then Cosin, Montagu became bishop of Chichester in 1628 and Francis White was

appointed by Charles I to Norwich. In 1633 Neile became Archbishop of York. The most important member of the Arminian group was William Laud, who rose rapidly to power: 1625 Bishop of St David's, 1626 Bishop of Bath and Wells, 1628 Bishop of London and finally in 1633, Archbishop of Canterbury.[36]

The Arminian or Laudian bishops and clergy undertook an extensive programme of beautification of churches. Images and screens were reintroduced, communion tables became altars and were suitably adorned with crucifixes and candlesticks. Paintings on walls were executed and there was a revival in the art of glazing, using enamel rather than pot-metal paints. In 1616 Passion scenes as well as heraldry were placed in the east window of the chapel of Trinity Hospital, Greenwich, and a series of prophets, Christ, the apostles and St Stephen in Wadham College Chapel, Oxford. More figural glass was commissioned in the 1620s and 1630s and considerable quantities survive in the Oxford colleges. Richard Greenbury painted the female saints in the antechapel at Magdalen College and another native glass-painter, Baptista Sutton, executed the story of Jacob and Esau and heraldic glass in the chapel of the Holy Trinity at Guildford. The Guildford windows are dated 1621, and in 1634 Sutton glazed the east window of St Leonard's Shoreditch (mostly destroyed by bombing during the Second World War). The same painter was also responsible for a window in a church at Tothilfields which was cited in the trial of Archbishop Laud. A London glazier named Richard Butler undertook some important commissions between 1609 and the 1630s, including work for Robert Cecil in the chapel of Hatfield House, Hertfordshire, the chapel of the Red House at Moor Monkton near York, the chapel of Lincoln's Inn in London and glazing for Laud himself in Lambeth Palace.[37]

The most important of the glass-painters during the Laudian ascendancy were the brothers Bernard and Abraham van Linge, who came from an Emden family of glaziers. The former painted the Passion scenes in the east window of Wadham College chapel in 1622, the prophets and other figures in the chapels of Lincoln's Inn, London (1623–6), Lincoln College (1629–30) and Christ Church, Oxford (*c.*1630–

40). Abraham also painted glass for Christ Church, notably the signed panel depicting Jonah before Nineveh, and for other Oxford colleges, including the Queen's College, Balliol and University College. Abraham's Deposition from *Hampton Court* in Hereford & Worcester is now in the Victoria and Albert Museum. This is based on the famous painting by Rogier van der Weyden, and is particularly interesting as the inscription makes clear that it was not to be treated as a religious image: 'The truth hereof is historicall deuine and not superstissious Anno Domini 1629.'[38]

*Fig. 195*

This disclaimer is a reminder that the restoration of ritual and seemliness into church fittings and furnishings was not a policy that found universal favour. On the contrary, despite (and also perhaps because of) the support of Charles as Supreme Governor of the Church of England, the Laudian hierarchy was out of tune with the sympathies of many parochial clergy and their congregations, which lay in the opposite direction. Concurrently with the commissioning of new glazing went the continuing destruction of old windows. In 1630 the Recorder of Salisbury, Henry Sherfield, was ordered by the Puritan-dominated vestry of St Edmund's church in that city to:

*take down the windowe wherin God is painted in many places, as if he were there creating the world: so he doe in steed there of new make the same window with white glasse, for that the sayde window is somewhat decaied and broken, and is very darksome, whereby such as sitt neere to the same cannot see to reade in their bookes.*

The Bishop of Salisbury got wind of this instruction and vetoed it. Sherfield disregarded the bishop's order and not content with removing the window proceeded to smash it with his pikestaff. The Attorney-General brought proceedings against the Recorder in the Court of Star Chamber. Sherfield based his defence on the Puritan view that what was not a literal interpretation of Scripture should not be depicted. He objected that the window in St Edmund's church was not a true portrayal of Creation:

*[F]or that it contained divers forms of little old men in blue and red coats, and naked in the heads, feet and hands, for the picture of God the Father; and that in one place he was*

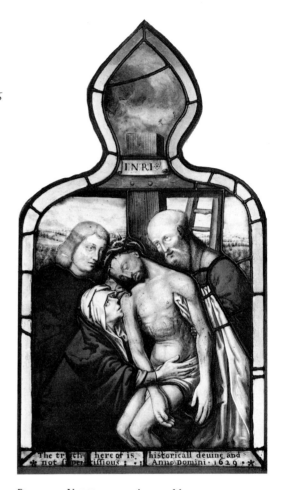

Fig. 195   VICTORIA AND ALBERT MUSEUM: deposition from Hampton Court (Heref. & Worcs.). By Abraham van Linge, dated 1629.

*set forth with a pair of compasses in his hands, laying them upon the sun and moon; and the painter had set Him forth creating the birds on the third day, and had placed the picture of beasts and men and women on the fifth day – the man was a naked man, and the woman naked in some part, as much from the knees upwards, rising out of the arm.*[39]

The revival of the art of glass-painting was short-lived and came to an end during the Civil War and its aftermath. The Puritan attitude that prevailed during this period was summed up by William Prynne, Laud's arch-foe: '[P]opery may creep in at a glasse window, as well as at a door.' Significantly, the charges against Archbishop

236

Laud at his trial in 1644 included 'countenancing the setting up of images in churches, church-windows and the places of religious worship. That in his own chapel at Lambeth he had repaired the Popish windows [the work was done by Richard Butler], that had been destroyed at the Reformation.' Laud denied that he had acted illegally in re-introducing religious imagery in windows by exploiting the confusion in the Edwardian and Elizabethan provisions on this subject. In addition he pointed out correctly that 'contemporary practice (which is one of the best expounders of the meaning of any law) did neither destroy all coloured windows, though images were in them in the Queen's time, nor abstain from setting up new, both in her and King James his time.'[40]

From the 1640s until the Restoration in 1660 destruction of stained glass seems to have reached its highest level since Edward VI's reign. Some losses resulted from the fighting between the Royalist and Parliamentary armies. Lichfield Cathedral was besieged in March 1642 and badly damaged. Subsequently the Parliamentary forces apparently embarked on an orgy of destruction. Fanatical elements amongst Cromwell's troops wrecked the church and cloister windows of Peterborough Cathedral:

*The Cloister Windows were most famed of all, for their great Art and pleasing variety.... All of which notwith-standing were most shamefully broken and destroyed.*

All the windows with painted glass were broken up in the cloister and the church except for the west window (parts of it still remain in the apse triforium and clerestory windows). 'Yea to encourage them the more in this Trade of breaking and battering windows down, *Cromwell* himself (as 'twas reported) espying a little Crucifix in a Window aloft, ... gets a ladder, and breaks it down zealously with his own hand.'[41]

Gunton's account was not published until 1686 and it should be noted that there was a natural tendency for post-Restoration writers and Royalist sympathizers to exaggerate the scale of the damage and lay the blame for it at the door of their opponents. Moreover not all Parliamentarians were indifferent to the monuments of the past: when Sir Thomas Fairfax captured York in July 1644 the Minster and parish churches were protected from desecration. In addition, as memories faded the respective destruction caused by Oliver Cromwell and Henry VIII's chief minister and architect of the dissolution of the monasteries, Thomas Cromwell, became confused in the popular imagination and resulted in the former tending to take the blame for the sins of the latter.[42]

In September 1641 the House of Commons published and sent out certain directives to ministers and churchwardens regarding 'the abolishing of superstition and innovation', which included the removal of images. The targets were the recent Laudian innovations even more than pre-Reformation survivals. Owing to the opposition of the House of Lords these directives did not become law until 28 August 1643, and the resulting ordinance stipulated the destruction of altars, altar-rails, chancel steps and the removal of crucifixes, crosses and images and pictures of the Virgin, the Holy Trinity and saints from places of worship. On 9 May 1644 another ordinance was issued 'for the further demolishing of monuments of idolatry and superstition'.[43] In order to ensure that the Parliamentary instructions were carried out, a number of commissioners were appointed. The Earl of Manchester gave the commission for the eastern counties to William Dowsing. Dowsing prosecuted his commission with the utmost zeal, recording his destruction in a journal. He and his deputies visited more than 150 places between December 1643 and 1 October 1644. Sepulchral monuments and stained glass windows suffered severely, as this entry for Stoke-by-Nayland demonstrates: 'We brake down an 100 superstitious Pictures; and took up 7 superstitious Inscriptions on the Grave-Stones, "ora pro nobis", etc.' Dowsing also extended his activities into Cambridgeshire, where not even the colleges of the University were spared his attentions. The writer of a contemporary tract lamented bitterly:

*And one who calls himself John [sic] Dowsing, and by vertue of a pretended Commission goes about the Country like a Bedlam breaking glasse windowes, having battered and beaten downe all our painted glasse, not only in our Chapples, but (contrary to order) in our publique Schooles, Colledge Halls, Libraryes and Chambers, mistaking perhaps the liberall Arts for Saints ... compelled*

*us by armed Souldiers to pay forty shillings a Colledge for not mending what he had spoyled and defaced, or forth-with go to Prison.*[44]

The Oxford colleges fared no better from Dowsing's colleagues. John Aubrey complained:

*When I came to Oxford crucifixes were common in the glass in the studies' window, and in the chamber windows were canonized saints (for example in my chamber window, St Gregory the Great, and another broken).... But after 1647 they were all broken.*[45]

Some Puritan-minded clergy were equally enthusiastic for the destruction of windows: one of the canons stamped furiously on the windows at Christ Church Cathedral when they were taken down.[46] The most notorious of the clerical iconoclasts was Richard Culmer, who, acting in similar official capacity to Dowsing, in December 1643 destroyed monuments of super-stition in Canterbury Cathedral. The glass windows suffered severely, none more so than the 'Royal' window in the north-west transept (NXXVIII). Culmer describes how he climbed to the top of the ladder to batter down 'the picture of God the Father, and of Christ, besides a large crucifix, and the picture of the Holy Ghost in the form of a dove, and of the twelve apostles'. He also 'rattled down proud Becket's glassy bones' in the same window.[47]

The destruction at *Canterbury* is particularly well chronicled. In addition to Culmer's own proud record of his activities, an artist named Thomas Johnson in 1657 painted a picture showing iconoclasts smashing windows and furnishings in the cathedral choir.[48]  *Fig. 196*

In strongly Puritan counties like Middlesex the laity could also be powerful advocates of destruction. A petition purportedly signed by 12,000 women from this county stated:

*We desire that prophane glass windowes, whose supersti-tious paint makes many idolators, may be humbled and dashed in pieces against the ground; for our conscions tell us that they are diabolicall, and the father of Darkness was the inventor of them, being the chief Patron of damnable pride.*[49]

As had been the case during the middle years of the sixteenth century, iconoclasm was not rife throughout the country and much depended on local attitudes. Neither did all the glass destroyed in the sixteenth and seventeenth centuries vanish without trace, for some of it was recorded in sketches and descriptions by antiquaries. Many of these were heralds and their prime concern was the compilation of evidence for shields of arms and genealogies; consequently they tended to ignore religious subject-matter and concentrated on heraldry and donor figures. Their draughtsmanship is frequently indifferent and quite often it is not clear whether they are describing stained glass windows or sepulchral monuments. Nevertheless the antiquaries are invaluable in providing dating evidence for lost and existing glass. The antiquarian sources are still relatively unexplored and very few have been transcribed and published, apart from various county histories and works such as Stow's *Survey of London*. One of the most important of the Elizabethan writers is the anonymous compiler of *The Rites of Durham*, mentioned above (pp. 230–1). Without his descriptions, which include iconography, know-ledge of the glazing of Durham Cathedral Priory would be negligible. Lieutenant Hammond of the Norwich militia, who kept journals of tours made in 1634 and 1635, is also one of the very few early antiquaries to take an interest in subject-matter. Two collections of church notes in the British Library are particularly useful to stained glass historians, although as usual they are almost exclusively confined to heraldry. *MS Egerton 3510* contains material by William *Fig. 197* Burton and others dating from the late sixteenth and early seventeenth centuries; MS Lansdowne 874 commences a few years later and includes the notes and sketches of Nicholas Charles, Lancaster Herald (1609–13), Richard St George, Clarenceux (1625–33), and later writers. These manuscripts encompass churches in several counties; important collections for individual counties include those of the Randle Hulme family in Cheshire and Roger Dodsworth (York-shire). The notes made in Kent between 1613 and 1642 by John Philipot, Somerset Herald, have been published.[50]

The most accomplished records of stained glass windows during this period were made by a heraldic painter named William Sedgwick. In

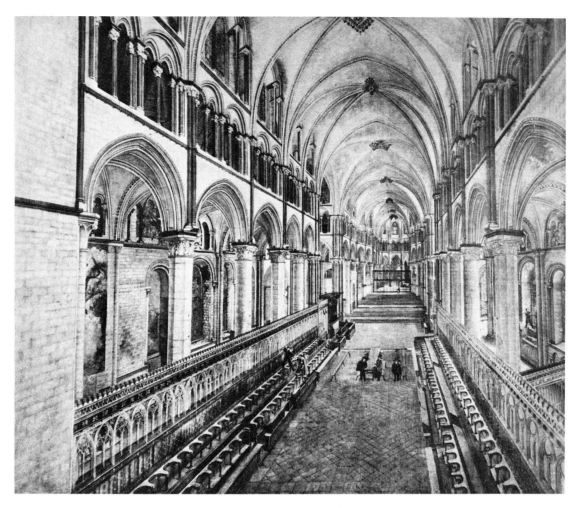

*Fig. 196*     Thomas Johnson: *Choir of Canterbury Cathedral.* Oil on panel, dated 1657 (private collection). The painting shows
iconoclasts attacking the glass.

1640 and 1641 he and Sir William Dugdale set
out on tours noting shields of arms, donors and
inscriptions in churches and cathedrals. Sedg-
wick made a fair copy known as the *Book of
Monuments* (BL Loan MS 38), as well as several
rough versions in the College of Arms. The *Book
of Monuments* is a splendidly illuminated record     *Figs 12, 73*
of tombs and stained glass windows, primarily in
churches in the Midlands. Sedgwick's work can
also be seen in a genealogy of the Howard family
compiled in 1638 and still in the possession of
the Duke of Norfolk.[51] The figures of Sir John
Howard (d.1426) and his wife Alice in *Stoke-by-*

*Nayland* church, which Sedgwick illustrated,     *Fig. 198*
were amongst the stained glass imagery destroyed
soon after his visit by Dowsing.

The post-Restoration antiquarians were less
concerned with matters genealogical and
heraldic and took a much greater interest in
iconography than had their predecessors. In the
late seventeenth century *Henry Johnston* and     *Fig. 31(c)*
James Torre made drawings and descriptions of
the windows in the Minster and parish churches
of York.[52] Some of the county historians of the
following century also made extensive records of
stained glass windows. Two of the most notable

*Fig. 197* Notes on heraldic glass in the counties of Devon, Dorset and Somerset (BL MS Egerton 3510, fol. 107r, detail). Early seventeenth century.

were *John Bridges* of Northamptonshire and Francis Blomefield of Norfolk. At the end of the eighteenth and in the early nineteenth centuries *Thomas Fisher* recorded glass in Bedfordshire and Kent in a series of coloured drawings which were, with the illustrations of William Fowler (1761–1832), the most accurate records of the medium seen to date. Valuable drawings were also made by the Revd Thomas Powell (*c.*1810) and John Carter (1748–1817).[53] Medieval glass was even responsible for one antiquarian fatality: in 1821 Charles Stothard was killed by falling

*Fig. 199*

*Pl. XXX*

from a ladder whilst making drawings of the windows at Bere Ferrers in Devon.[54]

Liturgical requirements in the Age of Reason for clearly and plainly lit interiors in order to foster much greater use by the laity of the Book of Common Prayer were incompatible with medieval stained glass windows and losses continued throughout the eighteenth century. Removal of medieval glass did not always go without protest. William Stukeley, rector of All Saints, Stamford in Lincolnshire, angrily recorded the destruction of the windows of *St*

*George's* church which contained the unique *Fig. 73* series of the Founder Knights of the Order of the Garter:

*28 November 1736: At St George's they have destroyed wholly several entire windows within three years last past.... The true secret is, next to the indolence of the inhabitants, the glaziers get the profit of putting up new glass.*

*19 December 1739: Walking by Exton the glazier's door, I saw a cart load of painted glass, just taken down from S George's church windows to put clear glass in the room.... I used my interest with Mr Exton and got the glass.*

*22 May 1741: I, hearing that they had taken down some more painted glass in S George's church, immediately hunted it out from one glazier to another, and found the founder's window quite gone ... except part of the founder's image, which I got.*[55]

Symptomatic of an all too common attitude is the fate of the medieval glazing of Salisbury Cathedral during James Wyatt's restorations of 1788. Even though Wyatt himself was very sympathetic to the Gothic style, his lack of supervision of the craftsmen resulted in the removal by the cart-load of most of the stained glass and its disposal in the city ditch. The motive is revealed by a letter written in that year by John Berry, glazier of Salisbury, to a Mr Lloyd of Conduit Street, London:

*Sir. This day I have sent you a Box full of old Stained & Painted glass, as you desired me to due, which I hope will sute your Purpos, it his the best that I can get at Present. But I expect to Beate to Peceais a great deal very sune, as it his of now use to me, and we do it for the lead. If you want more of the same sorts you may have what thear is, if it will pay for taking out, as it is a Deal of Truble to what Beating it to Peceais his; you will send me a line as soon as Possoble, for we are goain to move our glasing shop to a Nother plase, and thin we hope to save a great deal more of the like sort, which I ham your most Omble servant — John Berry.*[56]

The nave glazing of the former Yorkist dynastic mausoleum at *Fotheringhay* at Northamptonshire *Figs 165,* perished through similar neglect at some point *199* between 1787 and the early nineteenth century.[57]

Fortunately not all the medieval glass removed

from public places of worship in this period disappeared. The 'Gothick' was in vogue and medieval glass became a desirable collectors' item and an appropriate embellishment for the residences of the *cognoscenti*. Stukeley in the passage quoted above mentions that he rescued the figure of the 'founder's image', i.e. William Bruges, which he proceeded to install in his summer house. The taste for Gothic was fostered by men of discernment and knowledge like Horace Walpole and William Beckford, the extravagant and eccentric patron of Wyatt, who built his Gothic fantasy at Fonthill. In 1753 Walpole described to Sir Horace Mann his famous house at Strawberry Hill. The hall contained 'lean windows fattened with rich saints in painted glass'. The heads of each of two closet windows were 'glutted with the richest painted glass of the Arms of England, crimson roses, and twenty other pieces of green, purple, and historic bits'.[58] In 1757, in the face of strenuous opposition from the parishioners, the chancel glazing of Tattershall in Lincolnshire was removed to Burghley House, the residence of Lord Exeter, to whom the glass had been given by Lord Fortescue, the owner of the advowson. Some of it was set up in the Great Hall at Burghley and the remainder was given by Lord

*Fig. 198*   STOKE-BY-NAYLAND (Suffolk): a lost window depicting Sir John Howard (d. 1426) and his wife in the *Howard Genealogy* (Coll. Duke of Norfolk, Arundel Castle, W. Sussex), p. 106. Painted by William Sedgwick in 1638.

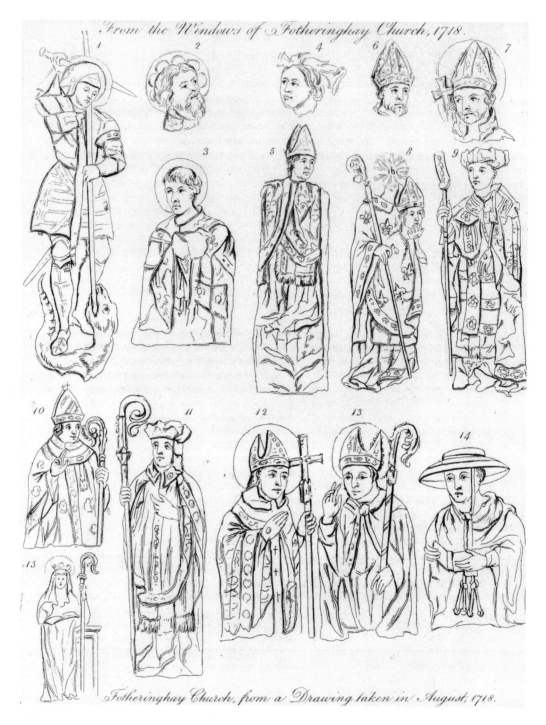

Fig. 199    FOTHERINGHAY (Northants.): engraving of lost figures published in J. Bridges, *The History and Antiquities of Northamptonshire.*

Exeter to the Earl of Warwick for his castle chapel and to *St Martin's* church at Stamford.` *Fig. 48* The glass still remains in these locations.[59]

From the middle of the eighteenth century English antiquaries and wealthy collectors began to seek out the treasures to be had on the Continent. Walpole in about 1743 commissioned an Italian named Asciotti, who was married to a Flemish woman, to buy small sixteenth- and seventeenth-century roundels in the Netherlands. Subsequently Asciotti's wife made further buying trips

*and sold her cargoes to one Palmer, a glazier in St Martin's Lane, who immediately raised the price to one, two, five guineas for a single piece, and fitted up entire windows with them.... In 1761, Paterson, an Auctioneer at Essex House in the Strand, opened the first Exhibition of painted glass, imported in like manner from Flanders. All this manufacture consisted in roundels stained in black and yellow, or in small figures of black and white, birds and flowers in colours, and Flemish coats of arms.*[60]

The first evidence of the removal of large panels from Continental churches is in 1787, when Lord Radnor purchased a Nativity at Angers which he placed in the east window of Coleshill parish church in Berkshire.[61]

The trade in stained glass between northern Europe and England received an enormous impetus from the French Revolution and the subsequent neglect, destruction and secularization of church buildings in France, Germany and the Netherlands. Dealers were able to buy vast quantities of ancient glass which found eager purchasers amongst English collectors. The most notable of these agents was the German-born John Christopher Hampp, who emigrated to England in 1750 and set up a cloth-weaving business at Norwich. After the Peace of Amiens in 1802 he crossed the Channel in search of orders for his cloth and also obtained much glass, as the Rouen historian Eustache de la Quérière recorded:

*The beautiful stained glass windows of St Jean were all carried off in 1802 during the Peace of Amiens by ... Hampp.... At the same time he acquired all the stained glass of St Nicolas, St Caude-le-Vieux, the Chartreuse, and part of that of St Herbland. These filled 17 great boxes which were transported to Calais and thence to Norwich'.*[62]

In 1803 Hampp purchased more glass in Rouen, Paris, Cologne and Aachen. Much of it was sold at Christie's in 1804, 1808 and 1814, and subsequently found its way to Wells Cathedral, York Minster and elsewhere, often via private collections such as that established by Sir William Jerningham in the chapel of his mansion at Costessey in Norfolk.[63] It was from the Earl of Bridgewater's chapel at Ashridge near Berkhamsted in Hertfordshire that the Victoria and Albert Museum acquired the impressive series of windows from the Cistercian abbey of Steinfeld and the Premonstratensian house at Mariawald.

Hampp was not the only agent at work on the Continent. In 1802 the chapter of Lichfield Cathedral took delivery of the magnificent sixteenth-century windows from the Cistercian abbey at Herkenrode in the diocese of Liège which they had obtained through the agency of Sir Brooke Boothby for the sum of £200.[64] The Rev W. G. Rowland, curate of Holy Cross, Shrewsbury, and a former member of the Lichfield chapter, was given the task of arranging the glass in the cathedral. He later became vicar of St Mary's at Shrewsbury and acquired much Continental glass for his parish church, including over sixty late fifteenth-century panels depicting scenes from the life of St Bernard of Clairvaux which came from the cloisters of Altenberg Abbey near Cologne, some panels from Trier of the same period and sixteenth-century windows from the church of Saint-Jacques at Liège.[65]

Most of the glass bought by Hampp and contemporary collectors was of the late Gothic or Renaissance periods and the taste for earlier glazing only developed several decades later. In 1839 the incumbent of Rivenhall in Essex purchased from the parish priest at Chènu in Sarthe some fine twelfth- and thirteenth-century medallions and other figural panels which are now in Rivenhall church. Shortly afterwards several contemporary panels from Saint-Denis and the Sainte-Chapelle found their way to the parish churches of Twycross in Leicestershire and Wilton in Wiltshire. More glazing from Saint-Denis was installed in private houses at Highcliffe near Bournemouth and Raby Castle in County Durham.[66]

The importation and installation of so much excellent medieval stained glass was not only some compensation for the losses suffered in the Reformation and later, it also acted as an important catalyst in the revival of the craft of glass-painting. Hitherto, eighteenth-century glass-painters like the Price family and William Peckitt of York (1731–95) had continued to use enamel paints and by and large their products read as transparent oil paintings, although Peckitt and William Eginton (1778–1834) in some of their work showed an interest in medieval glazing. The first signs of this revival, which utilized medieval techniques and styles, began in the 1820s. In this decade the Shrewsbury firm of Betton & Evans made good copies of Thomas Glazier of Oxford's glass in *Winchester College* Chapel and from 1832 'restored' much of *Fig. 31(a)* the fifteenth-century glass at Ludlow.[67] The wholesale church restorations undertaken during Queen Victoria's reign also prompted an interest in medieval glass. In 1819 George Austin Senior began work on repairs to Canterbury Cathedral. He was primarily concerned with the building fabric, but according to his 1848 obituary he painted windows indistinguishable from the originals. None of his work survives, but that of his son, George Austin Junior, who retired in 1862, can be seen in abundance in the cathedral.[68]

At the same time as restoration of medieval glass commenced, new windows in the 'Gothic' style began to be commissioned.[69] A pioneer was Thomas Willement (1786–1871); he was particularly interested in heraldic art of the early sixteenth century, although he also attempted window designs based on earlier periods using pot-metal glass. Understanding of the design and history of English medieval glass received a vital impetus with the publication of four books: James Ballantine's *A Treatise on Painted Glass* (1845), William Warrington's *History of Stained Glass* (1848), and two by Charles Winston, *An Inquiry into the Difference of Style Observable in Ancient Glass Paintings especially in England, with Hints on Glass Painting* (2 vols, 1847) and *Memoirs Illustrative of the Art of Glass-Painting*, published posthumously in 1865. Winston, a lawyer by profession, can be regarded as the father of modern stained glass studies. As early as 1830,

when he was only 16, he began what was to be an extensive series of meticulous watercolour illustrations of medieval windows, individual panels and small details; many of his observations and dating conclusions remain valid today. Winston also had a fundamental impact on contemporary glass-painting. In 1849–50 he initiated a series of chemical analyses on twelfth-century glass and then persuaded Messrs J Powell of Whitefriars to make glass according to the medieval formulae. By 1853 the new 'antique' glass was in commercial production. In both colour and texture this glass was far better than anything that had been produced for several centuries and opened up new opportunities for good design and craftsmanship. Winston's enthusiasm and his publications and lectures on medieval stained glass did much to popularize the medium with glaziers and patrons alike. As has justly been remarked: 'The transition from a mainly imitative phase to the creative phase of the High Victorian period, marked especially by the work of William Morris and his associates, owed an incalculable debt to Winston.'[70]

*Figs 56, 101(a), (b), 102(b), 104, 109, 121, 124, 200*

The large number of churches built in the middle of Victoria's reign and the popularity of the Anglo-Catholic movement in the Church of England led to a vast increase in the demand for stained glass windows. Championed by Augustus Pugin and Winston, Gothic of the late thirteenth and early fourteenth centuries became the accepted style for stained glass as well as ecclesiastical architecture and furnishings, and it was adopted by the glazing firms that came into existence to meet this demand. In addition to Betton & Evans and Powell, this list included Clayton & Bell, Heaton, Butler & Bayne, John Hardman, Lavers & Barraud and William Wailes.[71] Above all, the work of Edward Burne-Jones before and after he joined the firm of Morris & Co. in 1861 raised the art of glass-painting to a level it had not attained since the Reformation. William Morris and Burne-Jones were deeply interested in the art of the Middle Ages and they used medieval manuscripts and paintings as sources for their window designs. However, unlike so many of their contemporaries working in the Gothic Revival idiom, their glass is not a medieval pastiche but a free,

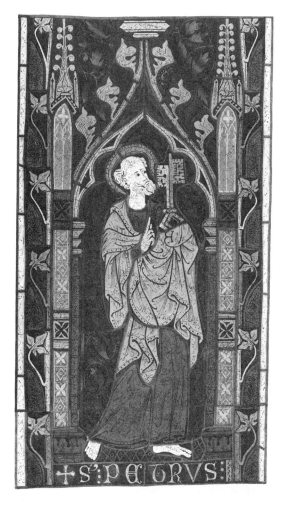 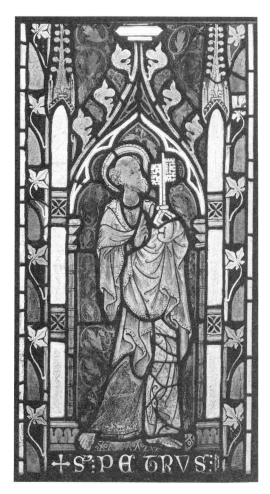

*Fig. 200*  STANFORD ON AVON (Northants.): St Peter in the chancel glazing of *c.* 1315–26: (*left*) as depicted by Charles Winston in a watercolour dated 1834 (BL MS Add. 35211); (*right*) as it existed in 1987.

creative reinterpretation. Morris's feeling and appreciation for the period is equally apparent in his far-sighted and sensitive approach to the restoration of medieval windows and his refusal to introduce new stained glass into ancient buildings, although this philosophy only evolved during the 1870s.[72]

Winston was followed in the academic study of English medieval glass by Lewis F. Day (1897) and N.H.J. Westlake (1881–94). In the years preceding the First World War the collector Philip Nelson produced the first county gazetteer of medieval glass (1913) and further studies

were published by Maurice Drake and F.S. Eden. In 1926 Herbert Read turned his attention to the subject and the same year saw the publication of J.D. Le Couteur's excellent account of English medieval glass. In the 1930s G.McN. Rushforth used the windows of Great Malvern as a vehicle for an important study of medieval iconography and J.A. Knowles brought together a series of his articles in *Essays in the History of the York School of Glass Painting*. The Revd Christopher Woodforde's books on medieval glass in Somerset, East Anglia and Oxford and a general survey were published between 1946 and 1954.[73] These are

but a few of the many works that have appeared on the subject since Winston's time. Until the 1960s publications on stained glass, however admirable, treated the subject without reference to medieval art as a whole. The situation changed in 1961 with the late Peter Newton's doctoral dissertation on glass in the Midlands. Regrettably this has remained unpublished, but all subsequent studies of consequence have reflected its emphasis on the relevance for English medieval stained glass of illuminated manuscripts, heraldry, iconography and anti-quarian sources.

The most important recent development has been the appearance of the first English volumes in the international *Corpus Vitrearum* series and it is intended that eventually all surviving medieval glass in the country will be published. To date volumes have been completed on King's College Cambridge, Canterbury Cathedral, Lincoln Cathedral, Oxfordshire and the west windows of York Minster.[74] Research undertaken in connec-

tion with the *Corpus Vitrearum* project has revealed hitherto unknown works of great quality and significance in parish churches, frequently in a poor state of preservation. This has led to a growing awareness, which is by no means confined to the United Kingdom, of the pressing need to conserve sensitively and protect as much as possible of this fragile medium.

Nevertheless, despite the efforts of church authorities and funding agencies like English Heritage and the availability of craftsmen specializing in stained glass restoration, such as the long-established firm of D.J. King & Son of Norwich, The York Glaziers Trust, the cathedral workshop at Canterbury, and those of Keith Barley and Alfred Fisher, the effects of modern atmospheric pollution, together with the closure of many churches and the lack of financial resources, have resulted in medieval stained glass facing what is arguably its greatest crisis since the Reformation.[75]

# Notes

## 1 Donors and Patrons

1 P. Nelson, *Ancient Painted Glass in England 1170–1500*, London, 1913; J.D. Le Couteur, *English Mediaeval Painted Glass*, London, 1926; B. Coe, *Stained Glass in England 1150–1550*, London, 1981.

2 See below, chapter 5, pp. 105–6.

3 ibid., pp. 106–8.

4 M.H. Caviness, *The Early Stained Glass of Canterbury Cathedral c.1175–1220*, Princeton, 1977; idem, *The Windows of Christ Church Cathedral Canterbury* (*CVMA* Great Britain vol. II), London, 1981; see also below, chapter 6, pp. 118–24.

5 Y. Delaporte and E. Houvet, *Les Vitraux de la cathédrale de Chartres*, Chartres, 1926.

6 A.M. Erskine (ed.), *The Accounts of the Fabric of Exeter Cathedral, 1279–1353*, Devon & Cornwall Record Soc., new series, vols XXIV, XXVI (1981, 1983) (especially pp. ix–xiii); C. Brooks and D. Evans, *The Great East Window of Exeter Cathedral: A Glazing History*, Exeter, 1988, pp. 11–36.

7 A. Gransden, 'The history of Wells Cathedral, c.1090–1547', in L.S. Colchester (ed.), *Wells Cathedral: A History*, Shepton Mallet, 1982, pp. 36–7.

8 J.A. Robinson, 'The fourteenth-century glass at Wells', *Archaeologia*, vol. LXXXI (1931), pp. 97–9, pl. XLV; R. Marks, 'The mediaeval stained glass of Wells Cathedral', in Colchester, op. cit., p. 140.

9 R.A. Brown, H.M. Colvin and A.J. Taylor, *The History of the King's Works: The Middle Ages*, vol. I, London, 1963, pp. 130–57; H.M. Colvin (ed.), *Building Accounts of King Henry III*, Oxford, 1971.

10 'Med. Glazing Accounts' (1927–8), pp. 116–17; T. Borenius, 'The cycle of images in the palaces and castles of Henry III', *Jnl Warburg & Courtauld Institutes*, vol. VI (1943), pp. 47–9.

11 L.F. Salzman, 'The glazing of St Stephen's Chapel, Westminster, 1351–2', *JBSMGP*, vol. I (1926–7), pp. 14–16, 31–5, 38–41; 'Med. Glazing Accounts' (1927–8), pp. 120, 188–90.

12 F.C. Eeles, 'The ancient stained glass of Westminster Abbey, from a manuscript dated 1938', *JBSMGP*, vol. XVII (sic) no. 2 (1978–9), pp. 22–9; H. Wayment, *The Windows of King's College Chapel Cambridge* (*CVMA* Great Britain Supplementary vol. I), London, 1972. See also below, chapter 10, pp. 213–20.

13 R. Marks, 'The glazing of Fotheringhay Church and College', *JBAA*, vol. CXXXI (1978), pp. 79–109; *Tattershall*. See also below, chapter 9, pp. 194–5, 200–1.

14 C. Winston, *Memoirs Illustrative of the Art of Glass Painting*, London, 1865, pp. 326–42; C.F. Hardy, 'On the music in the painted glass of the windows in the Bauchamp Chapel at Warwick', *Archaeologia*, vol. LXI (1909), pp. 583–614; P.B. Chatwin, 'Some notes on the painted windows of the Beauchamp Chapel, Warwick', *Trans. Birmingham Archaeological Soc.*, vol. LIII (1928), pp. 158–66. See also below, chapter 9, pp. 190, 194.

15 C. Woodforde, *The Stained Glass of New College Oxford*, Oxford, 1951; J.H. Harvey and D.G. King, 'Winchester College stained glass', *Archaeologia*, vol. CIII (1971), pp. 149–77.

16 H. Wayment, *The Stained Glass of the Church of St Mary, Fairford, Gloucestershire* (Society of Antiquaries of London Occasional Paper, new series, vol. V, 1984). See also below, chapter 10, pp. 209–12.

17 C.R. Councer, *Lost Glass from Kent Churches*, Kent Archaeological Soc., Kent Records, vol. XXII (1980), pp. 115–17.

18 O'Connor and Haselock, pp. 341–64.

19 T.W. French and D. O'Connor, *York Minster: A Catalogue of Medieval Stained Glass: The West Windows of the Nave* (*CVMA* Great Britain vol. III/I), London, 1987.

20 *Med. Christ. Im.*

21 R. Marks, 'The stained glass patronage of Sir Reginald Bray', *Report Soc. Friends of St George's & the Descendants of the Knights of the Garter*, vol. V no. 5 (1973–4), pp. 199–202.

22 *Tattershall*, pp. 79–81; *Med. Christ. Im.*, pp. 243–4.

23 *Med. Christ. Im.*, pp. 105–36.

24 C. Woodforde, *The Norwich School of Glass-Painting in the Fifteenth Century*, Oxford, 1950, pp. 74–127. See also below, chapter 9, pp. 198–9. See R. Morris, *Churches in the Landscape*, London, 1989, pp. 350–76 for a good account of communal church rebuilding in the late Middle Ages.

25 J. Blair, 'English monumental brasses before 1350: types, patterns and workshops', in J. Coales (ed.), *The Earliest English Brasses: Patronage Style and Workshops 1270–1350*, London, 1987, p. 144.

26 M. Norris, *Monumental Brasses: The Craft*, London, 1978, p. 52, fig. 72. The Lydd wills are quoted more extensively on p. 20 below.

27 E.B.S. Shepherd, 'The Church of the Friars Minors in London', *Arch. Jnl*, vol. LIX (1902), pp. 259–61.

28 E.W. Ganderton and J. Lafond, *Ludlow Stained and Painted Glass*, Ludlow, 1961, pp. 18–21, pls 7–9.

29 ibid., pp. 46–53, pls 32–6.

30 Woodforde, *Norwich School*, p. 72.

31 G.McN. Rushforth, *The Windows of the Church of St Neot, Cornwall* (reprinted from *Trans. Exeter Diocesan Architectural & Archaeological Soc.*, vol. XV), Exeter, 1937, pp. 30–9, pls IX–XI. For Croscombe see Bishop Hobhouse, *Churchwardens' Accounts*, Somerset Record Soc., vol. IV (1890), pp. 1–48.

32 Woodforde, *Norwich School*, pp. 72, 74.

33 VCH, *Lancashire*, vol. V, London, 1911, p. 156 with previous bibliography; G.F.T. Leather, 'The Flodden window in the Parish Church of St Leonard, Middleton, in the County of Lancaster', *Hist. of Berwickshire Naturalists Club*, vol. XXX (1938–46), pp. 82–3, pls VIII, IX.

34 A. Gibbons (ed.), *Early Lincoln Wills*, Lincoln, 1888, p. 34.

35 Borenius, op. cit., p. 49.

36 W.R. Lethaby, *Westminster Abbey Re-examined*, London, 1925, pp. 235–40, figs 146–50. For Chetwode see *Age of Chivalry*, no. 737. See also below, chapters 6 and 7, pp. 133–6, 141–3.

37 See J. Hughes, *Pastors and Visionaries: Religion and Secular Life in Late Medieval Yorkshire*, Woodbridge, 1988, pp. 16–18, 21–8 and A.R. Wagner and J.G. Mann, 'A fifteenth-century description of the brass of Sir Hugh Hastings at Elsing, Norfolk', *Ants. Jnl*, vol. XIX (1939), pp. 421–8. For a fuller discussion of heraldic glass see below, chapter 3, pp. 86–8.

38 L. Grodecki, *Le Vitrail roman*, Fribourg and Paris, 1977, p. 71, illus. 56.

39 For German examples see R. Becksmann and S. Waetzoldt, *Vitrea Dedicata: Das Stifterbild in der deutschen Glasmalerei des Mittelalters*, Berlin, 1975.

40 N.E. Toke, 'The medieval stained glass windows at Upper Hardres', *Archaeologia Cantiana*, vol. XLVII (1935), pp. 153–65.

41 Borenius, op. cit., p. 47.

42 Burrell Coll. reg. no. 45/2. See S.H. Steinberg, 'A portrait of Beatrix of Falkenburg', *Ants. Jnl*, vol. XVIII (1938), pp. 142–5; *Age of Chivalry*, no. 226.

43 *Age of Chivalry*, no. 227.

44 R. Marks, 'Cistercian window glass in England and Wales', in C. Norton and D. Park (eds), *Cistercian Art and Architecture in the British Isles*, Cambridge, 1986, pp. 221–2, pl. 96.

45 O'Connor and Haselock, pp. 350–1, 354, pl. 109.

46 Marks, 'Cistercian window glass', pp. 225–7, pls 103–4.

47 *Frühe Glasmalerei in der Steiermark*, exhib. cat., Graz Landesmuseum, 1975, no. 10, pl. 5.

48 Becksmann and Waetzoldt, op. cit., p. 69, col. pl. II.

49 VCH, *Berkshire*, vol. III, London, 1923, p. 497; E.A. Greening Lamborn, *The Armorial Glass of the Oxford Diocese 1250–1850*, Oxford, 1949, p. 32. Alternatively the figures represent angels.

50 G.McN. Rushforth, 'The glass in the quire clerestory of Tewkesbury Abbey', *Trans. Bristol & Glos. Archaeological Soc.*, vol. XLVI (1924), pp. 299–301, 320, pl. III; *Age of Chivalry*, no. 742.

51 This glass is unpublished.

52 Robinson, op. cit., pp. 109–10, pl. LI fig. 2; Marks, 'Wells', p. 134, pl. 63.

53 For Wroxall see 'Schools', vol. III, pp. 966–80; Eaton Bishop is published in G. Marshall, 'Some remarks on the ancient stained glass in Eaton Bishop church, co. Hereford', *Trans. Woolhope Naturalists' Field Club* (1921–3); pp. 101–14, illus. opp. p. 104.

54 Harvey and King, op. cit.

55 Becksmann and Waetzoldt, op. cit., pp. 67–8, fig. 2.

56 For Bere Ferrers see N.H.J. Westlake, *A History of Design in Painted Glass*, vol. II, London, 1882, pl. XVII; the Lowick figure is illustrated in S. Crewe, *Stained Glass in England 1180–1540*, London, 1987, p. 73, pl. 58.

57 Two early French examples are Henry II and Eleanor of Aquitaine at Poitiers and a panel in the Pitcairn Collection. For the former see Grodecki, op. cit., p. 71, illus. 56, cat. 73. The Pitcairn panel (of *c.* 1190–1200) is published in *Radiance and Reflection: Medieval Art from the Raymond Pitcairn Collection*, New York, 1982, no. 44, pp. 119–21. For a thirteenth-century German version see S. Beeh-Lustenberger, *Glasmalerei um 800–1900 im Hessischen Landesmuseum in Darmstadt*, Frankfurt am Main, 1967, pls 10, 11.

58 O'Connor and Haselock, pp. 350–3, pl. 109; Crewe, op. cit., col. pl. 7.

59 *Age of Chivalry*, no. 231; RCHM, *An Inventory of the Historical Monuments in the City of York*, vol. V, *The Central Area*, London, 1981, p. 18.

60 T. Legge, 'Trade guild windows', *JBSMGP*, vol. IV (1931–2), p. 51–64.

61 O'Connor and Haselock, p. 345, pl.104.

62 R. Marks, 'An English stonemason in stained glass', in A.

Borg and A. Martindale (eds), *The Vanishing Past, Studies of Medieval Art, Liturgy and Metrology presented to Christopher Hohler*, British Archaeological Reports, International Series, vol. III, 1981, pp. 105-7; *Age of Chivalry*, no. 477.

63 P.A. Newton, *The County of Oxford: A Catalogue of Medieval Stained Glass* (*CVMA* Great Britain vol. I), London, 1979, pp. 113-15, pl. 7(b), (c).

64 Woodforde, *Norwich School*, pp. 112, 118, pl. XXVII.

65 J.E. Hunt, *The Glass in S. Mary's Church, Shrewsbury*, 6th edn, Shrewsbury, 1980, pp. 7-11; F. Harrison, *The Painted Glass of York*, London, 1927, p. 199.

66 Newton, *County of Oxford*, pp. 202, 205-6, pl. 47.

67 For example, BL MS Egerton 3277, fol. 131v. See L.F. Sandler, *Gothic Manuscripts 1285-1385, A Survey of Manuscripts Illuminated in the British Isles, vol. V*, Oxford, 1986, no. 135, illus. 360. An earlier, isolated instance of a woman kneeling before a prie-dieu is in a manuscript of *c.*1250 in Vienna (N.J. Morgan, *Early Gothic Manuscripts 1250-1285, A Survey of Manuscripts Illuminated in the British Isles, vol. IV*, London, 1988, no. 104, illus. 42).

68 E.A. Gee, 'The painted glass of All Saints Church, North Street, York', *Archaeologia*, vol. CII (1969), p. 164, pl. XXVI(c).

69 For the Beauchamp Chapel see below, chapter 9, pp. 190, 194.

70 Caviness, *Christ Church Cathedral*, pp. 251-63, pls 183-8.

71 *Tattershall*, pp. 83-6, pl. 47; *Med. Christ Im.*, pp. 400-1, figs 183-4.

72 H. Wayment, 'The east window of St Margaret's, Westminster', *Ants. Jnl*, vol. LXI (1981), pp. 292-301, pls XLI, XLIV, XLVa. See also below, chapter 10, p. 220.

73 *Age of Chivalry*, no. 738.

74 O'Connor and Haselock, p. 354.

75 Sir William Dugdale's *Book of Monuments* (BL Loan MS 38), fols 60v, 61r.

76 Marshall, op. cit., pp. 110-13. See also below, chapter 8, pp. 187-8.

77 H. Druitt, *A Manual of Costume as Illustrated by Monumental Brasses*, London, 1906, pp. 211, 227, 251, 259; M. Norris, *Monumental Brasses: The Memorials*, London, 1977, pp. 197-8.

78 E. Panofsky, *Tomb Sculpture*, London, 1964, pp. 63-6, illus. 257-8.

79 ibid., illus. 261; L. Stone, *Sculpture in Britain: The Middle Ages*, 2nd edn, Harmondsworth, 1972, pp. 213-14; P.M. King, 'The cadaver tomb in England: novel manifestations of an old idea', *Church Monuments*, vol. V (1990), pp. 26-38.

80 See the list in M. Clayton, *Victoria and Albert Museum Catalogue of Rubbings of Brasses and Incised Slabs*, London, 1968, pp. 136-8.

81 E. Mâle, *L'Art réligieux de la fin du Moyen Age en France*, Paris, 1949, p. 432.

82 C.R. Councer, 'The medieval painted glass of West Wickham, Kent', *JBSMGP*, vol. X (1948-9), pp. 67-73.

83 Newton, *County of Oxford*, p. 205.

84 'Schools', vol. II, pp. 38, 48.

85 *Tattershall*, p. 80.

86 ibid., pp. 15-58.

87 *Age of Chivalry*, pp. 33-4.

88 Newton, *County of Oxford*, pp. 22, 24, pl. 14(a); Crewe, op. cit., col. pl. 7.

89 M. Camille in *Age of Chivalry*, pp. 33, 39; for Stow see J. Blair, 'The earliest epitaph in English?', *Bull. Monumental Brass Soc.*, vol. XI (February 1976), p. 15.

90 Woodforde, *Norwich School*, p. 6; Wagner and Mann, pp. 421-8.

91 Leverington has not been published in detail. For a brief description see VCH, *Cambridge and the Isle of Ely*, vol. IV, London, 1953, p. 194.

92 'Med. Glazing Accounts' (1929-30), pp. 26-7. See also below, chapter 4, pp. 94-5.

93 E. Green, 'The identification of the Eighteen Worthies commemorated in the heraldic glass in the hall windows of Ockwells Manor House', *Archaeologia*, vol. LVI (1899), pp. 323-36. See also below, chapter 4, p. 97.

94 For Birtsmorton see G.McN. Rushforth, 'The baptism of St Christopher', *Ants. Jnl*, vol. VI (1926), pp. 152-8; Stoke Charity is mentioned in Nelson, op. cit., p. 96 (the initials are wrongly dated by him to *c.*1470), and Farleigh Hungerford in C. Woodforde, *Stained Glass in Somerset 1250-1830*, Oxford, 1946, p. 16. For Old Warden see Marks, 'Cistercian window glass', pp. 225-7, pls 103, 104.

95 Badby and Cold Ashton are unpublished.

96 *Tattershall*, pp. 178-9, pl. 96.

97 N. Truman, 'Medieval glass in Holme-by-Newark Church, Notts.', *JBSMGP*, vol. VI (1935-7), p. 81.

98 Reg. no. 45/223: see W. Wells, *Stained and Painted Heraldic Glass, Burrell Collection*, Glasgow, 1962, no. 215.

99 Reg. no. 45/167: see Wells, op. cit., no. 89 and R. Marks, 'Recent discoveries in medieval art', *Scottish Art Review*, vol. XVI no. 1 (May 1984), pp. 17-18, fig. 12.

100 H.S. London, *The Life of William Bruges, the first Garter King of Arms*, Harleian Soc., vols CXI, CXII (1970), pp. 57-67, pls XI-XVI.

101 VCH, *Hertfordshire*, vol. III, London, 1912, p. 467, n. 42.

102 VCH, *Warwickshire*, vol. III, London, 1945, p. 83. See also below, chapter 10, pp. 224-5.

103 Councer, *Lost Glass*, p. 22.

104 ibid., pp. 79-80.

105 R. Marks, 'Henry Williams and his "ymage of deth" roundel at Stanford on Avon, Northamptonshire', *Ants. Jnl*, vol. LIV (1974), pp. 272-4, pl. LIV. For a very similar and far superior composition designed by Dürer see R. Becksmann, *Deutsche Glasmalerei des Mittelalters*, Stuttgart-Bad Cannstatt, 1988, p. 175, cat. no. 57.

106 Woodforde, *New College*, p. 7.

107 'Med. Glazing Accounts' (1927–8), p. 119.

108 ibid., p. 116; for Chichester see below, chapter 2, p. 50.

109 For Morbihan and Chartres see M.P. Lillich, 'Gothic glaziers: monks, Jews, taxpayers, Bretons, women', *Jnl Glass Studies*, vol. XXVII (1985), pp. 84–5.

110 R. Willis and J.W. Clark, *The Architectural History of the University of Cambridge and of the Colleges of Cambridge and Eton*, vol. II, Cambridge, 1886, pp. 347–8.

111 M. Baxandall, *The Limewood Sculptors of Renaissance Germany*, New Haven and London, 1980, pp. 102–6. For examples of similar artists' contracts from other countries see L. Campbell, 'The art market in the southern Netherlands in the fifteenth century', *Burlington Mag.*, vol. CXVIII no. 877 (April 1976), pp. 192–4; D. Bomford, J. Dunkerton, D. Gordon and A. Roy, *Art in the Making: Italian Painting before 1400*, London, 1989, pp. 7–9, 191–6; M. Baxandall, *Painting and Experience in Fifteenth Century Italy*, Oxford, 1974, pp. 5–11; P. Binski, *Medieval Craftsmen – Painters*, London, 1991, pp. 48–52; K. Staniland, *Medieval Craftsmen – Embroiderers*, London, 1991.

112 For Walsingham see A. Oswald, 'Barnard Flower, the King's Glazier', *JBSMGP*, vol. XI (1951–5), p. 15. For King's see Wayment, *King's*, pp. 124, 125.

113 French and O'Connor, op, cit., p. 85; for evidence of payment in stages for painted altarpieces and embroideries on the Continent from at least the fifteenth century, see Binski, op. cit., p. 52 and Staniland, op. cit., pp. 52–3.

114 See the transcriptions made by James Torre in York Minster Library, MSS YML L1/2, p. 34 (Latin version), L/7, fol. 7r (English version). The former gives the date of the contract as 10 October, the latter as 10 August.

115 W. Dugdale, *The Antiquities of Warwickshire*, 2nd edn, London, 1730, vol. I, pp. 446–7.

116 ibid., p. 446.

117 Torre, op. cit.

118 Wayment, *King's*, pp. 124–5.

119 The full text is given in H.H. Drake (ed.), *Hasted's History of Kent, Pt. I The Hundred of Blackheath*, London, 1886, pp. 86–7, n. 6. See also R. Marks and A. Payne (eds), *British Heraldry from its Origins to c.1800*, exhib. cat., British Museum, 1978, no. 127.

120 J.A. Goodall, 'Two medieval drawings', *Ants. Jnl*, vol. LVIII (1978), pp. 160–2, pl. L(b).

121 Dugdale, *Antiquities*, p. 446.

122 H.M. Colvin, D.R. Ransome and J. Summerson, *The History of the King's Works*, vol. III, 1485–1660 (Part I), London, 1975, p. 213.

123 Wayment, *King's*, pp. 124, 125.

124 M. Baxandall, *Painting and Experience*, pp. 3–5, pl. I; idem, *Limewood Sculptors*, pp. 102–3, 105, fig. 65, Binski, op. cit., p. 50.

125 H. Wentzel, 'Un projet de vitrail au XIVe siècle', *Revue de l'art*, vol. X (1970), pp. 7–14.

126 N.J. Morgan, *Early Gothic Manuscripts 1190–1250, A Survey of Manuscripts Illuminated in the British Isles, vol. IV*, London, 1982, no. 22 and illus. 72–5; *Age of Chivalry*, no. 37.

127 Most recently by the present writer in *Age of Chivalry*, p. 137. For the entry see Brooks and Evans, op. cit., p. 36. These authors and the present writer independently came to the conclusion that the entry must refer to a mason's design.

128 The contract is given in Brooks and Evans, op. cit., p. 167 and illustrated on pl. 55.

129 L.F. Salzman, *Building in England down to 1540*, reprinted Oxford, 1967, p. 178. In Italy in particular leading painters executed designs for stained glass. For a recent study see R.G. Burnam, 'Medieval stained glass practice in Florence, Italy: the case of Orsanmichele', *Jnl Glass Studies*, vol. XXX (1988), pp. 77–93.

130 Salzman, *Building*, p. 178.

131 H. Wayment, 'Twenty-four vidimuses for Cardinal Wolsey', *Master Drawings*, vol. XXIII/XXIV, no. 4 (1988), pp. 503–17.

132 ibid., pp. 506–7, fig. 2.

133 ibid., pp. 511–12.

134 H. Wayment, 'The great windows of King's College Chapel and the meaning of the word "vidimus"', *Proc. Cambridge Ant. Soc.*, vol. LXIX (1979), pp. 53–69.

135 ibid., pp. 54–5.

## *2 The Technique of Medieval Glass-painting and the Organization of Workshops*

1 See C.R. Dodwell (ed.), *Theophilus, De Diuersis Artibus*, London, 1961, pp. 36–60; for Eraclius see Mrs M. Merrifield, *Original Treatises ... on the Arts of Painting*, London, 1849, vol. I, pp. 166–257; Anthony of Pisa's treatise is published in R. Bruck, 'Der Tractat des Meisters Antonio von Pisa über die Glasmalerei', *Repertorium für Kunstwissenschaft*, vol. XXV (1902), pp. 240–69 and S. Pezzella, *Arte delle Vetrate Col Trattato di Antonio da Pisa*, Rome, 1977; D.V. Thompson (tr.), *Cennino D'Andrea Cennini: The Craftsman's Handbook*, New York, 1960, pp. 111–12.

2 The best survey is R.J. Charleston, 'Vessel glass', in J. Blair and N. Ramsay (eds), *English Medieval Industries*, London, 1991, pp. 237–64. See also Dodwell, op. cit., and D.B. Harden, 'Domestic window glass: Roman, Saxon and Medieval', in E.M. Jope (ed.), *Studies in Building History*, London, 1961, pp. 44–52; R. Newton and S. Davison, *The Conservation of Glass*, London, 1988. M.P. Lillich, 'Gothic glaziers: monks, Jews, taxpayers,

Bretons, women', *Jnl Glass Studies*, vol. XXVII (1985), pp. 75, 88, has argued that in France until the 1280s glass-making and glass-painting probably were carried out by the same craftsmen. In England the crafts appear to have been distinct from each other at an earlier date: at Westminster Abbey in the 1250s glass was purchased for the glaziers to paint.

3 N.H. Tennent and P. McKenna, 'Major, minor and trace element analysis of medieval stained glass by flame atomic absorption spectometry', *American Chemical Soc. Advances in Chemistry Series*, no. 205 (1984), pp. 133-50. This includes previous bibliography on glass analysis.

4 J. Krása, *The Travels of Sir John de Mandeville*, New York, 1983.

5 G.H. Kenyon, *The Glass Industry of the Weald*, Leicester, 1967.

6 E.S. Wood, 'A medieval glasshouse at Blunden's Wood, Hambledon, Surrey', *Surrey Archaeological Colls.*, vol. LXII (1965), pp. 54-79.

7 Kenyon, op. cit., p. 26.

8 L.F. Salzman, 'The glazing of St Stephen's Chapel, Westminster, 1351-2', *JBSMGP*, vol. I (1926-7), p. 38 and 'Med. Glazing Accounts' (1927-8), pp. 188-9.

9 Kenyon, op. cit., pp. 27-9, 115-16.

10 Salzman, 'St Stephen's', p. 14.

11 D.W. Crossley, 'Glassmaking in Bagot's Park, Staffordshire, in the sixteenth century', *Post-Medieval Archaeology*, vol. I (1967), p. 44-83.

12 L.F. Salzman, *Building in England down to 1540*, reprinted Oxford, 1967, p. 183.

13 Charleston, op. cit., p. 255.

14 *Tattershall*, p. 31.

15 Charleston, op. cit., p. 256; Salzman, *Building*, p. 182; R. Newstead, 'Glasshouse in Delamere Forest, Cheshire', *Jnl Chester & N. Wales Architectural, Archaeological & Historic Soc.*, new series, vol. XXXIII (1939), pp. 32-9; M.H. Ridgway and G.B. Leach, 'Further notes on the glasshouse site at Kingswood, Delamere, Cheshire', ibid., new series, vol. XXXVII, pt I (1948), pp. 133-40.

16 For opposing views see W.T. Thorne, 'Was coloured glass made in medieval England? Parts I and II', *JBSMGP*, vol. XII (1955-9), pp. 9-14, 108-16; J. Lowe, 'The medieval English glazier, Part I', *JBSMGP*, vol. XIII (1959-63), pp. 428-9.

17 *Cal. Patent Rolls Henry VI 1446-1452*, p. 255.

18 W. Dugdale, *The Antiquities of Warwickshire*, 2nd edn, London, 1730, vol. I, pp. 446-7.

19 Charleston, op. cit., p. 256.

20 A.M. Erskine (ed.), *The Accounts of the Fabric of Exeter Cathedral, 1279-1353*, Devon & Cornwall Rec. Soc., new series, vol. XXIV (1981), p. 98.

21 J.T. Smith, *Antiquities of Westminster*, London, 1807, pp. 191-6; R.A. Brown, H.M. Colvin and A.J. Taylor, *The History of the King's Works: The Middle Ages*, vol. I, London, 1963, p. 518.

22 J. Raine (ed.), *The Fabric Rolls of York Minster*, Surtees Soc., vol. XXXV (1858), p. 109.

23 *Testamenta Eboracensia. A Selection of Wills from the Registry at York vol. IV*, Surtees Soc., vol. LIII (1868), p. 334.

24 'Med. Glazing Accounts' (1929-30), p. 29.

25 As in the royal palaces. See A. Oswald, 'Barnard Flower, the King's Glazier', *JBSMGP*, vol. XI (1951-5), p. 12.

26 Salzman, 'St Stephen's', p. 38.

27 Salzman, *Building*, p. 184.

28 A. Oswald, 'The glazing of the Savoy Hospital', *JBSMGP*, vol. XI (1951-5), p. 227, n. 1.

29 H.M. Colvin (ed.), *Building Accounts of King Henry III*, Oxford, 1971, pp. 286-7; Erskine, op. cit., p. 98.

30 Salzman, 'St Stephen's', pp. 35, 38, 41; 'Med. Glazing Accounts' (1927-8), p. 120.

31 The best surveys are Dodwell, op. cit.; J. Lafond, *Le Vitrail*, Paris, 1966; E. Frodl-Kraft, *Die Glasmalerei: Entwicklung, Technik, Eigenart*, Vienna and Zurich, 1970; idem, 'Zur Frage der Werkstattpraxis in der mittelalterlichen Glasmalerei', *Bayerisches Landesamt für Denkmalpflege*, Arbeitsheft 32 (1986), pp. 10-22. See also P. Reyntiens, *The Technique of Stained Glass*, new edn, London, 1977; S. Brown and D. O'Connor, *Medieval Craftsmen – Glass-painters*, London, 1991.

32 J.A. Knowles, *Essays in the History of the York School of Glass-Painting*, London, 1936, p. 36.

33 M.R. James, 'An English medieval sketchbook, No. 1916 in the Pepysian Library, Magdalene College, Cambridge', *Walpole Soc.*, vol. XIII (1924-5), pp. 1-17. Some of my remarks are based on a paper given by Professor Robert Scheller at a symposium held in association with the *Age of Chivalry* exhibition at the Royal Academy on 18-20 March 1988. Nicholas Barker will shortly be publishing the sketchbook for the Roxburghe Club. The verso of a single sheet in the Department of Prints and Drawings in the British Museum has a series of early sixteenth-century heads by a Flemish artist which have some affinities with contemporary glass in England. See E. Croft-Murray, 'A leaf from a Flemish sketchbook of the early sixteenth century', *British Museum Quarterly*, vol. XVII (1952), pp. 8-10.

34 J. Vila-Grau, *El Vitrall Gòtic a Catalunya. Descoberta de la taula de vitraller de Girona*, Reial Acadèmia Catalana de Belles Arts de Sant Jordi, Barcelona, 1985; J. Ainaud i de Lasarte *et al.*, *Els vitralls de la Catedral de Girona* (*CVMA* Spain 7, Catalonia vol. II), Barcelona, 1987, p. 80.

35 Salzman, 'St Stephen's', p. 35.

36 *Age of Chivalry*, nos. 472-3.

37 Thompson, op. cit., p. 111; Brown and O'Connor, op. cit., p. 40.

38 'Med. Glazing Accounts' (1929-30), p. 27; see also below, p. 47.

39 As observed by Tom Owen in an unpublished study.

40 Knowles, *Essays*, pl. XXIV.

41 ibid., p. 170, pl. XLV; P.E.S. Routh, 'A gift and its giver: John Walker and the east window of Holy Trinity, Goodramgate, York', *Yorks Archaeological Jnl*, vol. LVIII (1986), p. 109, pl. I; RCHM, *An Inventory of the Historical Monuments in the City of York, vol. V, The Central Area*, London, 1981, pls 45, 46.

42 Knowles, *Essays*, p. 38.

43 Salzman, 'St Stephen's', pp. 32–40.

44 ibid., pp. 14, 33, 35, 39, 41.

45 Salzman, *Building*, p. 179.

46 Salzman, 'St Stephen's', p. 33.

47 Salzman, *Building*, p. 181. For a recent study of medieval leading see B. Knight, 'Researches on medieval window lead', *Jnl of Stained Glass*, vol. XVIII no. 1 (1983–4), pp. 49–51. Fragments of twelfth-century chalk came moulds found at Saint-Rémi are illustrated in pl. 67 of M.H. Caviness, *Sumptuous Arts at the Royal Abbeys in Reims and Braine*, Princeton, 1990.

48 'Med. Glazing Accounts' (1929–30), p. 29.

49 F. Cheetham, *English Medieval Alabasters*, Oxford, 1984, p. 25.

50 'Marks on the glass at Wells: A Discussion', *JBSMGP*, vol. IV (1931–2), pp. 71–80; H. Wayment, 'The glaziers' sorting marks at Fairford', in P. Moore (ed.), *Crown in Glory, A Celebration of Craftsmanship – Studies in Stained Glass*, Norwich, n.d., pp. 23–8; I am grateful to Michael Archer for drawing my attention to the Winchester marks.

51 M.H. Caviness, 'Canterbury Cathedral clerestory: the glazing programme in relation to the campaigns of construction', *Medieval Art and Architecture at Canterbury before 1220* (BAA Conference Transactions, vol. V, 1979), 1982, p. 53.

52 Erskine, op. cit.

53 Caviness, op. cit., p. 55, n. 45, citing F. Perrot, 'L'Eglise Saint Vincent', *Le Vieux Marché* (Bulletin des Amis des Monuments rouennais Numéro Spécial, Rouen, 1978–9), p. 57.

54 Colvin, op. cit., pp. 228–9, 424–31.

55 Salzman, 'St Stephen's', p. 14.

56 Lafond, op. cit., p. 49.

57 Salzman, 'St Stephen's', p. 39.

58 'Med. Glazing Accounts' (1929–30), p. 28.

59 J. Lafond, *Trois Etudes sur la technique du vitrail*, Rouen, 1943, pp. 39–116; idem, 'Un vitrail du Mesnil-Villeman (1313) et les origines du jaune d'argent', *Soc. Nat. des Antiquaires de France* (December 1954), pp. 94–5; M.P. Lillich, 'European stained glass around 1300: the introduction of silver stain', *Akten des XXV. Internationalen Kongresses für Kunstgeschichte vol. VI Europäische Kunst um 1300*, Vienna, 1986, pp. 45–60.

60 R. Becksmann, *Deutsche Glasmalerei des Mittelalters*, Stuttgart–Bad Canstatt, 1988, pp. 14, 23 n. 19, cat. no. 23; *Age of Chivalry*, no. 5.

61 Salzman, 'St Stephen's', pp. 31–5, 38–40.

62 R. Newton, 'Medieval methods for attaching "jewels" to stained glass', *Stained Glass* (spring 1981), pp. 50–3; J.R. Johnson, 'Stained glass and imitation gems', *Art Bulletin*, vol. XXXIX (1957), pp. 221–4.

63 A list (not exhaustive) is given in *Tattershall*, p. 72, nn. 24–7.

64 See M. Aubert *et al.*, *Le Vitrail français*, Paris, 1958, pls 50, 143; L. Grodecki, 'The Jacques Coeur window at Bourges', *Magazine of Art*, vol. XLII (1949), pp. 64–7.

65 Dodwell, op. cit., pp. 57–8; Newton, op. cit., p. 52, figs 7–9; RCHM, *York*, op. cit., frontispiece (colour).

66 Newton, op. cit., p. 53, citing O'Connor and Haselock, p. 377.

67 Thompson, op. cit., pp. 111–12; Lafond, op. cit., pp. 48–9.

68 Salzman, *Building*, p. 180.

69 O'Connor and Haselock, pp. 385–6, esp. no. 304.

70 Erskine, op. cit.

71 J.H. Harvey and D.G. King, 'Winchester College stained glass', *Archaeologia*, vol. CIII (1971), p. 162; *Age of Chivalry*, no. 612; J.D. Le Couteur, *Ancient Glass in Winchester*, Winchester, 1920, p. 65.

72 M.H. Caviness, '"De convenientia et cohaerentia antiqui et novi operis"; Medieval conservation, restoration, pastiche and forgery', *Intuition und Kunstwissenschaft Festschrift für Hanns Swarzenski*, Berlin, 1973, pp. 209–10; F. Perrot, 'Etude archéologique', *Les Monuments historiques de la France*, no. 1 (1977), pp. 37–51.

73 Caviness, 'Medieval conservation', p. 209 for York; for Exeter see *Age of Chivalry*, nos. 739, 746 and C. Brooks and D. Evans, *The Great East Window of Exeter Cathedral: A Glazing History*, Exeter, 1988, esp. pp. 83–145.

74 O'Connor and Haselock, pp. 319–25, 378–83. For a differing view of the original location of the mid-fourteenth-century panels see T. French, 'Observations on some medieval glass in York Minster', *Ants. Jnl*, vol. LI (1971), pp. 86–93. See also below, chapter 6, pp. 113–17, and chapter 7, p. 158.

75 'Schools', vol. I, pp. 62–6, vol. II, pp. 336–51.

76 Brooks and Evans, op. cit., pp. 37, 167.

77 Oswald, 'Flower', p. 10; B. Rackham, 'The ancient windows of Christ's College Chapel, Cambridge', *Arch. Jnl*, vol. CIX (1952), p. 136.

78 J.J. Wilkinson (ed.), 'Receipts and expenses in the building of Bodmin Church AD 1469 to 1472', *Camden Soc. Misc.*, vol. VII (1875), p. 2.

79 R.A. Croft and D.C. Mynard, 'A late 13th-century grisaille window panel from Bradwell Abbey, Milton Keynes, Bucks.', *Medieval Archaeology*, vol. XXX (1986), p. 107.

80 R.J. Charleston, 'The earliest recorded glassmaker in England', *Glass Technology*, vol. I, no. 4 (1960), p. 137; idem, 'Vessel glass'; p. 254; C. Woodforde, 'Glass-

painters in England before the Reformation', *JBSMGP*, vol. VI (1935–7), p. 121; idem, *English Stained and Painted Glass*, Oxford, 1954, p. 7.

81 'Med. Glazing Accounts' (1927–8), p. 117.

82 Woodforde, *Stained and Painted Glass*, p. 8. For movement of glaziers see below, chapter 6, p. 124.

83 Knowles, *Essays*, pp. 11–12; see also H. Swanson, *Building Craftsmen in Late Medieval York* (Borthwick Papers no. 63), York, 1983, Appendix on pp. 39–41.

84 D. O'Connor, 'Debris from a medieval glazier's workshop', *Bull. York Archaeological Trust*, vol. III no. I (August 1975), pp. 11–17.

85 Information from David King. See also C. Woodforde, *The Norwich School of Glass-Painting in the Fifteenth Century*, Oxford, 1950, pp. 9–15.

86 Brown, Colvin and Taylor, op. cit., p. 226.

87 'Med. Glazing Accounts' (1927–8), p. 118.

88 D.R. Ransome, 'The struggle of the Glaziers' Company with the foreign glaziers, 1500–1550', *Guildhall Misc.*, vol. II no. I (September 1960), p. 13.

89 *Cal. Patent Rolls 1348–50*, p. 481; Woodforde, 'Glass-painters', pp. 122–3.

90 *Tattershall*, pp. 31–4, 75–162.

91 For Twygge see ibid., p. 76, and for Thornton see below, chapter 8, pp. 180–3. For Prudde's work see Dugdale, op. cit., vol. I, pp. 446–7, 451; Hutchinson, op. cit., p. 37; Le Couteur, *Winchester*, p. 103; R. Willis and J.W. Clark, *The Architectural History of the University of Cambridge and of the Colleges of Cambridge and Eton*, vol. I, Cambridge, 1886, pp. 393–4, 403.

92 C. Woodforde, *The Stained Glass of New College*, Oxford, 1951, pp. 3–5.

93 *Tattershall*, pp. 101–2.

94 For traditional views see e.g. Knowles, *Essays*, and Woodforde, *Stained and Painted Glass*; for a fuller discussion of differing patterns in regional glazing see below, chapter 9.

95 Knowles, *Essays*, p. 236; C. Woodforde, 'Essex glass-painters in the Middle Ages', *JBSMGP*, vol. V (1933–4), pp. 111–12; L.S. Colchester, *Stained Glass in Wells Cathedral*, 5th edn, Wells, 1977, p. 31; Le Couteur, *Winchester*, p. 136.

96 Woodforde, 'Glass-painters', p. 67; for wills see Knowles, *Essays*, pp. 225–9, 233–5, 252–3; Swanson, op. cit., pp. 28–9 and Woodforde, *Norwich School*, p. 15.

97 For London see C.H. Ashdown, *History of the Worshipful Company of Glaziers*, London, 1919, p. 17; for the York craft see Knowles, *Essays*, and M. Sellers (ed.), *York Memorandum Book*, Surtees Soc., vol. CXX (1911), pp. 50–2, vol. CXXV (1914), pp. 208–10; the Chester ordinances are quoted in Woodforde, 'Glass-painters', pp. 68–9. See also Brown and O'Connor, op. cit., pp. 23–4 and for comparative evidence K. Staniland, *Medieval Craftsmen – Embroiderers*, London, 1991, pp. 13–18.

98 Woodforde, *Norwich School*, p. 14.

99 Knowles, *Essays*, p. 214, n. 2.

100 See n. 97.

101 Sellers (1914), op. cit., p. 209.

102 Knowles, *Essays*, pp. 246–7.

103 Ashdown, op. cit., p. 17.

104 Woodforde, 'Glass-painters', pp. 68–9.

105 Sellers (1914), op. cit., p. 209.

106 See below, chapter 10, pp. 227–8. The London embroiderers faced a similar challenge (Staniland, op. cit., p. 18). See also L. Campbell, 'The art market in the southern Netherlands in the fifteenth century', *Burlington Mag.*, vol. CXVIII, no. 877 (April 1976), pp. 191–2, 196–8.

107 'Med. Glazing Accounts' (1927–8), p. 119; for the term 'garcio' or 'garçon' see P. Binski, *Medieval Craftsmen – Painters*, London, 1991, p. 16.

108 Erskine, op. cit., pp. 56–7; Brooks and Evans, op. cit., pp. 12, 37, 167.

109 Knowles, *Essays*, pp. 38, 249–51.

110 Le Couteur, *Winchester*, p. 103; for Flower see A. Smith, 'Henry VII and the appointment of the King's Glazier', *Jnl of Stained Glass*, vol. XVIII, no. 3 (1988), pp. 259–61.

111 Salzman, 'St Stephen's', p. 35.

112 Transcriptions by James Torre in York Minster Library, MSS YMC L1/2, p. 34 (Latin), L1/7, fol. 7r (English).

113 Dugdale, op. cit., p.446. For division of labour in workshops see Frodl-Kraft, 'Zur Frage der Werkstattpraxis', and Caviness, *Sumptuous Arts*, pp. 100–2 (with earlier bibliography).

114 *Cennini*, op. cit., p. 111; for the employment of painters as designers in various media including glass see Binski, op. cit., pp. 21–3, Brown and O'Connor, op. cit., pp. 40–1, Staniland, op. cit., pp. 19–26.

115 For Athelard see Ramsay in *Age of Chivalry*, p. 52 (quoted in a good essay entitled 'Artists, craftsmen and design in England, 1200–1400'). The suggestion that the Herebright connection may have been significant for the Winchester College glass has been made in Harvey and King, op. cit., pp. 150–3.

116 For two interesting papers on this subject see W.M. Cothren, 'Suger's stained glass masters and their workshop at Saint-Denis', *Paris: Center of Artistic Enlightenment, Papers in Art History from the Pennsylvania State University*, 4 (1988), pp. 46–75; idem, 'Production practices in medieval stained glass workshops. Some evidence in the Glencairn Museum (Bryn Athyn, Pennsylvania, USA)', *Corpus Vitrearum Tagung für Glasmalereiforschung Akten des 16. Internationaler Kolloquiums in Bern 1991*, Bern and Stuttgart, 1991, pp. 120–3.

117 'Med. Glazing Accounts' (1929–30), p. 27.

118 ibid. (1927–8), p. 118.

119 For these figures and the dates of office see Brown, Colvin and Taylor, op. cit., p. 226.

120 Oswald, 'Flower', p. 13 and Smith, op. cit.

121 Brown, Colvin and Taylor, op. cit., p. 226.

122 H. Chitty, 'John Prudde, king's glazier', *Notes and Queries*, 12th series, vol. III (Sept. 1917), op. cit., pp. 419–21.

123 For Haina see H. Wentzel, 'Die Glasmalerei der Zisterzienser in Deutschland', in *Die Klosterbaukunst* (Arbeitsbericht der Deutsch-Französischen Kunsthistoriker Tagung), Mainz, 1951. For general surveys see M.P. Lillich, 'Gothic glaziers', op. cit., pp. 72–92 and F. Perrot, 'La Signature des peintres verriers', *Revue de l'art*, no. 26 (1974), pp. 40–5. The long-held assumption that John Thornton's monogram exists in the York Minster east window glass has been challenged in T. French, 'John Thornton's monogram in York Minster', *Jnl of Stained Glass*, vol. XIX, no. 1 (1989–90), pp. 18–23.

124 For Gerlachus see *Meisterwerke mittelalterlicher Glasmalerei aus der Sammlung des Reichsfrieherrn vom Stein*, exhib. cat., Hamburg, 1966, no. I, pls 4, 5, and for Clement of Chartres see G. Ritter, *Les Vitraux de la cathédrale de Rouen*, Rouen, 1926, pl. XIV.

125 For Thomas Glazier see Harvey and King, op. cit., pl. LXVII(b); the Petty figure is recorded in Henry Johnston's notes of 1669–70 (Bodl. Lib. MS Top. Yorks C14, fol. 74r); see also Brown and O'Connor, op. cit., fig. 18.

126 G.McN. Rushforth, *The Windows of the Church of St Neot, Cornwall* (reprinted from *Trans. Exeter Diocesan Architectural & Archaeological Soc.*, vol. XV), Exeter, 1937, pp. 39–40, pl. XII.

127 Le Couteur, *Winchester*, p. 136. Knowles, *Essays*, pls XIV, LXIII, Fig. 77; he dated the Stonegate shield to the seventeenth century, but David O'Connor has pointed out that it was executed in c.1520–30. For the Sherborne glass see B. Coe, *Stained Glass in England 1150–1550*, London, 1981, pl. opp. p. 6. The London Glaziers' Company shield does not appear to have been published.

128 'Med. Glazing Accounts' (1927–8), p. 189, (1929–30), p. 25; for a useful discussion of medieval wages and prices see Salzman, *Building*, chapter IV.

129 Colvin, op. cit., pp. 286–7. See also below, chapter 6, pp. 133–6.

130 Erskine, op. cit., pp. 24, 28, 30, 32, 35, 42, 49, 50, 56–7; *Age of Chivalry*, no. 739; Brooks and Evans, op. cit., pp. 11–13, 15, col. pl. XVII.

131 Erskine, op. cit., p. 35; Brooks and Evans, op. cit., p. 12.

132 T.W. French and D. O'Connor, *York Minster: A Catalogue of Medieval Stained Glass I: The West Windows of the Nave* (CVMA Great Britain vol. III/I), London, 1987, p. 85.

133 Brooks and Evans, op. cit., pp. 37–8, 167.

134 'Med. Glazing Accounts' (1929–30), p. 28; A. Oswald, 'The glazing of the Savoy Hospital', *JBSMGP*, vol. XI

(1951–5), p. 227: H. Wayment, *The Windows of King's College Chapel, Cambridge* (CVMA Great Britain, Supplementary vol. I), London, 1972, pp. 124–5.

135 'Med. Glazing Accounts' (1927–8), p. 189.

136 ibid., p. 192.

137 ibid. (1929–30), p. 25; for quarry designs see A.W. Franks, *A Book of Ornamental Glazing Quarries*, London, 1849, and C. Woodforde, 'Some medieval English glazing quarries painted with birds', *JBAA*, 3rd series, vol. IX (1944), pp. 1–11, pls I–XIX.

138 'Med. Glazing Accounts' (1929–30), pp. 25–7.

139 Dugdale, op. cit., vol. I, pp. 446–7.

140 A reconstruction of Prudde's variously priced schemes is in Knowles, *Essays*, p. 48, fig. 5.

141 'Med. Glazing Accounts' (1929–30), p. 28; Willis and Clark, op. cit., vol. I, pp. 393–4 (especially nn. 1 and 3 on p. 394).

142 Hutchinson, op. cit., p. 17 (see also below, chapter 8, pp. 188–9); *Tattershall*, op. cit., pp. 86–90, pls 48–51.

143 *Tattershall*, pp. 32–6; Willis and Clark, op. cit., vol. I, pp. 394, n. 1, 403, n. 4; Wayment, *King's*, pp. 124–5.

144 See above, chapter I, p. 22.

145 Oswald, 'Savoy', p. 228; Salzman, *Building*, p. 177.

146 Oswald, 'Flower', pp. 11–12.

147 See above, chapter 1, p. 22.

148 E. Law, *The History of Hampton Court Palace*, vol. I, London, 1890, p. 349. See also below, chapter 4, p. 96.

149 Oswald, 'Savoy', pp. 228–9.

150 French and O'Connor, op. cit., p. 85; 'Med. Glazing Accounts' (1927–8), p. 119.

151 See above, chapter 1, p. 23; Torre transcriptions.

152 'Med. Glazing Accounts' (1927–8), pp. 120, 188.

153 Salzman, *Building*, p. 175.

154 Erskine, op. cit., e.g. pp. 26, 53, 56–7, 107, 117, 129, 158, 171, 209, 267, 275, 284, 286.

155 'Med. Glazing Accounts' (1929–30), p. 27.

156 Le Couteur, *Winchester*, pp. 103, 120.

157 'Med. Glazing Accounts' (1927–8), p. 188.

158 Woodforde, *New College*, p. 5.

159 'Med. Glazing Accounts' (1927–8), p. 119.

160 Dugdale, op. cit., vol. I, p. 446.

161 *Age of Chivalry*, p. 92.

162 ibid., p. 67.

163 ibid., pp. 93 (Coldstream), 66 (Crossley), 115, fig. 78 (Heslop), 128, fig. 97 (Park) and cat. no. 122.

164 Both extracts are taken from M. Durliat, 'Les Attributions de l'architecte à Toulouse au début du XIVe siècle', *Pallas*, vol. XI (1962), pp. 205–12. I am most grateful to Jim Bugslag for drawing my attention to this article.

165 E.A. Greening Lamborn, *The Armorial Glass of the Oxford Diocese 1250–1850*, Oxford, 1949, p. 91, pl. 23. A similar but more elaborate woodland setting occurs on the seal of John de Warenne, Earl of Surrey; this also includes rabbits indicating a warren, a canting reference

to the family name (Heslop in *Age of Chivalry*, p. 117, fig. 81).

166 P.A. Newton, *The County of Oxford: A Catalogue of Medieval Stained Glass* (*CVMA* Great Britain vol. I), London, 1979, pp. 83–4.

167 C.R. Councer, 'The medieval painted glass of Mersham', *Arch. Cantiana*, vol. XLVIII (1936), pp. 81–90.

168 Salzman, *Building*, pp. 496–7.

169 See M. Norris, *Monumental Brasses: The Craft*, London, 1978, p. 84, and S.R. Badham, 'London standardisation and provincial idiosyncrasy: the organisation and working practices of brass-engraving workshops in pre-Reformation England', *Church Monuments*, vol. V (1990), pp. 3–25; the latter author's arguments for close links between brass design and glazing in York and East Anglia are based on similarities in costume and fashion rather than on stylistic links (pp. 9–11).

170 Ramsay in *Age of Chivalry*, pp. 49–54.

171 C. Norton and D. Park (eds), 'Introduction', in *Cistercian Art and Architecture in the British Isles*, Cambridge, 1986, p. 7. See also R. Marks, 'Cistercian window glass in England and Wales' and C. Norton, 'Early Cistercian tile pavements', in ibid., pp. 213–14, 231–40.

172 E. Eames, *Catalogue of Medieval Lead Glazed Earthenware Tiles in the Department of Medieval and Later Antiquities, British Museum*, London, 1980, design nos. 535, 536, 596, 597, 1328, 1329; see also N.J. Morgan, *The Medieval Painted Glass of Lincoln Cathedral* (*CVMA* Great Britain Occasional Paper III), London, 1983, p. 40, fig. C15; C. Hohler, 'Medieval pavingtiles in Buckinghamshire', *Records of Bucks.*, vol. XIV (1941), p. 26 H3.

173 P. Binski, 'The stylistic sequence of London figure brasses', in J. Coales (ed.), *The Earliest English Brasses: Patronage, Style and Workshops 1270–1350*, London, 1987, pp. 123–4, figs 122, 123.

174 Eames, op. cit., design nos. 1306–20; *Age of Chivalry*, no. 367; E. Eames and L. Keen, 'Some line-impressed tile mosaic from western England and Wales: an interim statement', *JBAA*, 3rd series, vol. XXXV (1972), pp. 65–70.

175 *Opus Anglicanum: English Medieval Embroidery*, exhib. cat., Arts Council, London, 1963, no. 30, pl. 2.

176 E. Croft-Murray, *Decorative Painting in England 1537–1837*, vol. I, London, 1962, pp. 14, 174 (no. 55), pl. 7.

177 H.W. Garrod, *Ancient Painted Glass in Merton College Chapel*, London, 1931, pp. 40–1.

178 L. Grodecki and C. Brisac, *Gothic Stained Glass 1200–1300*, London, 1985, p. 28.

179 *Age of Chivalry*, no. 255; N.J. Morgan, *Early Gothic Manuscripts 1190–1250. A Survey of Manuscripts Illuminated in the British Isles*, vol. IV, London, 1982, no. 51, illus. 167–74, fig. 12.

180 See below, chapter 6.

181 L.F. Sandler, *Gothic Manuscripts 1285–1385. A Survey of Manuscripts Illuminated in the British Isles*, vol. V, Oxford, 1986, no. 131, illus. 351; L. Dennison, 'The stylistic sources, dating and development of the Bohun workshop' (unpublished Ph.D. thesis, University of London, 1988), pp. 98–9, 134. See also below, chapter 8, p. 169.

182 See below, chapter 8 p. 183.

## 3 *The Iconography of English Medieval Windows*

1 P.A. Newton, *The County of Oxford: A Catalogue of Medieval Stained Glass* (*CVMA* Great Britain vol. I), London, 1979, p. 141.

2 C. Holmes, 'Drainers and fenmen: the problem of popular political consciousness in the seventeenth century', in A. Fletcher and J. Stevenson (eds), *Order and Disorder in Early Modern England*, Cambridge, 1985, p. 192.

3 C. Davis-Weyer, *Early Medieval Art 300–1150*, Toronto, 1986, p. 19.

4 See in particular M. Camille, 'Seeing and reading: some visual implications of medieval literacy and illiteracy', *Art History*, vol. VIII (1985), pp. 26–49; M.H. Caviness, 'Biblical stories in windows: were they bibles for the poor?', in B.S. Levy (ed.), *The Bible in the Middle Ages: Its Influence on Literature and Art* (Medieval and Renaissance Texts & Studies, 89), Binghamton, NY, 1992, pp. 103–47. Two recent studies of narrative and interpretation in the Chartres glazing are J.-P. Deremble and C. Manhes, *Les Vitraux légendaires de Chartres*, Paris, 1988 and W. Kemp, *Sermo corporeus: Die Erzählung der mittelalterlichen Glasfenster*, Munich, 1987. See also the review of these books by Madeline Caviness in *Speculum*, vol. LXV (1990), pp. 972–5.

5 L. Duncan (ed.), *Testamenta Cantiana: East Kent*, Kent Archaeological Soc., Kent Records (1910), p. 203; P. Slack, 'Religious protest and urban authority: the case of Henry Sherfield, iconoclast, 163', in D. Baker (ed.), *Schism, Heresy and Religious Protest* (Studies in Church History, vol. IX), Cambridge, 1972, pp. 295–302.

6 D. Park in *Age of Chivalry*, p. 129.

7 For the Guthlac Roll see above, chapter 1, p. 25. The suggestion regarding the Canterbury roll was first made by M.R. James, *The Verses Formerly Inscribed in the Choir of Canterbury Cathedral* (Cambridge Antiquarian Soc. Octavo Pub. No. 38), Cambridge, 1901. For the pilgrims see F.J. Furnivall and W.G. Stone (eds), *The Tale of Beryn*, Early English Text Soc., extra series, vol. CV (1909), p. 6.

8 M. Baker, 'Medieval illustrations of Bede's Life of St. Cuthbert', *Jnl Warburg & Courtauld Institutes*, vol. XLI (1978), pp. 16–49; C. Barnett, 'The St Cuthbert

window of York Minster and the iconography of St Cuthbert in the Late Middle Ages' (unpublished MA dissertation, University of York, 1991), pp. 18–21.

9  P. Binski, *The Painted Chamber at Westminster* (Society of Antiquaries of London Occasional Paper, new series, vol. IX, 1986), p. 156, n. 57.

10  See below, chapter 10, pp. 220–2 for a fuller discussion of the Balliol glass, with bibliography. I am indebted to Jill Kerr for the information that Wolsey possessed a copy of Dürer's *Passion*.

11  W. Dugdale, *The Antiquities of Warwickshire*, 2nd edn, London, 1730, vol. I, p. 411.

12  *Med. Christ. Im.*, pp. 216–17, figs 106, 110.

13  D. Park 'A lost fourteenth-century altar-piece from Ingham, Norfolk', *Burlington Mag.*, vol. CXXX no. 1019 (February 1988), pp. 132–6.

14  C. Woodforde, *Stained Glass in Somerset 1250–1830*, Oxford, 1946, pp. 149–54, pl. XXXI. See also below, chapter 10, pp. 226–7.

15  C.R. Councer, 'The medieval painted glass of West Wickham, Kent', *JBSMGP*, vol. X (1948–9), pp. 67–73.

16  Newton, op. cit., p. 228, n.7; O'Connor and Haselock, pp. 373–4. I have made use of the researches of Tom Owen on these windows.

17  F.E. Hutchinson, *Medieval Glass at All Souls College*, London, 1949, pp. 34–6, pl. XVIII.

18  See also below, chapter 9, p. 194.

19  See RCHM, *An Inventory of Historical Monuments: The Town of Stamford*, London, 1977, pp. 16–17, pl. 34.

20  *Tattershall*, pp. 208–15, 226–8.

21  M.H. Caviness, *The Early Stained Glass of Canterbury Cathedral c.1175–1220*, Princeton, 1977, pp. 101–6. See also below, chapter 6, pp. 118–24.

22  See below, chapter 7, for a discussion of the glazing of these churches.

23  G.McN. Rushforth, *The Windows of the Church of St Neot, Cornwall*, (reprinted from *Trans. Exeter Diocesan Architectural & Archaeological Soc.*, vol. XV), Exeter, 1937.

24  *Tattershall*, pp. 217–21.

25  *Med. Christ. Im.*, *passim*.

26  E. Bacher, 'Glasmalerei, Wandmalerei und Architektur', in *Bau-und Bildkunst im Spiegel internationaler Forschung* (*Festschrift zum 80. Geburtstag von Prof. Edgar Lehmann*), Berlin, 1989, pp. 14–26. S. Oosterwijk and C. Norton ('Figure sculpture from the twelfth century Minster', *Friends of York Minster Annual Report* (1990), p. 24) have suggested that the empty niches on the interior west wall of the Minster may have contained carved figures of Old Testament prophets which formed an integrated iconographical programme with the great west window glazing.

27  This observation has been made for France in Deremble and Manhes, op. cit., p. 13.

28  One of the few *Pietàs* in English glass is at Leverington

(window sIII) in Cambridgeshire (fifteenth century). The Mass of St Gregory occurs in the York Minster south choir aisle (sVII) and the Holy Kindred can be seen at All Souls College. This list is by no means exhaustive. For the Virgin of the Mantle in glass see above, p. 64.

29  The Lily Crucifix iconography is studied in W.L. Hildburgh, 'An alabaster table of the Annunciation with the Crucifix', *Archaeologia*, vol. LXXIV (1923–4), pp. 203–32; idem, 'Some further notes on the Crucifix on the Lily', *Ants. Jnl*, vol. XII (1932), pp. 24–6; C. Woodforde, *The Norwich School of Glass-Painting in the Fifteenth Century*, Oxford, 1950, p. 92, pl. XXII.

30  See D.M. Robb, 'The iconography of the Annunciation in the fourteenth and fifteenth centuries', *Art Bulletin*, vol. XVIII (1936), pp. 480–526, and *Lexikon der Christlichen Ikonographie*, vol. IV, Herder, 1972, cols 422–38, 549–58; G. Schiller, *Iconography of Christian Art*, vol. I, London, 1971, pp. 15–22, 33–52.

31  An important study of early cycles in all media can be found in the review by Alison Stones of L.F. Sandler, *The Peterborough Psalter in Brussels and other Fenland Manuscripts*, published in *Zeitschrift für Künstgeschichte*, vol. XLIII (1980), pp. 211–18. See also N. Stratford, 'Three English romanesque enamelled ciboria', *Burlington Mag.*, vol. CXXVI, no. 973 (April 1984), pp. 204–16.

32  ibid. (all works cited above); Caviness, *Early Stained Glass*, pp. 115–38.

33  M.R. James, 'Pictor in Carmine', *Archaeologia*, vol. XCIV (1951), pp. 141–66; D. Park, 'Cistercian wall painting and panel painting', in C. Norton and D. Park (eds), *Cistercian Art and Architecture in the British Isles*, Cambridge, 1986, pp. 199–200.

34  N.J. Morgan, *The Medieval Painted Glass of Lincoln Cathedral* (*CVMA* Great Britain Occasional Paper III), London, 1983, pp. 28–30. For the Lincoln glazing see below, chapter 6, pp. 124–5.

35  L.F. Sandler, 'Peterborough Abbey and the Peterborough Psalter in Brussels', *JBAA*, 3rd series, vol. XXXIII (1970), pp. 36–49; idem, *The Peterborough Psalter*. See also Caviness, *Early Stained Glass*, pp. 120–1, and Stones, op. cit. A typological cycle appears in another important manuscript, the *Sherborne Missal*, executed in the opening years of the fifteenth century. See J.A. Herbert, *The Sherborne Missal*, Roxburghe Club, 1920.

36  For the contents of the Peterborough windows see L.G. Wickham Legg (ed.), *A Relation of a Short Survey of the Western Counties*, The Camden Miscellany, vol. XVI (1936), pp. 88–9. The scenes are not related to the earlier Peterborough cycles. For St Albans see M.R. James, 'On Fine Art as applied to the illustration of the Bible in the ninth and five following centuries', *Proc. & Communications of the Cambridge Antiquarian Soc.*, vol.

VII (1888–91), pp. 61–9.

37 Tattershall, pp. 191–8; *Med. Christ. Im.*, pp. 2–3, 148–89, 270–301.

38 C. Winston, *An Inquiry into the Differences of Style Observable in Ancient Glass Paintings*, London, 1867, vol. I, p. 407, n.5; H. Wayment, *The Stained Glass of the Church of St Mary, Fairford, Gloucestershire* (Society of Antiquaries of London Occasional Paper, new series, vol. V, 1984), pp. 10–12.

39 H. Wayment, *The Windows of King's College Chapel, Cambridge* (*CVMA* Great Britain Supplementary vol. I), London, 1972, esp. pp. 5–9.

40 Caviness, *Early Stained Glass*, p. 106, no. 31.

41 The literature on the *Biblia Pauperum* is extensive. The most recent study of the block-book version is A. Henry, 'The living likeness: the forty-page blockbook *Biblia Pauperum* and the imitation of images in Utrecht and other manuscripts', *JBAA*, vol. CXXXVI (1983), pp. 124–36.

42 *Tattershall*, pp. 195–8.

43 *Med. Christ. Im.*, pp. 41–2, 148–89, 270–301; Wayment, *Fairford*, pp. 54–5, 58–9; idem, *King's*, pp. 6–7.

44 C. Woodforde, 'A group of fourteenth-century windows showing the Tree of Jesse', *JBSMGP*, vol. VI (1935–7), pp. 184–90; S. Crewe, *Stained Glass in England c.1180–c.1540*, London, 1987, p. 50 (the latter states that the Jesse Tree revived in popularity during the late fifteenth century; however the theme occurs regularly from the thirteenth century).

45 Newton, op. cit., pp. 8, 84.

46 Morgan, op. cit., pp. 29–30.

47 O'Connor and Haselock, p. 365.

48 Rushforth, *St Neot*, pp. 7–15, pls I, II. Others are listed in P. Cowen, *A Guide to Stained Glass in Britain*, London, 1985, pp. 245–6.

49 *Med. Christ. Im.*, pp. 61–3; R. Marks and N. Morgan, *The Golden Age of English Manuscript Painting 1200–1500*, London, 1981, p. 110, pl. 36.

50 *Med. Christ. Im.*, pp. 104–10, 115–17, figs 38–44, 46.

51 For the former see M.R. James, *The Apocryphal New Testament*, Oxford, 1924, pp. 38–49.

52 J. Toy, *A Guide and Index to the Windows of York Minster*, York, 1985, pp. 24, 30, 36; O'Connor and Haselock, pp. 378–81, pls 127–9.

53 St Denys Walmgate is published in RCHM, *An Inventory of the Historical Monuments in the City of York, vol. V, The Central Area*, London, 1981, pl. 55. For Lincoln see Morgan, op. cit., p. 30, pls 6(a), 7(c), (d), 8(a); the French examples are cited in notes 4 and 5 on p. 30 – also the bibliography on the Miracles of the Virgin, e.g. R. Von Dobschütz, 'Marienlegenden', in *Lexikon der Christlichen Ikonographie*, vol. IV, Herder, 1972, cols 594–7 and R.W. Southern, 'The English origins of the Miracles of the Virgin', *Medieval and Renaissance Studies*, vol. IV (1958), pp. 176–216.

54 Newton, op. cit., p. 189, pl. 44(c).

55 ibid., pp. 30–1, pls 1(b), 1(d); *Age of Chivalry*, nos. 30, 31.

56 For an excellent survey see *Lexikon der Christlichen Ikonographie*, vols V–VIII, Herder, 1973–6.

57 P.A. Newton in J. Sherwood and N. Pevsner, *The Buildings of England: Oxfordshire*, Harmondsworth, 1974, p. 79; RCHM, *An Inventory of the Historical Monuments in the City of Oxford*, London, 1939, p. 42, pl. 100; *Age of Chivalry*, no. 32.

58 F.C. Eeles and A.V. Peatling, *Ancient Stained and Painted Glass in the Churches of Surrey*, Surrey Archaeological Colls. (1930). p. 50, col. pl. on opp. page; Wickhambreaux has not attracted detailed notice; for York see Toy, op. cit., p. 18.

59 Toy, op. cit., O'Connor and Haselock.

60 P.A. Newton, 'Some new material for the study of the iconography of St Thomas Becket', *Thomas Becket Actes du Colloque International de Sédières*, 1973, pp. 258–9; for St Michael-le-Belfrey see RCHM, *York Central Area*, pl. 63.

61 For Worcester see F. Wormald, 'Some illustrated manuscripts of the lives of the saints', *Bulletin John Rylands Library*, vol. XXXV (1952–3), pp. 248–66; H.M. Colvin, 'Medieval glass from Dale Abbey', *Jnl Derbyshire Archaeological & Natural History Soc.*, vol. LX (1939), pp. 129–41.

62 For Greystoke see D.J. Chadwick, 'The ancient glass in the east window of the Church of St Andrew, Greystoke, Cumbria' (unpublished B. Phil. dissertation, University of York, 1974), and for Gresford see M. Lewis, *Stained Glass in North Wales up to 1850*, Altrincham, 1970, pp. 8, 45–6, pls 30–2. Hillesden is discussed in chapter 10, p. 212 and for North Moreton see VCH, *Berkshire*, vol. III, London, 1923, pp. 496–7 and Park, 'A lost fourteenth-century altar-piece'.

63 Rushforth, *St Neot*, pp. 26–30, pl. VIII. For Stamford see H.S. London, *The Life of William Bruges the first Garter King of Arms*, Harleian Soc., vols CXI, CXII (1970), pp. 57–62; W. Dugdale, *Book of Monuments* (BL MS Loan 38), fols 151v–162r. For the East Anglian examples see Woodforde, *Norwich School*, passim, and F.C. Eeles, 'The fifteenth century stained glass at Clavering', *Trans. Essex Archaeological Soc.*, new series, vol. XVI (1923), pp. 77–87. For York see Toy, op. cit., pp. 16, 42–3 and for Balliol see RCHM, *City of Oxford*, p. 22, pl. 75 and Sherwood and Pevsner, op. cit., pp. 76–7.

64 Colvin, op. cit.; H. Reddish, 'The St Helen window Ashton-under-Lyne: a reconstruction', *Jnl of Stained Glass*, vol. XVIII, no. 2 (1986–7), pp. 150–61; *Tattershall*, pp. 208–15.

65 For St Martin-le-Grand in York see below, chapter 8, p. 185. The St Albans glass is published in W. Carey Morgan, *St Peter's Church, St Albans*, St Albans, 1899, illus. on p. 16. Other narrative cycles are listed in

Cowen, op. cit., p. 38.

66 Caviness, *Early Stained Glass*, pp. 139-44, 146-50; idem, *The Windows of Christ Church Cathedral Canterbury* (*CVMA* Great Britain vol. II), London, 1981, pp. 158-64, 175-214, col. pls XIII-XVI, pls 110-60; Toy, op. cit., pp.10-12. For an analysis of narrative in the Chartres cycles see Deremble and Manhes, op. cit., pp. 73-112.

67 Newton, *County of Oxford*, p. 32.

68 For the iconography of this subject see C. Norton, D. Park and P. Binski, *Dominican Painting in East Anglia: The Thornham Parva Retable and the Musée de Cluny Frontal*, Woodbridge, 1987, pp. 51-3; *Med. Christ. Im.*, pp. 115-17.

69 *Age of Chivalry*, no. 33; 'Schools', vol. I, pp. 253-6.

70 F. Wormald, 'The Rood of Bromholm', *Jnl Warburg & Courtauld Institutes*, vol. I (1937-8), pp. 31-45; *Tattershall*, p. 210; Reddish, op. cit.

71 T. Borenius, *St Thomas Becket in Art*, London, 1932; Newton, 'Some new material'.

72 Borenius, op. cit., pp. 44-8; Newton, 'Some new material', pp. 256-9; Toy, op. cit., pp. 12, 41, 46.

73 Borenius, op. cit., pp. 32-4, pls III, fig. 4, XIII, fig. 3; RCHM, *City of Oxford*, p. 42, pl. 100; Newton, 'Some new material', pp. 255-6.

74 E.W. Ganderton and J. Lafond, *Ludlow Stained and Painted Glass*, Ludlow, 1961, pp. 46-53, pls 32-6; M.H. Caviness, 'A life of St Edward the Confessor in early fourteenth-century stained glass at Fécamp, in Normandy', *Jnl Warburg & Courtauld Institutes*, vol. XXVI (1963), pp. 22-37.

75 Toy, op. cit., pp. 9, 20, 21, 30.

76 Woodforde, *Norwich School, passim*; D.J. King, *Stained Glass Tours around Norfolk Churches*, Norfolk Soc., 1974, cover illus. and pl. IX.

77 For examples of John of Beverley in York stained glass see C. Davidson and D.E. O'Connor, *York Art: A Subject List of Extant and Lost Art*, Medieval Institute Publications, Michigan, 1978, p. 161.

78 For St Wulfstan see *Med. Christ. Im.*, pp. 114, 305 and for St Sidwell see Hutchinson, op. cit., pp. 34-6, Woodforde, *Somerset*, pp. 188-9.

79 Rushforth, *St Neot*.

80 Newton, *County of Oxford*, pp. 12, 80, 84, pls 4(a), 29(a), 31(a), (b); *Age of Chivalry*, no. 28.

81 *Age of Chivalry*, no. 29.

82 *Tattershall*, pp. 184-90. I am indebted to Tom Owen for information on the Scrope figure in York Minster.

83 D. Wilkins, *Concilia Magnae Britanniae et Hiberniae 1268-1349*, vol. II, London, 1737, p. 54. Pecham's commentaries on several of these articles follow on pp. 54-6. For a discussion of his canons and their relationship to earlier ones, see D.L. Douie, *Archbishop Pecham*, Oxford, 1952, pp. 133-42.

84 T.F. Kirby (ed.), *Wykeham's Register*, Hampshire Record Soc., vol. II (1899), p. 371; Douie, op. cit., p. 139; J.

Hughes, *Pastors and Visionaries : Religion and Secular Life in Late Medieval Yorkshire*, Woodbridge, 1988, esp. pp. 146-57.

85 C.F. Bühler, 'The Apostles and the Creed', *Speculum*, vol. XXVIII (1953), pp. 335-9; J.D. Gordon, 'The articles of the Creed and the Apostles', ibid., vol. XL (1965), pp. 634-40.

86 See M.H. Caviness, 'Fifteenth century stained glass from the Chapel of Hampton Court, Herefordshire: The Apostles' Creed and other subjects', *Walpole Soc.*, vol. XLII (1968-70), pp. 57-60.

87 A.C. Fryer, 'On fonts with representations of the Seven Sacraments', *Arch. Jnl*, vol. LIX (1902), pp. 17-66; idem, 'Additional notes', *Arch. Jnl*, vols LXIII (1906), pp. 102-5, LXX (1913), pp. 141-4, LXXXVII (1930), pp. 24-59, XC (1933), pp. 98-105.

88 For the theological background see L. Gougaud, *Devotional and Ascetic Practices in the Middle Ages*, London, 1927, pp. 80-130.

89 E.P. Baker, 'The Sacraments and the Passion in medieval art', *Burlington Mag.*, vol. LXVI (1935), pp. 82-4.

90 G.McN. Rushforth, 'Seven Sacraments compositions in English medieval art', *Ants. Jnl*, vol. IX (1929), pp. 83-100; *Med. Christ. Im.*, pp. 328-31, *Tattershall*, pp. 202-4.

91 See E.W. Tristram, *English Wall Painting of the Fourteenth Century*, London, 1955, esp. pp. 99-101 and A. Caiger-Smith, *English Medieval Mural Paintings*, Oxford, 1963, pp. 53-5. For stained glass see Woodforde, *Somerset* and *Norwich School*; also *Tattershall*, pp. 204-8.

92 Tristram, op. cit., pp. 99-101.

93 Woodforde, *Norwich School*, pp. 194-5.

94 E.A. Gee, 'The painted glass of All Saints' Church, North Street, York', *Archaeologia*, vol. CII (1969), pp. 162-4, pls XXV, XXVI; Leicester Museums, *Painted Glass from Leicester*, Leicester, 1962, pp. 20-5. Chinnor appears to be the earliest example of the Works in stained glass (see Newton, *County of Oxford*, p. 67, pl. 23(b)).

95 Tristram, op. cit., p. 99.

96 Woodforde, *Norwich School*, pp. 193-6; idem, *Somerset*, p. 171; *Tattershall*, p. 207.

97 Woodforde, *Norwich School*, pp. 183-92, pls XL, XLI.

98 *Age of Chivalry*, p. 41, fig. 13, nos. 557, 561.

99 See B. Brenk, 'Weltgericht', in *Lexikon der Christlichen Ikonographie*, vol. IV, Herder, 1972, cols 513-23; J.E. Ashby, 'English medieval murals of the Doom' (unpublished M.Phil. dissertation, University of York, 1980).

100 Toy, op. cit., p. 39; O'Connor and Haselock, p. 321; Caviness, *Early Stained Glass*, op. cit., pp. 100, 104, 116, fig. 146; idem, *Christ Church*, pp. 8, 50-1, 311-12, figs 586-8; Morgan, op. cit., pp. 14-17, pls 5, 6.

101 D.J. King, 'The glazing of the south rose of Lincoln Cathedral', *Medieval Art and Architecture at Lincoln* (BAA Conference Transactions vol. VIII, 1982), 1986,

pp. 132–45; J.A. Robinson, 'The fourteenth-century glass at Wells', *Archaeologia*, vol. LXXXI (1931), pp. 104–6, pls XLVII, XLVIII, XLIX; G.McN. Rushforth, 'The glass in the quire clerestory of Tewkesbury Abbey', *Trans. Bristol & Glos. Archaeological Soc.*, vol. XLVI (1924), pp. 295–301, pls I–IV; 'Schools', vol. I, p. 30, vol. II, pp. 370–2; C. Woodforde, *The Stained Glass of New College, Oxford*, Oxford, 1951, pp. 102, 105; J.H. Harvey and D.G. King, 'Winchester College stained glass', *Archaeologia*, vol. CIII (1971), esp. pp. 162–4, fig. 2, pls LXXI, LXXVII, LXXVIIIb, c, LXXXb, LXXXIb.

102 Wayment, *Fairford*, pp. 55–8, pls XXII, XXIII(a), LVIII, LIX, col. pls II, III, VII(c), VIII(a), (d).

103 For a good account of this window see L.S. Jones, 'St Michael and All Angels, Thornhill: a catalogue of the mediaeval glass' (unpublished B.Phil. dissertation, University of York, 1971), pp. 43–73. Copies of the pre-Restoration drawings used by the author are in the *CVMA* archive at the Royal Commission on Historical Monuments (England).

104 Not all of these have been published. For Coughton see VCH, *Warwickshire*, vol. III, London, 1945, pp. 83–4, and for Ticehurst see Crewe, op. cit., pl. 43.

105 This observation was made by O'Connor and Haselock, p. 365, pl. 117. See also Toy, op. cit., p. 5–7 and J. Rickers, 'The Apocalypse scenes in the great east window of York Minster' (unpublished MA dissertation, University of York, 1992)

106 Gee, op. cit., pp. 158–61, 199–202, pls XXIII, XXIV. For the popularity of the *Pricke of Conscience* see J. Hughes, 'The administration of confession in the diocese of York in the fourteenth century', in D.M. Smith (ed.), *Studies in Clergy and Ministry in Medieval England* (Borthwick Studies in History I), York, 1991, pp. 87–163, esp. pp. 106–8.

107 See Caiger-Smith, op. cit., p. 46 for wall-paintings of the Living and Dead Kings. The Norwich panel is illustrated in J. Harries, *Discovering Stained Glass*, Shire Publications, Princes Risborough, pl. 7.

108 *Tattershall*, pp. 233–4.

109 ibid; *Med. Christ. Im.*, pp. 369–402, figs 171–85.

110 *Tattershall*, p. 233, no. 146.

111 Toy, op. cit., p. 27; Woodforde, *Norwich School*, pp. 49–51; W. Wells, *Stained and Painted Glass, Burrell Collection*, Glasgow, 1965, nos. 123, 128, 205.

112 Woodforde, *Norwich School*, pp. 137–8; *Med. Christ. Im.*, p. 403.

113 J.P. Hoskins, P.A. Newton and D. King, *The Hospital of William Browne, Merchant, Stamford, Lincolnshire*, Stamford, n.d., p. 9; *Tattershall*, p. 126, pl. 65; RCHM, *Stamford*, col. pl. 36.

114 For Buckden and the Norfolk churches see Woodforde, *Norwich School*, pp. 137–42, pl. XXX; Cockayne Hatley is published in R. Marks, 'Medieval stained glass in

Bedfordshire', *Bedfordshire Mag.*, vol. XV, no. 117 (Summer 1976), p. 182, illus. on p. 183.

115 C.F. Hardy, 'On the music in the painted glass of the windows in the Beauchamp Chapel at Warwick', *Archaeologia*, vol. LXI (1909), pp. 583–614.

116 D.J. King, 'An antiphon to St Edmund in Taverham church', *Norfolk Archaeology*, vol. XXXVI, pt IV (1977), pp. 387–91.

117 Newton, *County of Oxford*, p. 155, pl. 39(d).

118 See especially M. Camille, *Image on the Edge: The Margins of Medieval Art*, London, 1992.

119 See A. Martindale, 'Patrons and minders: the intrusion of the secular into sacred spaces in the late Middle Ages', in D. Wood (ed.), *The Church and the Arts* (Studies in Church History, vol. XXVIII), Oxford, 1992, pp. 143–78.

120 See below, chapter 7, p. 148.

121 O'Connor and Haselock, pp. 342–6, pls 103, 105. For Norbury see below, chapter 7, p. 153, 'Schools', vol. II, pp. 65–78.

122 J.C. Cox, *Churchwardens' Accounts*, London, 1913, p. 87.

123 'Schools', vol. I, pp. 135–45. See also R. Marks and A. Payne (eds), *British Heraldry from its Origins to c.1800*, exhib. cat., British Museum, London, 1978, pp. 11–13; A.R. Wagner, *Aspilogia I. A Catalogue of English Mediaeval Rolls of Arms*, London, 1950, pp. xiv–xv.

124 J. Kerr, 'The east window of Gloucester Cathedral', *Medieval Art and Architecture at Gloucester and Tewkesbury* (BAA Conference Transactions vol. VII, 1981), 1985, pp. 125–6.

125 'Schools', vol. I, p. 144; vol. II, pp. 1–28, 358–9, 388–91.

126 For Shelton see King, *Tours*, p. 27, and for Long Melford, Woodforde, *Norwich School*, pp. 74–127 and chapter 1 above, pp. 5–6.

127 O'Connor and Haselock, p. 341, pl. 102; *Age of Chivalry*, no. 4.

128 G. McN. Rushforth, 'The great east window of Gloucester Cathedral', *Trans. Bristol & Glos. Archaeological Soc.*, vol. XLIV (1922), pp. 302–4; Kerr, op. cit., pp. 124–5.

129 S. Gunton, *The History of the Church of Peterburgh*, London, 1686, p. 103.

130 Caviness, *Christ Church*, pp. 231–9, col. pl. XVII, figs 380–432; *Age of Chivalry*, no. 748.

131 R. Marks, 'Yorkist-Lancastrian political and genealogical propaganda in the visual arts', *Family History*, vol. XII nos. 89/90, new series, nos. 65/66 (April 1982), pp. 149–66.

132 ibid., p. 152, pl. 2, citing E.F. Jacob, 'Founders and foundations in the later Middle Ages', *Bull. Institute of Historical Research*, vol. XXXV (1962), p. 37; Hutchinson, op. cit., pp. 37–45, pls XIX–XXIV.

133 B. Rackham, 'The glass-paintings of Coventry and its neighbourhood', *Walpole Soc.*, vol. XIX (1930–1), p. 110; R.S. Loomis, *Arthurian Legends in Medieval Art*,

London, 1938, p. 40; *Tattershall*, pp. 146-7.

134 M.A. Green, 'Old painted glass in Worcestershire, Part XI', *Trans. Worcs. Archaeological Soc.*, vol. XXIV (1947), p. 18.

135 Herbert, op. cit.; *The Benedictines in Britain*, London, 1980, no. 68, illus. 37 and cover.

136 Rushforth, 'Gloucester', op. cit., pp. 300-2.

137 O'Connor and Haselock, pp. 365, 377; Toy, op. cit., pp. 7, 32-4 37-8; F. Harrison, 'The west choir clerestory windows in York Minster', *Yorks. Archaeological Journal*, vol. XXVI (1922), pp. 353-73. Tom Owen has also studied the iconography of the choir clerestory.

138 G.McN. Rushforth, 'Tewkesbury'; R.K. Morris, 'Tewkesbury Abbey: the Despenser mausoleum', *Trans. Bristol & Glos. Archaeological Soc.*, vol. XCIII (1974), pp. 142-55; Martindale, op. cit., pp. 160-4; idem, *Heroes, Ancestors, Relatives and the Birth of the Portrait*, Groningen, 1988, pp. 16-19.

139 'Schools', vol. III, pp. 582-97.

140 London, op. cit., pp. 57-67, 114-15, pls XII-XVI; Dugdale, *Book of Monuments*, fols 151v-62. See also above, p. 73.

141 For this phenomenon see A. Gransden, 'Antiquarian studies in fifteenth-century England', *Ants. Jnl*, vol. LX (1980), pp. 75-97.

142 S. Pitcher, 'Ancient stained glass in Gloucestershire churches', *Trans. Bristol & Glos. Archaeological Soc.*, vol. XLVII (1925), p. 34. For Peterborough see Gunton, op. cit., pp. 103-12.

143 *Med. Christ. Im.*, pp. 120-34, figs 51-8.

144 Dugdale, *Book of Monuments*, fol. 55r; for an account of the college see VCH, *Staffordshire*, vol. III, London, 1970, pp. 309-15.

# 4 Domestic Glass

1 The only general surveys of domestic glass known to the present writer are L.F. Day, *Windows: A Book about Stained & Painted Glass*, 3rd edn, London, 1909, pp. 288-303; D.B. Harden, 'Domestic window glass: Roman, Saxon and Medieval', in E.M. Jope (ed.), *Studies in Building History*, London, 1961, pp. 39-63; P. Biver and E. Socard, 'Le Vitrail civil au XIVe siècle', *Bulletin Monumental*, vol. LXXVII (1913), pp. 258-64. The subject is touched upon in L.F. Salzman, *Building in England down to 1540*, reprinted Oxford, 1967, pp. 173-86 and M. Wood, *The English Mediaeval House*, London, 1965, pp. 358-9.

2 Salzman, *Building*, p. 173.

3 Harden, op. cit., p. 54.

4 Biver and Socard, op. cit., p. 259.

5 Harden, op. cit., p. 56.

6 ibid., p. 63 n. 98, citing Pipe Roll 25 Henry II, p. 125.

7 'Med. Glazing Accounts' (1927-8), p. 116; H.M. Colvin (ed.), *Building Accounts of King Henry III*, Oxford, 1971, pp. 138-9.

8 These references are taken from Salzman, *Building*, p. 174.

9 All these references are taken from T. Borenius, 'The cycle of images in the palaces and castles of Henry III', *Jnl Warburg & Courtauld Institutes*, vol. VI (1943), pp. 47-9. For Henry's taste for Dives and Lazarus scenes see P. Binski, *The Painted Chamber at Westminster* (Society of Antiquaries of London Occasional Paper, new series, vol. IX, 1986), pp. 35, 45.

10 R. Marks, 'Window glass' in T.B. James and A.M. Robinson, *Clarendon Palace* (Report of the Research Committee of the Society of Antiquaries of London, no. XLV), London, 1988, pp. 229-33, fig. 87. The Wolvesey finds are published by M. Biddle, J. Hunter and J. Kerr in M. Biddle, *Object and Economy in Medieval Winchester 7ii Artefacts from Medieval Winchester*, Oxford 1990. I am indebted to Jill Kerr and Professor Martin Biddle for their generosity in granting me access to their researches prior to publication; also to David O'Connor for the information on Ludgershall. The grisaille in the tracery of a window in No. 3, Vicar's Court, Lincoln, cited by N. Pevsner and J. Harris (*The Buildings of England: Lincolnshire*, Harmondsworth, 1964, p. 135) as dating from Bishop Sutton's time (1280-99) is nineteenth-century, probably copied from some of the grisaille in the cathedral.

11 These references are taken from 'Med. Glazing Accounts' (1927-8), pp. 119, 191, 192.

12 P.A. Newton, *The County of Oxford: A Catalogue of Medieval Stained Glass* (CVMA Great Britain vol. I), London, 1979, pp. 49-50; E.A. Greening Lamborn, *The Armorial Glass of the Oxford Diocese 1250-1850*, Oxford, 1949, pp. 116-17, frontispiece.

13 Southwick has not been the subject of a detailed study. For East Haddesley see H.E.J. Le Patourel, *The Moated Sites of Yorkshire*, Soc. for Medieval Archaeology, Monograph Series No. 5, 1973, pp. 83-4, fig. 33.

14 W.W. Skeat (ed.), *The Complete Works of Geoffrey Chaucer*, Oxford, 1912, p. 86.

15 Biddle, op. cit.

16 'Med. Glazing Accounts' (1929-30), pp. 26-7.

17 ibid. (1927-8), p. 192.

18 J. Bridges, *The History and Antiquities of Northamptonshire*, Oxford, 1791, vol. II, p. 448.

19 C. Woodforde, *Stained Glass in Somerset 1250-1830*, Oxford, 1946, p. 144.

20 See above, chapter 2, p. 49, quoting from 'Med. Glazing Accounts' (1929-30), p. 28.

21 C. Hussey, 'Ockwells Manor, Bray – II', *Country Life*, vol. LV (19 January 1924), pp. 92-9; E. Green, 'The identification of the Eighteen Worthies commemorated in the heraldic glass in the hall windows of Ockwells Manor

House', *Archaeologia*, vol. LVI (1899), pp. 323–36.

22 For the accounts see above, chapter 2, p. 49. The surviving glass is published in H.H.E. Craster, *A History of Northumberland, vol. IX, The Parochial Chapelries of Earsdon and Horton*, London, 1909, p. 19.

23 'Schools', vol. I, pp. 102–6, vol. II, pp. 33–64. See also below, chapter 8, p. 182.

24 M.H. Caviness, 'Fifteenth century stained glass from the Chapel of Hampton Court, Herefordshire: the Apostles' Creed and other subjects', *Walpole Soc.*, vol. XLII (1968–70), pp. 35–60. See also below, chapter 8, p. 183. The Annunciation and Assumption panels are now in the Burrell Collection, Glasgow.

25 C. Woodforde, 'The painted glass in Withcote Church', *Burlington Mag.*, vol. LXXV, no. 186 (1939), pp. 17–22; A.R. Dufty, 'Withcote Chapel', *Arch. Jnl*, vol. CXII (1955), pp. 178–81; H. Wayment, 'Twenty-four vidimuses for Cardinal Wolsey', *Master Drawings*, vol. XXIII/XXIV, no. 4 (March 1988), pp. 503–17. See also below, chapter 10, pp. 176, 224.

26 C. Woodforde, 'The stained and painted glass in Hengrave Hall, Suffolk', *Proc. Suffolk Institute of Archaeology & Natural History*, vol. XXII (1936), pp. 1–16; H. Wayment, 'The foreign glass at Hengrave Hall and St James', Bury St. Edmunds', *Jnl of Stained Glass*, vol. XVIII, no. 2 (1986–7), pp. 166–74. See also below, chapter 10, p. 222.

27 The Cotehele glass has not been the subject of a detailed study.

28 See above, chapter 1, p. 22.

29 R.E.G. Cole (ed.), *Lincolnshire Church Notes made by Gervase Holles, AD 1634 to 1642*, Lincoln Rec. Soc., vol. I, 1911, pp. 45, 53, 69.

30 VCH *Rutland*, vol. II, London, 1935, pp. 188–91; A.H. Thompson, 'Notes ... on a Visit to Liddington Bede House', *Report of the Rutland Archaeological & Natural Hist. Soc.*, vol. XII (1915), pp. 38–40.

31 For the background see M. Girouard, *Life in the English Country House*, New Haven and London, 1978, esp. pp. 30–8.

32 For the Ockwells bibliography see n. 21 above.

33 Woodforde, *Somerset*, pp. 53–4; C. Winston, *Memoirs Illustrative of the Art of Glass-Painting*, London, 1865, pp. 123–4.

34 A. Oswald, 'Barnard Flower, the King's Glazier', *JBSMGP*, vol. XI (1951–5), p. 16.

35 W. Wells, *Stained and Painted Heraldic Glass: Burrell Collection*, Glasgow, 1962, nos. 115–53.

36 C. Woodforde, *The Norwich School of Glass-Painting in the Fifteenth Century*, Oxford, 1950, pp. 149–60; the most comprehensive survey to date is K.M. Folcard, 'A preliminary catalogue of English figurative stained glass roundels produced before 1530' (unpublished MA dissertation, University of York, 1987). See also the same author's (writing as K. Ayre), 'English figurative

stained glass roundels produced before 1530', *Jnl of Stained Glass*, vol. XIX, no. 1 (1989–90), pp. 1–17.

37 G. Bailey, 'The stained glass at Norbury Manor House', *Trans. Derbyshire Archaeological & Nat. Hist. Soc.*, vol. IV (1882), pp. 152–8; Folkard, op. cit., p. 112–16.

38 Leicester Museums, *Painted Glass from Leicester*, Leicester, 1962; A. Hamilton, 'Orthodoxy in late fifteenth-century glass at Leicester', *Trans. Leicestershire Archaeological & Historical Soc.*, vol. LV (1979–80), pp. 22–37.

39 Salzman, *Building*, p. 185.

40 RCHM, *An Inventory of the Historical Monuments in Buckinghamshire*, vol. I, London, 1912, p. 38.

41 D. Verey, *The Buildings of England: Gloucestershire: The Cotswolds*, 2nd edn, Harmondsworth, 1979, p. 138; C.E. Long (ed.), *Diary of the Marches of the Royal Army during the Great Civil War kept by Richard Symonds*, Camden Soc., old series, vol. LXXIV (1859), p. 27.

42 Woodforde, *Somerset*, p. 128.

43 P.A. Newton in J. Sherwood and N. Pevsner, *The Buildings of England: Oxfordshire*, Harmondsworth, 1974, p. 83.

44 ibid., pp. 77–8.

45 F.E. Hutchinson, *Medieval Glass at All Souls College*, London, 1949, pp. 37–61, pls XIX–XXXI. Some at least of the fifteenth-century saints and donor clerics in the windows of the Old Library at Trinity College, Oxford, may also have originally formed part of the glazing. See R. Gameson and A. Coates, *The Old Library: Trinity College, Oxford*, Oxford, 1988, pp. 15–34.

46 R. Willis and J.W. Clark, *The Architectural History of the University of Cambridge and of the Colleges of Cambridge and Eton*, vol. III, Cambridge, 1886, pp. 461–3.

47 M.R. James, 'On the glass in the windows of the library at St Albans Abbey', *Proc. & Communications of the Cambridge Antiq. Soc.*, vol. VIII (1891–4), pp. 213–20.

48 D. Ingram Hill, *St Nicholas Harbledown*, n.d.

49 J.D. Le Couteur, *Ancient Glass in Winchester*, Winchester, 1920, pp. 121–32, pls XXXIII–XXXV; RCHM, *An Inventory of the Historical Monuments in Dorset vol. I – West*, London, 1952, p. 212, pl. 17; P.N. Dawe, 'Sherborne Almshouse building accounts 1440–1444', *Somerset & Dorset Notes & Queries*, vol. XXIX (1968–73), pp. 74–8, 112–13, 131–2; Woodforde, *Somerset*, pp. 82–3.

50 *Tattershall*, pp. 124–31, pls 64–7a; RCHM, *An Inventory of Historical Monuments: The Town of Stamford*, London, 1977, pp. 40–1, pls 36, 37, 39.

51 Wells, op. cit., nos. 234–40.

## 5 The Earliest English Stained Glass c. 670–1175

1 For Roman glass see D.B. Harden, 'Domestic window glass: Roman, Saxon and Medieval', in E.M. Jope (ed.), *Studies in Building History*, London, 1961, pp. 44–52.

2 C. Plummer (ed.), *Venerabilis Baedae: Opera Historica*, vol. I, Oxford, 1896, p. 368.

3 B. Colgrave (ed.), *The Life of Bishop Wilfrid by Eddius Stephanus*, Cambridge, 1927, pp. 34–5.

4 A. Campbell (ed.), *Aethelwulf: De Abbatibus*, Oxford, 1967, p. 50.

5 For Monkwearmouth and Jarrow see R. Cramp, 'Glass finds from the Anglo-Saxon monastery of Monkwearmouth and Jarrow', *Studies in Glass History and Design* (VIIIth International Congress on Glass), Sheffield, 1970, pp. 16–19; idem, 'Decorated window-glass and millefiori from Monkwearmouth', *Ants. Jnl*, vol. L (1970), pp. 327–35; idem, 'Window glass from the monastic site of Jarrow', *Jnl Glass Studies*, vol. XVII (1975), pp. 88–96. Escomb is published in M. Pocock and H. Wheeler, 'Excavations at Escomb Church, County Durham', *JBAA*, 3rd series, vol. XXXIV (1971), Appendix I, pp. 26–8 (by R. Cramp) and Whitby in L. Webster and J. Backhouse (eds), *The Making of England. Anglo-Saxon Art and Culture AD 600–900*, exhib. cat., British Museum, London, 1991, no. 107(j). For Brixworth see P. Everson, 'Excavations in the vicarage garden at Brixworth, 1972', *JBAA*, vol. CXXX (1977), pp. 55–122 (glass on pp. 77, 104–7, by J. Hunter).

6 Cramp, 'Decorated window-glass', p. 329.

7 R. Ljubinkovic, 'Sur un exemplaire de vitraux du monastère de Studenica', *Archaeologica Iugoslavica*, vol. III (1959), pp. 137–41.

8 For the non-Winchester and non-York material see Harden, op. cit., pp. 53–4. The Winchester finds are published by M. Biddle, J. Hunter and J. Kerr in M. Biddle, *Object and Economy in Medieval Winchester 7ii Artefacts from Medieval Winchester*, Oxford, 1990, pp. 350–449. I am very grateful to the authors for giving me access to the glass. Some of the glass is catalogued in J. Backhouse, D.H. Turner and L. Webster (eds), *The Golden Age of Anglo-Saxon Art*, exhib. cat., British Museum, London, 1984, no. 141, col. pl. XXVIII.

9 Harden, op. cit., p. 53.

10 Backhouse, Turner and Webster, op. cit., nos 6, 25. The accepted late ninth-century date for the wall-painting has been challenged by R. Gem, 'L'Architecture pré-romane et romane en Angleterre: problèmes d'origine et de chronologie', *Bulletin Monumental*, vol. CXLII (1989), p. 242.

11 Backhouse, Turner and Webster, op. cit.; E. Temple, *Anglo-Saxon Manuscripts 900–1066. A Survey of Manu-scripts Illuminated in the British Isles*, vol. II, London, 1976.

12 See F. Wormald, 'Decorated initials in English manuscripts from AD 900 to 1100', *Archaeologia*, vol. XCI (1945), pp. 107–35; idem, 'The survival of Anglo-Saxon illumination after the Norman Conquest', *Proc. Brit. Academy*, vol. XXX (1944), pp. 127–45; C.M. Kauff-mann, *Romanesque Manuscripts 1066–1140. A Survey of Manuscripts Illuminated in the British Isles*, vol. III, London, 1975; Backhouse, Turner and Webster, op. cit., pp. 194–209; G. Zarnecki, '1066 and architectural sculpture', *Proc. Brit. Academy*, vol. LII (1966), pp. 87–104.

13 Backhouse, Turner and Webster, op. cit., nos. 66, 264, 265, 269.

14 ibid., no. 148; O. Pächt, 'Hugo pictor', *Bodleian Lib. Record*, vol. III (1950), pp. 96–103; Kauffmann, op. cit., no. 26, illus. 60, 63.

15 D. Phillips, *Excavations at York Minster vol. II The Cathedral of Archbishop Thomas of Bayeux*, London, 1985, p. 159, col. frontispiece.

16 R.A. Brown, H.M. Colvin and A.J. Taylor, *The History of the King's Works: The Middle Ages*, vol. I, London, 1963, pp. 15–16; H.R. Luard (ed.), *Lives of Edward the Confessor* (Rolls series, vol. III), London, 1858, p. 90, line 2303.

17 Backhouse, Turner and Webster, op. cit., p. 141; R. Gem and P. Tudor-Craig, 'A "Winchester School" wall-painting at Nether Wallop, Hampshire', *Anglo-Saxon England*, vol. IX (1981), pp. 115–36. For a general survey see S. Cather, D. Park and P. Williamson (eds), *Early Medieval Wall Painting and Painted Sculpture in England* (Brit. Archaeological Reports, British Series 216), Oxford, 1990.

18 L. Grodecki, *Le Vitrail roman*, Fribourg and Paris, 1977, pp. 38–9; C. Mango, *The Art of the Byzantine Empire 312–1453*, New Jersey, 1972, p. 82.

19 Grodecki, op. cit., pp. 44, 298, pl. 28; C. Cechelli, 'Vetri da fenestra di San Vitale di Ravenna', *Felix Ravenna*, new series, vol. XXV (1930), pp. 14–20; G. Bovini, 'Les plus anciens vitraux de l'église Saint-Vital de Ravenne', *Annales du 3e congrès des 'Journées internationales du verre'*, Damascus (November 1964), pp. 85–90.

20 A.H.S. Megaw, 'Notes on recent work of the Byzantine Institute in Istanbul', *Dumbarton Oaks Papers*, no. XVII (1963), esp. pp. 349–67, figs 20–5.

21 Grodecki, op. cit., p. 44.

22 ibid.

23 ibid., p. 45, pl. 29.

24 For an interim report see R. Hodges and J. Mitchell (eds), *San Vincenzo al Volturno: The Archaeology, Art and Territory of an Early Medieval Monastery* (Brit. Archae-ological Reports, International Series 252), Oxford, 1985, esp. pp. 15, 16 and chapter 2 (by J. Moreland). I am indebted to Richard Hodges for communicating his

findings to me in advance of full publication.

25 For these references see Grodecki, op. cit., p. 43 and J. Lafond, *Le Vitrail*, Paris, 1966, pp. 18-29.

26 Grodecki, op. cit., pp. 45-6, 272, pls 30-1; R. Becksmann, *Deutsche Glasmalerei des Mittelalters*, Stuttgart-Bad Cannstatt, 1988, p. 8, text fig. 2.

27 Grodecki, op. cit., pp. 46, 48, 272-3, pls 32-4; R. Becksmann, 'Das Schwarzacher Köpfchen. Ein Ottonischer Glasmalereifund', *Kunstchronik*, vol. XXII (1970), pp. 3-10.

28 Grodecki, op. cit., pp. 49-50, 295, pl. 35.

29 C.R. Dodwell (ed.), *Theophilus De Diuersis Artibus*, London, 1961, pp. 49-51.

30 Grodecki, op. cit., pp. 50-5, 269, pls 36-40; Becksmann, op. cit., cat. I.

31 Grodecki, op. cit., for an excellent survey.

32 ibid., pp. 57-90.

33 N.E.S.A. Hamilton (ed.), *William of Malmesbury: De Gestis Pontificum Anglorum* (Rolls series, vol. LII), London, 1870, p. 138.

34 W. Stubbs (ed.), *The Historical Works of Gervase of Canterbury, vol. I* (Rolls series, vol. LXXIII), London, 1879, p. 12.

35 M.H. Caviness, 'Romanesque "belles verrières" in Canterbury?', in *Romanesque and Gothic. Essays for George Zarnecki*, Woodbridge, 1987, pp. 35-8.

36 J.C. Atkinson (ed.), *Cartularium Abbathiae de Rievalle*, Surtees Soc., vol. LXXXIII (1887), pp. 108-9.

37 R. Marks, 'Cistercian window glass in England and Wales', in C. Norton and D. Park (eds), *Cistercian Art and Architecture in the British Isles*, Cambridge, 1986, pp. 212-13.

38 ibid., p. 212.

39 ibid.; see also R. Gilyard-Beer and G. Coppack, 'Excavations at Fountains Abbey, North Yorkshire, 1979-80: the early development of the monastery', *Archaeologia*, vol. CVIII (1986), pp. 156-7.

40 I have benefited from discussions with the late Peter Newton and Professor George Zarnecki on this figure. It is briefly mentioned by Professor Caviness in *English Romanesque Art 1066-1200*, exhib. cat., Arts Council, London, 1984, p. 135 and S. Crewe, *Stained Glass in England c.1180-c.1540*, London, 1987, pp. 16-17, pl. 5.

41 The nearest approximation is the grisaille figure of St Nicholas dated to *c.*1170-80 from Oberndorf bei Arnstadt in Germany (on loan to the Thüringer Museum, Eisenach). Even this is more sophisticated than the Dalbury St Michael. See *Mittelalterliche Glasmalerei in der Deutschen Demokratischen Republik*, exhib. cat.,Angermuseum, Erfurt, 1989, no. 2.

42 *English Romanesque Art*, op. cit., p. 135; Crewe, op. cit., p. 16.

43 Grodecki, op. cit., pp. 50-6, 91-112, 124-5, 184-5, pls 1, 36-9, 72-7, 80, 82, 86, 88, 91, 105, 158, 160. For Theophilus's statement see Dodwell, op. cit., p. 51. A

stimulating discussion of white and coloured glass is J. Gage, 'Gothic glass: two aspects of a Dionysian aesthetic', *Art History*, vol. V (1982), pp. 36-58 (esp. 39-40).

44 P.M. Johnston, 'Poling and the Knights Hospitallers', *Sussex Archaeological Colls.*, vol. LX (1919), pp. 72-6, figs 1, 2; idem, 'The discovery of a pre-Conquest window … in Witley church, Surrey …', *Proc. Soc. Ants.*, 2nd series, vol. XXIX (1916-17), esp. pp. 192-3, fig. 1.

# 6  Stained Glass c. 1175-1250

1 For Durham see J. Haselock and D. O'Connor, 'The medieval stained glass of Durham Cathedral', *Medieval Art and Architecture at Durham Cathedral* (BAA Conference Transactions vol. III, 1977), 1980, pp. 105, 124 n. 2; the Peterborough reference is taken from G.A. Poole, 'On the Abbey Church of Peterborough', *Assoc. Architect. Soc. Reports & Papers*, vol. III (1855), p. 219.

2 For St Albans and Chichester see L.F. Salzman, *Building in England down to 1540*, reprinted Oxford, 1967, pp. 175, 379-80. The Chichester reference is quoted in full in chapter 2 above, p. 50. For Henry III's glazing see T. Borenius, 'The cycle of images in the palaces and castles of Henry III', *Jnl Warburg & Courtauld Institutes*, vol. VI (1943), pp. 40-50.

3 For general surveys see L. Grodecki, *Le Vitrail roman*, Fribourg and Paris, 1977; L. Grodecki and C. Brisac, *Gothic Stained Glass 1200-1300*, London, 1985.

4 The most recent discussions of the York glass are O'Connor and Haselock, pp. 319-25; Grodecki, op. cit., pp. 200-3; and Madeline Caviness in *English Romanesque Art 1066-1200*, exhib. cat., Arts Council, London, 1984, pp. 135-41.

5 O'Connor and Haselock, p. 342; J.A. Knowles, *Essays in the History of the York School of Glass-Painting*, London, 1936, fig. 62. David O'Connor and the present writer independently raised the possibility of the early date of the grisaille.

6 W.R. Lethaby, 'Archbishop Roger's cathedral at York and its stained glass', *Arch. Jnl*, vol. LXXII (1915), p. 47.

7 *English Romanesque Art*, pp. 135-6; L. Grodecki, *Les Vitraux de Saint Denis, vol. I* (*CVMA* France Etudes, vol. I), Paris, 1976, esp. p. 129, type F.

8 *English Romanesque Art*, p. 136.

9 This observation was made in Grodecki, *Le Vitrail roman*, p. 201.

10 *English Romanesque Art*, p. 136. For the St Oswald reliquary see J. Geddes, 'The twelfth-century metalwork at Durham Cathedral', *Medieval Art and Architecture at Durham Cathedral* (BAA Conference Transactions vol. III, 1977), 1980, pp. 143-8, pls XXI(e), (f), XXII(b). For the Troyes glass see Grodecki,

*Le Vitrail roman*, pp. 140-7, 294-5, pls 118-25.

11 *English Romanesque Art*, p. 136, nos. 75, 76, 77.

12 G. Zarnecki, 'Two late-twelfth century reliefs in York Minster', in *Studies in Romanesque Sculpture*, London, 1979, no. XVI, pp. 1-5. See also S. Oosterwijk and C. Norton, 'Figure sculpture from the twelfth century Minster', *Friends of York Minster Annual Report* (1990), pp. 11-30.

13 Zarnecki, op. cit., p. 4; *English Romanesque Art*, p. 136. For the suggestion that some of the glass came from the western parts of the Minster see Oosterwijk and Norton, op. cit., pp. 22-3.

14 Grodecki, *Le Vitrail roman*, pp. 279-80, 288, pls 72, 86; A. Watson, *The Early Iconography of the Tree of Jesse*, Oxford and London, 1934.

15 M.H. Caviness, *The Early Stained Glass of Canterbury Cathedral c.1175-1220*, Princeton, 1977, esp. Appendix, figs 1-5.

16 *English Romanesque Art*, pp. 136-7. For a ground plan of Archbishop Roger's choir see E.A. Gee, 'Architectural history until 1290', in G.E. Aylmer and R. Cant (eds), *A History of York Minster*, Oxford, 1977, p. 110, plan V.

17 W. Stubbs (ed.) *The Historical Works of Gervase of Canterbury, vol. I* (Rolls series, vol. LXXIII), London, 1879, p. 3. For an English translation see R. Willis, *The Architectural History of Canterbury Cathedral*, London, 1845, pp. 32-62.

18 What was for long the standard work on Canterbury, B. Rackham, *The Ancient Glass of Canterbury Cathedral*, Canterbury, 1949, has been superseded by Caviness, *Early Stained Glass*, and idem, *The Windows of Christ Church Cathedral Canterbury* (*CVMA* Great Britain vol. II), London, 1981. See also Grodecki, *Le Vitrail roman*, pp. 203-14; idem, 'A propos d'une étude sur les anciens vitraux de la cathédrale de Canterbury', *Cahiers de civilisation médiévale*, vol. XXIV (1983), pp. 59-65; Grodecki and Brisac, op. cit., pp. 181-4; E. Frodl-Kraft, review of Caviness, *The Windows*, in *Kunstchronik*, vol. XXXVII (1984), pp. 229-41.

19 Y. Delaporte and E. Houvet, *Les Vitraux de la cathédrale de Chartres*, Chartres, 1926, *passim*; Caviness, *Early Stained Glass*, pp. 32-3, 101-2.

20 Caviness, *Early Stained Glass*, p. 106.

21 See above, chapter 5, p. 110.

22 D.H. Turner, 'The customary of the shrine of St Thomas Becket', *The Canterbury Chronicle*, no. 70 (April 1976), p. 21.

23 Caviness, *Early Stained Glass*, p. 1.

24 ibid., p. 45. See also Grodecki, *Le Vitrail roman*, and Grodecki and Brisac, op. cit., esp. p. 17.

25 Caviness, *Early Stained Glass*, pp. 26-7; idem, 'Canterbury Cathedral clerestory: the glazing programme in relation to the campaigns of construction', *Medieval Art and Architecture at Canterbury before 1220* (BAA Conference Transactions vol. V, 1979),

1982, pp. 46-55.

26 Caviness, *Early Stained Glass*, p. 36.

27 ibid., pp. 48, 71-5.

28 ibid., pp. 49-58.

29 W. Oakeshott, *The Two Winchester Bibles*, Oxford, 1981.

30 Caviness, *Early Stained Glass*, pp. 63-5.

31 N. Stratford, 'Three English romanesque enamelled ciboria', *Burlington Mag.*, vol. CXXVI, no. 973 (April 1984), pp. 204-16; *English Romanesque Art*, no. 279.

32 Caviness, *Early Stained Glass*, pp. 71-5, figs 135-7.

33 ibid., pp. 77-82.

34 *Radiance and Reflection: Medieval Art from the Raymond Pitcairn Collection*, exhib. cat., Metropolitan Museum of Art, New York, 1982, nos. 46-9; M.H. Caviness, 'Rediscovered glass of about 1200 from the Abbey of St-Yved at Braine', *Studies on Medieval Stained Glass. Selected Papers from the XIth International Colloquium of the Corpus Vitrearum* (*CVMA* United States Occasional Papers I), New York, 1985, pp. 34-47; idem, *Sumptuous Arts at the Royal Abbeys in Reims and Braine*, Princeton, 1990, pp. 98-128.

35 Caviness, *Early Stained Glass*, pp. 83-100.

36 ibid., pp. 83-6, 91-5; Grodecki ('A propos', pp. 63-4) has challenged the Canterbury-Sens connections.

37 Closely comparable border fragments have been excavated at St Augustine's Abbey, Canterbury. See D. Sherlock and H. Woods, *St Augustine's Abbey: Report on Excavations 1960-78* (Kent Archaeological Soc. Monograph Series, no. IV, 1988), pp. 132-4, fig. 40, nos. 1, 5. See below, pp. 137-9, for Kent glass of this period.

38 A. Watkin (ed.) *The Great Chartulary of Glastonbury, vol. II* (Somerset Record Soc. vol. LXIII for 1948), 1952, pp. 307, 473-4, nos. 514, 860-1. I am indebted to Nigel Ramsay for this reference and the information that Alice was the daughter of Simon of St Albans.

39 N.J. Morgan, *The Medieval Painted Glass of Lincoln Cathedral* (*CVMA* Great Britain Occasional Paper III), London, 1983, p. 44; D. O'Connor, 'The medieval stained glass of Beverley Minster', *Medieval Art and Architecture in the East Riding of Yorkshire* (BAA Conference Transactions vol. IX, 1983), 1989, pp. 62-90, pls X-XIV.

40 J.F. Dimock, *Metrical Life of St Hugh, Bishop of Lincoln*, Lincoln, 1860, p. 36, lines 934-5.

41 The chief studies of Lincoln are J. Lafond, 'The stained glass decoration of Lincoln Cathedral in the thirteenth century', *Arch. Jnl*, vol. CIII (1947), pp. 119-56, and Morgan, op. cit.; for a review of the latter see M.H. Caviness in *Burlington Mag.*, vol. CXXVII, no. 983 (February 1985), pp. 95-6; Grodecki and Brisac, op. cit., pp. 184-5, 264; *Age of Chivalry*, nos. 732, 733.

42 Morgan, op. cit., p. 44, pls 7(c), (d), 8(a), 10, 11(b).

43 N.J. Morgan, *Early Gothic Manuscripts 1190-1250. A Survey of Manuscripts Illuminated in the British Isles, vol. IV*, London, 1982, no. 22, illus. 72-5; G.D.S. Henderson,

'The imagery of St Guthlac of Crowland', in W.M. Ormrod (ed.), *England in the Thirteenth Century* (Proc. 1984 Harlaxton Symposium), Woodbridge, 1985, pp. 76–94; *Age of Chivalry*, no. 37. See also above, chapter 1, p. 25.

44 Morgan, *Lincoln*, p. 47.

45 ibid., pp. 45, 47; Caviness in *Burl. Mag.*, op. cit., p. 95.

46 *The Journeys of Celia Fiennes*, intro. by J. Hillaby, London, 1983, p. 25.

47 In the absence of a modern analytical study of Salisbury, see C. Winston, *Memoirs Illustrative of the Art of Glass-Painting*, London, 1865, pp. 106–29; P. Nelson, *Ancient Painted Glass in England 1170-1500*, London, 1913, pp. 208–9; J.M.J. Fletcher, 'The stained glass in Salisbury Cathedral', *Wilts. Archaeological & Natural Hist. Mag.*, vol. XLV (1930-2), pp. 235–53; R.O.C. Spring, *The Stained Glass of Salisbury Cathedral*, Salisbury, rev. edn. 1987. An important unpublished description of Salisbury Cathedral (including the glass) by the poet Thomas Gray in 1764 was read by Professor Marion Roberts of the University of Virginia at the British Archaeological Association Conference in 1991. The chapter house glazing is studied in P.Z. Blum, 'The Salisbury chapter house and its Old Testament cycle' (unpublished Ph.D. thesis, Yale University, 1978); *Radiance and Reflection*, no. 90; H.J. Zakin, 'Grisailles in the Pitcairn Collection', *Studies on Medieval Stained Glass. Selected Papers from the XIth International Colloquium of the Corpus Vitrearum* (*CVMA* United States Occasional Papers I), New York, 1985, pp. 83–4, fig. I.

48 Fletcher, op. cit., p. 238. For the altars see P. Draper in *Age of Chivalry*, pp. 84 (fig. 50), 86, and for Chartres see *Les Vitraux du Centre et des Pays de la Loire* (*CVMA* France Série complémentaire Recensement vol. II), Paris, 1981, p. 28, fig. 12.

49 See below, p. 133.

50 For Lyons see Grodecki and Brisac, op. cit., pl. 76; Dijon and Sens are published in *Les Vitraux de Bourgogne, Franche-Comté et Rhône-Alpes* (*CVMA* France Série complémentaire Recensement vol. III), Paris, 1986, p. 37, fig. 21, p. 179, fig. 157.

51 See above, p. 123.

52 Winston, op. cit., p. 121; Fletcher, op. cit., p. 250. More Salisbury grisaille is in the Toledo Museum of Art, Ohio. See *Stained Glass before 1700 in American Collections: Midwestern and Western States* (*Corpus Vitrearum* Checklist III), Washington, 1989, p. 218 (wrongly dated *c*. 1275).

53 For important discussions of glazing aesthetics see L. Grodecki, 'Le vitrail et l'architecture au XIIe et au XIIIe siècle', *Gazette des Beaux-Arts*, vol. XXXIII (1949), pp. 5–24 and J. Gage, 'Gothic glass: two aspects of a Dionysian aesthetic', *Art History*, vol. V (1982), pp. 36–58; see also above, chapter 2, p. 51.

54 See L.F. Day, *Windows: A Book about Stained & Painted Glass*, 3rd edn, London, 1909, pp. 137–67 and Morgan, *Lincoln*, pp. 38–41, for an analysis and comparison of English and Continental grisaille designs in this period.

55 See H.J. Zakin, *French Cistercian Grisaille Glass*, New York and London, 1979, pp. 120–5 and E.C. Norton, 'Varietates pavimentorum: contribution à l'étude de l'art cistercien en France', *Cahiers archéologiques*, vol. XXXI (1983), pp. 69–113.

56 Zakin, *Cistercian Grisaille Glass*, pl. 8; for the dating of Brabourne see J. Newman, *The Buildings of England: North East and North Kent*, 2nd edn, Harmondsworth, 1976, pp. 46, 155–6, 394.

57 R. Marks, 'Cistercian window glass in England and Wales', in C. Norton and D. Park (eds), *Cistercian Art and Architecture in the British Isles*, Cambridge, 1986, p. 214, pl. 89; C. Norton, 'Early Cistercian tile pavements', in ibid., pp. 231–2, fig. 27a.

58 D. Park, 'Cistercian wall painting and panel painting', in ibid., pp. 187, 193, pls 75, 78.

59 Zakin, *Cistercian Grisaille Glass*.

60 *Age of Chivalry*, no. 734; O'Connor and Haselock, p. 342; Knowles, *Essays*, fig. 62; Winston, op. cit., p. 121, pl. IV.

61 For Petham see C.R. Councer, 'The ancient glass from Petham Church now in Canterbury Cathedral', *Archaeologia Cantiana*, vol. LXV (1952), pp. 167–70, and Caviness, *Christ Church*, pp. 318–19, figs 598–601a. Stockbury is published in C. Winston, *An Inquiry into the Difference of Style Observable in Ancient Glass Paintings*, London, 1867, vol. II, p. 3, pl. 4.

62 See P. Wynn Reeves, 'English stiff-leaf sculpture' (unpublished Ph.D. thesis, University of London, 1952) and S. Gardner, *English Gothic Foliage Sculpture*, Cambridge, 1927.

63 See Day, op. cit., pp. 137–67, and Morgan, *Lincoln*, pp. 38–41.

64 Day, op. cit., figs 103–5, 107–10.

65 Morgan, *Lincoln*, fig. C16; M.P. Lillich, *The Stained Glass of Saint-Père de Chartres*, Connecticut, 1978, p. 29, fig. 6. See Winston, *Memoirs*, pp. 116–19 for an analysis of the superimposed system.

66 Day, op. cit., figs 112, 113.

67 For Westwell see Winston, *Inquiry*, vol. II, p. 2, pl. I; for the other patterns see Morgan, *Lincoln*, fig. C9; R. Marks, 'Window glass', in T.B. James and A.M. Robinson, *Clarendon Palace* (Report of the Research Committee of the Society of Antiquaries of London no. XLV), 1988, pp. 229–33, fig. 87; Knowles, *Essays*, p. 150, fig. 65; Newton, *County of Oxford*, p. 203; W.R. Lethaby, *Westminster Abbey Re-examined*, London, 1925, pp. 239–41, figs 152–4.

68 Morgan, *Lincoln*, pp. 40–1 (esp. n. 14). See also above, chapter 2, p. 55.

69 O'Connor and Haselock, pp. 325–7, pls 91, 92.

70 J. Browne, *The History of the Metropolitan Church of St*

*Peter, York*, London, 1847, vol. I, pp. 81–92, vol. II, pls LXI, LXIII, LXV, LXVII, LXIX.

71 The Westminster Abbey bibliography is extensive. Of particular relevance for the glass are R.A. Brown, H.M. Colvin and A.J. Taylor, *The History of the King's Works: The Middle Ages*, vol. I, London, 1963, pp. 139–40, 150; H.M. Colvin (ed.), *Building Accounts of King Henry III*, Oxford, 1971; F.S. Eden, 'Ancient painted glass in the conventual buildings, other than the Church of Westminster Abbey', *Connoisseur*, vol. LXXVII (1927), pp. 81–8; F.C. Eeles, 'The ancient stained glass of Westminster Abbey, from a manuscript dated 1938', *JBSMGP*, vol. XVII (*sic*), no. 2 (1978–9), pp. 17–29, vol. XVI, no. 3 (1979–80), pp. 47–53; Grodecki and Brisac, op. cit., pp. 187–8; W.R. Lethaby, *Westminster Abbey and the King's Craftsmen*, London, 1906, pp. 299–304; idem, *Westminster Abbey Re-examined*, pp. 234–53; *Age of Chivalry*, nos. 735, 736. Nineteenth-century drawings of the grisaille are in the Victoria and Albert Museum, Department of Prints, Drawings & Design (Acc. nos. D448-1907, D449-1907, E4664-4666-1910) and in the Society of Antiquaries of London (R.W. Paul Collection). A photograph of one of the grisaille panels is in the National Monuments Record.

72 Brown, Colvin and Taylor, op. cit., esp. pp. 137–50; C. Wilson, P. Tudor-Craig, J. Physick and R. Gem, *Westminster Abbey* (New Bell's Cathedral Guides), London, 1986, pp. 28–9.

73 Colvin, op. cit., *passim*.

74 Brown, Colvin and Taylor, op. cit., p. 150.

75 J. Dart, *Westmonasterium*, London, 1723, vol. I, pp. 36, 38.

76 ibid., p. 61; F. Sandford, *A Genealogical History of the Kings and Queens of England and Monarchs of Great Britain, etc.*, London, 1707, p. 129; Wilson, Tudor-Craig, Physick and Gem, op. cit., pp. 28, 67, 91–2.

77 Brown, Colvin and Taylor, op. cit., p. 142; for the Salisbury chapter house see below, chapter 7, pp. 141–3.

78 R. Marks and A. Payne (eds), *British Heraldry from its Origins to c. 1800*, exhib. cat., British Museum, London, 1978, p. 15; Borenius, op. cit. See also above, chapter 4, p. 93.

79 Wilson, Tudor-Craig, Physick and Gem, op. cit., p. 25.

80 The significance of the introduction of bar tracery for stained glass is discussed in chapter 7.

81 Lethaby claimed to have observed fragments of large crowns in the apsidal clerestory windows (*Westminster Abbey Re-examined*, p. 241, fig. 157), which do not, however, appear to be visible today. Westminster was the coronation church and if there was a series of crowned figures in the Westminster clerestory they could have paralleled the French monarchs depicted in the nave clerestory at Rheims, where they are associated with the archbishops who performed the coronation ceremony (Grodecki and Brisac, op. cit., pp. 117–18).

82 Caviness, *Early Stained Glass*, Appendix, fig. 5, figs 214, 215, 217; for the manuscripts see Morgan, *Early Gothic Manuscripts 1190–1250*, illus. 150, 236, 238.

83 For Madley and Saxlingham Nethergate see below, pp. 139–40.

84 Grodecki and Brisac, op. cit., pp. 187–8.

85 P. Williamson, 'The Westminster Abbey chapter house Annunciation group', *Burlington Mag.*, vol. CXXX, no. 1019 (February 1988), pp. 122–4. The broken-fold drapery style is discussed below, chapter 7, p. 143.

86 For the manuscripts see Morgan, *Early Gothic Manuscripts 1190–1250*, nos. 51, 52, illus. 167–78 and idem, *Early Gothic Manuscripts 1250–1285. A Survey of Manuscripts Illuminated in the British Isles*, vol. IV, London, 1988, nos. 121, 123, illus. 87, 88, 120, 121. I am grateful to Professor George Henderson for drawing my attention to the first two manuscripts.

87 This was apparent in the *Age of Chivalry* exhibition, where the Westminster and Lincoln panels were displayed side by side (nos. 732–3, 735–6). The coloured illustrations in the catalogue give a very misleading impression.

88 For the location of the grisaille at Westminster see Lethaby, *Westminster Abbey and the King's Craftsmen*, p. 299.

89 Lethaby, *Westminster Abbey Re-examined*, pp. 240–1, figs 152, 154.

90 J. Kerr, 'The window glass', in J.N. Hare, *Battle Abbey: The Eastern Range and the Excavations of 1978–80* (Historic Buildings and Monuments Commission for England, Archaeological Report no. 2), London, 1985, pp. 127–38.

91 The dating of this panel to *c.* 1225 in *Age of Chivalry*, no. 28, is more convincing than the *c.* 1250 proposed in Newton, *County of Oxford*, op. cit., pp. 84–5, pl. 31(a).

92 Marks, 'Cistercian window glass', pp. 215–17, fig. 25.

93 Councer, 'Petham'; Caviness, *Christ Church*, pp. 318–19, figs 598–601(a). For West Horsley see F.C. Eeles and A.V. Peatling, *Ancient Stained and Painted Glass in the Churches of Surrey*, Surrey Archaeological Colls. (1930), pp. 50–1 and Winston's watercolours (BL MS Add. 35211, vol. III, nos. 147, 148).

94 See Winston's watercolours (BL MS Add. 53211, vol. II, nos. 338–40).

95 Doddington and Woodchurch have not been the subject of a detailed study.

96 Caviness, *Christ Church*, p. 319.

97 Astley Abbots is unpublished. For the Canterbury Noah figure see M.H. Caviness, 'Romanesque "belles verrières" in Canterbury?' in *Romanesque and Gothic Essays for George Zarnecki*, Woodbridge, 1987, p. 35, pl. 2; for Châlons see Grodecki and Brisac, op. cit., pl. 105 and for Norrey-en-Auge see M.P. Lillich, 'The band-

window: a theory of origin and development', *Gesta*, vol. IX, no. 1 (1970), p. 33, n. 29, figs 9, 10. For the manuscripts see C.M. Kauffmann, *Romanesque Manuscripts 1066–1190. A Survey of Manuscripts Illuminated in the British Isles, vol. III*, London, 1975, nos. 35, 59, 68, 75, 84, 96, illus. 92, 159, 187, 209, 240, 273; Morgan, *Early Gothic Manuscripts 1190–1250*, nos. 2, 4, 50, 67, 86, 92, 93, illus. 8, 13, 14, 161, 204, 291, 304–6. For enframing devices in early thirteenth-century wall-paintings see E. Roberts, *A Guide to the Medieval Murals in St Albans Abbey*, St Albans, 1971, pls 2, 7.

98 For Kidlington see Newton, *County of Oxford*, p. 129, pl. 37. His dating of *c.*1250–80 appears to be too late.

99 West Horsley is published in Eeles and Peatling, op. cit., p. 51, col. pl. opp. p. 50; Aldermaston is illustrated in Nelson, op. cit., pl. IX. For Madley see RCHM, *An Inventory of the Historical Monuments in Herefordshire, vol. I – South-West*, London, 1931, p. 196, pl. 130; J. Baker, *English Stained Glass of the Medieval Period*, London, 1978, pl. 18 and P. Cowen, *A Guide to Stained Glass in Britain*, London, 1985, p. 118; the last author also briefly describes Ashbourne (p. 92). For St Denys Walmgate see RCHM, *An Inventory of the Historical Monuments in the City of York, vol. V, The Central Area*, London, 1981, p. 18, pl. 55.

100 For Compton see Eeles and Peatling, op. cit., p. 28 and col. pl. opposite.

101 I am indebted to Penny Dawson for drawing my attention to Croxton; Easby has escaped detailed attention.

102 For White Notley see Baker, op. cit., pl. 16, and for West Horsley, Eeles and Peatling, op. cit., p. 50, col. pl. opposite.

103 Cowen, op. cit., p. 118; D. King, *Stained Glass Tours around Norfolk Churches*, Norfolk Soc., 1974, p. 25, pl. IX and cover illus.; C. Woodforde, 'Painted glass in Saxlingham Nethergate Church, Norfolk', *JBSMGP*, vol. V (1933–4), pp. 163–9.

104 David O'Connor pointed out this comparison to me.

105 For the Gercy glass see Grodecki and Brisac, op. cit., p. 92.

# 7 The Decorated Style
## c. 1250–1350

1 For Chetwode see *Age of Chivalry*, no. 737; Oxford St Michael's is published in RCHM, *An Inventory of the Historical Monuments in the City of Oxford*, London, 1939, p. 142, pl. 209 and Stanton Harcourt in P.A. Newton, *The County of Oxford: A Catalogue of Medieval Stained Glass (CVMA* Great Britain vol. I), London, 1979, pp. 182–8, pls 43(f–i), 44(b), (d). For Kempsey see M.A. Green, 'Old painted glass in Worcestershire, Part VII',

*Trans. Worcs. Archaeological Soc.*, new series, vol. XIX (1942), pp. 42–4, pl. II; the Hereford glass is described in F.C. Morgan, *Hereford Cathedral Church Glass*, 2nd edn, Leominster, 1967, pp. 11–13, and illustrated in B. Coe, *Stained Glass in England 1150–1550*, London, 1981, col. pl. opp. p. 48; also in RCHM, *An Inventory of the Historical Monuments in Herefordshire vol. I – South-West*, London, 1931, p. 108, pl. 130. For Salisbury see P.Z. Blum, 'The Salisbury chapter house and its Old Testament cycle' (unpublished Ph.D. thesis, Yale University, 1978), *Radiance and Reflection: Medieval Art from the Raymond Pitcairn Collection*, exhib. cat., Metropolitan Museum of Art, New York, 1982, no. 90, C. Winston, *Memoirs Illustrative of the Art of Glass Painting*, London, 1865, pp. 112–21. Blum's dating to the 1280s is challenged by C. Wilson, *The Gothic Cathedral*, London, 1990, p. 175, illus. 130. For the heraldic glass see H. Shortt, '13th-century heraldry from the chapter house', *Annual Report of the Friends of Salisbury Cathedral*, vol. XXVIII (1958), pp. 16–21. For York see O'Connor and Haselock, pp. 334–41.

2 N.J. Morgan, *The Medieval Painted Glass of Lincoln Cathedral (CVMA* Great Britain Occasional Paper III), London, 1983, p. 40.

3 L. Grodecki and C. Brisac, *Gothic Stained Glass 1200–1300*, London, 1985, pp. 154, 160, 162, pl. 149. For an interesting discussion of changing aesthetics in glazing between the twelfth and thirteenth centuries see J. Gage, 'Gothic glass: two aspects of a Dionysian aesthetic', *Art History*, vol. V (1982), pp. 36–58.

4 C. Wilson, P. Tudor-Craig, J. Physick and R. Gem, *Westminster Abbey* (New Bell's Cathedral Guides), London, 1986, pp. 27–8.

5 W. Sauerländer, *Gothic Sculpture in France 1140–1270*, London, 1972, pp. 56–8; R. Branner, *Manuscript Painting in Paris during the Reign of Saint Louis*, Berkeley, 1977; idem, 'The painted medallions in the Sainte-Chapelle in Paris', *Trans. American Philosophical Soc.*, new series, vol. LVIII (1968), pp. 1–42.

6 *Age of Chivalry*, nos. 276, 279, 287–8; P. Williamson, 'The Westminster Abbey chapter house Annunciation group', *Burlington Mag.*, vol. CXXX, no. 1019 (February 1988), pp. 122–4; N.J. Morgan, *Early Gothic Manuscripts 1250–85. A Survey of Manuscripts Illuminated in the British Isles, vol. IV*, London, 1988, pp. 20–1, nos. 98–103, 151, illus. 13–39, 44, 45, 244–54, figs 1, 3, 5, 9, 14. See also P. Binski, *The Painted Chamber at Westminster* (Society of Antiquaries of London Occasional Paper, new series, vol. IX, 1986), esp. pp. 52–64; L. Stone, *Sculpture in Britain: The Middle Ages*, 2nd edn, Harmondsworth, 1972, chapter 11.

7 East Tytherley is unpublished. For the manuscripts see Morgan, *Early Gothic Manuscripts 1250–85*, nos. 100, 103, 151, illus. 20, 28, 30–9, 244–54, figs 3, 5, 9; *Age of Chivalry*, nos. 347, 352.

8  For Lincoln see Stone, op. cit., chapter 11, and V. Glenn, 'The sculpture of the Angel Choir at Lincoln', *Medieval Art and Architecture at Lincoln Cathedral* (BAA Conference Transactions vol. VIII, 1982), 1986, pp. 102–8. For the Westminster Retable see Binski, op. cit., and *Age of Chivalry*, no. 329. The *Alphonso Psalter* is discussed in L.F. Sandler, *Gothic Manuscripts 1285–1385. A Survey of Manuscripts Illuminated in the British Isles, vol. V*, Oxford, 1986, no. 1, illus. 1, 2, 4.

9  O'Connor and Haselock, pp. 334–41. For its sculpture and painting see *Age of Chivalry*, nos. 343–4.

10  Rheims is usually considered to be the first monument to have adopted naturalistic foliage, but Denise Jalabert has drawn attention to the carvings on the jambs of the Virgin portal of Notre-Dame, Paris, dating them to c. 1210–20 (*La Flore sculptée des monuments du Môyen Age en France*, Paris, 1965, pp. 99–100, pl. 65). For the English material see J. Givens, 'The garden outside the walls: plant forms in thirteenth-century English sculpture', in *Medieval Gardens* (Dumbarton Oaks Research Library and Collections, 1986), pp. 189–98. For Windsor and Westminster see Wilson, Tudor-Craig, Physick and Gem, op. cit., p. 90. Naturalistic foliage in the two manuscripts can be seen in G. Henderson, 'Studies in English manuscript illumination Part I: stylistic sequence and stylistic overlap in thirteenth-century English manuscripts', *Jnl Warburg & Courtauld Institutes*, vol. XXX (1967), pp. 86–8, pl. 3c, and A.G. and W.O. Hassall (eds), *The Douce Apocalypse*, London, 1961, pls 1, 3, 5, 7, 8, 11, 14; see also Morgan, *Early Gothic Manuscripts 1250–85*, nos. 123, 153.

11  See M.P. Lillich, *The Stained Glass of Saint-Père de Chartres*, Connecticut, 1978. For Saint-Urbain see L. Grodecki, 'Les Vitraux de Saint-Urbain de Troyes', *Congrès Archéologique*, vol. CXIII (1955), pp. 123–38; Grodecki and Brisac, op. cit., p. 154. This important monument would repay further study. It is uncertain whether the glass dates from between the start of the work in 1262 and a fire in 1266, or was executed during the repairs and second building campaign of the 1270s. The figural glazing is not homogeneous in style. For the latest account of the history of the fabric see C. Bruzelius, 'The second campaign at Saint-Urbain at Troyes', *Speculum*, vol. LXII/LXIII (1987), pp. 635–40. I am indebted to Neil Stratford for drawing my attention to this article.

12  O'Connor and Haselock, pp. 326–7, pl. 92.

13  ibid., pp. 335–7, pl. 98; R. Marks, 'The mediaeval stained glass of Wells Cathedral', in L.S. Colchester (ed.), *Wells Cathedral: A History*, Shepton Mallet, 1982, p. 132; *Age of Chivalry*, no. 226.

14  N.H.J. Westlake, *A History of Design in Painted Glass*, vol. II, London, 1882, pl. LXXXII(b); A.M. Erskine (ed.), *The Accounts of the Fabric of Exeter Cathedral, 1279–1353*, Devon & Cornwall Record Soc., new series, vol.

XXVI (1983), pp. xxvii, 317–18.

15  *Age of Chivalry*, nos. 4, 738; O'Connor and Haselock, p. 341, pl. 102. For Southwell see J. Beaumont, *The Stained Glass of Southwell Minster*, Southwell, 1988, p. 45 and 'Schools', vol. I, pp. 23–4, vol. III, pp. 479–88.

16  Newton, *County of Oxford*, pp. 188–9, pl. 45(a). Illustrations of the Chartham windows were made by Winston (BL MS Add. 35211, vol. II) and a relevant light published in his *An Inquiry into the Difference of Style Observable in Ancient Glass Paintings*, 2nd edn, London, 1867, pl. 20. In 1294 the king gave 50 marks towards the work on Chartham begun by the incumbent (*Cal. Patent Rolls 1294*, p. 269).

17  Winston, Inquiry, pl. 18; Westlake, op. cit., vol. I, pl. LVI(c–f); J. Newman, *The Buildings of England: North East and East Kent*, 2nd edn, Harmondsworth, 1976, p. 451, pl. 45.

18  R. Becksmann, *Die architektonische Rahmung des hochgotischen Bild-Fensters. Untersuchungen zur oberrheinischen Glasmalerei von 1250 bis 1350*, Berlin, 1967.

19  See above, chapter 2, pp. 51–2 and Wilson, *Gothic Cathedral*, pp. 192–4; for the Eleanor Crosses see D. Parsons (ed.), *Eleanor of Castile 1290–1990*, Samford, 1991.

20  Grodecki and Brisac, op. cit., p. 154.

21  For Petham, St Denys Walmgate and West Horsley see above, chapter 6, pp. 137–40.

22  Grodecki and Brisac, op. cit., pp. 137–42, 160–4, 172–4, pls 9, 128; M.P. Lillich, 'The band-window: a theory of origin and development', *Gesta*, vol. IX, no. I (1970), pp. 26–33; idem, *Saint-Père*; Grodecki, 'Saint-Urbain'; J. Lafond, 'Les Vitraux de la cathédrale de Sées', *Congrès Archéologique*, vol. CXI (1953), pp. 59–83.

23  *Age of Chivalry*, p. 144, fig. 109, no. 738; Newman, op. cit., pl. 45.

24  See J.A. Knowles, *Essays in the History of the York School of Glass-Painting*, London, 1936, pl. XXI, fig. 14; *Age of Chivalry*, no. 560; For further bibliography on Stanford see below, n. 46.

25  Grodecki, 'Saint-Urbain', pp. 136–7, fig. 6.

26  M.A. Green, 'Old painted glass in Worcestershire, Part I', *Trans. Worcs. Archaeological Soc.*, new series, vol. XI (1934), p. 53, pl. II; the window is illustrated in C. Woodforde, *English Stained and Painted Glass*, Oxford, 1954, pl. 12; Newton, *County of Oxford*, pp. 182, 185, pl. 43(f).

27  For the Jesse windows see C. Woodforde, 'A group of fourteenth-century windows showing the Tree of Jesse', *JBSMGP*, vol. VI (1935–7), pp. 184–90; 'Schools', vol. I, pp. 62–71; for North Moreton see D. Park, 'A lost fourteenth-century altar-piece from Ingham, Norfolk', *Burlington Mag.*, vol. CXXX, no. 1019 (February 1988), pp. 132–6, fig. 72; and for Newark see J. Howson, 'East window of south choir, Newark Parish Church', *JBSMGP*, vol. XII (1955–9), pp. 264–9 and 'Schools', vol.

I, pp. 12–14, vol. III, pp. 429–34, 454–6.

28 For all of these except Deerhurst, see *Age of Chivalry*, nos. 29, 227, 559. Deerhurst is illustrated in colour in Grodecki and Brisac, op. cit., pl. 178.

29 For Chartham see C. Winston, *Inquiry*, pl. 20; idem, *Memoirs*, pl. III, fig. 2 (opp. p. 118) and BL MS Add. 35211, vol. II. For Norbury see L.F. Day, *Windows: A Book about Stained & Painted Glass*, 3rd edn, London, 1909, p. 159, fig. 137 and 'Schools', vol. II, pp. 65–78.

30 C. Brooks and D. Evans, *The Great East Window of Exeter Cathedral: A Glazing History*, Exeter, 1988; these authors give a more precise dating and disprove some of the arguments for the original location of the figures suggested by the present author in *Age of Chivalry*, no. 739. See also above, chapter 2, p. 48.

31 O'Connor and Haselock, pp. 341–64, pls 103–15; T.W. French and D. O'Connor, *York Minster: A Catalogue of Medieval Stained Glass I: The West Windows of the Nave* (*CVMA* Great Britain vol. III/I), London, 1987.

32 See above, chapter 6, pp. 113–17.

33 O'Connor and Haselock, pp. 353–4, n. 177, pls 109–11.

34 R.A. Croft and D.C. Mynard, 'A late 13th-century grisaille window panel from Bradwell Abbey, Milton Keynes, Bucks.', *Medieval Archaeology*, vol. XXX (1986), pp. 110–11 (reconstruction by J. Kerr), fig. 8. For the manuscripts see Morgan, *Early Gothic Manuscripts*, no. 162, illus. 310, 313; Sandler, op. cit., no. I, fig. I; *Age of Chivalry*, nos. 355, 357.

35 O'Connor and Haselock, pp. 354–8, pls 113, 114.

36 E.K.C. Varty, *Reynard the Fox. A Study of the Fox in Medieval English Art*, Leicester, 1967.

37 H.W. Janson, *Apes and Ape-lore in the Middle Ages and Renaissance*, London, 1952. For the iconography of the Funeral of the Virgin see above, chapter 3, pp. 71–2.

38 See L.M.C. Randall, *Images in the Margins of Gothic Manuscripts*, Berkeley, 1966, pp. 56, 203, 216, for examples.

39 The most recent account of this window is in *Age of Chivalry*, no. 5.

40 See also above, chapter 2, p. 38.

41 For Lowick see 'Schools', vol. I, pp. 62–6, vol. II, pp. 336–51 and Woodforde, 'Jesse', pp. 184–5.

42 Barby is unpublished. The comparisons between Evington and the Tickhill group were first made by the late Peter Newton ('Schools', vol. I, pp. 18–21). See also D.D. Egbert, *The Tickhill Psalter and Related Manuscripts*, New York and Princeton, 1940, esp. illus. 127, 132, 134, 187; Sandler, *Gothic Manuscripts*, nos. 26, 31, illus. 73, 74; *Age of Chivalry*, no. 568.

43 This group was first analysed in 'Schools', vol. I, pp. 53–61. Penny Dawson drew my attention to Heydour.

44 J.A. Robinson, 'The fourteenth-century glass at Wells', *Archaeologia*, vol. LXXXI (1931), pp. 85–118; Marks, 'Wells Cathedral'.

45 P. Draper, 'The sequence and dating of the Decorated work at Wells', *Medieval Art and Architecture at Wells and Glastonbury* (BAA Conference Transactions vol. IV, 1978), 1981, pp. 18–29; J.H. Harvey, 'The Building of Wells Cathedral, II: 1307–1508', in Colchester, op. cit., pp. 76–101 (esp. 76–87). These authors differ to some extent in their interpretation of the building chronology.

46 The fullest account of the Stanford nave glazing is 'Schools', vol. I, pp. 29–45, vol. II, pp. 370–82. A comprehensive study of the church will shortly be published by the present author in the *CVMA* Great Britain series.

47 O. Pächt, 'A Giottesque episode in English medieval art', *Jnl Warburg & Courtauld Institutes*, vol. VI (1943), pp. 51–70; R. Marks and N. Morgan, *The Golden Age of English Manuscript Painting 1200–1500*, London, 1981, pls 20, 21; Sandler, *Gothic Manuscripts*, pp. 22–3, nos. 43, 50, 104, 105, illus. 96–8, 122, 264–7, 270–3.

48 For Hugh Peyntour see P. Binski, *Medieval Craftsmen – Painters*, London, 1991, pp. 12–13; P. Binski and D. Park, 'A Ducciesque episode at Ely: the mural decorations of Prior Crauden's Chapel', in W.M. Ormrod (ed.), *England in the Fourteenth Century* (Proc. 1985 Harlaxton Symposium), Woodbridge, 1986, pp. 28–41; *Age of Chivalry*, nos. 593–6.

49 *Age of Chivalry*, nos. 675, 670.

50 K. Morand, *Jean Pucelle*, Oxford, 1962; F. Deuchler, 'Jean Pucelle – facts and fictions', *Metrop. Mus. of Art Bulletin*, vol. XXIX, no. 6 (February 1971), pp. 253–6; F. Avril, *Manuscript Painting at the Court of France, The Fourteenth Century*, New York, 1978, pp. 13–20, pls 3–13.

51 L.F. Sandler, 'A follower of Jean Pucelle in England', *Art Bulletin*, vol. LII (1970), pp. 363–72; idem, *The Psalter of Robert De Lisle*, London, 1983; idem, *Gothic Manuscripts*, no. 38, illus. 85; *Age of Chivalry*, no. 569.

52 French and O'Connor, op. cit.; see also my review in *Ants. Jnl*, vol. LXIX (1989), pp. 374–6.

53 T. French, 'Observations on some medieval glass in York Minster', *Ants. Jnl*, vol. LI (1971), pp. 86–93; French and O'Connor, op. cit., p. 19; O'Connor and Haselock, pp. 378–83, pls 127–30.

54 Morand, op. cit., pls IVa, c, IXd, XVIIc.

55 French, op. cit.; French and O'Connor, op. cit., pp. 22–3.

56 The evidence was presented by Dr Patricia Stirnemann in a paper given at a symposium held in association with the *Age of Chivalry* exhibition at the Royal Academy on 18–20 March 1988; see also *Age of Chivalry*, no. 501.

57 French and O'Connor, op. cit., pp. 19–22, pls 25–9; *Age of Chivalry*, no. 6.

58 P. Lasko and N.J. Morgan (eds), *Medieval Art in East Anglia 1300–1520*, exhib. cat., Norwich, 1973, no. 33; *Age of Chivalry*, nos. 230, 743. The tracery light glazing

has not been published and I am grateful to Keith Barley for drawing it to my attention. For the date of the Lady Chapel see P. Lindley, 'The fourteenth-century architectural programme at Ely Cathedral', in Ormrod, op. cit., pp. 126–7.

59 J. Lafond, *Les Vitraux de l'église Saint-Ouen de Rouen* (*CVMA* France, vol. IV, 2/1), Paris, 1970, pp. 156–64, pls 40–3.

60 Buckland is unpublished, but the date is recorded in N. Salmon, *The History of Hertfordshire*, London, 1728, p. 304.

61 L. Dennison, '"The Fitzwarin psalter and its allies": a reappraisal', in Ormrod, op. cit., pp. 53, 55–6, figs 9, 21, 23.

62 ibid., p. 53. I am indebted to Penny Dawson for knowledge of Messingham; see P. Binnall, 'Early painted glass in Messingham Church', *JBSMGP*, vol. IV no. 1 (1931), pp. 14–16.

63 Dennison, op. cit., pp. 57–8, figs 4, 5, 6, 8, 33.

64 C. Woodforde, 'The medieval glass in Elsing Church, Norfolk', *JBSMGP*, vol. IV (1931–2), pp. 134–6. Kingerby is unpublished.

65 For the *Oscott Psalter* see above, n. 7. The Flemish material is studied in M.R. James, *The Romance of Alexander MS Bodley 264*, Oxford, 1933, and L. Dennison, 'The stylistic sources, dating and development of the Bohun workshop' (unpublished Ph.D. thesis, University of London, 1987), chapter 3.

66 J.T. Smith, *Antiquities of Westminster*, London, 1807, pls between pp. 232 and 233; for Simon de Lenne see L.F. Salzman, 'The glazing of St Stephen's Chapel. Westminster 1351–2', *JBSMGP*, vol. I (1926–7), pp. 31, 35. French and O'Connor (op. cit., pp. 22–3) noted the French affinities of the St Stephen's fragments.

67 For this glass see *Age of Chivalry*, no. 740; M.A. Green, 'Old painted glass in Worcestershire, Part V', *Trans. Worcs. Archaeological Soc.*, new series, vol. XV (1938), pp. 10–12; idem, 'Old painted glass, Part VII', ibid., new series, vol. XIX (1942), pp. 42–4, pl. I; idem, 'Old painted glass, Part XI', ibid., new series, vol. XXIV (1947), p. 8. For Merevale see R. Marks, 'Cistercian window glass in England and Wales', in C. Norton and D. Park (eds), *Cistercian Art and Architecture in the British Isles*, Cambridge, 1986, p. 219, pls 90, 91. Mme Isler de Jongh kindly drew my attention to the Corning and Montreal angels. The architectural evidence for the Latin chapel in Christ Church points to a date of *c.*1330–40 for its construction; see Richard Morris in J. Blair (ed.), *Saint Frideswide's Monastery at Oxford: Archaeological and Architectural Studies*, Guildford, 1990, p. 182.

68 The late Peter Newton first drew attention to this trend in Midlands glass-painting ('Schools', vol. I, pp. 72–97), notably by a workshop active at Astley in Warwickshire (1337–43) and several other churches in the area. The

mode can also be seen in Northamptonshire, at Great Weldon and Great Everdon, and even in as remote an area as East Sussex, at Hooe and Ticehurst. Newton noted the related manuscripts, which are discussed in Dennison, 'Fitzwarin psalter', and idem, 'Bohun workshop', esp. chapter 1.

69 M.Q. Smith, *The Stained Glass of Bristol Cathedral*, Bristol, 1983, pp. 50–69, 75–7, 93, pls opp. pp. 17, 32; J. Kerr, 'The east window of Gloucester Cathedral', *Medieval Art and Architecture at Gloucester and Tewkesbury* (BAA Conference Transactions vol. VII, 1981), 1985, pp. 126–7, pls XXIIIc, XXIVa, XXVa.

70 G.McN. Rushforth, 'The glass in the quire clerestory of Tewkesbury Abbey', *Trans. Bristol & Glos. Archaeological Soc.*, vol. XLVI (1924), pp. 289–324; Kerr, op. cit., pp. 126–7, pls XXVc, e, g, XXVIa; R. Morris, 'Tewkesbury Abbey: the Despenser mausoleum', *Trans. Bristol & Glos. Archaeological Soc.*, vol. XCIII (1974), pp. 142–55; *Age of Chivalry*, no. 742. See also A. Martindale, 'Patrons and minders: the intrusion of the secular into sacred spaces in the late Middle Ages', in D. Wood (ed.), *The Church and the Arts* (Studies in Church History vol. XXVIII), Oxford, 1992, pp. 143–78 (esp. 160–3). I am grateful to Mrs Sarah Brown for sharing the fruits of her researches on Tewkesbury.

71 Winston, *Memoirs*, pp. 285–311; Rushforth, 'The great east window of Gloucester Cathedral', *Trans. Bristol & Glos. Archaeological Soc.*, vol. XLIV (1922), pp. 293–304; Kerr, op. cit.; D. Welander, *The Stained Glass of Gloucester Cathedral*, Frome, 1985, pp. 11–26.

72 Sandler, 'Follower of Jean Pucelle'.

## 8 *The International Style* c. 1350–1450

1 For this period see M. Rickert, *Painting in Britain: The Middle Ages*, 2nd edn, Harmondsworth, 1965, pp. 147–51; L. Dennison, 'The stylistic sources, dating and development of the Bohun workshop' (unpublished Ph.D. thesis, University of London, 1987), esp. p. 275; idem, '"The Fitzwarin psalter and its allies": a reappraisal', in W.M. Ormrod (ed.), *England in the Fourteenth Century* (Proc. 1985 Harlaxton Symposium), Woodbridge, 1986, esp. p. 55.

2 See above, chapter 2, n. 89.

3 M. Postan, *The Medieval Economy and Society*, Harmondsworth, 1975, p. 117.

4 Y. Delaporte and E. Houvet, *Les Vitraux de la cathédrale de Chartres*, Paris, 1926, p. 21, pl. XXXII; G. Ritter, *Les Vitraux de la cathédrale de Rouen*, Cognac, 1926, pp. 10–12, 57–63, pls XXXIX–XLI, XLVI–L, LVII–LX. For the date of the Rouen glass see F. Perrot, *Le Vitrail à Rouen* (Connaître Rouen), Rouen, 1972, pp. 18–20.

5 The Elsing quarries have escaped attention. For the Tewkesbury examples see G.McN. Rushforth, 'The glass in the quire clerestory of Tewkesbury Abbey', *Trans. Bristol & Glos. Archaeological Soc.*, vol. XLVI (1924), pl. II; the Skelton panel is published in *Age of Chivalry*, no. 231. For other early examples see A.W. Franks, *A Book of Ornamental Glazing Quarries*, London, 1849, pls 23, 35, 92.

6 M. Clayton, *Victoria and Albert Museum Catalogue of Rubbings of Brasses and Incised Slabs*, London, 1968, pl. 63; *Age of Chivalry*, no. 679. I am indebted to David O'Connor for the information on the York west window.

7 J.T. Smith, *Antiquities of Westminster*, London, 1807, pl. opp. p. 233; for Merevale see R. Marks, 'Cistercian window glass in England and Wales', in C. Norton and D. Park (eds), *Cistercian Art and Architecture in the British Isles*, Cambridge, 1986, p. 219, pls 90, 91. The Wells inscriptions are illustrated and discussed in J.A. Robinson, 'The fourteenth-century glass at Wells', *Archaeologia*, vol. LXXXI (1931), p. 99. The Elsing reference was kindly provided by David King.

8 See above, chapter 7, pp. 153–4. See also Robinson, op. cit., pls XLIV, XLVI, L, LI; Smith, op. cit., pl. between pp. 232 and 233.

9 E.C. Norton, D. Park and P. Binski, *Dominican Painting in East Anglia: The Thornham Parva Retable and the Musée de Cluny Frontal*, Woodbridge, 1987, pp. 73–5, pls 102, 113, 114.

10 *Age of Chivalry*, no. 232; Rushforth, op. cit., pl. III.

11 None of these works has been illustrated previously.

12 VCH, *Buckinghamshire*, vol. IV, London, 1927, pp. 501–2; RCHM, *An Inventory of the Historical Monuments in Buckinghamshire*, vol. 2, London, 1913, p. 317.

13 The charter is illustrated in M. Michael's review of L.F. Sandler, *Gothic Manuscripts 1285–1385. A Survey of Manuscripts Illuminated in the British Isles*, published in the *Burlington Mag.*, vol. CXXIX no. 1015 (October 1987), p. 670, fig. 18.

14 C. Woodforde, 'Ancient glass in Lincolnshire I – Haydor', *Lincolnshire Mag.*, vol. I, pt 3 (1933), pp. 93–7. I am grateful to Penny Dawson for providing me with the donor evidence for this window and to Mr A.V.B. Norman for information on the armour.

15 Not all have been published. For Kimberley see D. King, *Stained Glass Tours around Norfolk Churches*, Norfolk Soc., 1974, p. 28, pl. XI, and for Old Warden see Marks, 'Cistercian window glass', pp. 225–7, pl. 104; for York see O'Connor and Haselock, pp. 370–2, pl. 119 and below, p. 180.

16 For the Royal and Fitzwarin books see L.F. Sandler, *Gothic Manuscripts 1285–1385. A Survey of Manuscripts Illuminated in the British Isles*, vol. V, Oxford, 1986, nos. 120, 131, illus. 315–16, 351; Dennison, 'Fitzwarin psalter', op. cit., p. 47, fig. 8. The Bohun manuscripts are discussed in M.R. James and E.G. Millar, *The Bohun Manuscripts*, Roxburghe Club, 1936; Sandler, op. cit., nos. 133–42; Dennison, 'Bohun workshop'.

17 See Delaporte and Houvet, op. cit., pp. 21–2, *Les Vitraux de Centre et des Pays de la Loire* (*CVMA* France, Série complémentaire, Recensement vol. II), Paris, 1981, p. 44, fig. 30.

18 See R. Becksmann, 'Die mittelalterliche Farbverglasung der Oppenheimer Katharinenkirche. Zum Bestand unter seiner Uberlieferung', in C. Servatius, H. Steitz and F. Weber, *St Katharinen zu Oppenheim*, Oppenheim?, 1989, pp. 382–5, pl. 22.

19 'Med. Glazing Accounts', (1927–8), p. 190. For canopies of the 1340s see above, chapter 7, pp. 160–1.

20 For Old Warden see Marks, 'Cistercian window glass', pl. 104. The other works cited here are unpublished.

21 James and Millar, op. cit.; Dennison, 'Bohun workshop', esp. pp. 80–92.

22 M. Rickert, *The Reconstructed Carmelite Missal*, London, 1952.

23 Most of these are unpublished. For Wormshill see J. Newman, *The Buildings of England: North East and East Kent*, 2nd edn, Harmondsworth, 1976, p. 499, pl. 59. For Aston Rowant see P.A. Newton, *The County of Oxford: A Catalogue of Medieval Stained Glass* (*CVMA* Great Britain vol. I), London, 1979, p. 27, pls 14(f), (g) (the dating given here appears to be too late). For Weston Underwood see n. 12 above. David King drew my attention to the Saxlingham Nethergate apostles and for Bardwell see H. Wilkinson, 'Fifteenth-century [glass] in Bardwell Church, Suffolk', *JBSMGP*, vol. V (1933–4), pp. 159–62.

24 For the *Lytlington Missal* see Sandler, op. cit., no. 150, illus. 402–5; *Age of Chivalry*, no. 714; Dennison, 'Bohun workshop', esp. chapter 9, pp. 203–36.

25 *Age of Chivalry*, no. 744.

26 C. Woodforde, *Stained Glass in Somerset 1250–1830*, Oxford, 1946, pp. 16–17; R. Marks, 'The mediaeval stained glass of Wells Cathedral', in L.S. Colchester (ed.), *Wells Cathedral: A History*, Shepton Mallet, 1982, p. 144, pl. 71; G.McN. Rushforth, 'The baptism of St Christopher', *Ants. Jnl*, vol. VI (1926), pp. 152–8. Long Sutton is unpublished.

27 F. and C.R. Hudleston, 'Medieval glass in Penrith church', *Trans. Cumberland & Westmorland Antiquarian & Archaeological Soc.*, new series, vol. LI (1951), pp. 96–102.

28 Rickert, *Painting*, p. 163, pl. 163; N. Pevsner and A. Wedgwood, *The Buildings of England: Warwickshire*, Harmondsworth, 1968, p. 74, pl. 10(b).

29 J. Kerr, 'The east window of Gloucester Cathedral', *Medieval Art and Architecture at Gloucester and Tewkesbury* (BAA Conference Transactions vol. VII, 1981), 1985, pl. XXII.

30 C. Woodforde, *The Stained Glass of New College Oxford*, Oxford, 1951, p. 1.

31 ibid., p. 4.

32 J.H. Harvey and D.G. King, 'Winchester College stained glass', *Archaeologia*, vol. CIII (1971), pp. 149-77. For the 1421-2 reference see J.D. Le Couteur, *Ancient Glass in Winchester*, Winchester, 1920, p. 117.

33 Woodforde, *New College*, pp. 4-8.

34 ibid., pp. 67-105; Sherwood and Pevsner, op. cit., pp. 84-6. For High Melton see T. Brighton and B. Sprakes, 'Medieval and Georgian stained glass in Oxfordshire and Yorkshire. The work of Thomas of Oxford (1385-1427) and William Peckitt of York (1731-95) in New College Chapel, York Minster and St. James, High Melton', *Ants. Jnl*, vol. LXX (1990) pp. 380-415.

35 For Hermann see M.-L. Hauck, 'Glasmalereien von Hermann von Münster in Musée Lorrain in Nancy', *Raggi Zeitschift für Kungstgeschichte und Archäologie*, vol. VIII, no. 2 (1968), pp. 44-60; B. Lymant, *Die Mittelalterlichen Glasmalereien der Ehemaligen Zisterzienserkircher Altenberg* (Jahresgabe des Altenberger Domvereins), Bergisch Gladbach, 1979, pp. 111-62, pls 95-136; J. Helbig, *Les Vitraux médiévaux conservés en Belgique 1200–1500* (*CVMA* Belgium vol. I), Brussels, 1961, pp. 79, 83-98, figs 38, 42, 43.

36 See above, chapter 2, pp. 31-3.

37 Le Couteur, op. cit., pp. 72-98, Harvey and King, op. cit; *Age of Chivalry*, nos. 612, 613, 747.

38 The late Peter Newton was the first to notice the close connections between the New College Jesse and Winchester ('Schools', vol. I, pp. 126-7).

39 For good general surveys see *Europäische Kunst um 1400*, Council of Europe, exhib. cat., Vienna, 1962, and E. Panofsky, *Early Netherlandish Painting*, vol. I, Cambridge, Mass., 1953, pp. 51-89.

40 Rickert, *Painting*, p. 151, pl. 154c; *Age of Chivalry*, no. 696.

41 N.J. Rogers, 'The Old Proctor's Book: a Cambridge manuscript of *c.*1390', in Ormrod, op. cit., pp. 213-23 (esp. pp. 219-23).

42 Harvey and King, op. cit., pp. 150-1. For a useful survey of Cologne painting see *Vor Stefan Lochner Die Kölner Maler von 1300 bis 1430*, exhib. cat., Wallraf Richartz Museum, Cologne, 1974; for the St Veronica Master see nos. 63 16-22, col. pls on pp. 156-63. Conrad von Soest's figures are more slender than Thomas's, but there are affinities between the head of the Virgin and the pose of the king on the extreme right in his Adoration of the Magi altarpiece of 1403 (Bad Wildung parish church) and the Virgin and figure of Jeconias at Winchester.

43 W. Sauerländer, review of the *Age of Chivalry* exhibition in the *Burlington Mag.*, vol. CXXX, no. 1019 (February 1988), p. 150. For Beauneveu see M. Miess, *French Painting in the Time of Jean de Berry: The Late Fourteenth Century and the Patronage of the Duke*, 2nd edn, London,

1969, pp. 135-54. Some sculpture in Winchester Cathedral and College has been unconvincingly attributed to Beauneveu; see H.J. Dow, 'André Beauneveu and the sculpture of fourteenth-century England', *Peregrinatio*, vol. I (1971), pp. 19-38. I am grateful to Dr Phillip Lindley for drawing this article to my attention.

44 Helbig, op. cit., pp. 61-71, figs 24-30.

45 Newton, *County of Oxford*, pp. 20-1, pl. 13; Woodforde, *New College*, p. 6, pl. XI.

46 The Thenford glass is unpublished, although its importance was recognized by the late Peter Newton.

47 Sherwood and Pevsner, op. cit., pp. 81-2; Le Couteur, op. cit., pp. 25-31, pls VIIIb, IX, X. William of Wykeham's will is quoted in chapter 1 above, p. 21.

48 C. Brooks and D. Evans, *The Great East Window of Exeter Cathedral: A Glazing History*, Exeter, 1988, pp. 37-8, 128-45, 166-7, col. pls X-XIII, pls 10, 43-6, 55; *Age of Chivalry*, no. 746. See also above, chapters 1 and 2, pp. 25, 40, 48.

49 M.H. Caviness, *The Windows of Christ Church Cathedral, Canterbury* (*CVMA* Great Britain vol. II), London, 1981, pp. 231-9, col. pl. XVII, figs 380-432; *Age of Chivalry*, no. 748.

50 O'Connor and Haselock, pp. 370-2, pl. 119.

51 Caviness, op. cit., p. 238.

52 O'Connor and Haselock, p. 372.

53 For the documentary references to Thornton see J. Lancaster, 'John Thornton of Coventry, glazier', *Trans. Birmingham Archaeological Soc.*, vol. LXXIV (1956), pp. 56-8; O'Connor and Haselock, pp. 364-7. See also above, chapter 2, pp. 44, 46, 54. For James Torre's transcriptions of the east window contracts see York Minster Library, MSS YML L1/2, p. 34 (Latin), L1/7, fol. 7r (English). The Norwich reference is in E.C. Fernie and A.B. Whittingham, *The Early Communar and Pitancer Rolls of Norwich Cathedral Priory with an Account of the Building of the Cloister*, Norfolk Rec. Soc., vol. XLI (1972), p. 38. For Lord Scrope see J. Hughes, 'The administration of confession in the diocese of York in the fourteenth century', in D.M. Smith (ed.), *Studies in Clergy and Ministry in Medieval England* (Borthwick Studies in History 1), York, 1991, p. 108.

54 O'Connor and Haselock, pp. 373-8.

55 T. French, 'The glazing of the St William window in York Minster', *JBAA*, vol. CXL (1987), pp. 175-81.

56 E.A. Gee, 'The painted glass of All Saints' Church, North Street, York', *Archaeologia*, vol. CII (1969), pp. 151-202. For the debt see RCHM, *An Inventory of the Historical Monuments in the City of York, vol. III: South-west of the Ouse*, London, 1972, pp. 3-4.

57 I am indebted to the researches of Tom Owen for this information. See also RCHM, *An Inventory of the Historical Monuments in the City of York, vol. V: The Central Area*, London, 1981, pls 52, 53, 62 (colour) and T. Challis, 'The Creed and Prophet series in the east

window of Beverley Minster, Yorkshire', *Jnl of Stained Glass*, vol. XVIII, no. 1 (1983-4), pp. 15-31.

58 O'Connor and Haselock, p. 377, n. 267; J. Haselock and D.E. O'Connor, 'The medieval stained glass of Durham Cathedral', *Medieval Art and Architecture at Durham Cathedral* (BAA Conference Transactions vol. III, 1977), 1980, p. 113.

59 'Schools', vol. I, pp. 98-134.

60 B. Rackham, 'The glass-paintings of Coventry and its neighbourhood', *Walpole Soc.*, vol. XIX (1930-1), pp. 89-110.

61 'Schools', vol. I, pp. 98-109. For the Ludlow glass see also Ganderton and Lafond, op. cit., p. 12, pls 3, 9, 12, 20.

62 M.H. Caviness, 'Fifteenth century stained glass from the chapel of Hampton Court, Herefordshire: the Apostles' Creed and other subjects', *Walpole Soc.*, vol. XLII (1968-70), pp. 35-60. See also above, chapter 4, p. 96.

63 R. Marks and N. Morgan, *The Golden Age of English Manuscript Painting 1200-1500*, London, 1981, pp. 25-8, 94-111, pls 28-36.

64 Woodforde, *Somerset*, pp. 59-61, 156-7, pl. XXXIII; M.Q. Smith, *The Stained Glass of Bristol Cathedral*, Bristol, 1983, p. 94, illus. on p. 6.

65 P. Lasko and N.J. Morgan (eds), *Medieval Art in East Anglia 1300-1520*, exhib. cat., Norwich, 1973, nos. 50, 53, 55, 56.

66 King, *Tours*, pp. 21-2, 25, 33-5; Lasko and Morgan, op. cit., no. 76, col. pl. on p. 60.

67 C. Woodforde, 'Painted glass in Saxlingham Nethergate Church, Norfolk', *JBSMGP*, vol. V (1933-4), pp. 163-9.

68 idem., *The Norwich School of Glass-Painting in the Fifteenth Century*, Oxford, 1950, pp. 55-67, pls XVI-XVIII; King, *Tours*, pp. 32-3, pl. XIII.

69 O. Pächt and J.J.G. Alexander, *Illuminated Manuscripts in the Bodleian Library, Oxford, vol. III, British, Irish and Icelandic Schools*, Oxford, 1973, no. 803, pls LXXVI, LXXVII; J.J.G. Alexander and C.M. Kauffmann, *English Illuminated Manuscripts 700-1500*, Brussels, Bibliothèque Royale Albert 1er, exhib. cat., 1973, no. 79, pl. 38.

70 Marks and Morgan, op. cit., pp. 28, 104-7, 113, pls 33, 34A, 37. For the Boucicaut Master see M. Miess, *French Painting in the Time of Jean de Berry the Boucicaut Master*, London, 1968.

71 Woodforde, *Norwich School*, op. cit., pp. 140-2, pl. XXX.

72 O'Connor and Haselock, p. 377; M. Baker, 'Medieval illustrations of Bede's "Life of St Cuthbert"', *Jnl Warburg & Courtauld Institutes*, vol. XLI (1978), pp. 16-49; French, op. cit., pp. 180-1; C. Barnett, 'The St Cuthbert window of York Minster and the iconography of St Cuthbert in the late Middle Ages' (unpublished MA dissertation, University of York, 1991); the last author has pointed out the quality of the window. The large quantity of coloured glass purchased by Bishop Langley in 1429 and sent to Hedon near Hull may have been connected with this window (see R.L. Storey, *Thomas Langley and the Bishopric of Durham*, London 1961, p. 96).

73 For St Martin-le-Grand see RCHM, *York Central Area*, pls 54, 56, 61 (colour); Thornhill is studied in L.S. Jones, 'St Michael and All Angels, Thornhill: a catalogue of the mediaeval glass' (unpublished B.Phil. dissertation, University of York, 1971), pp. 20-30, 106-19.

74 O'Connor and Haselock, p. 329, pls 93, 94; Gee, op. cit., pp. 188-9, pls XXXVI-XXXVIII.

75 W.G.D. Fletcher, 'The stained glass formerly in Battlefield Church', *Trans. Shropshire Archaeological & Natural History Soc.*, 3rd series, vol. III (1903), pp. XIX-XXI; see also the watercolours of the glass made in *c.*1800 in BL MS Add. 21236, fols 339-50.

76 G. Marshall, 'Some remarks on the ancient stained glass in Eaton Bishop Church', *Trans. Woolhope Naturalists' Field Club* (1921-3), pp. 101-14.

77 *Med. Christ. Im.*, pp. 47-104, figs 12-37; 'Schools', vol. I, pp. 120-3.

78 *Med. Christ. Im.*, pp. 104-36, figs 38-58.

79 VCH, *Rutland*, vol. II, London, 1935, pp. 189-91; A.H. Thompson, 'Notes … on a visit to Liddington Bede House', *Report of the Rutland Archaeological & Natural Hist. Soc.*, vol. XII (1915), pp. 38-40.

80 King, *Tours*, pp. 21-2, pl. VIII.

81 F.E. Hutchinson, *Medieval Glass at All Souls College*, London, 1949; the payment references occur on pp. 17, 37.

## 9  *The End of the Middle Ages*

1 See above, chapter 2, pp. 39, 49.

2 A list of examples (not definitive) is given in *Tattershall*, p. 72, nn. 24-7.

3 E.W. Ganderton and J. Lafond, *Ludlow Stained and Painted Glass*, Ludlow, 1961, pp. 43-6, pls 26-31.

4 *Med. Christ. Im.*, figs 171-85; *Tattershall*, pls 44-7.

5 B. Rackham, 'The glass-paintings of Coventry and its neighbourhood', *Walpole Soc.*, vol. XIX (1930-1), p. 110; *Tattershall*, pp. 146-7, pl. 77. For Winchester see J.D. Le Couteur, *Ancient Glass in Winchester*, Winchester, 1920, pp. 110-13, pl. XXXI; H. Chitty and J.H. Harvey, 'Thurbern's chantry at Winchester College', *Ants. Jnl*, vol. XLII (1962), pp. 218-19, 223-4, pl. XXXIII(b).

6 'Med. Glazing Accounts' (1929-30), p. 27. See also above, chapter 2, p. 49.

7 See M. Aubert *et al.*, *Le Vitrail français*, Paris, 1958, pls 140, 144.

8 J.J.G. Alexander, 'William Abell "lymnour" and 15th Century English illumination', *Kunsthistorische Forschungen Otto Pächt zu seinem 70 Geburtstag*, Salzburg, 1972, pp. 166-72; R. Marks and N. Morgan, *The Golden Age of English Manuscript Painting 1200-1500*, London, 1981, pp. 30-1, 118-19, fig. XXI, pl. 40.

9 This workshop is briefly studied in C. Brooks and D. Evans, *The Great East Window of Exeter Cathedral: A Glazing History*, Exeter, 1988, pp. 95-112, col. pls VI, VII, IX XIV-XVI, XIX, XXIII-XXVII, pls 22-40, figs V-XIX, although Sherborne is not mentioned. The same authors are preparing a fuller study of this atelier.

10 *Tattershall*, p. 67, pl. 25; RCHM, *An Inventory of Historical Monuments: The Town of Stamford*, London, 1977, pp. 16-17, pl. 34.

11 Alexander, op. cit., p. 167, pl. 2; Marks and Morgan, op. cit., fig. XXI. For St George's see RCHM, *Stamford*, p. 13; H.S. London, *The Life of William Bruges, the first Garter King of Arms*, Harleian Soc., vols CXI, CXII (1970), esp. pp. 57-67, pls XI-XVI. See also above, chapter 3, p. 90.

12 RCHM, *Stamford*, op. cit., pl. 38.

13 For the Beauchamp Chapel see C. Winston, *Memoirs Illustrative of the Art of Glass-Painting*, London, 1865, pp. 326-42; C. Hardy, 'On the music in the painted glass of the windows in the Beauchamp Chapel at Warwick', *Archaeologia*, vol. LXI (1909), pp. 583-614; P.B. Chatwin, 'Some notes on the painted windows of the Beauchamp Chapel, Warwick', *Trans. Birmingham Archaeological Soc.*, vol. LIII (1928), pp. 158-66; *Tattershall*, pp. 69-72.

14 R. Marks, 'Medieval stained glass in Bedfordshire: I', *Bedfordshire Mag.*, vol. XV, no. 117 (Summer 1976), pp. 180, 182; no. 118 (Autumn 1976), p. 233.

15 R. Marks, 'The glazing of Fotheringhay Church and College', *JBAA*, vol. CXXXI (1978), pp. 79-109.

16 I owe this information to David King. See also C. Woodforde, *The Norwich School of Glass-Painting in the Fifteenth Century*, Oxford, 1950, pp. 11-15.

17 P. Lasko and N.J. Morgan (eds), *Medieval Art in East Anglia 1300-1520*, exhib. cat., Norwich, 1973, pp. 44, 50 (cat. no. 75), 57, 62 (cat. no. 96); Woodforde, *Norwich School*, pp. 16-42, frontispiece, pls I-VIII, XXXVII; idem, *The Medieval Glass of St Peter Mancroft, Norwich*, Norwich, n.d.; King, *Tours*. Much light will be shed on Mancroft with the appearance of David King's monograph in the *CVMA* series. I am deeply grateful to him for allowing me to read the manuscript prior to publication. Most of the remarks made here on Mancroft and associated monuments are based on his researches, although I have not used his title of the Name of Jesus window for the Marian cycle.

18 This artist's work will be fully discussed in David King's forthcoming study.

19 Woodforde, *Norwich School*, pp. 42-55, pls IX-XV;

Lasko and Morgan, op. cit., p. 57; King, *Tours*, pp. 29-31, pl. XII.

20 Lasko and Morgan, op. cit., no. 72; see most recently S.F. Badham, 'London standardisation and provincial idiosyncrasy: the organisation and working practices of brass-engraving workshops in pre-Reformation England', *Church Monuments*, vol. V (1990), pp. 10-12, figs 3-6.

21 C. Woodforde, 'Schools of glass-painting at King's Lynn and Norwich in the Middle Ages', 'Further notes on ancient glass in Norfolk and Suffolk', 'Essex glass-painters in the Middle Ages', *JBSMGP*, vol. V (1933-4), pp. 4-18, 57-68, 110-15.

22 Lasko and Morgan, op. cit., p. 45; King, *Tours*, pp. 8-10, 12-13, pls II, IV; R. Marks, 'Recent discoveries in medieval art', *Scottish Art Review*, vol. XVI, no. 1 (May 1984), pp. 18-19, fig. 14.

23 Woodforde, *Norwich School*, pp. 74-127, pls XXII-XXVIII. See also above, chapter 1, pp. 5-6.

24 ibid.; Lasko and Morgan, op. cit., p. 57, no. 97.

25 For Norton see Lasko and Morgan, op. cit., no. 80; Brandeston is mentioned in Woodforde, *Norwich School*, p. 112.

26 C. Woodforde, *Stained Glass in Somerset 1250-1830*, Oxford, 1946, esp. pp. 22-91.

27 See above, chapter 2, pp. 34, 41.

28 P.E.S. Routh, 'A gift and its giver: John Walker and the east window of Holy Trinity, Goodramgate, York', *Yorks. Archaeological Jnl*, vol. LVIII (1986), pp. 109-21; for good illustrations see RCHM, *An Inventory of the Historical Monuments in the City of York, vol. V: The Central Area*, London, 1981, pls 45, 46, 51, 55, 56, 57-9 (colour). For Thornhill see above, chapter 8, pp. 185-6.

29 J.A. Knowles, *Essays in the History of the York School of Glass-Painting*, London, 1936, pp. 10-11; J. Haselock and D. O'Connor, 'The medieval stained glass of Durham Cathedral', *Medieval Art and Architecture at Durham Cathedral* (BAA Conference Transactions vol. III, 1977), 1980, p. 108.

30 O'Connor and Haselock, p. 331, pl. 96.

31 Haselock and O'Connor, op. cit., pp. 108-9.

32 H. Reddish, 'The St Helen window, Ashton-under-Lyne: a reconstruction', *Jnl of Stained Glass*, vol. XVIII, no. 2 (1986-7), pp. 150-61; G.F.T. Leather, 'The Flodden window in the parish church of St Leonard, Middleton, in the County of Lancaster', *Hist. of Berwickshire Naturalists Club*, vol. XXX (1938-46), pp. 82-3. See also above, chapter 1, p. 6.

33 *Tattershall*; R. Marks, 'The glazing of the Collegiate Church of the Holy Trinity, Tattershall (Lincs.): a study of late fifteenth-century glass-painting workshops', *Archaeologia*, vol. CVI (1979), pp. 133-56.

34 *Tattershall*, pp. 56-7, 59-61, 191-8, pls 3-15; RCHM, *Stamford*, op. cit., pl. 35 (colour).

35 *Tattershall*, pp. 150-1.

36 See above, chapters 3 and 4, pp. 85, 102; RCHM, *Stamford*, pls 36-7 (colour), 39.

37 *Tattershall*, pp. 117-53, pls 63-72; R. Marks, 'A late medieval glass-painting workshop in the region of Stamford and Peterborough', in P. Moore (ed.), *Crown in Glory. A Celebration of Craftsmanship – Studies in Stained Glass*, Norwich, n.d., pp. 29-39.

38 *Tattershall*, pp. 154-62, pls 85-95.

39 ibid., pp. 75-116, pls 35-60.

# 10 The Dominance of the Foreign Glaziers

1 J. Lafond, 'Le Vitrail anglais de Caudebec-en-Caux', *La Revue des arts*, vol. IV (1954), pp. 201-6. The Coronation of the Virgin is illustrated in M. Aubert *et al.*, *Le Vitrail français*, Paris, 1958, pls 155-6.

2 See Aubert, op. cit., pp. 213-56, for a survey of French glass of the early sixteenth century.

3 M. Rickert, *Painting in Britain: The Middle Ages*, 2nd edn, Harmondsworth, 1965, p. 184, pl. 185; M.R. James, *The Chaundler MSS. Introduction on the Life and Writing of Thomas Chaundler*, Roxburghe Club, 1916.

4 See *Marguerite d'York et son temps*, exhib. cat., Brussels, 1967, esp. pp. 13-4, and for Edward IV's manuscripts see L. Scofield, *The Life and Reign of Edward the Fourth*, London, 1923, vol. II, pp. 429-54.

5 K.B. McFarlane, *Hans Memling*, Oxford, 1971; L. Campbell and C. Thompson, *Hugo van der Goes and the Trinity Panels in Edinburgh*, London, 1974.

6 *Tattershall*, pp. 73, 191-8; *Med. Christ. Im.*, pp. 41-2, 148-89, 270-301. See also above, chapter 3, p. 68.

7 K.L. Scott, 'A mid-fifteenth-century English illuminating shop and its customers', *Jnl Warburg & Courtauld Institutes*, vol. XXXI (1968), pp. 170-96; idem, *The Caxton Master and his Patrons* (Cambridge Bibliographical Soc. Monograph no. 8), Cambridge, 1976, pp. 25-46.

8 M.R. James and E.W. Tristram, 'The wall paintings in Eton College Chapel and in the Lady Chapel of Winchester Cathedral', *Walpole Soc.*, vol. XVII (1928-9), pp. 1-43; A.H.R. Martindale, 'The early history of the choir of Eton College Chapel', *Archaeologia*, vol. CIII (1971), pp. 179-98.

9 C.H. Ashdown, *History of the Worshipful Company of Glaziers*, London, 1919, p. 19; J.D. Le Couteur, *English Mediaeval Painted Glass*, London, 1926, pp. 28-9.

10 M.H. Caviness, *The Windows of Christ Church Cathedral Canterbury* (*CVMA* Great Britain vol. II), London, 1981, pp. 251-73, pls 181-96; see also F. Hepburn, *Portraits of the Later Plantagenets*, Woodbridge, 1986, pp. 57-8, 66-7, pls 45, 46.

11 Caviness, op. cit., pp. 257-8; RCHM, *An Inventory of Historical Monuments: The Town of Stamford*, London, 1977, p. 20.

12 C.R. Councer, 'The medieval painted glass of West Wickham, Kent', *JBSMGP*, vol. X (1948-9), pp. 67-73. See also above, chapters 1 and 3, pp. 16-17, 63.

13 L.S. Jones, 'St Michael and All Angels, Thornhill: a catalogue of the mediaeval glass' (unpublished B.Phil. dissertation, University of York, 1971), pp. 74-100, 122, 123. For the earlier windows see also above, chapters 8 and 9, pp. 185-6, 200.

14 H. Wayment, *The Windows of King's College Chapel, Cambridge* (*CVMA* Great Britain, Supplementary vol. I) London, 1972, pp. 11-12; A. Oswald, 'Barnard Flower, the King's glazier', *JBSMGP*, vol. XI (1951-5), pp. 8-21; idem, 'The glazing of the Savoy Hospital', *JBSMGP*, vol. XI (1951-5), pp. 224-32; A. Smith, 'Henry VII and the appointment of the King's Glazier', *Jnl of Stained Glass*, vol. XVIII no. 3 (1988), pp. 259-61.

15 Wayment, op. cit., pp. 12-13.

16 See above, chapter 1, pp. 25-7.

17 Wayment, op. cit., p. 14.

18 ibid.

19 D.R. Ransome, 'The struggle of the Glaziers' Company with the foreign glaziers, 1500-1550', *The Guildhall Miscellany*, vol. II no. 1 (September 1960), p. 13.

20 Wayment, op. cit., p. 13.

21 ibid., pp. 13-15. For this glass see B. Rackham, 'The Ancient Windows of Christ's College, Cambridge', *Arch. Jnl*, vol. CIX (1952), pp. 132-42.

22 W.H. St John Hope, *Windsor Castle: An Architectural History*, London, 1913, vol. II, pp. 375-85, 454; H.M. Colvin, D.R. Ransome and J. Summerson, *The History of the King's Works, vol. II, 1485-1660 (Part I)*, London, 1975, pp. 311-15. Brief surveys of the glass are A. Deane, 'The west window, St George's Chapel', *Annual Report of the Friends of St George's Chapel & the Descendants of the Knights of the Garter* (1945), pp. 12-15 and unattributed, 'Great west window St George's Chapel', ibid. (1947), pp. 15-17.

23 W. Wells, *Stained and Painted Glass. Burrell Collection*, Glasgow, 1965, no. 211.

24 O.G. Farmer, *Fairford Church and its Stained Glass Windows*, 8th edn, Bath, 1968; H.G. Wayment, 'The enigma of the Fairford glass', *Source*, vol. II, no. 1 (1982), pp. 16-20; idem, *The Stained Glass of the Church of St Mary, Fairford, Gloucestershire* (Society of Antiquaries of London Occasional Paper, new series, vol. V, 1984).

25 For a summary account of Netherlandish altarpieces of the period see T. Müller, *Sculpture in the Netherlands, Germany, France and Spain 1400 to 1500*, Harmondsworth, 1966, pp. 93-7.

26 Wayment, *Fairford*, op. cit., p. 87.

27 ibid., p. 85, col. pl. I.

28 ibid., p. 89.

29 ibid., pp. 94–6.

30 L. Toulmin-Smith (ed.) *The Itinerary of John Leland in or about the Years 1535–1543*, London, 1964, vol. I, p. 127, vol. IV, p. 28.

31 I am most grateful to Dr Hilary Wayment for his observations on the similarities between Fairford and Windsor.

32 O.B. Carter, *A Series of the Ancient Painted Glass of Winchester Cathedral*, London, 1845; R. Willis, *Architectural History of Some English Cathedrals*, London, 1845, pp. 39–40, 47–52; J.D. Le Couteur, *Ancient Glass in Winchester*, Winchester, 1920, pp. 34–47, pls XII–XV; Winston, *Memoirs*, pp. 68–9. Fox's artistic patronage has been the subject of a Warburg Institute doctoral dissertation by Angela Smith.

33 RCHM, *An Inventory of the Historical Monuments in Buckinghamshire*, London, 1913, vol. II, pp. 149–50; VCH, *Buckinghamshire*, vol. IV, London, 1927, pp. 179–80; G.G. Scott, 'All Saints' Church, Hillesden, Bucks.', *Records of Bucks.*, vol. IV (1877), pp. 309–25; J. Baker, *English Stained Glass of the Medieval Period*, London, 1978, pls 77–82. The dating is suggested by the lack of reference to any dilapidations in the 1519 visitation although they are mentioned in 1491: see A. Hamilton Thompson (ed.), *Visitations in the Diocese of Lincoln 1517–1531*, Lincoln Record Soc., vol. XXXIII (1936), p. 46. For the 1491 date see M. Bowker, *The Secular Clergy in the Diocese of Lincoln 1495–1520*, Cambridge, 1968, p. 131.

34 N.H.J. Westlake, *A History of Design in Painted Glass*, vol. III, London, 1886, pp. 62–3.

35 Colvin, Ransome and Summerson, op. cit., pp. 210–17; Wayment, *King's*, p. 124; C. Wilson, P. Tudor-Craig, J. Physick and R. Gem, *Westminster Abbey* (New Bell's Cathedral Guides), London, 1986, p. 70.

36 Westlake, op. cit., vol. IV, London, 1894, pp. 27–8; RCHM, *An Inventory of the Historical Monuments in London, vol. I, Westminster Abbey*, London, 1924, p. 63, pls 118, 119; W.R. Lethaby, *Westminster Abbey Re-examined*, London, 1925, pp. 174–83, figs 99–101; F.C. Eeles, 'The ancient stained glass of Westminster Abbey from a manuscript dated 1938', *JBSMGP*, vol. XVII (sic), no. 2 (1978–9), pp. 17–29. Good photographs of the glass are in the Victoria and Albert Museum Picture Library and Department of Ceramics & Glass; also in the National Monuments Record.

37 For Henry VII's will see Colvin, Ransome and Summerson, op. cit., p. 213.

38 For the connection of Henry VII's chapel with palace architecture see Wilson, Tudor-Craig, Physick and Gem, op. cit., p. 72.

39 Wayment, *King's*, p. 124.

40 RCHM, *Westminster*, pl. 119; Carter, op. cit., (plate not numbered); Wayment, *Fairford*, pl. LIII(d); idem, *King's*, pls 36 (colour), 37(1), 38(4), (6), (7), 39(1), (3).

41 Carter, op. cit.

42 Westlake, op. cit., vol. IV, pl. XXIV(a); Wayment, *Fairford*, p. 15, fig. 2 (type C).

43 Westlake, op. cit., vol. IV, pls XXIV(a), (b), XXV, XXVI; Wayment, *King's*, pls 53, 55.

44 Wayment, *King's*; idem, *King's College Chapel Cambridge: The Great Windows. Introduction and Guide*, Cambridge, 1982.

45 Wayment, *King's*, pp. 123–5.

46 ibid., p. 4.

47 ibid., pp. 17–22; idem, *The Great Windows*, pp. 10–13.

48 Wayment, *King's* pp. 5–8; idem, *The Great Windows*, p. 10.

49 Wayment, *The Great Windows*, p. 13.

50 For a discussion of these motifs (with further bibliography) see R. Marks, 'The Howard tombs at Thetford and Framlingham: new discoveries', *Arch. Jnl*, vol. CXLI (1984), pp. 262–3, pls XIIa, XVIc–e, XVIIa, b, XVIIIa, XIXa.

51 A. Blunt, 'L'Influence française sur l'architecture et la sculpture décorative en Angleterre pendant la première moitié du XVIe siècle', *Revue de l'art*, vol. IV (1969), pp. 17–29.

52 H. Wayment, 'The east window of St Margaret's, Westminster', *Ants. Jnl*, vol. LXI (1981), pp. 292–301.

53 H. Arnold, *The Glass in Balliol College Chapel*, Oxford, 1914; RCHM, *An Inventory of the Historical Monuments in the City of Oxford*, London, 1939, p. 22, pls 74–5; VCH, *Oxfordshire*, vol. III, London, 1965, pp. 90–1; P.A. Newton, in J. Sherwood and N. Pevsner, *The Buildings of England: Oxfordshire*, Harmondsworth, 1974, pp. 76–7; H. Wayment, 'Twenty-four vidimuses for Cardinal Wolsey', *Master Drawings*, vol. XXIII/XXIV no. 4 (March 1988), pp. 512–13. I am most grateful to Jill Kerr for giving me the benefit of her detailed knowledge of the Balliol glass, which will be the subject of a forthcoming fascicle in the *Corpus Vitrearum* series. For Wolsey's glazing see H. Wayment, 'Wolsey and stained glass' in S.J. Gunn and P.G. Lindley (eds), *Cardinal Wolsey: Church, State and Art*, Cambridge, 1991, pp. 116–30.

54 G. McN. Rushforth, 'The painted windows in the Chapel of the Vyne in Hampshire', *Walpole Soc.*, vol. XV (1926–7), pp. 1–20; H. Wayment, 'The stained glass in the Chapel of the Vyne', *National Trust Studies* (1980), pp. 35–47; idem, 'The stained glass of the Chapel of the Vyne and the Chapel of the Holy Ghost, Basingstoke', *Archaeologia*, vol. CVII (1982), pp. 141–52.

55 Wayment in *Archaeologia* (1982), op. cit., pp. 145–8.

56 Ransome, op. cit., p. 16.

57 C. Woodforde, 'The stained and painted glass in Hengrave Hall, Suffolk', *Proc. Suffolk Institute of Archaeology & Natural History*, vol. XXII (1936), pp. 1–16; H. Wayment, 'The foreign glass at Hengrave Hall and St James', Bury St Edmunds', *Jnl of Stained Glass*, vol. XVIII

no. 2 (1986-7), pp. 166-74; see also above, chapter 4, p. 96.

58 K. Harrison, 'Early sixteenth-century glass at Sampford Courtenay, Devon', *JBSMGP*, vol. XI (1951-5), pp. 204-5.

59 This glass is very briefly mentioned in VCH, *Sussex*, vol. IX, London, 1937, p. 171.

60 This glass is unpublished.

61 The Brington glass is unpublished, but for the will see R.M. Serjeantson and H. Isham Longden, 'The parish churches and religious houses of Northamptonshire: their dedications, altars, images and lights', *Arch. Jnl*, vol. LXX (1913), p. 287. For the Spencer family see M. Beresford, *History on the Ground*, London, 1957, pp. 105-10.

62 Serjeantson and Isham Longden, op. cit., p. 362. These fragments are unpublished.

63 C. Woodforde, 'The painted glass in Withcote Church', *Burlington Mag.*, vol. LXXV (1939), pp. 17-22; A.R. Dufty, 'Withcote Chapel', *Arch. Jnl*, vol. CXII (1955), pp. 178-81. For the comparisons with King's College see Wayment, *King's*, pp. 13 n. 3, 107, pl. 14, illus. 7-9 (colour).

64 Toulmin Smith, op. cit., vol. IV, p. 50; VCH, *Warwickshire*, vol. III, London, 1945, pp. 83-4.

65 D.J. King, *Stained Glass Tours around Norfolk Churches*, Norfolk Society, 1974, p. 27, pl. X. See also above, chapter 3, p. 88.

66 For Stambourne see RCHM, *An Inventory of the Historical Monuments in Essex*, vol. I, London, 1916, p. 273; the figure of Christian Mackwilliam is illustrated in B. Coe, *Stained Glass in England 1150-1550*, London, 1981, p. 39.

67 O'Connor and Haselock, pp. 332-4, pl. 97; D.J. Chadwick, 'The ancient glass in the east window of the Church of St Andrew, Greystoke, Cumbria' (unpublished B.Phil. dissertation, University of York, 1974); for St Michael-le-Belfrey see RCHM, *An Inventory of the Historical Monuments in the City of York, vol. V, The Central Area*, London, 1981, pp. 38-9, pls 49, 63 (colour).

68 J.R. Whitehead, 'An archbishop and his chantry: the Rokeby Chapel, Kirk Sandall, near Doncaster', *Country Life*, vol. CLXXIII (24 March 1983), pp. 738-9.

69 C. Woodforde, *Stained Glass in Somerset 1250-1830*, Oxford, 1946, pp. 149-54. See also above chapter 3, p. 63.

70 Ransome, op. cit., p. 13. The following account of the disputes is based on this article.

71 ibid.

72 ibid., p. 19.

## 11  The Reformation and After

1 R. Marks, 'Cistercian window glass in England and Wales', in C. Norton and D. Park (eds), *Cistercian Art and Architecture in the British Isles*, Cambridge, 1986, pp. 212-13.

2 J. Stacey, *Wyclif and Reform*, Philadelphia, 1964, pp. 22-3, 48-9. For Lollard attitudes to images see A. Caiger-Smith, *English Medieval Mural Paintings*, Oxford, 1963, pp. 109-10 and M. Aston, *England's Iconoclasts, vol. I. Laws against Images*, Oxford, 1988, pp. 96-159.

3 W.W. Skeat (ed.), *The Vision of William concerning Piers the Plowman*, Early English Text Soc., vol. LIV (1873), pt 3, passage IV, p. 45.

4 Aston, op. cit., esp. pp. 212-15, 401-6. This study has largely superseded J. Phillips, *The Reformation of Images: Destruction of Art in England 1535-1660*, Berkeley, 1973. For a regional study of iconoclasm in the diocese of Exeter see R. Whiting, 'Abominable idols: images and image-breaking under Henry VIII', *Jnl Ecclesiastical History*, vol. XXXIII (1982), pp. 30-47.

5 Most of those mentioned here are discussed elsewhere in this book. For Launde see A. Herbert, 'The fifteenth-century glass at Launde Priory', *Trans. Leics. Archaeological Soc.*, vol. XXX (1954), pp. 21-5.

6 D. Knowles, *The Religious Orders in England III: The Tudor Age*, Cambridge, 1961, p. 384.

7 A. Vere Woodman, 'The accounts of the churchwardens of Wing', *Records of Bucks.*, vol. XVI (1953-60), p. 316; H.M. Colvin, 'Medieval glass from Dale Abbey', *Jnl Derbyshire Archaeological & Natural History Soc.*, vol. LX (1939), pp. 129-41. See also above, chapter 3, p. 73.

8 T. Borenius, *St Thomas Becket in Art*, London, 1932, p. 110.

9 C. Woodforde, *The Norwich School of Glass-Painting in the Fifteenth Century*, Oxford, 1950, p. 203; W. Lovell, 'Grays Inn: Thomas a Becket anniversary', *Notes & Queries*, 7th series, vol. IV (July-December 1887), p. 306. For surviving images see Borenius, op. cit., and P.A. Newton, 'Some new material for the study of the iconography of St Thomas Becket', *Thomas Becket: Actes du Colloque International de Sédières*, 1973, pp. 255-63.

10 Aston, op. cit., pp. 256, 262-3.

11 ibid., p. 257, esp. n. 10.

12 ibid., pp. 258, 263, n. 25.

13 J.T. Fowler (ed.), *The Rites of Durham*, Surtees Soc., vol. CVII (1902), p. 77.

14 Aston, op. cit., p. 259; Woodforde, *Norwich School*, pp. 203-4.

15 C. Woodforde, *English Stained and Painted Glass*, Oxford, 1954, p. 39.

16 Aston, op. cit., p. 260, esp. n. 19.

17 For Hooper see A.G. Dickens, *The English Reformation*, London, 1964, *passim*; F.D. Price, 'Gloucester diocese under Bishop Hooper, 1551-3', *Trans. Bristol and Glos.*

*Archaeological Soc.*, vol. LX (1938), pp. 51–151.

18  Aston, op. cit., pp. 277–94, 340, n. 32.

19  ibid., p. 300; Phillips, op. cit., p. 114.

20  Aston, op. cit., pp. 314–16.

21  ibid., pp. 334–5.

22  Woodforde, *Stained and Painted Glass*, p. 38.

23  Quoted in Aston, op. cit., p. 330.

24  C.R. Councer, *Lost Glass from Kent Churches*, Kent Archaeological Soc., Kent Records, vol. XXII (1980), p. 125.

25  J.C. Cox, *Churchwardens' Accounts*, London, 1913, p. 87.

26  For Salisbury Cathedral see C.E. Long (ed.), *Diary of the Marches of the Royal Army during the Great Civil War kept by Richard Symonds*, Camden Soc. old series vol. LXXIV (1859), p. 140. The St Thomas's reference is in P. Nelson, *Ancient Painted Glass in England 1170–1500*, London, 1913, p. 44.

27  Cox, op. cit., p. 88.

28  E.A. Greening Lamborn, *The Armorial Glass of the Oxford Diocese 1250–1850*, Oxford, 1949, pp. 14–21.

29  H. Wayment, *The Windows of King's College Chapel, Cambridge* (*CVMA* supplementary vol. I), London, 1972, p. 13.

30  Woodforde, *Norwich School*, p. 206.

31  J.A. Knowles, 'Glass-painters of York. VIII – the Thompson family', *Notes & Queries*, 12th series, vol. IX (1921), pp. 163–5. The 1551 reference is in the Household Books (I owe this information to David O'Connor).

32  J. Bilson, 'Gilling Castle', *Yorks. Archaeological Jnl*, vol. XIX (1907), pp. 105–92. See also B. Sprakes, 'Baernard Dininckhoff, armorial glass painter extraordinary – Part I', *JBSMGP*, vol. XVII, no. 2 (1981–2), pp. 29–37.

33  H.T. Kirby, 'The Compton Verney glass', *Country Life*, vol. CXV (15 April 1954), pp. 1132–3; the Cave panels will be discussed in my forthcoming *CVMA* volume on Stanford on Avon. For the relevant tombs see A. Blunt, 'L'Influence française sur l'architecture et la sculpture décorative en Angleterre pendant la première moitié du XVIe siècle', *Revue de l'art*, vol. IV (1969), pp. 17–29, and R. Marks, 'The Howard tombs at Thetford and Framlingham: new discoveries', *Arch. Jnl*, vol. CXLI (1984), esp. pp. 258–60. Some quarries bearing Provost Robert Brassie's initials were installed in his chapel in King's College Chapel between 1556 and 1558. See H. Wayment, *King's College Chapel Cambridge: The Side-Chapel Glass*, Cambridge, 1988, pp. 13, 192.

34  M. Archer, 'Richard Butler, glass-painter', *Burlington Mag.*, vol. CXXX, no. 1046 (May 1990), p. 308.

35  F.W. Steer, 'Heraldic glass in Stopham Church, Sussex, England', *New England Historical & Genealogical Register*, vol. CXII (1958), pp. 308–12. The panel depicting Blanche Parry and Queen Elizabeth I at Atcham appears to be a nineteenth-century copy of the former's sepulchral monument at Bacton in Hereford and Worcester; see G. McN. Rushforth, 'The Bacton glass at Atcham in Shropshire', *Trans. Woolhope Naturalists' Field Club* (1933–5), pp. 157–62.

36  For Arminianism see C. Cross, *Church and People 1450–1660*, Fontana, 1983, pp. 175–98.

37  Woodforde, *Stained and Painted Glass*, pp. 42–4; Archer, op. cit., pp. 308–15.

38  For brief accounts of glass in this period see Woodforde, *Stained and Painted Glass*, pp. 41–8, and M. Archer, *An Introduction to English Stained Glass*, London, 1985, pp. 25–8.

39  Phillips, op. cit., pp. 163–4; P. Slack, 'Religious protest and urban authority: the case of Henry Sherfield, iconoclast, 163', in D. Baker (ed), *Schism, Heresy and Religious Protest* (Studies in Church History, vol. IX), Cambridge, 1972, pp. 295–302.

40  Phillips, op. cit., pp. 177, 184.

41  S. Gunton, *The History of the Church of Peterburgh*, London, 1686, pp. 336–7. For the St Peter scenes from the west window, see above, chapter 9, pp. 201–2.

42  For Fairfax see O'Connor and Haselock, pp. 313, 315. See Aston, op. cit., pp. 63–74 for a good account of how Oliver Cromwell came to be stereotyped as the great destroyer.

43  ibid., pp. 75–7.

44  C.H. Evelyn White, *The Journal of William Dowsing*, Ipswich, 1885, pp. 7, 16. For Dowsing see also Aston, op. cit., pp. 74–84.

45  Aston, op. cit., p. 82, citing John Aubrey, *Brief Lives and Other Selected Writings*, ed. A. Powell, London, 1949, p. 8.

46  Woodforde, *Stained and Painted Glass*, p. 45.

47  R. Culmer, *Cathedrall Newes from Canterbury*, 1644, reprinted by G. S[mith], *Chronological History of Canterbury Cathedral*, Canterbury, 1885, pp. 310–11. See also Aston, op. cit., pp. 84–95.

48  W.D. Caröe, 'Canterbury Cathedral choir during the Commonwealth and after, with special reference to two oil paintings', *Archaeologia*, vol. LXII (1911), pp. 353–66; T. Cocke, 'Monuments of power. The rediscovery of the Romanesque in 17th-century England', *Country Life*, vol. CLXXV (21 June 1984), p. 1778, fig. 3; *English Romanesque Art 1066–1200*, exhib. cat., Arts Council, London, 1984, no. 502.

49  Woodforde, *Stained and Painted Glass*, pp. 44–5.

50  A useful survey of antiquarian records and county histories can be found in J. Bertram, *Lost Brasses*, London, 1976, pp. 95–111. For the *Rites of Durham* see Fowler, op. cit.; Lieutenant Hammond's travels are published in L.G. Wickham Legg (ed.), *A Relation of a Short Survey of the Western Counties*, The Camden Miscellany, vol. XVI, 1936. For Philipot see C.R. Councer (ed.), *A 17th Century Miscellany*, Kent Archaeological Soc., Kent Records, vol. XVII (1960), pp. 68–114.

51 For the *Book of Monuments* see R. Marks and A. Payne (eds), *British Heraldry from its Origins to c. 1800*, exhib. cat., British Museum, London 1978, no. 87, and *Age of Chivalry*, no. 379. The present writer is working on an edition of this manuscript. For the College of Arms material see S. Badham, 'A lost bronze effigy of 1279 from York Minster', *Ants. Jnl*, vol. LX (1980), pp. 59-65. The *Howard Genealogy* is in the possession of the Duke of Norfolk; for a description see Marks, 'Howard tombs', pp. 264-6.

52 Johnston's notes are in the Bodlein Library (MS Top. Yorks. c14) and Torre's manuscript volumes are in the library of York Minster.

53 J. Bridges, *The History and Antiquities of Northampton-shire*, 2 vols, Oxford, 1791; his manuscript notes in the Bodleian Library contain far more information on stained glass. F. Blomefield, *An Essay towards a Topographical History of the County of Norfolk*, 11 vols, London, 1805-10. T. Fisher, *Collections, Historical, Genealogical and Topographical, for Bedfordshire*, London, 1812-36; some of his illustrations of Kent glass are published in colour in Councer, *Lost Glass*. For Fowler see S. Crewe, *Stained Glass in England c. 1180-c.1540*, London, 1987, col. pl. 15. For the collections by Powell and Carter see BL MSS Add. 17456, 29939.

54 *Dictionary of National Biography*, vol. LIV, London, 1898, pp. 432-3.

55 *The Family Memoirs of the Rev. William Stukeley, M.D., vol. II*, Surtees Soc., vol. LXXVI (1883), pp. 325, 328-9. For the Garter windows see above, chapter 3, pp. 73, 90.

56 G. White, *The Cathedral Church of Salisbury* (Bell's Cathedral Series), London, 1901, pp. 91-2; J.M. Robinson, *The Wyatts: An Architectural Dynasty*, Oxford, 1979, p. 73.

57 R. Marks, 'The glazing of Fotheringhay Church and College', *JBAA*, vol. CXXXI (1978), pp. 79-109.

58 J.A. Knowles, 'Horace Walpole and his collection of stained glass at Strawberry Hill', *JBSMGP*, vol. VII (1937-9), p. 46.

59 *Tattershall*, pp. 42-4.

60 Quoted in J. Lafond, 'The traffic in old stained glass from abroad during the 18th and 19th centuries in England', *JBSMGP*, vol. XIV, no. I (1964), p. 63.

61 Lafond, op. cit., p. 64.

62 ibid., p. 58, citing Eustache de la Quérière, *Description historique des maisons de Rouen*, vol. I, Paris, 1821, p. 213.

63 M. Drake, *The Costessey Collection of Stained Glass formerly in the Possession of G.W. Jerningham, 8th Baron Stafford in the County of Norfolk*, Exeter, 1920.

64 Y. Vanden Bemden and J. Kerr, 'The glass of Herkenrode Abbey', *Archaeologia*, vol. CVIII (1986), pp. 189-226.

65 J.E. Hunt, *The Glass in S. Mary's Church, Shrewsbury*, 6th edn, Shrewsbury, 1980.

66 F.S. Eden, 'The 12th century medallions at Rivenhall', *JBSMGP*, vol. I, no. 3 (1925), pp. 20-3; F. Perrot and A. Granboulan, 'The French 12th, 13th and 16th century glass at Rivenhall, Essex', *Jnl of Stained Glass*, vol. XVIII, no. I (1983-4), pp. 1-14; L. Grodecki, *Les Vitraux de Saint-Denis, vol. I* (*CVMA* France Etudes vol. I), Paris, 1976, pp. 66-8, illus. 29-31, 59-65, 88-103, 149-54, 161-2; M. Aubert, L. Grodecki, J. Lafond and J. Verrier, *Les Vitraux de Notre-Dame et de la Sainte-Chapelle de Paris* (*CVMA* France vol. I), Paris, 1959, pp. 345-9, pl. 101; D. O'Connor and P. Gibson, 'The chapel windows at Raby Castle, County Durham', *Jnl of Stained Glass*, vol. XVIII, no. 2 (1986-7), pp. 124-49.

67 J.H. Harvey and D.G. King, 'Winchester College stained glass', *Archaeologia*, vol. CIII (1971), pp. 154-5; E.W. Ganderton and J. Lafond, *Ludlow Stained and Painted Glass*, Ludlow, 1961.

68 M.H. Caviness, *The Early Stained Glass of Canterbury Cathedral c.1175-1220*, Princeton, 1977, pp. 16-17; idem, *The Windows of Christ Church Cathedral Canterbury* (*CVMA* Great Britain vol. II), London, 1981, *passim*.

69 See M. Harrison, *Victorian Stained Glass*, London, 1980, and V.C. Raguin, 'Revivals, revivalists, and architectural stained glass', *Jnl Soc. Architectural Historians*, vol. XLIX, no. 3 (1990), pp. 310-29, for general surveys.

70 A.C. Sewter, 'The place of Charles Winston in the Victorian revival of the art of stained glass', *JBAA*, 3rd series, vol. XXIV (1961), p. 84. Less well-known than Winston's watercolours of medieval glass are those made by two contemporaries, C.E. Gwilt (in the possession of Chapel Studios) and O. Hudson (Dept. of Prints, Drawings and Design, Victoria and Albert Museum).

71 Harrison, op. cit., especially the Appendix on pp. 75-85, which gives details of the main Victorian workshops.

72 D. O'Connor, 'Morris stained glass: "an art of the Middle Ages"' in J. Banham and J. Harris (eds), *William Morris and the Middle Ages*, Manchester, 1984, pp. 31-46; A.C. Sewter, *The Stained Glass of William Morris and his Circle*, 2 vols, New Haven and London, 1974 and 1975.

73 All these works are cited in the present book.

74 Again, all these works are cited in the present book.

75 An excellent recent handbook to conservation of windows is J. Kerr, *The Repair and Maintenance of Glass in Churches*, published for the Council for the Care of Churches, London, 1991.

# Select Bibliography

The publications cited below include those articles and monographs on architecture and arts related to stained glass which have been consulted extensively in the preparation of this study as well as works devoted to stained glass itself; more titles are mentioned in the notes. This bibliography is far from being a comprehensive list of publications on English medieval stained glass; for this the reader should consult M. Caviness and E.R. Staudinger, *Stained Glass before 1540: An Annotated Bibliography*, Boston, 1983, and D. Evans, *A Bibliography of Stained Glass*, Cambridge, 1982. The present bibliography includes a number of publications which have appeared since the above lists.

*Age of Chivalry*, see under Alexander, J. and Binski, P. (eds).

Alexander, J.J.G., 'William Abell "lymnour" and 15th century English illumination', *Kunsthistorische Forschungen Otto Pächt zu seinem 70. Gerburtstag*, Salzburg, 1972, pp. 166–72.

Alexander, J. and Binski, P. (eds), *Age of Chivalry: Art in Plantagenet England 1200–1400*, exhib. cat., Royal Academy of Arts, London, 1987.

Archer, M., *An Introduction to English Stained Glass*, London, 1985.

—— 'Richard Butler, glass-painter', *Burlington Mag.*, vol. CXXX, no. 1046 (May 1990), pp. 308–15.

Arnold, H., *The Glass in Balliol College Chapel*, Oxford, 1914.

Ashdown, C.H., *History of the Worshipful Company of Glaziers*, London, 1919.

Aston, M., *England's Iconoclasts, vol. I, Laws Against Images*, Oxford, 1988.

Aubert, M., *et al.*, *Le Vitrail français*, Paris, 1958.

Aubert, M., Grodecki, L., Lafond, J. and Verrier, J., *Les Vitraux de Notre-Dame et de la Sainte-Chapelle de Paris* (*CVMA* France, vol. I), Paris, 1959.

Ayre, K. 'English figurative stained glass roundels produced before 1530', *Jnl of Stained Glass*, vol. XIX no. 1 (1989–90), pp. 1–17.

Backhouse, J., Turner, D.H. and Webster, L. (eds), *The Golden Age of Anglo-Saxon Art*, exhib. cat., British Museum, London, 1984.

Baker, J., *English Stained Glass of the Medieval Period*, London, 1978.

Barnett, C., 'The St Cuthbert window of York Minster and the iconography of St Cuthbert in the late Middle Ages' (unpublished MA dissertation, University of York, 1991).

Becksmann, R., *Die architektonische Rahmung des hochgotischen Bildfensters: Untersuchungen zur oberrheinischen Glasmalerei von 1250 bis 1350*, Berlin, 1967.

—— *Deutsche Glasmalerei des Mittelalters*, Stuttgart-Bad Cannstatt, 1988.

Becksmann, R. and Waetzoldt, S., *Vitrea Dedicata: Das Stifterbild in der deutschen Glasmalerei des Mittelalters*, Berlin, 1975.

Benson, G., *The Ancient Painted Glass Windows in the Minster and Churches of the City of York* (Annual Report of the Council of the Yorkshire Philosophical Society, 1915).

Biddle, M., *Object and Economy in Medieval Winchester, Winchester Studies 7ii Artefacts from Medieval Winchester*, Oxford, 1990 (section on glass by M. Biddle, J. Hunter and J. Kerr).

Binski, P., *Medieval Craftsmen – Painters*, London, British Museum, 1991.

—— *The Painted Chamber at Westminster* (Society of Antiquaries of London Occasional Paper, new series, vol. IX, 1986).

Biver, P. and Socard, E., 'Le vitrail civil au XIVe siècle', *Bulletin Monumental*, vol. LXXVII (1913), pp. 258–64.

Blair, J. and Ramsay, N. (eds), *English Medieval Industries*, London, 1991.

Bony, J., *The Decorated Style*, Oxford, 1979.

Borenius, T., 'The cycle of images in the palaces and castles of Henry III', *Jnl Warburg & Courtauld Institutes*, vol. VI (1943), pp. 40-50.

—— *St. Thomas Becket in Art*, London, 1932.

Brooks, C. and Evans, D., *The Great East Window of Exeter Cathedral: A Glazing History*, Exeter, 1988.

Brown, R.A., Colvin, H.M. and Taylor, A.J., *The History of the King's Works, vols I and II, The Middle Ages*, London, 1963.

Brown, S. and O'Connor, D., *Medieval Craftsmen – Glasspainters*, London, British Museum, 1991.

Burnam, R.G., 'Medieval stained glass practice in Florence, Italy: the case of Orsanmichele', *Jnl Glass Studies*, vol. XXX (1988), pp. 77-93.

Caiger-Smith, A., *English Medieval Mural Paintings*, Oxford, 1963.

Camille, M., *Image on the Edge. The Margins of Medieval Art*, London, 1992.

—— 'Seeing and reading: some visual implications of medieval literacy and illiteracy', *Art History*, vol. VIII (1985), pp. 26-49.

Caviness, M.H., 'Biblical stories in windows: were they Bibles for the poor?', in B.S. Levy (ed), *The Bible in the Middle Ages: Its Influence on Literature and Art* (Medieval and Renaissance Texts and Studies, 89), Binghamton, New York, 1992, pp. 103-47.

—— 'Canterbury Cathedral clerestory: the glazing programme in relation to the campaigns of construction', *Medieval Art and Architecture at Canterbury before 1220* (BAA Conference Transactions vol. V, 1979), 1982, pp. 46-55.

—— '"De convenienta et cohaerentia antiqui et novi operis": Medieval conservation, restoration, pastiche and forgery', *Intuition und Kunstwissenschaft Festschrift für Hanns Swarzenski*, Berlin, 1973, pp. 205-21.

—— *The Early Stained Glass of Canterbury Cathedral c. 1175–1220*, Princeton, 1977.

—— 'Fifteenth century stained glass from the Chapel of Hampton Court, Herefordshire: the Apostles' Creed and other subjects', *Walpole Soc.*, vol. XLII (1968-70), pp. 35-60.

—— 'A life of St Edward the Confessor in early fourteenth-century stained glass at Fécamp, in Normandy', *Jnl Warburg & Courtauld Institutes*, vol. XXVI (1963), pp. 22-37.

—— 'Re-discovered glass of about 1200 from the Abbey of St-Yved at Braine', *Studies on Medieval Stained Glass: Selected Papers from the XIth International Colloquium of the Corpus Vitrearum* (*CVMA* United States Occasional Papers I), New York, 1985, pp. 34-47.

—— 'Romanesque "belles verrières" in Canterbury?', in *Romanesque and Gothic Essays for George Zarnecki*, Woodbridge, 1987, pp. 35-8.

—— *Sumptuous Arts at the Royal Abbeys in Reims and Braine*, Princeton, 1990.

—— *The Windows of Christ Church Cathedral Canterbury* (*CVMA* Great Britain vol. II), London, 1981.

Chadwick, D.J., 'The ancient glass in the east window of the Church of Saint Andrew, Greystoke, Cumbria' (unpublished B.Phil. dissertation, University of York, 1974).

Challis, T., 'The Creed and Prophet series in the east window of Beverley Minster, Yorkshire', *Jnl of Stained Glass*, vol. XVIII no. 1 (1983-4), pp. 15-31.

Charleston, R.J., 'Vessel glass', in J. Blair and N. Ramsay (eds), *English Medieval Industries*, London, 1991, pp. 237-64.

Chatwin, P.B., 'Some notes on the painted windows of the Beauchamp Chapel, Warwick', *Trans. Birmingham Archaeological Soc.*, vol. LIII (1928), pp. 158-66.

Coe, B., *Stained Glass in England 1150-1550*, London, 1981.

Colvin, H.M., 'Medieval glass from Dale Abbey', *Jnl Derbyshire Archaeological & Natural History Soc.*, vol. LX (1939), pp. 129-41.

Colvin, H.M. (ed.), *Building Accounts of King Henry III*, Oxford, 1971.

Colvin, H.M., Ransome, D.R. and Summerson, J., *The History of the King's Works, Vol. II, 1485-1660 (Part I)*, London, 1975.

Councer, C.R., 'The ancient glass from Petham Church now in Canterbury Cathedral', *Archaeologia Cantiana*, vol. LXV (1952), pp. 167-70.

—— *Lost Glass from Kent Churches*, Kent Archaeological Soc., Kent Records, vol. XXII (1980).

—— 'The medieval painted glass of Mersham', *Archaeologia Cantiana*, vol. XLVIII (1936), pp. 81-90.

—— 'The medieval painted glass of West Wickham, Kent', *JBSMGP*, vol. X (1948-9), pp. 67-73.

Cowen, P., *A Guide to Stained Glass in Britain*, London, 1985.

Cox, J.C. *Churchwardens' Accounts*, London, 1913.

Cramp, R., 'Decorated window-glass and millefiori from Monkwearmouth', *Ants. Jnl*, vol. L (1970), pp. 327-35.

—— 'Glass finds from the Anglo-Saxon monastery of Monkwearmouth and Jarrow', *Studies in Glass History and Design* (VIIIth International Congress on Glass), Sheffield, 1970, pp. 16-19.

—— 'Window glass from the monastic site of Jarrow', *Jnl Glass Studies*, vol. XVII (1975), pp. 88-96.

Crewe, S., *Stained Glass in England c. 1180-c. 1540*, London, 1987.

Croft, R.A. and Mynard, D.C., 'A late 13th-century grisaille window panel from Bradwell Abbey, Milton Keynes, Bucks', *Medieval Archaeology*, vol. XXX (1986), pp. 106-12.

Day, L.F., *Windows: A Book about Stained & Painted Glass*, 3rd edn, London, 1909.

Delaporte, Y. and Houvet, E., *Les Vitraux de la cathédrale de Chartres*, 4 vols, Chartres, 1926.

Dennison, L., '"The Fitzwarin psalter and its allies": a re-appraisal', in W.M. Ormrod (ed.), *England in the Fourteenth Century* (Proc. 1985 Harlaxton Symposium), Woodbridge, 1986, pp. 42-66.

—— 'The stylistic sources, dating and development of the Bohun workshop' (unpublished Ph.D. thesis, University of London, 1987).

Deremble, J-P. and Manhes, C., *Les Vitraux légendaires de Chartres*, Paris, 1988.

Dodwell, C.R., *Theophilus, De Diuersis Artibus*, London, 1961.

Drake, F.M., 'The fourteenth-century stained glass of Exeter Cathedral', *Trans. Devonshire Assoc.*, vol. XLIV (1912), pp. 231–51.

Dufty, A.R., 'Withcote Chapel', *Arch. Jnl*, vol. CXII (1955), pp. 178–81.

Dugdale, W., *The Antiquities of Warwickshire*, 2 vols, 2nd edn, London, 1730.

Eden, F.S., 'Ancient painted glass in the conventual buildings, other than the Church, of Westminster Abbey', *Connoisseur*, vol. LXXVII (1927), pp. 81–8.

Eeles, F.C., 'The ancient stained glass of Westminster Abbey, from a manuscript dated 1938', *JBSMGP*, vol. XVII (*sic*), no. 2 (1978–9), pp. 17–29; vol. XVI, no. 3 (1979–80), pp. 47–53; vol. XVII, no. 1 (1980–1), pp. 10–17.

—— 'The fifteenth century stained glass at Clavering', *Trans. Essex Archaeological Soc.*, new series, vol. XVI (1923), pp. 77–87.

Eeles, F.C. and Peatling, A.V., *Ancient Stained and Painted Glass in the Churches of Surrey*, Surrey Archaeological Colls. (1930).

Egbert, D.D., *The Tickhill Psalter and Related Manuscripts*, New York and Princeton, 1940.

*English Romanesque Art 1066–1200*, exhib. cat., Arts Council, London, 1984.

Erskine, A.M. (ed.), *The Accounts of the Fabric of Exeter Cathedral, 1279–1353*, Devon & Cornwall Record Soc., new series, vols XXIV, XXVI (1981–3).

*Europäische Kunst um 1400*, Council of Europe exhib. cat., Vienna, 1962.

Evelyn White, C.H., *The Journal of William Dowsing*, Ipswich, 1885.

Fletcher, J.M.J., 'The stained glass in Salisbury Cathedral', *Wilts. Archaeological & Natural Hist. Mag.*, vol. XLV (1930–2), pp. 235–53.

Fletcher, W.G.D., 'The stained glass formerly in Battlefield Church', *Trans. Shropshire Archaeological & Natural History Soc.*, 3rd series, vol. III (1903), pp. XIX–XXI.

Folkard, K.M., 'A preliminary catalogue of English figurative stained glass roundels produced before 1530' (unpublished MA dissertation, University of York, 1987).

Fowler, J.T. (ed.), *Rites of Durham*, Surtees Soc., vol. CVII (1902).

Franks, A.W., *A Book of Ornamental Glazing Quarries*, London, 1849.

French, T., 'The glazing of the St William window in York Minster', *JBAA*, vol. CXL (1987), pp. 175–81.

—— 'John Thornton's monogram in York Minster', *Jnl of Stained Glass*, vol. XIX no. 1 (1989–90), pp. 18–23.

—— 'Observations on some medieval glass in York Minster', *Ants. Jnl*, vol. LI (1971), pp. 86–93.

French, T.W. and O'Connor, D., *York Minster: A Catalogue of Medieval Stained Glass I: The West Windows of the Nave* (*CVMA* Great Britain vol. III/1), London, 1987.

Frodl-Kraft, E., *Die Glasmalerei: Entwicklung, Technik, Eigenart*, Vienna and Zurich, 1970.

—— review of M.H. Caviness, *The Windows of Christ Church Cathedral Canterbury* (*CVMA* Great Britain vol. II), London, 1981, in *Kunstchronik*, vol. XXXVII (1984), pp. 229–41.

—— 'Zur Frage der Werkstattpraxis in der mittelalterlichen Glasmalerei', *Bayerisches Landesamt für Denkmalpflege*, Arbeitsheft 32 (1986), pp. 10–22.

Gage, J., 'Gothic glass: two aspects of a Dionysian aesthetic', *Art History*, vol. V (1982), pp. 36–58.

Ganderton, E.W. and Lafond, J., *Ludlow Stained and Painted Glass*, Ludlow, 1961.

Garrod, H.W., *Ancient Painted Glass in Merton College Oxford*, London, 1931.

Gee, E.A. 'The painted glass of All Saints' Church, North Street, York', *Archaeologia*, vol. CII (1969), pp. 151–202.

Green, E., 'The identification of the Eighteen Worthies commemorated in the heraldic glass in the hall windows of Ockwells Manor House', *Archaeologia*, vol. LVI (1899), pp. 323–36.

Greening Lamborn, E.A., *The Armorial Glass of the Oxford Diocese 1250–1850*, Oxford, 1949.

Grodecki, L., 'A propos d'une étude sur les anciens vitraux de la cathédrale de Canterbury', *Cahiers de civilisation médiévale*, vol. XXIV (1981), pp. 59–65.

—— 'Le vitrail et l'architecture au XIIe et au XIIIe siècles', *Gazette des Beaux-Arts*, vol. XXXIII (1949), pp. 5–24.

—— *Le Vitrail roman*, Fribourg and Paris, 1977.

—— *Les Vitraux de Saint-Denis*, vol. I (*CVMA* France Etudes vol. I), Paris, 1976.

—— 'Les Vitraux de Saint-Urbain de Troyes', *Congrès Archéologique*, vol. CXIII (1955), pp. 123–38.

Grodecki, L., and Brisac, C., *Gothic Stained Glass 1200–1300*, London, 1985.

Harden, D.B., 'Domestic window glass: Roman, Saxon and Medieval', in E.M. Jope (ed.), *Studies in Building History*, London, 1961, pp. 39–63.

Hardy, C.F., 'On the music in the painted glass of the windows in the Beauchamp Chapel at Warwick', *Archaeologia*, vol. LXI (1909), pp. 583–614.

Harrison, F., *The Painted Glass of York*, London, 1927.

Harvey, J.H. and King, D.G., 'Winchester College stained glass', *Archaeologia*, vol. CIII (1971), pp. 149–77.

Haselock, J. and O'Connor, D., 'The medieval stained glass of Durham Cathedral', *Medieval Art and Architecture at Durham Cathedral* (BAA Conference Transactions vol. III, 1977), 1980, pp. 105–29.

Hawthorne, J.G. and Smith C.S. (trs), *Theophilus, On Divers Arts*, New York, 1979.

Herbert, J.A., *The Sherborne Missal*, Roxburghe Club, 1920.

Hope, W.H., St J., *Windsor Castle: An Architectural History*, 2 vols, London, 1913.

Hudleston, F. and Hudleston C.R., 'Medieval glass in Penrith Church', *Trans. Cumberland & Westmorland Antiquarian & Archaeological Soc.*, new series, vol. LI (1951), pp. 96-102.

Hughes, J., *Pastors and Visionaries: Religion and Secular Life in Late Medieval Yorkshire*, Woodbridge, 1988.

Hunt, J.E., *The Glass in S. Mary's Church, Shrewsbury*, 6th edn, Shrewsbury, 1980.

Hutchinson, F.E., *Medieval Glass at All Souls College*, London, 1949.

James, M.R., 'An English medieval sketchbook, no. 1916 in the Pepysian Library, Magdalene College, Cambridge', *Walpole Soc.*, vol. XIII (1924-5), pp. 1-17.

—— 'On the glass in the windows of the library at St Albans Abbey', *Proc. & Communications of the Cambridge Anti-quarian Soc.*, vol. VIII (1891-4), pp. 213-20.

—— 'Pictor in carmine', *Archaeologia*, vol. XCIV (1951), pp. 141-66.

James, M.R. and Millar, E.G., *The Bohun Manuscripts*, Roxburghe Club, 1936.

James, M.R. and Tristram, E.W., 'The wall paintings in Eton College Chapel and in the Lady Chapel of Winchester Cathedral', *Walpole Soc.*, vol. XVII (1928-9), pp. 1-43.

Jones, L.S., 'St Michael and All Angels, Thornhill: a catalogue of the mediaeval glass' (unpublished B.Phil. dissertation, University of York, 1971).

Kauffmann, C.M., *Romanesque Manuscripts 1066-1190. A Survey of Manuscripts Illuminated in the British Isles, vol. III*, London, 1975.

Keen, M., *English Society in the Later Middle Ages 1348-1500*, London, 1990.

Kenyon, J.H., *The Glass Industry of the Weald*, Leicester, 1967.

Kerr, J., 'The east window of Gloucester Cathedral', *Medieval Art and Architecture at Gloucester and Tewkesbury* (BAA Conference Transactions vol. VII, 1981), 1985, pp. 116-29.

—— *The Repair and Maintenance of Glass in Churches*, Council for the Care of Churches, London, 1991.

Kidson, P., 'Panofsky, Suger and St Denis', *Jnl Warburg & Courtauld Institutes*, vol. L (1987), pp. 1-17.

King, D.J., 'An antiphon to St. Edmund in Taverham Church', *Norfolk Archaeology*, vol. XXXVI pt. IV (1977), pp. 387-91.

—— *Stained Glass Tours around Norfolk Churches*, Norfolk Soc., 1974.

Kirby, H.T., 'The Compton Verney glass', *Country Life*, vol. CXV (15 April 1954), pp. 1132-3.

Knight, B., 'Researches on medieval window lead', *Jnl of Stained Glass*, vol. XVIII no. I (1983-4), pp. 49-51.

Knowles, J.A., *Essays in the History of the York School of Glass-Painting*, London, 1936.

—— 'Horace Walpole and his collection of stained glass at Strawberry Hill', *JBSMGP*, vol. VII (1937-9), pp. 100-10, 131-3, 192.

Lafond, J., 'The stained glass decoration of Lincoln Cathedral in the thirteenth century', *Arch. Jnl*, vol. CIII (1947), pp. 119-56.

—— 'The traffic in old stained glass from abroad during the 18th and 19th centuries in England', *JBSMGP*, vol. XIV no. I (1964), pp. 58-67.

—— *Trois Etudes sur la technique du vitrail*, Rouen, 1943.

—— *Le Vitrail*, Paris, 1966.

—— 'Le Vitrail anglais de Caudebec-en-Caux', *La Revue des arts*, vol. IV (1954), pp. 201-6.

—— 'Un vitrail du Mesnil-Villeman (1313) et les origines du jaune d'argent', *Soc. Nat. des Antiquaires de France* (December 1954), pp. 94-5.

—— *Les Vitraux de l'église Saint-Ouen de Rouen* (CVMA France vol. IV, 2/1), Paris, 1970.

Lancaster, J., 'John Thornton of Coventry, glazier', *Trans. Birmingham Archaeological Soc.*, vol. LXXIV (1956), pp. 56-8.

Lasko, P. and Morgan, N.J. (eds), *Medieval Art in East Anglia 1300-1520*, exhib. cat., Norwich, 1973.

Leather, G.F.T., 'The Flodden window in the parish church of St Leonard, Middleton, in the County of Lancaster', *Hist. of Berwickshire Naturalists Club*, vol. XXX (1938-46), pp. 82-3.

Le Couteur, J.D., *Ancient Glass in Winchester*, Winchester, 1920.

—— *English Mediaeval Painted Glass*, London, 1926.

Legge, T., 'Trade guild windows', *JBSMGP*, vol. IV (1931-2), pp. 51-64.

Leicester Museums, *Painted Glass from Leicester*, Leicester, 1962.

Lethaby, W.R., 'Archbishop Roger's cathedral at York and its stained glass', *Arch. Jnl*, new series, vol. LXXII (1915), pp. 37-48.

—— *Westminster Abbey and the King's Craftsmen*, London, 1906.

—— *Westminster Abbey Re-examined*, London, 1925.

Lewis, M., *Stained Glass in North Wales up to 1850*, Altrincham, 1970.

*Lexikon der Christlichen Ikonographie*, 8 vols, Herder, 1968-76.

Lillich, M.P., 'The band-window: a theory of origin and development', *Gesta*, vol. IX no. I (1970), pp. 26-33.

—— 'European stained glass around 1300: the introduction of silver stain', *Akten des XXV Internationalen Kongresses für Kunstgeschichte, vol. VI, Europäische Kunst um 1300*, Vienna, 1986, pp. 45-60.

—— 'Gothic glaziers: monks, Jews, taxpayers, Bretons, women', *Jnl Glass Studies*, vol. XXVII (1985), pp. 72-92.

—— *The Stained Glass of Saint-Père de Chartres*, Connecticut, 1978.

London, H.S., *The Life of William Bruges, the first Garter King of Arms*, Harleian Soc., vols CXI, CXII (1970).

Lowe, J., 'The medieval English glazier, Part I', *JBSMGP*, vol. XIII (1959-63), pp. 425-32.

Mâle, E., *L'Art réligieux de la fin du Moyen Age en France*, Paris, 1949.

Marks, R., 'Cistercian window glass in England and Wales', in C. Norton and D. Park (eds), *Cistercian Art and Architecture in the British Isles*, Cambridge, 1986, pp. 211-27.

—— 'An English stonemason in stained glass', in A. Borg and A. Martindale (eds), *The Vanishing Past, Studies of Medieval Art, Liturgy and Metrology presented to Christopher Hohler*, British Archaeological Reports, International Series vol. III, 1981, pp. 105-7.

—— 'The glazing of the Collegiate Church of the Holy Trinity, Tattershall (Lincs.): a study of late fifteenth-century glass-painting workshops', *Archaeologia*, vol. CVI (1979), pp. 133-56.

—— 'The glazing of Fotheringay church and college', *JBAA*, vol. CXXXI (1978), pp. 79-109.

—— 'Henry Williams and his "ymage of deth" roundel at Stanford on Avon, Northamptonshire', *Ants. Jnl*, vol. LIV (1974), pp. 272-4.

—— 'A late medieval glass-painting workshop in the region of Stamford and Peterborough', in P. Moore (ed.), *Crown in Glory. A Celebration of Craftsmanship - Studies in Stained Glass*, Norwich, n.d., pp. 29-39.

—— 'Medieval stained glass in Bedfordshire', *Bedfordshire Mag.*, vol. XV (1976), pp. 179-84, 228-33.

—— 'The mediaeval stained glass of Wells Cathedral', in L.S. Colchester (ed.), *Wells Cathedral: A History*, Shepton Mallet, 1982, pp. 132-47.

—— 'Recent discoveries in medieval art', *Scottish Art Review*, vol. XVI no. I (May 1984), pp. 13-20.

—— *The Stained Glass of the Collegiate Church of the Holy Trinity, Tattershall (Lincs.)*, New York and London, 1984.

—— 'The stained glass patronage of Sir Reginald Bray', *Report Soc. Friends of St George's & the Descendants of the Knights of the Garter*, vol. V no. 5 (1973-4), pp. 199-202.

—— 'Window glass' in J. Blair and N. Ramsay (eds), *English Medieval Industries*, London, 1991, pp. 265-94.

—— 'Window glass', in T.B. James and A.M. Robinson, *Clarendon Palace* (Report of the Research Committee of the Society of Antiquaries of London no. XLV), 1988, pp. 229-33.

Marks, R. and Morgan, N., *The Golden Age of English Manuscript Painting 1200-1500*, London, 1981.

Marks, R. and Payne, A. (eds), *British Heraldry from its Origins to c.1800*, exhib. cat., British Museum, London, 1978.

Marshall, G., 'Some remarks on the ancient stained glass in Eaton Bishop church, co. Hereford', *Trans. Woolhope Naturalists' Field Club* (1921-3), pp. 101-14.

Martindale, A., 'Patrons and Minders: The intrusion of the secular into sacred spaces in the late Middle Ages', in D. Wood (ed.), *The Church and the Arts* (Studies in Church History, vol. XXVIII), Oxford, 1992, pp. 143-78.

Moore, P. (ed.), *Crown in Glory. A Celebration of Craftsmanship - Studies in Stained Glass*, Norwich, n.d.

Morgan, F.C., *Hereford Cathedral Church Glass*, 2nd edn, Leominster, 1967.

Morgan, N.J., *Early Gothic Manuscripts 1190-1250. A Survey of Manuscripts Illuminated in the British Isles*, vol. IV, London, 1982.

—— *Early Gothic Manuscripts 1250-1285. A Survey of Manuscripts Illuminated in the British Isles*, vol. IV, London, 1988.

—— *The Medieval Painted Glass of Lincoln Cathedral* (CVMA Great Britain Occasional Paper III), London, 1983.

Morris, R., *Churches in the Landscape*, London, 1989.

Morris, R.K., 'Tewkesbury Abbey: the Despenser mausoleum', *Trans. Bristol & Glos. Archaeological Soc.*, vol. XCIII (1974), pp. 142-55.

Nelson, P., *Ancient Painted Glass in England 1170-1500*, London, 1913.

Newstead, R., 'Glasshouse in Delamere Forest, Cheshire', *Jnl Chester & N. Wales Architectural, Archaeological & Historic Soc.*, new series, vol. XXXIII (1939), pp. 32-9.

Newton, P.A., *The County of Oxford: A Catalogue of Medieval Stained Glass* (CVMA Great Britain vol. I), London, 1979.

—— 'Schools of glass-painting in the Midlands 1275-1430' (unpublished Ph.D. thesis, University of London, 3 vols, 1961).

—— 'Some new material for the study of the iconography of St. Thomas Becket', *Thomas Becket: Actes du Colloque International de Sédières*, 1973, pp. 255-63.

Newton, R., 'Medieval methods for attaching "Jewels" to Stained Glass', *Stained Glass* (Spring 1981), pp. 50-3.

Newton, R., and Davison, P., *The Conservation of Glass*, London, 1988.

Norton, C., Park, D. and Binski, P., *Dominican Painting in East Anglia: The Thornham Parva Retable and the Musée de Cluny Frontal*, Woodbridge, 1987.

O'Connor, D., 'Debris from a medieval glazier's workshop', *Bull. York Archaeological Trust*, vol. III no. I (August 1975), pp. 11-17.

—— 'The medieval stained glass of Beverley Minster', *Medieval Art and Architecture in the East Riding of Yorkshire* (BAA Conference Transactions vol. IX, 1983), 1989, pp. 62-90.

O'Connor, D. and Haselock, J., 'The stained and painted glass', in G.E. Aylmer and R. Cant (eds), *A History of York Minster*, Oxford, 1977, pp. 313-93.

Oswald, A., 'Barnard Flower, the King's Glazier', *JBSMGP*, vol. XI (1951-5), pp. 8-21.

—— 'The glazing of the Savoy Hospital', *JBSMGP*, vol. XI (1951-5), pp. 224-32.

Pächt, O., 'A Giottesque episode in English medieval art', *Jnl Warburg & Courtauld Institutes*, vol. VI (1943), pp. 51-70.

Panofsky, E., *Early Netherlandish Painting*, 2 vols, Cambridge, Mass., 1953.

Park, D., 'A lost fourteenth-century altar-piece from Ingham, Norfolk', *Burlington Mag.*, vol. CXXX no. 1019 (February 1988), pp. 132-6.

Perrot, F., 'La signature des peintres verriers', *Revue de l'art*, no. 26 (1974), pp. 40-5.

Pevsner, N. (and co-authors), individual volumes in *The Buildings of England* series.

Phillips, D., *Excavations at York Minster, vol. II, The Cathedral of Archbishop Thomas of Bayeux*, London, 1985.

Phillips, J., *The Reformation of Images: Destruction of Art in England 1535-1660*, Berkeley, 1973.

Pitcher, S., 'Ancient stained glass in Gloucestershire churches', *Trans. Bristol & Glos. Archaeological Soc.*, vol. XLVII (1925), pp. 287-345.

Rackham, B., *The Ancient Glass of Canterbury Cathedral*, Canterbury, 1949.

—— 'The ancient windows of Christ's College Chapel, Cambridge', *Arch. Jnl*, vol. CIX (1952), pp. 132-42.

—— 'The glass-paintings of Coventry and its neighbourhood', *Walpole Soc.*, vol. XIX (1930-1), pp. 89-110.

*Radiance and Reflection: Medieval Art from the Raymond Pitcairn Collection*, exhib. cat., Metropolitan Museum of Art, New York, 1982.

Randall, L.M.C., *Images in the Margins of Gothic Manuscripts*, Berkeley, 1966.

Ransome, D.R., 'The struggle of the Glaziers' Company with the foreign glaziers, 1500-1550', *Guildhall Miscellany*, vol. II no. I (September 1960), pp. 12-20.

Reddish, H., 'The St. Helen window, Ashton-under-Lyne: a reconstruction', *Jnl of Stained Glass*, vol. XVIII no. 2 (1986-7), pp. 150-61.

Reyntiens, P., *The Technique of Stained Glass*, new edn., London, 1977.

Rickers, J., 'The Apocalypse scenes in the east window of York Minster' (unpublished MA dissertation, University of York, 1992).

Rickert, M., *Painting in Britain: The Middle Ages*, 2nd edn, Harmondsworth, 1965.

Ridgway, M.H. and Leach G.B., 'Further notes on the glass-house site at Kingswood, Delamere, Cheshire', *Jnl Chester & N. Wales Architectural, Archaeological & Historic Soc.*, new series, vol. XXXVII, pt. I (1948), pp. 133-40.

Ritter, G., *Les Vitraux de la cathédrale de Rouen*, Cognac, 1926.

Robinson, J.A., 'The fourteenth-century glass at Wells', *Archaeologia*, vol. LXXXI (1931), pp. 85-118.

Routh, P.E.S., 'A gift and its giver: John Walker and the east window of Holy Trinity, Goodramgate, York', *Yorks. Archaeological Journal*, vol. LVIII (1986), pp. 109-21.

Royal Commission on Historical Monuments of England, volumes on individual counties, towns and cities.

Rushforth, G. McN., 'The baptism of St. Christopher', *Ants. Jnl*, vol. VI (1926); pp. 152-8.

—— 'The glass in the quire clerestory of Tewkesbury Abbey', *Trans. Bristol & Glos. Archaeological Soc.*, vol. XLVI (1924), pp. 289-324.

—— 'The great east window of Gloucester Cathedral', *Trans. Bristol & Glos. Archaeological Soc.*, vol. XLIV (1922), pp. 293-304.

—— *Medieval Christian Imagery*, Oxford, 1936.

—— 'The painted windows in the Chapel of the Vyne in Hampshire', *Walpole Soc.*, vol. XV (1926-7), pp. 1-20.

—— 'Seven Sacraments compositions in English medieval art', *Ants. Jnl*, vol. IX (1929), pp. 83-100.

—— *The Windows of the Church of St. Neot, Cornwall* (reprinted from *Trans. Exeter Diocesan Architectural & Archaeological Soc.*, vol. XV), Exeter, 1937.

Salzman, L.F., *Building in England down to 1540*, reprinted Oxford, 1967.

—— 'The glazing of St. Stephen's Chapel, Westminster, 1351-2', *JBSMGP*, vol. I (1926-7), pp. 14-16, 31-5, 38-41.

—— 'Medieval glazing accounts', *JBSMGP*, vol. II (1927-8), pp. 116-20, 188-92; vol. III (1929-30), pp. 25-30.

Sandler, L.F., 'A follower of Jean Pucelle in England', *Art Bulletin*, vol. LII (1970), pp. 363-72.

—— *Gothic Manuscripts 1285-1385. A Survey of Manuscripts Illuminated in the British Isles, vol. V*, 2 vols, Oxford, 1986.

—— *The Peterborough Psalter in Brussels and Other Fenland Manuscripts*, London, 1974.

—— *The Psalter of Robert De Lisle*, London, 1983.

Sauerländer, W., *Gothic Sculpture in France 1140-1270*, London, 1972.

Schiller, G., *Iconography of Christian Art*, 2 vols, London, 1971, 1972.

Sewter, A.C., 'The place of Charles Winston in the Victorian revival of the art of stained glass', *JBAA*, 3rd series, vol. XXIV (1961), pp. 80-91.

Slack, P., 'Religious protest and urban authority: the case of Henry Sherfield, iconoclast, 1633', in D. Baker (ed), *Schism, Heresy and Religious Protest* (Studies in Church History, vol. IX), Cambridge, 1972, pp. 295-302.

Smith, A., 'Henry VII and the appointment of the King's Glazier', *Jnl of Stained Glass*, vol. XVIII no. 3 (1988), pp. 259-61.

Smith, J.T., *Antiquities of Westminster*, London, 1807.

Smith, M.Q., *The Stained Glass of Bristol Cathedral*, Bristol, 1983.

Steinberg, S.H., 'A portrait of Beatrix of Falkenburg', *Ants. Jnl*, vol. XVIII (1938), pp. 142-5.

Stone, L., *Sculpture in Britain: The Middle Ages*, 2nd edn, Harmondsworth, 1972.

Swanson, H., *Building Craftsmen in late Medieval York* (Borthwick Papers no. 63), York, 1983.

Temple, E., *Anglo-Saxon Manuscripts 900-1066. A Survey of Manuscripts Illuminated in the British Isles, vol. II*, London, 1976.

Thorne, W.T., 'Was coloured glass made in medieval England? Parts I and II, *JBSMGP*, vol. XII (1955-9), pp. 9-14, 108-16.

Toke, N.E., 'The medieval stained glass windows at Upper Hardres', *Archaeologia Cantiana*, vol. XLVII (1935), pp. 153-65.

Toy, J., *A Guide and Index to the Windows of York Minster*, York, 1985.

Tristram, E.W., *English Medieval Wall Painting. The Thirteenth Century*, 2 vols, Oxford, 1950.

—— *English Wall Painting of the Fourteenth Century*, London, 1955.

Victoria History of the Counties of England, volumes on individual counties.

Vila-Grau, J., *El Vitrall Gòtic a Catalunya. Descoberta de la taula de vitraller de Girona*, Reial Acadèmia Catalana de Belles Arts de Saint Jordi, Barcelona, 1985.

Wagner, A.R. and Mann, J.G., 'A fifteenth-century description of the brass of Sir Hugh Hastings at Elsing, Norfolk', *Ants. Jnl*, vol. XIX (1939), pp. 421-8.

Watson, A., *The Early Iconography of the Tree of Jesse*, Oxford and London, 1934.

Wayment, H., 'The east window of St. Margaret's, Westminster', *Ants. Jnl*, vol. LXI (1981), pp. 292-301.

—— 'The foreign glass at Hengrave Hall and St. James', Bury St. Edmunds', *Jnl of Stained Glass*, vol. XVIII no. 2 (1986-7), pp. 166-74.

—— 'The glazier's sorting marks at Fairford', in P. Moore (ed.), *Crown in Glory*, Norwich, n.d., pp. 23-8.

—— *King's College Chapel Cambridge: The Great Windows. Introduction and Guide*, Cambridge, 1982.

—— 'The stained glass in the Chapel of the Vyne', *National Trust Studies* (1980), pp. 35-47.

—— 'The stained glass of the Chapel of the Holy Ghost, Basingstoke', *Archaeologia*, vol. CVII (1982), pp. 141-52.

—— *The Stained Glass of the Church of St. Mary, Fairford, Gloucestershire* (Society of Antiquaries of London Occasional Paper, new series, vol. V, 1984).

—— 'Twenty-four vidimuses for Cardinal Wolsey', *Master Drawings*, vol. XXIII/XXIV no. 4 (1988), pp. 503-17.

—— *The Windows of King's College Chapel, Cambridge* (*CVMA* Great Britain supplementary vol. I), London, 1972.

Welander, D., *The Stained Glass of Gloucester Cathedral*, Frome, 1985.

Wells, W., *Stained and Painted Glass. Burrell Collection*, Glasgow, 1965.

—— *Stained and Painted Heraldic Glass. Burrell Collection*, Glasgow, 1962.

Wentzel, H., *Meisterwerke der Glasmalerei*, 2nd edn, Berlin, 1954.

—— 'Un projet de vitrail au XIVe siècle', *Revue de l'art*, vol. X (1970), pp. 7-14.

Westlake, N.H.J., *A History of Design in Painted Glass*, 4 vols, London and Oxford, 1881-94.

Whitehead, J.R., 'An archbishop and his chantry: the Rokeby Chapel, Kirk Sandall, near Doncaster', *Country Life*, vol.

CLXXIII (24 March 1983), pp. 738-9.

Wilkinson, H., 'Fifteenth-century |glass| in Bardwell Church, Suffolk', *JBSMGP*, vol. V (1933-4), pp. 159-62.

Willis, R. and Clark, J.W., *The Architectural History of the University of Cambridge and of the Colleges of Cambridge and Eton*, 4 vols, Cambridge, 1886.

Wilson, C., *The Gothic Cathedral*, London, 1990.

Wilson, C., Tudor-Craig, P., Physick, J. and Gem, R., *Westminster Abbey* (New Bell's Cathedral Guides), London, 1986.

Winston, C., *An Inquiry into the Difference of Style Observable in Ancient Glass Paintings*, 2 vols, 2nd edn, London, 1867.

—— *Memoirs Illustrative of the Art of Glass-Painting*, London, 1865.

Wood, E.S., 'A medieval glasshouse at Blunden's Wood, Hambledon, Surrey', *Surrey Archaeological Colls.*, vol. LXII (1965), pp. 54-79.

Wood, M., *The English Mediaeval House*, London, 1965.

Woodforde, C., 'Ancient glass in Lincolnshire I – Haydor', *Lincolnshire Mag.*, vol. I, pt 3 (1933), pp. 93-7.

—— *English Stained and Painted Glass*, Oxford, 1954.

—— 'Essex glass-painters in the Middle Ages', *JBSMGP*, vol. V (1933-4), pp. 110-15.

—— 'Glass-painters in England before the Reformation', *JBSMGP*, vol. VI (1935-7), pp. 62-9, 121-8.

—— 'A group of fourteenth-century windows showing the Tree of Jesse', *JBSMGP*, vol. VI (1935-7), pp. 184-90.

—— 'The medieval glass in Elsing Church, Norfolk', *JBSMGP*, vol. IV (1931-2), pp. 134-6.

—— *The Norwich School of Glass-Painting in the Fifteenth Century*, Oxford, 1950.

—— 'Painted glass in Saxlingham Nethergate Church, Norfolk', *JBSMGP*, vol. V (1933-4), pp. 163-9.

—— 'The painted glass in Withcote Church', *Burlington Mag.*, vol. LXXV (1939), pp. 17-22.

—— 'Some medieval English glazing quarries painted with birds', *JBAA*, 3rd series, vol. IX (1944), p. 1-11.

—— 'The stained and painted glass in Hengrave Hall, Suffolk', *Proc. Suffolk Institute of Archaeology & Natural History*, vol. XXII (1936), pp. 1-16.

—— *Stained Glass in Somerset 1250-1830*, Oxford, 1946.

—— *The Stained Glass of New College Oxford*, Oxford, 1951.

Zakin, H.J., *French Cistercian Grisaille Glass*, New York and London, 1979.

—— 'Grisailles in the Pitcairn collection', *Medieval Stained Glass: Selected Papers from the XIth International Colloquium of the Corpus Vitrearum* (*CVMA* United States Occasional Papers I), New York, 1985, pp. 82-92.

# Index

Aaron 101
Abbey Dore (Heref. & Worcs.) 128, 136, Fig. 100
Abbreviated Domesday Book, *see* London, Public Record Office
Abdy, Roger, Master of Balliol College Oxford 99
Abell, William *see* manuscript illuminators
Abia 110, Fig. 85
Abingdon (Oxon.) 171
*Abdingdon Missal see* Oxford, Bodleian Library
abrasion 38, Pl. II(a)
Absalom 70, 181
Acaster Malbis (N. Yorks.) 158
accounts, glazing 3, 4, 21, 25, 30, 31, 33, 36, 37, 39, 40, 44, 47–51, 87, 92–7, 153, 173, 189, 191, 222, 230, 231, 232
Accursius 101
Adam 119
Adderbury (Oxon.) 173, 177, 178
Admont, Henry von, Abbot of St Walpurgis bei St Michael (Austria) 11
Adoration of the Magi *see* Christ
Aelfheah, Bishop of Winchester 106
Aethelwold, Bishop of Winchester 106
Aethelwulf, monk of Lindisfarne 105
*Age of Chivalry* exhibition xxv
Agincourt, Battle of (France) 76
*Agnus Dei* 99
Ailnoth the Engineer 92
Albumasar 101
Alcock, John, Bishop of Worcester 5, 17, 42, 203

Aldermaston (Berks.) 139
Aldwin, Prior of Great Malvern 90,Fig. 74
Aldwincle (Northants.), St Peter's 168, Fig. 2(a)
Alfonso X, King of Castile 38
Alfred, King 88
Alkham, Thomas, rector of Southfleet 4
Allexton (Leics.) 155
Alnwick, William, Bishop of Lincoln 19, 97, 185, 188, Fig. 155
*Alphonso Psalter see* London, British Library
Altenberg Abbey (Germany) 174, 243
Amalekite, death of the 68
Amiens (France) 143
Aminadab 122, 123, Pl. VI
Angels 65, 85, 96, 99, 101, 143, 155, 157, 159–60, 162, 170, 178, 184–5, 188, 194–5, 201, 206, 211, 212, 215, 217, 224, Pl. XXX, Figs 51, 68–9, 115, 125, 127, 133, 165, 175, 182; *see also* Archangels
Angels, Orders of 82, 173, 181, 182, 185, 188
Angers Cathedral (France) 39, 76, 110
Anglo-Norman glass 110–12, Figs 85–6
Anglo-Saxon glass 92, 105–9, Pl. IV, Fig. 83
Annunciation *see* Mary, Annunciation to
Anthony of Pisa 28
Antona, Nicholas de, mason 52
Apocalypse *see* Revelation, Book of
Apostles 25, 54, 96, 125, 140, 153, 154, 158, 165, 170, 173, 174, 188–9, 206, 211, 212, 235, 238, Figs 98, 123, 141, 200; *see also under* Creed and names

Appledore (Kent) 231
Archangels 85, 193, 199 *see also* Annunciation, Gabriel, St Michael, Raphael, Uriel
Archimedes 101
architecture and stained glass 41, 51–5, 105–6, 127–9, 135, 142–3, 147, 148, 165, 166, 171, 190, 195, 204, 211, 215, Figs 32–5, 92, 132
Arden family 93
Aristotle 101
armatures 37, 117, 122, Fig. 29
Arminianism 235
Arthur, King 88, 89
Arundel (W. Sussex) 80
Asciotti 243
Ascot Doilly Castle (Oxon.) 92
Ashbourne (Derbys.) 139, 140
Ashleworth (Glos.) 203
Ashridge (Herts.) 243
Ashton (Devon) 193
Ashton, Sir Thomas 200
Ashton-under-Lyne (Greater Manchester) 73, 200
Assheton, Sir Richard 6
Asterius, Archbishop Pl. IX
Asthall (Oxon.) 17
Astley Abbots (Salop.) 139, Fig. 110
Astley (Warwicks.) 171
Aston Rowant (Oxon.) 170
Athelstan, King 88
Aubrey, John 238
Augsburg Cathedral (Germany) 39, 109
Augustinian glass 10, 40, 54, 55, 68, 76, 81, 110, 136, 141–3 145, 148, 153, 162, 164–5, 182, 226, 229, Pl. IX, Figs 35, 57, 111, 124, 130, 131; *see*

*also under* individual foundations and cause

Auxerre Cathedral (France) 129, Fig. 103

Avioth Cathedral (France) 39

Aylesbury (Bucks.), King's Head Hotel 99

Aylewyn family 6, 20

Ayston (Leics.) 76

Badby (Northants.) 19

badges 5, 19, 48–9, 93–7, 99, 102, 213, 215, 224, Figs 15, 82, 183

Badlesmere (Kent) 129

Bagot's Park (Staffs.) 30

Ballantine, James 244

band windows 148, 150, 167, Pl. XI, Figs 116, 120, 123

Barby (Northants.) 155, Fig. 125

Bardwell (Suffolk) 170

Barfreston (Kent) 112

Barkway (Herts.) 169

Barley, Keith 246

Barnack (Cambs.) 202

Barton Turf (Norfolk) 198

*bas-de-page* illumination 153, 154, 155

Basingstoke (Hants), Chapel of Holy Ghost 222

Basset, Lord Ralph of Drayton 16, Fig. 12

Battle Abbey (E. Sussex) 136

Battlefield (Salop.) 187, 188, Fig. 155

Bawburgh (Norfolk) 85

Beauchamp, Richard *see* Warwick, Earl of

*Beauchamp Pageants see* London, British Library

Beaufort, Lady Margaret 25, 202

Beauvais (France) 109

Bec family 6

Becket, Thomas *see* St Thomas Becket

Beckford, William 241

Beckley (Oxon.) 71, Fig. 51

Becksmann, Rüdeger 147

Bede 105, 108

Bede, *Life of St Cuthbert see* Cambridge, Corpus Christi College and Oxford, University College

Bedford, St Paul's 78

Beeston-next-Mileham (Norfolk) 6

Bekesbourne (Kent) 137

*Belleville Breviary see* Paris, Bibliothèque Nationale

Benedict, Prior of Canterbury and Abbot of Peterborough 64, 68, 118

Benedictine glass (English) *see under* Battle Abbey, Bury St Edmunds, Canterbury Cathedral, Durham Cathedral, Ely Cathedral, Evesham Abbey, Gloucester Cathedral, Great Malvern Priory, Little Malvern Priory, Long Melford, Meldreth, Peterborough Cathedral, Ramsey Abbey, St Albans Abbey, St Benet at Holme Abbey, Sherborne Abbey, Tewkesbury Abbey, Westminster Abbey, Winchester Cathedral, New Minster, Nunnaminster, Old Minster, Worcester Cathedral, Wroxall

Bere Ferrers (Devon) 12, 240

Berne Cathedral (Switzerland) 39

Berners, Sir James 171

Beverley, John de 8

Beverley Minster (Humberside) 113, 124, 158, 182

*Biblia Pauperum* 61, 68, 205, 217, Fig. 48

Biddle, Martin 106

Birtsmorton (Heref. & Worcs.) 19, 171, Fig. 139

Biscop, Benedict, Abbot of Monkwearmouth 3, 105

Bisham (Berks.) 167, 232

Black Death 166

black letterscript 167

Blackfriars 64

Blakeborne, Henry de, canon of Exeter Cathedral 25

Blasphemy 80

Bledington (Glos.) 203

Blomefield, Francis, antiquary 217, 240

Blore Ray (Staffs.) 203

Blunden's Wood, Hambledon (Surrey), glass-house 29 and Fig. 23, 30

Blunt, Anthony 220

Blythburgh (Suffolk) 51, 75

Bodmin (Cornwall) 40

Bohun, Earls of Northampton 93

Bohun manuscripts 169, 170

Bolton, Alice 84

Bolton Percy (N. Yorks.) 182

borders 19, 48, 49, 55, 85–6, 93, 99, 101, 114–15, 121, 123, 124, 125, 126, 127, 133, 139, 141, 143, 147, 150, 153–4, 155, 157, 162, 167, 169, 174, 196, 222, 225, Figs 36, 70, 75, 89, 124, 137

Bordesley (Heref. & Worcs.) 136

Boroughbridge (N. Yorks.) 139

Boston, Mass. (USA), Museum of Fine Arts 78

Bothal (Northumberland) 159

Bothe, John, Bishop of Exeter 193–4

Boucicaut Master *see* manuscript illuminators

Bourchier, Thomas, Archbishop of Canterbury 206

Bourges Cathedral (France) 37, 39, 124, 136

Bourges, Jewish Boy of 71

Brabourne (Kent) 128, 137, 143, Pl. VIII(a)

Bradley (Staffs.) 82

Bradwell Abbey (Bucks.) 40, 153, Fig. 124

Brailes, William de *see* manuscript illuminators

Braine, St-Yved (France) 124

Brandenburg Cathedral (Germany) 33

Brandeston (Suffolk) 80, 199

Bray, Sir Reginald 5, 42, 202, Fig. 11

Brede (E. Sussex) 223

Bredon (Heref. & Worcs.) 150

Breggs, John 20

Brent Eleigh (Essex), wall-paintings 168

Brescia, Queriniana Lib. MS A.V.17 (Psalter) 160

*Breviarium ad Usum Insignis Ecclesiae Sarum* 61

Breviary 72

Bridges, John 240, Fig. 199

Brinsop (Heref. & Worcs.) 180

Bristol Cathedral 141, 164, 165, 184, 229, Fig. 131

British Library *see* London: British Library

Brixworth (Northants.) 105, 106

Broadwell (Oxon.) 235

Bromholm (Norfolk), Rood of 75

Bromley Hurst nr Abbot's Bromley (Staffs.) 30

Broughton (Bucks.) 80

Broughton (Staffs.) 203, Fig. 172

Broughton Castle (Oxon.) 93

Browne, William 102, Fig. 82

Bruges (Belgium), St John's Hospital Memling Museum 97

Bruges, William, Garter King of Arms 73, 241

Brussels (Belgium): Bibliothèque Royale MS 9961–62 (*Peterborough Psalter*) 67, 68; Musée Royaux des Beaux-Arts 25, Fig. 176

Bryn Athyn, Penn. (USA), Pitcairn Collection Fig 114

Bubwith, Nicholas, Bishop of Bath and Wells 99

Buckden (Cambs.) 85, 184, Fig. 69

Buckland (Glos.) 99, 203

Buckland (Herts.) 160, 169

Buildwas Abbey (Salop.), tile mosaic pavement 55, Fig. 38

Bullen, Anne 206

Bullen, Sir Geoffrey 206

Burghley House (Cambs.) 206, 241

Burton, William 238

Bury St Edmunds (Suffolk) 198, 222; Abbots of 199, *see also* Codenham, Rattlesden; St Mary's 85

Cadbury (Devon) 79, 194

Calder Abbey (Cumbria) 136

Calvin, John 230

CAMBRIDGE
    Christ's College 40, 209; Corpus Christi College MS 61 (Chaucer, *Troilus and Criseyde*) 184; Corpus Christi College MS 183 (Bede's *Life of St Cuthbert*) 61, 107; Emmanuel College MS 252 (psalter) 135; Fitzwilliam Museum 184; Fitzwilliam Museum MS 242 (Book of Hours) 155; Great St Mary's 207; Jesus College 101; King's College, *Founder's Charter upon Act of Parliament* 194; King's College chapel xxv, 4, 22, 23, 25, 27, 30, 37, 44, 48, 49, 64, 67, 68, 191, 207, 209, 212, 213, 215, 217, 219, 224, 246, Pls XXVIII, XXIX, Figs 184, 185; Magdalene College Pepysian MS 1916 (*Pepysian Sketchbook*) 31, 32, 55, 174, Fig. 24(a); St John's College 21, 22, 23, 49, 50, 97; Trinity College MS B. 11.4 (psalter) 57, 135; Trinity College MS R 14.5 205; University Archives, MS Collect Admin. 3, 176; University Library MS Ee.3.59 (*L'Estoire de Seint Aedward le Rei*) 108, 135

Campiun, William, stonemason 13, Figs 9, 27

canopies 33, 46, 48, 49, 51-4, 58, 95, 139, 147-8, 157, 158, 159-61, 165, 169, 174, 176-7, 178, 180, 183, 184, 188, 191-2, 199, 202, 203, 211, 212-13, 217, 220, 223, 224, 225, 226, Pls I, III(b), XVII, XVIII,

Figs 24(c), (d), 25, 33, 40, 110, 122, 124, 128, 135, 136, 137, 141, 159, 160, 200

CANTERBURY (Kent)
    Archbishops of 99, 101, *see also* St Augustine, Bourchier, Chichele, Cranmer, Laud, Pechan, St Thomas Becket, Wetherset 1; *Canterbury Psalter see* Paris, Bibliothèque Nationale; Cathedral xxv, 3, 14, 37, 46, 60, 61, 64, 65, 67, 68, 71, 73, 75, 81, 88, 110, 113, 114, 117-24, 125, 126, 127, 135, 137, 139, 140, 178, 180, 204, 206, 229, 238, 244, 246, Pls VI, VIII, XXV, Figs 29, 85, 92-6, 143, 144(c), 196; Cathedral Library MS C 246, 61; St Augustine's Abbey 108, 264 note 37; St John's Hospital 20, 25

Cantilupe, Thomas *see* St Thomas Cantilupe

Cantilupe, Walter de, Bishop of Worcester 78

Canute, King 108, 178

Carlisle (Cumbria), Cathedral 81; St Cuthbert's 159

Carlton Scroop (Lincs.) 11, 153, Fig. 2(b)

*Carmelite Missal see* London, British Library

Carslegh, Peter, rector of Winscombe 63, 226

Carter, John 240

Cartmel Fell (Cumbria) 79, 200, 226

Cartmel Priory (Cumbria) 182, 226, 229

cartoons 31, 33, 34, 44, 46, 181, 182, Fig. 25

Catechism 65

Catherine of Aragon, wife of Henry VIII 14, 25, 49, 220, 222, 224

Catterick (N. Yorks.) 16

Caudebec-en-Caux (France) 205

Cave, Sir Thomas 234

Caviners, Madeleine 115, 121, 122, 125, 206

Caxton, William 61

Cecil, Robert 235

Cecily, Duchess of York *see* York, Duchesses of

Cecily, Princess, daughter of Edward IV 206, Pl. XXV

Cennini, Cennino 28, 39, 46

Chalgrave (Beds.) Fig. 102(d)

Châlons-sur-Marne (France) 121, 124, 129, 139

Chamberlain, Sir William 198

Chantilly (France), Musée Condé MS 1695 (*Ingeborg Psalter*) 123

Charles the Bald, Emperor 92

Charles the Bold, Duke of Burgundy 205

Charles, Nicholas (Lancaster Herald) 238

Charles I 235, 236

Charleton, Sir John de 13, 17

Charter of Indulgence (London, PRO E/135/15 1) 169

Chartham (Kent) 147, 153, Fig. 121

Chartres (France): Cathedral 21, 37, 40, 51, 65, 76, 112, 115, 117, 118, 121, 124, 126-7, 136, 167, 169; St-Pierre 144

Chase, Thomas, Master of Balliol College 99

Chaucer, Geoffrey 61, 94, 184

Chaundler, Thomas, Chancellor of Oxford University 205

Checkley (Staffs.) 70, 76, 97, 153

Chertsey Abbey (Surrey), tiles 55, Fig. 36

Chester, guild of glaziers 42-3

Chetwode Priory (Bucks.) 10, 141, 142, 143, 148, Fig. 111

Chichele, Henry, Archbishop of Canterbury 16, 89, 101

Chichester Cathedral (W. Sussex) 21, 50, 113

Chiddingfold (Surrey) 29, 30, 31,

Chinnor (Oxon.) 80

CHRIST 25, 54, 65, 68, 70, 72, 79, 80, 81, 109, 119, 121, 124, 125, 139, 143, 153, 154, 165, 168, 170, 183, 184, 193, 194, 196, 201, 211, 235, Figs 4, 94, 110, 112, 161, 179; Adoration of Magi 126-7, 213, Fig. 188; Agony in the Garden 211, 230; ancestors of 110, 117, 119, 196, Pl. VI, Figs 85, 93; Ascension 101, 120, 184; as Child 10, 11, 12, 33, 39, 68, 70, 93, 96, 117, 139, 165, 174, 178, 184, 186, 193, 206, Pls I, II(d), XIX, Figs 6, 24(c), 142; Crucifixion 12, 25, 70, 96, 139, 167, 168, 169, 173, 174, 176, 193, 202, 203, 206, 211, 215, 220, 222, 226, Pl. VIII(b), Figs 8, 21, 46, 84, 134, 140, 178, 187; Deposition 211, 236, Figs 176, 195; Entombment Fig. 176; Entry into Jerusalem 70, 211; Flight into Egypt 115, 139, 211, Fig. 188; Incarnation 85, 120, 190; Infancy 65,

126, 158, 196, Fig. 188; in Majesty
81, 93, 108, 125, 135, 170, Pl. XXX;
Last Supper 58, 70, 183, Figs 40,
156; Marriage at Cana Fig. 91;
Massacre of the Innocents 134, 135;
Miraculous Draught of Fishes 114,
Fig. 91; Nativity 93, 155, Fig. 125;
*Noli me tangere* 203; Passion 25, 65,
70, 79, 81, 93, 114, 117, 120, 134,
157, 158, 188, 196, 211, 220, 222,
235, Pl. XXVI, Fig. 176; Pentecost
70, 78, 120, 134, 184, 211;
Resurrection 134, 222, Fig. 176;
Second Coming 81; Showing
Wounds 184, Figs 138, 153; *see also*
Last Judgement, Mary, New
Testament, *Pietà*, Trinity, typology
Christie's 243
Chrysippus 101
Cicero 101
Cistercian glass 11, 19, 40, 110-11,
128-9, 136-7, 162, 167, 169, 174,
180, 200, 229, 230, Figs 7, 100, 137;
*see also under* individual foundations
and works
Clare, Eleanor de 12, 89, 165, Fig. 2(d)
Clare Chasuble 55
Clarendon (Wilts.) 10, 37, 61, 93, 129
Clavering (Essex) 73
Cley (Norfolk) 198
Cliffe Castle (Northants.) 93
Clifton, Walter de, Abbot of Warden 11,
Fig. 137
Clipstone (Northants.) 93
Clopton family 5, 88, 198
Clothall (Herts.) 169
Cockayne Hatley (Beds.) 85
Codenham, William, Abbot of Bury St
Edmunds 199
Coel, King, of Colchester 75
Colchester (Essex) 198
Cold Ashton (Avon) 19, 223
Coldstream, Nicola 51
Coleshill (Berks.) 243
Colet family 6
Collyweston (Northants.) 25, 31
Cologne (Germany), Schnütgen
Museum 11
Combs (Suffolk) 73
Compostella (Spain), shrine of St James
the Greater 64
Compton (Surrey) 139
Compton Verney (Warwicks.) 235,
Fig. 193
Conrad, Prior of Canterbury 110

Constantine, Emperor 75, 88, 89,
Pl. XXIII
Constantinople, Haghia Sophia 108;
Kariye Camii (church of the Chora)
108; Zeyrek Camii (Pantocrator
monastery) 108
contracts, glazing 21-5, 30, 44, 50, 52,
54, 158, 180-1, 207, 209, 213, 215,
217
Copenhagen, Royal Library MS Thott
143.2 (*Copenhagen Psalter*) 115
*Copenhagen Psalter see* Copenhagen,
Royal Library
Corby Glen (Lincs.) 80
Corning Museum of Glass *see* New York
(USA)
Cornwall, Richard, Earl of, King of the
Romans 11, 135
Coronation of the Virgin *see* Mary,
Coronation of
Corpus Christi play 234
*Corpus Vitrearum* xxv, 246
Cosin, John, Bishop of Durham 235
Costessey (Norfolk) 243
Cotehele (Cornwall) 96
Coughton (Warwicks.) 20, 82, 224, 225
Courtenay, Henry, Marquess of Exeter
222-3
Coutances Cathedral (France) 76, 127
Coventry, former cathedral 82, 182,
Fig. 147; St Mary's Hall 89, 182, 191,
Fig. 159
Cranford St John (Northants.) 154-5
Cranmer, Thomas, Archbishop of
Canterbury 230
Creation 61, 68, 70, 96, 196, 222-36,
Fig. 47
Credenhill (Heref. & Worcs.) 76, 78,
153, Fig. 58
Creed 65, 78-9, 190-1, 194, 224,
Pl. XXII, Fig. 60
Crewe, Thomas 182
Cormwell, Oliver 237
Cromwell, Ralph, Lord Treasurer of
England 4, 17, 19, 42, Fig. 15
Cromwell, Thomas 228, 237
Croscombe (Somerset) 6
Crossley, Paul 51
Croxton (Humberside) 139, 140
Crucifixion *see* Christ, Crucifixion
Crudwell (Wilts.) 79, 194
*Cuerden Psalter see* New York, Pierpont
Morgan Library
Culmer, Richard 238
Curson family 13, 17, Fig. 10

Dalbury (Derbys.) 111, 112, Fig. 86
Dale Abbey (Derbys.) 73, 230, Fig. 52
Daniel 113, 119, Fig. 190
Darmstadt (Germany), Hessisches
Landesmuseum 109
Dartford (Kent) 207
David, King 39, 102, 110, 201, 211,
Fig. 48
David I, King of Scotland 110
Day, Lewis F. 245
De Fresnes family 4
*De Lisle Psalter see* London, British
Library
*De Transitu Beatae Mariae* 71
Decalogue 65
Deddington Castle (Oxon.) 92
Deerhurst (Glos.) 153
Deguileville 79
Delamere Forest (Cheshire) 30
Dene, Peter de, canon of York Minster 4,
154
Dent, Giles, rector of Long Melford 5
Despenser, Hugh le 89, 165
Despenser, Isabella 188
Didymus 101
Dijon (France) 127
Doctors of the Church 25, 65, 74, 99,
201, 211; *see also* St Augustine of
Hippo, St Gregory the Great, St
Jerome
Doddington (Kent) 137, 139
Doddiscombsleigh (Devon) 75, 193
Dodsworth, Roger 238
domestic glass 19, 48-50, 92-102,
106-7, 188, 191, 201, 207, 222, 224,
Pls II(a), XXIV, Figs 75-81, 149,
155, 159, 170, 188, 190
Dominicans 64
Donatus 101
Donnington (Salop.) 82
Donne, Sir John 205
donors 3-27, 47, 51, 59, 61, 63, 64, 67,
73, 78, 80, 82, 85, 86, 88, 89, 90,
92-3, 94-7, 99, 101, 105, 109, 113,
118, 141, 145, 153, 159, 160, 165,
167, 168, 169, 170, 171, 173, 178,
181, 182, 185, 187, 188, 192, 193-4,
196, 198-9, 200, 202, 203, 204, 205,
206, 207, 212, 213, 220, 222-3, 224,
225, 226, 229, 232, 234, 235, 239,
243, Pls X, XII, XIX, XXI, XXV,
Figs 1-4, 6-8, 10-16, 18-20, 31(c),
40, 46, 123, 137, 138, 139, 155, 167,
169, 171, 193, 198; *see also under*
individual names

Doom *see* Last Judgement

Dorchester (Oxon.) 54, 68, 76, 136, 229, Pl. IX, Fig. 35

Douai (France), Bibliothèque Municipale MS 171 (*Douai Psalter*) 157, 165

*Douce Apocalypse see* Oxford, Bodleian Library

Dowsing, William 237, 239

Drake, Maurice 245

Draycott, Anthony, rector of Checkley 97

Drayton Basset (Staffs.) 16, 55, Fig. 12

Drayton Beauchamp (Bucks.) 78, Fig. 60

Drayton St Leonard (Oxon.) Fig. 55

Dronfield (Derbys.) 55, 85, 155

Duccio *see* painters

Dugdale, Sir William 239

Dugdale's *Book of Monuments see* London, British Library

Durandus, William 79

Dürer, Albrecht *see* painters.

Durham: Cathedral 61, 73, 108, 113, 140, 182, 192, 200, 230, 238; Cathedral Library MS A.II.I (*Puiset Bible*) 115; St Mary Magdalene church 200

Earsdon (Northumberland) 96, Fig. 77

Easby (N. Yorks.) xxv, 46, 139, 140, Pl. VIII(b)

East Barsham (Norfolk) 198

East Dereham (Norfolk) 184

East Haddesley (N. Yorks.) 94, Fig. 75

East Harling (Norfolk) 85, 198, 199, Fig. 167

East Tytherley (Hants.) 143, Fig. 112

Eaton Bishop (Heref. & Worcs.) 12, 164, 180

Eden, F.S. 245

Edenbridge (Kent) 137

Edenhall (Cumbria) 139, 140, Fig. 107

Edgar, King 88, 90

Edgcumbe family 96

Edinburgh: National Galleries of Scotland 25, 205, Fig. 21; Trinity church 205

Edington (Wilts.) 167, 169, 180, Fig. 134

Edington, William of, Bishop of Winchester 169

Edmund Crouchback, Earl of Lancaster *see* Lancaster, Dukes and Earls of

Edmund, King 88

Edward I 30, 88, 134, 135

Edward II 88, 89

Edward III 4, 51, 75, 87, 89, 90, 157, 158, 165, 166, 174, 235

Edward IV 99, 204, 205, 206

Edward VI 229, 230, 231, 237

Eleanor of Aquitaine, wife of Henry II 10

Eleanor of Castile, wife of Edward I 88, 134, 135, 154

Eleanor of Provence, wife of Henry III 11, 61, 93, 135

Eleanor Crosses 148, Fig. 33(a)

Elijah Fig. 185

Elizabeth I 231, 232

Elizabeth, Duchess of Suffolk 5

Elizabeth (Woodville), wife of Edward IV 204, 206

Ellingham (Northumberland) 200

Elsing (Norfolk) 19, 160, 167; brass 55, 160, Fig. 37

Eltham Palace (Kent) 19, 48, 49, 94, 95, 180, 191, 207

Ely (Cambs.): Cathedral 5, 12, 39, 51, 141, 157, 160, 161, 166, Pl. XVII, Figs 32, 127; Prior Craudon's chapel, wall-painting 157; Stained Glass Museum 129, 153, 162, Pl. VIII(c), Figs 33(d), 130

Emma, wife of King Canute 108

enamel-painting 39, 235-6, 244, Figs 194, 195

English Heritage 246

Eraclius 28

Erneys, William, steward of hospice of Tattersall 64

Esau 235

Escomb (Co. Durham) 105, 106

Espec, Walter l' 110

Esslingen (Germany), Franciscan church 38

Etchingham (E. Sussex) 81

Ethelbert, King 88

Eton College (Berks.) 30, 49, 206, 207

Euclid 101

Eve 174

Everard family 19

Evesham Abbey (Heref. & Worcs.) 19

Evington (Leics.) 155

Evreux Cathedral (France) 39, 158, 192

Exeter Cathedral (Devon) 3, 16, 25, 30, 31, 37, 39, 40, 48, 50, 63, 64, 88, 141, 145, 153, 154, 178, 193, Pl. XIII, Fig. 144(a)

Ezekiel 119

Fairfax, Sir Thomas 237

Fairford (Glos.) 4, 28, 37, 51, 64, 67, 68, 81, 190, 209, 210-12, 213, 215, 217, 219, 225, Pls XXVI, XXVII, Figs 178, 179

Farleigh Hungerford (Somerset) 19, 169, 171, 184

Farley, William, Abbot of Gloucester 42

Fawsley Hall (Northants.) 97, 102, Pl. II(d), Fig. 78

Fécamp Abbey (France) 40, 76

*fenestra caeli* 85, 201, Fig. 170

*ferramenta* 27, 37

Ferrer, Bonifacio *see* painters

Ferrers, Ralph, dean of Tamworth 90

Ferrers, William de 12

Field of the Cloth of Gold 207

Field Dalling (Norfolk) 198

Fiennes, Celia 125

Finchale Priory (Co. Durham) 200

Fisher, Alfred 246

Fisher, Thomas 240, Pl. XXX

Fitzhamon, Robert 89

Fitzherbert, Sir John, *Boke of Husbandrie* 97

Fitzhugh, Sir Henry 20, Fig. 17

*Fitzwarin Psalter see* Paris, Bibliothèque Nationale

Fitzwilliam, Sir William 224

Fladbury (Heref. & Worcs.) 33, 99, 148, Pl. I

Fledborough (Notts.) 78

Fleming, Richard, Bishop of Lincoln 16

Flight into Egypt 115, 137, 211

Flodden, Battle of 6

Flower, Barnard *see* glass-painters

Fonthill (Wilts.) 241

Fotheringhay (Northants) 4, 64, 78, 95, 192, 194-5, 241, Figs 165, 199

Fountains Abbey (N. Yorks.) 111, 128

Fowler, William 240

Fox, Richard, Bishop of Winchester 212, 213, 217, 222

Franciscan glass 6, 11, Pl. X

Frolesworth (Leics.) 182

Frost, Robert, rector of Thornhill 206

Froxmere, Thomas 24, 25, Fig. 20,

Furness Abbey (Lancs.) 200

Gabriel, archangel 85, 135, 186, Fig. 154 *see also* Mary, Annunciation to

Galen 101

Garter, Order of 19-20, 75, 90, 194, 209, 241, Figs 17, 73

Gedney (Lincs.) 68

Genesis 70, 181

Gercy (France) 140

Gerona Cathedral (Spain) 33, Fig. 25
Gervase of Canterbury 110, 118
Gilbert, Robert, rector of Horley 13
Gilby, Anthony 232
Gilling Castle (N. Yorks.) 234
Gillingham (Kent) 93
Glanville, Bartholomew 101
Glasgow: Burrell Collection 11, 19, 20,
    85, 97, 102, 198, 209, Pls II(a), X,
    XV, XXIV, XXV, Figs 16, 68, 149,
    168; University, Hunterian Library
    MS Hunter U.3.2 (psalter) 115
Glasier, Thomas of Oxford *see*
    glass-painters
glass-houses 28–30, Fig. 23
glass-makers:
    Alemayne, John, of Chiddingfold
    30–1; Glasman, John, of Rugeley 30;
    Laurence *Vitrearius* 30; Powell,
    Messrs J. 244; Schurterre, John 30;
    Utynam, John 30
glass-making 28–31, Figs 22–3
glass-painters:
    Andru, Adrean 207; Arnoult de
    Nijmuegen 47, 209; Athelard, John
    46; Austin, George Jnr 244; Austin,
    George Snr 244; Bernard 169; Berry,
    John 241; Betton & Evans 244,
    Fig. 31(a); Bond, Richard 23, 49,
    209, 217; Borser, Roger 134;
    Bouesdun, Thomas de, of York 23,
    158; Brampton, John 30, 47, 48, 93;
    Burgh, John 180; Burgh, William 48,
    180, 191; Burr, John 234; Butler,
    Richard 235, 237; Butler & Bayne
    244; Chamber, John 200; Chamber,
    John the younger 44; Chamber
    family of York 43; Clayton & Bell
    244; Clement of Chartres 47; Coeck,
    Pieter 222; Creping, Nicholas de 41;
    Curteign, Wynand 207; Daniel
    *vitrearius* of Ramsey 40; Delyon, John
    25; Dininckhoff, Bernard 234; Drake,
    Frederick 153, 178; Edward 134;
    Eginton, William 244; Elmden,
    William, of Durham 200; Flower,
    Barnard 22, 31, 44, 47, 49, 97, 207,
    213, 217, 220; foreign 4, 14, 41, 44,
    67, 169, 190, 204, 205–8, 222;
    Gerlachus 47; Glasiere, John le, of
    Calne 50, 93; Glasier, John, of
    Coningsby 41; Glasier, John, of
    Stamford 41, 201–2; Glasier, Thomas
    of Oxford 4, 37, 39, 42, 44, 46, 47,
    51, 171, 173, 174, 176, 177, 178,

190, 244, Pl. XIX, Figs 31(a), 141,
    142, 144(b); Glayzier, Richard, of
    Durham 200; Glazier, John, of
    Oxford 173, 189; Glazier, William,
    of Newcastle 200; Gloucester, Roger
    47; Godwin, John, of Wells 42;
    Greenbury, Richard 235; Gugle,
    Richard 234; Hardman, John 244;
    Harys, Ralph 47; Heaton 244;
    Hedgeland 6; Hone, Glayon 23, 49,
    96, 207, 217, 227, 228, 234, Fig. 77;
    Inglish family of York 43; Inglish,
    William 34, 200; Jesse Tree Master
    (Canterbury) 122, 123, Pl. VII; John
    of Bristol 134; John of Chichester 50;
    Ketelbarn, Robert, of York 22, 158,
    Pl. XVI; Lavers & Barraud 244;
    Lawrence 134; Lenne (Kings Lynn),
    Simon de 42, 159, 161; Linge,
    Abraham van 235–6, Fig. 195; Linge,
    Bernard van 235; Lupuldus of Haina
    (Germany) 47; Lyen, Robert 25, 40,
    44, 48, 178, Fig. 144(a); Master
    Fitz-Eisulf (Canterbury) 124, Fig. 96;
    Master of the Parable of the Sower
    (Canterbury) 124, 139, Fig. 95;
    Master of the Staring Eyes (Lincoln)
    125, Fig. 98; Methuselah Master
    (Canterbury) 123, Fig. 94; Mulys,
    Cornelius 207; Münster Hermann
    von 174; Neve, William 40;
    Nicholson, James 23, 25, 207, 217,
    220; Nicholson, Peter 207, 222, 228;
    Osbernus *vitrearius* of Ramsey 40;
    Passion Master 196; Peckitt, William
    244; Peghe, Thomas 40; Peter the
    Painter 21; Petronella Master
    (Canterbury) 123, 124, Pl. VI; Petty,
    John 31, 34, 42, 47, Fig 31(c); Petty,
    Matthew 200; Petty, Robert 34, 44,
    200, 226; Petty family of York 43;
    Pontefract, William 182; Power,
    Robert, of Burton-on-Trent 41, 201,
    202, 203, Pl. XXIII; Preston, Robert
    of York 200; Price family 244;
    Pruddle, John 23, 24, 30, 39, 41, 44,
    46, 47, 49, 50, 51, 61, 96, 189, 190,
    194, Pls II(c), III(d), Figs II, 69, 164;
    Pyle, Gherard 207; Reve 23; Reve,
    Thomas 209, 217; Roelant 235; Roo,
    Robert 234; Savage, Richard 47;
    Shawden, Thomas, of Durham 200;
    Shirley, Robert & Thomas 44, 46;
    Shirley family of York 43; Simon of
    King's Lynn *see* Lenne, Simon de;

Smart, Henry 42, 47, Fig. 31(b);
    Southwark, William 134; Stauerne,
    Henry 48; Sutton, Baptista 235;
    Sutton, Henry 207, 227; Symondes
    87; Symondes, Simon 23, 209, 217;
    Thompson, William 31; Thornton,
    John, of Coventry and York 23, 41,
    44, 46, 50, 82, 89, 96, 180, 181, 182,
    183, 185, 186, 187, 190, Figs 65,
    144(d), 145; Twygge, Richard, of
    Malvern 41, 42, 201, 203, 204,
    Pls II(b), III(a), (c), Figs 11, 61, 158,
    173, 174; Vellert, Dierick 217;
    Verour, Roger le 124; Verrator,
    Walter le *see* Walter of Exeter;
    Verrer, Matthew le, of Colchester
    42; Verrour, Walter le, of York 41;
    Verur, Albin le 92; Verur, John le 92;
    Wailes, William 244; Walter of
    Exeter 44, 48, 153; Walworth, John
    de 21, 44, 51; Willement, Thomas
    97, 244; William of Kent 47;
    Williamson, Francis 23, 207, 217;
    Wodshawe, Thomas, of Malvern 41,
    42, 201, 203, 204, Pls II(b), III(a), (c),
    Figs 11, 61; Wright, Richard 21, 22,
    23, 49; Wright, (possibly Richard)
    25; Wright, Robert 222;
    Wymondeswalde, John, of
    Peterborough 41, 85, 201, 202
Glastonbury Abbey (Somerset) 80, 106,
    107, 124
Glaziers Company of the City of London
    *see* London, Glaziers Company
glaziers' marks 36–7, Fig. 28
Gloucester Cathedral 64, 87, 88, 89, 90,
    99, 141, 143, 150, 164, 165, 192,
    203, 229, Figs 71, 132, 133
Gnosall (Staffs.) 203
*Golden Book of St Albans see* London,
    British Library
Goliath Fig. 48
Goodstone-next-Faversham (Kent)
    Pl. XXX
*Gorleston Psalter see* London, British
    Library
*Gospel of Pseudo-Matthew* 70
*Gospels of Otto III see* Munich, Bayerische
    Staatsbibl.
Gossiping 80–1, Fig. 62
*Gough Psalter see* Oxford, Bodleian
    Library
Grafton, William, rector of Buckland 99
Grandisson, John, Bishop of Exeter 157
Grateley (Hants) 126, Fig. 99

Gratian 101

Gray, Thomas 126

Gray, Walter de, Archbishop of York 133

Gray, William, Bishop of Lincoln 185

Great Brington (Northants.) 224, Fig. 189

Great Malvern Priory (Heref. & Worcs.) 5, 14, 42, 51, 65, 67, 68, 70, 75, 76, 78, 85, 88, 90, 188, 190, 192, 203, 204, 205, 229, 245, Figs 11, 42, 47, 74, 156, 158

Greenfield, William de, Archbishop of York 4

Greenwich *see* London, Greenwich

Gresford (Clywdd) 73

Grey, Sir Robert 155

Greystoke (Cumbria) 73, 200, 226, Fig. 53

grisaille 30, 40, 48, 55, 65, 87, 93, 94, 114, 124, 125, 127, 128, 129, 133, 136, 137, 141, 142, 143, 147, 150, 153, 154, 158, 165, 167, 206, 223, Pl. VIII(a), (c), Figs 24(b), 36, 98, 100, 101, 102, 103, 104, 105, 108, 111, 114, 117, 118, 119, 121, 123, 124

Grosseteste, Robert, Bishop of Lincoln 78

Grymestone, Sir Edward 205

Guestwick (Norfolk) 80

Guido of Arezzo 101

Guildford Castle (Surrey) 41, 235

guild windows 6, 17, Figs 3, 4; glaziers' 41–4, 57, 227–8, Fig. 30

Gunthorpe, John, Dean of Wells 95

Gurk Cathedral (Austria), glass and wall-painting 65

*Guthlac Roll see* London, British Library

Haddon Hall (Derbys.) 17, 96, 182

Hadleigh Castle (Essex) 48

Hadreshull, Sir John de and Margaret 11, Fig. 7

Hadzor (Heref. & Worcs.) 162, Fig. 130

Hailes Abbey (Glos.) 136

Hal (Belgium), St Martin's basilica 174

Halle, John 19, 97

Hammond, Lieutenant, of Norwich militia 238

Hampp, John Christopher 243

Hampton Court (Heref. & Worcs.) 78, 96, 183, 188, 236, Figs 149, 195

Hampton Court Palace *see* London, Hampton Court Palace

Hamstall Ridware (Staffs.) 202

Hanse Merchants 30

Harbledown (Kent), St Nicholas' Hospital 101

Hardingstone (Northants.), Eleanor Cross Fig. 33(a)

Hardres(?), Philip and Salomon de 10, Fig. 6

Harling, Anne 198, 199

Harpley (Norfolk) 75

Harpsfield, Nicholas, Archdeacon 231

Harrison, William 232

Harset family 6

Hastingleigh (Kent) 129, 137, 143, Fig. 108

Hastings, Sir Hugh, brass of 55, 160, Fig. 37

Hatfield House (Herts.) 235

Havering (Essex), King's chapel 93

Heath (Salop.) 112

Helena, Empress 64

Helmdon (Northants.) xxv, 13, Figs 9, 27

Hengrave (Suffolk) 96, 222, Fig. 188

Henry II 10, 110, 230

Henry III 4, 10, 11, 48, 89, 92, 113, 134, 135, 141, 142

Henry IV 77, 89, 180, 187

Henry V 89, Fig. 81

Henry VI 4, 78, 89, 97, 99, 213

Henry VII 24, 202, 204, 206, 212, 213

Henry VIII 4, 14, 25, 49, 212, 217, 220, 222, 230, 237, Fig. 187

Heraclius, Emperor 64

heraldry 10, 16, 19, 21, 22, 23–4, 38, 39, 47, 49, 54, 76, 86–9, 93, 94, 96, 97, 99, 102, 134, 135, 141, 153, 154, 155, 188, 198, 209, 212, 213, 215, 224, 225, 232, 234, 235, 238, 239, Pls II(a), XV, Figs 2(c), 5, 7, 10–12, 14, 17, 19, 20, 30, 31, 34, 75, 76, 78, 119, 120, 123, 135, 140, 159, 183, 194, 197; *see also under* individual names

Herebright of Cologne *see* painters

Hereford Cathedral 70, 141, 145

Herkenbrode Abbey (Belgium) 243

Hertingfordbury (Herts.) 20

Hessett (Suffolk) 73

Heydon family 16, 63, 206, Fig. 14

Heydon (Norfolk) 80

Heydour (Lincs.) 58, 155, 168, 169, 180, Fig. 135

Hezekiah 122, Fig. 93

Highclere (Hants) 42, 173

Highcliffe, Bournemouth (Hants) 243

High Melton (S. Yorks.) 173

Hildesheim Cathedral (Germany), St Oswald reliqeary 115

Hillesden (Bucks.) 73, 212, Fig. 181

Hingham (Norfolk) 6

Hippocrates 101

Holdenby (Northants.) 143, Fig. 115

Hollmer, William, *limnour* 25

Holme-by-Newark (Notts.) 19, Fig. 15

Holy Kindred 65, 70, 186, Fig. 45

Hone, Galyon *see* glass-painters

Hooper, John, Bishop of Gloucester 231

Horley, (Oxon.) 13

Horne, Robert, Dean of Durham 230, 231

Horton Priory, (Kent) 128

*Hours of Elizabeth the Queen see* London, British Library

*Hours of Jeanne d'Evreux see* New York, Cloisters Collection

*Hours of Jeanne de Navarre see* Paris, Bibliothèque Nationale

Houte, Adrian van den 212, 217

Howard, Sir John and Alice 239, Fig. 198

Howe family 6

Hoxne (Suffolk) 80

Hugo *see* manuscript illuminators

Hugutio 101

Hugutius 101

Hulme, Randle 238

Hungerford, Sir Thomas 171

Hunton, Thomas, Prior of Winchester 212

Hygdon, John 222

Hyne family 6

iconoclasm 229–32, 237–8, Fig. 196

*Ignorantia Sacerdotum* 78

imitation of earlier glass-painting styles 39, 40

*Ingeborg Psalter see* Chantilly, Musée Condé

Ingham (Norfolk) 63

initials 19, 97, 169, 215, 223, 225, Figs 40, 80, 137, 139, 182

inscriptions 5, 6, 10, 17, 19, 20, 47, 59, 61, 80, 85, 89, 96, 167, 229, 232, 234, Figs 10, 14, 15, 69

Ipswich (Suffolk) 184, 198, 231

Isaac, Sacrifice of 70

Isaiah 68, 119, 153, 194, Pl. XIII

Islip, John, Abbot of Westminster 19, Fig. 16

Iwardby, John and Katherine 59

Jacob 235, Fig. 125
James I 235, 237
Jarrow (Tyne & Wear) 105, 106, 109,
    Pl. IV, Fig. 83
Jean, Duke of Berry 176
Jeremiah 119
Jerningham, Sir William 243
*Jerome's Commentary on Isaiah see*
    Oxford, Bodleian Library
Jesse, Tree of *see* Tree of Jesse
Jewel, John, Bishop of Salisbury 232
jewelling 38-9, 97, 185, 188, 190, 201,
    203-4, Pls II(c), III(b), (d)
Joachim and Anne 70, 71, 210, Fig. 50
Johannes *see* manuscript illuminators
John, Prior of Great Malvern 5
John of Gaunt *see* Lancaster, Dukes and
    Earls of
Johnston, Henry 239 Fig. 31(c)
Jonah 236
Joseph 70
Judas 70
Judgement of Solomon 68
Jumièges, Abbey (France) 158
Justinian, Emperor 101, 108

Kempsey (Heref. & Worcs.) 141, 162
Kennington (Kent) 137
Kerr, Jill 165
Kettlethorpe (Lincs.) 160
Key, Thomas, rector of Cold Ashton 19,
    223
Keyes, Roger, canon of Exeter Cathedral
    63
Kidlington (Oxon.) 139
Kimberley (Norfolk) 169
King, D.J. & Son 246
King's Glazier 44, 47, 50, 189, 207
Kingerby (Lincs.) 160, Fig. 128
kings 88-9, 93, 99, 101, 102, 110, 126,
    143, 165, 178, 180, 191, 209, Pl. XV,
    Figs 39, 71, 82, 93, 113, 122, 143,
    144(c), 159, 177; *see also under*
    individual names, Tree of Jesse
Kingsbury (Old Windsor, Berks.) 92,
    106
Kingscliffe (Northants.) 195, Fig. 165
Kinlet (Salop.) 169
Kirk Sandall (S. Yorks.) 226, Fig. 192
Kirkham Priory (N. Yorks.) 110, 111
Kirkstall Abbey (W. Yorks.) 136
Kirton-in-Lindsey (Humberside) 79
Knightley, Sir Edward and Ursula 97

Knolles, Thomas, sub-dean of York 222
Knowles, J.A. 245
Kyston, Sir Thomas 96, 222

La Benisson-Dieu Abbey (France) 128,
    129
La Mailleraye (France) 158
Labours of the Months 86, 97, Pl. XXIV
Lacock Abbey (Wilts.) 168, 169
Lambeth, Council of 78
Lambeth Palace chapel *see under*
    London, Lambeth Palace
Lamech 122, Fig. 119
Lammas (Norfolk) 80
Lancaster, Dukes and Earls of:
    Bolingbroke, Henry (*see also* Henry
    IV) 88; Crouchback, Edmund,
    Fig. 33(b); Gaunt, John of 89, 159;
    Thomas 78
Lancaster Herald 87
Lanchester (Tyne & Wear) 139, 140
Langley, Thomas, Bishop of Durham
    182, 185, 230
Laon Cathedral (France) 37, 117, 121,
    126
Last Judgement 20, 25, 65, 68, 80, 81,
    82, 84, 96, 114, 117, 119, 125, 159,
    165, 173, 211, 222, Pl. XXVII,
    Figs 21, 63, 64; *see also Pricke of
    Conscience*
Laud, William, Archbishop of
    Canterbury 235, 236, 237
Launde Priory (Leics.) 229
*Lay Folk's Catechism* 78
Le Mans Cathedral (France) 39, 110
Le Mesnil-Villeman (France) 38,
Le Couteur, J.D. 245
*Legenda aurea* 61, 72
Leicester 80, 97, Figs 79, 80
Leland, John 212, 225
Lenthall, Sir Roland 96
*L'Estoire de Seint Aedward le Rei see*
    Cambridge, University Library
Letcombe Regis (Berks.) 169, 170, 174,
    Fig. 138
Leverington (Cambs.) 19, 170
Liberal Arts 123
library glazing 99, 101, Figs 80, 81
Lichfield Cathedral (Staffs.) 63, 237, 243
Liège, (Belgium) 243
*Life of St Ludger* 109
Lily Crucifix 67, Fig. 46
*limnours* 25
LINCOLN
    Bishops of *see* Alnwick, Russell,

Smith; Bishop's Palace, great hall 97;
    Cathedral 55, 67, 68, 71, 81, 88, 93,
    113, 124, 125, 127, 128, 129, 133,
    136, 140, 143, 246, Figs 36, 98,
    102(a), 103
Lindesey, Robert de, Abbot of
    Peterborough 113
Lindisfarne (Northumberland) 72, 105
Linton Priory (N. Yorks.) 110
Lisle, Sir John Fig. 73
Litcham (Norfolk) 184
Little Kimble (Bucks.), glass and
    wall-painting 65
Little Malvern Priory (Heref. & Worcs.)
    5, 17, 42, 203, 204
Little Saxham Hall (Suffolk) 25
Littleton, William de, precentor of Wells
    167
Liturgy 14, 61, 65, 84-5, 190, 194,
    Figs 68-9, 158, 170
Llandyrnog (Denbighshire) 79
Lobbens, John, mason 222
Lockington (Humberside) 158
Lockington (Leics.) 155
Lombardic script 167
LONDON
    Bishop's Palace 40; British Library,
    manuscripts in:
        Loan MS 38 (Dugdale's *Book of
        Monuments*) 239, Figs 12, 73;
        Loan MS 90 (*Salisbury Roll*) 88;
        Add.24189 (Sir John Mandeville's
        *Travels*) 29, Fig. 22; Add. 24686
        (*Alphonso Psalter*) 143, 153; Add.
        25588 (Missal) 184; Add.
        29704-5, 44892 (*Carmelite
        Missal*) 170, Fig. 138; Add. 32363,
        Pl. XXX; Add. 33241, 108; Add.
        35211, Figs 56, 101(a), (b),
        102(b), 104, 109, 121, 124, 200;
        Add. 42130 (*Luttrell Psalter*), 16,
        55, 165, Fig. 12; Add. 42131
        (*Psalter and Hours of John Duke of
        Bedford*) 184, Fig. 152; Add.
        49622 (*Gorleston Psalter*) 157;
        Add. 50000, 54215 (*Oscott
        Psalter*) 143, 160; Add. 50001,
        (*Hours of Elizabeth the Queen*) 70,
        183, Fig. 40; Arundel 83 (*De Lisle
        Psalter*), 17, 158, 159, 164,
        Fig. 133; Arundel 91, 108;
        Cotton Julius Eiv, art. 6
        (*Beauchamp Pageants*) 206;
        Cotton Nero Dvii (*Golden Book of
        St Albans*) 89; Cotton Tiberius

Cvi 107, Fig. 84; Cotton Vespasian A.1 (psalter) 135; Cotton Vitellius Cxii 108; Egerton 2341a, 23–4, Fig. 19; Egerton 3510, 238, Fig. 197; Harley 2372, 102; Harley Roll Y.6 (*Guthlac Roll*) 25, 61, 125, Fig. 97; Lansdowne 874, 24, 238, Fig. 20; Royal 2 B vii (*Queen Mary Psalter*) 78; Royal 13 D i, 58, 69, Fig. 136; Yates Thompson 14, (*St Omer Psalter*) 157, 165, 167, 170; Yates Thompson 26 (Bede's *Life of St Cuthbert*) 125, 140, Fig. 107; British Museum, tiles Figs 33(c), 36; Charterhouse 169; Coldharbour 31; College of Arms 239; Franciscan church 6; Glaziers Company 41, 47, 206, 207, 209, 222, 227, 228, Fig 30; Gray's Inn Chapel 230; Greenwich, Observant Friars' church 23 Fig. 19; Palace 207; Trinity church 235; Hampton Court Palace 25, 49, 96, Figs 77, 176; Lambeth Palace Chapel 67, 231, 235, 237; Lincoln's Inn 235; National Gallery 178, 205; Public Record Office, (E36) 284 (Abbreviated Domesday Book) 135; E/135/151 (Charter of Indulgence) 169; Richmond Palace 207; Savoy Hospital 48, 49, 207, 209; St James', Palace 207; St Mary Rotherhithe 234; Shoreditch, St Leonard's 235; Southwark 207, 227; Strawberry Hill 241; Temple 61; Temple Bar 227; Tothilfields 235; Tower of London 49, 61, 93, 174, 207; Westminster Abbey, Palace, *Westminster Retable*, St Margaret's, St Stephen's chapel *see* separate headings; Victoria and Albert Museum 55, 123, 174, 198, 236, 243, Fig. 195; York Place (later Whitehall Palace) 25, 97, 148, 207, 220

Long Melford (Suffolk) 5, 13, 88, 198, Figs 46, 169
Long Sutton (Lincs.) 171
Lord's Prayer 65
Lorsch Abbey (Germany) 109
Lovell, Sir Thomas 14
Lowick (Northants.) 12, 40, 154, Fig. 125
Ludgershall (Wilts.) 50, 93
Ludlow (Salop.) 6, 16, 17, 76, 78, 150, 164, 182, 190, 191, 194, 232, 244,

Pl. XXII
Luffwyk, William de, rector of St Peter's, Aldwincle 168, Fig. 2(a)
Luther, Martin 230
Luton (Beds.) 194
Luttrell, Sir Geoffrey 16, Fig. 12
*Luttrell Psalter see* London, British Library
Lydd (Kent), All Saints 6, 20
Lyddington Bedehouse (Leics.) 19, 97, 188, Fig. 155
Lydiard Tregoze (Wilts.) 75
Lyminge (Kent) 60
Lyons Cathedral (France) 127
*Lytlington Missal see* Westminster Abbey
Lytlington, Nicholas, Abbot of Westminster 171
Lyttelton, Sir Thomas 63

Mackwilliam family 225
Madley (Heref. & Worcs.) 135, 139, 140, 150, 164
Magdeburg Cathedral (Germany) 109
*Magnificat* 5, 14, 42, 65, 70, 84, 85, 190, 203, Figs 10, 158
Majesty Master *see* manuscript illuminators
Mâle, Louis de, Count of Flanders 176
Mamesfeld, Henry de 16, Pl. XII, Fig. 123
Manasses, King Fig. 144(b)
Mancetter (Warwicks.) 150, 167, 182
Manchester, John Rylands Library, MS Lat. 24 (*Missal of Henry of Chichester*) 143
Mandeville, Sir John, *Travels see* London, British Library
Mann, Sir Horace 241
manuscript illumination and stained glass 13–14, 16, 17, 55, 56–8, 61, 70, 85, 107–9, 115–16, 123, 125, 135, 139, 140, 142, 143, 144, 155, 157, 158, 159, 160–1, 165, 167, 169, 170, 171, 174, 183, 184, 192–3, 194, 205–6, 223, Figs 12, 40, 70, 84, 97, 107, 126, 128, 133, 136, 138, 140, 151, 152; *see also under* individual manuscript and *bas-de-page* illumination
manuscript illuminators: Abell, William 192–4; Boucicaut Master 184; Brailes, William de 135; Hugo 108; Johannes 58, 183, Fig. 40; Majesty Master 158, 159, 165, Fig. 133; Master of the Morgan Leaf 123; Pucelle, Jean 158, 159, 161,

165, Fig. 126; Sarum Master 143; Scheerre, Herman 183; Siferwas, John 183
Mapledurham (Oxon.) 59
Margaret, Queen of Scots 222
Margaret of Anjou, wife of Henry VI 97
Margaret of York 205
Margaretting (Essex) 68, Fig. 49
Marholm (Cambs.) 224
Mariawald Abbey (Germany) 243
Marienstatt, (Germany) 129
Marlborough Castle (Wilts.) 21
Marmion, Robert de 90
Marriage at Cana Fig. 91
Martham (Norfolk) 196
Martin family 5, 198
MARY, Virgin 11, 70, 71, 84, 85, 93, 96, 97, 102, 117, 119, 125, 126, 139 158, 165, 174, 176, 183, 190, 196, 198, 201, 202, 210, 212, 213, 237, Pl. VII, Figs 138, 158, 170, 179; Annunciation 48, 67, 70, 71, 85, 96, 126, 135, 143, 157, 158, 162, 186, 193, 194, 226, Figs 126, 130, 149, 154, 164; Assumption 71, 96, 196, 211, Fig. 57; birth 70, 71; and Child Christ 10, 11, 12, 33, 39, 68, 70, 93, 96, 139, 165, 174, 178, 184, 186, 193, 206, Pls I, II(d), XIX, Figs 6, 24(c), 142, 188; coronation 54, 70, 85, 139, 143, 162, 165, 170, 173, 184, Figs 34, 115, 133; at Crucifixion 81, 139, 167, 202, Figs 21, 134, 140, 178, 18; death 70, 71, 139, 196, Fig. 50; funeral 70, 71, 86, 154, 196, Fig. 70; girdle 72, Fig. 51; miracles 71, 125, 139, Fig. 98; presentation in the Temple 70, 71; purification 70; and St Anne 16, 75, 178, 194, 203, 206, Figs 13, 43, 45, 56, 142; suitors in the Temple Fig. 148; Virgin of the Mantle 64, 65; visitation 194, 196, Fig. 166; *see also* Bourges (Jewish boy of), Christ, *fenestra caeli*, Holy Kindred, Joachim (annunciation to), Last Judgement, Theophilus, Tree of Jesse
Maryell family 6
Mason, Thomas 234
Mass of St Gregory 65, 186
Master of the Morgan Leaf *see* manuscript illuminators
Mauley family 13, 153
Maxey (Cambs.) 169, 170
Melbourne (Australia), National Gallery of Victoria 11, Fig. 7

Melbury Bubb (Dorset) 79

Meldreth (Cambs.) 12

Mells (Somerset) 184, Fig. 150

Melrose Abbey (Scotland) 136

Melton, William de, Archbishop of York 4

Membury, Simon 174

Memling, Hans *see under* Painters

Mere (Wilts.) 72

Merevale (Warwicks.) 11, 162, 167, Fig. 7

Mersden, John, rector of Thurcaston 182, Pl. XXI

Mersham (Kent) 54

Messingham (Humberside) 160

metalwork (including brasses) and stained glass 6, 13, 16, 55, 56, 61, 107–8, 115–16, 123, 148, 157, 160, 194, 198, Fig. 37

Metz Cathedral (France) 174

Michalus 101

Middleton (Greater Manchester) 6, 200, Fig. 3

Minster-in-Sheppey (Kent) 16

Miraculous Draught of Fishes *see* Christ

*Missal of Henry of Chicester see* Manchester, John Rylands Library

Moccas (Heref. & Worcs.) 4, 164

Mohun family 93

Mondeville (France) 108

Monkwearmouth (Tyne & Wear) 105, 106, 108, 109

Montagu, Richard, Bishop of Chichester 235

Montreal (Canada), Museum of Fine Arts 162

Moor Monkton (N. Yorks.), Red House 235

Morgan, Nigel 124, 125

Morley (Derbys.) 6, 73, 230, Fig. 52

Morpeth (Northumberland) 68

Morris, William 244

Mortimer, Roger de, Archdeacon of Wells 167

Mortmain, Statute of 89

Moses 68, 70, 101, 119, 125, 223, Fig. 48

Moses, Rabbi 101

Mottisfont (Hants.) 230

mottoes 5, 19, 95–6, 97, 212, Figs 76–7,

Moulton (Norfolk) 80

Mount Athos 72

Mulbarton (Norfolk) 196

Munich (Germany) Bayerische

Staatsbibl. clm 4453 (*Gospels of Otto III*) 109

Musaeus 101

Mussy-sur-Seine (France) 129

Naasson 123

Nackington (Kent) 137, 139

Nathan 110

Nativity *see* Christ

Neile, Richard, Archbishop of York 235

Nelson, Philip 245

Nether Poppleton (N. Yorks.) 158

Netherseal (Derbys.) 155

Nether Wallop (Hants.) 108

Nettlestead (Kent) 76

Nevill, Ralph, Earl of Westmorland 171

Neville, George, Bishop of Exeter 193

Newark on Trent (Notts.) 70, 150, 153, 183, Fig. 148

Newbold, Thomas, Abbot of Evesham 19

New Hall (Essex) 220

Newington (Oxon.) 85

Newmarch, John de, 153 Fig. 2(b)

Newminster Abbey (Northumberland) 136

New Testament 65, 67, 68, 119, 120, 121, 150, 215 *see also* Christ, Mary, Saints, typology

Newton, Peter xxv, 111, 113, 182, 246

NEW YORK (USA)

Cloisters Coll. 54.1.2 (*Hours of Jeanne d'Evreux*) 158, Fig 126; Cloisters Coll. 6986 (*Psalter of Bonne of Luxembourg*) 158; Corning Museum of Glass 162; Metropolitan Museum of Art 198; Pierpont Morgan Library M 756 (*Cuerden Psalter*) 153; Public Library MS Spencer 26 (*Tickhill Psalter*) 155, 160

Nicholas of Verdun, goldsmith 123

Nichomacus 101

Nine Orders of Angels *see under* Angels

Nix, Richard, Bishop of Norwich 217

Noah, 70, 139

Norbury (Derbys.) 87, 97, 153, Fig. 123

Norrey-en-Auge (France) 139

Norreys, Sir John 97

Northampton, Earls of, Bohun family 93

Northampton, Great Hall 93

North Moreton (Oxon.) 11, 63, 73, 150, 153

North Tuddenham (Norfolk) 73, 184, 196, Figs 151, 152

Norton (Suffolk) 199

NORWICH (Norfolk)

Cathedral 181, 184; Dominican church 84; glaziers 40–2, 195–9, 234; St Andrew's 84, Fig. 67; St Augustine's 231; St George Colegate 231; St John Maddermarket 198; St John's Bere Street 230; St Mary at Coslany 231; St Michael-at-Coslany 97, Pl. XXIV; St Michael-at-Plea 231; St Peter Hungate 85; St Peter Mancroft 73, 195, 196, 198, Fig. 166; t Stephen's 234

*Nunc dimittis* 65, 85

Obazine Abbey (France) 128, 129

Ockwells (Berks.) 19, 96, 97 Fig. 76

O'Connor, David 124

Oddingley (Heref. & Worcs.) 49, 78, 203, Pl. IIIa, Fig. 173

Okeover (Staffs.) 155, 167

Old Buckenham (Norfolk) 85

Old Testament 65, 67, 68, 70, 78, 96, 113, 117, 119, 120, 125, 139, 150, 157, 181, 210, 215, 224 *see also* Creation, Prophets, typology

Old Warden (Beds.) 11, 19, 169, 174, 180, Fig. 137

Oppenheim (Germany) 169, Fig. 136

Orbais (France) 121

Orchardleigh (Somerset) 184

*Ormesby Psalter see* Oxford, Bodleian Library

Orpheus 101

*Oscott Psalter see* London, British Library

Osric, founder of Gloucester Abbey 88

Oxenbridge, Sir Goddard 223

Oxenbridge, John, canon of St George's Chapel, Windsor 223

OXFORD

All Souls College 47, 49, 63, 88, 89, 99, 173, 188, 190, Figs 44, 45, 61; Balliol College 61, 73, 99, 220, 222, 236; Bodleian Library 76, 177; Bodleian Library, manuscripts in: Bodley 264 (*Romance of Alexander*) 160; Bodley 717 (*Jerome's Commentary on Isaiah*) 108; Digby 227 (*Abingdom Missal*) 193; Don. d.85 (psalter) 184, Fig. 151; Douce 180 (*Douce Apocalypse*) 144; Douce 366 (*Ormesby Psalter*) 157; Gough Liturg. 2 (*Gough Psalter*) 115, 117, Fig. 91; Liturg. 198 (psalter) Fig. 128; Top. Yorks c14, Fig. 31(c)

Canterbury College 173; Cardinal College 25, 207, 220, 222; Castle 93; Christ Church Cathedral 55, 72, 76, 162, 229, 235, 236, 238, Figs 57, 130; Exeter College MS 47, 169; Franciscan church 11 Pl. X; Lincoln College 235; Magdalen College 235; Merton College 16, 64, 99, 147, 148, 150, 154, 157, 178, Pl. XII, Figs 80, 123, 142; New College 4, 37, 42, 46, 64, 81, 171, 173, 174, 176, 178, Figs 141, 144(b); The Queen's College 236; St Mary's 173; St Michael's 141, 143, Fig. 115; Trinity College, Old Library 26(n45); University College 236; University College MS 165 (Bede's *Life of St Cuthbert*) 108; Wadham College 235

PAINTERS
Bertram of Hamburg 176; Burne-Jones, Edward 244; Christus, Petrus 205; Duccio 158; Dürer, Albrecht 46, 61, 217, 220, 222; Eyck, Jan van 211; Ferrer, Bonifacio 79; Gilbert 206; Goes, Hugo van der 205; Herebright of Cologne 176; Johnson, Thomas 240, Fig. 196; Master of St Veronica 176; Memling, Hans 205, 211; Orley, Bernard van 222; Parker, William 206; Peyntour, Hugh of St Albans 157; Sedgewick, William 236, 239, Figs 12, 73, 198; Soest, Conrad van 176; Weyden Rogier van der 236
Palladius 101
*Paris Apocalypse see* Paris, Bibliothèque Nationale
PARIS
Bibliothèque Nationale, manuscripts in:
fr 403 (*Paris Apocalypse*) 143; Lat. 765 (*Fitzwarin Psalter*) 160, 169; Lat. 8846 (*Canterbury Psalter*) 123; Lat. 10483-4 (*Belleville Breviary*) 158; Nouv. Acq. Lat. 3145 (*Hours of Jeanne de Navarre*) 158
Musée de Cluny 140; Notre-Dame Cathedral 124, 144; St-Chapelle 40, 135, 136, 147, 243
Parlett, Dame Elizabeth 235
Patrick Brompton (N. Yorks.) 153
Peada, King of Mercia 88, 90
Pecham, John, Archbishop of Canterbury 78

Pelican 212
Penrith (Cumbria) 171
Pentecost *see* Christ
*Pepysian Sketchbook see* Cambridge, Magdalene College
Percy family 5, 187
Peter de Crescentiis 101
Peterborough Cathedral (Cambs.) 5, 67, 88, 90, 113, 180, 201, 237
*Peterborough Psalter see* Brussels Bibliothèque Royale
Petham (Kent) 129, 133, 137, 139, 140, 148
Philipot, John (Somerset Herald) 238
*Pictor in Carmine* 61, 67
Pie, John and Alice 6
*Pietà* 65, Figs 4, 46
Pipewell Abbey (Northants.) 40
Pittington (Co. Durham) 200
Plato 101
Ploermel, Carmelite monastery (France) 21
Poitiers Cathedral (France) 10, 110
Pole, Francis 230
Pole, Reginald, Cardinal 231
Poling (W. Sussex) 112, Fig. 87
Ponteland (Northumberland) 159
Pontigny, Abbey (France) 129
Poore, Richard, Bishop of Salisbury 126
Pope, Sir Thomas 235
Porphyry 101
Portchester Castle (Hants.) 93
Potter Heigham (Norfolk) 80
Powell, Revd Thomas 240
Prees (Salop) 82, 187
Preston near Faversham (Kent) 129, 137
prices and payments 22-3, 25, 31, 44, 47, 48-51, 92, 173, 201, 207, 217, 231, 232
*Pricke of Conscience* 82, 182, Fig. 66
Priscian 101
Prophets 25, 49, 68, 98, 99, 119, 122, 140, 153, 165, 183, 188, 193, 201, 206, 211, 215, 217, 235, Pl. XIII, Figs 40, 85, 93, 157, 190; *see also under* Tree of Jesse and names
*Protoevangelium of St James* 70
Prudde, John *see* glass-painters
Prynne, William 236
*Psalter of Bonne of Luxembourg see* New York, Cloisters Collection
*Psalter and Hours of John Duke of Bedford see* London, British Library
Ptolemy 101
Pucelle, Jean *see* manuscript illuminators

Pugin, Augustus 244
*Puiset Bible see* Durham Cathedral Library
Puiset, Hugh du, Bishop of Durham 113
Pulham St Mary (Norfolk) 196
punning devices 19, Figs 15, 16
Pythagoras 101

quarries 19, 20, 48, 96, 97, 99, 129, 133, 136, 167, 169, 190, 193, 213, 215, 232, Frontispiece, Figs 15, 16, 19, 73, 80, 104(a)
*Queen Mary Psalter see* London, British Library
Queenborough Castle (Kent) 93
Quérière, Eustache de la 243
Quidenham (Norfolk) 80

Raby Castle (Co. Durham) 243
Radnor, Lord 243
Ramsey Abbey (Cambs.) 40
Ranworth (Norfolk) 198
Raphael, archangel 85
Ratcliffe, Roger 96, 224
Rattlesden, Thomas, Abbot of Bury St Edmunds 5, 13, Fig. 169
Raunds (Northants) 170
Ravenna (Italy), San Vitale 108
Read, Herbert 245
Reading (Berks.) 75, 231
rebuses 19, 88, 95, 99, 225, Figs 15, 16
repairs of medieval glass 39, 50, Pls II(d), XIX
Repton (Derbys.) 105, 106
Restwold family 202
Resurrection of Dead 81, Fig. 63
*Reuner Musterbuch see* Vienna, Nationalbibliothek
re-use of glass 40, 99, 110, 113-17, 154, 158, 178, 222, 230, Pls V, XIII, Figs 50, 89-91, 101(c), (d), 125, 144(a)
Revelation, Book of 59, 82, 176, 181, Figs 65, 145
Rheims (France): Cathedral 127, 135, 143, 144; St-Rémi Abbey 109, 115, 121, 124
Richard I 89, 123
Richard II 95, 174, 180
Richard III 5
Richard, Duke of York *see* York, Dukes of,
Richard of Bury, Bishop of Durham 157
Richmond Palace *see* London, Richmond Palace

Rievaulx Abbey (N. Yorks.) 110, 111, 128, 136

Riplingham, Robert de, Chancellor of York Minster 4, 153

Ripon Minster (N. Yorks.) 200

*Rites of Durham* 230, 238

Rivenhall (Essex) 243

Roboam 110

Rochester Castle (Kent) 10, 93

Rockingham Castle (Northants) 40

Roger of Pont l'Eveque, Archbishop of York 117

Rokeby, Richard 226

Rokeby, William, Archbishop of Dublin 226

Rolls of Arms 87

*Romance of Alexander see* Oxford, Bodleian Library

Roper, John 20, 25

Ross-on-Wye (Heref. & Worcs.) 16, 187, Fig. 13

Rouen (France): Cathedral 124, 136, 158, 167; Château 142, 148; St-Ouen Abbey 76, 158, 160; St Vincent's 37

roundels 21, 49, 97, 98, Pl. XXIV, Figs 18, 79, 80

Rowland, Revd W.G., curate of Holy Cross, Shrewsbury 243

Rumworth, Henry, rector of Horley 13

Rushforth, G. McN. 245

Russell, John, Bishop of Lincoln 206

Ruyhale family 19, 171, Fig. 139

Rymius/Brunus Lasca 101

saddle-bars (*soudeletts*) 37

SAINTS
Agnes 11; Alban 20, 61, 73, 194; Alphege 120; Amphibalus 20, 73; Andrew 72, 73, Fig. 53; Anne 16, 63, 70, 71, 74, 75, 96, 177, 178, 194, 203, 206, 210, Figs 13, 43, 45, 56, 142 *see also* Holy Kindred, Joachim, Mary; Anthony 73; Apollonia 74; Athanasius 101; Augustine of Canterbury 101; Augustine of Hippo 101; Barbara 74, 193, 226; Benedict 40, 101, 114, 212; Bernard of Clairvaux 243; Bernard of Monte Cassino 101; Birinus 76, 136, Pl. IX; Blaise 74, 75; Catherine of Alexandria 63, 65, 72, 73, 74, 96, 139, 153, 162, 182, 193, 194, 203, 206, 220, 222, 226, Figs 33(d), 109, 128, 130, 163, 186; Chad 63, 187; Christopher 60, 61, 63, 65, 72, 74,
171, 178, 202, 206, Figs 42, 171; Clement, Pl. III(b); Clere 76; Cuthbert 72, 76, 125, 140, 162, 230, Figs 41, 107; Denis 72, 125; Dorothy 63, 206; Dunstan 120; Edith 90; Edmund of Abingdon Fig. 115; Edmund of East Anglia 72, 76, 85, 88, 93, 115, 139, 178, 199, Figs 135, 169; Edward the Confessor 6, 48, 76, 88–9, 93, 108, 134, 135, 178f, Figs 135, 144(a); Edward the Martyr 88; Elizabeth 96; Elizabeth of Hungary 196; Etheldreda of Ely 64, 72, 125; Eustace 93; Francis 65, 196; George 48, 61, 63, 65, 73, 75, 90, 96, 165, 171, 177, 184, 187, 196, 203, 209, 220, 226, Figs 42, 135, 151, 191; Germanus 76; Gregory the Great 120, 186, 238, Fig. 122; Guthlac 65, Fig. 97; Helena 75, 178, 200, 224, Pl. XXIII, Fig. 160; Hugh of Lincoln 125, 139; James 125, 139; James the Greater 64, 143, 186, 223, Fig. 114; Jerome 99; John the Baptist 12, 20, 34, 48, 72, 73, 74, 126, 134, 141, 143, 169, 186, 187, 212, 224, Figs 111, 136, 189 *see also* Zacharias; John of Beverley 76; John of Bridlington 61, 76, 194; John Chrysostom 101; John the Evangelist 6, 48, 59, 76, 81, 82, 93, 96, 125, 140, 176, 178, 181, 196, 203, Pls VIII(b), XVI, Figs 65, 145; Joseph 71; Lalluwy 76; Lawrence 65, 72, 74, 178; Leonard 74, Fig. 55; Luke 42; Mabena 76, Fig. 4; Mancus 76; Margaret 73, 74, 162, 184, 196, 203, Fig. 152; Martin 72, 73, 114, 120, 124, 185, 193, 203, Pl. III(a), Fig. 54; Mary of Egypt 150; Mary Magdalene 72, 150, Fig. 168; Matthew 115, 124, 125, Fig. 162; Meubred 76, Fig. 4; Michael, archangel 81, 85, 96, 108, 111, 112, Fig. 86; Mildred 232; Nicholas 20, 63, 73, 74, 101, 114, 115, 124, 125, 134, 135, 187, 212, Pl. V, Figs 90, 106, 181; Nicholas Trivet 101; Oswald 72, 88, 115, 209; Paul 72, 101, 102, 201, 215, 226, Figs 124, 184, 192; Paulinus, Bishop of York 63, Fig. 40; Peter the Apostle 34, 71, 63, 72, 81, 82, 101, 124, 196, 198, 201, 226, Figs 98, 184, 185, 200; Peter the Desacon 63, 226; Peter the Exorcist 63, 226; Peter
Martyr 64, 72, Fig. 162; Philip 11; Richarius 114; Robert of Knaresborough 73, Fig. 52; Roche 74, 203, Fig. 172; Sidwell 63, 76, 178, Fig. 44; Sigismund 115; Sitha 212, Fig. 180; Stephen 63, 72, 74, 126, 127, 134, 135, 235, Pl. IX, Fig. 99; Thomas the Apostle 48, 72, Figs 51, 60, 141; Thomas Becket 27, 39, 61, 73, 75, 76, 78, 120, 121, 122, 124, 153, 194, 230, 232, 238, Pls II(c), III(d), Figs 57, 58, 96; Thomas Cantilupe, Bishop of Hereford 76, 78, 129, 153, Fig. 58; Vincent 72; Wilfrid 3, 105, 226; William of York 25, 73, 76, 78, 226, pl. XX; Winifred 61, 187, 194; Wulfstan, Bishop of Worcester 65, 73, 76, 90, Fig. 74

St Albans (Herts.): Abbey 67, 101, 113; St Peter's church 73

St Benet-at-Holme Abbey (Norfolk) 40

St-Denis Abbey (France) 112, 115, 117, 126, 243

St George, Richard, (Clarenceux Herald) 238

St-Germer-de-Fly (France) 144

St John, Lord 231

St Kew (Cornwall) 68, 70

St Neot (Cornwall) 6, 47, 64, 70, 73, 76, Fig. 4

St-Omer Abbey (France) 108

*St Omer Psalter see* London, British Library

St-Quentin (France) 121, 124

Salehurst (E. Sussex) 33, Fig. 24(b)

SALISBURY (Wilts.)
Cathedral 55, 63, 68, 93, 113, 125–33, 135, 136, 142, 232, 241, Figs 99, 101(a), 101(b), 102(b); chapter house 126, 127, 135, 141, 142, 143, Figs 113, 114; St Edmund's 61, 236

*Salisbury Roll see* London, British Library

Salle (Norfolk) 184, 188, Fig. 157

Sallust 101

Salome 72

Sampford Courtenay (Devon) 222

Samson Fig. 48

Sandys, Lord William 222

Sandiacre (Derbys.) 155

San Vincenzo al Volturno (Italy) 109

Sarum Breviary 85

Sarum Gradual 194

Sarum Master *see* manuscript illuminators

Sarum Missal 194

Sauerländer, Willibald 176

Savile family 82

Saxham Hall (Suffolk) 102

Saxlingham Nethergate (Norfolk) 135, 139, 140, 170, 184, 196

Scheerre, Herman *see* manuscript illuminators

Schon, Erhard of Nuremberg, engraver 25,

Schwarzach (Germany) 109

Scrope, Henry, Lord of Masham 169, 181

Scrope, Richard, Archbishop of York 77-8, Fig. 59

Scrope, Stephen, Archdeacon of Richmond 78

sculptors:
'Antitue' Master of Rheims 123; Beauneveu, Andre 176; Maiano, Giovanni da 219; Nunziata, Antonio Totri del 219-20; Torrigiano 219

Sealwys, John 20

Sedgwick, William, *Howard Genealogy* 239, Fig 198

Sées Cathedral (France) 148

Selby Abbey (N. Yorks.) 158

Selling (Kent) 86-7, 147, 148, Fig. 120

Semer, Robert, vicar of St Martin-le-Grand, York 73, 185

Seneca 102

Sens Cathedral, (France) 37, 75, 121, 123, 124, 127

service books 72

Séry-les-Mézières (France) 109

Seven Sacraments 6, 20, 61, 65, 79, 97, 194, 201, 203, Pls II(b), III(c), Fig. 79

Seven Works of Mercy 61, 79, 80, 87, 182, 201, Figs 61, 146

Seymour, Jane, wife of Henry VIII 224

Shelton (Norfolk) 88, 225

Shelton family 88, 225

Shene Palace (Surrey) 36, 47, 48, 49, 93, 96, 207

shepherds, Annunciation to 71, Fig. 50

Sherborne (Dorset): Abbey 47, 192, 193, Fig. 161; almshouse of SS John the Baptist & John the Evangelist 102

*Sherborne Missal,* (Alnwick, collection of the Duke of Northumberland)

Sherfield, Henry, Recorder of Salisbury 236

Sheriff Hutton Castle (N. Yorks.) 31

shields of arms *see* heraldry

Shorton, Robert, Master of St John's College, Cambridge 21, 23

Shrewsbury (Salop.): Battle of 187; St Mary's 13, 243

Sibyls 224

Sichem (Belgium) 176

Siena Cathedral (Italy) 158

Siferwas, John *see* manuscript illuminators

Silkstede, Thomas, Prior of Winchester 206, 212

Sitten, Notre-Dame de Valère (Switzerland) 128

Skelton, Robert, Chamberlain of York 12, Frontispiece

Skirlaw, Walter, Bishop of Durham 82, 89, 181, 230

Smith, William, Bishop of Lincoln 19, 97

Smyth, William 99

Soissons Cathedral (France) 121, 124

Solomon 102, 201, 211, Figs 82, 136

Solomon, Rabbi 101

Southampton (Hants), Hamwih 92

South Creake (Norfolk) 85

Southfleet (Kent) 4

Southwell Minster (Notts), chapter house 145, 147

Southwick Hall (Northants.) 93

Sparrow family 6

*Speculum Humanae Salvationis* 68, 217

Spencer, Sir John 224

Spofford, Thomas, Bishop of Hereford 16, 187, Fig. 13

Stafford, John, Bishop of Bath and Wells 78

Stafford, Sir Henry 202

Stambourne (Essex) 225

Stamford (Lincs.): All Saints 240; Browne's Hospital 85, 102, 201, 232, Figs 82, 170; St George's 20, 73, 90, 194, Figs 73, 163; St John's 64, 194, Figs 24(d), 162; St Martin's 201, 206, 243, Figs 48, 175

stanchions 37

Stanford on Avon (Northants.) xxv, 21, 46, 75, 81, 85, 87, 150, 153, 154, 155, 157, 180, 234, Figs 18, 56, 62, 124, 200

Stanton Harcourt (Oxon.) 141, 142, 143, 145, 148, 150, Fig. 114

Stanton St John (Oxon.) 71, 147, Figs 70, 119

Stapleton, Miles de 63, 150

Star Chamber, Court of 61

Stathum, Sir Thomas, brass of 6

Steinfeld Abbey (Germany) 243

Stockbury, (Kent) 129, 133, 137, Fig. 104(c)

Stockerston (Leics.) 202, Pl. III(b), Fig. 171

Stodmarsh (Kent) 129, 137

Stody (Norfolk) 198

Stoke Charity (Hants.) 19, 169, 174

Stoke-by-Nyland (Suffolk) 237, 239, Fig 198

Stopham (W. Sussex) 235, Fig. 194

Stopham, William de 235

Stothard, Charles 240

Stottesdon, (Salop.) 89-90, Fig. 72

Stow (Lincs.) 17

Stowbardolph (Norfolk) 133, Fig. 104(b)

Stowe's *Survey of London* 238

Strasbourg (France), Musée de l'Oeuvre Notre Dame 109

Stretton Sugwas (Heref. & Worcs.) Bishop's chapel 187

Stubbs, Lawrence 220, 222

Stubbs, Richard, Master of Balliol College, Oxford 220, 222

Stukeley, William, rector of All Saints, Stamford 240

Suger, Abbot of St-Denis (France) 118

Surfleet (Lincs.) 54

Sutton family 93

Swannington Court (Norfolk) 80

Symonds, Richard 99

Tame family 4, 212

Tamworth (Staffs.) 90

Tattershall (Lincs.) 4, 17, 19, 41, 42, 44, 49, 51, 64, 65, 67, 68, 73, 80, 85, 192, 200-4, 205, 241, 243, Pls II(b), III(c), XXIII, Figs 15, 48, 61

Taverham (Norfolk) 85

Tavistock (Devon) 232

techniques of glass-painting 31-40

*Te Deum* 61, 85, Fig. 68

Tenterden (Kent) 232

Tewkesbury Abbey (Glos.) 11, 64, 84, 89, 141, 150, 158, 164-5, 166, 167, 168, 169, 229, Pl. XVIII, Fig. 2(d)

Thaxted (Essex) 70

Thenford (Northants.) 75, 177, 178, Fig. 142

Theophilus and the Virgin, 71, 139, Fig. 98

Theophilus, *De Diversis Artibus* 28, 33, 39, 109, 112

Thetford (Norfolk) 92, 106

Thomas of Bayeux, Archbishop of York 108

Thomas of Lancaster *see* Lancaster, Dukes and Earls of

Thomas Glasier of Oxford *see* glass-painters

Thoresby, John, Archbishop of York 78

Thornhill (W. Yorks.) 82, 185-6, 200, 206, 226

Thornton, John, of Coventry and York *see* glass-painters

*Thornham Parva Retable* 168

Three Living and Three Dead Kings 17, 84

Throgmorton family 225

Thurcaston (Leics.) 182, Pl. XXI

Thurton (Norfolk), Trinity 196

Ticehurst (E. Sussex) 82, Fig. 64

Tickhill, John, Prior of Worksop 155

*Tickhill Psalter see* New York, Public Library

Tidenham (Glos.) 230

tiles and stained glass 55, 128, Figs 33(c), 36, 38

Titchfield (Hants.) 230

Tong (Salop) 39, 182

Torre, James 239

Toulouse (France), Austin Friars 54

Tours Cathedral (France) 148

transporting of glass, 50-1, 173

Tree of Jesse 40, 54, 65, 67, 68, 93, 113, 114, 115, 117, 120, 123, 125, 126, 137, 139, 140, 150, 157, 162, 164, 170, 173, 174, 182, 206, 209, 226, Pl. VII, Figs 35, 49, 88, 108, 125, 131, 144(b)

Trinity 34, 48, 85, 93, 170, 232, 235, 237, 238, Figs 26, 138

Troyes (France): Cathedral 115, 121, 124, 139; St-Urbain 142, 144, 148, 150

True Cross, legend of 64, 73, 75, Pl XXIII

Tunnoc, Richard, goldsmith and bell-founder 5, Fig. 1

Twycross (Leics.) 243

typology 61, 67-8, 70, 117, 120, 123, 125, 201, 211, 215, 217, Pls XXVIII, XXIX, Figs 48, 94-5; *see also* Old and New Testaments

Upper Hardres (Kent) 10, 17, Fig. 6

Uriel, archangel 85

*Utrecht Psalter see* Paris, Bibliothèque Nationale

Vale Royal Abbey (Cheshire) 30

Valencia (Spain) 52, 79

Valkenburg, Beatrix van 11, 145, Pl. X

Vavasour family, 5

Vere, John de, Earl of Oxford 97

Verney, Lady Anne 235, Fig. 193

Vernon, Sir Richard and Benedicta 96

Verulam Collection, Earl of 205

*vidimus* 24, 25, 27, 31, 61, 207, 217, 222, Figs 21, 176, 184

Vienna, Osterreich. Naionalbibliotheki Cod. 507 (*Reuner Musterbuch*) 55; Cod. 1826 (psalter), 160, 165

Virgil 101

Virgin *see* Mary

Voragine, Jacobus de, *Legenda aurea*, 61, 72

Vulgate 99

Vyne, The (Hants.) 222, Fig. 187

Walberswick (Suffolk) 6

wall-painting 17, 51, 52, 55, 61, 65, 79, 80, 84, 108, 110, 139, 157, 160, 168, 174, 206, 235

Walpole, Horace 241, 243

Walsingham (Norfolk) Chapel of Our Lady 22, 207

Waltheof, Prior of Kirkham 110, 111

Warden Abbey (Beds.) 111, 136

Warenne family 54, Fig. 34

Warham St Mary (Norfolk) 196

Warndon (Heref. & Worcs.) 33, 148, Pl. I

Warrington, William 244

Warwick: Castle chapel 201; Earl of, Richard Beauchamp 5, 14, 61, 188, 194, Fig. 10; St Mary's, Beauchamp Chapel 4, 14, 23, 24, 30, 39, 44, 46, 47, 49, 51, 61, 85, 188, 189, 190, 192, 194, 203, Pls II(c), III(d), Figs 11, 69, 164

Waryn family 6

Waterperry (Oxon.) 13, 17, 129, Fig. 10

Wayment, Hilary 211, 217

Waynflete, William, Bishop of Winchester 42, 203

Wells Cathedral (Somerset) 3, 37, 60, 64, 75, 81, 88, 99, 141, 145, 148, 150, 153, 156-7, 158, 164, 166, 169, 171, 243, Pl. XIV, Figs 8, 28, 63, 118, 122

Wenlock, Sir John 194

Wensley (N. Yorkshire), wall-paintings 17

Werden Abbey (Germany) 109

Weseham, Roger de, Bishop of Lichfield 78

West Horsley (Surrey) 55, 72, 137, 139, 140, 148, 171, Fig. 109

West Rudham (Norfolk) 184, 196, Fig. 153

Westlake, N.H.J. 245

Westminster: Abbey 4, 24, 31, 36, 37, 41, 42, 48, 55, 72, 76, 93, 108, 113, 124, 127, 128, 129, 133-6, 142, 144, 192, 203, 204, 213, 215, 217, 230, Pl. IX, Figs 5, 33(b), 102(c), 106, 174; chapter house 135, 141, 143, 176; glazier's lodge 34; Henry VII's Chapel 64, 67, 87f, 212, 213, 215, 217, Figs 182, 183; MS 37 (*Lytlington Missal*) 171, 174, Fig. 140; Palace 21, 47, 48, 49, 92, 93, 134, 180, 207; St Margaret's 14, 87, 209, 220, 224, Fig. 186; St Stephen's Chapel 4, 30, 31, 33, 34, 36, 37, 38, 41, 44, 50, 51, 161, 166, Fig. 129

*Westminster Retable* 143, 148

Weston Underwood (Bucks.), 169, 170

Westwell (Kent) 68, 129, 136, 137, 139, 140, 231, Figs 104(a), 108

West Wickham (Kent) 16, 63, 206, Figs 14, 43

Westwood (Wilts.) Fig. 46

Wetheral (Cumbria) 200

Wetherset, Richard de, Archbishop of Canterbury 79

Whetehamstede, John de, Abbot of St Albans 67, 101

Whitby Abbey (N. Yorks.) 105, 182

White Notley (Essex) 139

White, Francis, Bishop of Norwich 235

Whitehall Palace *see* London, York Place

Wickhambreaux (Kent) 72, 169, Fig. 136

Wickhampton (Norfolk) 80

Wighton (Norfolk) 198

Wigston, Roger, Mayor of Leicester 97

Wilfrid, Bishop of York *see* St Wilfrid

William I 89, 90, 180

William, Abbot of St Alban's 113

William the Englishman, mason of Canterbury 118

William of Malmesbury 110

William, physician 101
William of Sens, mason of Canterbury 118
Williams, Henry, vicar of Stanford on Avon 21, Fig. 18
Willoughby family 160
Wilson, Christopher 135
Wilton (Wilts.) 243
*Wilton Diptych* (London, National Gallery) 178
WINCHESTER (Hants.)
  *Winchester Bible* (Winchester Cathedral Library) 123; Bishops of *see* Aelfheah; Aethelwold; Edington; Fox; Waynflete; Wykeham; Castle 92, 93; Cathedral 21, 168, 169, 177, 178, 206, 212–13, 215, 217, Fig. 180; College 4, 12, 37, 39, 42, 44, 46, 47, 50, 51, 64, 81, 173, 174, 176, 178, 180, 191, 244, Pls II(d), XIX, Figs 31(a), 160; Lower Brook Street 106; New Minster 3, 106, 107, Pl. IV; Nunnaminster 106, 107, Pl. IV; Old Minster 3, 106, 107, Pl. IV; St Cross Hospital 101; Westgate 47, Fig. 31(b); Wolvesey Palace 93, 94
Windermere (Cumbria) 200, 226
Windsor (Berks.): Castle 48, 93, 95, 207; St George's (and other) chapels 5, 19, 30, 31, 41, 56, 144, 209, Figs 39, 177
Wing (Bucks.) 54, 230, Fig. 34
Wingfield, Sir Robert 198, Fig. 167
Winscombe (Avon) 8, 63, 226–7
Winston, Charles 127, 137, 244–5, Figs 56, 101(a), 101(b), 102(b), 104, 109, 114, 121, 124, 150, 200
Wisbech, John of, monk of Ely 159
Wissembourg Abbey (France) 109
Withcote (Leics.) 96, 224, Fig. 190

Witley (Surrey) 112
Wixford (Warwicks.) 182
Woburn Abbey (Beds.) 230
Woking (Surrey), royal manor 207
Wolfe, Thomas, rector of Frolesworth 183
Wolseley nr Rugeley (Staffs.) 30
Wolsey, Thomas, Cardinal 25, 61, 96, 97, 207, 220, 222, 226
Wolveden, Canon Robert 63, Fig. 40
Wood Walton (Cambs.) 153, Fig. 33d
Woodchurch (Kent) 137, 139
Woodforde, Christopher 245
Woodstock Palace (Oxon.) 207
Worcester, Bishops of, *see* Alcock; Cantilupe; St Wulfstan
Worcester Cathedral 5, 63, 73, 76, 89, 162
Works of Mercy *see* Seven Works of Mercy
Wormald, Francis xxv
Wormshill (Kent) 170
Wroxall (Warwicks.) 12, 229
Wyatt, James 241
Wycliffe (N. Yorks.) 169
Wycliffe, John 229
Wykeham, William of, Bishop of Winchester 4, 12, 21, 39, 42, 46, 51, 78, 171, 173, 174, 176, 177, 178, Pl. XIX

YORK 180; All Saints North Street 75, 80, 82, 84, 181, 186, Figs 66, 146; Archbishops of *see* Gray; Greenfield; Melton; Neile; Roger of Pont l'Eveque; Scrope; Thomas of Bayeux; Thoresby; Blake Street 41; Duchesses of, Cecily 206; Dukes of, Richard 7, 206; glaziers 34, 41–7, 48,

158, 180–2, 199–200, 226, 234, Figs 30, 31(c), *see also* under glass-painters; Glaziers Trust 111, 246; Holy Trinity Goodramgate 34, 199, Fig. 26; Minster 4, 5, 11, 12, 13, 16, 17, 22, 23, 30, 31, 34, 38, 40, 44, 46, 47, 48, 50, 54, 55, 60, 61, 63, 65, 68, 71, 72, 73, 74, 76, 77, 78, 81, 82, 85, 87, 89, 105, 106, 108, 113–17, 124, 127, 128, 129, 133, 140, 141, 142, 145, 150, 153, 154, 158, 165, 166, 167, 169, 173, 180–1, 182, 183, 185, 186, 200, 226, 237, 239, 243, 246, Pls V, XI, XVI, XX, Figs 1, 2(c), 31(c), 36, 37, 40, 41, 50, 59, 65, 70, 88, 89, 90, 91, 101(c), (d), 105, 126, 144(b), (d), 145, 154; chapter house 55, 70, 71, 72, 141, 143–8, 153, 154, Figs 116, 117; chapter house vestibule 88, 143, 148, 157, Fig. 122; Mystery Plays 234; St Denys Walmgate 12, 71, 129, 139, 167, 182, 185, Frontispiece; St Helen's Stonegate 41, 47, 158, 226, Fig. 30; St John's Ousebridge 158; St Martin-le-Grand, Coney Street 34, 73, 85, 185, Figs 26, 54; St Mary's Abbey 116, 187; St Michael-le-Belfrey 39, 76, 226, Fig. 191; St Michael Spurriergate 39, 182; St Olave's Marygate 185; Stonegate 41; Yorkshire Museum 116, 158, Pl. XV

Zacharias 126–7 *see also* St John the Baptist
Zarnecki, George 115
Zephaniah 99
Zwingli, Huldreich 230